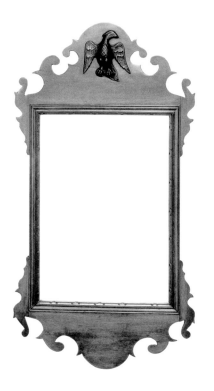

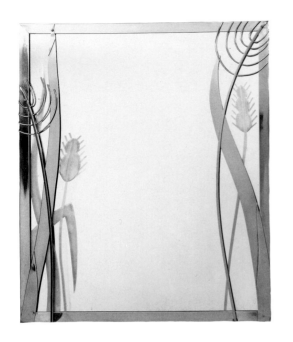

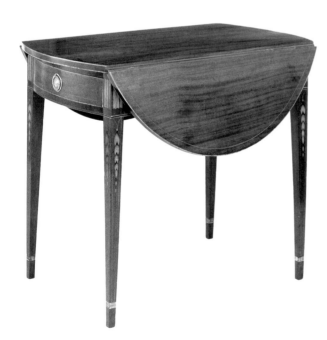

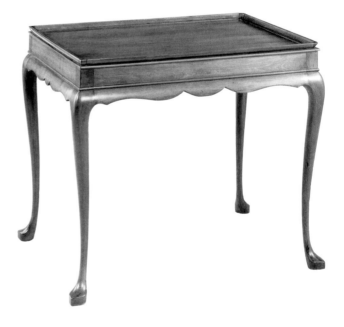

American Tables and Looking Glasses

*in the Mabel Brady Garvan and Other Collections
at Yale University*

By David L. Barquist

Essays by Elisabeth Donaghy Garrett and Gerald W. R. Ward

Photographs by Charles Uht

Yale University Art Gallery · New Haven · Connecticut · 1992

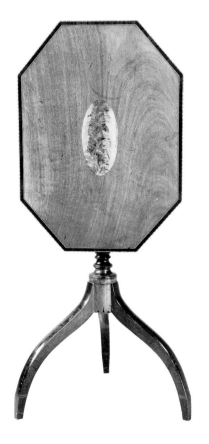

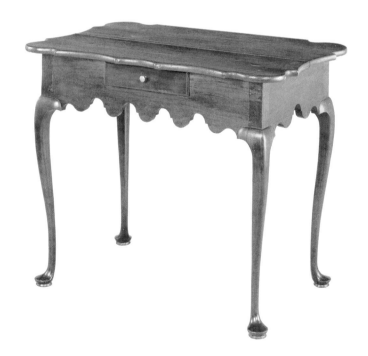

The research for this publication was made possible by a grant
from the National Endowment for the Humanities,
a Federal agency,
and the ongoing support
of the Friends of American Arts at Yale.

Conservation of objects in the catalogue
was supported by gifts from Dr. Benjamin A. Hewitt
and the Dobson Foundation.

The funds for photography were generously contributed
by Dr. Benjamin A. Hewitt,
Mr. and Mrs. George M. Kaufman,
and the Andrew W. Mellon Foundation.

Publication costs were underwritten by a grant
from the National Endowment for the Arts, a Federal agency,
monies from the Garvan Publication Fund,
and gifts from the Virginia and Leonard Marx Publication Fund,
the Chipstone Foundation,
and the Wunsch Americana Foundation.

Library of Congress Catalogue Card Number 91–50993
ISBN 0-300-05240-5

Distributed for Yale University Art Gallery
by Yale University Press, New Haven and London

PRINTED IN THE UNITED STATES OF AMERICA

For my parents, George and Carol Barquist

Contents

9 Foreword *by Mary Gardner Neill*

11 Preface *by Patricia E. Kane*

12 Acknowledgments

14 The Intersections of Life: Tables and Their Social Role *by Gerald W. R. Ward*

26 Looking Glasses in America, 1700–1850 *by Elisabeth Donaghy Garrett*

37 **C A T A L O G U E**

38 Notes to the Catalogue

39 Color Plates

69 **Tables**

69 Stationary Tops

69 Without Drawers

73 *Pedestal Bases*

80 *Pier Tables*

89 *Square Tea Tables*

94 *Low Tables*

101 With Drawers

118 **Tops with Falling Leaves**

118 Pivot Leg Supports

126 Other Pivot Supports

135 Hinged Leg Supports

147 Hinged Fly Supports

164 **Folding Tops: Card Tables**

164 Late Colonial Style

173 Federal Style

174 *New England*

174 Northern New England: Maine, New Hampshire, rural Massachusetts

183 Newburyport, Massachusetts

186 Salem, Massachusetts

191 Boston and environs

206 Providence, Rhode Island

209 *The Middle Atlantic States*

209 New York City

212 Philadelphia

216 Pillar-and-Claw Card Tables

220 Swivel-Top Card Tables

232 **Tops That Turn Up**

250 **Extension Tops**

254 **Other Table Forms**

262 **Related Forms**

267 Basin Stands

271 Carts

274 Work Tables

294 **Looking Glasses**

294 Terminology

294 Connoisseurship

299 **Eighteenth- and Early Nineteenth-Century Looking Glasses**

299 Looking Glasses with Crests with Arched Centers

308 Pediment Looking Glasses

314 Neoclassical Looking Glasses with Openwork Crests

323 Pillar Looking Glasses

338 Looking Glasses from Northern Continental Europe

342 **Later Nineteenth- and Twentieth-Century Mirrors**

342 Rococo Revival Style

342 Colonial Revival Style

349 Modernist Style

354 **Small Looking Glasses and Dressing Glasses**

366 **Study Collection**

366 Misidentified Objects

368 Alterations and Restorations

373 Objects Constructed from Old Parts

378 Fakes

382 **Appendices**

382 A. Diagrams of Terminology

388 B. Woods

389 C. Donors to the Collection

391 D. Dealers Patronized by Francis P. Garvan

393 E. Bibliographical Abbreviations

411 F. Concordance of Art Gallery Accession Numbers and Catalogue Numbers

412 Index

423 Photograph Credits

Foreword

The Yale University Art Gallery is fortunate to possess one of the largest and most important collections of American decorative arts ever assembled. The core of these holdings is the splendid collection given to the University in 1930 by Francis P. Garvan, Class of 1897, in honor of his wife, Mabel Brady Garvan. The Garvan Collection has been augmented in the ensuing six decades by gifts from many alumni and friends of Yale. In this, the fourth volume to record the American furniture, we are particularly grateful to those donors who have added significant tables and looking glasses to the collection: Mr. and Mrs. Henry A. Bartels, Waldron Phoenix Belknap, Jr., Millicent Todd Bingham, Abraham Bishop, Mr. and Mrs. W. Scott Braznell, C. Sanford Bull, Edward P. Eggleston, Mr. and Mrs. John J. Evans, Jr., Thomas W. Farnam, Marshall Field, the Estate of Bernard W. Fischer, Julian H. Fisher, Martin and Judith Foreman, Mr. and Mrs. Richard E. Kuehne, Herman W. Liebert, Mr. and Mrs. John E. Loeb, Mrs. Clark McIlwaine, Mr. and Mrs. Kenneth Milne, Mr. and Mrs. Gifford Phillips, Mrs. Andrew C. Ritchie, Stewart Rosenblum, Mrs. Roswell Skeel, Jr., Keith Smith, Jr., Mary Byers Smith, Theodore H. Stebbins, Jr., Charles Stetson, Mr. and Mrs. Richard Stiner, Henry H. Strong, Mr. and Mrs. John Walton, A. Pennington Whitehead, and Mrs. Glen Wright. Prominently featured in this book are the important gifts of Olive Louise Dann; Doris M. Brixey, the daughter of a Yale alumnus; and Benjamin A. Hewitt, Class of 1943, Ph.D. 1952. The avant-garde furniture commissioned by Marie-Louise and J. Marshall Osborn, Lecturer in English at Yale, has enriched the Art Gallery's holdings in twentieth-century decorative arts as the gift of their sons, J. Marshall and Thomas M. Osborn. Important documented objects collected by Charles F. Montgomery, Curator of the Garvan and Related Collections at the Art Gallery and Professor of the History of Art at Yale from 1970 to 1978, have come to the Art Gallery through the generosity of his wife, Florence M. Montgomery.

Detailed, scholarly catalogues that are so essential to a university museum and its audience have become increasingly difficult to realize without considerable financial support. The costs of conserving objects in this catalogue were met by gifts from Benjamin A. Hewitt and the Dobson Foundation, which has supported conservation of American art at the Art Gallery for two decades. Funds to cover the cost of black-and-white photography were provided by Mr. and Mrs. George M. Kaufman and the Andrew W. Mellon Foundation. The color photography was funded by Dr. Hewitt. Preparation of the manuscript was made possible by a grant from the National Endowment for the Humanities. The National Endowment for the Arts supported the costs of publication, with matching funds provided by the Virginia and Leonard Marx Publication Fund, the Chipstone Foundation, and the Wunsch Americana Foundation. Graduate students who assisted with the research for this catalogue received fellowships from Mr. and Mrs. Philip Holzer, the Rose Herrick Jackson Fund of The New Haven Foundation, and the Marcia Brady Tucker Fund. Many expenses were met with general operating revenues of the American Arts Office, which has been blessed with the steadfast support of the Friends of American Arts at Yale. To all these individuals and organizations, we are deeply grateful.

The catalogue is the work of David L. Barquist, Associate Curator of American Decorative Arts. David is an exceptionally gifted connoisseur, curator, and scholar; he, more than any other individual, is responsible for the high quality of this volume. Its preparation has also involved many staff members of the Art Gallery and other institutions, as well as other colleagues and scholars. Some have made a direct contribution of their special talents to the final product. Patricia E. Kane, Curator of American Decorative Arts, has been a guiding force behind the four stellar volumes of Yale's furniture catalogue. Elisabeth Donaghy Garrett, Director of Sotheby's Educational Studies, generously agreed to take time from her busy schedule to write one of the introductory essays. We have been particularly fortunate to draw once again upon the skills of friends who have shared in the creation of many Art Gallery publications: Greer Allen, designer; R. Bruce Hoadley, Professor of Forestry and Wood Technology, University of Massachusetts, Amherst; Sheila Schwartz, editor; Charles Uht, photographer; and Gerald W.R. Ward, Curator, Strawbery Banke Museum, Portsmouth, New Hampshire. To them, and to many others who contributed to this publication in ways large and small, we extend our heartfelt thanks.

Mary Gardner Neill
The Henry J. Heinz II Director

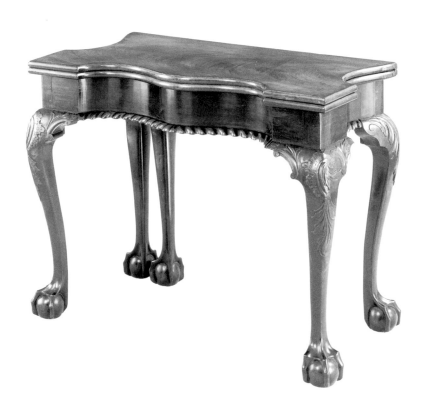

Preface

This publication is the fourth and final volume in the series of catalogues of Yale University's collection of American furniture. The series began in 1973 with *The American Clock, 1725–1865: The Mabel Brady Garvan and Other Collections at Yale University*, coauthored by Edwin A. Battison and myself. *300 Years of American Seating Furniture: Chairs and Beds from the Mabel Brady Garvan and Other Collections at Yale University*, which I authored, appeared in 1976 and was followed in 1988 by Gerald W.R. Ward's *American Case Furniture in the Mabel Brady Garvan and Other Collections at Yale University*.

The complex history of the preparation of these catalogues began in 1958, when Meyric R. Rogers was named Curator of the Garvan and Related Collections of American Art. With the encouragement and financial support of Mabel Brady Garvan, Rogers undertook the task of bringing the Art Gallery's collection of American decorative arts, then scattered on loan throughout the country, back to New Haven to be studied, conserved, and photographed in preparation for publication. He established the Garvan Furniture Study, a 14,000 square-foot facility in the basement of a building near the Art Gallery, to process and store more than 700 pieces of furniture. In 1961, he hired John T. Kirk as research assistant and Allan I. Ludwig as photographer; in 1962, Emilio Mazzola joined the staff as cabinetmaker in charge of restorations. By the time of Rogers' retirement in 1964, this team had completed the most critical restoration, record photography, and preliminary cataloguing.

Jules D. Prown succeeded Rogers as Curator. During his tenure, John Kirk amplified and refined the manuscript for what was conceived as a one-volume catalogue of the furniture. When Kirk became Director of the Rhode Island Historical Society in 1965, Prown kept the project moving forward by engaging Fernande E. Ross as editor and Marion F. Sandquist as typist. In 1968, I was hired by Prown as Assistant Curator. As part of the ongoing cataloguing process, I spent that summer reviewing condition reports and verifying measurements with Elton W. Hall and Curatorial Assistant D. Roger Howlett. Prown was appointed Director of the proposed Yale Center for British Art in 1968, and Theodore E. Stebbins, Jr., Associate Curator of the Garvan and Related Collections, assumed responsibility for supervising the catalogue project. At the same time, the clock movements, which had been researched and restored by Edwin Battison of the Smithsonian Institution with the support of The National Association of Watch and Clock Collectors, were returned to New Haven. In the spring of 1969, a decision was made to publish the clocks as a separate volume. Following this precedent, the three subsequent volumes were organized around discrete formal categories: seating furniture in volume two, case furniture in volume three, and tables, looking glasses, and related objects in volume four. Although the subsequent authors have naturally reassessed the work of their predecessors, each volume owes a considerable debt to the preliminary work of Rogers and the subsequent cataloguing by Kirk.

This history of publications is also a history of the Art Gallery's long-standing commitment to publications that make its collections available to the widest possible audience. In this regard, David L. Barquist has done a laudable job with the last book in this series. With the assistance of graduate students, he has carefully scrutinized every object and, in the process, has made noteworthy discoveries, such as the signature of the cabinetmaker Robert McGuffin on an important and much-studied Philadelphia work table. In addition, David has provided more detailed provenances than were possible in the earlier catalogues. His painstaking review of Francis P. Garvan's correspondence, given to the Archives of American Art in 1980 by the Garvan family, yielded considerable new information concerning the previous histories of objects in Garvan's collection. He has researched other donors, makers, designers, and manufacturers with equal care. In completing this comprehensive catalogue, he has provided an essential tool of scholarship that faithfully records the physical properties and provenances of these objects. Furthermore, the addition of interpretive essays by Elisabeth Donaghy Garrett and Gerald W.R. Ward enhance the book's usefulness to scholars, educators, students, and others interested in the history of American furniture.

Patricia E. Kane
Curator of American Decorative Arts

Acknowledgments

Many colleagues have participated in the genesis of this catalogue, and several of them deserve special acknowledgment here. Elisabeth Garrett and Gerald Ward wrote thoughtful essays that provide contexts for the individual objects. The wood analyses by Bruce Hoadley were of critical importance to the entries, as they often were a determining factor in deciding a given object's date or regional identity. Sheila Schwartz brought organization and simplicity to the text, making both the author's and reader's tasks much easier. Charles Uht's superb photographs for all four volumes of the Art Gallery's American furniture catalogue present Yale's collection in its best light. This verbal and visual information has been given magnificent shape and definition by Greer Allen's impeccable design and typography. With fellowships provided by the Marcia Brady Tucker and Rose Herrick Jackson Funds, Jonathan Bloom, James Weiss, Joshua Lane, Susan Prendergast Schoelwer, Karen Suchenski, Nancy Spiegel, and Martin A. Berger, graduate students in the Departments of the History of Art and American Studies at Yale, actively participated in every facet of the preparation and research for this catalogue. I am very grateful for their contributions and commitment to this project.

This catalogue also reflects the wealth of expertise in many different departments of Yale University and its Art Gallery. Mary Gardner Neill, The Henry J. Heinz II Director, and her predecessor, Alan Shestack, have offered unstinting encouragement. I have been fortunate to be able to study this collection under the guidance of Patricia Kane, who gave me the opportunity to work on this catalogue as well as the constructive criticism and moral support essential to its completion. Her own publications in this series of volumes and her insights have been a constant inspiration. Marion Sandquist has my thanks not only for her superior talents as a secretary but also for the extraordinarily well-organized records and library that she has assembled and maintained in the Furniture Study during the past twenty-five years. With customary aplomb, she has negotiated myriad administrative tasks necessary to a book of this size. Janine E. Skerry assumed the duties of Assistant Curator during the eighteen months that I had a leave of absence to work on the manuscript; her presence and continued advice have had many positive effects on the project. I am indebted to other past and present members of the Art Gallery staff for their assistance with research, administrative tasks, and the compli-

cated logistics of photographing and examining objects: Michael Agee, William Cuffe, Louisa Cunningham, Lisa Davis, Maishe Dickman, Howard el-Yasin, Richard S. Field, Carolyn Fitzgerald, Susan Frankenbach, Paula Freedman, Diane Hart, Anthony G. Hirschel, Burrus Harlow, Lisa Hodermarsky, Richard Johnson, Dianne Johnson, Christina Kita, Michael Komanecky, Susan Matheson, Brigitte Meshako, Richard Moore, Bernice Parent, Rosalie Reed, Caroline Rollins, Beverly Rogers, Robert C. Soule, Robert M. Soule, Lynne Sunter, Joseph Szaszfai, and Marie Weltzien. I am also grateful to Theresa Fairbanks, Anne-Marie Logan, and Patrick Noon of the Yale Center for British Art and Marie Devine and Joan Sussler of The Lewis Walpole Library for their willingness to help with special problems. Barbara McCorkle, Curator of the Map Collection at Sterling Memorial Library, provided information on globes. Stephen Parks, Curator of the Osborn Collection at the Beinecke Rare Book and Manuscript Library, guided me through the Osborn family papers. Abbott Lowell Cummings, Charles F. Montgomery Professor of American Decorative Arts, freely shared his wealth of information on seventeenth-century New England and its furniture. Graduate and undergraduate students who helped in many ways include Darrell Barker, Melanie Bode, Denise Byrd, Louis Cathemer, Marguerite French, Jennifer Hrabcheck, Mariam Ishage, Susan Kleckner, Shannon Koenig, Sharon Lubkemann, Gillian McPhee, Anthony Nygren, Casey Riley, Jay Tobler, Marian Vaillant, and Christopher Yulo. Melinda McLaughlin patiently read the galleys of this manuscript. The illuminating diagrams of terminology were skillfully drawn by John O.C. McCrillis. The typesetting at the Yale University Printing Service was in the skilled hands of John Moran and Glenn Fleishman under the direction of Roland A. Hoover. Judith B. Metro of Yale University Press has coordinated details of the book's distribution.

The Friends of American Art at Yale are the mainstay of the American Arts Office, and their continued support is deeply appreciated. I would like to second Mary Neill's thanks to Dr. Benjamin A. Hewitt, Mr. and Mrs. Philip Holzer, Mr. and Mrs. George M. Kaufman, Mr. and Mrs. Leonard Marx, and Mr. and Mrs. E. Martin Wunsch for their generous gifts that funded different stages of this catalogue's preparation and publication. Anthony N.B. Garvan and Mrs. Frank J. Coyle preserved and made available their father's papers, and Beatrice B. Garvan shared her research on Henry Connelly and Robert McGuffin. Benjamin Hewitt patiently answered repeated queries for information on Federal-period card tables, and his study of that subject, *The Work of Many Hands*, was perhaps the most frequently consulted source in preparing the present catalogue. Henry Bartels provided information on the provenance of the table given by him and his wife, Nancy. Philip and Anne Holzer,

George and Linda Kaufman, and Thomas and Alice Kugelman all generously allowed me to study related objects in their collections.

This catalogue has drawn on the knowledge and research of many colleagues and friends. Four of the artists represented in this catalogue engaged me in lively discussions their work: Alfons Bach, Judy Kensley McKie, Rosanne Somerson, and David Zelman. Sharon S. Buck, Susanna Wilson Coggeshall, Helen Cullinan, Donnie Johnson, Norma Kerlin, Richard E. Kuehne, Amelia Lynde Foote Roe, and Margaret B. Wise shared reminiscences and information on their relatives or friends. Collectors who kindly permitted me access to important objects were Richard and Gloria Manney, Les and Mary Peterson, and Derrill McGuigan and the late William H. Short. Independent scholars Davida Deutsch, Eugene Landon, Jackson Parker, Charles Santore, Van Gorden Stedman, and Elizabeth Stillinger shared their special expertise. Florence M. Montgomery determined the appropriate fabrics and designs for bags on the work tables. The skillful conservation of objects in this catalogue by Peter Arkell, Karl Derbacher, Linda Merk, and Larry Price offered many new insights. I would like to extend additional thanks to individuals who were willing to respond to requests for obscure information: Donald Valente, Semon Bache and Company, Brooklyn, New York; Alex W. Mitchell, Baker Furniture, Holland, Michigan; Dean Failey, Christie's, New York; Jacques-Pierre Caussin, First 1/2, New York; Marianne A. Snyder, INCO United States, Inc., New York; John H. Welsch, InterMetro Industries Corporation, Wilkes-Barre, Pennsylvania; Carol A. Kim, Knoll International, New York; S. Dean Levy, Bernard and S. Dean Levy, New York; Ronald Bourgeault, Northeast Auctions, Hampton, New Hampshire; Albert and Harold Sack, Israel Sack, Inc., New York; Anne M. Androski, Skinner, Inc., Bolton, Massachusetts; Carl W. Stinson, Carl W. Stinson, Inc., Reading, Massachusetts; Ronald C. Bauman, David Stockwell, Inc., Wilmington, Delaware; and Leonard Goss, Trinity Episocopal Church, New Haven.

Staff members at many libraries, museums, and universities have greatly facilitated the research for this book. For their own careful research and timely cooperation, I would especially like to thank W. Scott Braznell, American Silver Museum, Meriden, Connecticut; Kevin Sweeney, Amherst College, Massachusetts; Charlotte E. Smith, Andover Historical Society, Massachusetts; Judy Throm, Darcy Johnson, Margaret Myers, and Cynthia Ott, Archives of American Art, Smithsonian Institution, Washington, D.C.; James T. Ulak and Milo M. Naeve, The Art Institute of Chicago; Wendy A. Cooper and Deborah A. Federhen, The Baltimore Museum of Art; Michael K. Brown, The Bayou Bend Collection, The Museum of Fine Arts, Houston, Texas;

Hetty Tye, Bowdoin College Museum of Art, Brunswick, Maine; Barry Harwood, Marianne Lamonaca Loggia, and Kevin Stayton, The Brooklyn Museum, New York; Nancy E. Richards, Cliveden, Philadelphia; Ronald Hurst, Jonathan Prown, and Aline Zeno Landy, Colonial Williamsburg, Virginia; Elizabeth Pratt Fox, The Connecticut Historical Society, Hartford; Clement E. Conger, Gail Serfaty, and Mary Itell, Diplomatic Reception Rooms, United States Department of State, Washington, D.C.; Dean A. Lahikainen, Essex Insitute, Salem, Massachusetts; William S. Ayres, Fraunces Tavern Museum, New York; J. Stephen Catlett, Greensboro Historical Museum, North Carolina; Philip Zea, Historic Deerfield, Massachusetts; James C. Jordan, III, Historic Hope Plantation, Windsor, North Carolina; Mrs. Carol Day, The Holland Society, New York; Barry L. Shifman, Indianapolis Museum of Art, Indiana; Walter J. Rantanen, The Institute of Paper Chemistry, Appleton, Wisconsin; Edwin A. Churchill, Maine State Museum, Augusta; Barbara B. Ford, Alice Cooney Frelinghuysen, Morrison H. Heckscher, Ellin Rosenzweig, and Frances Gruber Safford, The Metropolitan Museum of Art, New York; Christopher Monkhouse and Thomas S. Michie, Museum of Art, Rhode Island School of Design, Providence; Frank Horton, Bradford L. Rauschenberg, and Martha W. Rowe, Museum of Early Southern Decorative Arts, Winston-Salem, North Carolina; Edward S. Cooke, Jr., and Jeannine J. Falino, Museum of Fine Arts, Boston; Deborah Dependahl Waters, Museum of the City of New York; Brock Jobe, Society for the Preservation of New England Antiquities, Boston; Deborah J. Johnson, The Museums at Stony Brook, New York; Ulysses G. Dietz, The Newark Museum, New Jersey; Jonathan P. Cox and Wendell Zercher, The State Museum of Pennsylvania, Harrisburg; Christopher Wilk, Victoria and Albert Museum, London; William N. Hosley, Jr., Wadsworth Atheneum, Hartford; Bert R. Denker, Donald L. Fennimore, E. Richard McKinstry, Eleanor Thompson, Robert F. Trent, and Philip D. Zimmerman, The Henry Francis du Pont Winterthur Museum, Delaware; and Susan Strickler and Joanne H. Carroll, Worcester Art Museum, Massachusetts. All these colleagues and other friends have offered encouragement of immeasurable importance.

My parents have provided me with steadfast, unquestioning support throughout my life. I hope the dedication of this volume conveys a small part of my admiration for their unselfish giving to others and their unwavering faith in their ideals.

D.L.B.

The Intersections of Life
TABLES AND THEIR SOCIAL ROLE

Gerald W. R. Ward

Tables and stands are the common foot soldiers of the furniture world. Plentiful in number but often overlooked, their flat, horizontal surfaces provide the stage for many of the manifold activities that combine to form what we call civilization. Eating, writing, playing poker, conducting business, having a committee meeting: all rely on tables. Yet these commonplace objects are often covered with a cloth, cloaking the form and ornament of their underlying structure, or their tops are cluttered with the small impedimenta of everyday life, again obscuring the importance of the supporting frame. Where, for example, is the table in William M. Harnett's still life entitled *A Study Table*? It is nowhere to be found beneath the books, papers, flagons, musical instruments, and other objects piled on top of an Oriental carpet (Fig. 1). Like so many things essential to life, we take tables for granted even though we would find it difficult to live without them.

The importance of the table can be seen in the definition of the word itself. One meaning of table (derived from the Latin *tabula*) is simply a flat board—only the tabletop. From the Middle Ages until the eighteenth century, the supporting structure was often known as the *frame*. Usually these two components— the top and the frame—were separate units, as in the monumental seventeenth-century trestle table in The Metropolitan Museum of Art (Fig. 2), one of the few American examples of a form common much earlier. Our current, generally accepted understanding of table—"an article of furniture consisting of a flat top of wood, stone, or other material, supported on legs or on a central pillar, and used to place things for various purposes, as for meals, . . . for some work or occupation, or for ornament"—is but one of many definitions for the word given in the *Oxford English Dictionary*.[1]

The numerous American tables and stands in the Yale collection represent a broad cross section of the many types and varieties that have been produced during the last four centuries, ranging from a small candlestand to a large extension dining table, with a host of forms in between. They all share the same basic characteristics given in the definition above: each has a flat, horizontal surface for work, play, or storage; each top is supported at an appropriate height by perimetal legs, a central pedestal, or some other system. Many tables and stands are shaped in conventional squares, rectangles, ovals, or circles, but others

have been produced in almost any configuration. For example, the detailed examination of American Federal-period card tables undertaken by Benjamin A. Hewitt revealed that the tops of these objects were produced in at least twenty-six different shapes. For all this variety, however, no eighteenth-century table approached the amoeba shape of the 1940s table designed by Paul Frankl (cat. 25), which stands apart from the crisp geometry and symmetry characteristic of most early tables.[2]

In many instances, tables are a "moveable piece of furniture," as Thomas Sheraton pointed out in his *Cabinet Dictionary* (1803), and many examples are fitted with one or more drawers or compartments for the storage of small items, such as sewing tools and needlework. Many types of table are adjustable in some manner, such as the gateleg table with its swinging gate or leaves, the card table with its leaf supported by a fly leg, or the tilt-top tea table, which rotates and tilts on its "bird cage" or "box." In each case, these features allow the table to occupy less space when not in use, a long-standing and still current desideratum for tables.[3]

Although the number of types was somewhat limited in the seventeenth century, since the mid-eighteenth century tables have been made for an impressive range of functions. They have become perhaps our most specialized form of furniture, at least in nomenclature if not in practice. Thomas Chippendale's *Director* (1762) gives designs for china, breakfast, shaving, sideboard, bureau dressing, commode, writing, library, and toilet tables. (Bureau dressing tables and commode tables, because of their multiple drawers, are actually considered today as case furniture.) Sheraton, a half century later, mentioned dining, card, library, pier, sideboard, sofa, and writing tables. There have been, of course, many other types produced during the nineteenth and twentieth centuries. The catalogue of furniture offered for sale about 1850 by cabinetmaker George J. Henkels of Philadelphia itemizes at least nine types of table, including center, console, work, boquet, extension, toilet, occasional, pier, and library tables in various materials.[4]

Because of their adaptability, tables became a significant material expression of two important developments in the eighteenth century: the increase in the number and variety of consumer products, referred to by historians as the consumer revolution, and the parallel rise in genteel manners and dress. The table was a logical vehicle for cabinetmakers anxious to supply expanding markets, since there was an expanding number of functions that seemed to require specialized tables. Moreover, consumers needed places to store, display, and use the ever growing number of household goods—such as sets of china, glassware, and silver—that were becoming available to individuals of relatively modest means. The concerns of the new gentility for fashion, manners, and dress could all be answered in

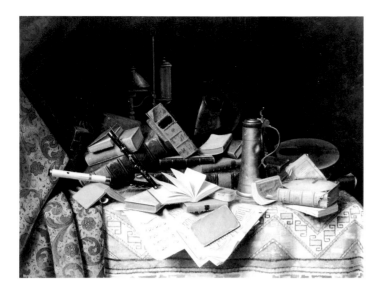

Fig. 1. William M. Harnett, *A Study Table*, 1882. Oil on canvas.
Munson-Williams-Proctor Institute Museum of Art, Utica, New York.

Fig. 3. John Jones, *Black Monday or the Departure for School* (detail), 1790. Engraving. The Henry Francis du Pont Winterthur Museum, Delaware.

Fig. 2. Trestle table, New England, c. 1650. Oak and pine. The Metropolitan Museum of Art, New York, Gift of Mrs. Russell Sage, 1909.

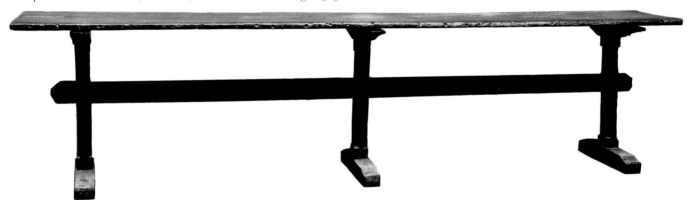

part by a function-specific table. Every new custom, such as the drinking of tea, introduced in America early in the eighteenth century, seemed to demand its own type of table (Fig. 3). As the eighteenth century progressed, more relaxed attitudes toward cardplaying and gambling, a preoccupation with the accoutrements of dress, and a rise in literacy all found material expression in tables owned by Anglo-American consumers.[5]

Many of these specialized tables were derived, we can be sure, as a marketing ploy, for almost any table can serve a multitude of functions with ease. In fact, this ability was tacitly underlined by the frustrating habit of the appraisers of many early estates, who often listed a table simply as a table in their inventory of a deceased individual's possessions. If any modifier was used, it was usually an adjective denoting material ("one Black Walnut Table"), shape ("one Round Table"), size ("1 large Table" or "one three foot table"), age ("1 old table"), or, occasionally, decoration ("1 Round painted Table" or "One neat carved Card Table"). Although references to tea, card, kitchen, and other tables are not uncommon, appraisers generally seemed to believe that the tangible attributes of tables—size, material, configuration, and so forth—were the most useful clues in identifying the most variegated of furniture forms.[6]

One can understand the appraisers' predicament, for a table's given name in a pattern book or trade catalogue does not always reflect its use; many proper names bear little relationship to the actual functions served by the object. Some names, like that of the occasional table, are so vague as to be almost meaningless (although the versatility of tables as a whole is perhaps underlined by the ability of this specific form to meet any occasion). Consider, as well, the modern coffee table. As one home decorator explained in 1954, "coffee tables are not to be taken literally. There is no need to keep your coffee service on them unless you are actually pouring. For display purposes, a low flower arrangement, a cigarette box and lighter, and a huge ash tray are good and useful choices." From prescriptive literature such as this, it seems clear that coffee tables were more intimately associated with the smoking ritual than with coffee drinking. As one writer in 1939 noted, coffee tables "replace the old-fashioned round table that sat right in the middle of the room with a big lamp on it." The coffee table "can carry magazines, books, a vase of flowers, ash trays, refreshments." In fact, these "accessories" were considered extremely important, and great care in their selection was urged by interior decorators. The "coffee-table book," a modern version of the nineteenth-century "gift book" (a large, lavishly illustrated annual meant to sit on a center table), was a key accessory.[7]

In addition to their intended uses, tables are often employed for purposes not necessarily conceived of by their makers. They provide a good surface for sitting (Fig. 4), standing (Fig. 5), sleeping, or just plain foot-propping (Fig. 6). One need only think of the myriad functions a modern folding card table performs to realize that the specific name of a table is not always an accurate indicator of how the object is used.

Questions of function aside, tables have an important aesthetic dimension to fill. Some types, such as pier tables (cats. 11–17), are primarily meant to occupy space in a pleasing manner. Crisply turned legs and stretchers, gracefully curved cabriole legs, richly carved knees and aprons, or inlaid or marble-covered tops contribute to the visual interest and success of many tables. John T. Kirk has isolated a characteristic of tables that he sees as an important contribution to American design. The wide, overhanging tops of some early American tables, he argues, constitute an original and distinct American statement, part of "the opening up of designs that would soon become essential to America's new aesthetic." Although this may not take into sufficient account the many early tables that have replaced tops, the replacements themselves may reinforce the tendency for American tables to have large surface areas.[8]

Thus, like all furniture, tables and stands fulfill a variety of practical and ornamental functions. One crucial aspect of many tables, however, and a key to their significance in the social history of furniture, is that they involve people in social interaction in ways that case furniture and chairs do not. They provide intersections for human relationships, places where people come together and relate to one another. Although it is possible to develop a relationship with a table alone (James Thurber observed that "no man who has wrestled with a self-adjusting card table can ever be quite the man he once was"), it is the ability of tables to draw people together dynamically that elevates them to artifacts of prime cultural importance.[9]

The eight South Carolina gentlemen sitting around a rectangular table in George Roupel's drawing *Peter Manigault and His Friends* (Fig. 7) are brought together by more than wine and good fellowship. They interact around the table, passing glasses, facing each other directly or obliquely, even touching feet in one instance. The table even helps to support power relationships here: the gentlemen are seated in stylish chairs at the table, whereas the black servant is not allowed at the table and must lean, under the bird cage, against the window sill at the right.

The eighteen men depicted having dessert in Henry Sargent's *The Dinner Party* (Fig. 8) of about 1821 reflect a different pattern of interaction. Here the artist's vision shows us a man seated alone at the head of a long table, with another isolated man at the foot, with groups of eight diners along each side. The men have divided themselves into four or five smaller subgroups, although at least two individuals on the right seem to be gazing into space. These men are perhaps feeling the uncomfortable sense of isolation created at a large rectangular table when the people to one's right and one's left each turn away to engage the person on their other side in conversation. Again, the servants, flanking the sitters, are denied access to the table.

The possibilities for interaction at a table are illuminated even more clearly in a 1969 advertisement for pants, in which the boss's wife plays footsie with a rising young executive (Fig. 9). This staged scene reflects, among other things, the advertising agency's understanding that the tabletop creates dual spheres of life, and that what goes on under the table may not bear much relationship to the more formal posturing above.

Of course, to paraphrase an aphorism, a table can only bring people together, it can't make them interact, as Norman Rockwell's view of a stereotypical young couple so well demonstrates (Fig. 10). Here, an exaggeratedly small breakfast table—so small that the husband's and wife's knees must be interlocked—brings the couple together at a personal, almost intimate distance. To avoid interaction, the husband must raise a vertical barrier—his newspaper—to offset the propinquity that the table creates (and that he wishes to avoid at this particular moment).

The seemingly benign or inert flat surface offered by a table can be seen, then, as affecting human behavior in many ways by

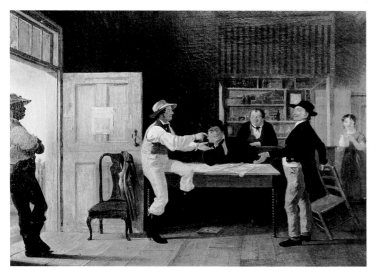

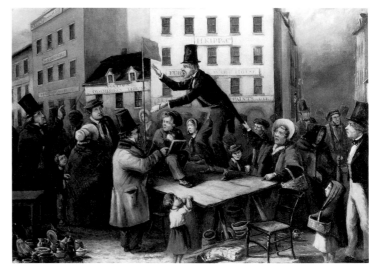

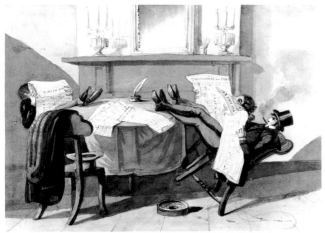

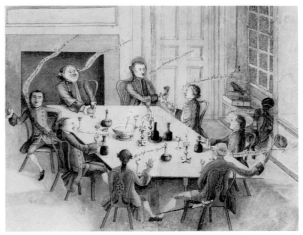

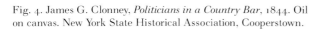

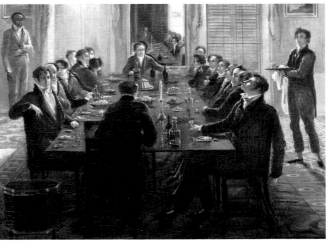

Fig. 4. James G. Clonney, *Politicians in a Country Bar*, 1844. Oil on canvas. New York State Historical Association, Cooperstown.

Fig. 5. E. Didier, *Auction in Chatham Square*, 1843. Oil on canvas. Museum of the City of New York, Anonymous gift.

Fig. 6. Nicolino V. Calyo, *Reading Room, Astor House*, c. 1840. Pencil, ink, and wash. Museum of the City of New York.

Fig. 7. George Roupel, *Peter Manigault and His Friends*, 1768. Ink and wash. The Henry Francis du Pont Winterthur Museum, Delaware.

Fig. 8. Henry Sargent, *The Dinner Party* (detail), c. 1821. Oil on canvas. Museum of Fine Arts, Boston, Gift of Mrs. Horatio A. Lamb in memory of Mr. and Mrs. Winthrop Sargent.

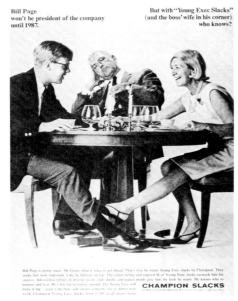

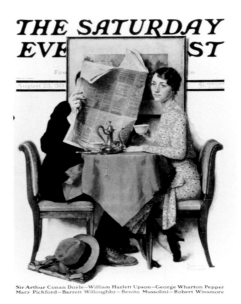

Fig. 9. Advertisement
for Champion Slacks, 1969.

Fig. 10. Norman Rockwell,
At the Breakfast Table,
from *The Saturday Evening Post*,
August 23, 1930.
Reproduced by permission
of the Estate of Norman Rockwell.
©1930 Estate of Norman Rockwell.

Fig. 11. Frontispiece to Catharine E. Beecher
and Harriet Beecher Stowe,
The American Woman's Home, 1869.

Fig. 12. New England (?) artist,
The Adams Family, 1845–50.
Oil on canvas. Abby Aldrich Rockefeller
Folk Art Center, Williamsburg, Virginia.

9 10

presenting opportunities for interaction. It divides the world in a planar fashion: it creates spheres above board (all that is moral and good) and below the table (all that is immoral and bad). Negotiators, for example, are expected to "keep both hands on the table" if they wish to be perceived as bargaining in good faith. Bribes are often described as having been made "under the table." Faces, arms, chests, and breasts are above the table; buttocks, genitals, legs, and feet are below. Most sounds made above the table are socially correct; many sounds made below are not.[10]

While thus dividing the world horizontally, a table can also create vertical boundaries by establishing distances and relationships between people. Thomas Sheraton, for example, advised "allowing 2 feet to each person sitting at [a dining] table; less than this cannot with comfort be dispensed with." Depending on the size and configuration of the table, the sitters' placement at it, and the sitters' expectations, the object can stimulate confrontations, create feelings of good- or ill will, and either foster or limit discourse. Erving Goffman found, for example, that Thomas Sheraton's allowance of 2 feet of space per person may have been far too much for residents of a small community in the outer Shetland Islands. He observed that "as one moves from middle-class urban centers in Britain to the rural lower-class islands, the distance between chairs at table decreases, so that . . . actual body contact during meals and similar social occasions is not considered an invasion of separateness and no effort need be made to excuse it."[11]

Tables are the stage where theoretical standards of etiquette, protocol, and manners are acted out, where prescriptive advice meets the test of reality. How do we react when someone sits "too close" to us? How do we behave when forced to dine at the same table with strangers, as in the dining car on a train? How do we formulate a seating arrangement for important guests at a party? The physical characteristics of the table involved in each situation can play an important role in answering these questions.

Tables are thus a key artifactual element in the study of human behavior now known as proxemics, or how people structure and perceive space. In particular, they help us understand those small, micro-encounters of everyday life that are at once prosaic in their ubiquity yet critical in their effect on our sense of well-being and the fitness of things. Tables are, in the terminology of proxemics, the key "environmental props" of "semifixed-feature space" that people use to shape and structure their physical surroundings.

The term proxemics was coined by Edward T. Hall and first given wide circulation in *The Hidden Dimension* (1966). Hall and other researchers, such as Robert Sommer, Norman Ashcraft, and O. Michael Watson, are interested in how people use space to establish territories, create privacy, avoid intrusions, and to otherwise regulate their interaction with others. Sommer, for example, took particular interest in "small group ecology" and presented the results of studies of seating arrangements in such institutions as a mental hospital, a school, a

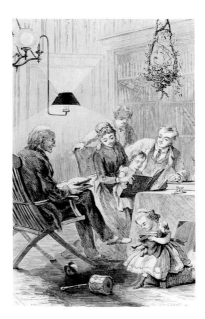

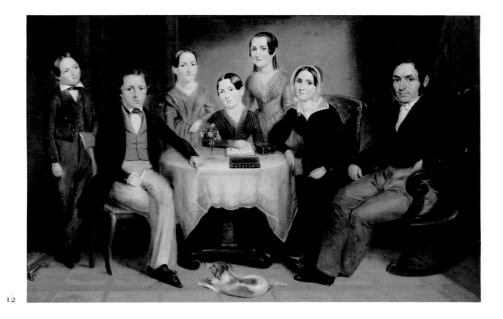

11 12

tavern, and a college dormitory. One such study attempted to examine the impact of furniture on conversations in a hospital cafeteria by observing patterns of behavior at a 36 by 72–inch table, large enough to accommodate six people. Conversations at six different distances and orientations were counted: across the corner, side by side, across the width, across the length, diagonally across the width, and diagonally across the length. Sommer found that "corner situations with people at right angles to each other produced six times as many conversations as face-to-face situations across the 36–inch span of the table, and twice as many as the side-by-side arrangement." As Sommer and others point out, the results of such studies are limited; the conclusions drawn in one are not easily applied to another, if the context— the actors, the props—is quite different. Yet the underlying principle—that tables can affect and reflect our attitudes and behavior—remains constant.[12]

Architects and interior decorators have long recognized the importance of tables for drawing people together (known as a sociopetal effect) or keeping them apart (a sociofugal effect). For example, the center table was widely recognized in the mid-nineteenth century as an important sociopetal tool. The architect A.J. Downing recommended the center table for use in country homes, for it "draws all talkers to a single focus" and is thus "the emblem of the family circle." A family gathered around such a table is illustrated as the frontispiece to Catharine E. Beecher and Harriet Beecher Stowe's *American Woman's Home* of 1869 (Fig. 11) and can be seen in a slightly earlier fam-

ily portrait (Fig. 12), which is just one of many similar examples. The Beecher sisters recommended that an inexpensive table would work quite well, since it was going to be almost completely covered, and suggested that the housewife secure such a table with ample dimensions, so that "a family of five or six may all sit and work, or read, or write around it, and it is capable of entertaining a generous allowance of books and knick-knacks." The illuminative power of a gas or oil lamp placed on or near these tables, replacing the earlier lighting system of scattered candlesticks on individual tables, also served to make center tables the focus of many sociopetal activities.[13] These center tables, Downing noted, acted in the opposite fashion to sofa tables, which were popular in cities. Sofa tables "scattered here and there in a room, afford various gathering places for little conversation parties" and thus led to a diffusion that, in his mind, was not acceptable in the country.[14]

A rectangular table offers opportunities for different proxemic behavior. People facing each other directly across the table are liable to find themselves in a confrontational situation. The fellow on the left in Richard Caton Woodville's *Politics in an Oyster House* (Fig. 13) is demonstrating a good example of proxemic behavior. His averted gaze reduces the tension between himself and his agitated, gesturing companion. This man reaches across the table, violating his neighbor's space and probably making him uncomfortable, since he has negated what Hall calls "social distance" and encroached upon the other man's "personal distance."[15]

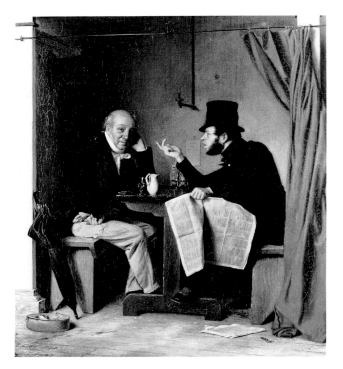

Fig. 13. Richard Caton Woodville, *Politics in an Oyster House*, 1848. Oil on canvas. Walters Art Gallery, Baltimore.

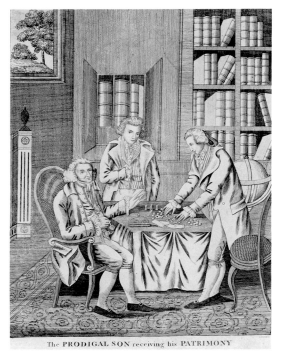

The PRODIGAL SON receiving his PATRIMONY

Fig. 14. Amos Doolittle, *The Prodigal Son Receiving His Patrimony*, 1814. Etching. The Henry Francis du Pont Winterthur Museum, Delaware.

The artist Amos Doolittle may have utilized the affectivity of tables to help underscore the visual impact of his *Prodigal Son* series of 1814. As the series begins, the prodigal son receives his patrimony at a square or rectangular table, chastely draped with a deep cloth, in a scene of great formality in dress and body language (Fig. 14). However, at a later moment, in *The Prodigal Son Revelling with Harlots* (Fig. 15), the son is wasting "his Substance with Riotious Living" in company with two friends and three harlots all gathered at an undraped round table, with clothing in disarray and with body language of an entirely different character.

To sit at the head of a table, or in the center of a long table, is a traditional and familiar indicator of social hierarchy. In an 1867 view of Thanksgiving dinner (Fig. 16), for example, the master of the house, charged with the privilege and responsibility of carving, is denoted by his placement in the center of one side of the table, and his position is reinforced by his more comfortable upholstered chair. Again, a servant is denied access to the table. The seating of guests can follow rigid conventions, and questions of just who gets to sit next to whom can get quite complicated. In the late nineteenth century, for example, one etiquette manual suggested that the arrangement of guests at the dinner table

involved "as much thought as a game of chess, for in no way is tact more called into exercise than in the distributing of guests at a dinner-table." The same manual stated that "the seats of the host and hostess may be at the middle, on opposite sides of the table, or at the ends." The "seat of honor" for the most distinguished male guest was to the hostess's right, with a parallel place of importance to the host's right for the woman deserving precedence. Once the dignitaries were placed, "care must necessarily be taken that those whom you think will be agreeable to each other are placed side by side around the festive board." This side-by-side placement was seen as bringing people "into closer contact than at a dance, or any other kind of a party." In fact, this arrangement created such an intimate bond that "two persons, unknown to each other," were allowed to "enter into conversation without any introduction."[16]

The "code of diplomatic etiquette," however, altered the normal rules with its own set of ritualized behavior. If the hostess did not want to follow diplomatic codes, she should, the same author advised, "leave out from dinners those who are in official positions if you do not wish to seat them where they have a right to expect to be seated." One additional example can suffice as testimony to the continuing importance of placement at table.

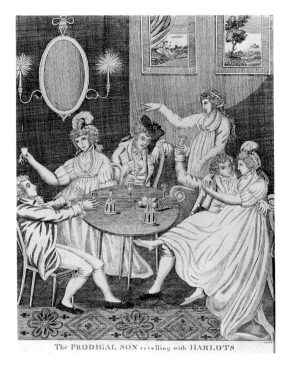

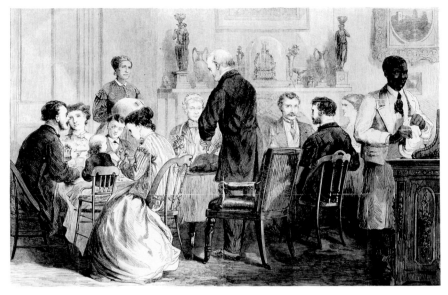

Fig. 16. *Thanksgiving Dinner*, from *Harper's Weekly*, November 30, 1867.

Fig. 15. Amos Doolittle, *The Prodigal Son Revelling with Harlots*, 1814. Etching. The Henry Francis du Pont Winterthur Museum, Delaware.

The large room known as the State Dining Room in the White House is ordinarily outfitted with a rectangular table designed by McKim, Mead and White in 1902. At many diplomatic functions, however, this table is augmented with a number of small, round tables. These tables simplify seating protocol, for it has long been recognized that round tables decrease questions of precedence and hierarchy and promote, as with King Arthur's round table, a feeling of equality. The propriety of having the person with the greatest status at the head of the table is not as great an issue with a round table, where distinctions among sitters are blurred. Thus, the White House protocol staff has to make fewer delicate decisions about the relative importance of guests.[17]

Most studies of proxemic behavior are concerned primarily with questions of cross-cultural differences and the importance of proxemics for architecture and urban design. Differences between Western and Asian cultures, for example, or between Western and Arab behaviors have formed the focus of many scholars' research. These cross-cultural differences can be dramatic. For example, in Western society we have become used to tables of an almost standard height. George Hepplewhite stated in 1794 that most tables should be 28 inches high, a standard for

Western design that has not changed much in the last two hundred years. Thus it is difficult for Americans and other Westerners to use tables made at the lower height more commonly found in Asian cultures (Fig. 17). Such standards can be overcome, of course, as the innovative coffee table—one of the few Western tables customarily made at a non-Western height—demonstrates. One decorating manual suggested that the appropriate height for a coffee table is only 11 inches, less than half the customary Western table height.[18]

It is in a sense easier to discern and measure these cross-cultural differences between peoples who are separated by space than it is to discover historical differences between peoples who share the same tradition but are separated by time. Most modern studies of proxemic behavior are based on direct field observation or interviews. The challenge of historical proxemics is to use evidence—from documents, from paintings, prints, other pictorial sources, and from surviving objects—to determine patterns of continuity and change. This approach is complicated by numerous factors. Pictorial evidence is often problematic since it may well reflect artistic conventions or an artist's own vision rather than any sort of contemporary reality. People's sense of proxemics is largely on an unconscious level,

and thus statements about it are not common in the written record. Prescriptive literature often provides only idealized guidelines rarely followed in practice. Much proxemic behavior is also of an ephemeral nature, and we cannot observe, obviously, the people of the past as they went about living and interacting. Finally, the objects themselves, now generally stripped from their original contexts, raise as many questions as they answer concerning how people behaved.

Yet a quick examination of one type of table—tables for dining—may provide some insight into changing proxemic patterns since the seventeenth century, even if the view is painted in very broad strokes. In early seventeenth-century America, tables for dining were not necessarily a part of every home. (For example, on her way to New York in 1704, Madam Sarah Knight saw "a little Hutt" in the Narragansett country furnished only with "A Bord wth sticks to stand on, instead of a table.") In many poorer houses, people may have taken their meals on top of a chest, or perhaps simply held their utensils in their hands. Homes of high station were equipped with the long trestle table or the draw table, like the rare and important surviving example at The Connecticut Historical Society (Fig. 18). These large tables reflected and reinforced the importance of hierarchy within the seventeenth-century world. Figures of authority within the household would be seated at "great" chairs at a position of importance, while those of lesser status, as well as children, would be seated at the table on forms or stools in places of shared space. Relationships were formalized and centralized. A glimpse of an arrangement of this type is afforded in a mid-seventeenth-century view of a Swiss family at dinner (Fig. 19). The husband and wife are located together at the head, or narrow, end of the table, while a dozen children of varying ages are seated along the sides or standing at the foot. The arrangement is reminiscent of medieval views in which the lord of the house and his lady were seated, perhaps alone, on just one side of the table, with the servants and all others at a distance.[19]

By late in the century, the table typically used for dining was the gateleg table with turned legs. It opened to an oval, round, or occasionally square shape, was somewhat portable, and thus could be used at various locations throughout the house. As Abbott Lowell Cummings and others have observed, prior to the American Revolution no one space within most households was used exclusively for dining. Meals are recorded as having taken place in parlors, chambers, and elsewhere throughout the house. This relative informality was reflected in the gateleg table, which thereby becomes an important material manifestation of the waning of the seventeenth-century world view in America. The oval or round form is itself less formal than the rectangular tables of the early seventeenth century, and it was

more easily transported from place to place. Several tables might be used in the same room, with the diners eating in small groups, thus fostering a diffusionist rather than centralized atmosphere. The Boston diarist Samuel Sewall records many such multitable dinners. On October 27, 1699, for example, he was present at a dinner party given by the Lieutenant-Governor for "the Governour and his Lady and many more" who sat at "Two tables." Later, on December 28, 1705, he records "a very good Dinner at three Tables." (Sewall also notes dinners "at the great Oval Table" in his "wives Chamber" at which as many as eleven people might be present, as on November 24, 1708.)[20]

This trend toward diffusion and informality was continued in the eighteenth century with small dining tables with cabriole legs ending in pad or claw-and-ball feet. Many of these had round or rectangular tops. Although it may be stretching a point, one can perhaps see round-top tables as being owned by individuals whose outlook—perhaps even unconsciously—favored relationships characteristic of the 1680 to 1720 period, while those who owned rectangular tables were more comfortable with the more formal attitudes characteristic of life later in the eighteenth century.

The anthropologist-historian Rhys Isaac, for example, found that in Virginia by the mid-eighteenth century, the "ceremonial space" of the dining room and dining table became increasingly important to members of the upper class (although change came more slowly to those of lesser economic means). Unlike the more communal atmosphere of earlier times, the custom of dining, "with its reserved space, its linen-covered table, and its fashionably matching sets of plates, knives, forks, and other eating accoutrements . . . marked off the table as sacrosanct within the time and space of daily domestic life." The dinner table became the focus of ritual and hospitality.[21]

The special nature of dining was perhaps underlined by the habit of bringing the dining table out from the wall and placing it in the center of the room for eating, then returning it to the wall, a custom that persisted in rural areas of America well into the nineteenth century. The furniture historian Wallace Nutting, who was born in 1861, recalled in a 1924 publication that "when he was a boy, it was the custom in country houses, everywhere to drop the leaves of the dining table, and to set it against the wall between meals. There was no possible reason for it then more than now. It was a continuation of an ancient habit, that is all. We remember one ancient and huge kitchen where two members of the family were left. Invariably the dining table was closed and pushed to the wall after every meal, leaving a great empty space of no possible benefit. Our grandmothers would as soon have thought of leaving the dishes unwashed as of leaving the table in the floor." (In typical Nutting fashion, he concluded his tale with the observation that this custom "is one of the most

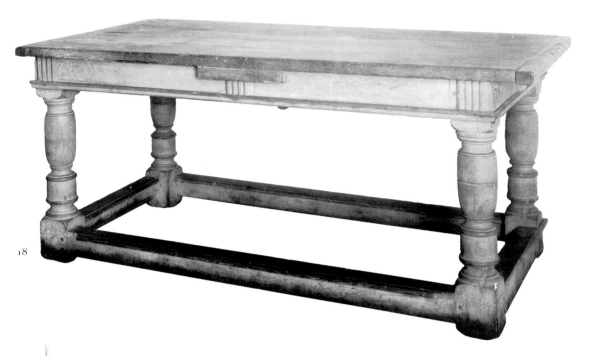

18

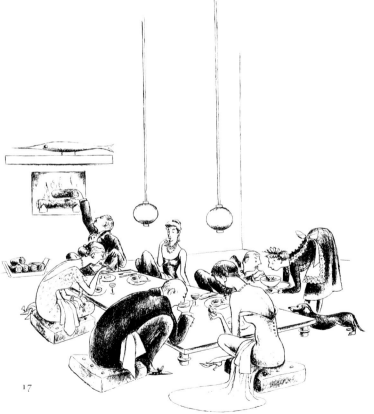

17

Fig. 17. Mary Petty, *Low-Life "Modern,"*
from T.H. Robsjohn-Gibbings, *Homes of the Brave*, 1954.

Fig. 18. Draw table, Windsor, Connecticut, 1640–70. White oak.
The Connecticut Historical Society, Hartford, Gift of Henry Halsey.

Fig. 19. Conrad Meyer, *Tischzucht* [*Table Manners*], 1645. Etching.
Germanisches Nationalmuseum, Nuremberg.

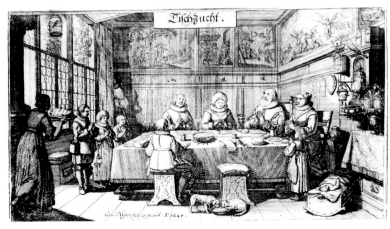

19

curious instances of the failure of the human mind.") This need for open spaces at the center of rooms, so characteristic of the eighteenth century, is at direct odds with the attitude toward space prevalent in the nineteenth century, when empty spaces were to be filled, and the centers, as well as the walls, of rooms were to be furnished.[22]

During the late eighteenth century, it became more common in homes of greater economic means to leave dining tables in the center of the room. Pedestal-base dining tables and larger extension dining tables, usually of mahogany, became fixed features in function-specific rooms. Many of these tables can best be described as rectangles with rounded ends, which allowed for seating patterns more hierarchical than diffusionist in nature. Rooms designated specifically as dining rooms became typical, and scenes like Sargent's *Dinner Party* became more common. The ritualized behavior so characteristic of the late nineteenth century may have been fostered by the necessity for people to deal with one another at these more formal tables.

If one sketches out an evolution of dining tables roughly from 1620 to 1820, a cyclical flow develops, at least in an impressionistic sense. The key elements in the progression seem to be the shape of the tabletops and the movability of the tables themselves. Recognizing that exceptions abound, as is so often the case when using material evidence, and that innovations tend to be introduced at higher rather than lower economic levels, we can nevertheless see a pattern developing along the following lines.

Time period	Form, placement, relationships engendered
1620–1680	Often rectangular shape and static placement; hierarchical relationships; space private and shared.
1680–1790	Varied shapes, including oval, round, square, and rectangular; generally portable, and thus diffusionist and tending toward informality; shared space emphasized in oval and round examples.
1790–1820	A return to rectangular tables, or rectangles with rounded ends, at high economic levels; often static placement in function-specific rooms; more emphasis on hierarchical arrangement, with private space for heads of households and shared space for others.

After 1820 the forms seem to follow the configuration and relationship patterns of the preceding periods, with alternating trends toward formality and informality, until relatively recent times. The tradition of formal dining has now been challenged, however, by the phenomenon often described as *grazing*. In this kind of behavior, characteristic of some dual-career families

with children, the family rarely gathers for a formal meal in the traditional sense. Rather, each member grabs something to eat when time permits.

In considering the evolution of dining tables, the eighteenth century thus emerges as a period of multiple options and variations. John T. Kirk has demonstrated this in a detailed look at dining tables made by the English firm of Gillows and Company between 1784 and 1817, a period when the eighteenth-century modes were weakening but those of the nineteenth century were not yet firmly established. His study of the firm's drawings reveals a wide range of tables available—some in new styles, several in old, many with unusual variations in design and construction—all suggesting that the needs of the customer were paramount, and that those needs varied, and did not necessarily reflect consistent patterns of behavior or thought. The variety that he found also suggests that there was some confusion, or at least indecision, in people's minds about the "proper" relationships between people during this period of rapid social and technological change.[23]

The variations found in the artifactual record underline the importance of preserving large and wide-ranging collections such as the one examined in this catalogue. Each table in the collection represents in microcosm a whole world of social behavior and reminds us of the people who made and used them.

I am grateful to Patricia E. Kane for the invitation to prepare this essay in 1984 and to David L. Barquist for his critical reading of several drafts. An early version was given as a paper in a session entitled "New Approaches and Interpretations of the Decorative Arts" at the 76th Annual Meeting of the College Art Association of America, held in Houston on February 13, 1988. I am indebted to Thomas S. Michie, convenor of that session, to those in attendance, and in particular to Jules D. Prown, discussant, for their comments and criticisms. Another earlier version was delivered as part of the Yale material culture group meetings in New Haven in September 1988; Abbott Lowell Cummings kindly gave me the opportunity to share these ideas in their formative stage, and those in attendance made helpful suggestions. As always, Barbara McLean Ward provided wise advice and counsel.

1. *Oxford English Dictionary*, ed. 1971, s.v. "table." See also John Gloag, *A Social History of Furniture Design from B.C. 1500 to A.D. 1960* (New York: Crown Publishers, 1966), pp. 76–77.
2. Hewitt/Kane/Ward 1982, pp. 68–69.
3. Sheraton 1803, p. 315.
4. Chippendale 1762; Sheraton 1803, pp. 128, 195, 260, 284, 304, 305, 334. The Henkels catalogue is printed in Oscar P. Fitzgerald, *Three Centuries of American Furniture* (1982; reprint, New York: Gramercy Publishing Company, 1985), pp. 296–302.
5. Of the many sources on consumerism and gentility in this period, see Neil McKendrick, John Brewer, and J.H. Plumb, *The Birth of a Consumer Society: The Commercialization of Eighteenth-Century England*

(Bloomington: Indiana University Press, 1982), and Richard L. Bushman, "American High-Style and Vernacular Cultures," in *Colonial British America: Essays in the New History of the Early Modern Era*, ed. Jack P. Greene and J.R. Pole (Baltimore: Johns Hopkins University Press, 1984), pp. 345–83. For the introduction of tea tables, see Rodris Roth, *Tea Drinking in 18th-Century America: Its Etiquette and Equipage* (Contributions from the Museum of History and Technology, Paper 14), *United States National Museum Bulletin 225* (Washington, D.C.: Smithsonian Institution, 1961), pp. 61–91. For changing attitudes toward cardplaying, see Gerald W.R. Ward, "'Avarice and Conviviality': Card Playing in Federal America," in Hewitt/Kane/Ward 1982, pp. 15–38. The modern designer's manipulation of the table form to sell innovative designs is touched on in Jean Thompson, "Turning Tables into Launching Pads for Flights of Fancy," *Philadelphia Inquirer*, July 17, 1988, p. 6F.

6. In Cummings 1964, p. 301, there are some 270 references to tables described as birch, bureau, card, chamber, frame, great, joined, kitchen, long, mahogany, maple, oak, painted, pine, reading, red cedar, round, stool, tea, japanned tea, truckle, twilight, and walnut. The examples quoted in the text are drawn at random from Cummings' book.

7. Elizabeth T. Halsey, *Ladies' Home Journal Book of Interior Decoration* (Philadelphia: Curtis Publishing Company; Garden City, New York: Doubleday and Company, 1954), pp. 139–40. Draper 1939, p. 87, also pp. 88, 104. *Webster's Ninth New Collegiate Dictionary* defines coffee-table book as "an expensive, lavishly illustrated, and oversize book suitable for display on a coffee table," and dates this definition to 1962. The same source gives 1877 as the first appearance of the term coffee table.

8. Kirk 1982, p. 144.

9. Thurber is quoted in Walter Blair and Hamlin Hill, *America's Humor from Poor Richard to Doonesbury* (New York: Oxford University Press, 1978), p. 444. The small stands that are such a major part of this catalogue are generally excluded from the present discussion; my emphasis is on the larger tables at which people can sit and interact.

10. I am grateful to Jules D. Prown for pointing out several of these differences between the two spheres of the table.

11. Sheraton 1803, p. 196. Erving Goffman, *Behavior in Public Places* (New York: Free Press of Glencoe, 1966), p. 63.

12. This essay is principally indebted to the following works on proxemics: Edward T. Hall, *The Hidden Dimension* (Garden City, New York: Doubleday and Company, 1966); Robert Sommer, *Personal Space: The Behavioral Basis of Design* (Englewood Cliffs, New Jersey: Prentice-Hall, 1969), especially part two, in which the example summarized in my text is discussed; Norman Ashcraft and Albert E. Scheflen, *People Space: The Making and Breaking of Human Boundaries* (Garden City, New York: Anchor Books, 1976); Albert E. Scheflen with Norman Ashcraft, *Human Territories: How We Behave in Space-Time* (Englewood Cliffs, New Jersey: Prentice-Hall, 1976); Robert Gutman, "The Social Function of the Built Environment" and Albert E. Scheflen, "Some Territorial Layouts in the United States," in *The Mutual Interaction of People and Their Built Environment: A Cross-Cultural Perspective*, ed. Amos Rapoport (The Hague: Mouton, 1976), pp. 37–49, 177–221; Irwin Altman, *The Environment and Social Behavior: Privacy, Personal Space, Territory, Crowding* (Monterey, California: Brooks/Cole, 1975); and O. Michael Watson, *Proxemic Behavior: A Cross-Cultural Study* (The Hague: Mouton, 1970). Works on social interaction by Michael Argyle and Erving Goffman have also been helpful. Robert B. St. George looked at proxemic behavior in the seventeenth century in his essay in Fairbanks/Trent 1982, II, pp. 159–87.

13. Downing 1850, pp. 428–29. Catharine E. Beecher and Harriet Beecher Stowe, *The American Woman's Home* (1869; reprint, Hartford, Connecticut: The Stowe-Day Foundation, 1975), p. 90.

14. Downing 1850, p. 429.

15. Hall, *The Hidden Dimension*, pp. 107–22, discusses types of distance.

16. Mrs. H.O. Ward, *Sensible Etiquette of the Best Society*, 10th ed. (Philadelphia: Porter and Coates, 1878), pp. 159, 160, 157, 160. An overview of nineteenth-century dining etiquette is given in Susan Williams, *Savory Suppers and Fashionable Feasts: Dining in Victorian America* (New York: Pantheon Books in association with The Strong Museum, Rochester, 1985), chap. 2. See also Kathryn Grover, ed., *Dining in America, 1850–1900* (Amherst: University of Massachusetts Press; Rochester, New York: The Strong Museum, 1987), especially John F. Kasson, "Rituals of Dining: Table Manners in Victorian America," pp. 114–41, and Clifford E. Clark, Jr., "The Vision of the Dining Room: Plan Book Dreams and Middle-Class Realities," pp. 142–72.

17. For the advice to the hostess, see Ward, *Sensible Etiquette*, p. 177. Information concerning the White House seating arrangements was provided by Betty Monkman, curator of the White House, April 1986. The room is illustrated set up with one rectangular table, and with the same table augmented by several smaller round tables, in [Mrs. John N. Pearce], *The White House: An Historic Guide* (Washington, D.C.: White House Historical Association, 1962), pp. 96, 98–99.

18. Hepplewhite 1794, p. 11. Draper 1939, pp. 87–88.

19. Among the many works consulted on the use of furniture, especially for dining, are Peter Thornton, *Authentic Decor* (New York: The Viking Press, 1984), and Mayhew/Myers 1980, chaps. 1–6. See also Gerard Brett, *Dinner Is Served: A Study in Manners* (Hamden, Connecticut: Archon Books, 1969). For an overview of English tables, see Edwards 1964 and Maurice Tomlin, *English Furniture: An Illustrated Handbook* (London: Faber and Faber, 1972). For background on medieval dining, see Barbara Ketchum Wheaton, *Savoring the Past: The French Kitchen and Table from 1300 to 1789* (Philadelphia: University of Pennsylvania Press, 1983), and Bridget Ann Henisch, *Fast and Feast: Food in Medieval Society* (University Park: Pennsylvania State University Press, 1976). For Madam Knight, see *The Journal of Madam Knight* (Boston: David R. Godine, 1972), p. 13. See also Barbara McLean Ward, ed., *A Glimpse into the Shadows: Forgotten People of the Eighteenth Century*, exhibition catalogue (Winterthur, Delaware: Henry Francis du Pont Winterthur Museum, 1985), pp. 12–13, fig. 5.

20. Cummings 1964, p. xxiii. M. Halsey Thomas, ed., *The Diary of Samuel Sewall, 1674–1729*, 2 vols. (New York: Farrar, Straus, and Giroux, 1973), I, pp. 416, 538, 608.

21. Rhys Isaac, *The Transformation of Virginia, 1740–1790* (Chapel Hill: University of North Carolina Press, 1982), p. 76.

22. Nutting 1924, pp. 459–60.

23. Kirk 1982, pp. 31–43.

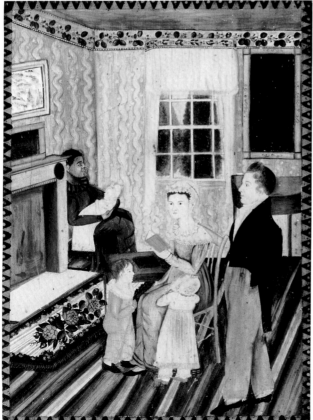

Fig. 20. *York, Pennsylvania, Family with Servant*, c. 1828.
Oil on panel. The St. Louis Art Museum, Missouri,
Bequest of Edgar William and Bernice Chrysler Garbisch.

Fig. 21. Chimney glass, probably English, 1750–70. Pine.
The Metropolitan Museum of Art, New York, Rogers Fund, 1928.

Fig. 22. Looking glass with painting (one of a pair),
probably French, 1790–1800. Pine; oil on canvas.
Collection of Mrs. Norman Herreshoff.

Fig. 23. Matthew Brady, Dining room, James Brown House, New
York City, 1869. Photograph. Museum of the City of New York.

Looking Glasses in America
1700–1850

Elisabeth Donaghy Garrett

The looking glass in America bespeaks ritual and symbolic meaning as much as utility and household use, metaphor as much as mirror. Several years after the American Revolution, a Quaker poet, looking back over the "holy experiment," the abandonment of that spirituality and simplicity which had been the essence of Quakerism, wrote a poem exhorting his brethren to spiritual renewal. Its title, "The Little Looking Glass New Fram'd and Enlarg'd,"[1] appropriated the symbol of the looking glass as a means of investing the profane with the sacred, of finding a symbol of identity in the synthetic ideal. The transposition is characteristic of a democratic nation where figural modes of common use have often been engaged to express ideological consensus and national identity.

The early years of the eighteenth century witnessed a tremendous expansion both in the number and scale of looking glasses. The choice was multifarious, and by 1761 Sidney Breese could advertise "Looking-glasses upon Looking-glasses."[2] Among the least expensive would have been a pocket glass such as the "12 Pocket Looken Glasses" listed in Meriam Potts' Philadelphia inventory in 1774; or, perhaps one of the "house wives with Glasses" which Samuel Powell of that same city was amply supplied with in 1736.[3] "Housewives" were little compartmented folding purses that women carried in the deep pockets hanging at their hips. The use of the more expensive types of glasses—chimney, pier, sconce, and dressing glasses—which were to illuminate, replicate, and seemingly aggrandize American interiors for the next two centuries, had become well established by the second decade of the eighteenth century. In 1850, Andrew Jackson Downing illustrated a variety of these types in his *Architecture of Country Houses*, maintaining that nothing added "to the splendor and gayety of an apartment as mirrors" and reiterating the accepted theory that the most effective position for them was over the mantel or in the window pier.[4] A portrait of a York, Pennsylvania, family of about 1828 shows looking glasses in both locations (Fig. 20).

Chimney glasses, designed to enliven the architectural focal point of a room and calculatingly positioned to reflect and maximize firelight, were most frequently displayed in parlors and dining rooms (which, throughout much of the eighteenth century, was a second parlor). "New Fashion Looking-Glasses and Chimney-Glasses" from England were advertised in Boston in 1715; by 1738 a Boston home offered for sale boasted of marble chimney pieces "all with Glasses over them."[5] Throughout the eighteenth and the first half of the nineteenth centuries, the chimney glass was often composed of three segmental plates to save expense, for the cost of a looking glass was largely dependent upon the size of the plate (Fig. 21). Often fitted with candle arms and gilded to further reflect the light, the overmantel or chimney glass might be painted to accord either with the wall or wainscot color. In April 1777 a thief skulked out of Robert Crommeline's Manhattan home implausibly concealing "a Chimney looking glass, with an elegant carv'd frame, painted of a stone colour."[6]

The mid-century vogue in England for an overmantel combination of plate glass and oil on canvas was contemporaneously echoed in Charleston, South Carolina, where John Colleton displayed "A Chimney Glass and a fowling Peice in Oyle" in 1751, and where neighbor John Dart exhibited "1 Chimney Glass & Fruit Piece" four years later.[7] John Brown had a pair at his fashionable seat in Providence, Rhode Island, with pastoral genre scenes above the handsome French plates (Fig. 22). Reverse painting on glass, or *verre églomisé*, was added to the decorative options in the early years of the new nation, and confections of gilded wood, trailing wire, composition work, and *verre églomisé* graced many a Republican mantel.

As the nineteenth century advanced, the overmantel mirror stretched toward the cornice. The sprightly, imaginative, often colorful creations of an earlier era were now disciplined into a plain, broad plate of rectangular glass turned on end and set upright into a window-type enframement, the pediment of which made a fanciful allusion to whatever exotic time the interior feigned to evoke—ancient Greece, Renaissance Italy, Elizabethan England, or medieval France (Fig. 23).

The most common disposition for a looking glass was in a window pier. By 1761, when "Sally Tippet," in a spoof of extravagance, railed against the New York ladies, she held before them as proof positive of their uncouth, rustic ways the accusation that a goodly half of them had neither milliners, dressing-maids, nor—the worst indictment of all—"pier-glasses."[8] In fact, "a goodly half" of them probably did have pier glasses and handsome ones at that. A wide diversity of type and size was readily available throughout the eighteenth century, with the most coveted and highly esteemed being the largest. The eighteenth-century regard for symmetry implies that pairs of such glasses were displayed between the windows. "Two very handsome Large Looking Glasses, about Eight Feet in Height," could have been purchased at public auction in Boston in 1762.[9] Alone and in pairs, large glasses compare favorably in value with other expensive items in household inventories: often more

than a desk and bookcase, equal to a dozen or more chairs, and something less than a fine tall case clock or the best bed resplendent in its hangings. Joseph Wragg's pair of large pier glasses, valued at £50 in Charleston in 1751, was equal to his dozen mahogany chairs with leather bottoms and accompanying elbow chair; while the finest looking glass in John Trail's Boston front lower room was priced at £45 in March 1750, comparing quite favorably with the chimney glass at £30, a desk and bookcase at £40, a clock at £80, and the front chamber bed and curtains at £50.[10]

The presence of a table underneath the glass is often implied and sometimes explicitly stated in Colonial documents. Among the furnishings in Elbert Haring's New York parlor in 1773, for example, was "1 Looking Glass and a Table under it."[11] Pairs of looking glasses and tables were particularly favored for the symmetry they bestowed upon a room. The west front room of Joseph Cutler's Boston house, with its pair of glasses, pair of card tables, and tandem portraits of George Washington and John Adams displayed such attention to genteel balance.[12] Marble-topped pier tables were the most costly type of table to be displayed under a looking glass. A Manhattan widow left her youngest daughter "the two large looking-glasses and the two marble tables which are placed and stand under them" in 1760; and Sarah Anna Emery, recalling a period some thirty years later, said that the typical parlor in Newburyport, Massachusetts, would have displayed card tables in the piers, sometimes with marble tops, with "large Dutch mirrors" hanging above—a singular reference to "large" Dutch mirrors, a type imported in quantity throughout the eighteenth century but generally particularized as small.[13]

Circular, convex mirrors were particularly favored for early nineteenth-century parlors and dining rooms, where they were often suspended above the sideboard, reflecting in their candle-lit, curved surfaces the impressive display of polished silver and cut glass that ornamented the sideboard top (Fig. 24). The sideboard was meant to be the most conspicuous object in the dining room, and this calculated pairing of sideboard and looking glass created an effective focal point. An alternative solution was to incorporate the looking glass in the sideboard itself, as Thomas Sheraton had suggested. Lewis Bond had "One large mahogany Sideboard, with looking-glasses in the back board" for sale in Tarboro, North Carolina, in 1829.[14] The handsomest examples boasted marble tops, and extant pieces by Anthony Quervelle of Philadelphia or William Alexander of Pittsburgh, Pennsylvania, evoke the once-sparkling display of conjoined mahogany, looking glass, marble, silver, and crystal (Fig. 25).

Throughout the eighteenth and nineteenth centuries, other furniture forms might have mirrored elements that brightened dining room and parlor. The desk and bookcase with mirrored doors could be found in both rooms (Fig. 26). With slides to support candlesticks in front of the glasses, these would have played a supplemental role in lighting the room. Because nineteenth-century theorists claimed that possessions had the power to convey the true character of the home owner, a number of multi-shelved forms with mirrored backs were devised to showcase objects that portrayed their owner's taste. Many Victorian parlors displayed a "Pyramidal whatnot" or étagère with mirrored back, the better to reflect treasured bric-a-brac (Fig. 27). Another furniture form that appears with some regularity in nineteenth-century middle-class parlors and sitting rooms is the bureau with attached dressing glass. Polly Bennett was undoubtedly proud of the "1 Mahogany Dressing Beauro with L. Glass attached" which graced her Vermont sitting room in 1849, but in affluent, urban homes this piece would have been confined to the bedchambers.[15]

Inventories and other documents suggest that the "best" bedchamber—the room that included the most elaborately draped bed—might be almost as handsomely appointed with looking glasses as the parlor. Amidst the "French luxury and novel elegance" at Anna Thaxter Parsons' Boston home in the early 1800s was a guest chamber in which "the silken canopy to the bed . . . was gathered around an oval mirror set in the centre of the arched top."[16] More typically, sconce glasses were favored for this apartment and, as in the parlor, pairs were particularly admired. Reflecting in the pair of sconce glasses and the chimney glass in William Hall's Boston front chamber in 1771 were a crimson bed with easy chair and crimson-bottomed sidechairs upholstered *en suite*. In 1794, John Hancock's "Great Chamber" in Boston must have been radiant with two looking glasses and five glass sconces.[17] Of course, the disposition of looking glasses in bedchambers mirrored the hierarchy of the beds: from the best bed and sconce glasses of the front chamber down to the cot bed and trifling glass—"school-slate size"—in the back bedroom or garret.

Some of the most genteel Colonial chambers in centers such as Boston, New York, Philadelphia, and Charleston were furnished with japanned glasses, of both English and native manufacture, which might complement a matching highchest and dressing table. A grouping that undoubtedly was found in the chamber of John Billings' Boston home in 1763 included a japanned chest of drawers, decked out with beakers and glasses, a japanned dressing table, and a long japanned looking glass.[18] The visual effect of these companionate pieces in a candlelit chamber must have been enchanting.

Chamber glasses, including japanned examples, typically came in the form of hanging glasses or small, standing dressing glasses which could be swung back and forth for greater viewing efficiency (Fig. 28). These so-called "swingers" came with

Fig. 24. Benjamin Henry Latrobe, *Proposed Interior Elevations for the Dining Room of the Tayloe House* (detail), 1795–99. Watercolor on paper. Library of Congress, Washington, D.C.

Fig. 25. William Alexander, Sideboard, Pittsburgh, 1837–44. Mahogany and pine. The Henry Francis du Pont Winterthur Museum, Delaware.

Fig. 26. Job Coit, Sr., and Job Coit, Jr., Desk and bookcase, Boston, 1738. Walnut; eastern white pine and sugar pine. The Henry Francis du Pont Winterthur Museum, Delaware.

Fig. 27. Étagère, possibly New York, c. 1850. Rosewood. Mississippi State Society, Daughters of the American Revolution, "Rosalie," Natchez, Mississippi.

Fig. 28. August Hervieu, *The Toilet*, from Frances Trollope, *Domestic Manners of the Americans*, 1832.

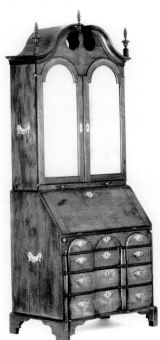

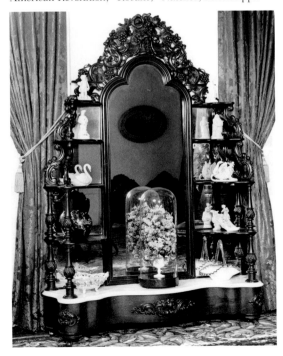

or without drawers. "Swinging glasses with drawers and without" were advertised in Boston by 1737, the drawers being used for the storage of pins or scent bottles, boxes of rouge and jars of pomatum, or perhaps a vial of "Royal milk-water," which promised to take "all spots, scurfs, pimples and freckles off the face."[19] These dressing glasses stood on a dressing table, a bureau table or a chest of drawers (cats. 206–207). It must have proved difficult for fashionable women who favored "the mode to make a lady's head of twice the natural size" to get their towering coiffures in full view.[20]

Hanging and dressing glasses resided harmoniously side by side in American bedchambers throughout the eighteenth and early nineteenth centuries. By 1768, James Reynolds was prepared to follow his client's inclinations and could supply dressing glasses, with or without drawers, swinging or hanging glasses as well as shaving and pocket glasses.[21] By 1840, however, Eliza Leslie, in *The House Book, or, A Manual of Domestic Economy*, would pronounce that the "small movable looking-glasses, standing on feet, are much out of favour for dressing tables, as they scarcely show more than your head, and are easily upset." Rather, she continued:

It is now customary to fix a large glass upon the wall at the back of the table or bureau; suspending it by a double ribbon to a strong hook, and making the string long enough to allow the glass to incline considerably forward, so as to give the persons that look into it a better view of their figures.[22]

There might be a number of toilette amenities hanging on the wall beside the glass. Nathaniel Hawthorne rested comfortably in a bedchamber in July 1837, "its walls ornamented with a small gilt-framed, foot-square looking-glass with a hair-brush hanging beneath it"; and Eliza Leslie imagined another arrangement where over the bureau "was suspended a tall looking-glass in a narrow mahogany frame, on one side of which hung a combcase of yellow paper bound with green ribbon, and on the other, a new calico [curling] iron holder; also a nasturtian [sic] growing in water."[23]

Dressing bureaus with large looking glasses attached proved a satisfactory compromise in the early nineteenth century. Miss Leslie pronounced the most elegant dressing tables to be those of mahogany "with marble tops, having at the back a large mirror, with candle-branches or lamp-brackets on each side."[24] Candle arms attached to the dressing glass would have promoted a more efficient toilette by freeing the hands. Otherwise an additional helper was required; the Chinn girls in New Orleans in the 1830s typically had two candles to dress by and "two dusky maids to follow . . . all about, and hold them at proper points so the process of the toilet could be satisfactorily accomplished."[25] Candle branches might also be attached to the tall

standing dressing glass or cheval glass which came into fashion in the early nineteenth century; a particularly handsome example in The Metropolitan Museum of Art boasts adjustable ormolu candle arms and swinging side trays to hold toilette accoutrements (Fig. 29). The grouping of "a dressing Table & Glass & a pr Glass Shades" in James Postell's Charleston "Blue Room" in August 1773 suggests yet another attempt to efficiently light the dressing process—by protecting the candles from drafts.[26]

The growing emphasis on personal cleanliness that began to manifest itself in the second half of the eighteenth century brought with it a novel diversity of furniture forms to assist in the care and cleansing of the body.[27] Washstands, dressing tables, commodes, and beau brummels all frequently secreted looking glasses. At the same time, hanging and dressing glasses grew ever larger. By the second half of the nineteenth century, the properly hygienic bedchamber and dressing room would have contained a wardrobe, preferably with mirrored doors, a mirrored shaving stand (cat. 209) and washstand, and a bureau with its cornice-stretching mirror.

Such expanses of plate glass, silvered glass, and gilded frames required special care and handling if they were to look well in fire, candle, and lamp-smoked interiors. Two additional problems seemed to have plagued looking glasses in America—the climate and the servants. Certainly the stifling heat of summer and the frigid blasts of winter cannot have been beneficial to the glass plates, nor was the problem of dampness. Nicholas Geffroy, a looking-glass dealer in Newport, Rhode Island, in the early years of the nineteenth century, was convinced that "two thirds of the Glasses are generally spoilt in this climate by what people generally call *being touched by worms*, but it is the dampness of the air which produces that effect." He invented a composition that would prevent the glass from being damaged "even against the water," which he warranted for ten years or new silvering gratis.[28] When Charles Carroll of Carrollton ordered a handsome pair of gilt carved girandoles and an *en suite* pair of pier glasses for his Maryland home from his London agent in 1774, he wanted them to be "as fashionable & as handsome as can be purchased for 15 guineas each." But he also took note of the circumstances peculiar to his American setting, mandating that the carving was "to be of a solid kind; it has been found by experience, that slight carving will neither endure the extreames of Heat & Cold nor the rough treatment of negro servants."[29] Citizens of a country vexed by weather extremes, beleaguered by a proverbial dearth of servants, and harassed by the inefficiency and clumsiness of those who did serve, might well choose a solid style free of superfluous carving and other ornamentation. The fickleness of the servant help in this land of democracy meant that it was often the mistress her-

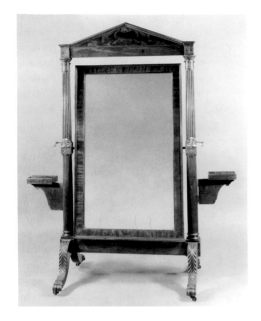

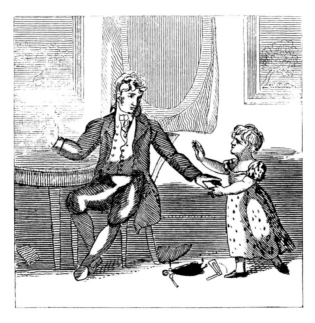

Fig. 29. Cheval glass, probably New York,
c. 1815. Mahogany. The Metropolitan Museum
of Art, New York, Gift of Ginsburg and Levy, Inc.,
in memory of John Ginsburg
and Isaac Levy, 1969.

Fig. 30. *Careless Maria*, from *The Rose Bush;
or Stories in Verse*, n.d. Old Sturbridge Village,
Sturbridge, Massachusetts.

self who had to care for the family possessions. Catharine
Beecher sagely advised in 1873 that every American girl
"should be taught to know the right and the wrong way of pro-
tecting or cleansing every article, from the rich picture-frames
and frescoes to the humblest crockery and stew-pan."[30]

In addition to regular feather-tipped dustings, looking
glasses (and all objects found between "the rag hole in the gar-
ret" and "the rat hole in the cellar") were subjected to the semi-
annual cleanings that prepared the house for the rigors of winter
or summer. Hibernal threats came in the form of smoke from
coal and wood fires, candles, and lamps. Summer brought a
double-flanked invasion of dust and flies. Paintings, prints, and
looking glasses had to be taken off the walls, cleaned, prepared
for the summer onslaught and returned to their customary
positions.[31] An oft-quoted recipe for deterring flies from light-
ing on gilded frames involved washing the frames in water in
which onions or leeks had been boiled; if this did not thwart the
attacks, one might wash off fly specks with a heady dose of gin
on a soft flannel rag. Alternative solutions included covering
gilt-framed looking glasses with net, cambric, tissue, or muslin
(Fig. 30). Eliza Leslie thought that a particularly tasteful solu-
tion would be to cut out "large jagged leaves, laid closely over
each other, so as to cover completely the gilt frames of mirrors

and pictures, and looking like a thick mass of foliage all
around."[32] Nonetheless, many a looking glass was enshrouded
in muslin, "muffled to its throat from March to December."[33]

Death brought a reason to cover looking glasses, for it was
believed that the soul of the living person, projected in the form
of a mirror image, could be carried off by the ghost of the
deceased, which remained in the house until burial.[34] How
prevalent this custom was in eighteenth- and early nineteenth-
century America has not been determined. Prudence Punder-
son's needlework picture, perhaps copied from a print source, is
the earliest pictorial documentation (Fig. 31). Following a death
in Harriet Beecher Stowe's *Poganuc People* of 1878, "every
pleasant thing in the house was shrouded in white; every picture
and looking-glass in its winding-sheet"; and subsequent to lit-
tle Eva's heart-wrenching death in *Uncle Tom's Cabin*, "the stat-
uettes and pictures in Eva's room were shrouded in white nap-
kins."[35] Lloyd Douglas, who was born in 1877, recalled that
during his Indiana boyhood "when there was a death in the
family it was a country custom for some helpful neighbor to stop
your clocks," and others would "turn all your mirrors to face the
wall."[36]

The hazards of enshrouding, cleaning, hanging, taking
down, and transporting glasses meant that frames were often

chipped and plates worn or cracked. The relentlessness of the cleaning season claimed some; servants claimed others; climate took its toll; and then there was that "Old Cat" who, in January 1802, "injured the looking glass (by breaking off some of the gilt Ornaments) which was bought last week. Cost 25 dol."[37] More dramatic and costly was the scene at Mrs. Alexander Spotswood's Virginia home in 1732, as narrated by Colonel William Byrd:

I was carried into a room elegantly set off with pier glasses, the largest of which came soon after to an odd misfortune. Amongst other favourite animals that cheered this lady's solitude, a brace of tame deer ran familiarly about the house, and one of them came to stare at me as a stranger; but, unluckily spying his own figure in the glass, he made a spring over the tea table that stood under it and shattered the glass to pieces and, falling back upon the tea table, made a terrible fracas among the china.[38]

Some seventy-two years later, Elizabeth Bleecker McDonald was dismayed to return to her Manhattan home and find "our Looking Glass in the Parlour had fallen down, and broken in several places—the cord by which it was suspended had entirely rotted through."[39]

Inventories confirm such tales of damage: "1 Large Pier Looking Glass Crackt in 2 Places," "A Large Pier Glass the Plate broke," "1 Broken Sconce Glass," "1 Swinging Looking Glass old fashioned most the Silver off," and "1 large Looking Glass Very much Out of Order & Several Places the Quicksilver Wanting."[40] Inventories that list possessions room by room suggest that old-fashioned glasses were likely to be relegated to lesser apartments. Large, important looking glasses that were cracked or chipped might be left *in situ* on parlor, dining room, or bedchamber walls, the master or the mistress of the house knowing that the carver and gilder, the upholsterer, the dry goods merchant, the looking-glass manufacturer, or the cabinetmaker might all come to their aid. These tradesmen were willing to oblige in a number of ways: removing, repairing, altering, cleaning, and hanging. John Elliott, Sr., of Philadelphia was prepared to "undertake to cure any English looking glass that shews the face either too long or too broad or any other way distorted."[41] Elliott, and many others, were happy to purchase broken plates, could resilver or otherwise mend old plates, regild and repaint frames, make new frames for old glasses, and fit new glasses to old frames.

Many tradesmen offered to assist taking down and hanging looking glasses—a boon to housewives at housecleaning time. Charleston cabinetmaker Thomas Elfe billed Thomas Phaepoe for taking down four glasses and rehanging them with four brass cloak pins in September 1774. Catharine Gansevoort of Albany paid Lawson Annesley for four yards of green cord with

which he hung four looking glasses in June 1824.[42] Listed in Maria Gerritse's Albany inventory in August 1749 are "2 small brass Shells for under a looking glass,"[43] while in 1793 Kneeland and Adams of Hartford offered "Elegant Looking-Glasses, from one to thirty Dollars each and a good assortment of China faced Clo[a]k Pins."[44] Richard Brunton's portrait of Mrs. Reuben Humphreys, painted about 1800, shows a looking glass supported by cloak pins (Fig. 32).

Correlative with the increased attention to personal grooming was a heightened regard for cleanliness about the house, at least in the homes of the upper classes, and the reflective polish of the looking glass became a metaphor for fastidious housekeeping. Several of the French officers and observers of the American scene in the 1700s and early 1800s were particularly impressed with the sparkle of American interiors. Felix de Beaujour commented that in America it was "impossible not to admire the polish of the furniture, and even the extreme cleanliness of the floors"—a shine that Louis de Robertnier in 1780 found enabled "anyone to look at himself anywhere."[45] Indeed, the ultimate compliment to a housewife seems to have been that her mahogany, silver, brass, and pewter emulated the looking glasses in their brightness. Caroline Trumbull of Worcester, Massachusetts, spent a Saturday in January 1832 helping her mother clean the andirons and the door latch, which she did so well "as to see your face in it"; while the old mahogany dining table at the King residence in Salem was "rubbed with a brush and beeswax until one could see one's face in it."[46] John Adams was impressed with Mrs. Eustis' "very neat house" in Portland, Maine, in July 1774, where the "desk and table shine like mirrors."[47] And in the fiction of the time we can admire the aptly named Mrs. Worthy's best room, where beside the window "stood a large maple table, which for its bright polish resembled the looking glass which hung over it."[48]

Persistent references to reflection were a leitmotif in accounts of early interiors, and looking glasses played a prominent role in these narratives. The dramatic alliance of artificial light and plate glass was clearly stated in the use of sconce glasses in parlor, dining room, and bedchamber; and reiterated in the strategic placement of candles, lamps, and chandeliers before all glasses. Much impressed with the elegance of Mrs. Israel Pemberton Hutchinson's Philadelphia home in 1841, Sidney George Fisher effused over the scene about her fireplace, "the gold ornaments on the mantel & the large mirror above glittering with lights from candelabra and chandeliers," which he thought produced "a very beautiful effect."[49] When Mary Hill Lamar wrote from London in the 1770s to her brother, Henry Hill of Philadelphia, responding to his request for looking glasses, she advised that "a best room furnished in the present style and plainest taste is nothing more than two sofas, twelve or

more chairs, a marble half circular table under the glass or glasses, glass lustres on the slabs to hold four lights . . . or, in place of them, silver or plated branches for three candles."⁵⁰

The careful tabulation of lights before glass and the emphasis on reflection expressed in this letter convey the typical pier grouping that had evolved in Europe in the 1600s: a table with a looking glass suspended above and a pair of candlestands to either side.⁵¹ By day these pieces were illuminated by incoming light from the flanking windows. By night, the candles on the stands would reflect in the tall glass and play about the carved elements of this so-called triad. The candlestands had disappeared from this grouping by the eighteenth century, but candle arms were frequently attached to the glass. Pier tables were often designed, both in form and surface ornamentation, to be seen doubled in the glass which, by the late eighteenth century, might appear to extend down to the floor. Inlaid and painted semicircles on the back edge of these tabletops would come full circle through reflection. There might be serpentine stretchers similarly designed with a doubled image in mind and a platform in the center of the stretchers upon which to place some decorative device, such as a basket of flowers. Nineteenth-century housewives, taking advantage of these reflective possibilities, sometimes exhibited their shell collections on the bottom shelf of the pier table.⁵² A good deal of forethought, therefore, went into the placement of objects before mirrors, whether the mantel garniture, shells, or perhaps the carefully calculated fall of a curtain tassel swagged across a pier glass. Eliza Leslie described a room gaily illuminated by astral lamps and crystal chandeliers with curtains of the richest crimson, their "deep silken fringes reflected in the mirrors, whose polished surfaces were partially hidden by folds of their graceful drapery."⁵³

A common arrangement, designed to give the illusion of greater spaciousness and to maximize reflection, was to place chimney and pier glasses across from each other, often with a chandelier or ceiling lamp suspended between them. Other arrangements were more sophisticated, designed to suggest theatrical enfilades of rooms (Fig. 33). One fortunate enough to attend a ball at John Brown's home in 1788 was delighted with just such a magical effect: "Two of the largest and most elegant mirrors I ever saw ornamented the rooms. Standing in the door which is in the middle of the partition you are just in line with

31

32

33

Fig. 31. Prudence Punderson, *The First, Second, and Last Scene of Mortality*, Preston, Connecticut, c. 1775. Silk thread on satin. The Connecticut Historical Society, Hartford.

Fig. 32. Richard Brunton, *Anne Humphreys with her Daughter Eliza*, c. 1800. Oil on canvas. The Connecticut Historical Society, Hartford.

Fig. 33. Francis Heinrich, *Mr. and Mrs. Ernest Fiedler and Their Children*, 1850. Oil on canvas. Private collection.

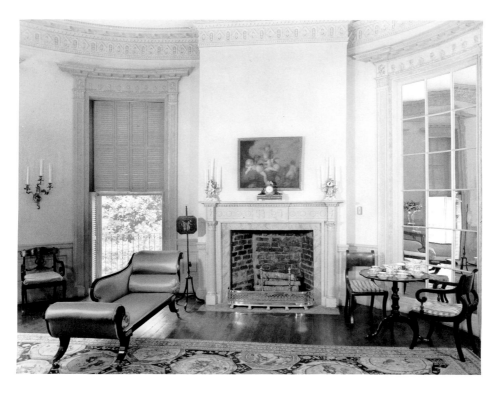

Fig. 34. Drawing room, c. 1809,
Nathaniel Russell House,
Charleston, South Carolina.
Historic Charleston Foundation.

them, so that at the head of the dance you can look down through a variegated crowd of sprightly dancers."⁵⁴ Nineteen-year-old Eliza Southgate Bowne described a similar scene at Elias Hasket Derby's House in Salem, Massachusetts, in 1802:

. . . Mr. Hasket Derby [Jr.] asked if we should not like to walk over to his house and see the garden. . . . We entered the house, and the door opened into a spacious entry . . . and at the farther part of the entry a door opened into a large, magnificent oval room; and another door opposite the one we entered was thrown open and gave full view of the garden below. The moon shone with uncommon splendor. The large marble vases, the images, the mirrors to correspond with the windows, gave it so uniform and finished an appearance, that I could not think it possible I viewed objects that were real, every thing appeared like enchantment.⁵⁵

Regardless of the cost, large expanses of plate glass became popular in the reception rooms of the upper classes. The more elegant the interior, the larger and more numerous the glasses. Evelina du Pont admired Mrs. Ralph Izard's Charleston home, Landsdowne, in May 1813, commenting on the "two immense parlors, one of which is almost covered up with large Looking Glasses."⁵⁶ The large-scale glasses and mirrored doors and false windows in the homes of Joseph Barrell, William Bingham, John Brown, Harrison Gray Otis, Nathaniel Russell (Fig.

34), and other members of the Republican elite were calculated to enhance the effect of candlelight in a social age that relished conviviality and evening entertainment. By 1851 one American newspaper could report that "the use of large mirrors have [*sic*] become much more fashionable among us; and, in fact, there is no finer decoration for our saloons."⁵⁷ Frances Trollope conceded that the mirrors in the homes of the higher classes "are as handsome as in London," while Amelia Murray insisted in 1855 that fine mirrors were more common in America than in England.⁵⁸

Silvered elements of all kinds reflected in these glasses, proclaiming the American taste for glitter. The wallpaper might be one of those with "the most fashionable silver Grounds," or perhaps one of the "frosted, spangled, and velvet papers" with "frosted and spangled borders" that could be purchased in Boston in 1790.⁵⁹ Silver- and gold-spangled needlework and mica-flecked sconces might further enliven the walls; even the floorcloth might be "tinsel'd." Ladies appeared "in a white robe trim'd with silver" or in "white muslin thickly spangled with gold."⁶⁰ Silvered-glass doorknobs and curtain tiebacks could have sparkled in a nineteenth-century parlor, and in the dining room there might be a mirrored plateau on the center of the table, similar to the one Joseph Barrell had ordered in 1795.⁶¹ For weddings and other special occasions this table might glim-

mer with baskets "rarely ornamented with silver spangles" or a pair of small silver globes like those William Wirt described from Williamsburg, Virginia, in 1806: these "might have *passed*—if Charlotte, to enhance their value, had not told us that they were a fruit—whose name I don't recollect—between the size of a shaddock [grapefruit] and an orange, covered with silver leaf;—which was rather too outlandish for my palate."[62]

One other type of silvered, mirror globe could be found in the American home. Lucy Clark Allen, born in Hingham, Massachusetts, in 1791, recalled childhood visits to a neighbor's home where she admired "the glass globe which hung on the great beam in the middle of the room, and reflected the whole room in its mirrored surface in miniature, very wonderful to my childish eyes."[63] Eliza Susan Quincy pictured Ebenezer Storer's Boston drawing and dining rooms where, from the center of the large summer beam which traversed each room, "depended a glass globe, which reflected, as in a convex mirror, all surrounding objects." The 1807 inventory of Mr. Storer's estate tellingly tallies "1 Glass Globe" in the front parlor and "A Globe" in the dining parlor.[64] In Royall Tyler's attempt to portray the quintessential parlor in a stately Boston mansion, we find that "From the middle of the ceiling, in the center of a circular department of stucco work, was depended a glass globe, the inside coated with quicksilver."[65] The 1771 inventory of the estate of Royall Tyler's father lists "1 large Glass globe" that appears to hang in the parlor and quite clearly had seemed as wonderful to young Royall as the other globe had to Lucy Allen.[66]

By 1850, technological innovations in the manufacture of glass plates and transportation advances ensured that every American family, from city to outpost, from villa to cabin, might subscribe to the taste for glitter and select from a wide variety of looking glasses in an equally diverse price range. No one need go without a looking glass. But in the preceding hundred years, pride, emulation, and a host of other causes had led some to stretch beyond their means for a disproportionately fine looking glass. Captain Patrick Gatee must have been proud of the "large Looking Glass" that was prized at three times as much as any other furnishing in his Boston "Fore Room" in 1750.[67] Benjamin Franklin's apocryphal Mrs. Anthony Afterwit replaced an old-fashioned looking glass with a more handsome and creditable one and thereafter embarked on a catastrophic spending spree. The great debacle came after the purchase of the looking glass, tea table, chairs, tea equipage, clock, and fine prancing mare, all of which—except the glass—were disposed of by her outraged husband while she was out visiting. The treasured glass Mr. Afterwit craftily retained as a bribe

because I know her Heart is set upon it. I will allow her when she comes in, to be taken suddenly ill with the Headach, *the* Stomach, Fainting-Fits, *or whatever other Disorder she may think more proper; and she may retire to Bed as soon as she pleases: But if I do not find her in perfect Health both of Body and Mind the next Morning, away goes the aforesaid Great Glass . . . to the Vendue that very Day.*[68]

Mrs. Afterwit's lust for a creditable looking glass speaks for an aspiration shared by thousands of Americans before and since. Possession of pride, symbol of vanity, icon of conspicuous consumption; in fiction as in fact, in ritual as in reality, the looking glass in the American home has tenaciously held a symbolic meaning that transcends conventional utility and function.

1. Frederick B. Tolles, *Meeting House and Counting House: The Quaker Merchants of Colonial Philadelphia 1682–1763* (Chapel Hill: University of North Carolina Press, 1948), pp. 242–43.
2. Singleton 1902, p. 236.
3. Alice Hanson Jones, *American Colonial Wealth: Documents and Methods* (New York: Arno Press, 1977), I, p. 178; Samuel Powell, Jr., manuscript day book, 1735–39, Joseph Downs Manuscript Collection, Henry Francis du Pont Winterthur Museum, Delaware.
4. Downing 1850, pp. 435, 383, pls. facing pp. 379, 383, 384.
5. Dow 1927, pp. 107, 212.
6. Gottesman 1954, p. 131.
7. Colleton, November 27, 1751; Dart, March 12, 1755, Charleston County, South Carolina, Inventories, 1748–56, microfilm, Museum of Early Southern Decorative Arts, Winston-Salem, North Carolina.
8. Singleton 1902, p. 242.
9. Dow 1927, p. 129.
10. Wragg, September 18, 1751, Charleston County, South Carolina, Inventories, 1748–56; Trail, March 26, 1750, SCPR, 44, pp. 20–22.
11. December 14–15, 1773, Inventories of Estates, New York City and Vicinity 1717–1844, roll 1; microfilm, The New-York Historical Society.
12. December 18, 1806, SCPR, 105, p. 51.
13. Singleton 1902, p. 74; Emery 1879, p. 244.
14. Sheraton 1803, pp. 304–05. James H. Craig, *The Arts and Crafts in North Carolina 1699–1840* (Winston-Salem, North Carolina: Museum of Early Southern Decorative Arts, 1965), p. 219.
15. Pauline W. Inman, "House Furnishings of a Vermont Family," *Antiques* 96 (August 1969), p. 232.
16. Emery 1879, p. 243.
17. Hall, November 15, 1771, SCPR, 71, pp. 61–62; Hancock, January 28, 1794, SCPR, 93, p. 13.
18. April 1763, SCPR, 62, p. 173.
19. Dow 1927, p. 127; Singleton 1902, p. 211.
20. Singleton 1902, p. 205.
21. Prime 1929, p. 225.
22. Eliza Leslie, *The House Book, or, A Manual of Domestic Economy* (Philadelphia: Carey and Hart, 1840), p. 300.
23. Randall Stewart, ed. *The American Notebooks by Nathaniel Hawthorne* (New Haven: Yale University Press, 1932), p. 15; Miss [Eliza] Leslie, *Atlantic Tales: or, Pictures of Youth* (Boston: Munroe and Francis; New York: C.S. Francis, 1835), p. 209.
24. Leslie, *The House Book*, p. 300.
25. Eliza Ripley, *Social Life in Old New Orleans* (New York: D. Appleton and Company, 1912), p. 36.

26. August 16, 1773, Charleston County, South Carolina, Inventories, 1771–76.
27. Richard L. Bushman and Claudia L. Bushman, "The Early History of Cleanliness in America," *The Journal of American History* 74 (March 1988), pp. 1213–38.
28. *Antiques* 118 (September 1980), p. 418.
29. Charles Carroll, manuscript letterbook, October 1711–July 1833, Arents Collection, The New York Public Library.
30. Catharine Beecher, *Miss Beecher's Housekeeper and Healthkeeper: Containing Five Hundred Recipes for Economical and Healthful Cooking, Also Many Directions for Securing Health and Happiness* (New York: Harper and Brothers, 1873), p. 129.
31. For a more in-depth discussion of seasonal housekeeping practices, see Elisabeth Donaghy Garrett, "The American Home, Part VI: The Quest for Comfort: Housekeeping Practices and Living Arrangements the Year Round," *Antiques* 128 (December 1985), pp. 1210–23.
32. Leslie, *The House Book*, p. 344.
33. Christopher Crowfield [Harriet Beecher Stowe], *House and Home Papers* (Boston: Ticknor and Fields, 1865), p. 37.
34. See Benjamin Goldberg, *The Mirror and Man* (Charlottesville: University Press of Virginia, 1985).
35. Harriet Beecher Stowe, *Poganuc People* (1878; ed. Hartford, Connecticut: The Stowe-Day Foundation, 1977), p. 283; idem, *Uncle Tom's Cabin* (1852; ed. New York: The Library of America, 1982), p. 347.
36. Lloyd C. Douglas, *A Time to Remember* (Boston: Houghton Mifflin, 1951), p. 222.
37. A.G. Roeber, ed., "A New England Woman's Perspective on Norfolk, Virginia, 1801–1802: Excerpts from the Diary of Ruth Henshaw Bascom," *Proceedings of the American Antiquarian Society* 88, part 2 (1978), p. 291.
38. *A Progress to the Mines in the Year 1732*, in *The Prose Works of William Byrd of Westover*, ed. Louis B. Wright (Cambridge, Massachusetts: Belknap Press of Harvard University Press, 1966), pp. 355–56.
39. Elizabeth DeHart Bleecker McDonald, manuscript journal, entry for March 19, 1804, The New York Public Library.
40. Joseph Wragg, September 18, 1751; David Hext, October 19, 1754, Charleston County, South Carolina, Inventories, 1748–56. John McQueen, February 2, 1764; Lillias Moubray, May 24, 1765, Charleston County, South Carolina, Inventories, 1763–71. James Nappier, New York, March 26, 1754, manuscript book of inventories, Joseph Downs Manuscript Collection, Henry Francis du Pont Winterthur Museum, Delaware.
41. Prime 1929, p. 196.
42. Webber 1939, p. 59; manuscript receipt, Gansevoort-Lansing Family Papers, The New York Public Library.
43. Downs 1952, no. 257.
44. Nancy E. Richards, "Furniture of the Lower Connecticut River Valley," *Winterthur Portfolio* 4 (1968), p. 9.
45. Felix de Beaujour, *Sketch of the United States of North America at the Commencement of the Nineteenth Century from 1800 to 1810*, transl. William Walton (London: J. Booth et al., 1814), p. 150; in L.J.B.S. Robertnier, "Rhode Island in 1780," *Rhode Island Historical Collections* 26 (July 1923), p. 69.
46. Louisa Jane Trumbull, manuscript diary, vol. I, Trumbull Family Papers, American Antiquarian Society, Worcester, Massachusetts; Caroline Howard King, *When I Lived in Salem 1822–1866* (Brattleboro, Vermont: Stephen Daye Press, 1937), pp. 22–23.
47. *Familiar Letters of John Adams and His Wife Abigail Adams, During the Revolution with a Memoir of Mrs. Adams by Charles Francis Adams* (New York: Hurd and Houghton; Cambridge, Massachusetts: The Riverside Press, 1876), p. 11.
48. Enos Hitchcock, *The Farmer's Friend, or the History of Mr. Charles Worthy* (Boston: I. Thomas and E.T. Andrews, 1793), p. 100.
49. Nicholas B. Wainwright, ed., *A Philadelphia Perspective: The Diary of Sidney George Fisher Covering the Years 1834–1871* (Philadelphia: The Historical Society of Pennsylvania, 1967), p. 116.
50. Quoted in Smith 1854, p. 198.
51. Thornton 1978, pp. 93–94.
52. A silhouette of an unidentified family by Augustin A.C.F. Edouart, made in New York City in 1842, shows a pier table with shells displayed on the shelf (Henry Francis du Pont Winterthur Museum, Delaware, no. 54.4.2)
53. Miss [Eliza] Leslie, *Pencil Sketches: or, Outlines of Character and Manners* (Philadelphia: A. Hart, 1852), p. 225.
54. Cooper 1980, p. 258.
55. *A Girl's Life Eighty Years Ago: Selections from the Letters of Eliza Southgate Bowne* (New York: Charles Scribner's Sons, 1887), p. 113.
56. Quoted in Betty-Bright P. Low, "The Youth of 1812: More Excerpts from the Letters of Josephine du Pont and Margaret Manigault," *Winterthur Portfolio* 11 (1976), p. 195 n. 104.
57. Quoted in Charles Lockwood, *Bricks and Brownstone: The New York Row House, 1783–1929* (New York: McGraw-Hill, 1972), p. 175.
58. Frances Trollope, *Domestic Manners of the Americans* (1832; ed. New York: Alfred A. Knopf, 1949), p. 338; the Hon. Amelia M. Murray, *Letters from the United States, Cuba and Canada* (1856; ed. New York: Negro Universities Press, 1969), p. 403.
59. Prime 1932, p. 285; Walter Kendall Watkins, "Early Use and Manufacture of Paper-Hangings in Boston," *Old-Time New England* 12 (January 1922), p. 117.
60. Rodris Roth, "The Interior Decoration of City Houses in Baltimore 1783–1812," M.A. thesis, University of Delaware, Newark, 1956, p. 44; Sally Armitt to Susanna Wright, 1755, quoted in *Pennsylvania Magazine of History and Biography* 38, no. 1 (1914), p. 122; *Pennsylvania Magazine of History and Biography* 22, no. 3 (1898), p. 378.
61. Dean A. Fales, Jr., "Joseph Barrell's Pleasant Hill," *Transactions 1956–1963* (Publications of the Colonial Society of Massachusetts, 43 [1966]), p. 384.
62. John P. Kennedy, *Memoirs of the Life of William Wirt, Attorney-General of the United States* (Philadelphia: Blanchard and Lea, 1852), I, p. 135.
63. *Memorial of Joseph and Lucy Clark Allen by Their Children* (Boston: George H. Ellis, 1891), p. 39.
64. Eliza Susan Quincy, *Memoir of the Life of Eliza S.M. Quincy* (Boston: John Wilson and Son, 1861), p. 89; March 16, 1807, SCPR, 105, p. 202.
65. Royall Tyler, "The Bad Boy," quoted in *Antiques* 99 (May 1971), p. 688.
66. December 20, 1771, SCPR, 71, p. 133.
67. March 27, 1750, SCPR, 43, p. 525.
68. Leonard W. Labaree et al., eds., *The Papers of Benjamin Franklin* (New Haven: Yale University Press, 1959), I, p. 240.

Catalogue

Notes to the Catalogue

This catalogue completes a series of four volumes on the American furniture collection of Yale University. The present volume records objects in the categories not covered by its predecessors: 140 tables, 22 related objects, and 47 looking glasses that were in the Yale University Art Gallery's collection as of May 1, 1991. Within the primary categories the objects have been grouped by formal characteristics rather than by function, regional origin, or chronology. This arrangement was adopted because of the narrow chronological range of the Art Gallery's looking-glass collection and the fact that many tables cannot be specifically classified as to function. The 43 tables and looking glasses in the Art Gallery's Study Collection follow the main catalogue and are designated by the letter A preceding the catalogue number. Detailed physical descriptions are omitted, but exhibitions, publications, and provenances are included.

Nomenclature contemporary with the objects, such as "oval table with falling leaves" or "dressing box and swinging glass," has been used whenever it can be determined.

If an object is listed as "one of a pair" in the heading, both objects are in the Art Gallery's collection, but the data was recorded from the example whose accession number is given. Objects with mates in other collections have this information noted in the text rather than the heading.

The exterior, or primary, materials are listed before the interior, or secondary, materials; these categories are separated by a semicolon. All woods have been identified by microanalysis, with the exceptions of cats. 128, A10, A31, and A38. Veneers have been included in the list of materials only when they could be positively identified by sight. The scientific names for the common names cited in the entries are given in Appendix B.

Dimensions are recorded in centimeters, followed by inches, which have been rounded to the nearest eighth. Dimensions are outside measurements; height precedes width precedes depth or diameter.

Structure: Terminology used to describe parts of objects has been keyed to diagrams in Appendix A. "Left" and "right" refer to the object's proper left or right.

Inscription: Objects are unmarked unless otherwise indicated. All notations, numbers, and labels added to an object have been recorded, with the exception of Francis P. Garvan's catalogue number or the Art Gallery's accession number.

Condition: All parts of an object and its construction as described in the Structure section are considered original unless otherwise noted. When records exist, the dates of any repairs or restoration and the name of the workman have been noted.

Exhibitions: Long-term loans are not recorded, particularly those from the Mabel Brady Garvan Collection to other museums and historic houses between 1930 and 1958. The inclusion of an object in a temporary exhibition is recorded by a bibliographical citation of the exhibition catalogue, if one exists; full citations for abbreviated forms appear in Appendix E. An exhibition citation is not repeated in the Reference section. If no exhibition catalogue was published, the exhibition is cited in full.

References: Bibliographical references for publications in which an object was illustrated are in chronological order; full citations for abbreviated forms appear in Appendix E. If the entry for an object does not include a Reference section, that object has never been published.

Provenance: An absence of data concerning provenance indicates that the provenance cannot be traced back beyond the donor listed in the credit line. Background information on donors of more than one piece of furniture appears in Appendix C and is not repeated in the entries. The dealers from whom Francis P. Garvan purchased the furniture in this volume are discussed in Appendix D. The provenances of most pieces owned by Garvan are recorded in more than one source, including correspondence, bills of sale, and notations on lists and catalogue cards. Specific citations to these sources have not been made unless the data is contradictory or of special interest.

Plate 1. Card table, attributed to Samuel Barnard, Salem, Massachusetts, 1800–20 (cat. 91).

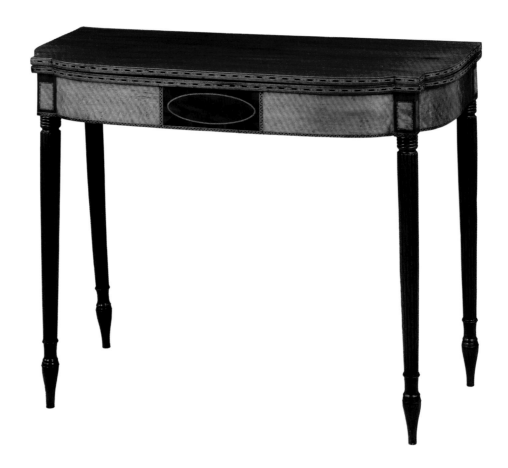

Plate 2. Oval table with falling leaves, southeastern Virginia or northeastern North Carolina, 1690–1740 (cat. 43).

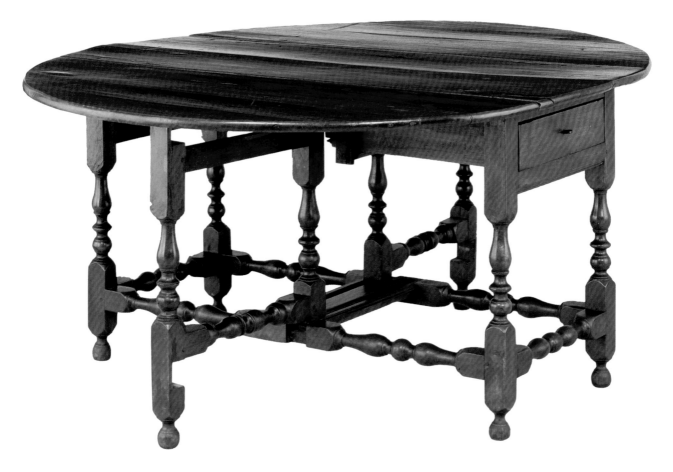

Plate 3. Oval table with falling leaves, southern New England, 1690–1720 (cat. 46).

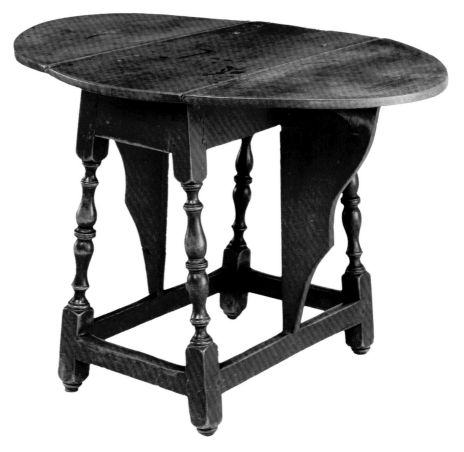

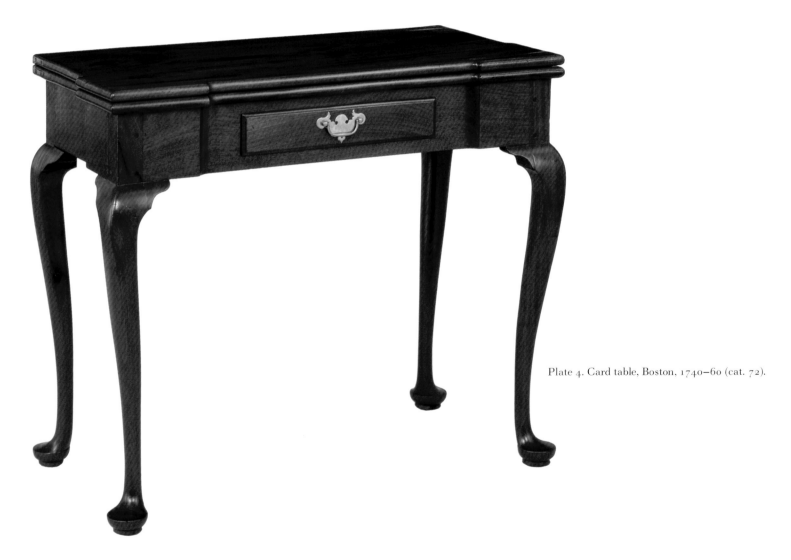

Plate 4. Card table, Boston, 1740–60 (cat. 72).

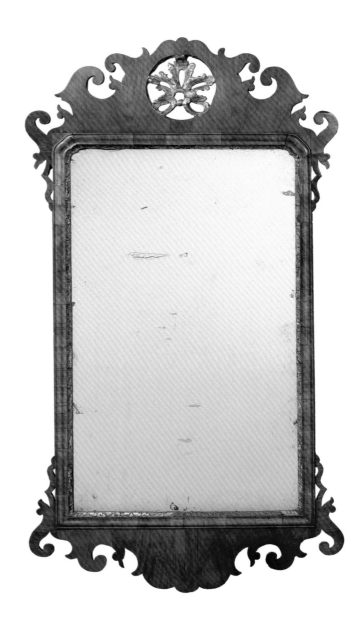

Plate 5. Looking glass, probably England, 1750–80 (cat. 167).

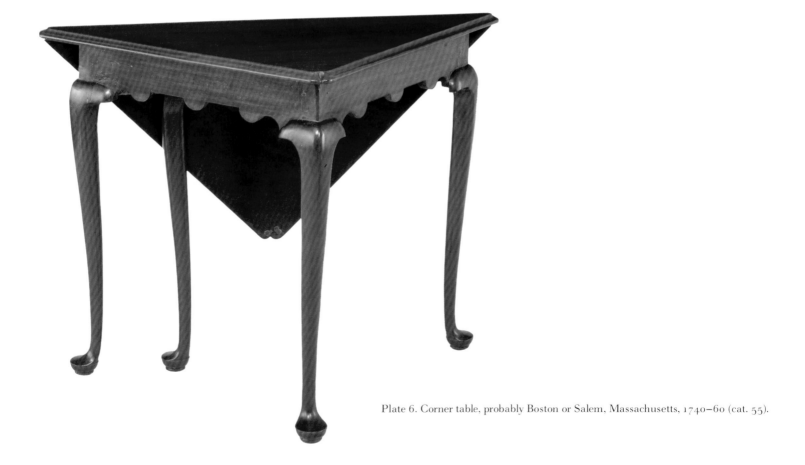

Plate 6. Corner table, probably Boston or Salem, Massachusetts, 1740–60 (cat. 55).

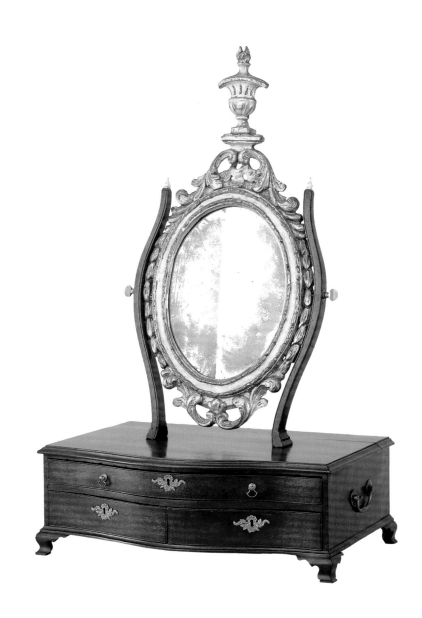

Plate 7. Dressing box with swinging glass, Jonathan Gostelowe and James Reynolds, Philadelphia, 1789 (cat. 207).

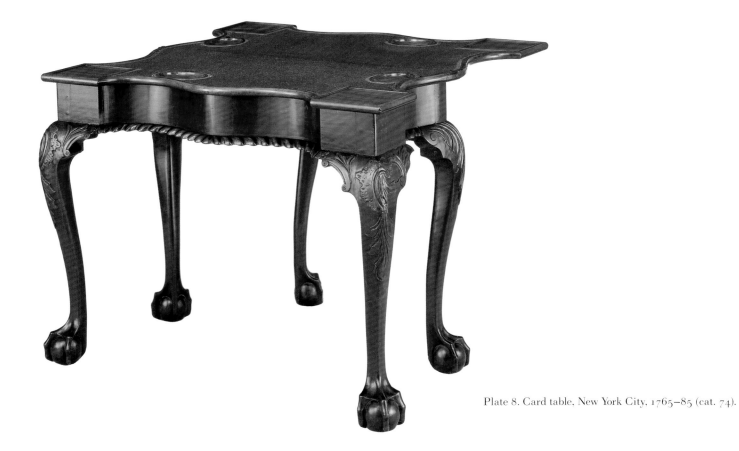

Plate 8. Card table, New York City, 1765–85 (cat. 74).

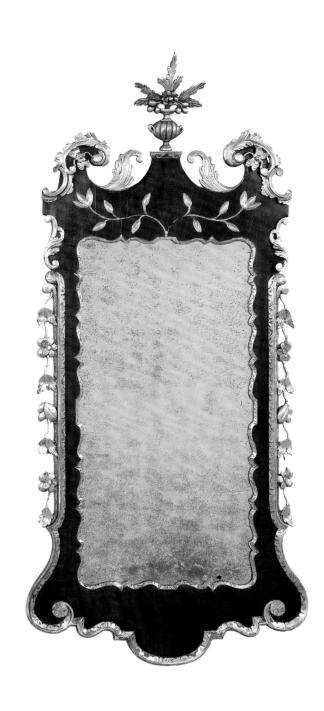

Plate 9. Looking glass, possibly America, 1750–80 (cat. 173).

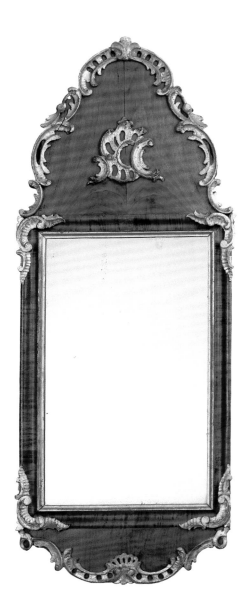

Plate 10. Looking glass, probably northern Continental Europe, 1760–80 (cat. 192).

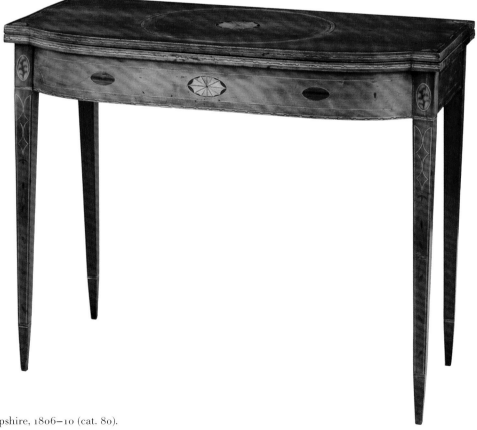

Plate 11. Card table, John Dunlap II, Antrim, New Hampshire, 1806–10 (cat. 80).

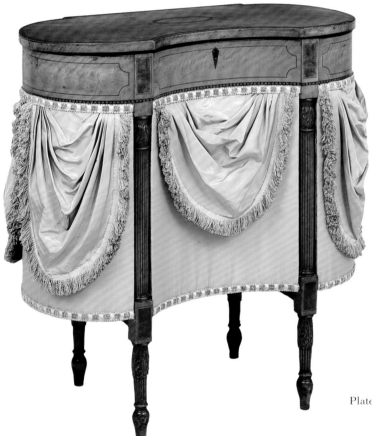

Plate 12. Work table, Robert McGuffin, Philadelphia, 1808 (cat. 162).

Plate 13. Looking glass, probably England, possibly America, 1790–1810 (cat. 178).

Plate 14. Card table, New York City,
1810–1820 (cat. 117).

Plate 15. Looking glass, attributed to John Doggett, Roxbury, Massachusetts, 1802–25 (cat. 180).

Plate 16. Pillar-and-claw pembroke table, New York City, 1820–30 (cat. 69).

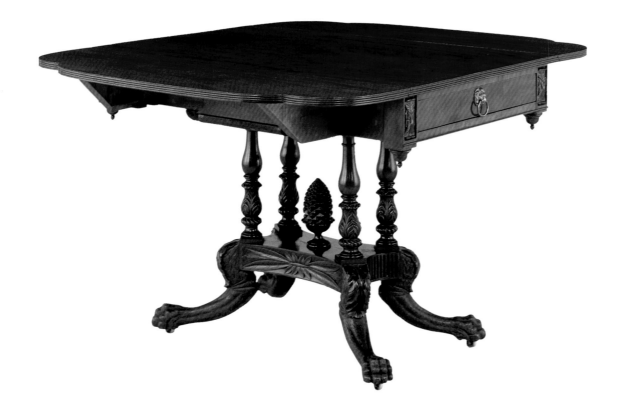

Plate 17. Card table, New York City, 1810–25 (cat. 119).

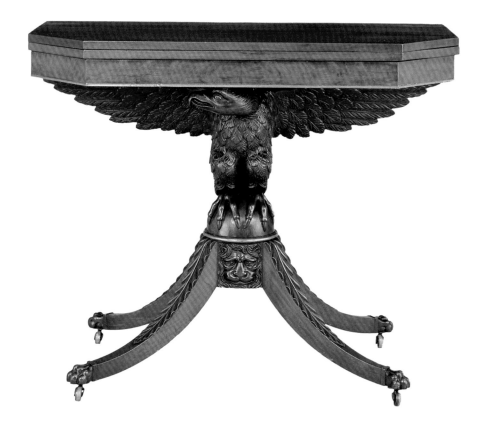

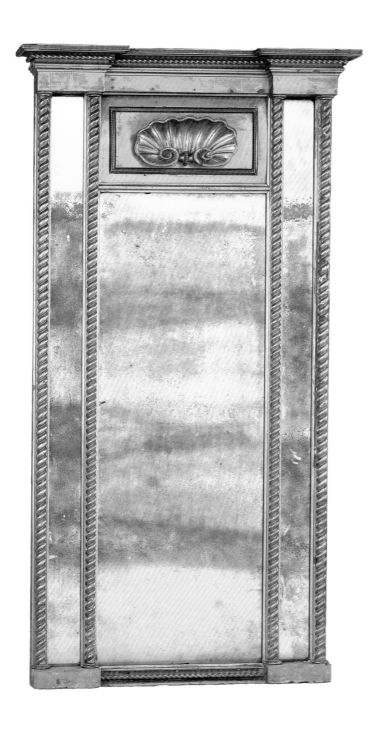

Plate 18. Looking glass, possibly by Stillman Lothrop, Boston or Salem, Massachusetts, 1804–52 (cat. 186).

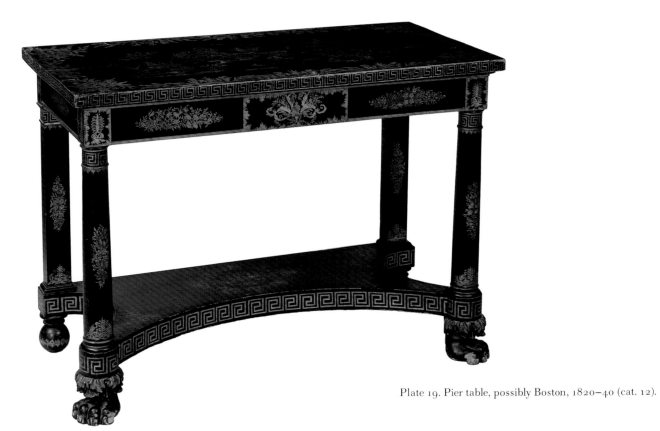

Plate 19. Pier table, possibly Boston, 1820–40 (cat. 12).

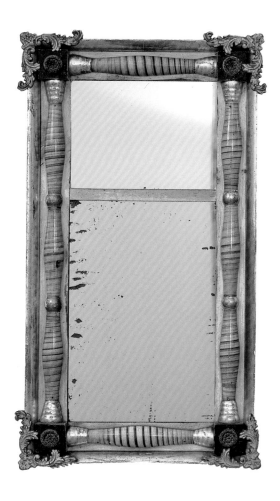

Plate 20. Looking glass, possibly New York State, 1830–50 (cat. 191).

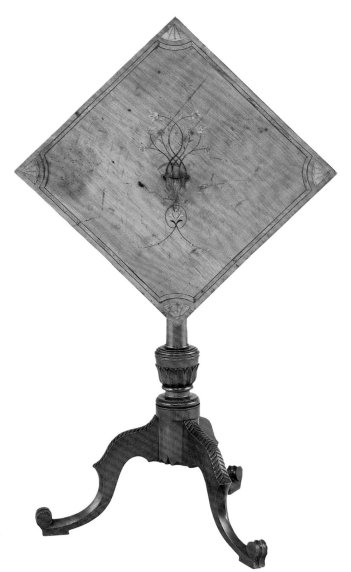

Plate 21. Stand, probably central Massachusetts, 1801 (cat. 126).

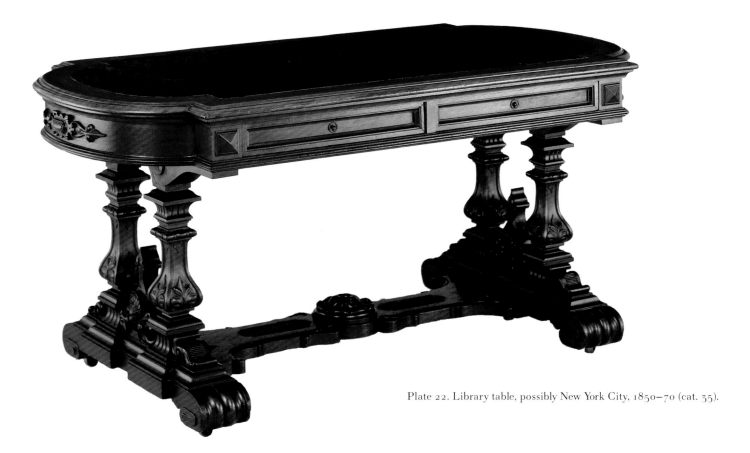

Plate 22. Library table, possibly New York City, 1850–70 (cat. 35).

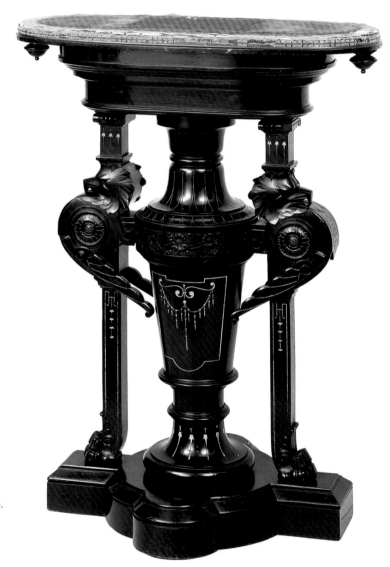

Plate 23. Pedestal, northeastern United States, 1870–90 (cat. 142).

Plate 24. Mirror, Bernard W. Fischer, New York City, 1925–30 (cat. 203).

Plate 25. Folding screen, Max Kuehne, New York City, 1924–28 (cat. 144).

Plate 26. Coffee table, designed by Paul T. Frankl, Grand Rapids, Michigan, 1944–50 (cat. 25).

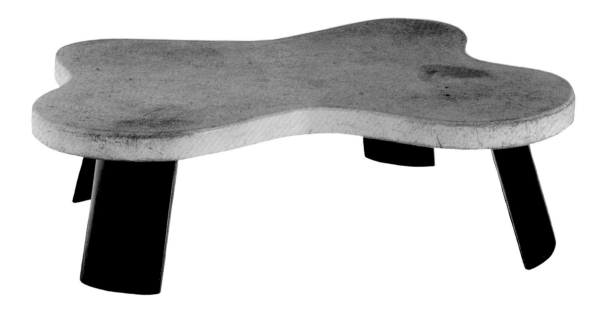

Plate 27. Bridge table, northeastern or midwestern United States, 1920–40 (cat. 139).

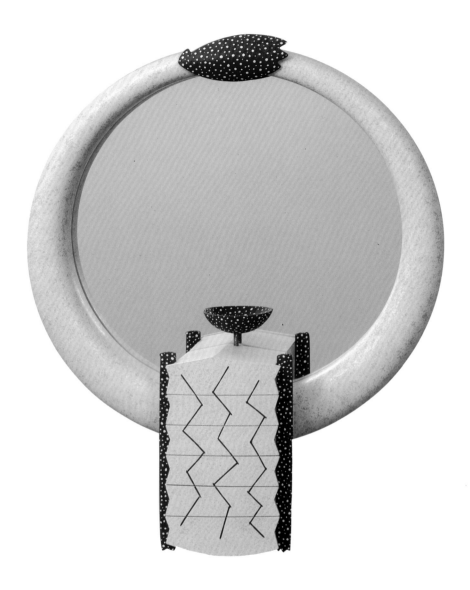

Plate 28. Earring cabinet, Rosanne Somerson, Westport, Massachusetts, 1989 (cat. 210).

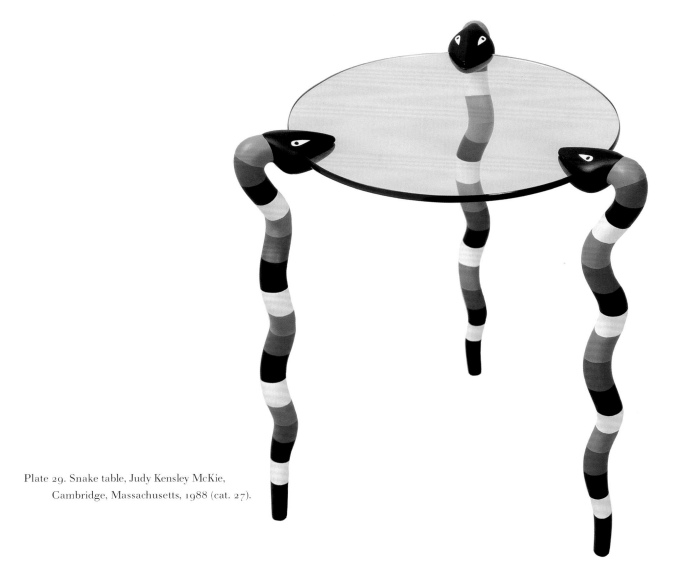

Plate 29. Snake table, Judy Kensley McKie,
Cambridge, Massachusetts, 1988 (cat. 27).

Plate 30. Card table, New York City, 1790–1805 (cat. 108).

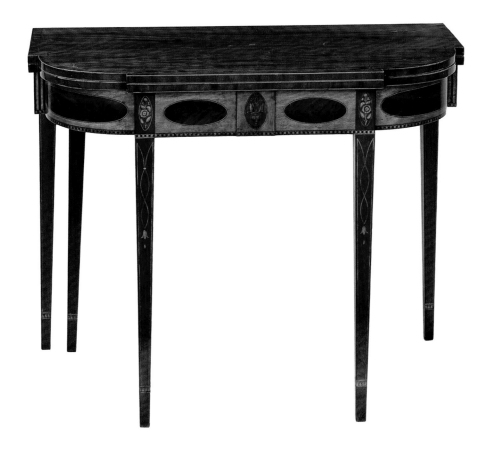

Stationary Tops

The tables with stationary tops in Yale's collection can be subdivided into two main groups, without drawers (cats. 1–27) and with drawers (cats. 28–39). The majority served the elementary function of providing a level surface of a certain height for a variety of activities. Within these broad categories are a number of specialized forms, including pier tables (cats. 11–17) and an unusual card table (cat. 39).

Without Drawers

Tables with tops fixed permanently to simple frames (cats. 1–5) represent the earliest and most basic version of the form. Examples were known in Egypt from about 3000 B.C. and became common in Greece and Rome.[1] The majority of these were relatively small and portable, as they continue to be up to the present (cats. 4–5, 18–27). Larger tables of this kind were uncommon, particularly in America, until the middle of the nineteenth century. Prior to that time, the largest tables were composed of board tops set up on temporary bases (Fig. 2) or falling-leaf and extension top tables (cats. 40–45, 53–60, 135, 136).

1. Baker 1966, pp. 27–28; Richter 1966, pp. 63–70, 110–11.

1

TABLE

Probably Middle Atlantic Colonies, 1680–1725
Black cherry
71.9 x 97.5 x 72 (28 1/4 x 38 3/8 x 28 3/8)
The Mabel Brady Garvan Collection, 1930.2044

Structure: Three frame rails are composed of two boards that are tenoned and pinned into the legs. The fourth rail is a single board tenoned and double pinned into the legs. The side stretchers are tenoned and pinned into the legs, with the center stretcher tenoned and pinned between them.

Condition: The top is a replacement. The feet are very worn and

have each been pieced to repair damage. The square end of one stretcher cracked off and has been reattached with a nail.

Provenance: Garvan purchased this table from J.K. Beard.

"Joined" tables, with frame rails tenoned and pinned into the legs, appeared in New England inventories from the first decades of the seventeenth century. This example's construction and ornamental features are uncharacteristic of contemporary New England tables, which were square in shape and had four perimetal stretchers and shaped skirts with drops.[1] Distinctive features of the Art Gallery's table include deep frame rails with a narrow molding along their lower edges and stretchers in an H-shaped arrangement. The squat baluster turnings and particularly the pronounced rings are also unusual variations on standard seventeenth-century forms. Related turnings appear on a slightly later falling-leaf table from Northumberland County, Virginia, and on two walnut tables with square stretchers made about 1765 in the Moravian community of Salem, North Carolina.[2] An eighteenth-century table attributed to Pennsylvania has more attenuated turnings of the same type and a narrow bead molding along the lower edge of its deep frame (cat. 32).

1. Lyon 1924, pp. 192–94; Fairbanks/Trent 1982, no. 177; Nutting 1924, nos. 688, 762.
2. MESDA research files S-5182, S-2659; Old Salem, Inc., Winston-Salem, North Carolina (no. 2268).

2

TABLE

Possibly eastern Virginia, North Carolina, or South Carolina, 1725–1800
Southern yellow pine
73.1 x 102.5 x 88.2 (28 3/4 x 40 3/8 x 34 3/4)
The Mabel Brady Garvan Collection, 1930.2536

Structure: The top is made of two boards held together by batten ends. Each board is attached to the battens by both a tongue-and-groove joint and by tenons that extend through the battens. The top is pinned into the frame rails with pegs that extend through them. Some of the pegs are wedged, which may have

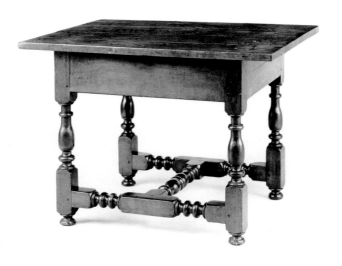
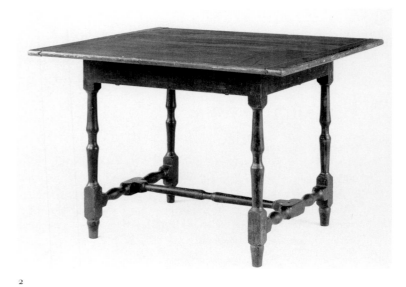

occurred when the top was removed and reattached. The frame rails are tenoned and pinned into the legs with pegs that extend through the legs on the frame's longer sides. The side stretchers are tenoned and pinned into the legs. The center stretcher is tenoned and pinned into the side stretchers.

Inscription: "Pine Tavern Table / Garvan Collection" is written in ink on a paper label attached to the underside of the top.

Condition: The table was originally stained a reddish-brown color. It was subsequently painted a greenish blue, which in turn was covered with dark green-black paint. Two butterfly cleats have been added to the underside of the top; one of these is now lost.

Reference: Bivins 1988, fig. 5.38.

Provenance: Garvan purchased this table from Wilkinson and Traylor.

This simple, utilitarian table is difficult to date or place in a specific regional context. The simplified baluster turnings are probably a late example of this type, which was superseded on high-style furniture in the second quarter of the eighteenth century. John Bivins has attributed the table to the Chowan River basin area of North Carolina, although without conclusive evidence to support his attribution.[1] A southern origin is indicated by the exclusive use of southern yellow pine and the fact that this table was purchased in Richmond in the early twentieth century. A yellow-poplar and southern yellow pine

table of similar form but with more conventional baluster turnings was discovered about 1900 in Camden, South Carolina.[2]

1. Bivins 1988, p. 131.
2. MESDA research file S-13185.

3

TABLE

Designed 1945–52 by Florence Schust Knoll (b. 1917)

Manufactured by Knoll International (founded 1938)

East Greenville, Pennsylvania, 1974

High-pressure laminate veneer, chrome-plated steel; black walnut (upper laminate of top), particle board (lower laminate of top)

72.5 x 243.8 x 100.2 (28 1/2 x 96 x 39 1/2)

The Mabel Brady Garvan Fund, 1975.4.1

Structure: The veneered top is composed of two laminates. The metal frame rails are screwed to the underside of the top and soldered to the legs. The latter joints are reinforced by diagonal braces that are soldered and bolted into the frame's corners. Each leg is a piece of steel with a small, circular core.

Provenance: This table was purchased by the Art Gallery in 1974 from the wholesale firm James Furniture of Palisades Park, New Jersey. It is still in use as office furniture.

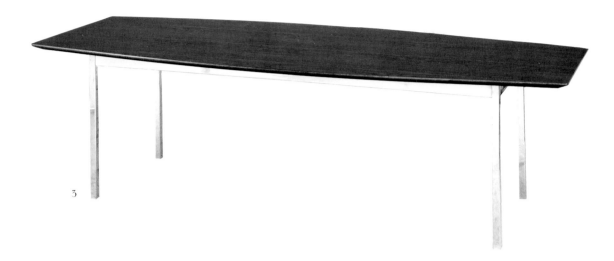

3

The bold, simple form and non-traditional materials of this table make it a prime example of the Knoll aesthetic in the 1950s. Florence Knoll's table designs invariably combined a top that appeared to be a slab of some natural material with a chrome-plated metal base. The contrast between natural and man-made materials was augmented in this design by the top's subtle curves and beveled outside edges, which added an organic quality to a "wooden" top that was photographically printed on a synthetic veneer.

Florence Knoll designed this table between 1945, when she first became associated with the firm, and 1952, when the table was illustrated in a book on modern furnishings.[1] Like most Knoll furniture from this period, the table was marketed for more than one purpose, in this instance as both a dining and conference table. It was available in eight different sizes: the smallest was 8 feet (243.8cm), the length of the present example, and the largest was 26 feet 3 in. (800.1cm). A contemporary brochure proclaimed, "Knoll furniture is planned for today's interiors. Versatile and flexible, every piece is designed for use in more than one room, for more than one purpose."[2] This versatility also reflected the company's post-World War II expansion into the market for office furniture, which it previously had downplayed in favor of domestic furnishings.

1. Hennessey 1952, p. 85.
2. Undated brochure for Knoll Associates, Furniture Study Library, Yale University Art Gallery.

4

STAND

Coastal New England, 1800–25
Soft maple, maple veneer; eastern white pine
70.6 x 43.6 x 42.6 (27 3/4 x 17 1/8 x 16 3/4)
The Mabel Brady Garvan Collection, 1930.2482

Structure: The top is a single board that is screwed to two of the frame rails from inside. This joint is reinforced on all four sides with champfered glue blocks. The veneered and painted frame rails are tenoned into the legs. Two quarter-round glue blocks reinforce this joint at each corner.

Inscriptions: "OK HH" and "ROAO / 7667 2[encircled]" are written in crayon on the underside of the top.

Condition: It seems likely that the upper surface of the top was once decorated to match the rest of the table; it is now cleaned of any paint. The top has been removed from the table and the glue blocks have been reattached. One glue block is lost.

Exhibition: New Haven Colony Historical Society, "The Universal Instructor of the Home Arts," October 21, 1974–January 14, 1975.

Provenance: Garvan purchased this table from Charles Woolsey Lyon. It may be the "decorated curl maple stand" listed on an invoice from Lyon of May 1, 1921 (Lyon correspondence, FPG-AAA).

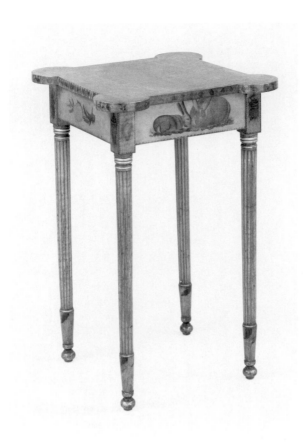

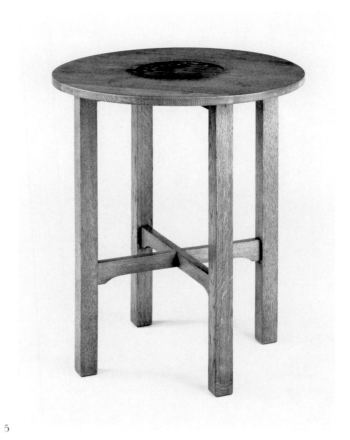

4 5

4 *Frame rail painting*

5 *Red label*

This stand is one of three objects in the Art Gallery's collection that undoubtedly were decorated by young women as part of their curriculum at fashionable New England girls' schools (see also cats. 150, 151). Each part of the stand is painted with a simple subject, such as rabbits, oranges, chestnuts, berries, or shells, instead of the elaborate landscape scenes or floral compositions found on other tables. The unaccomplished amateur who executed this ornament probably worked from natural models rather than printed sources. Like many tables made to be decorated, this stand's turnings are unusual and make its precise origin difficult to determine.

5

TABLE

Designed c. 1904 by Gustav Stickley (1857–1942)
Manufactured by the Craftsman Workshops (1904–1918)
Eastwood, New York, 1907–12
White oak; birch
73.6 x 60.8 diameter (29 x 23 7/8)
Gift of Mr. and Mrs. John J. Evans, Jr., 1972.10

Structure: The top is made of four boards fitted together with tongue-and-groove joints. A pair of cleats lapped at right angles are screwed to the underside of the top and glued and possibly tenoned to the upper ends of the legs. Each leg is screwed to the underside of the top through an eye ring screwed into its upper end. The lapped stretchers are tenoned and pinned into the legs.

Inscriptions: "Als / ik / kan [enclosed in a joiner's compass] / Gustav Stickley" is printed in red on the inside face of one leg. A printed paper label is pasted to the underside of the top: "The name 'CRAFTSMAN' is our / registered TRADE MARK and / identifies all our Furniture. / 'CRAFTSMAN' / Table [hand-written] / No. 654 [handwritten] / Fin. 3# [hand-written] Cov. / Als / ik / kan [enclosed in a joiner's compass] / SHOP MARK / Made by Gustav Stickley in the / CRAFTSMAN WORKSHOPS / Eastwood New York / NEW YORK CITY SHOW-ROOMS / 29 West Thirty-fourth Street."

Condition: A circular, blackened stain appears at the center of the top; it was probably caused by a chemical reaction between the oak and the bottom of a metal planter.

Reference: YUAGB 34 (June 1973), p. 66.

Provenance: This table is one of a pair acquired from the Gustav Stickley Company about 1910 by Perin B. Monypeny of Columbus, Ohio, together with an extension dining table, sideboard, desk, center table, settee, and chairs. The furniture was purchased for "Camp Waialva," Monypeny's summer home at Lake Asquam, New Hampshire, which had been built about 1900 by his brother-in-law, Richard Beckwith. In 1917 or 1918, Monypeny sold "Camp Waialva" and its furniture to John J. Evans, Sr., from whom the objects descended to the donors. The settee is now in The Art Institute of Chicago (no. 1971.748).

Designed about 1904, this table illustrates the influence of architect Harvey Ellis (1852–1904) on Gustav Stickley's work in that year and afterwards. Ellis had created designs for Stickley in 1903 that lightened the massive appearance of Stickley's earlier furniture with thinner elements, curved lines, and inlaid ornament. These designs reflected Ellis' familiarity with the work of leading European designers, particularly Charles Rennie Mackintosh and C.F.A. Voysey.[1] The thin top, absence of through tenons, and the stretchers' arched ends all belong to the vocabulary introduced by Ellis. This table was first illustrated in the 1905 *Supplement* to Stickley's furniture catalogue "D" as model number 654. Tables illustrated in the 1904 catalogue "D" had thicker tops with less overhang and tenons at the ends of the stretchers that extended through the legs.[2] The date of the Yale table's manufacture is indicated by the paper label that was in use during those years.[3]

Subsequent listings of table number 654 in Stickley's catalogues reveal the imprecision of terminology connected with tables. In the 1905 *Supplement*, it was called a "Round Table." Both the 1909 and 1910 editions of Stickley's *Catalogue of Craftsman Furniture* listed it as a "Tea Table."[4]

1. Gray 1987, pp. 7–8; Cathers 1981, p. 51.
2. Gray/Edwards 1981, pp. 73–74; Gray 1987, p. 137.
3. Cathers 1981, pp. 66–67.
4. Gray 1987, p. 137; Stickley 1909, p. 49; Stickley 1910, p. 37.

Pedestal Bases

The tops of tables in this category are mounted on a single, central pedestal with three or four short legs. This form was used by ancient Greeks and Romans, primarily for small stands.[1] During the second half of the seventeenth century, pairs of stands supporting candles became popular in England and America as components of a fashionable chamber ensemble that included a matching dressing table and looking glass.[2] In 1698, William Fitzhugh of Westmoreland County, Virginia, ordered from London "A [dressing] Table, Pair of Stands, Case Drawers, & looking Glass answerable. Two large leather Car-

pets. Two gall: Florence Oyl. A Set of Dressing boxes answerable to the Table & Stand &r."[3] Single stands of the same type were quickly adopted for use throughout the home for lighting, as indicated by the names "stand for a Candlestick" or "lightstand" used in contemporary documents.[4] They also functioned as occasional tables. During the later seventeenth century, Randle Holme called a tripod table a "little round table," which might be used "to set a Bason on whilest washing, or a candle to read by, with many other uses for a chamber."[5] An 1821 portrait of the elderly Barzillai Hudson of Hartford (Fig. 35) shows him with his books piled on a stand similar to that in cat. 6. Many of these stands were fitted with tops that turned up to permit easy movement and storage (cats. 126–133).

Larger tables with fixed tops and a central pedestal were not common in England or America until the beginning of the nineteenth century, although they had been made in Continental Europe since the late Middle Ages.[6] In Anglo-American furniture, large tables with central pedestal bases almost invariably had tilting tops in the eighteenth century (cats. 123–125). During the first decade of the nineteenth century, Thomas Hope, George Smith, and Richard Brown illustrated designs for large, center-pedestal tables with fixed tops that were intended for dining, cardplaying, and other diverse activities, as reflected by the names "round monopodium," "déjeuné table," "library table," and "loo table."[7] One of the earliest American tables of this type was based on French designs and can be attributed to Charles-Honoré Lannuier, who worked in New York between 1803 and 1819.[8] Joseph Meeks of New York made a Classical Revival center table in 1828.[9]

By the 1820s, Americans began using this form as a center table, placed in the middle of the room as a focus for family or group activities (cat. 9). This large, immovable table represented a dramatic change from eighteenth-century practice, when tables and chairs were arranged along the walls of the room, leaving the middle empty. Joseph Russell's painted recollection of his parents' parlor in the early 1800s (Fig. 36) depicted a circular, center pedestal table near the room's center, with most of the chairs and other furniture lined up against the walls. Center tables became ubiquitous in American homes and were made in a variety of forms, either with central pedestals or three or four legs. Some examples from the 1820s and 1830s had tops of marble, mosaic, or stone painted with landscape scenes. By mid-century the center table was described by Andrew Jackson Downing as "the emblem of the family circle," and in 1878 another home furnishing guide declared, "Nothing can take the place of a firm, neatly made center-table, . . . for what can appear so altogether social, so cosy, and withal so convenient?"[10] Reformers of the 1870s, however, condemned its size and immobility, and by the end of the century most homes had

discarded the center table in favor of smaller, movable tables (see p. 94).

1. Richter 1966, pp. 70, 112–13, figs. 565–66.
2. Thornton 1978, pp. 277–80.
3. Davis 1965, p. 367.
4. Downs 1952, no. 280; Swan 1934, p. 5.
5. Holme 1688, p. 18.
6. Eames 1977, p. 226; Bayerisches Nationalmuseum, Munich (no. L81/54); Thornton 1978, pl. 30.
7. Hope 1807, pl. 39; Smith 1808, pls. 82, 89; Brown 1820, pl. 8.
8. Cooper 1980, p. 249, pl. 48.
9. Owned in 1988 by the dealer Joan Bogart of Roslyn, New York.
10. Downing 1850, pp. 428–29; Williams/Jones 1878, p. 175.

6

STAND

Probably Connecticut, 1775–1800
Black cherry
66.1 x 51.4 diameter (26 x 20 1/4)
The Mabel Brady Garvan Collection, 1930.2457

Structure: The legs are blind-dovetailed into the pedestal. Three iron strips are nailed to the underside of the pedestal and legs to reinforce this joint.

Inscriptions: A handwritten note is attached to the underside of the top: "An old + very beautiful / round top stand or table / with three legs, which I / bought from a patient / in the summer of 1880. / It was carefully repaired + / put in good order by Mr. / E. Simons at Robbins Bros / soon after I purchased it. / I have presented it to my / daughter Mary E. Lyon / with the wish that she always / keep it to remember me by. / Irving W. Lyon / Nov. 1880." "402" is written on a small, circular paper tag glued to the upper right corner of this note.

Condition: The circular top and rectangular cleat have been replaced, probably by Edwin Simons at Robbins Brothers of Hartford in 1880. One foot broke off above the ankle and has been reattached with a screw.

Provenance: The note attached to this stand states that Irving W. Lyon purchased it from a patient in 1880 and presented it in that same year to his daughter Mary. Garvan acquired the stand among the objects purchased from her in 1929.

This stand probably was made in the Hartford area, where it was found in 1880. A similar stand was represented in a portrait of Barzillai Hudson of Hartford (Fig. 35), and another with simpler legs and turnings was owned by Lot Norton Seymour (1788–1844) of New Hartford, Connecticut.[1] The tight, scal-

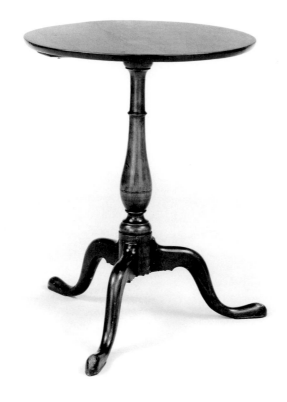

6

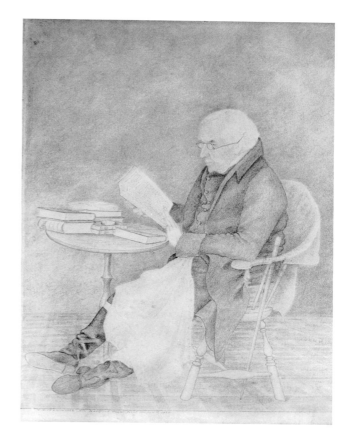

Fig. 35. Thomas H. Wentworth, *Barzillai Hudson*, 1821. Pencil. The Connecticut Historical Society, Hartford, Gift of Lois Aplington, Wheaton Hudson, Jr., and Dr. James Hudson.

Fig. 36. Joseph Shoemaker Russell, *South Parlour of Ab^m Russell, Esq., New Bedford*, 1848. Watercolor. The Whaling Museum, New Bedford, Massachusetts.

loped edge on the lower end of the shaft and legs as well as the narrow incised lines on the baluster and lower end of the shaft suggest that this example was made toward the end of the century.

1. *Seymour* 1958, p. 131.

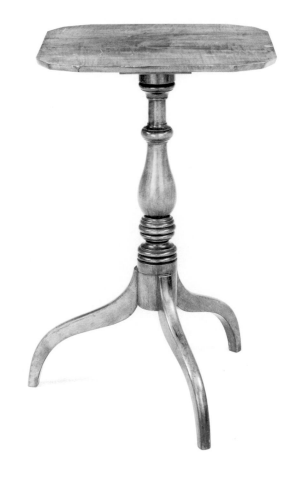

7

7

STAND

T. Paige (dates unknown)
Springfield, Massachusetts, 1897
Soft maple (top, legs), birch (pedestal)
78 x 46.6 x 45 (30 3/4 x 18 3/8 x 17 3/4)
Bequest of Henry H. Strong, B.A. 1883, 1930.498

Structure: The top is a single board that is screwed to a rectangular cleat from the underside. The upper end of the pedestal is tenoned and wedged into this cleat. The legs are blind-dovetailed into the pedestal.

Inscriptions: "TPaigE / Jan 19 - [?] / 1897 / Springfield / Mass" is written in pencil on the tenon at the pedestal's upper end. "10^50 / 2 / -" is written in pencil on the inside surface of the cleat. "Bequest of / HENRY H. / STRONG / June:1930" is written on a paper label pasted to the underside of the top.

Condition: A reinforcing screw has been added to the base above one leg.

Provenance: Henry Hastings Strong (1860–1930) was born in Southampton, Massachusetts, and lived in Springfield for much of his life, although many of his business interests were in New York City. He probably acquired this stand as a new piece of furniture. The few pieces of Massachusetts silver flatware and other objects he bequeathed to Yale do not indicate that he was a collector.

Made in what its maker undoubtedly considered the Colonial style, this stand was misidentified as an early American object when it was bequeathed to Yale only thirty years later. Like many Colonial Revival objects from the turn of the century, this stand actually imitated furniture of the early nineteenth century. A stand with similar proportions, turnings, and shaped top was made by Amos Darlington, Jr., of West Chester, Pennsylvania, between 1813 and 1853.[1]

No cabinetmaker with the name T. Paige has been found in Springfield records. Theodore D. Paige and Thomas A. Paige were listed in the 1897 city directory; the former was an

employee of the federal government and the latter was an assistant janitor.[2] One of these men might have made the stand as an amateur woodworker.

1. Schiffer 1966, no. 27.
2. *Springfield Directory* 1897, p. 332.

8

EXAMINATION TABLE

Possibly New Haven, 1853–1900

Black cherry

71.3 x 59.8 x 58.1 (28 1/8 x 23 1/2 x 22 7/8)

Gift of Mr. and Mrs. John M. Walton, 1979.49

Structure: The top is made of two boards with a circular depression for an inkwell near one edge. A rectangular cleat is screwed to the underside. The cleat is fitted and nailed over the pedestal's upper end. The legs are blind-dovetailed into the pedestal and are secured by three metal strips screwed to the underside.

Inscription: "YALE COLLEGE" is branded into the underside of the top and the cleat.

Condition: Numerous initials, letters, and geometric designs are carved into the top's upper surface. The edges of the top and the upper edge of the legs are worn.

Provenance: This table was made for use in the examination room of Alumni Hall, which was demolished in 1911.

This is one of the individual writing tables purchased for an examination room created in Alumni Hall in 1853, when President Theodore Woolsey of Yale instituted biennial written examinations for undergraduates. A satirical lithograph of about 1860 represented the tables set up in rows during an examination (Fig. 37); a photograph of the room taken about 1878 (Fig. 38) recorded the same arrangement. The chairs in the photograph included Bent and Brothers side chairs, which were apparently used throughout the University as seating furniture.[1] Despite the large number of tables purchased, no record of their maker has come to light. One possibility is Frederick Daggett of New Haven, who was paid $15.75 in 1853 for "6 small tables for Library & c."[2]

Woolsey's system of examinations at Alumni Hall continued for fifty years, and the University ordered replacement tables until the beginning of the twentieth century. This long period of use undoubtedly accounts for variations in the design of surviving examples. In the first group purchased, the tables were reportedly made of maple and had rounded outside edges; later replacements reportedly had square edges and were made of birch and cherry.[3] Different details may also indicate that the tables were purchased from more than one manufacturer.

Although aesthetically undistinguished, the historical associations of these tables invest them with tremendous popularity, even among alumni who never sat in the examination room. After the system of biennial group examinations was discontinued in the early twentieth century, Alumni Hall was torn down and the tables were sold by the University. Former students were so eager to acquire them as souvenirs that the supply was inadequate, and Yale had reproductions made for sale. These reproduction examination tables lacked the hole for the inkwell as well as the heavy surface wear found on institutional furniture. When the Art Gallery licensed a series of reproductions in 1983, this table was the one most frequently purchased.

1. See Kane 1976, no. 255.
2. Entry for January 20, 1853, daybook, 1844–55, Treasurer's Records, Yale University Archives, Manuscripts and Archives, Yale University Library, New Haven.
3. J. Hill to Mr. Keogh, June 12, 1936, Library Records, Yale University Archives, Manuscripts and Archives, Yale University Library. Hill cited Carl A. Lohmann, Curator of Prints at the Art Gallery from 1926 to 1930 and Secretary of the University from 1927 to 1953, as her source of information on the examination tables.

9

CENTER TABLE

Northeastern United States, 1835–50

Mahogany (including underside of top, moldings, veneer); yellow-poplar (lower three laminates of frame rail, pedestal), black cherry (plinth, laminates of feet), butternut (medial braces, base), white oak (wedges), hickory (wedges)

76.8 x 90.2 diameter (30 1/4 x 35 1/2)

Yale University Art Gallery, 1971.126

Structure: With the exception of the moldings, the entire surface of this table is veneered. The top is composed of four boards and is screwed to the frame from inside. The rounded outside edges are applied. The circular frame is composed of four horizontal laminates, of which the top laminate is the cavetto molding beneath the top. A bead molding is glued to the underside of the frame. The top and frame are supported by two medial braces fitted into rabbets in the circular rails and screwed in place. Rabbets on the braces' lower edges are fitted over a square, central cleat and screwed from the underside. The pedestal is double tenoned into the cleat and double tenoned and wedged into the base. Two of the projecting corners are applied

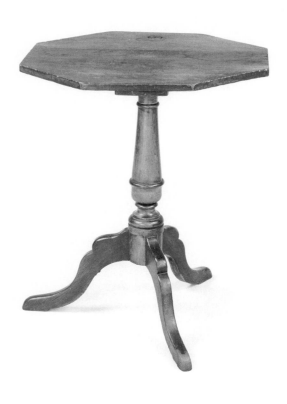

8

Fig. 37. Emil Crisand after W.H. Davenport, *Yale Biennial Examination*, 1858–60. Lithograph. Yale University Archives, Manuscripts and Archives, Yale University Library, New Haven.

Fig. 38. Interior of Alumni Hall, Yale University, c. 1878. Photograph. Yale University Archives, Manuscripts and Archives, Yale University Library, New Haven.

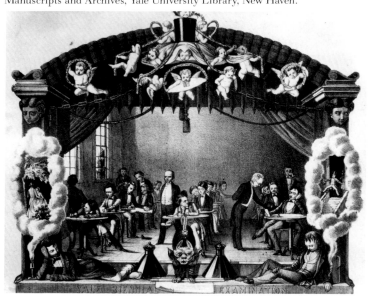

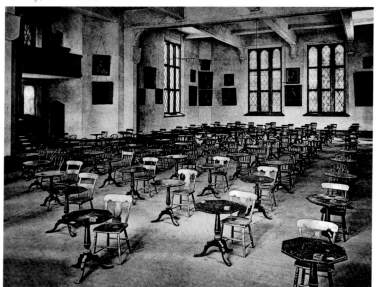

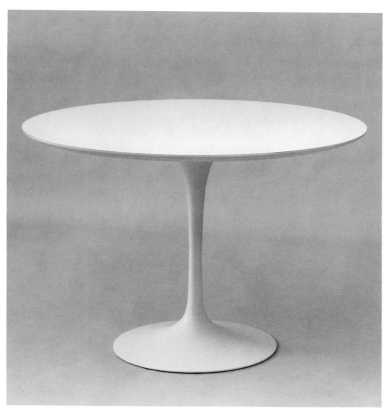

10

Mésangère issued numerous designs for furniture in this style.[2] The style was adopted in England and America during the early 1830s. A center table of this type with a marble top was purchased in 1834 by Solomon Van Rensselaer for his home, "Cherry Hill," near Albany, New York.[3] Tables with large scale, scrolled feet were published by J.C. Loudon in 1833, the same year that John and Joseph Meeks of New York City issued a broadside illustrating similar forms with veneered instead of carved surfaces.[4] Both the Meeks' broadside and John Hall's *Cabinet Makers' Assistant*, published in Baltimore in 1840, illustrated center tables almost identical in design to the Art Gallery's example, making its regional origin difficult to determine with certainty.[5]

1. An example of the type of Classical Revival table from which this center table was derived is illustrated in "American Furniture" 1980, p. 25.
2. Cornu, pls. 90, 93, 99, 111.
3. Blackburn 1976, no. 81.
4. Loudon 1833, figs. 1872, 1940; the Meeks broadside is in The Metropolitan Museum of Art (illustrated in Otto 1962, fig. 1).
5. Hall 1840, pl. 20, shows the "platform" and "pillar" seen on Yale's table.

10

DINING TABLE

Designed 1956 by Eero Saarinen (1910–1961)

Manufactured by Knoll International (founded 1938)

East Greenville, Pennsylvania, c. 1970

High-pressure laminate veneer, cast and painted aluminum; particle board (interior of top), birch (disk)

72.3 x 106.7 diameter (28 1/2 x 42)

Yale University Art Gallery, 1987.2.1

Structure: A disk is screwed to the underside of the top and glued to the pedestal's upper end.

Provenance: This table was purchased as office furniture for the Art Gallery between 1970 and 1973.

"I wanted to clear up the slum of legs," Eero Saarinen observed in discussing the pedestal-base chairs and tables he created in 1956.[1] One of the outstanding furniture designs of the twentieth century, this sleek table continues to be imitated and used in interiors three decades after it was first introduced. Through his use of such non-traditional materials as particle board and cast aluminum, Saarinen was able to reduce the table's mass to its essential elements: a flat, usable surface and a base just large enough to support it. Low and high bases of this design were

to the base, which is otherwise a solid block. Each foot is composed of three vertical laminates. The center laminate extends into a channel cut into the underside of each projecting corner and is screwed in place.

Condition: Numerous minor repairs were made to the veneer by Peter Arkell in 1982. The casters are replacements.

Provenance: In 1971 this table was removed from the former Yale Infirmary, built in 1892 at 276 Prospect Street. The table's previous history is unknown.

This center table is an example of the austere, architectonic style that superseded the later Classical Revival style about 1830. Its form is derived from furniture of the preceding two decades, but with greatly exaggerated moldings and without carved ornament.[1] The untextured, monochromatic surface emphasized the bold, abstract shapes of the piece.

This style originated in France during the restoration of the Bourbon monarchy in the late 1810s and is frequently referred to as "Restauration." Beginning in the early 1820s, Pierre de la

used for round- and oval-top tables as well as a small stand. Knoll has marketed all these variations with tops of wood and marble in addition to the veneered particle board on this example.

1. Saarinen 1962, p. 68. An armchair and side chair from these 1956 designs are also in the Art Gallery's collection; see Kane 1976, no. 285.

Pier Tables

Most tables made prior to 1600 were intended to be moved and stored after use. During the last quarter of the seventeenth century, the fashion for state apartments furnished to convey their owners' wealth and power inspired large, sculptural tables that functioned as part of the interior architecture.[1] These tables were intended to be stationary, and their back sides were left unfinished. During the eighteenth century, the form was developed in England into two distinct varieties. The "sideboard table," used for serving food and displaying silver, was rectilinear and had a top of either wood or stone. The "pier table," which stood against the pier between windows, usually had a stone top and frequently was an unusual shape or richly carved to match a looking glass (Fig. 50).[2]

The distinction between these two types was greater in eighteenth-century England than in the American Colonies. The 1772 Philadelphia price book distinguished between "Sidebord Tables" and a "frame for Marble Slab," but the distinctions were subtle. Sideboard tables were listed only with straight legs and wooden tops in both walnut and mahogany. Frames for slabs had marble tops and were offered only in mahogany, with both straight and curved legs. Apart from the cost of the marble slab itself, however, the prices of these two forms were almost identical.[3] Neither of these high-style forms typically had drawers, although one unusual slab table made in Philadelphia about 1760–75 had a single drawer filling the width of the frame.[4]

Among surviving American tables from the Colonial period, only a few examples can be considered "pier tables," as English designers used the term. A Philadelphia pier table associated with the Cadwalader family is floridly carved like English tables made to match looking glasses, and a pair of Boston-area tables have intricately carved marble tops that undoubtedly were intended to be decorative rather than functional.[5] Most of the surviving examples resembled the sideboard table form in their relative restraint (cat. 11). No gilded eighteenth-century American pier tables have been identified.

Sideboard and pier tables were rare in America until the second quarter of the eighteenth century. Governor John Endicott

had a "marble Table" in the hall of his Boston home in 1665, although its size and exact character are uncertain.[6] References to the form appear in urban inventories beginning in the 1730s, and by the 1760s it had become popular among wealthy Americans.[7] Josiah Claypoole of Philadelphia advertised "all Sorts of Tea Tables and Sideboards" in 1738.[8] An English relative of Charles Carroll of Carrollton, Maryland, informed him in 1761: "Mr. Bird sent by the fleet a venture of marble tables; I hope the event will answer his expectations."[9]

After about 1780, the sideboard table evolved into a piece of case furniture, and the term gradually came to denote only this form. All types of immovable side tables came to be called pier tables, whether or not they stood in a pier or were used with a looking glass. By the second quarter of the nineteenth century, many pier tables were made with mirrors incorporated in their lower sections (cat. 14), and matching pier tables and mirrors have remained a desirable furniture form into the twentieth century (cat. 15). The sideboard table, although eclipsed by sideboards with drawers and cabinets, continued to be made, although it was rarely referred to by that name after the mid-nineteenth century (see cat. 16).[10] All the tables of this type in Yale's collection are more than 85cm (33 1/2 in.) high, making their tops more accessible to someone standing.

1. Hayward 1965, pp. 66–67; Thornton 1978, pp. 230–32, pl. 238.
2. Chippendale 1762, pls. 56–61, 170, 175–76; Ince/Mayhew 1762, pls. 11–12, 73–75; *London Prices* 1788, pp. 43–44, 47–48; Hepplewhite 1794, pls. 31–34, 64–66; Sheraton 1803, pp. 284, 304–05.
3. Weil 1979, pp. 187, 189.
4. Hipkiss 1941, no. 52.
5. Heckscher 1985, no. 97; Swan 1953, fig. 2; Sack 1987b, p. 169.
6. Dow 1916–18, II, p. 41.
7. Hornor 1935a, p. 61; Downs 1952, no. 363; Lyon 1924, p. 206.
8. *Pennsylvania Gazette*, May 18–25, 1738, p. 3.
9. Elder 1975, p. 273.
10. *Victorian* 1853, pl. 14, refers to them as "slab sideboards."

11

SIDEBOARD TABLE

Probably Annapolis, Maryland, 1770–90
Mahogany; southern yellow pine
97.2 x 112.8 x 63.7 (38 1/4 x 44 3/8 x 25 1/8)
The Mabel Brady Garvan Collection, 1930.2686

Structure: The top is a single board that is screwed to the frame rails from inside. A medial brace is screwed to the underside of the top and is probably tenoned into the front and back rails. The rails are tenoned into the legs. Two quarter-round blocks reinforce the joints in each corner. The brackets are nailed to the legs and rails.

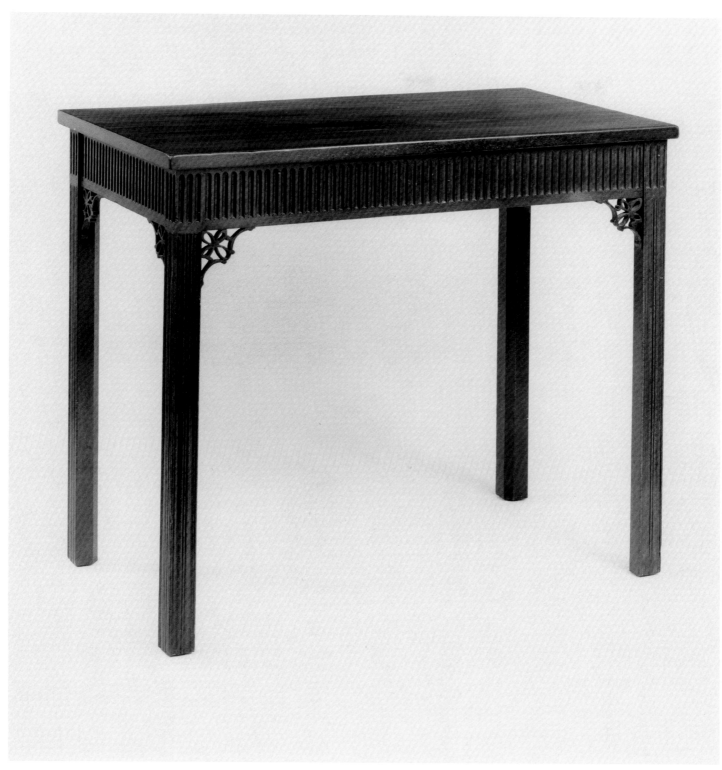

11

Condition: Only the side bracket on the right front leg and the bracket on the left rear leg are original; both were broken and have been repaired. The other four brackets are restored. There are nail holes on both outer faces of the front legs at the level of the lower edge of the frame rails; it is possible that a molding or mount was originally applied at this juncture. All of the blocks have been reglued and some have been replaced.

Exhibition: Elder 1968, no. 34.

References: Miller 1937, II, no. 1429; Davis 1947, pp. 58, 61.

Provenance: Acting as Garvan's agent, A.W. Clarke purchased this table on May 20, 1925, at the sale of the contents of the Hammond-Harwood House in Annapolis (Clarke to Garvan, May 20, 1924 [*sic*], Clarke correspondence, FPG-AAA). The house had been built in 1774 for Matthias Hammond, whose nephew Philip Hammond acquired it in 1776 and sold it in 1810 to Ninian Pinkney. One year later, Jeremiah Townley Chase purchased the house as a wedding gift for his daughter Frances, who married Richard Loockerman. It was inherited by their daughter Hester Ann, who married William Harwood in 1847. Their youngest daughter, Hester Ann Harwood, never married and lived in the house until her death in 1924. Since Miss Harwood's family did not acquire the house until 1811, the traditional identification of this table as the original sideboard from the dining room is unlikely (Elder 1968, p. 51).

This rectilinear table, with subtle, geometric ornament on its frame and legs and openwork knee brackets is similar to the designs for sideboard tables published by Chippendale and Ince and Mayhew.[1] Eighteenth-century American examples of this form are uncommon; a marble-top table with similar features was made in Philadelphia about 1766 for John Penn, probably by Thomas Affleck.[2] The Art Gallery's table has simplified edge moldings and unusual proportions in contrast to the English and Philadelphia models, which are deeper, wider, and shorter. Its distinctive size and details suggest a provincial hand. Although the table may not be original to the Hammond-Harwood House (see *Provenance*), it probably was made in Annapolis at about the same time that the house was built. The table is in the architectural, rectilinear manner that became popular in America during the later 1760s and 1770s; in addition to the Philadelphia furniture frequently attributed to Affleck (see cat. 77), a group of tea tables and kettle stands made in Portsmouth, New Hampshire, represent an expression of the same taste in New England.[3] Two other sideboard tables in a similar style have histories of ownership in Maryland.[4]

1. Chippendale 1762, pls. 56–59; Ince/Mayhew 1762, pls. 11–12.
2. Hornor 1935a, pl. 261.
3. For a discussion of this group, see Heckscher 1985, no. 118.
4. Elder 1968, nos. 32, 35.

12

PIER TABLE *Color plate 19*

Possibly Boston, 1820–40

Eastern white pine (top, rear rail of upper frame, laminates of lower frame, applied moldings on pilasters, front feet), basswood (front and side rails of upper frame), birch (legs, corner blocks in upper frame, rear feet), yellow-poplar (top of shelf, applied moldings on pilasters)

88.5 x 119 x 58.1 (34 7/8 x 46 7/8 x 22 7/8)

The Mabel Brady Garvan Collection, 1930.2661

Structure: The top is made of two boards screwed to the frame rails from inside. The rectangular panels at the center of the front rail and the corners of the front and side rails are applied. A black-painted molding above a gilt fillet molding is applied to each rail's upper edge. A gilt fillet molding is applied to each rail's lower edge between the applied panels. The frame rails are dovetailed together at the back and possibly at the front; the construction of the front corners is hidden by the triangular blocks glued into them. The front legs appear to be tenoned between the upper frame and the shelf. The upper ends of the rear legs are cut to fit into the corners of the frame and are screwed to the back rail. The lower ends appear to be butted against the shelf. The shelf frame is composed of two horizontal laminates, to which the top of the shelf is glued. The incurving front and side rails are both tenoned into the same mortise behind the front blocks. The rear corners are formed by two shaped blocks of wood glued together. The two laminates of the side rails are tenoned into the same mortise in each rear leg block. The back rail is glued across these blocks. All four feet are tenoned into the shelf frame. The front feet are also nailed into the front blocks.

Condition: A varnish applied over the entire painted surface has discolored the gold decorations, which appear to be in at least two different colors of gold. The fillet moldings and the small fillet above the ovolo base molding on the rear legs were originally gilt but were covered with black paint sometime after 1930, probably when the front and inside ovolo base moldings on the rear legs were replaced. The outside front edge of the top and the toes of both paw feet are badly abraded. The capital moldings on the left rear leg and the capital and fillet moldings from the front of the right rear leg are lost.

Provenance: Garvan purchased this table and an accompanying pier glass (cat. 186) from Henry V. Weil in July 1929. According to Weil, the two objects had been owned in the "Hasket Derby family of Salem, Massachusetts." If this provenance is correct, these objects originally were owned by one of the numerous early nineteenth-century descendants of Richard

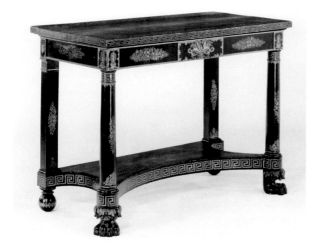

12

12 *Top*

12 *Front rail tablet*

Derby (1679–1715) and Martha Hasket (d. 1746), who were married in 1703 (Derby 1861).

The taste for Chinese decoration, after having been displaced during the early phase of Neoclassicism, revived in England and America after 1800. The best-known expression of this revival was the redecoration of the Royal Pavilion in Brighton between 1815 and 1822. During the same years in both England and America, furniture painted in imitation of lacquer became popular. Many of these pieces were Classical forms with lacquerlike surface decoration combining Classical and Chinese motifs. Notable American examples include a Baltimore armchair at Winterthur and a table signed by Eliza Anthony of New York and dated 1830.[1]

This pier table shows a similar combination of styles. The overall form of the table is Classical, with Doric columns and animal-paw feet. The large-scale Greek-key pattern painted on the sides of the top and shelf and the clusters of foliage, fruit, and flowers painted on the columns and frame rails were part of the Western ornamental vocabulary (see cats. 150, 151, 156). Other elements of the decoration are derived from Asian sources. The landscape on the top probably was copied, if only indirectly, from a scene of Paradise in a Chinese or Japanese Buddhist

Sūtra.[2] The Buddha-like seated figures at the centers of the front frame rail and the top of the shelf are reminiscent of eighteenth-century chinoiserie. The colors of the decoration—at least two colors of gold on a black background—undoubtedly were chosen to imitate Asian lacquer.

The regional origin of this table has proved difficult to determine with certainty. When it was offered for sale in 1929, it was associated with a Boston-area looking glass and given a history in the Derby family of Salem (see *Provenance*). Although this history cannot be substantiated, the presence of birch and basswood suggests a New England origin. The table's overall form, particularly the shape of the shelf, is similar to pier tables labeled by Emmons and Archibald of Boston.[3] The painted ornament resembles the chinoiserie decoration added in the nineteenth century to a set of earlier chairs that descended in a Boston family, although the table was painted by a more accomplished craftsman.[4] The spherical rear feet are unlike Boston work, however; such naturalistically carved animal-paw feet are more frequently associated with New York City.

1. Montgomery 1966, no. 455; Venable 1989, no. 51.
2. For similar scenes in *Sūtras* ranging in date from the ninth to the nineteenth centuries, see Zwalf 1985, nos. 314, 315, 339, 377, 378.

3. Talbott 1975, figs. 2–4.
4. Warren 1975, no. 36; Fales 1976, nos. 71–72; *Sack Collection*, VII, pp. 1794–95; Fairbanks 1981, pl. 11.

13

COMMUNION TABLE

Probably New Haven, c. 1825

Mahogany, mahogany veneer; yellow-poplar (frame rails), black cherry (medial braces), eastern white pine (inner side rails, plinth)

80.2 x 130.2 x 70.1 (31 5/8 x 51 1/4 x 27 5/8)

Yale University Collection

Structure: The top is made of two boards; the piece left over from when the front was cut out is butted to its back. The top is screwed to the frame from inside. The veneered frame rails have a bead molding nailed to their undersides. Each rail is composed of two vertical sections screwed and glued together. The larger section of the rear rail is composed of two horizontal laminates. Two medial braces are screwed into cutouts in the front and back rails. The base's uprights are tenoned between these medial braces and the plinth. The plinth appears to be a single block with a veneered outer surface. The legs are double tenoned into the canted corners. Four turned pads are applied to the underside of each foot.

Inscriptions: "W. CLEAVELAND" is printed on three small paper labels glued to the underside of the frame rails. "COMMUNION TABLE / From / THE OLD YALE CHAPEL" is engraved on a silver plaque attached to the front rail.

Condition: The left front leg broke out of the plinth and has been reattached; the surrounding area of the plinth has been pieced. L-shaped metal braces have been added to the joints between the legs and the plinth. The turned pads below the feet may be later additions.

Provenance: see text below

This table was made for Yale College's second chapel, constructed in 1824 in a conservative, late Federal style as part of what came to be called the Old Brick Row. An interior photograph from about 1870 shows the table standing in front of the pulpit at the center of the chapel's end wall (Fig. 39); another photograph shows it stored in the space below the pulpit. The maker of Yale's communion table has not been identified, although the simplicity of the form and schematic carving suggest that it may have been a local product. The University purchased furniture from several individuals during the 1820s and

1830s, although it has not been established that any of these men were cabinetmakers. Edward Bull supplied "furniture for Hall" in 1821; Charles C. Rowley provided six settees and one chair for the "Theological Room" in 1832; and John Kay delivered a center table costing $400 together with other tables and chairs in 1838.[1] The communion table bears several labels of William Cleaveland, who was listed as a joiner in the New Haven city directories between 1868 and 1872; he appeared as a scrap-iron dealer between 1872 and 1874.[2] Cleaveland probably repaired or refinished the table, perhaps between 1874 and 1876, when Battell Chapel was erected and the second chapel was converted to a classroom building; the latter was demolished in 1896. There is no evidence that the table was ever used in the lavish Reform Gothic interior of Battell Chapel.

Aside from the unusual shape of its top, which may have been intended to accommodate someone standing behind it during communion, this table's design is identical to that of contemporary domestic tables (see cat. 69). The adoption of secular forms for ceremonial purposes was part of a long-standing reformist, Protestant desire to demystify church ritual.[3] Communion tables made for the First Church of Berlin, Massachusetts, in 1826 and the First Universalist Society in Salem, Massachusetts, in 1855 were in a similar, late Classical Revival style that gave no indication of their sacred purpose.[4]

1. Ledger, Yale College Treasury Accounts, 1817–23, p. 34r; bill from Charles C. Rowley to the President and Fellows of Yale College, December 20, 1832; bill from John Kay to A.R. McDonough, 1838, Treasurer's Records; Yale University Archives, Manuscripts and Archives, Yale University Library, New Haven.
2. *New Haven Directory* 1868, p. 103; 1872, p. 212.
3. Benes/Zimmerman 1979, p. 75.
4. Ibid., no. 131; Fales 1965, no. 46.

14

PIER TABLE

Northeastern United States, 1835–50

Mahogany (including side members of back frame), mahogany veneer; yellow-poplar (horizontal molding above mirror), eastern white pine (all other secondary wood)

85.6 x 97.2 x 51.2 (33 3/4 x 38 1/4 x 20 1/8)

Yale University Art Gallery, 1974.64.1

Structure: The exterior surface of the table is almost entirely veneered. The front and side frame rails appear to be mitered at the front corners and dovetailed to the rear frame rail. Solid fillet and ovolo moldings are mitered together and nailed to the top surface of the front and side rails. A solid ovolo molding is attached to the frame's underside. The back frame rail is a sin-

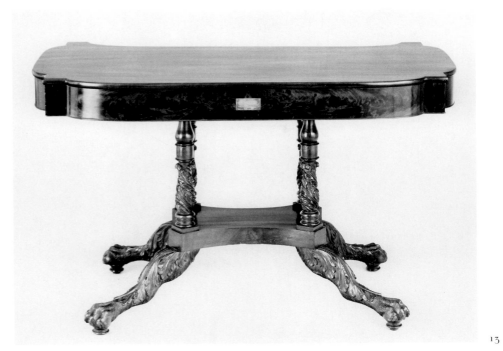

13

14

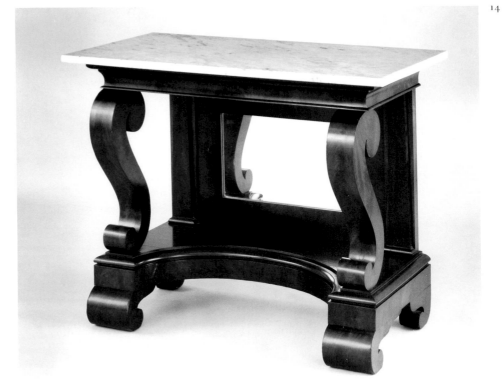

Fig. 39. Interior of the College Chapel, Yale University,
c. 1870. Photograph. Yale University Archives,
Manuscripts and Archives,
Yale University Library, New Haven.

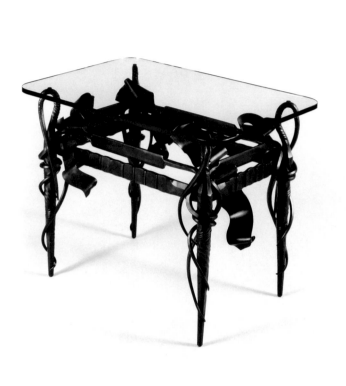

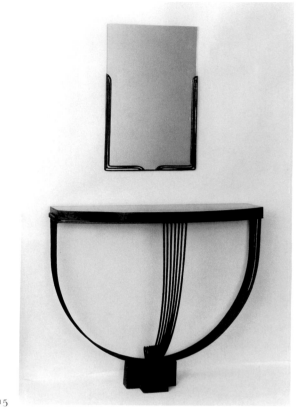

17

15

gle board with filler strips nailed to its upper and lower edges. A rectangular, horizontal glue block reinforces each corner. The front legs are composed of four vertical laminates. They are probably tenoned or doweled between the upper frame rail and the shelf. The rear uprights are dovetailed to the back rails of the upper and lower frames. A pilaster is applied to the front of each upright. A rectangular mirror frame is fitted into the back of the table between the upper and lower frames. The side members of the mirror frame are butted between the top and bottom. Rabbets on the frame's side rails fit over the table's uprights and are screwed in place. The top of the shelf rests on a solid ovolo molding that is nailed through a solid, square molding to the frame rails. The side rails of the lower frame are two thick, rectangular blocks. These blocks and the curved front rail are composed of three horizontal laminates. The center laminate of the front rail is extended at either end to fit into a reciprocal space in the side blocks as a tongue-and-groove joint. The back rail is dovetailed to the ends of the blocks and has filler strips on its upper edge. The front feet are composed of two vertical lami-

nates, whereas the rear feet are made of three. All four feet are screwed to the undersides of the side blocks.

Inscriptions: "TOP / LEFT" is written in pencil on the upper end of the left rear upright and "TOP / RIGHT" is written in pencil on the upper end of the right rear upright. "TOP" is scratched onto the back of the upper mirror frame member.

Condition: At one time the back of the table was taken apart and reassembled, perhaps when the mirror was replaced. The backboards covering the mirror are also not original. Cutouts in the sides of the upper frame rail suggest that a lateral brace for the top was positioned there, although the cutouts do not line up. There are two plugged nail holes on the outside face of each rear upright. The dovetail joints in the back frame have been reinforced with pins. The front corners of the curved front rail of the shelf are separate pieces, and the joint separated as the wood shrank, causing the veneer to buckle. At one time the table had casters.

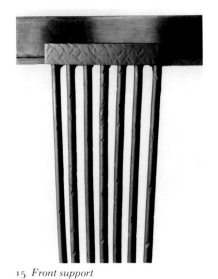

15 *Front support*

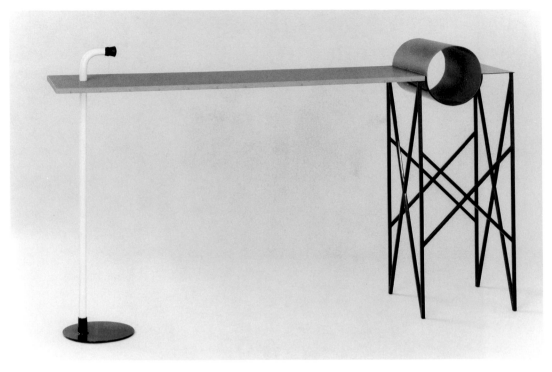

16

Exhibition: Yale University Art Gallery, New Haven, "A Century of Tradition and Innovation in American Decorative Arts, 1850–1930," September 8, 1979–January 20, 1980.

Provenance: This table was removed in 1974 from the Mary Briggs Prichard House, designed by Alexander Jackson Davis and built in 1837 at 35 Hillhouse Avenue in New Haven. The house passed through three other owners and a period of vacancy before it was acquired in 1953 by Yale University for use as a residence. A library table (cat. 35) and a side chair in the Art Gallery's collection also came from this house (Kane 1976, no. 247).

Found in a New Haven house that was built in 1837, this pier table may have been made locally as one of the original furnishings. The house's date is consistent with the table's simplified, late Classical style (see cat. 9). Neither its secondary woods nor its design offer any specific information concerning its origin, and similar tables were made in many cities along the Atlantic coast. Two pier tables of this type without shelves were made by Duncan Phyfe in 1834 and 1837–40.[1] A broadside published by John and Joseph Meeks of New York City in 1833 included a design for a more curvilinear pier table with a shelf that was offered with either a white marble or "Egyptian marble" top.[2] The book of furniture designs published by the Baltimore architect John W. Hall in 1840 featured a variety of designs for pier table "consols" and "platforms," as well as a pier table design that is almost identical to the piece at Yale; a Baltimore-made pier table of this type is at the Maryland Historical Society.[3] The maker may also have been inspired by a nearly identical pier table published in Pierre de la Mésangère's *Meubles et Objets de Goût* between 1825 and 1827.[4]

1. Pearce 1962, fig. 6; McClelland 1939, pl. 111.
2. The Metropolitan Museum of Art, New York; illustrated in Otto 1962, fig. 1.
3. Hall 1840, pls. 11, 13, 17 (fig. 86); Weidman 1984, no. 173.
4. Cornu, pl. 99.

15

PIER TABLE AND MIRROR

Probably New York City, c. 1930

Table: wrought iron, steel sheet, high-pressure laminate veneer;
 yellow-poplar

Mirror: wrought iron

Table, 94 x 108.5 x 31.5 (37 x 42 3/4 x 12 3/8); mirror, 76.9 x
 49.1 (30 1/4 x 19 3/8)

Gift of J. Marshall and Thomas M. Osborn in memory of Mr.
 and Mrs. James M. Osborn, 1977.40.4A–C

Structure: The table's top is a thick board veneered over its entire surface. It rests on a conforming wrought-iron shelf that screws to the wall through two projecting brackets. The shelf is soldered to curved uprights with flat upper ends that overlap the shelf and hold the top in place. The two side uprights are one continuous element. The lower end of the front upright is soldered to the center of the side uprights and its lower end curves upward. The uprights are soldered to a hollow base formed from a single sheet.

The back of the mirror frame is composed of a continuous narrow strip. Three brackets for screws are soldered to this strip. The front of the frame consists of two sections of three iron rods soldered to the back strip.

Inscription: "SEMON BACHE & CO / NEW YORK CITY / EVALAST / 092039 [between two Greek crosses]," is stamped twice on the back of the glass plate. Semon Bache and Company was founded in 1847 and was located in lower Manhattan until 1985, when it moved to Brooklyn.

Condition: The glass plate was replaced in 1939, when the Osborns returned from four years in England.

Exhibition: Yale University Art Gallery, New Haven, "A Century of Tradition and Innovation in American Decorative Arts, 1850–1930," September 8, 1979–January 20, 1980.

References: Kane 1980, fig. 15; Weber 1985, p. 73.

Provenance: Mr. and Mrs. James M. Osborn purchased this pier table and mirror for their apartment at 14 Sutton Place, New York, where they lived from September 1930 to June 1932 (see Appendix C).

Wrought-iron furniture was created in the late 1920s and early 1930s by a number of American modernist designers, including Jules Bouy, Hunt Diederich, and Raymond Hood.[1] Like other furniture owned by the Osborns (cats. 52, 140), however, this pier table and mirror apparently were made to imitate contemporary French models. Wrought-iron console tables with curved supports represented a traditional French form that was revived and modernized at the 1925 Paris exhibition by leading French ironworkers, including Edgar Brandt, Raymond Subes, Malatre et Tonnellier, and Christofle.[2] The hammered surface favored by French ironworkers was imitated by the shallow, gouged pattern on both the table and mirror frames.[3]

A number of features indicate that the Osborns' table and mirror were an American-made interpretation of French models. Unlike costly French work, the table and mirror were made of rods instead of the traditional square bars, and the base was made of thin-gauge steel. These inexpensive materials as well as the yellow-poplar core of the top and plastic veneer suggest that the iron framework was made in New York to convey the look but not the cost of stylish imported furniture. The mirror frame is unlike any exhibited in France. It strongly resembles a frame with a stepped profile that partly enclosed the glass plate designed in 1929 by Donald Deskey for the widely publicized modernist home of Glendon and Louise Allvine.[4] The pier table and mirror are also significantly smaller than the massive French exhibition pieces. Their small size and the table's shallow top undoubtedly were determined by space limitations in the Osborns' apartment. One source on furnishing noted in 1915, "Console tables also have come into widespread use in apartments, especially for the foyer hall, which is generally so diminutive a place that nothing but a console and perhaps a mirror and chair are possible."[5] The Osborns may have used these objects in their dining room (see cat. 140).

1. Simons 1929; Davies 1983, nos. 20–21, 48, 53.
2. Yates 1989, nos. 30, 200; Clouzot, 1st series, pls. 5, 29; 2nd series, pls. 19, 26.
3. Clouzot, 1st series, pls. 14, 27, 30; 2nd series, pls. 4, 23; Roche/ Courage/Devinoy 1985, no. 302.
4. Christie's 1980, no. 425. The mirror was illustrated in Gillespie 1930, p. 53.
5. Herts 1915, p. 150.

16

BUFFET TABLE

David Zelman (b. 1945)

New York City, 1983

Aluminum grate, steel mesh and tube

101.8 x 166.7 x 37.3 (40 1/8 x 65 5/8 x 14 5/8)

Funded by Martin and Judith Foreman in honor of their children,
 Julia Sarah Foreman and Robert Neil H. Foreman, 1986.64.1

Structure: The table is composed of six painted metal parts. The top is an aluminum grate. Its right end is supported on a

cross piece soldered to the top of a steel tube. A separate curved piece of tube terminating in a black rubber cap is screwed to the leg through the grate. The leg fits into a socket welded to a circular base. The top's other end is screwed to a narrow lip that projects from the base's inside top edge. The base is composed of four legs connected by crossbraces that are soldered to them. A semicircular trough abutting the top holds a removable steel dot-mesh cylinder.

Provenance: The Art Gallery purchased this table from an exhibition of Zelman's furniture at Gallery Jazz, New Haven, June 4–28, 1986.

In creating this table, David Zelman was inspired by his love of industrial machinery and the romanticized machine aesthetic of the 1920s and 1930s. He manipulated industrial materials in unconventional ways, turning the steel mesh into a cylinder and perforating the aluminum grate with a steel tube that is bent at one end and fitted with a rubber cap. The geometric forms and brilliant, primary colors of Zelman's table were influenced by furniture of the late 1910s by Gerrit Thomas Rietveld and other members of De Stijl. The expense of using electromagnetic powder paints to create the hard, enamel-like surfaces induced Zelman to make three buffet tables at one time.[1]

Zelman conceives of his furniture as functional sculpture, placing great value on its novelty:

People get too complacent. They're comfortable within a certain type of environment and they stop thinking, stop questioning. The rules that we had for furniture no longer have to be the rules. I see my furniture as throwing out all those old images—the ones that dictate large wooden tables for cozy kitchens.[2]

The functions of such parts of this table as the mesh cylinder and capped tube are deliberately ambiguous, requiring the user to approach this object without preconceived ideas of use. A similar emphasis on visual impact over function is found in furniture by the Milan-based Memphis group, which had its first show in 1981 and was dissolved in 1988.[3]

1. Zelman provided information on his work to Patricia E. Kane in a personal conversation, July 24, 1986, and to the author in a telephone conversation, January 7, 1991.
2. Teal 1984.
3. Zelman's buffet table has been included in at least one survey of the Memphis style (Horn 1986, p. 67), although his use of industrial materials is distinct from the work of Memphis designers. Zelman does not consider his furniture influenced by Memphis products.

1 7

SIDEBOARD TABLE

Designed 1989 by Albert Paley (b. 1944)

Rochester, New York, 1990

Forged steel, steel plate, glass

75.7 x 91.5 x 61.2 (29 3/4 x 36 x 24 1/8)

Funded by Julian H. Fisher, B.A. 1969, in memory of Wilbur J. Fisher, B.A. 1926, and Janet H. Fisher, 1990.3.1

Structure: The lower frame rails are forged into a single unit that is welded to the legs. The twisted ends of the upper frame rails are wrapped and welded around the legs. The steel plate ribbon elements are welded to the legs and rails. The top rests on the legs. The steel surfaces have been treated with chemicals to resemble iron.

Provenance: The Art Gallery commissioned this table for use in its entrance foyer.

Albert Paley began working with steel on a large scale in 1974, when he won the competition for a set of gates at the Renwick Gallery in Washington, D.C. His first commissions were primarily for architectural elements. He began making tables and stands about 1980, and his designs from the first half of the decade were composed of cordlike elements twisted into elaborate curves and circles.[1] This table exhibits the stable quality of his more recent work, in which ribbonlike elements, often in contrasting colors, play the most active part in his designs.

1. Springfield 1985.

Square Tea Tables

The tables in this section (cats. 18–22) are finished on all four sides and relatively small. With one exception, their tops are between 66 and 67cm (26 and 26 3/8 in.) in height, roughly the height of someone's lap when seated in a chair. Traditionally described as tea tables, they were intended for serving food or drink to a seated group. Their height is less suitable for writing, reading, dining, or other activities normally undertaken at tables with tops at the normal height of about 72cm (28 3/8 in).

The term "tea table" was used to describe a variety of forms in eighteenth-century documents. In a 1772 list of furniture prices in Philadelphia, "Tea Tables" had circular tops that turned up and "Squarr Tea Tables" denoted the type included in this section of the catalogue.[1] The square tea table first appeared in Europe in the late seventeenth century, derived from Asian lacquerwork trays that were fitted with stands after

importation to suit Western height requirements.[2] The earliest American references to tea tables—such as the "Tee Table" in a Boston inventory in 1708 and a "Tea Table and Stand" in Philadelphia in 1717—probably denoted this type of tray rather than a piece of furniture.[3] Two tables with removable faience tray tops, both from Beverly, Massachusetts, are late survivals of this form in America.[4]

After about 1725, stands with removable trays were superseded by rectangular tables with fixed tops as the most fashionable form of tea table. The moldings around the top's perimeter were clearly conceived as an evocation of the earlier tray form. As this transformation occurred, the table took on the additional function of storage for tablewares. During his visit to Alexander Spotswood's home in Germanna, Virginia, in 1732, William Byrd described a tea table set against the wall with the china in place (see p. 32). Tea tables and ceramics were frequently listed together in inventories, such as the "Tea Table and Set of burnt China" in Boston in 1732 and a "Black Japand Tea Table & a sett of China Ware belonging" in Philadelphia in 1741.[5] As these references indicate, tea tables of this type were in use in all American cities during the middle two decades of the eighteenth century, although they were made more frequently in New England than in the mid-Atlantic or southern Colonies. In a 1756 list of prices drawn up by cabinetmakers in Providence, Rhode Island, the "Common Tea table," costing £7, was one of the least expensive furniture forms.[6] The finest square tea tables were products of the late Baroque and Rococo styles; the form rapidly went out of fashion with the advent of Neoclassicism. In response to her brother Henry's request for help in the furnishing of his home in Philadelphia, Mary Hill Lamar wrote from London in 1771, "Neither tea or card tables stand in the best room, but are brought in when wanted; [they are kept] in the back room or common sitting room."[7]

It is difficult to ascertain whether most of the examples at Yale primarily functioned as tea tables or simply as small, all-purpose surfaces. Only one table in this group (cat. 18) can be said with certainty to have served more or less exclusively as a tea table because of the applied molding around the perimeter of its top, which rendered it useless for most purposes but protected the china stored on it. The other four small tables were probably used for serving tea and other foods but not for storing tea equipage. These four tables provide an excellent idea of the range in quality and cost available to eighteenth-century consumers, from an expensive walnut version (cat. 19) to moderate stained or painted maple tables (cats. 20, 21) to an inexpensive turner's table of maple and pine (cat. 22).

1. Weil 1979, pp. 187–88.
2. Thornton 1978, p. 230; Thornton/Tomlin 1980, p. 84.
3. Lyon 1924, p. 232; McElroy 1970, pp. 48–49.

4. One of the tables is at The Henry Francis du Pont Winterthur Museum and is discussed in Goyne 1968; the other is at the Department of State, Washington, D.C.
5. Jobe/Kaye 1984, p. 286; Lyon 1924, p. 217; Hornor 1935a, p. 49.
6. Rhode Island 1965, p. 174.
7. Smith 1854, p. 198.

18

TEA TABLE

New York City or Albany, 1750–75

Black cherry

67.5 x 77.4 x 55.8 (26 5/8 x 30 1/2 x 22)

The Mabel Brady Garvan Collection, 1930.2489

Structure: The top is made of two boards with a bead molding on their outside edges. The underside of the top is rabbeted on all four sides to fit into the frame. A cavetto molding composed of four strips and triangular corner pieces is nailed to the frame rails through the top. The frame rails are shaped single boards tenoned into the legs. Each joint is reinforced with a rectangular corner block.

Condition: The two pieces of the top have separated. One section of the cavetto molding has been repaired with a piece of mahogany, and the entire molding has been renailed to the rails. The frame was disassembled at some point; all of the corner blocks have been replaced.

References: Rogers 1960, no. 5; Rogers 1962a, p. 8; Comstock 1962, no. 231; Naeve 1981, p. 20; Kirk 1982, fig. 1274.

Provenance: Garvan purchased this table from Henry V. Weil.

The distinctive feet on this table have been associated with New York City and areas within its influence. Unlike related furniture with histories of ownership on Long Island, the feet do not have defined, central ridges, and the finesse of its design is atypical of Long Island work.[1] The table was probably made in New York City or Albany, where cherry furniture with similar feet has been attributed.[2] A cherry falling-leaf table with similar feet descended in the Glen-Sanders family at "Scotia," their estate near Albany; an almost identical walnut falling-leaf table has a history of ownership in the Beekman family of New York.[3] Unlike most examples of New York furniture, this table has a tight, attenuated silhouette, probably because it is a late example of the form. A strikingly similar table, also of cherry but with a skirt with a straight edge and drops instead of cyma curves, has been published.[4] Most square tea tables are more robust, with thicker moldings around the top and deeper frame rails, particularly in relation to the curved skirt section.

1. Failey 1976, no. 138; Ward 1988, no. 139.
2. Downs 1952, no. 108; Kane 1976, no. 60; Failey 1976, no. 139.
3. Williamsburg 1966, no. 16; Downs 1952, no. 318. An undocumented mahogany card table with similar feet at The Henry Francis du Pont Winterthur Museum (no. 1953.152.4) has been attributed to New York City.
4. Formerly owned by David Stockwell; see *Antiques* 89 (January 1966), p. 1; *Antiques* 103 (May 1973), p. 825.

19

TABLE

Probably eastern Virginia or North Carolina, 1725–75
Black walnut
72.5 x 76.1 x 51.3 (28 1/2 x 30 x 20 1/4)
The Mabel Brady Garvan Collection, 1930.2047

Structure: The top is made of two boards butted together and pinned to all four frame rails. The frame rails and side stretchers are tenoned and pinned into the legs. The center stretcher is tenoned and pinned into the side stretchers.

Condition: The top has been reattached to the frame, probably with screws covered by wooden plugs. At one time the top was covered with leather that was tacked to the underside.

Exhibition: Yale University Art Gallery, New Haven, "A Wide View for American Art: Francis P. Garvan, Collector," May 8–September 25, 1980.

Provenance: Garvan purchased this table from J.K. Beard in 1929. It may be one of the "two tavern tables" listed by Beard on an invoice dated May 1, 1929 (Beard correspondence, FPG-Y).

This table belongs to a small group with similar tapered, columnar turnings. Like the Art Gallery's table, most of these pieces were found in eastern Virginia and North Carolina, and a few have histories in that region. What is probably the earliest table, with an applied molding around the perimeter of its top and a scalloped skirt, has been tentatively attributed to Williamsburg about 1710.[1] Two tables found in North Carolina, including one that belonged to Charles Pettigrew (1743–1807) of Edenton, have bolder turnings and square stretchers and probably date to the second quarter of the eighteenth century.[2] The overhanging top with a quarter-round molding and the delicate ring turnings on the Art Gallery's table are closer in style to two small tables with Virginia associations: one descended in the Joyner family of Franklin, Virginia, and the other is believed to have been owned by George Washington at Mount Vernon in 1759.[3] A large table with a drawer found about 1870 near Vicksville in Southampton County, Virginia, has identical turn-

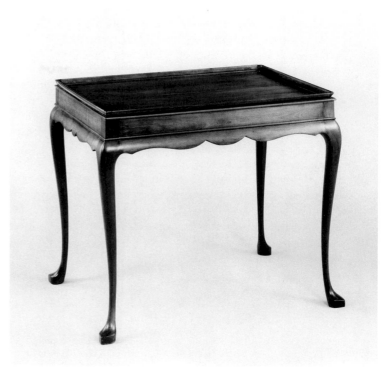

18

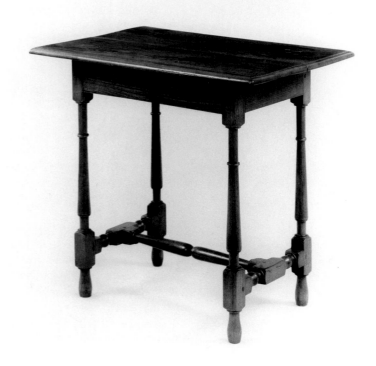

19

ings to the Yale example, with the distinctive detail of the straight-sided cylinder below the flared column.[4]

Although this table may well have been made as late as 1775, its columnar legs represented the provincial survival of a much older English tradition. Columnar turnings derived from the Roman or Tuscan Doric order were part of the vocabulary of late Renaissance furniture design that was adopted in England during the middle decades of the seventeenth century.[5] These turnings became popular in many parts of England and were used on less sophisticated pieces of furniture into the eighteenth century. In America, they were most common in Virginia, where they appeared on falling-leaf tables made during the first half of the eighteenth century.[6] A group of joined chairs and stools made in the New Haven Colony between 1640 and 1670 have robust Doric turnings that are distinct from the more attenuated versions on these southern tables.[7]

1. Gusler 1979, pp. 22–23.
2. Bivins 1988, figs. 5.31–32; for the history of the latter table, see Smith 1979, p. 1266.
3. Comstock 1967, p. 105; Fede 1966, p. 17.
4. MESDA research file S-5824.
5. Chinnery 1979, pp. 438–39.
6. MESDA research files S-6453, S-4053. The former table is probably English but has a history of ownership in Virginia. The latter table is illustrated in Sale 1927, p. 264.
7. Kane 1973, nos. 25–28.

20

TABLE

New England, 1740–1800
Soft maple
66.8 x 91.1 x 71.7 (26 1/4 x 35 7/8 x 28 1/4)
The Mabel Brady Garvan Collection, 1930.2252

Structure: The top is made of two boards pinned to the frame rails. The brackets are cut out of the lower corners of each rail. The rails are tenoned and pinned into the legs.

Inscription: "49" is printed on a paper label attached to the inside of the right side rail.

Condition: The table was originally finished with a dark brown stain. It was subsequently painted a dark gray color with red paint added to suggest graining. A varnish applied over the paint now makes the gray appear dark green. The two pieces of the top have separated. The top has been removed from the table, the underside has been sanded, and butterfly cleats have been added to join the halves together. The top was reattached to the frame with screws through its upper surface.

Exhibition: Cullity 1987, no. 7.

Reference: Kirk 1975, fig. 95.

Provenance: Garvan purchased this table from R.S. Somerville on August 7, 1929.

An immense number of small tables with turned legs ending in offset, circular feet was made in New England during the eighteenth century. Made by turners from local woods, these tables were undoubtedly popular as stylish but inexpensive alternatives to urban furniture with carved, cabriole legs (cat. 18).

21

TABLE

New England, 1740–1800
Soft maple
66.4 x 86.2 x 66.9 (26 1/8 x 33 7/8 x 26 3/8)
The Mabel Brady Garvan Collection, 1930.2580

Structure: The frame rails are tenoned and pinned into the legs.

Inscription: "# 94" is typed on a paper label affixed to the inside of one frame rail.

Condition: The base was originally painted red and later a dark brown or black. The left front foot and one quarter of the right front foot have been restored. When Garvan acquired this table, it had an inappropriate replacement top. The present top was made from old wood by Peter Arkell in 1986, based on tops of similar tables, particularly cat. 20.

Provenance: This table was in the collection of Irving W. Lyon. It was one of the pieces Garvan purchased from Irving P. Lyon in 1929.

This table apparently was made by a joiner without access to a lathe. The legs were shaped with a draw knife; they are square in section at the knee and taper sharply to narrow, circular ankles. Unlike cat. 20, the feet are not offset, but contained within the perimeter of the stock.

22

TABLE

New England, 1770–90
Soft maple (turnings), eastern white pine (top)
67.7 x 75.1 x 63.1 (26 5/8 x 29 5/8 x 24 7/8)

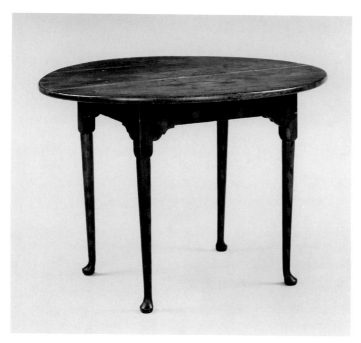

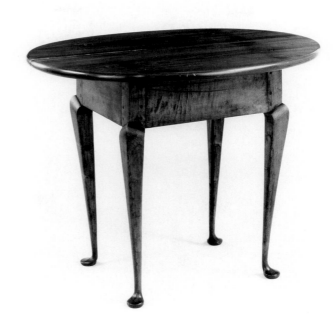

20 21

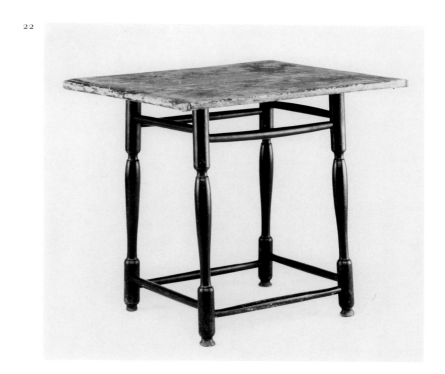

22

The Mabel Brady Garvan Collection, 1930.2255

Structure: The top is a single board with batten ends that is pinned to the legs. Two sets of stretchers are tenoned into the legs.

Condition: Traces of green and black paint survive on the top. At one time the top was covered with a white cotton or wool material that was itself covered with a dark green baize and later with a dark, closely striped fabric. The base was originally finished with a red stain and was subsequently painted green and later black. There are three large shrinkage cracks in the top, and the feet are chipped and worn.

Provenance: Garvan purchased this table from Frank Mac-Carthy on October 4, 1929.

This table was made by a turner who produced an inexpensive, utilitarian object without the labor-intensive work required in joined furniture. It resembles rush-bottom or Windsor chairs in its lack of square frame rails, although the maker pinned the top into the legs instead of tenoning the legs into the top. Tables of this type undoubtedly were more common in the eighteenth century than their survival would indicate today, and this rarity makes it difficult to determine a specific date or regional origin. The baluster and cylinder turnings with ring feet are similar to those found on Windsor furniture made before the 1790s. Similar tables, although with less attenuated turnings, have all been assigned to New England, which is consistent with the history of this example.[1]

1. Greenlaw 1974, nos. 115 and 127; Santore 1981, fig. 249; *Antiques* 128 (September 1985), p. 406.

Low Tables

Small tables with tops less than 60cm (23 5/8 in.) high became popular during the last quarter of the nineteenth century as a reaction against the massive furniture of the preceding fifty years. Decorators and authors of domestic furnishing guides were particularly opposed to large center tables in parlors (cat. 9). One book, written in 1878, declared, "We should advocate the use of several small tables rather than one large one; these to stand on the sides and in the corners, and not to obstruct the limited space in the center. . . . They are Liliputian [*sic*] affairs of only from twenty inches to two and a half feet in height. . . ."[1] Similar recommendations dominated the advice literature for seventy-five years. Discussing the arrangement of living room furniture, one author observed in 1936: "Beside each chair,

[place] a small table for smoking things, a magazine or two, or a cool drink."[2] These tables were intended as both accessories to pieces of seating furniture, such as end tables (cat. 23), and accessories to entertaining, such as coffee tables (cat. 25), tea tables (cat. 24), and cocktail tables (cat. 26).

By the early twentieth century, the size and particularly the height of these tables were seen as responses to twentieth-century life. The small size was a boon to urban apartment residents. "The big centre table is effective only in a big room," one author stated. "The small room must, therefore, have small tables."[3] The low tops, which made them useless for virtually any activity other than supporting objects to be picked up by a seated person, were interpreted as a reflection of the comfort of twentieth-century furniture, which did not demand rigid, upright postures. Most contemporary chairs and sofas had seat heights at what one source called "long low comfort lines." In a discussion of "Essential Living-Room Details," Emily Post decreed: "For comfort, the chairs and sofas must be low and deep and completely restful. . . . If its chairs be so low and deep that getting out of them again is difficult, no matter!"[4]

The coffee table is a specific type of low table that is large in size and generally occupies a fixed, central position among the living room seating furniture. This form did not appear prior to about 1920. During the late nineteenth and early twentieth centuries, the term "coffee table" was used to describe small, low tables on which coffee services could be placed (Fig. 40). These tables were frequently designed in vaguely Near Eastern or north African styles as components of "Turkish" interiors, since coffee drinking was associated with those regions, and such rooms often functioned as a place to serve coffee after a meal.[5] The larger, multipurpose form that is today identified as a coffee table was essentially an updated version of the nineteenth-century center table; several sources recommended cutting down old center tables for use as coffee tables.[6] During the 1920s this form was only intermittently identified as a coffee table—one 1922 source called it "a very low table to draw up to a low couch"—but by the late 1930s the use of the term became frequent.[7] The name may have been chosen to suggest its low height and informal character in contrast to a tea table, which carried associations of formality.

Several authors of home decorating books have described the coffee table as an American innovation.[8] Although the name apparently was first used in the United States, the primary inspiration for the form appears to be European. A large, low table—called a *basse boulle*—placed at the center of a seating group was designed in 1918–19 by Jacques-Émile Ruhlmann for the Paris apartment of Fernande Cabanel. Ruhlmann, Charlotte Chauchet-Guilleré, Armand-Albert Rateau, and Jean-Michel Frank all produced dramatic designs for this type

Fig. 40. Francis Lathrop, *Coffee-Table with Chair*, from Clarence Cook, *The House Beautiful*, 1878.

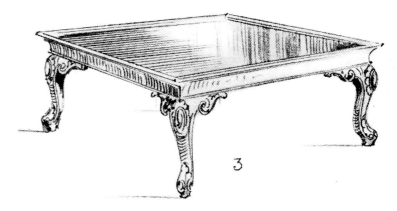

Fig. 41. F. J. Kegel, *Small Tables Which Go Far Toward Humanizing Any Room* (detail), from Emily Burbank, *Be Your Own Decorator*, 1922.

of table during the 1920s.[9] Glass-top tables of this type designed by Ludwig Mies van der Rohe in 1927 and 1930 are in production today as coffee tables but were originally marketed as *Blumentisch* (flower table) and *Teetisch* (tea table).[10] The form probably gained popularity in fashionable American interiors as part of the craze for French design following the 1925 Paris exposition. One of the earliest American designs for a coffee table is a 1922 drawing by F. J. Kegel of the Grand Rapids Furniture Company in a Rococo Revival style (Fig. 41). Modernist designs for coffee tables were produced after 1925 by leading artists, designers, and architects, including Paul Frankl (cat. 25), Isamu Noguchi, and Dan Cooper.

1. Williams/Jones 1878, p. 175.
2. Fales 1936, p. 125. Among the many books recommending the use of several low tables in the living room are de Wolfe 1913, pp. 140–41; *Modern Priscilla* 1925, p. 101; Koues 1945, p. 32; Derieux/Stevenson 1950, p. 23.
3. Herts 1915, p. 146.
4. Derieux/Stevenson 1950, p. 14; Post 1930, p. 342.
5. For a discussion of "Turkish" interiors, see Grier 1988, pp. 163–99. Small coffee tables are illustrated in Cook 1878, nos. 22, 74, and Grier 1988, figs. 33, 35.
6. Gillies 1940, p. 183, pl. facing p. 118; Morton 1953, p. 129; see also p. 16, above.
7. Burbank 1922, pl. 2; Burris-Meyer 1937, p. 7; Draper 1939, p. 87.
8. Pepis 1957, p. 100; Pahlmann 1960, p. 105.

9. Camard 1984, pp. 99, 282; Duncan 1984, figs. 32, 198; Todd/Mortimer 1929, pl. 45; Kahle 1930, p. 201; Rutherford 1983, no. 34; Sanchez 1980, pp. 21, 178–81, 184.
10. Johnson 1947, p. 55; Glaeser 1977, nos. 27, 60; Drexler 1986, p. 126; Russell 1986, pp. 53–54.

23
END TABLE

Designed c. 1934 by Alfons Bach (b. 1904)

Manufactured by Lloyd Manufacturing Company (1906–c. 1976–78)

Menominee, Michigan, 1934–40

Birch plywood, chrome-plated steel tube

58.5 x 64.5 x 28.9 (23 x 25 3/8 x 11 3/8)

Gift of Keith Smith, Jr., B.A. 1928, 1981.73.4

Structure: The two plywood tops are screwed to the base from the underside. The base is composed of three bent steel tubes. Two additional tubes with capped ends are screwed to the underside of the base. The top is stained to resemble rosewood or macassar ebony.

Inscriptions: "99 / T 57A / 52" is written on the underside of

the lower top in yellow chalk. A printed paper label is attached to the underside of the center support for the upper top: "PATENT PROCESS / Lloyd LOOM / Products / REG. U.S. PAT. OFF. / Menominee, Michigan / METHOD PATENTED OCTOBER 16, 1917 / OTHER PATENTS PENDING."

Provenance: The donor, Keith Smith, Jr., purchased this table prior to 1941. According to his daughter, he kept the table in a room in his home where he made jewelry as a hobby (Sharon Buck to the author, July 19, 1990, Art Gallery files; see also Appendix C).

Bent metal furniture had been introduced at the Bauhaus by Marcel Breuer with the Wassily chair in 1925. As Christopher Wilk has pointed out, tubular steel furniture quickly became the symbol of progressive, modernist design in the later 1920s and 1930s.[1] Alfons Bach was among the many foreign-born designers who immigrated to the United States during these years, and this table represents American manufacturers' attempts to use these designers to create marketable wares in avant-garde European styles. In 1934, Lloyd Manufacturing Company brought out a line of tubular steel furniture, designed by Bach and Kem Weber, which the company promoted as "offering modern structural strength and modern smartness."[2] This table exemplifies the overall rectilinearity of Bach's designs for this project: all of his tables had bases composed of three parallel steel tubes bent into a rectangular form and feet created by short, capped tubes soldered perpendicularly to the base. In contrast, Weber's designs for Lloyd manipulated the tubular style in a more curvilinear and dramatic manner.[3] Modernistic metal furniture of this type was made for only a few years; production ceased during World War II, and metal was superseded by plywood in the 1940s (see cats. 24, 148).

Alfons Bach was born and trained in Magdeburg, Germany, and studied architecture in Berlin, where he worked as a set designer for a motion picture company. He moved to New York City in 1926, working as a freelance industrial designer. In 1932, he opened his own firm, Alfons Bach Associates, at 724 Fifth Avenue. Shortly thereafter, he was retained as a furniture designer by the Heywood-Wakefield Company of Gardner, Massachusetts, creating lines of "Streamline Modern" and rattan furniture, as well as the tubular steel group for Lloyd Manufacturing, a subsidiary of Heywood-Wakefield. Bach also designed showrooms for Heywood-Wakefield in New York City and Chicago, and became successful as an architect in remodeling interiors for retail stores. Other architectural work included his own house in Stamford, Connecticut, in 1939 and alterations to the Seneca Textile Building in New York in 1952–53. In addition, Bach created furniture for Pulaski Veneer and Trans World Airlines, rugs and textiles for Bigelow-

Sanford Carpet and Pacific Mills, and metalwares for Keystone Silver and International Silver. Objects he designed were included in the biennial exhibitions "Contemporary American Industrial Art" at The Metropolitan Museum of Art between 1934 and 1940. In 1948 he closed his design practice to devote himself to development of the Ridgeway Shopping Center in Stamford, which he had begun two years earlier.[4]

1. Wilk, in Ostergard 1987, pp. 136–40.
2. Sironen 1936, p. 193.
3. *Lloyd Chromium Furniture* 1938, nos. T-85-D and T-86-D. The table with the model number written on the underside of the Art Gallery's table (T-57-A) is credited to Alfons Bach but not illustrated. For examples of Weber's furniture, see Sironen 1936, p. 141. I am indebted to Van Gorden Stedman for bringing Bach's role as designer to my attention and to Jacques-Pierre Caussin for generously providing me with access to the 1938 and 1940 Lloyd catalogues in his possession.
4. I am grateful to Alfons Bach for much of the information concerning his career and particularly for making available his personal archives. Aspects of his career are discussed in Herbert 1939, "New House" 1943, and West 1956. Additional information was taken from Bach's U.S. Patent applications, nos. 96,803–05; *Architectural Forum* 82 (April 1945), p. 66; *Stamford Directory*, 1941–62; and *Who's Who*, 1947, p. 34; 1953, p. 19; 1959, p. 23. W. Scott Braznell kindly recommended some of these sources.

24
TEA TABLE

Designed c. 1942 by Calvert Coggeshall (1907–1990)
Manufactured by Plyline Products, Incorporated (founded 1942)
Washington, D.C., c. 1947
Mahogany plywood
43.9 x 75.2 x 63.9 (17 1/4 x 29 5/8 x 25 1/8)
Gift of Jane Ritchie in memory of Andrew C. Ritchie, 1981.53.6

Structure: The top is a plywood board. Four narrow plywood strips are screwed to its underside and mitered together at the corners. The two U-shaped leg elements are cut from around the outside edge of the top. The legs are glued between the mitered strips and lapped together at the center. Glides are attached to their undersides.

Inscription: "ALBRIGHT ART GALLERY / BUFFALO, N.Y." is printed on a small adhesive tag on the underside of the top; "26" is typed above the legend.

Exhibition: Bennet et al. 1947, no. 26.

Provenance: Andrew Carnduff Ritchie (1907–1978) and his wife Jane Thompson Ritchie (1907–1985), who were friends of Coggeshall's, purchased this table in 1947 from the exhibition

"Good Design Is Your Business." Andrew Ritchie was then director of the Albright Art Gallery; the Ritchies later lived in New York City during his tenure at The Museum of Modern Art (1949–57) and in New Haven when he was director of the Yale University Art Gallery (1957–71).

Throughout his career, Calvert Coggeshall was interested in creating inexpensive furniture in simple, geometric shapes. A table he designed in 1937 consisted of a circular glass top on two walnut boards joined to form a cross.[1] Most of his furniture was produced by plywood companies; the Art Gallery's table was one of a group made from individual plywood boards, with the leg units cut from around the top. This furniture could be shipped flat and assembled by the consumer.[2] None of Coggeshall's designs was ever marketed on a large scale, despite his adherence to the criteria for furniture established in home decorating guides of the later 1940s and 1950s. Plywood, which Alvar Aalto had pioneered for furniture during the early 1930s, was promoted as inexpensive and easy for the homemaker to maintain.[3] As a lightweight object that could be shipped and assembled with ease, this table was also well suited to the booming national market in prefabricated homes following World War II. Rounded edges represented another desirable feature in furniture during the baby boom; one interior was praised because "every detail is engineered to combine comfort and safety for the children with ease of upkeep. There are no sharp corners. Even the drawer and cabinet handles are curved."[4]

Calvert Coggeshall was born in Utica, New York, and attended the University of Pennsylvania, Philadelphia, and the Art Students League, New York. He was active throughout his life as both a painter and designer. The firm of C. Coggeshall Design, established in New York during the 1930s, specialized in commercial and residential interiors, including the shop and residence of the milliner Lilly Daché and an office suite for the Rockefeller Foundation. From about 1945 to 1952, Coggeshall also worked as a consultant for Henry Dreyfuss. He was invited to join Knoll International but preferred to work independently in order to continue painting. After studying with Bradley Walker Tomlin in 1949 and becoming associated with the Betty Parsons Gallery during the 1950s, he began to devote more time to this aspect of his career. His paintings were exhibited at The Museum of Modern Art, and one, *Red Core* of 1968, was acquired by the Art Gallery.[5]

1. *Interior Design and Decoration* 9 (October 1937), n.p.
2. "Designed" 1942.
3. Wright/Wright 1951, pp. 20–23; Rogers 1962b, p. 229.
4. Derieux/Stevenson 1950, p. 6; see also Rutt 1948, p. 241.
5. Yale University Art Gallery (no. 1969.8). I am grateful to Susanna Wilson Coggeshall for information concerning her husband's career. Additional information is given in *Who's Who*, 1953, p. 82; 1966, p. 81; 1970, p. 73; 1973, p. 137.

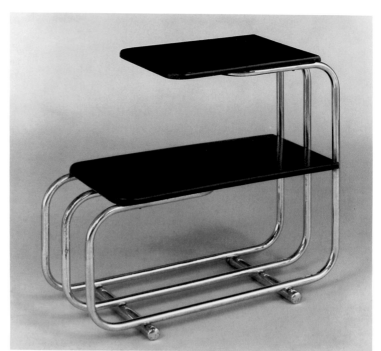

23

23 *Paper label*

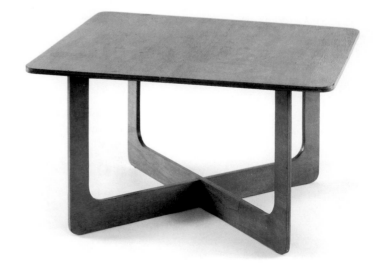

24

25

COFFEE TABLE *Color plate 26*

Designed 1944 by Paul T. Frankl (1887–1958)

Manufactured by the Johnson Furniture Company (founded 1908)

Grand Rapids, Michigan, 1944–50

Mahogany (legs), cork veneer (top); yellow-poplar (frame rails, leg plinths), plywood with soft maple, birch, and red gum laminates (leg braces), plywood with Douglas-fir and red gum laminates (top)

37.3 x 121.5 x 91 (14 5/8 x 47 7/8 x 35 7/8)

Gift of Mr. and Mrs. John E. Loeb, L.L.B. 1944, 1983.111

Structure: The top is made from a plywood board with a frame of eight curved rails screwed to its underside along the outside edges. Cork veneer is glued over the top and the sides of the frame. Four plinths are screwed to the underside of the top at the corners, and the legs are apparently glued to the plinths. A shaped bracket is fitted over each plinth and screwed to the underside of the top. Two metal glides are attached to the underside of each leg.

Inscriptions: "5005 # 166" is stamped on the underside of the top. "JIII/P [0?]/5005" is written in crayon on the underside of the top. "57" is inscribed in pencil on the underside of the top adjacent to three of the legs.

Condition: The beige-painted surface of the cork is original.

Provenance: The donors acquired this table from its original owner, who was a psychiatrist in Hamden, Connecticut.

Through his books as well as his designs for furniture and interiors, Paul Frankl was one of the foremost exponents of the American modernist movement of the 1920s. In the 1940s, he designed three lines of furniture for the Johnson Furniture Company. A desk, card table, and at least two different coffee tables with curvilinear tops were part of one collection.[1] These tables represented a striking departure from his earlier work, such as the coffee tables with circular and rectangular tops he designed in the late 1920s and 1930s.[2] As Grace Keating has demonstrated, Frankl's move in 1934 from New York City to California was paralleled in his style by a move away from urban architectural imagery toward streamlining and industrial motifs. Keating suggested that the curvilinear tops and oval legs on these tables were inspired by airplanes and aerodynamics.[3]

Just as his skyscraper furniture captured the spirit of the late 1920s, Frankl's coffee table embodied American modernist taste of the 1940s. The cork surface, one of the *materia nova*

Frankl had advocated for domestic use in *Form and Re-Form*, was frequently used for wall and floor coverings.[4] The top's curvilinear shape, called "free-form" in contemporary sources, was used by many American designers of the 1940s, particularly for coffee tables. Formal inspiration for the "free-form" shape had come from European Surrealism of the previous decade. Salvador Dali created a sofa in the shape of Mae West's lips in 1936, and the architect Carlo Mollino designed low, curvilinear tables beginning in 1938.[5] As early as 1935, Frederick Kiesler, whose work in New York was influenced by direct contact with Surrealist artists, designed two- and three-part low, curvilinear tables that were executed in cast aluminum over the following three years.[6] Perhaps the most important American coffee table of this type was a wood and glass table designed by Isamu Noguchi for A. Conger Goodyear in 1939; a simplified version was mass-produced by the Herman Miller Company beginning in 1947.[7] Martin Craig and Ann Hatfield exhibited a small coffee table with a light-colored, curvilinear top at the "Organic Design" exhibition at The Museum of Modern Art in 1941, and Alexander Girard, Marcel Breuer, and Dan Cooper had designed similar coffee tables prior to 1945.[8]

1. Heard 1950, p. 141; Ketchum 1982, no. 76; Phillips 1987, no. 272.
2. Frankl 1928, pl. 29; Frankl 1930, pp. 38, 166; Ford/Ford 1942, p. 49.
3. Grace Keating, "Practical Solutions: Paul T. Frankl's Approach to Modern Interior Design," paper delivered at the symposium "Merchandising Interior Design: Methods of Furniture Fabrication in America between the World Wars," Yale University Art Gallery, April 1, 1989.
4. Frankl 1930, p. 167.
5. Rutherford 1983, no. 68; Brino 1987, pp. 67–70.
6. Phillips 1989, p. 26, fig. 24; Galerie nächst St. Stephan 1975, p. 40.
7. Ford/Ford 1942, p. 53; *Herman Miller* 1948, pp. 56–57.
8. Noyes 1941, p. 20; Storey 1945, p. 22; Ford/Ford 1942, p. 24; Cooper 1946, p. 94; Rutt 1948, p. 241.

26

COCKTAIL TABLE

Designed 1951 by Finn Juhl (1912–1989)

Manufactured by Baker Furniture (founded 1890)

Holland, Michigan, c. 1954

Black cherry (edges and lower laminate of top), black walnut (legs, stretchers, top support), bleached maple veneer; yellow-poplar (inner laminate of top)

47.1 x 90.9 x 51.3 (18 1/2 x 35 3/4 x 20 1/4)

Gift of Mr. and Mrs. Gifford Phillips, B.A. 1942, 1984.14.5

Structure: The top has an applied outside edge with a raised cavetto molding. The upper surface of the top is veneered. The

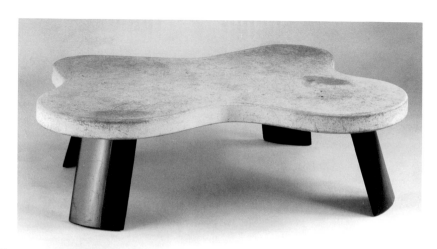

25

26 *Metal label*

26

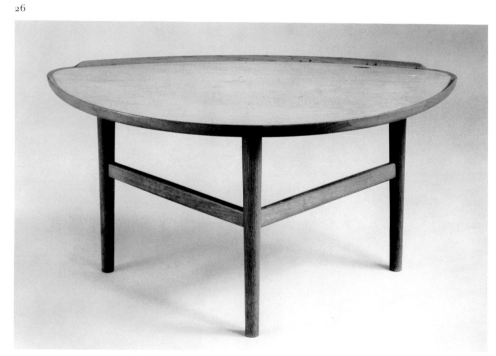

26 *Stamped label*

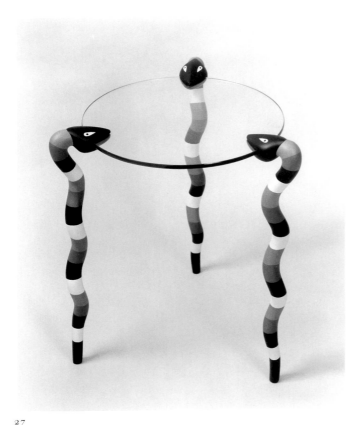

27

27 *Incised initials*

frame is screwed to the top from the underside. The frame rails and stretchers are presumably doweled into the legs.

Inscriptions: Several marks and labels appear on the underside of the top. "Baker / [crowned B with a tulip] / Furniture" is embossed on an oval metal tag. "INSPECTOR / [star] / BAKER / No. 4" (enclosed in a circle) is stamped twice. "754" is incised and "528" is stamped once.

Condition: The top has been treated with a colorless, liquid-resistant synthetic finish.

Provenance: The donors purchased this table about 1955 for a house in Santa Monica, California.

Furniture designed by the architect Finn Juhl for Danish master craftsmen was credited as a primary inspiration for the style known as Danish Modern.[1] The simple elements, subtle curves, smooth surface, and light-colored finish of these objects were characteristic of the postwar Scandinavian furniture marketed extensively in the United States (see cat. 148). To compete with these popular imports, Hollis S. Baker of Baker Furniture commissioned Juhl in 1951 to design the "Baker Modern" line of mass-produced furniture that included this table, model number 528. The line was in production for about five years; the number 754 stamped on the Art Gallery's table probably refers to July 1954, the date for cutting out the pattern.[2] This table design was made in at least two larger sizes and was offered with Formica as well as wood veneer tops. Juhl's drawings and Baker's sales catalogues labeled this model a "cocktail-table," although articles on the Baker line described it as a "coffee table."[3]

1. Pepis 1957, p. 128.
2. Alex W. Mitchell to the author, August 7, 1990, Art Gallery files.
3. *Baker Modern*, pp. 4–5; "Baker" 1951.

27

SNAKE TABLE *Color plate 29*

Judy Kensley McKie (b. 1944)

Cambridge, Massachusetts, 1988

Hard maple, glass

53.8 x 49 x 41.1 diameter of top (21 1/8 x 19 1/4 x 16 1/8)

Bequest of Marie-Antoinette Slade, by exchange, 1989.95.1

Structure: The legs are separate elements. The top is fitted into a slot in each snake's head and secured by a rubber stop that is screwed against it from below.

Inscription: "© JKM 1988" is incised on one leg near the bottom.

Exhibition: Canadian Craft Council Gallery, Saskatoon, Saskatchewan, Canada, 1989.

Provenance: The Art Gallery purchased this table from the artist.

One of the outstanding American woodworkers of her generation, Judy McKie trained as a painter at the Rhode Island School of Design and first began making furniture professionally in 1971.[1] The most distinctive feature of her work is its animated, whimsical quality, created in large part by her stylized rendition of animal motifs. McKie designed the first snake table while working in Santa Fe, New Mexico, and was influenced by the primitive animal figures she saw in New Mexican folk art. The vividly painted snakes that form the legs of this table allowed her to create a simple table with unusual visual interest; they also provided a conceit for integrating the glass top into the design.[2] McKie's playful design is part of a long tradition of sculptural animal supports, beginning with Egyptian furniture of the 18th Dynasty (1567–1320 B.C.) and continuing to the bronze furniture of Armand-Albert Rateau in the 1920s.[3] The snakes' twisted bodies suggest the twist-turned legs on seventeenth-century Anglo-American furniture. Glass tops have a tradition of their own in the twentieth century, being favored for tables by modernist designers of the 1920s and 1930s as an industrial material that revealed the underlying structure. In McKie's table, however, the glass focuses attention on the disquieting presence of three life-size snakes with demonic expressions.

McKie designed the first version of this table in 1987, when she received a commission from a friend to make a small side table. In all, she has made thirty-two snake tables, her largest edition of a single design.

1. For further information on McKie's career, see Cooke 1989, pp. 80–83.
2. McKie provided the author with information concerning the snake table in a telephone conversation, September 30, 1990.
3. Baker 1966, figs. 64–65, 75, 89, 143–47; Duncan 1984, figs. 197–98, 200–01.

With Drawers

Tables with fixed tops and drawers or other storage spaces were unknown in antiquity and the Middle Ages. The addition of a storage function to the table form did not occur until the end of the fifteenth century in southern Germany, where substantial, joined table frames were made with drawers and compartments.[1] This form apparently was not adopted in England until a century later; a 1626 inventory contained an early reference to "one side table of walnuttree wth drawers."[2] Joined tables with drawers appeared in America during the second half of the sev-

enteenth century (cat. 28). A "small Table wth drawers" was recorded in the "dyning Roome" of the Boston merchant Antipas Boyse in 1669.[3]

During the eighteenth century, the table with drawer was developed into a number of high-style, specialized forms, including dressing tables and sideboard tables (see p. 80).[4] Although both dressing tables and sideboards were related in appearance to the type of table with drawer catalogued in this section, their primary function was to provide storage. These forms had back rails made of secondary woods and little overhang at the rear of the top, indicating their use as wall furniture. In contrast, all but one (cat. 38) of the seventeenth- and eighteenth-century tables with drawers in the Art Gallery's collection were made to be used freestanding in an interior. The back frame rails were made of primary wood, moldings on the top and frame rails were continued on the back, and the tops had equal amounts of overhang on all four sides. The depth of the tops, much greater than on pier tables (cats. 11–17), would have required access from all four sides. The wear on the tables at Yale further suggests that these tables were used in the middle of a room, since the wear is not always related to the position of the drawer (see cat. 29).

With the advent of such case furniture as dressing tables and sideboards, tables with drawers became less fashionable. In both English and American metropolitan style centers, most non-specialized tables with drawers made after the first quarter of the eighteenth century were constructed from inexpensive native woods as utilitarian furniture.[5] The 1772 Philadelphia price list included a "Pine Kitchen Table . . . Single frame 3 f[t] 6 I[n] with a drawer" at a price of 16 shillings; a 1796 Philadelphia price book described "Single frame" pine or yellow-poplar tables in two sizes, with and without drawers and "Lower rails," that ranged in cost between £1.7.6 and £2.3.9.[6] Neither book included a version of this form in hardwoods. However, in micropolitan and rural Pennsylvania, the valley of Virginia, the North Carolina piedmont, and other regions settled by people who were not directly influenced by urban English models, tables with drawers continued to be made from hardwoods with expensive brass hardware (cats. 29, 31–34).[7] In 1784, the Lancaster, Pennsylvania, cabinetmaker Johannes Bachman recorded making "ein Düsch mitt zweÿ schubladen [a table with two drawers]" for £1.12, a price that in comparison to the Philadelphia listings is high enough to suggest the use of an expensive hardwood like walnut.[8]

Eighteenth-century tables with drawers have been described in the twentieth century as "tavern tables," a term that was not used in any period documents. The expensive hardwoods and brasses on most of the seventeenth- and eighteenth-century tables with drawers at Yale suggest that these objects

were used in relatively formal, domestic settings. Aside from scattered references to a "Small Turned Table & Drawer" or a "Table with a drawer & Carpitt" in eighteenth-century inventories, there is little documentation for their nomenclature or usage, if either followed any consistent pattern.[9] The Philadelphia price books cited above listed two different falling-leaf table forms as well as stationary-top tables with and without drawers under the heading "Pine Kitchen Tables." Less expensive, softwood tables of this type were undoubtedly intended for use in preparing food, as were their metal counterparts in the twentieth century (cat. 37).

Library tables are a specialized form of table with drawer that was first made in America during the second quarter of the nineteenth century as the practice of devoting a room to books increased. Little if any American furniture from the eighteenth or early nineteenth centuries was made specifically for use in a home library, as few Americans prior to 1825 gave over an entire room in their houses to the storage and use of books. Large, freestanding tables had been a fixture in English domestic libraries as early as the seventeenth century, although these tables usually lacked drawers and were intended to be covered with a cloth.[10] A few large eighteenth-century American tables, made with or without drawers and finished on all four sides, may have been intended for this purpose (cat. 34).[11] A 1797 inventory of "Richmond Hill," the home of Aaron Burr in New York City, listed a "Library Table" in the library.[12] An 1811 watercolor by Samuel F.B. Morse shows his family gathered around a table of this type (Fig. 42). Although it is unclear what room the figures occupy, they are studying a terrestrial globe, a popular accoutrement of libraries at this time (see cat. 141).

By the second quarter of the nineteenth century, libraries were being promoted as an essential part of American upper- and middle-class life, and library tables served the same function in that room as did center tables in the parlor. Many library tables of this period had circular tops on central pedestals and were essentially interchangeable in appearance with center tables (see cat. 39 and p. 74), although library tables usually were fitted with drawers and had leather-covered tops. A distinct type of library table that appeared by about 1840 was larger in scale and had a rectangular frame with at least one drawer (cat. 35). An early documented example of this type is the Gothic style library table made for Henry Wadsworth Longfellow by Abraham Kimball of Salem, Massachusetts, in 1843.[13] This form was developed from the French *bureau plat* of the early eighteenth century, although library tables only rarely were made in the Rococo Revival style, which was considered too decorative and feminine for this room. Most domestic libraries prior to about 1875 were decorated in Classical, Medieval, and Renaissance Revival styles that evoked great literary

epochs and were sufficiently masculine in character. Authors of home furnishing manuals stressed massiveness and solidity as a library table's most important qualities.[14]

1. Müller-Christensen 1948, p. 37, figs. 27–28, 36; Kreisel/ Himmelheber 1973, I, p. 36, figs. 72–3, 267–69; Mercer 1969, p. 80, pls. 78, 81.
2. Chinnery 1979, p. 314.
3. SCPR, V, p. 178. I am indebted to Abbott Lowell Cummings for this reference and for his thoughts on table usage in seventeenth-century New England.
4. The dressing tables in the Art Gallery's collection were catalogued in Ward 1988, nos. 93–121.
5. Temple Newsam 1977, nos. 14, 38, 46, frontispiece; Cotton 1987, figs. 12/3, 13; Jobe/Kaye 1984, nos. 56–57.
6. Weil 1979, p. 190; *Philadelphia Prices* 1796b, p. 27.
7. A large walnut table with a drawer has a history of ownership in Rockingham County, Virginia (MESDA research file S-11201); a similar walnut table was found in southwest Virginia (MESDA research file S-13630). Walnut tables of this type found in North Carolina include examples from Mecklenburg (MESDA research file S-11817) and Buncomb (MESDA research file S-10328) counties, as well as tables preserved at Old Salem (Bivins/Welshimer 1981, figs. 1-18, 1-19, 1-21).
8. Cited in Forman 1983, p. 117.
9. Schiffer 1974, pp. 125, 128.
10. Thornton 1978, p. 310.
11. Heckscher 1985, no. 92; Montgomery 1966, no. 344.
12. "Richmond Hill" 1927, p. 18.
13. Longfellow National Historic Site, Cambridge, Massachusetts.
14. Williams/Jones 1878, p. 130; Humphreys 1897, p. 104.

28

TABLE WITH DRAWER

Probably Boston, 1675–1700
Birch (turnings), eastern white pine (side rails)
63.7 x 94.1 x 68.5 (25 1/8 x 37 x 27)
The Mabel Brady Garvan Collection, 1963.5

Structure: The frame rails are tenoned and pinned into the legs. The center stretcher is tenoned and pinned into the side stretchers; the other stretchers are tenoned and pinned into the legs.

Inscription: "s c" is carved into the side of the right front leg.

Condition: The black paint is not original. One long side of the frame originally held a drawer that was supported by a rail tenoned between the front legs and runners nailed between the front and rear legs. The frame was disassembled at one time, probably when the drawer was replaced with a molded rail. The feet are replacements. This table had no top when it was acquired by the Art Gallery in 1963. An old, batten-end top was

Fig. 42. Samuel F.B. Morse, *The Morse Family*, c. 1809. Watercolor. Smithsonian Institution, Washington, D.C.

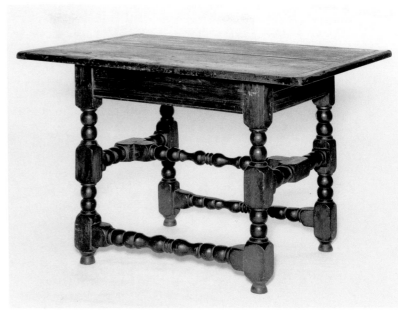

28

added in 1974; this top was selected because of its similarity to the top on the related table at the Henry Ford Museum.

Exhibitions: Kirk 1967a, no. 138; Myers/Mayhew 1974, no. 2.

References: Kirk 1970, fig. 201; Kirk 1982, fig. 1228.

Provenance: The Art Gallery purchased this table from the dealers Frederick and Jean C. Fuessenich of Litchfield, Connecticut, in 1962. According to the Fuessenichs, this table was "from the Allyn Family, New London, Ct." (F.W. & Jean C. Fuessenich to Meyric R. Rogers, December 18, 1962, Art Gallery files), although they provided no documentation to support this provenance. The Allyns of New London are descended from Robert Allyn (1608–1683), who moved to New London from Salem, Massachusetts, in 1651. One of his children may have been the original owner of this table; if it descended to someone with the Allyn surname, its most likely owner was his only son, John Allyn (1642–1709) (*New London* 1905, pp. 362–63).

Only the turnings and three frame rails survive from this diminutive table, which originally was fitted with a drawer on one of its long sides (see Condition). These surviving parts are enough to confirm that the table once was a superb example of the form. The sophisticated interplay of spheres, balusters, and blocks in the turnings has an animated quality characteristic of furniture influenced by the Baroque style of the Stuart restora-

tion. The maker's concern with articulating the turnings, particularly the arched ends of the blocks, suggests that the original top may have had a molding defining its outside edges, as in contemporary English examples of similar quality.[1]

Because of its purported descent in the Allyn family of New London, this table has been featured in two landmark exhibitions of Connecticut furniture. The turnings, however, are unlike any firmly documented Connecticut work. They relate closely to leather-upholstered chairs produced in Boston during the last quarter of the seventeenth century.[2] The table's small size raises the possibility that it was made in Boston for export to Connecticut, just like the leather chairs. Among similar tables are four in museum collections that have been attributed to Massachusetts in the absence of any reliable histories of ownership.[3] The Yale table is distinct in having low front and back stretchers and a high medial stretcher, whereas the opposite arrangement is found on most other tables of this type. Many of these tables also have frame rails with shaped skirts, unlike the table at Yale.

The original function of these tables with drawers is unclear. Victor Chinnery has advanced the theory that the "side table" mentioned in seventeenth-century English inventories was a small table with a drawer for storing and displaying objects used in dining.[4] The only use of this term in a seventeenth-century Massachusetts inventory appeared in Freegrace Bendell's din-

ing room in Boston in 1676, although the small table with drawers in Antipas Boyse's dining room in 1669 was probably the same form.[5] Three of the four related tables mentioned above are about 71cm (28 in.) high, a customary height for a side table to be used by standing people. Although the loss of its original top and feet make the original dimensions uncertain, the Art Gallery's table was clearly at least 10cm (3 7/8 in.) lower; a similar table at the Wadsworth Atheneum is almost identical in size. It seems more likely that these two tables were used by seated people rather than as side tables; the low heights may have been intended to accommodate someone seated on a stool or cushions instead of a chair. The wear on the stretcher below the drawer front, which is much more worn than its counterpart on the other side, suggests that the Art Gallery's table occupied a fixed position in a room.

1. Chinnery 1979, pl. 15.
2. Fairbanks/Trent 1982, no. 284; Forman 1988, nos. 45–47.
3. Related tables are in The Metropolitan Museum of Art, New York (Nutting 1928, I, no. 855), Wadsworth Atheneum, Hartford, Connecticut (Nutting 1928, I, no. 854), The Art Institute of Chicago (no. 46.532), and the Henry Ford Museum, Dearborn, Michigan (no. 54.17.2, illustrated in *Antiques* 73 [February 1958], p. 152).
4. Chinnery 1979, pp. 312–15.
5. SCPR, XII, p. 167; V, p. 178. I am indebted to Abbott Lowell Cummings for these references.

2 9
TABLE WITH DRAWER

Southern New England, probably Connecticut, 1700–50

Soft maple; red oak (rear frame rail, drawer runners), yellow-poplar (drawer sides and back), southern yellow pine (drawer bottom)

67.9 x 86.8 x 77.2 (26 3/4 x 34 1/8 x 30 3/8)

Gift of C. Sanford Bull, B.A. 1893, 1952.50.2

Structure: The top, pinned to the legs and frame, is made of four boards with battens pinned to the ends. The frame rails and stretchers are tenoned and pinned into the legs. The drawer front and back are dovetailed to the sides, and the two bottom boards are nailed to all four drawer members. The drawer runners are L-shaped pieces of wood nailed to the sides of the frame.

Condition: At one time the table had a reddish-brown stain and was later painted white; its surface is now stripped. A narrow strip has been added to the top to fill in shrinkage between two boards. The front and side stretchers are worn, with the left side stretcher exhibiting particularly heavy wear that also appears on the left end of the top. All four feet have been worn away; they

originally may have been baluster shape. The drawer bottom has been renailed. The keyhole escutcheon appears to be original. The backplates of the handles are replacements; the drops may be original.

Provenance: Cornelius Sanford Bull (1871–1955) gave the Art Gallery thirty-four pieces of furniture between 1949 and 1953. He began collecting as an undergraduate with his classmate Irving P. Lyon, the son of pioneer furniture historian Irving W. Lyon (see Appendix C, p. 389). Composed largely of New England furniture, Bull's collection furnished his home in Middlebury, Connecticut. Two tables owned by Bull are included in the Study Collection (cats. A20 and A23).

This table's turnings follow a pattern common throughout New England (see cat. 40), although this form apparently went out of fashion in the region in the second quarter of the eighteenth century.[1] The combination of oak, yellow-poplar, and southern yellow pine as secondary woods is atypical of coastal, urban furniture from New England and indicates an inland origin, probably in Connecticut.[2]

1. A Massachusetts table with turnings of this pattern is illustrated in Randall 1965, no. 74.
2. Jobe/Kaye 1984, p. 78; Wadsworth 1985, p. 185.

3 0
TABLE WITH DRAWER

Southern Colonies, 1725–50

Southern yellow pine (top, side rails, and drawer front, sides, and back), ash (turnings), soft maple (drawer knob); baldcypress (drawer bottom)

68.7 x 84.6 x 108.7 (27 x 33 1/4 x 42 3/4)

The Mabel Brady Garvan Collection, 1930.2763

Structure: The top is composed of two boards joined together by three splines pinned in place. The batten ends are mitered at the corners and fit into the projecting mitered corners of the top boards. The battens are attached to the top with splines and pinned. The top is nailed to the legs and frame. The frame rails are tenoned and triple pinned into the legs, with the exception of the front rail, which is double pinned. The stretchers are tenoned and pinned into the legs. Two drawer runners were originally dovetailed into the front rail and a board nailed in a corresponding position on the opposite side of the frame. The drawer extends the full depth of the frame. The front and back of the drawer are dovetailed to the sides; the bottom is a single board fitted within the frame and nailed in place from the sides and back. A single peg also secures the back.

Inscription: "G Coll 17" is written in ink on a fabric tape glued inside the drawer.

Condition: Traces of the original red stain survive on the surface. The right rear mitered corner of the top has been repaired with a lap joint. All four feet have been worn away. The two drawer runners are modern replacements. The drawer knob appears to be original.

Reference: Bivins 1988, fig. 5.37.

Provenance: Acting as Garvan's agent, Henry Hammond Taylor purchased this table from J.K. Beard on March 17, 1930.

John Bivins published this table as a product of the Roanoke River basin region of North Carolina, basing his attribution in part on the supposed use of mulberry for the turnings.[1] Subsequent microanalysis, however, has identified them as ash. The drawer bottom was made of baldcypress, a tree that grows most commonly in river swamps on the south Atlantic coast.[2] The presence of baldcypress and the fact that the table was acquired from a Richmond, Virginia, dealer in 1930 indicate a southern origin, but the table has a number of distinctive design and construction features that confound any attempt to make a specific identification. The bold turnings and thick boards used in the table's construction suggest a date in the second quarter of the eighteenth century, although the cylindrical, ring-turned stretchers terminating in balusters have no exact parallel in American furniture of this period. The drawer in a short rail extends the full length the frame, whereas most tables of this type have one or more drawers in the long frame rail (cats. 29, 31–33).[3] The top has a deeper overhang than other examples of this type at Yale. The mitered battens on the top and the use of two or more small pins to secure each mortise-and-tenon joint are other unusual construction techniques.

1. Bivins 1988, pp. 130–31.
2. Sargent 1926, p. 65.
3. Bivins 1988, p. 131, notes that tables from Virginia as well as North Carolina have a single drawer in one of the short frame rails. A documented example from Virginia was found about 1870 near Vicksville, in Southampton County (MESDA research file S-5824). A southern yellow pine table with a drawer in its short rail was discovered in Wake Forest, North Carolina (MESDA research file S-14553).

31

TABLE WITH DRAWERS

Pennsylvania, 1725–75

Black walnut; yellow-poplar (drawer runners, interiors of right and center drawers), eastern white pine (interior of left drawer)

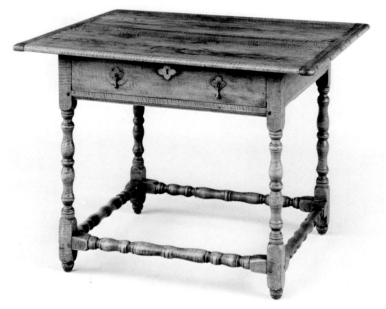

29

30

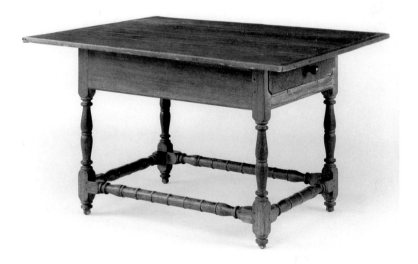

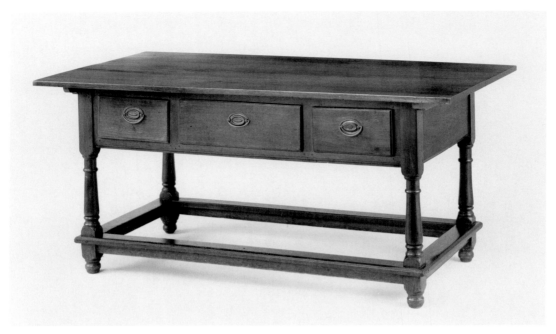

31

69.5 x 146.6 x 79.8 (27 3/8 x 57 3/4 x 31 3/8)
The Mabel Brady Garvan Collection, 1930.2181

Structure: The top is composed of three boards. Two cleats were dovetailed to the underside and pinned through the side frame rails. The side and back frame rails are double tenoned and pinned into the legs. The front rails are tenoned and double pinned into the legs. Vertical drawer dividers are tenoned through these rails and triple pinned. The stretchers are tenoned and pinned into the legs. Footboards are pinned through the front and back stretchers and fitted into cutouts in the legs, where they are secured with nails and pins. The footboards are mitered together at the corners. All three drawers are constructed in the same manner: the front and back are dovetailed to the sides, and the bottom has feathered edges fitted into grooves in the front and sides and nailed to the back. The drawer runners are tenoned into the back of the frame. The two center runners are double tenoned to the front frame rail; the side runners have cutouts that fit around the upper sides of the legs and are tenoned into the front rail.

Inscription: "Outside" is written in chalk on the inside of the right frame rail.

Condition: The center board of the top split in half. The top was disassembled and this board was planed on its edges before the top was put back together. The replacement cleats are secured with screws through the original pinholes. The right leg broke out, and all of the joints connected to it have been resecured. The footboards are broken in the right rear corner. The right side drawer runner has been reattached to the frame with glue. The left side drawer runner has been pieced. The brasses on the drawers are replacements. The table was fitted with casters at one time.

Large hardwood tables with drawers were primarily produced in parts of this country settled by Continental Europeans. This table exhibits a number of design and construction details associated with Germanic craft traditions and was probably made in Pennsylvania. The footboards on the stretchers are a German and Dutch feature found on other eighteenth-century Pennsylvania tables.[1] The table's thick boards (the drawer sides are 3 cm [1 1/8 in.] thick), multiple pins, and through tenons on the vertical drawer dividers are also atypical of English and New England workmanship.

1. Kreisel/Himmelheber 1973, I, nos. 70, 267, 343–44; Rijksmuseum 1952, no. 293; Lunsingh Scheurleer 1961, fig. 18; Nutting 1928, I, no. 857; Garvan 1982, pp. 47–50, nos. 3, 5, 6, 14.

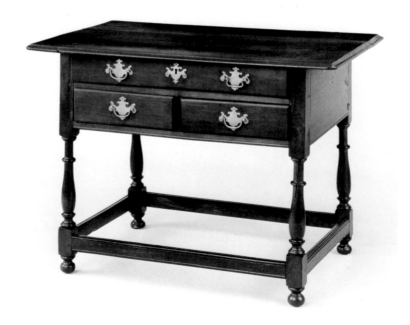

32

32

TABLE WITH DRAWERS

Eastern Pennsylvania, possibly Philadelphia, 1745–75

Black cherry (top, turnings, drawer fronts), birch (frame rails, front drawer supports, stretchers); Atlantic white-cedar (drawer interiors), southern yellow pine (lower drawer runners), yellow-poplar (central drawer runner and drawer guide, right upper drawer runner), soft maple (left upper drawer runner)

73.1 x 96.2 x 64.1 (28 3/4 x 37 7/8 x 25 1/4)

The Mabel Brady Garvan Collection, 1930.2581

Structure: The top is composed of three boards butted together. It originally was pinned to the legs and the narrow sides of the frame. The frame rails and stretchers are tenoned and pinned into the legs. All three drawers are constructed in the same manner: the front and back are dovetailed to the sides with wedged dovetails; the bottom is made of two boards fitted into a channel in the front and nailed to the sides and back. The side drawer runners are nailed to the sides of the frame. The center drawer runner is tenoned to the lower front rail and nailed to the back rail. The vertical drawer divider is tenoned to the upper front rail and nailed to the lower one. A horizontal drawer guide is pinned to the central drawer runner.

Condition: The top has been patched where the original pegs that joined it to the frame broke out; it is now screwed in place. Two cleats have been screwed to the inside of the frame for new pins that also secure the top. The top's front corners have been damaged and reshaped, a few large cracks have been filled, and a split has been repaired with a butterfly patch. There is a large crack in the left front leg, and the left front foot has been replaced with a birch foot that is secured with a dowel. The right front foot and the right upper drawer runner are also replacements. Peter Arkell recolored the finish in 1982. The brasses and lock are original.

Provenance: Garvan purchased this table from Charles R. Morson on October 24, 1924.

An eastern Pennsylvania origin is likely for this large, solidly constructed table with two registers of drawers, particularly given the combination of Atlantic white-cedar, southern yellow pine, and yellow-poplar as secondary woods. The table's overall design was a simplified version of late seventeenth-century models (see cat. 1). Georgian brasses with lively silhouettes undoubtedly were chosen as a means of updating and enriching this otherwise conservative form. The deeply scored lines around the widest parts of the baluster turnings may indicate the hand of a Philadelphia craftsman, since similar lines have

been identified as a characteristic of early eighteenth-century Philadelphia furniture (see cat. 42).

1. Nutting 1928, I, no. 837; Scott 1979, fig. 3; Garvan 1975, pl. 6; Garvan 1982, p. 50, no. 14.
2. New Hampshire Auction 1990, no. 301.

33

TABLE WITH DRAWERS

Pennsylvania, 1750–1800
Black walnut; yellow-poplar
72 x 71 x 51.1 (28 3/8 x 28 x 20 1/8)
The Mabel Brady Garvan Collection, 1930.2048

Structure: The top is made of two boards pinned to the legs and side frame rails. The frame rails and stretchers are tenoned and pinned into the legs. The front and back of each drawer are dovetailed to the sides, and one dovetail at each end is nailed. The bottom is rabbeted into a groove in the drawer front and is nailed to the sides and back. The L-shaped drawer runners are nailed to the corner posts. The central drawer runner and vertical drawer divider are nailed together. Both are nailed into the back and the runner is nailed into the front rail. A piece of walnut is nailed over the front edge of the vertical divider and tenoned and pinned to the front rail.

Inscriptions: "L" is written in pencil in nineteenth-century script on the right drawer runner; "R" is inscribed on the left runner.

Condition: Jacob Margolis billed Garvan for extensive repairs made to this table (Margolis file, FPG-AAA). The top's boards had separated and were badly warped when the table was purchased, and Margolis planed and refinished them. The present drawer knobs were put on after 1929, presumably by Margolis, to replace badly worn wooden knobs. Both drawers had spring locks on the underside, which raises the possibility that they originally had no hardware. The larger drawer had interior partitions at one time. The table retains traces of green paint, although it is unlikely that a walnut table originally was painted.

References: Ormsbee 1934, p. 86; Kirk 1982, fig. 1249.

Provenance: Garvan purchased this table from A.J. Pennypacker before August 1929.

This small table exhibits the same traditional design and solid construction as the preceding examples (cats. 31, 32). Two drawers of unequal size were common in Pennsylvania tables of this type, although the larger drawer typically was twice the size of the smaller.[1] A table almost identical in size and appearance to this example was sold at auction in 1990.[2]

34

TABLE WITH DRAWER

Charleston, South Carolina, 1765–90
The primary wood, as well as the diagonal brace under the top and the drawer runners, has been identified as belonging to the family *Lauraceae* (laurel) and may possibly be red bay. The other secondary woods are mahogany (drawer sides and back) and baldcypress (drawer bottom).
73 x 109.1 x 72.2 (28 3/4 x 43 x 28 3/8)
The Mabel Brady Garvan Collection, 1930.2586

Structure: The top is made of three boards with beveled upper and lower edges that were held together by butterfly cleats on the underside. It was originally pinned to the frame rails. A brace supporting the top is tenoned diagonally between the front and rear frame rails. The frame rails are tenoned and pinned into the legs. Brackets are nailed to either side of each leg. The drawer front and back are dovetailed to the sides. The bottom is made of two boards nailed to the undersides of all four members. Each L-shaped drawer runner is made of a vertical and a horizontal piece of wood tenoned into the same mortises in the front and back frame rails.

Inscriptions: "# 59" is handwritten in ink on a paper label affixed to the inside of the right frame rail. "The Litchfield / Historical / Society" is printed and "B / 87 / 5151" is written on a paper label attached to the inside of the drawer.

Condition: The outside edges of the top appear to have been shaped originally but are now worn down to a smooth, square edge. Butterfly cleats have been lost from the underside of the top. These cleats were replaced with strips of wood that are screwed to both the top and the side frame rails. The boards of the top have been reduced in width and the top has been reassembled and nailed to the frame. The feet have been cut down by approximately 2cm (3/4 in.) of their original height and the talons are abraded. Both of the knee brackets on the right rear leg and the side bracket on the left rear leg are replacements. The drawer bottom has been renailed. The brass drawer pull is original, but the lock has been lost.

Provenance: Acting as Garvan's agent, A.W. Clarke purchased this "walnut claw and ball foot table with drawer in skirt" at the Charleston Auction and Sales Company in Charleston, South Carolina, on February 8, 1929 (bill from Charleston Auction

and Sales Company, February 8, 1929, C-miscellaneous file, FPG-AAA; see also Clarke to Garvan, February 9, 1929, Clarke file, FPG-AAA).

This table was purchased in 1929 in Charleston, the largest and most cosmopolitan southern port of the late Colonial period. The distinctive woods provide substantial evidence for an origin in that city. Both the primary wood, tentatively identified as red bay, and baldcypress are found in swampland along the south Atlantic and Gulf coasts and point to a southern, coastal origin.[1] Red bay appears frequently in Charleston records and apparently was popular among cabinetmakers for making tables.[2] The extravagant use of mahogany for the drawer interior indicates a place of manufacture where such wood was easily obtained through trade with the West Indies. Milby Burton noted that in Charleston mahogany furniture was owned by a wider spectrum of society than in other American cities and concluded that it was less costly because of its abundance.[3]

Through recent research and discoveries, Bradford Rauschenberg and others at the Museum of Early Southern Decorative Arts have identified a distinct group of tables made in Charleston that share the stylistic characteristics of this example. All have broad, angular knees with exaggerated cyma curve brackets. The thick, relatively stiff legs have feet with flat balls and claws with pronounced knuckles. These features are found on a slab table that descended in the Ladsen family of Charleston.[4] A table with a drawer and a card table with histories of ownership in Charleston have baldcypress drawer interiors and similar legs and knees.[5] The drawer in the Art Gallery's table has an incised molding on its front that is slightly recessed within the table frame, a detail seen on a group of mahogany and cypress side or dressing tables that were owned in the vicinity of Charleston.[6]

As noted above (p. 101), the table with a drawer intended to be a freestanding piece of furniture is an uncommon form in Anglo-American urban furniture made in the Georgian style. Perhaps this lack of models accounts for the awkward quality of the Art Gallery's table. The absence of carving, the stiff cabriole legs, and narrow cyma molding along the frame's lower edges do little to relieve the table's heavy, foursquare character. The maker's lack of finesse is further demonstrated by his choice of an outmoded, engraved brass handle for a drawer front with an incised bead molding. Although inferior in quality to the best Charleston furniture, this table is important as an unusual form with distinctive stylistic features made from local woods.

1. Sargent 1926, pp. 65, 358.
2. Burton 1955, pp. 33–34. In the course of his extensive research on Charleston furniture, Bradford Rauschenberg has discovered that references to red bay are more common than Burton suggests; the

wood was also used for a greater variety of furniture forms than indicated by Burton.
3. Ibid., pp. 29–31.
4. MESDA (no. 3163).
5. Both in the MESDA collection (nos. 2764 and 2976).
6. MESDA research file S-8437; Burton 1952, figs. 23–24; Burton 1955, fig. 90.

35

LIBRARY TABLE *Color plate 22*

Possibly New York City, 1850–70

Black walnut; eastern white pine (underside of top, frame interior), black cherry (drawer sides), yellow-poplar (drawer bottoms and backs)

76.2 x 152.5 x 83.1 (30 x 60 x 32 3/4)

Yale University Art Gallery, 1974.64.3

Structure: The top is made of two boards; the semicircular ends are separate pieces. The center of the upper surface is covered with leather and has an applied, raised edge. The top is glued to a frame with applied moldings on its outside edges. The semicircular ends are fitted with tongues into grooves in the ends of the front and back frame members. A lateral brace across the entire width of the top is fitted into cutouts in strips applied to the frame ends.

The top and its frame are attached to the underframe that encloses the drawers. The underframe rails butt against four large corner blocks with applied pyramidal bosses on their outside faces. The curved end rails are butted and glued to the corner blocks. Each curved rail is made in two pieces that are butted together vertically at the center. The ornaments on the curved rails are applied.

The front corner blocks are dovetailed to the bottom front rail; the bottom side rails are fitted and glued around the corners. A vertical drawer divider is fitted between the top and the bottom front rail. A medial brace is tenoned between the bottom front rail and the back rail and supports a central drawer guide. A bead molding is applied to the table's lower outside edge.

The pedestal bases are glued to the underside of the frame. The upper part of each pedestal is composed of two pieces that form a central arch flanked by brackets. All four feet have casters. The stretcher is tenoned between the pedestals.

The front and back of each drawer is dovetailed to the sides. The bottom has feathered edges fitted into grooves in the front and sides and is nailed to the back. The drawers are supported by the medial brace and by the bottom side rails. Small rectangular stops are glued to the bottom side rails.

Inscriptions: "Be——be /—hmer" is written in pencil on the

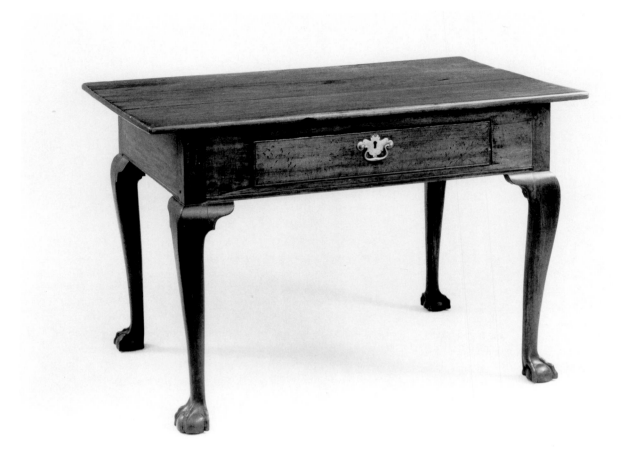

34

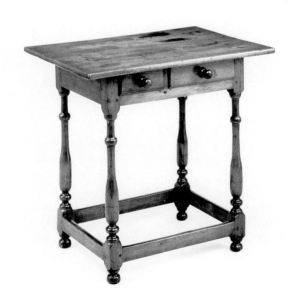

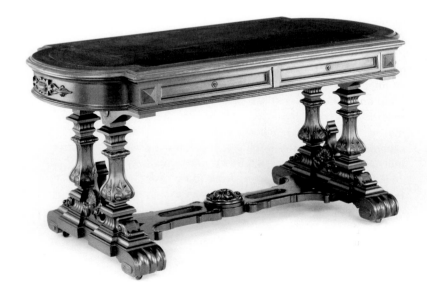

33 35

underside of the rosette. The numerals 1, 2, 3, and 4 as well as other markings are inscribed several times in pencil on the table's underside.

Condition: Four turned drops that were attached to the undersides of the frame's corners are lost. When found in 1974, the table had a faded red wool cover that was replaced by Peter Arkell with black buffalo leather. The left cavetto molding on the left drawer front is a replacement, as is the right drawer stop. The locks are original.

Provenance: This table was removed in 1974 from the Mary Briggs Prichard House, designed by Alexander Jackson Davis and built in 1837 at 35 Hillhouse Avenue in New Haven. The house passed through three other owners and a period of vacancy before it was acquired by Yale University for use as a residence in 1953. A pier table (cat. 14) and a side chair in the Art Gallery's collection also came from this house (Kane 1976, no. 247).

This library table was designed in what probably was called an "Elizabethan" style, although today it would be classified as Renaissance Revival.[1] The raised bosses, strapwork cartouches, now-missing drops, and complicated, architectural pedestals were derived from the Mannerist style that permeated English architecture during the Renaissance, particularly the reign of Elizabeth I. English designer Richard Bridgens created tables and other furniture that revived these motifs as early as 1819 and published them in 1838.[2] Furniture in the same style was designed or made by many leading American cabinetmakers of the succeeding generation, including a library table made by Alexander Roux of New York City between 1850 and 1857, a center table designed by John Jelliff of Newark between 1843 and 1860, and a cabinet and dining room suite made by Daniel Pabst of Philadelphia about 1868.[3] This table most closely resembles the Jelliff design, as both are composed of geometric, architectural forms. The curvilinear, naturalistic details of shells and foliage on Roux's table are distinct from the stylized renditions on both the Yale and Pabst examples, which suggests that these two are closer in date. Large and substantial, with ornament taken from an appropriate historical source, this table met every criteria of the contemporary advice literature (see p. 102). The maker created an integrated ornamental scheme by repeating certain elements: the shape of the top is echoed in the openings in the stretcher and the cartouches on the frame rails, and the pointed, ogee-shaped leaf appears at either end of the cartouches and as a freestanding element between the legs.

The pencil inscription on the underside of the carved rosette, which appears to include the name "Bembe," may provide a clue to the maker's identity. The French cabinetmaker Anthony

Bembe formed a partnership with Anthony Kimbel of New York from 1854 to 1863, although Bembe himself apparently did not work in the United States. New York city directories gave his home address as "Paris" or "Europe."[4] Kimbel had previously worked in New York as the principal designer for Charles Baudouine. An 1854 newspaper article described the firm as "the French house of Bembe and Kimbel" and noted:

They have a manufactory at Mayence, in France, as well as in New York, and M. Bembe, the senior partner, has furnished many of the noblest palatial residences in Western Europe. The branch of the concern in New York has therefore the advantage of an eminent European connection, and receives, as they appear abroad, all the new models and designs, in furniture, that may be introduced, to give beauty and finish to the parlor, the drawing-room, and the chamber.[5]

The only documented furniture by Bembe and Kimbel known to the author was made in 1857 from Thomas U. Walter's designs for the House of Representatives in the United States Capitol.[6] The lavish carving on this furniture is similar in quality to the ornament on the Art Gallery's table. However, if the inscription on the latter object is indeed "Bembe," it could also refer to a cabinetmaker named Carl Bembe. Following the dissolution of Bembe and Kimbel in 1863, Carl Bembe was listed in directories at the firm's former address, 928 Broadway and East 22nd Street. Between 1867 and 1870, he worked at 33 East 17th Street and 39 West 49th Street. Carl Bembe probably was a relative of Anthony, although his home was listed as Hoboken, New Jersey.[7] No furniture identified as his work is known to the author.

1. Downing 1850, p. 390: "We follow most English writers in calling this style Elizabethan, because it came into use in England during the reign of Elizabeth. . . . It is known as the *Cinque Cento*, or Fifteenth century style, in Italy; as the *Renaissance* or revived Roman style in France; and the former is undoubtedly the correct term to be applied to it."
2. Glenn 1979.
3. "American Furniture" 1980, p. 34; Johnson 1972, fig. 6; Hanks/Talbott 1977, figs. 4, 6–9.
4. *New York Directory*, 1855, p. 77; 1863, p. 69.
5. "Parlor View" 1854.
6. Tracy 1970, p. xx. A chair from this commission is illustrated in Hanks/Peirce 1983, p. 85.
7. *New York Directory*, 1867, p. 79; 1870, p. 83.

36

TABLE WITH DRAWER

Probably Northeastern United States, 1870–90

Black walnut; eastern white pine (board underneath top, drawer

guides and runners, filler blocks), yellow-poplar (drawer interior), ash (filler strips nailed to sides)

73.7 x 76.3 x 45.8 (29 x 30 1/8 x 18)

Bequest of Millicent Todd Bingham, 1969.42.3

Structure: The top is composed of four mitered pieces of wood that frame a single board. It supports a marble inset and is screwed to the frame rails from inside. The frame rails are tenoned and glued into the legs. Strips of wood are glued to the side rails between the upper ends of the legs. The legs are fitted with casters. Paired stretchers are glued between the front and back legs, and the turned spindles are glued between each pair of stretchers. A medial stretcher is glued between the paired stretchers. Pieces of wood simulating a through tenon and key are glued to the outside of each side stretcher. The drawer front and back are dovetailed to the sides. The bottom has angled edges fitted into grooves in the front and sides and nailed to the back. Drawer runners are glued to filler strips that are glued to the side frame rails and fitted into the front rails with tongue-and-groove joints. Drawer guides are also fitted with tongues into the front rail and glued to the side rails. Additional filler strips are nailed to the side frame rails. Drawer stops are glued to the inner surfaces of the upper and lower front rails.

Inscriptions: "# 4" is painted on the underside of the marble inset and the upper surface of the board that supports it. "L= 0V2X / =0" is written in crayon on the underside of the marble. "D" is punched into the underside of the marble. "G—55 / 4" is written in chalk on the inside of the back frame rail.

Condition: The brasses are original. One of the drawer stops is lost.

The writings of design reformers such as Charles Locke Eastlake influenced the design of this small table, which contrasts dramatically with the preceding example (cat. 35). Its design emphasizes structural elements over motifs derived from architecture and features incised and turned ornament instead of carving. Moreover, this object was produced in quantity and relatively inexpensive. Its manufacturer eliminated costs by simulating hand work; the through tenons are not integral to the medial stretcher, but are separate pieces glued to the side stretchers.

The precise function of this table is difficult to determine. The marble top and single drawer are characteristic of side tables, but the low height, casters, and back side finished to look like the front indicate that this table was intended to be free-standing in a room.

37

"SMARTLINE" KITCHEN TABLE

Designed 1933 by Raymond E. Patten (1897–1948)

Manufactured for The International Nickel Company (founded 1902) by Mutschler Brothers Company (dates unknown)

Nappanee, Indiana, 1933–40

Monel metal (top), enameled sheet metal (frame sides, drawer members, leg capitals), chrome-plated steel tube (leg elements), rubber (caps on feet); southern yellow pine (top frame and medial braces), corrugated cardboard (underside of top)

77.9 x 102.8 x 63.4 (30 5/8 x 40 1/2 x 25)

Gift of Mr. and Mrs. Richard Stiner, B.A. 1945W, 1982.94

Structure: The Monel metal sheet that forms the top surface is folded around a rectangular wooden frame with two medial braces tenoned into grooves in the frame. A sheet of corrugated cardboard is fitted between the metal top and the wood frame, and the entire underside is painted sage green. The frame rails are screwed to the wooden frame of the top. The table frame is composed of five bracket-shaped metal strips that run between the upper ends of the leg elements. Inside the frame a rectangular piece of metal bent around the upper end of each leg is screwed into the leg and soldered to the rails. A horizontal triangular brace is also soldered in each upper corner of the frame. The fluted capitals on the exteriors of the upper ends of the legs have a circular base section that fits over the leg, and the remainder is cut out to fit over the corner. Four small metal cylinders are soldered onto the undersides of the tubing as feet.

The drawer front is made of two interlocking bracket-shaped strips. The drawer sides and bottom are a single sheet of metal that has been folded into shape and screwed to the front. The back of the drawer is a single sheet of metal fitted into the sides and bottom and folded over at the top. The drawer is fitted between two horizontal, bracket-shaped strips soldered between the two front frame rails. Two bracket-shaped side runners are soldered between the front and back of the frame. The drawer is attached to these runners by two bracket-shaped strips that are screwed to its sides and extend beyond the back as stops. A small piece of metal is riveted to the back bottom corner of the drawer to act as an additional stop.

Inscriptions: "DESIGNED FOR / THE INTERNATIONAL NICKEL COMPANY, INC. / BY / RAY PATTEN" is printed on a paper label attached to the left side of the drawer interior. A second paper label is attached to the inside bottom of the drawer: "Finger-Printing / Scratching and Cleaning / *Finger Printing* / Why do Monel Metal tables finger-print when / new? Because in polish-

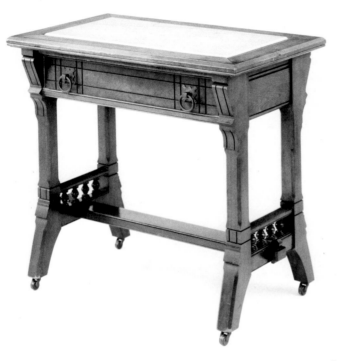

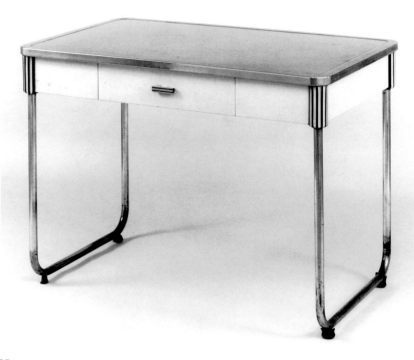

36　　37

37 *Instructions for care*

37 Instructions for care

**Finger-Printing
Scratching and Cleaning**

Finger Printing

Why do Monel Metal tables finger-print when new? Because in polishing these tables, grease compounds are used, which is largely responsible for the finger-printing. Ordinary cleaning will in a short time remove the grease.

Scratching

Monel Metal will take on a lacework of filigreed lines, which with use blend and resemble burnished old silver.

Cleaning

This table only requires ordinary cleaning. Since the table has a satin finish, the more it is cleaned, the brighter it looks. As Monel Metal is solid clear through, with no coating to wear off, no cleaner can injure it. Use Bon Ami or any abrasive household cleaner to keep Monel Metal looking bright and lustrous.

37 Label

DESIGNED FOR
THE INTERNATIONAL NICKEL COMPANY, INC.
— BY —
RAY PATTEN

ing these tables, grease / compounds are used, which is largely respon- / sible for the finger-printing. Ordinary cleaning / will in a short time remove the grease. / *Scratching* / Monel Metal will take on a lacework of fili- / greed lines, which with use blend and resemble / burnished old silver. / *Cleaning* / This table only requires ordinary cleaning. / Since the table has a satin finish, the more / it is cleaned, the brighter it looks. As Monel / Metal is solid clear through, with no coating / to wear off, no cleaner can injure it. Use Bon / Ami or any abrasive household cleaner to keep / Monel Metal looking bright and lustrous."

Condition: The table retains its original surface treatments. The chrome-plating on the leg elements is worn, and the ivory enamel has discolored. The four feet were originally fitted with rubber caps, only one of which is still attached to the right rear foot.

Provenance: The donors purchased this table from the estate of Mrs. Daniel Foster, who lived at 28 Nash Street, New Haven.

Ray Patten was one of the vanguard generation of industrial designers who changed the look of American products during the early years of the Depression. Born in Malden, Massachusetts, Patten graduated from the Massachusetts Institute of Technology in 1921. He began his career as an automobile designer, first for the Hume Body Corporation of Boston and later for the General Motors Corporation, where he worked on the Cadillac. In 1928, Patten was hired by the General Electric Company as director of the Appearance Design Division and remained in this position until his death. His role was to provide contemporary styling for the company's products that would increase their marketability.[1]

Practical considerations clearly governed Patten's design for a table intended for a kitchen. Metal-topped tables made for use with hot foods had a long tradition in America: a mahogany tea table with a painted sheet iron top was made in Philadelphia about 1770-90 as a piece of parlor furniture, and Emily Post mentioned a "zinc-topped table" as one of the basic pieces of equipment in a kitchen in 1930.[2] Household advice literature traditionally was filled with concerns for household safety and hygiene, and beginning in the 1890s metal was considered superior to wood, slate, and other materials for kitchens because it was easier to clean and did not develop cracks that harbored germs.[3] This table's top is made of Monel metal, a trademark of The International Nickel Company. An alloy of nickel and copper, it was praised in advertisements both for its durability and the ease with which it could be kept "immaculately clean."[4]

Patten's primary objective in designing this table, however, undoubtedly was to provide a stylistically compatible piece of furniture for General Electric's contemporary kitchen appliances. Advertised under the name "Smartline," the table

was featured in several General Electric model kitchens of the early 1930s.[5] Contemporary women's magazines and advice books conceived of housework as a "domestic science" that required the use of technologically sophisticated, labor-saving appliances.[6] Manufacturers such as General Electric responded to this trend by packaging their appliances in a modernist style that reinforced their technological sophistication. By the early 1930s, the design of non-mechanical objects was being influenced by this aesthetic.[7] Patten drew on European tubular steel furniture, which was considered emblematic of modernist design (see cat. 23), adding rounded angles and corners that evoked the efficiency of contemporary cars, boats, and airplanes with streamlined contours. The striking interplay of black, ivory, and silver on the table was an almost doctrinaire color scheme for modernist furniture of the period, and Patten's use of such new materials as chromium-plating and Monel metal reinforced this contemporaneity.[8] Although modest echoes of their high-style progenitors, kitchen tables like this one were probably the first modernist furniture to be purchased by many American consumers.

The Art Gallery's table is the largest of four sizes in which Patten's design was available. The table was marketed in a variety of color combinations: ivory or white with black accents, light green with dark green accents, and black with white accents.[9]

1. Biographical information on Ray Patten was taken from *Philadelphia Art Alliance Bulletin* 24 (May 1945), p. 10; Meikle 1979, p. 40; and his obituary in *The New York Times*, September 15, 1948, p. 31.
2. *Sack Collection*, VIII, p. 2311; Post 1930, p. 384.
3. Clark 1986, pp. 156–57.
4. *Ladies' Home Journal* 50 (September 1933), p. 50; *Ladies' Home Journal* 50 (November 1933), p. 50.
5. *GE Supplement*, p. 4; Heard 1933, p. 37; "Design for Utility" 1933, p. 24.
6. Clark 1986, pp. 156–70.
7. Wilson/Pilgrim/Tashjian 1986, pp. 270–311.
8. Post 1930, pp. 500–501.
9. *American Home* 15 (December 1935), p. 60; *House and Garden* 64 (December 1933), p. 5.

38

TABLE WITH DRAWER

Central Connecticut, 1750–80

Black cherry; eastern white pine

74.5 x 88.4 x 57.5 (29 3/8 x 34 3/4 x 22 5/8)

The Mabel Brady Garvan Collection, 1930.2604

Structure: The top is made of two boards pinned to the legs and the side rails of the frame. The frame rails are tenoned and dou-

38 *Top*

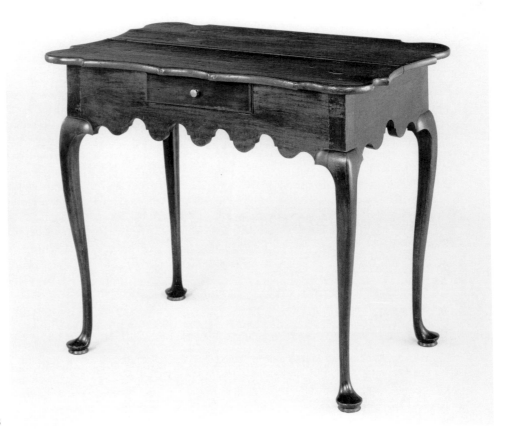

38

ble pinned into the legs. The drawer front and back are dove-tailed to the sides. The bottom has feathered edges that fit into grooves in the front and sides and is nailed to the back. The drawer is supported by runners with angled ends fitted into the front and back frame rails and secured with nails.

Condition: The old finish on the surface has darkened and become opaque. The drawer front had been stripped when the table was acquired and subsequently was colored to match the table. The joint between the two boards of the top separated and has been filled, and both boards have been repinned to the frame. All six knee brackets were restored by Emilio Mazzola in 1962 following shadows of the lost originals. The brass drawer knob appears to be original.

Exhibition: Kirk 1967a, no. 162.

References: Kirk 1967b, p. 528; Kirk 1982, fig. 20.

Provenance: Garvan purchased this table from Henry V. Weil in November 1929.

Unlike the other eighteenth-century tables with drawers in the Art Gallery's collection, this example has an unfinished back rail, no knee brackets on the back side of the rear legs, and an unshaped back edge of the top, all of which indicate that it was intended to be placed against the wall. These features are more characteristic of dressing tables, although eighteenth-century dressing tables usually contained four or more drawers. The single, small drawer in this table may have been intended to provide minimal storage with greater mobility and adaptability to a variety of uses.

Cherry tables and case furniture with what probably were

called "scollop'd" tops and skirts were made in three major areas of the Connecticut River Valley: central Connecticut in the vicinity of Hartford and Wethersfield; Hatfield and Northampton, Massachusetts; and Deerfield, Massachusetts.[1] Although this table has no provenance, the design of its top and skirt relate to objects in the Connecticut group. An apparently identical table was purchased in Kensington, Connecticut, by the dealer Kenneth Hammitt in 1961; unfortunately, the present location of this object is not known.[2] A desk-on-frame with an identical scalloped skirt was owned by Luther Stocking of Kensington.[3] A highchest base with a similar skirt has no provenance.[4] Tops of the same pattern are found on objects made in more than one center, including a table with drawer that descended in the Hart family of Granby, Connecticut; a tea table owned by the Allerton family of Wethersfield, Connecticut; a dressing table that descended in the Billings family of Hatfield, Massachusetts; and a number of undocumented dressing tables.[5]

1. Brown 1980.
2. Brown 1980, p. 1094; *Antiques* 79 (June 1961), p. 539.
3. *Barbour* 1963, pp. 58–59.
4. Colonial Williamsburg, Virginia (Greenlaw 1974, no. 146). The base has suffered major alterations, including replaced legs and a top fabricated from old wood; its front skirt originally had three additional scallops across the center.
5. The table from the Hart family, now in a private collection, is a smaller version of the Art Gallery's table. The other examples cited are illustrated in Brown 1980, fig. 2; Fales 1976, no. 445; Sack 1950, p. 196; Kirk 1967a, no. 180; *Antiques* 134 (July 1988), p. 4.

39

CARD TABLE

Philadelphia, 1795–1810

Mahogany, mahogany veneer; basswood (sections of top, two diagonal braces beneath top, drawer runners), eastern white pine (smaller braces beneath top, frame rails, drawer fronts), yellow-poplar (drawer interiors)

76.3 x 80.7 diameter (30 x 31 3/4)

Gift of Benjamin A. Hewitt, B.A. 1943, PH.D. 1952, 1982.109

Structure: The top is composed of eight wedge-shaped pieces that are butted together. A medial brace is glued across the underside, and a smaller brace is lapped across it. Twelve subsidiary braces that radiate out from the central lapped joint are also glued to the top's underside. All of the braces butt against the ring that forms the top's outside edge. These braces are separated by rectangular blocks with angled ends glued and nailed to the inside edge of the outer ring. The ring consists of eight

rounded pieces of wood lapped together and glued to the underside of the top. The top is screwed to the frame rail from inside.

The veneered frame has a bead molding nailed to its underside. The frame is composed of four rounded sections, each made of six horizontal laminates. Rounded pieces of wood are fitted between the upper and lower laminates of each section and contain the drawer fronts. The frame is reinforced by four braces dovetailed to the lower drawer rails and lapped over each other. Narrow sections of the laminated units fit into channels cut into the legs. The legs' upper ends are shaped to fit into wedge-shaped cutouts in the laminated units.

The frame holds two long drawers and two short drawers. Each veneered drawer front has a bead molding applied to its outside edges. The drawer front and back are dovetailed to the sides. The bottom has feathered edges fitted into grooves in the front and sides and nailed to the back. Closely spaced glue blocks reinforced the joint between each side and the bottom. The drawers are supported by the frame braces, which have guide strips glued to their upper surfaces. Small blocks that serve as stops have been glued to the braces supporting the long drawers; the long drawers serve as the stops for the short drawers.

Inscriptions: "T. Roberts" is scratched on the underside of the larger diagonal brace beneath the top. "Thomas / Roberts . . .[illegible] / June 1 1897" is written twice in pencil on the braces beneath the top, as is a pencil drawing of a man's profile with an animal head above and the name "Tom Roberts" written below. Attempts to identify Thomas Roberts have been unsuccessful. No Thomas Roberts is listed as either a cabinetmaker or furniture repairman in Philadelphia directories during the 1890s.

Condition: The baize was replaced by Peter Arkell in 1981. Two reinforcing strips have been nailed to the braces supporting the short drawers. Two opposing legs have broken off and been reattached to the frame with screws. Some of the blocks on the drawers' undersides have been reattached, and the knobs are replacements. A thin strip of wood has been glued to the underside of each long drawer.

Exhibition: Hewitt/Kane/Ward 1982, no. 50.

Provenance: The donor purchased this table from John Walton, Inc., of Griswold, Connecticut, on May 27, 1978.

The turnings, monochromatic veneer, and subtle bead moldings of this table are characteristic of Philadelphia work during the first quarter of the nineteenth century (see cat. 111). The baize cover on the top and four small drawers identify this object as a card table, although it is unlike any other American card table of the Federal period. Its diameter is narrower than the standard

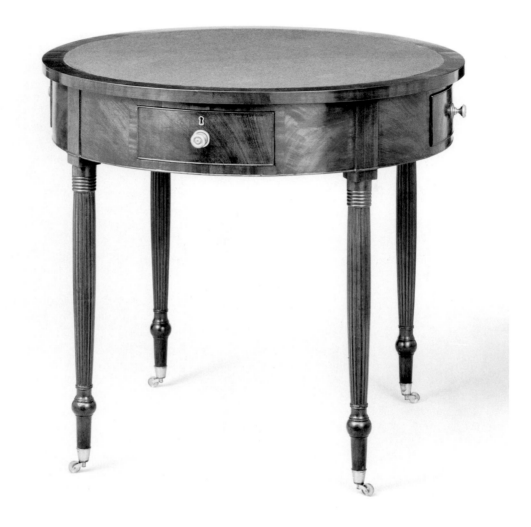

39

3-foot width of card tables, and its stationary, circular top and frame with four fixed legs may be unique.

This form is a variant of the "Circular Library Writing Table" described in the Philadelphia price book of 1795. The standard library table had four drawers in a circular frame and could have a top lined with cloth, but unlike this card table it had a larger top (42 in. in diameter) that revolved on a center pedestal.[1] Circular library tables apparently were never popu-

lar in Philadelphia; the form was not included in the 1811 price book. A contemporary example made in New York City is at Boscobel.[2]

1. *Philadelphia Prices* 1795, p. 31.
2. Tracy 1981, no. 71.

Tops with Falling Leaves

Tables used in antiquity and the Middle Ages had stationary tops fixed to a frame or loose tops placed on the frame during use. The idea of making tops variable in size by means of auxiliary leaves hinged to it was an invention of the sixteenth century.[1] Tables of this type were far more popular in England and its colonies than in Continental Europe, and the form probably was an English innovation. F.J.B. Watson has proposed that the term *table à l'anglaise* in late eighteenth-century French documents referred to a table with falling leaves.[2] Such tables were less massive than earlier ones of equivalent scale, as the hinged leaves permitted a more compact frame in relation to the top's full size. This suited the gradual shift from large, transient medieval households with portable furniture to smaller eighteenth-century households with more permanent furniture that nevertheless was moved to the perimeter of a room when not in use (Fig. 43; see also pp. 22–24). Two methods of attaching the auxiliary leaves to the stationary portion of the top appeared simultaneously: the hinged leaf resting on top of the fixed leaf (cats. 72–122) or suspended below it, the type catalogued in this section.

Tables with falling leaves were owned widely in America during the eighteenth and early nineteenth centuries, and the mechanisms used to support the top changed over time. The earliest was an auxiliary leg unit that pivoted on its inner leg (cats. 40–45). For smaller tables, single pieces of wood that pivoted to support the top were used (cats. 46, 47). Pivoting supports were largely superseded during the second quarter of the eighteenth century by hinged frame rails and legs, which dramatically changed the appearance of tables (cats. 53–60). During the late eighteenth and early nineteenth centuries, hinged sections of the frame's outer rail, known as "flys," were used for the smaller leaves on pembroke tables (cats. 61–71).

After about 1840, as furniture began to occupy fixed positions in interiors, stability became more important than mobility or compactness. Pivot supports were revived during the second quarter of the nineteenth century in an attempt to create a more stable frame (cats. 48–51). Older tables with falling leaves became unsuitable for use in fixed positions, since their supports could be disturbed too easily. Most large-scale tables of the later nineteenth and twentieth centuries were made without hinged leaves (cats. 3, 135, 136, 140).

1. *DEF*, III, pp. 224–28; Chinnery 1979, p. 305.
2. Watson 1973, p. 26.

Pivot Leg Supports

The earliest table with falling leaves to be made in America had a rigid frame with stretchers. The leaves fitted against the top with tongue-and-groove joints and were supported by auxiliary leg units consisting of two uprights connected by parallel stretchers; the inner upright pivoted between a side frame rail and stretcher. The frame and top's center section are narrow in contrast to the large leaves, so that the table occupied comparatively little space when placed against the wall, as shown in an engraving on an English broadside song sheet of c. 1690 (Fig. 43). When opened, however, the leaves created a sizable top. This form was made in a variety of sizes for different purposes. Some were immense: a table owned by Sir William Johnston of Schenectady County, New York, has a top that is 199.5cm (78 1/2 in.) wide (Fig. 44). All of the examples in the Art Gallery's collection are large dining tables, ranging in height from 68 to 75cm (26 3/4 to 29 1/2 in.), the standard for seated company.

Tables of this type are known today as "drop-leaf" or "gate-leg" tables, but neither of these terms was used in England or America during the seventeenth or eighteenth centuries.[1] Most such tables were identified as "oval" in inventories and can usually be distinguished from smaller tables with stationary oval tops (cats. 20, 21) by their value and the presence of large sets of chairs used with them. The "Walnut Oval Table" appraised at £6 in the 1749 inventory of William Dudley of Roxbury, Massachusetts, was immediately preceded by "12 Chairs with Leather Bottoms."[2] A few terms were occasionally used to denote tables with suspended leaves. Prior to the middle of the eighteenth century, the terms "falling table" or a table with "falling sides" or "falling leaves" appeared. Among "Things necessary for and belonging to a dineing Rome," Randall Holme listed in 1688 a "Larg Table in the middle . . . Round or oval with falling leaves."[3] Other terms used to describe this form included "flap tables" and "folding tables," as in the "maple writing Table, turn'd Frame 2 Flaps" destroyed by fire in Charlestown, Massachusetts, in 1775 or the "6 large folding tables of mahogany and black walnut" owned by Governor William Keith of Pennsylvania in 1726.[4] "Folding table" is sometimes difficult to interpret since it was also applied to card tables (p. 164).

Large dining tables of this type had been fashionable in England from the early seventeenth century onward, and scholars have associated their popularity with the periods of Stuart rule and the newly fashionable practice of having a large company dine at more than one table in the same room.[5] These tables were not adopted in the American Colonies until the latter decades of the seventeenth century. As Benno Forman has

shown, the Baroque style sponsored by the Stuart monarchy was accepted very slowly by wealthy New England residents.[6] One of the earliest American references to a falling-leaf table is the "Ovall Table" valued at £3.10 in the 1669 inventory of Antipas Boyse in Boston; it was located in the hall with other dining furniture, such as a "Standing Cubbert" and twelve "Turkey worke chayres."[7] The "Folding Table" valued at £2 in the 1691 inventory of Richard Wharton, another wealthy Boston merchant, was located in the "dining room" together with twelve chairs upholstered in Turkey work.[8] Furniture in the Baroque style may have made an earlier appearance in the mid-Atlantic and southern Colonies. In 1685, William Penn sent instructions from England to Philadelphia to purchase "two or three Eating Tables to flap down—one less than another."[9]

The turnings on these tables were intended to harmonize with the sets of caned or leather-upholstered chairs used with them, particularly since the outer legs were a table's most prominent feature when it was closed and placed against the wall of a room with the chairs. This relationship offers some evidence for determining the date and regional origin of these tables, which survive in quantity but only infrequently with histories of ownership. What are probably the earliest American examples have the stacked spherical turnings similar to chairs of the 1660–90 period.[10] The tables in the Art Gallery's collection have more elaborate patterns found on chairs made between 1690 and 1740, with two distinct regional types represented. The New England tables feature baluster turnings with central elements that mirror each other (cats. 40, 41). The elongated single balusters on cats. 42–44 are associated with Pennsylvania and the South. A group of tables with histories in New York feature urns below a single baluster (Fig. 44); no example of this type is in the Art Gallery's collection. English prototypes can be found for all these variations, but the histories and secondary woods of the Art Gallery's tables reinforce these traditional regional distinctions.

1. The writer has not observed these terms in any seventeenth- or eighteenth-century documents. The earliest citations in the *Oxford English Dictionary*, ed. 1989, s.v. "drop-leaf" and "gate-leg," are from the early twentieth century.
2. Cummings 1964, p. 147.
3. Holme 1688, p. 15.
4. Jobe/Kaye 1984, p. 269; Hornor 1935a, p. 18.
5. *DEF*, III, p. 224; Thornton 1978, p. 226.
6. Forman 1970, pp. 20–27.
7. SCPR, V, p. 179.
8. SCPR, I (new series), p. 272. I am indebted to Abbott Lowell Cummings for this reference.
9. McElroy 1979, p. 62.
10. St. George 1979, no. 52; Hind 1979, p. 19.

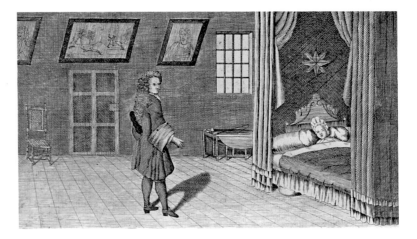

Fig. 43. *The Curtain Lecture* (detail), c. 1690.
Engraving on a broadside song sheet.
The Print Collection, The Lewis Walpole Library,
Farmington, Connecticut, a department of Yale University Library.

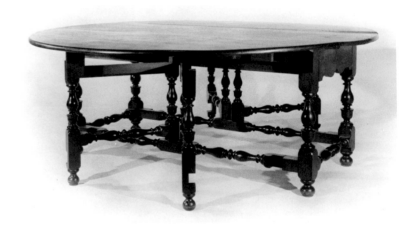

Fig. 44. Oval table with falling leaves, New York, 1725–50.
Mahogany; redgum and yellow-poplar.
Albany Institute of History and Art, New York.

40

OVAL TABLE WITH FALLING LEAVES

Probably Boston, 1690–1725

Black walnut; hard maple (side rails), eastern white pine (drawer interior, runner, stops), southern yellow pine (drawer guide)

72.6 x 43.4 (145.5 open) x 109.1 (28 5/8 x 17 1/8 [57 1/4] x 43)

The Mabel Brady Garvan Collection, 1950.695

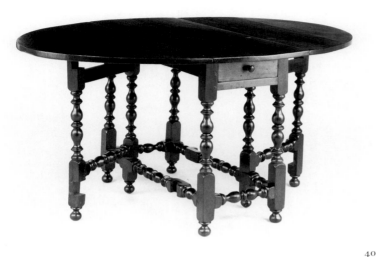
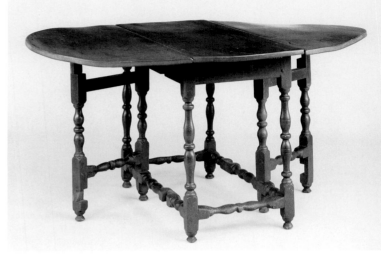

Structure: All three parts of the top are composed of two boards butted together. The hinged leaves fit against the center with tongue-and-groove joints. The center section is pinned to the sides of the frame. The frame rails and stretchers are tenoned and double pinned into the fixed legs. The gate stretchers are tenoned and double pinned into the gatelegs. Each gate pivots on the inside leg, which is tenoned between a side rail and stretcher. The outside gatelegs have cutouts at either end that fit into reciprocal cutouts in the side rails and stretchers.

The drawer front and back are dovetailed to the sides. The bottom is nailed to a rabbet in the drawer front and to the undersides of the sides and back. The medial drawer runner is nailed into a cutout in the front rail and tenoned into the back rail. A tapered drawer guide is nailed to the interior of the right side rail; L-shaped drawer stops are nailed to the interiors of both siderails near the center.

Condition: The table has been heavily refinished, particularly the top. Both leaves of the top are old but may not be original. The drawer bottom was replaced at an early date. The hinges and the drawer knob are more recent replacements. The left rear leg broke out from the frame and has been repaired. The applied feet below the pivot legs are later additions.

Provenance: John Marshall Phillips, the Art Gallery's director, purchased this table from Katherine R. Rogers of New Canaan, Connecticut, on November 1, 1950.

This table was probably made in Boston, where craftsmen had access to walnut imported from the southern Colonies. The dovetailed drawer and crisp turnings indicate the work of an urban craftsman. In terms of its style, this table is a classic example of Boston work from the first quarter of the eighteenth century. Its balusters resemble the arm supports on a chair that descended in the Hancock family of Boston.[1] An early table of this type with mirror-image baluster turnings separated by rings was owned by Governor Joshua Winslow of Plymouth, who died in 1680.[2] The more refined turnings on this table are related to a number of walnut tables with falling leaves that have histories in the Boston area. These include one that descended in the Bowdoin family of Boston; one with Spanish feet that apparently belonged to Josiah Franklin of Boston; and another that was among the furnishings of the Joseph Reynolds house in Bristol, Rhode Island.[3]

1. Forman 1988, no. 56.
2. Pilgrim Hall, Plymouth, Massachusetts; illustrated in Lockwood 1926, II, fig. 677.
3. Fales 1976, no. 237; *Sack Collection*, III, pp. 734–35; Levy 1988, p. 5. The last table was formerly in the collections of Philip Flayderman and the Henry Ford Museum, Dearborn, Michigan.

41

OVAL TABLE WITH FALLING LEAVES

Possibly Connecticut, 1725–50

Sycamore; red oak (side rails), soft maple (rectangular stretchers on gatelegs)

72.2 x 43.6 (139.8 open) x 113.1 (28 3/8 x 17 1/8 [55] x 44 1/2)

The Mabel Brady Garvan Collection, 1930.2274

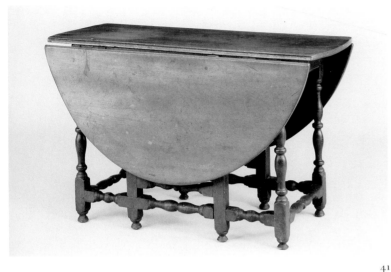

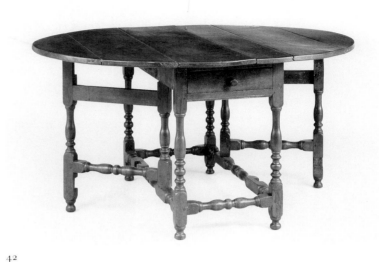

41 42

Structure: The three parts of the top are each made from a single board. The leaves fit against the center with tongue-and-groove joints. The center section is pinned to all four frame rails. The frame rails are tenoned and double pinned into the legs. The stretchers are tenoned and pinned into the fixed legs. The feet beneath the pivot legs are tenoned and pinned into the stretchers. These stretchers are tenoned and pinned between the gatelegs. Each gate pivots on the inside leg, which is tenoned between the side rail and stretcher. The outside gatelegs have cutouts at either end that fit into reciprocal cutouts in the side rails and stretchers.

Condition: The table was originally painted red; portions of this surface survive on the frame and the underside of the top. All three sections of the top are warped and have been repinned. The leather hinges are replacements. Both the front and back stretchers and the feet are worn. The right side stretcher and lower stretcher on the right gateleg have been broken and repaired. The left rear foot is pieced.

Provenance: Garvan purchased this table from Charles Woolsey Lyon in April 1929.

This table represents a micropolitan or rural craftsman's imitation of an urban model such as the preceding example (cat. 40). Although its turnings follow the standard pattern, the exaggerated rings and attenuated balusters are unusual. Instead of a costly wood like walnut, the craftsman used an inexpensive, local material that he finished with red paint. Sycamore was not commonly employed as a primary wood in eighteenth-century

American furniture. A corner chair at Yale, also made of sycamore, oak, and maple and also originally painted red, has been attributed to Connecticut.[1] A sycamore highchest in the Art Gallery's collection descended in the Clap family of Connecticut and may have been made in New Haven.[2]

1. Kane 1976, no. 86.
2. Ward 1988, no. 131.

42

OVAL TABLE WITH FALLING LEAVES

Probably Philadelphia area, 1700–40

Black walnut; Atlantic white-cedar (drawer interior, runner, stops), yellow-poplar (side rails)

68.1 x 42.6 (128.9 open) x 106.9 (26 3/4 x 16 3/4 [50 3/4] x 42 1/8)

The Mabel Brady Garvan Collection, 1930.2049

Structure: The three parts of the top are each composed of two boards. The center section is butted together and the leaves are nailed together at the outside edges. The leaves fit against the center with tongue-and-groove joints. The center section is pinned to the legs and the front and back frame rails. The frame rails and stretchers are tenoned and pinned into the legs. The stretchers on the gates are tenoned and pinned into the gatelegs. Each gate pivots on the inside leg, which is tenoned between the table's side rail and stretcher. The outside gatelegs have cutouts

at either end that fit into reciprocal cutouts in the table's side rails and stretchers.

The drawer front is dovetailed to the sides with a single large dovetail. The back is dovetailed to the sides with two dovetails. The bottom is nailed to a rabbet in the drawer front and to the undersides of the sides and back. The medial drawer runner is nailed into a cutout in the front rail and tenoned into the back rail. Drawer stops are nailed to the interiors of the side rails near the center.

Condition: At one time the table was painted white. The center section of the top is warped and has been repinned. The hinges are replacements; at one time the table had butterfly hinges. The original drawer knob is lost. The joint of the left front leg and the front stretcher has cracked and been repaired. The left rear foot is pieced.

Provenance: Garvan purchased this table from Mrs. J. L. Brockwell.

Although acquired in Virginia, several features of this table suggest that it was made in Philadelphia or environs. The combination of yellow-poplar and Atlantic white-cedar as secondary woods was standard in that region throughout the eighteenth century. Unlike many tables of this type, the drawer on this example is dovetailed together. This feature suggests a level of skill and sophistication characteristic of an urban shop, as does the cyma molding along the lower edge of the front and back frame rails.

The turnings provide the most convincing evidence for an origin in the Philadelphia area. Benno Forman argued that an upright baluster turning with a single ring above, incised lines around its widest point, and a spool turning below was a distinctive characteristic of contemporary Philadelphia chairs.[1] Although ultimately derived from English models, turnings of this type appear to have been a regional preference in eastern Pennsylvania that was never adopted to any extent by craftsmen in other areas.[2] Walnut falling-leaf tables with these turnings descended in the Bartram family of Chester County, Pennsylvania, and the Hopkins family of Haddonfield, New Jersey.[3] Another example was found in Cecil County, Maryland, in the early twentieth century.[4] A somewhat later table of a characteristic Pennsylvania form (cat. 32) not only has similar baluster turnings but also a bead along the lower edge of its frame that creates a similar effect to the cyma molding on this example.

1. Forman 1988, p. 346.
2. Kirk 1982, no. 1229.
3. Schiffer 1966, no. 120; Hopkins/Cox 1936, pl. 14.
4. Elder/Stokes 1987, no. 91.

43

OVAL TABLE WITH FALLING LEAVES

Color plate 2

Southeastern Virginia or northeastern North Carolina, 1690–1740

Black walnut (including glue blocks beneath top); yellow-poplar (side rails of frame, drawer runner, rear drawer support), southern yellow pine (gate tracks), baldcypress (drawer interior)

71.7 x 47.6 (149.7 open) x 131.5 (28 1/4 x 18 3/4 [58 7/8] x 51 3/4)

The Mabel Brady Garvan Collection, 1930.2110

Structure: The top's center section is composed of two boards, the leaves of three boards. These boards are butted together and joined with square pins. The leaves fit against the center with a tongue-and-groove joint. The center section of the top was pinned to the legs and the long sides of the frame. Four glue blocks reinforced the joint between the side rails and the top. The frame rails and stretchers are tenoned and pinned into the legs. The two draw-leg components each consist of two legs with rectangular upper stretchers and turned lower stretchers tenoned and pinned between them. The inside legs terminate in tongues that slide in grooves cut into boards pinned across the side frame rails and stretchers. The outside legs of the gates have cutouts at either end that fit into reciprocal cutouts in the table's side rails and stretchers.

The drawer front and back are dovetailed to the sides. Square pins are driven into the lowest front dovetails. The bottom has feathered edges fitted into grooves in the front and sides and nailed to the back. The drawer is supported by a medial runner nailed to the lower front rail and to a U-shaped frame that supports the back end of the drawer when the drawer is closed. This frame is nailed to the side frame rails.

Condition: The center section of the top was pinned and nailed to the front and rear frame rails at some time after the table was made; these nails and pins were subsequently removed. Wooden strips have been added to the underside of the center section to hold the boards together. The hinges have been replaced at least twice. At one time the feet were fitted with casters. All four glue blocks are replacements. The wrought-iron drawer pull appears to be original.

Exhibition: "Southern Furniture 1640–1820," The Virginia Museum of Fine Arts, Richmond, January 21–March 1, 1952.

References: "Southern Table" 1925; Lockwood 1926, II, fig. CIX; Wenham 1928, no. 517; *YUAGB* 3 (December 1928), p. 32; Richardson 1929, p. 501; Burroughs 1931, pl. 1; Ormsbee 1934, p. 84; Nagel 1949, pl. 4b; Comstock 1952, no. 144.

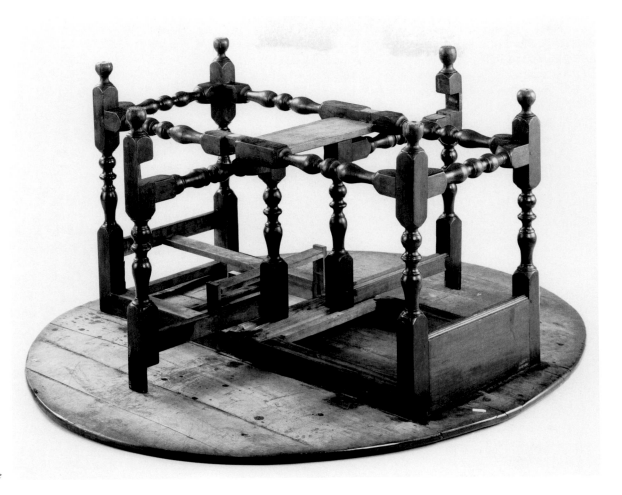

43 Underside

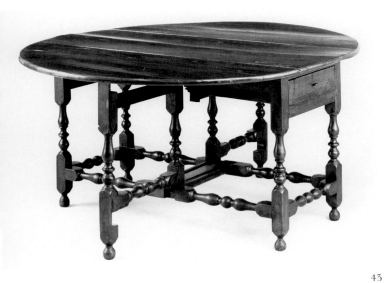

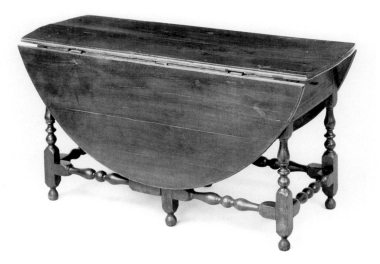

43 43

Provenance: There is uncharacteristic ambiguity concerning the provenance of this table, which Garvan purchased in 1924. A notation on Garvan's catalogue card reads: "This table was brought out of Albermarle [*sic*] Swamp, Virginia, in 1924 by Negroes." When it was published in *Antiques* in 1925, however, the table was said to have been found "in the Albemarle Sound district of North Carolina," information that was supplied by Garvan's secretary (letter to Homer Eaton Keyes, January 22, 1925, Keyes file, FPG–Y). Given the fact that no Virginia swamp is commonly known by the name "Albemarle," it seems likely that the account published in *Antiques* is correct. The photograph of this table published by Paul H. Burroughs in 1931 was credited to the antiques dealer Mrs. J.L. Brockwell, but no correspondence between Mrs. Brockwell and Garvan survives to prove that he purchased the table from her.

At the time of its discovery in 1924, this table was recognized as an extraordinary survival of Colonial southern furniture. The presence of baldcypress, a native tree in mid-Atlantic lowland swamps, strengthens its connection to the Albemarle Sound region (see *Provenance*), as does a dressing table that was also discovered in this area.[1] Both objects are stylish forms, made of walnut, with cyma moldings along the lower edges of their frames and turnings of a similar pattern.

The craftsman who made this table apparently was unfamiliar with the form. The use of sliding gates to support the top as well as construction errors in the frame rails suggest that this was an initial attempt to imitate a newly fashionable table. The table nevertheless provides ample evidence of the sophistication of a southern craftsman isolated from large urban centers. Instead of following the usual stretcher pattern, he devised a unique, symmetrical arrangement for the sides of the frame by repeating the stretcher from the ends on an enlarged scale. Of the three tables of this type at Yale with drawers, this is the only one with a feathered drawer bottom that is fitted into grooves in the drawer front and sides.

1. Bivins 1988, fig. 5.36.

44

OVAL TABLE WITH FALLING LEAVES

Coastal Southern Colonies; possibly Charleston, South Carolina,
 1700–25
Black walnut
75 x 39.3 (108 open) x 92.8 (29 1/2 x 15 1/2 [42 1/2] x 36 1/2)
The Mabel Brady Garvan Collection, 1930.2717

Structure: The three parts of the top are each composed of two boards. The hinged leaves fit against the center with tongue-and-groove joints. The center section is pinned to the legs and frame. The frame rails are tenoned and pinned into the legs; the end rails are double pinned. The stretchers are tenoned and pinned to the fixed legs. The stretchers on the gates are tenoned and pinned into the gatelegs. Each gate pivots on the inside leg, which is tenoned at its upper end between the side rail and a rectangular block nailed and glued to the rail. The leg's lower end is tenoned into the stretcher. The outside legs have cutouts at either end that fit into reciprocal cutouts in the side rails and stretchers.

Inscription: "696J / 6" is written in chalk on the underside of the top.

Condition: The leaves have been reduced in size and reshaped. Blocks originally were glued between the top and frame sides, and all but two of these are now lost. The hinges are replacements.

Reference: Antiquarian 14 (February 1930), p. 22.

Provenance: The surviving documentation for the acquisition of this table illuminates the procedures Garvan followed in his collecting. The table was advertised by the firm of H.C. Valentine and Company of Richmond, Virginia, in the February 1930 issue of *Antiquarian*. Immediately upon receiving his copy and seeing the illustration, Garvan had his secretary write to Valentine (January 29), asking to have the table sent to his loft on approval. Valentine did so on January 31, noting in the cover letter that "this table was purchased by us from a family here in Richmond" Once at the loft, the table was examined by Jacob Margolis, who prepared a detailed report on its condition. Margolis noted that the end of one leaf was pieced and that a later painted surface had been removed, although "the color is still there and the finish is not entirely spoiled." Garvan purchased the table on October 9, 1930 (Correspondence in H.C. Valentine and Company file, FPG-AAA).

Tables such as this one, with simplified baluster turnings and square stretchers, were identified by Wallace Nutting as a southern form.[1] Many American tables of this type have southern associations: a heavily restored example was found in the 1940s on St. George's Island, Maryland; another fragmentary table was discovered in Caroline County, Maryland; and Nutting found one in Richmond, Virginia, where the Art Gallery's table was purchased.[2] This table appears to have been made by the same craftsman as a falling-leaf table that descended in the Brantly family of Beaufort, North Carolina. John Bivins proposed that the latter table probably was made in Charleston, South Carolina, because of its unusual drawer support and

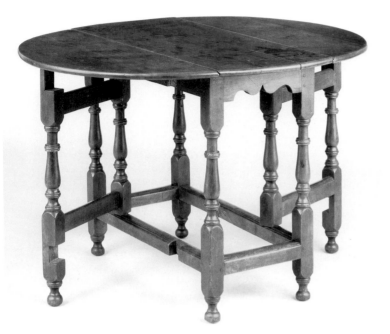

44 44 *Pivot leg construction*

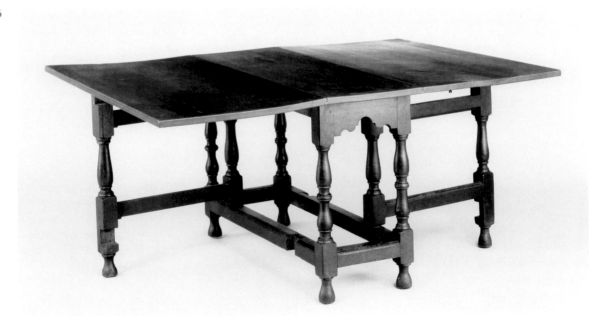

45

additional feet under the pivot legs.[3] Neither of these features is present on the Art Gallery's table, but both tables share identical turnings and the distinctive technique of pinning the pivot leg between a block and the rail.

Unlike most American furniture of this period, both these tables have unusually thin rails and gate stretchers. Such economical workmanship was commonplace in England, where nearly identical tables were made.[4] It seems likely, however, that these two objects were the work of an English-trained craftsman who had recently immigrated to the southern American Colonies. The Art Gallery's table is constructed entirely of American black walnut, a wood that was imported into England but generally used for furniture of exceptional cost and quality, as Benno Forman has demonstrated.[5] A craftsman working in England probably would not have used a prized, exotic wood for the secondary members of this relatively simple table.

1. Nutting 1924, p. 496.
2. Colonial Williamsburg, no. 1966–212; MESDA research file S-9673; Nutting 1924, no. 715. Two additional tables of this type were in Baltimore collections in 1937 (Miller 1937, II, nos. 1294, 1298).
3. Bivins 1988, p. 384, fig. 7.3.
4. Kirk 1982, nos. 1241–42.
5. Forman 1988, p. 318.

45

TABLE WITH FALLING LEAVES

Probably eastern Pennsylvania, Maryland, or Virginia, 1700–30
Black walnut; red oak (side rails), yellow-poplar (glue blocks)
72.1 x 36.7 (152.5 open) x 109.4 (28 3/8 x 14 1/2 [60] x 43 1/8)
The Mabel Brady Garvan Collection, 1930.2535

Structure: The front and back frame rails are tenoned and double pinned into the legs, whereas the side rails are tenoned and single pinned. The stretchers are tenoned and pinned to the fixed legs. The stretchers on the gates are tenoned and pinned between the gatelegs with glue blocks behind them. Each gate pivots on the inside leg, which is tenoned between the table's side rail and stretcher. The outside gatelegs have cutouts that fit into reciprocal cutouts in the table's side rails and stretchers.

Condition: This table probably had an oval top originally. The present top, which has rule joints and is screwed to the frame, appears to be a legitimate repair made about a century later. The side frame rails are also replacements. All of the glue blocks in the frame are replacements; one glue block from the left gateleg and all of the blocks from the right gateleg are lost. A large crack in the outside leg of the left gate has been repaired. The feet are extremely worn.

Provenance: According to Garvan's records, this table came from Fredericksburg, Virginia. He purchased it from Mrs. Philomen Watson.

A precise place of origin has not been determined for the unusual, superimposed baluster turnings on this table. A closely related example, with more refined turnings of the same pattern, square stretchers, and shaped end rails was published by Wallace Nutting without identification.[1] Square stretchers have been described as a southern characteristic (see cat. 44), and the woods suggest an origin south of New York.[2] The arched openings on the end rails relate to contemporary highchests and dressing tables, but no specific regional association can be identified.

1. Nutting 1924, no. 723.
2. In addition to the examples from Maryland cited in cat. 44, falling-leaf tables with single baluster turnings and square stretchers have been found in eastern Virginia with histories of ownership in Accomack County (MESDA research file S-4009), Jamestown (MESDA research file S-10,021), and Lyells, Westmoreland County (MESDA research file S-2255).

Other Pivot Supports

The pivot mechanism used on the dining tables catalogued above was adapted to other table forms. Small falling-leaf tables with a distinct type of pivot support (cats. 46, 47) were made in New England contemporaneously with the larger tables. The tops required less substantial supports, which were shaped pieces of wood tenoned between the stretcher and the top's fixed center. These small tables are known today as "butterfly" tables, a term that apparently dates from the last quarter of the nineteenth century. Irving W. Lyon did not use the term "butterfly" table in *The Colonial Furniture of New England* (1891), but he recorded in his notebook in 1880 that a table he had recently purchased was called "butterfly" by Edwin Simons of Hartford. Lyon presumably made this entry when he had the table restored.[1] The two tables of this type in the Art Gallery's collection are the same height as square tea tables (cats. 18–22) and were probably also used by a small, seated group.

The origin of this form has baffled furniture scholars, most of whom have concluded that it was an American innovation. Lyon suggested that the sharply raked legs might indicate a German antecedent.[2] This theory seems unlikely, however; not only do raked legs appear on joint stools and other Anglo-American forms, but no tables of this type have been found in Pennsylva-

nia or other parts of the country settled by German immigrants. Yet the form is also uncommon in England, and the few examples published there appear to be spurious.[3] During the 1920s, *Antiques* published illustrations of purportedly sixteenth-century Italian tables with similar supports, but these tables bear little visual similarity to the tables made in America.[4]

Evidence from the tables themselves suggests that this form was not an expensive, style-conscious object, but an accessory table that could be easily moved and stored. Most tables of this type, including the two at Yale, are made from maple and cherry; no genuine example made of walnut or mahogany is known to the writer. The majority follow a simple design of turned legs with square stretchers, and the construction required considerably less effort than the large oval tables. Although the quality of the turnings on some tables, including cat. 46, suggests that they were made in urban shops, the form may have enjoyed its greatest popularity outside of large cities. Documented examples known to the writer have histories of ownership in micropolitan and rural New England communities, primarily in Connecticut.[5] The form remained popular for at least half a century. Versions made with rule joints in the tops must date after about 1740, when stretcher bases and pivot supports on dining tables went out of fashion (see p. 135).[6]

After about a half century of disuse, pivot supports were revived at the beginning of the nineteenth century on pembroke tables (cats. 48–51). These pivot supports were thin, rectangular pieces of wood that fit into cutouts in the side frame rails and pivoted on a dowel between the rail and the top's center section. They required less skill to make than did hinged flys (see cats. 61–71) and permitted larger leaves than had been customary without hinged legs. In at least one instance during this period, they were marketed as a less expensive alternative to flys. A manuscript cabinetmakers' price book drawn up in the District of Columbia in 1831 called these pivot supports "swivels" and listed them as basic features of both pine and mahogany "Breakfast Tables." The mahogany version could be "made with flyes" at an additional charge of 25¢ per fly; two flys would have cost the same as the addition of a drawer.[7]

The revival of pivot supports coincided with an increasing reluctance to use moving legs of any kind on high-style furniture during the early nineteenth century. Swivel tops on card tables were another manifestation of this phenomenon (cats. 116–122). There seems to have been a distinct preference for tables with tops that could be opened without changing the substructure's stability or appearance. The calculated invisibility of these early nineteenth-century pivot supports distinguishes them from those that were an important part of the design of early eighteenth-century tables as well as a few twentieth-century ones (cat. 52).

1. Lyon Notebook, p. 183.
2. Lyon 1924, p. 201.
3. Kirk 1982, no. 1252, where he also questions the authenticity of Chinnery 1979, fig. 3:231. Another example that appears to be an altered joint stool is illustrated in *DEF*, III, p. 276, fig. 3.
4. Sartorio 1925, fig. 4; Bondome 1927.
5. Documented tables of this type were owned in North Bridgton, Maine (*Flayderman* 1930, no. 453); West Newbury, Massachusetts (Monkhouse/Michie 1986, no. 59); Colebrook, Connecticut (*Barbour* 1963, p. 28); Newington, Connecticut (*Seymour* 1958, pp. 124–25); North Branford, Connecticut (Skinner 1989, no. 119); Portland, Connecticut (Keyes 1927); Putnam, Connecticut (Kirk 1967a, no. 143); Suffield, Connecticut (Bissell 1956, pl. 10); and Windsor, Connecticut (Keyes 1935, fig. 5; Kirk 1967a, no. 145).
6. A table with rule joints is illustrated in Fales 1976, no. 242.
7. Garrett 1975, p. 891.

46

OVAL TABLE WITH FALLING LEAVES

Color plate 3

Southern New England, 1690–1720

Beech (top, left leaf support), soft maple (legs, stretchers), birch (frame rails)

67.4 x 32.5 (94.9 open) x 71.3 (26 1/2 x 12 3/4 [37 3/8] x 28 1/8)

The Mabel Brady Garvan Collection, 1930.2130

Structure: Each section of the top is made of a single board. The hinged leaves fit against the center with tongue-and-groove joints. The center section is pinned into the side frame rails. The frame rails and stretchers are tenoned and double pinned into the legs. The pivot supports are tenoned between the side stretchers and two half-octagonal pieces of wood that are nailed at the centers of the side rails just below the top. Cutouts in the supports' upper ends permit them to swivel around these pieces of wood.

Condition: The base retains an old coat of red paint. An additional pin has been added to the top. At one time the top probably had leather hinges, which have been replaced with metal ones. The right leaf support is an old replacement made of red oak. All four feet have been worn down to the rings that were above the original terminals.

Reference: Richardson 1929, p. 500.

Provenance: Garvan purchased this table from Harry Arons on December 18, 1924.

Despite the loss of the feet, this table's beautifully modulated turnings are exceptional and distinguish an otherwise modest form. John T. Kirk has noted that maple was almost unknown in

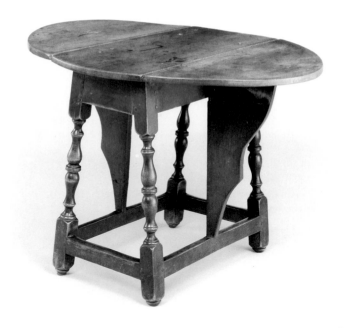

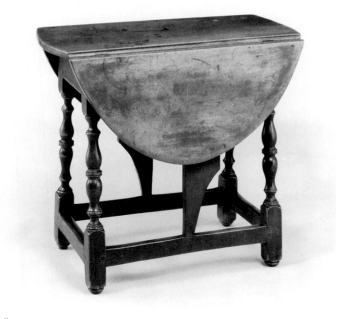

46 46

England prior to the 1770s, making turnings with this wide range of dimensions a distinctly American statement.[1] The thick frame rails, boldly shaped pivot supports, and vigorous, crisply turned legs indicate a date of manufacture early in the Colonies' adoption of the Baroque style. Closely related turnings appear on maple furniture that undoubtedly originated in New England, including a table with a long history of ownership in West Newbury, Massachusetts, and a joint stool found in Cheshire, Connecticut.[2]

1. Kirk 1982, p. 144.
2. The table from West Newbury is at the Museum of Art, Rhode Island School of Design, Providence (Monkhouse/Michie 1986, no. 59), and the joint stool is now owned by The Antiquarian and Landmarks Society, Hartford, Connecticut (Kirk 1967a, no. 135). Other related tables are illustrated in Kettell 1929, no. 101; Fairbanks 1967, p. 856; and Kirk 1982, fig. 394.

47

OVAL TABLE WITH FALLING LEAVES

Southern New England, 1725–50

Black cherry; birch (side frame rails)

67 x 31.5 (96.4 open) x 93.1 (26 3/8 x 12 3/8 [38] x 36 5/8)

The Mabel Brady Garvan Collection, 1930.2131

Structure: Each section of the top is made of a single board. The hinged leaves fit against the center with rule joints. The center section of the top is pinned to the frame rails. The rails and stretchers are tenoned and double pinned into the legs. The pivot supports are tenoned between the side stretchers and the underside of the top's center section.

Condition: The hinges are replacements.

Reference: Nagel 1949, p. 22.

Provenance: Garvan purchased this table from Harry Arons on December 18, 1924.

The rule joints in the top and simplified turnings and leaf supports suggest that this table was made when the Baroque idiom that had inspired the form was no longer fashionable. A maple table of this type was in the collection of Howard Reifsnyder early in this century.[1]

1. *Reifsnyder* 1929, no. 516.

48

PEMBROKE TABLE

Connecticut River Valley area of Massachusetts or Connecticut, 1790–1810

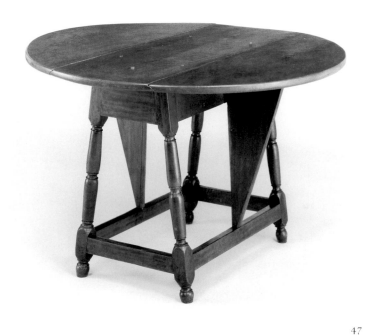

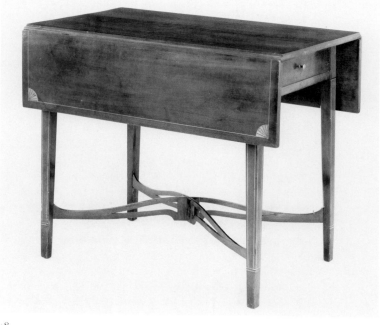

47 48

48

Black cherry; eastern white pine

72 x 47.8 (95.1 open) x 86.3 (28 3/8 x 18 7/8 [37 1/2] x 34)

The Mabel Brady Garvan Collection, 1930.2652

Structure: The top's center section is composed of two boards whereas the leaves are each a single board. The center section is screwed to the frame rails from the inside. The leaves fit against the center with rule joints. The pivot supports were cut from the side rails and pivot on dowels between the side rails and the underside of the top. The lower front, side, and back frame rails are tenoned and pinned into the legs. The upper front rail is tenoned into the tops of the two front legs. The stretchers are tenoned into the legs and lapped together at the center. Pieces of veneer are glued over the latter joint.

The drawer front and back are dovetailed to the sides. The bottom has feathered edges that fit into grooves in the front and sides and is nailed to the back. The drawer runners are nailed to the side rails through a second, larger piece of wood that acts as a drawer guide. Small drawer stops are nailed to this second piece of wood above the runners at the rear.

Condition: The joints in the center section of the top have been reglued, and there is a 20cm (7 7/8 in.) split in the top at the front edge. The hinges appear to be original, but new screws and paper shims have been added to them. Both the left front

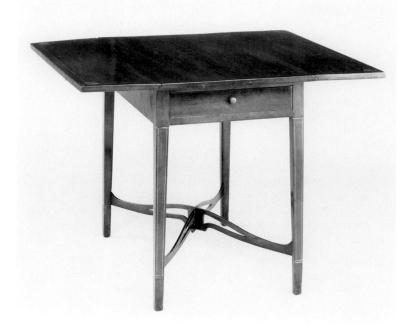

and right rear legs have cracked at their joints with the frame rails and been repaired with additional pins. One cuff inlay on each of these two legs has been replaced. The front end of both stretchers has been broken and repaired. The drawer has been taken apart and reassembled. A strip of new wood has been pieced into the center of the bottom, and the interior has been stained a dark color. The bottom has been renailed. The drawer knob is a replacement.

Provenance: This table was in Irving W. Lyon's collection. Garvan purchased it from Mary Lyon Penney.

Pembroke tables with arched, openwork stretchers—called "rais'd" stretchers in the 1796 New York price book—were popular at the turn of the nineteenth century in the central Connecticut River Valley but uncommon elsewhere in New England.[1] The cabinetmakers' price lists from Hartford, Connecticut (1792), and Hatfield, Massachusetts (1796), both included stretchers as an extra for a "plain Breakfast Table."[2] Three related pembroke tables of similar construction with pierced, arched stretchers were made by Daniel Clay of Greenfield, Massachusetts; one of these was the "Pembrook table" sold by him in 1805 to Epaphras Sheldon of Deerfield.[3] An undocumented example of this form with molded legs and pierced brackets has also been published.[4]

The "rais'd" stretchers on this group of tables may represent an example of the taste for Philadelphia designs that existed in the Connecticut River Valley at this time. Similar stretchers were found on high-style, Rococo tables made during the late Colonial period in Philadelphia as well as Portsmouth, New Hampshire, and Charleston, South Carolina.[5] Just as Eliphalet Chapin of East Windsor, Connecticut, appropriated Philadelphia furniture forms, the craftsman who made this table successfully distilled a taut, linear silhouette from an elaborate, Rococo prototype. He relied on simple techniques for construction and ornament that were characteristic of a craftsman like Daniel Clay, working outside a metropolitan center: pivot rather than hinged supports, incised rather than applied beading on the drawer front, and plain rather than patterned or pictorial inlays. As with many elaborately ornamented urban models (cats. 61, 65, 66), however, this pembroke table probably cost considerably more than tables without inlay, such as the one Clay charged $5 for in 1805.[6] The same price was given in the 1796 Hatfield list for a breakfast table "with stretchers and drawer"; it was similar in cost to a large tea table with a top that turned up (cat. 123).[7] A "plain" pembroke table with a drawer but no stretchers was made in 1813 by William Lloyd of Springfield, Massachusetts.[8]

1. *New York Prices* 1796, p. 34.

2. Wadsworth 1985, p. 472; Fales 1976, p. 286. For a discussion of the interchangeability of the terms "pembroke" and "breakfast" table, see pp. 147–48.
3. Fales 1976, nos. 257–58; Barnes/Meals 1972, no. 108.
4. Barnes/Meals 1972, no. 107.
5. See, for example, Heckscher 1985, nos. 113, 118.
6. Fales 1976, no. 257.
7. Fales 1976, p. 286.
8. Harlow 1979, pl. X.

49

PEMBROKE TABLE

James Stokes (dates unknown)

Catawissa, Pennsylvania, 1820–28

Black cherry, mahogany inlay (herringbone panels, dark lozenges); eastern white pine

72.7 x 44.8 (98.2 open) x 90.5 (28 5/8 x 17 5/8 [38 5/8] x 35 5/8)

The Mabel Brady Garvan Collection, 1930.2461

Structure: The center section of the top is made of two boards, whereas the leaves are each a single board. The center is screwed to the frame rails from the inside. The hinged leaves fit against the center with rule joints; when open, the leaves rest on thin, rectangular leaf supports that are doweled between the side rails and the top. The side and back frame rails are tenoned into the legs. The lower front rail is double tenoned, whereas the upper front rail is dovetailed to the legs. The side rails are pieced on their upper ends flanking the leaf supports. The joints between the side rails and the legs are reinforced by two-piece glue blocks whose smaller upper sections correspond to the filler pieces at the rails' upper ends. The joints between the back rail and the legs are reinforced by rectangular glue blocks.

The drawer front and back are dovetailed to the sides. The bottom has feathered edges that fit into grooves in the front and sides and is nailed to the back. Four narrow glue blocks reinforce the joint between each side and the bottom. The drawer is supported by side runners that are nailed to the side rails through a second, larger piece of wood that acts as a drawer guide. Small drawer stops are nailed to this second piece of wood at the rear.

Inscriptions: "JAMES STOKES, / CABINET MAKER / Roaring Creek Valley." is printed on a paper label affixed to the inside of the left drawer side. "14" is printed on a very small paper label applied to the underside of the lower front rail. "42 24 / 10" is written in crayon on the inside of the drawer bottom.

Condition: At one time the top was pinned or screwed to the frame through its upper surface; these holes have been

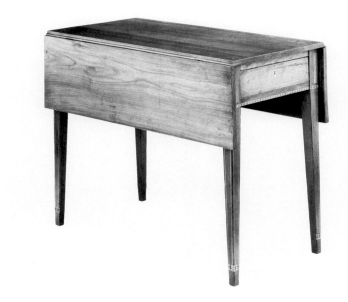

49 *Label*

49

plugged. The keyhole inlay and portions of the cuffs were restored by Peter Arkell in 1985 and 1981, respectively. The glue blocks in the rear corners of the frame have been reattached, as have the blocks on the underside of the drawer. One screw for the top has been put through a small block of wood added to the rear rail. The drawer stops are replacements, and the drawer sides have been planed on the exterior. The lock appears to be original.

Provenance: Garvan purchased this table from Charles Woolsey Lyon on July 2, 1929.

This table is the only recorded piece of furniture made by the rural Pennsylvania cabinetmaker James Stokes, who apparently was not related to the Philadelphia merchant of the same name (cat. 176). At the time he made the table, Stokes resided on the north side of Roaring Creek in Catawissa Township, in the southwestern corner of Columbia County. He was listed in Catawissa tax assessments for four non-consecutive years. He was unmarried in 1821 but had to be at least twenty-one years old to be included. In 1823, his profession was given as "joiner," although the 1827 list recorded that he owned two cattle. His name was crossed off the 1828 tax assessment, with the notation "removed."[1]

Stokes moved to Muncy Township in Lycoming County, bordering Columbia County on the northwest, before 1830. The United States census of that year recorded him as between thirty and forty years old, with a household that included his wife in the same age range, four male children under age ten, and a female between forty and fifty years old, presumably a relative. In the 1840 census the older woman had disappeared, and Stokes' occupation was classified under "manufactures and trades," suggesting that he continued to work as a cabinetmaker.[2] Presumably, however, he did not use the "Roaring Creek Valley" label after his move to Muncy Township. Stokes did not appear in the 1850 census for Pennsylvania.

Although his label suggests an aspiration to be a skilled craftsman, Stokes probably made furniture in addition to engaging in agriculture, as his ownership of cattle in 1827 indicates. This table's unsophisticated design and construction reflect its rural origin. Made from a native wood, the table is a simple form embellished with lightwood stringing and somewhat naive inlaid panels on the pilasters. Its most ornamental detail, the lozenge-pattern inlay on the skirt and cuffs, is similar to inlay on furniture found in central Pennsylvania.[3] The pivot supports may reflect Stokes' limited training, as they required less skill to make than hinged flys (see p. 127).

1. Columbia County Tax Assessments, 1820–29, Pennsylvania State Archives, Harrisburg. I am indebted to Wendell Zercher for his research in the Northumberland and Columbia County records.
2. Population schedules: 5th Census (1830), Pennsylvania, XXIV, sheet 181; 6th Census (1840), Pennsylvania, XVII, sheet 40. Records of the Bureau of the Census, National Archives, Washington, D.C.
3. An undocumented chest of drawers with lozenge-pattern inlay is in the Hershey Museum of American Life, Hershey, Pennsylvania.

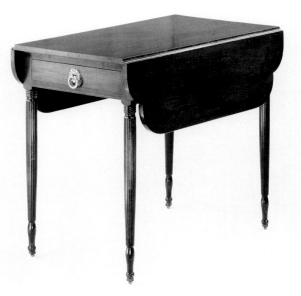
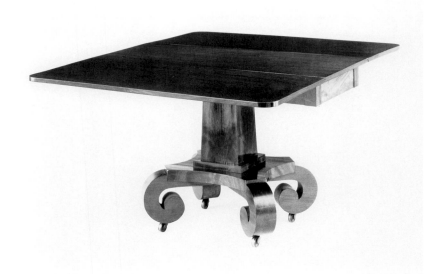

50

PEMBROKE TABLE

New York City area or possibly New Haven, 1820–40

Mahogany, mahogany veneer; yellow-poplar (back and lower
 front rails, right leaf support, drawer interior and guides),
 eastern white pine (upper front rail, drawer runners), elm
 (side frame rails, left leaf support)

76 x 49.4 (101.5 open) x 87.1 (29 7/8 x 19 1/2 [40] x 34 1/4)

The Mabel Brady Garvan Collection, 1930.2082

Structure: The front and back frame rails are veneered. The
two front rails are double tenoned into the legs, and the side and
back rails are tenoned into the legs. Thin, rectangular leaf sup-
ports that pivot on a central dowel are fitted within cutouts in
the side rails. The drawer front and back are dovetailed to the
sides. The bottom has feathered edges that fit into grooves in the
front and sides and is nailed to the back. The drawer is sup-
ported by side runners that are nailed to the side rails, as are the
drawer stops and guides.

Condition: The top and right pivot support are replacements.
The gilt brass ring pull and stamped backplate are original.
The leather-covered casters appear to be original.

Provenance: Acting as Garvan's agent, Henry Hammond Tay-
lor purchased this table from an unidentified Mrs. DuBois, "an
old lady in great need of money," on October 23, 1929. Taylor

reported that the table originally had belonged to Ezra Stiles
(1727–1795), seventh president of Yale and an ancestor of Mrs.
DuBois (Taylor file, FPG-AAA). The table could not have
belonged to Stiles himself, and attempts to connect it to his
descendants have been unsuccessful. When a detailed family
genealogy was published in 1895, none of his descendants had
this surname. The only unmarried female recorded in 1895
who would have been over fifty-seven years old in 1929 was
Sarah Wells Foote (1859–1955) of North Haven, the great-
granddaughter of Stiles' daughter Emilia and the owner of sev-
eral pieces of Stiles family furniture (Stiles 1895, p. 209). A
stand with a similar provenance is also at Yale (cat. 128).

This table represents the survival of the early Neoclassical style
into the second quarter of the nineteenth century. Perhaps
made for a conservative client, it imitated tables made in New
York City during the preceding decades (cat. 63) but appears
anemic and uninspired by comparison. The provenance sug-
gests that the table may have been made in New Haven, as may
a stand that was also based on New York models (cat. 128). The
drawer pull provides the best clue to the table's date of manufac-
ture. Large-scale ring pulls were characteristic of the later
phase of Neoclassicism; an almost identical pull is illustrated in
an English brass catalogue of 1825–30.[1]

1. Goodison 1975, pl. 41, no. 4497.

51

BREAKFAST TABLE

Northeastern United States, 1835–50

Mahogany, mahogany veneer; eastern white pine

72.8 x 44 (133.8 open) x 106.7 (28 5/8 x 17 3/8 [52 5/8] x 42)

Bequest of Millicent Todd Bingham, 1969.42.12

Structure: Each section of the top is made of a single board. The center is screwed to the frame from inside. The hinged leaves fit against the center with rule joints; when open, each leaf rests on a thin, rectangular leaf support that is doweled between the top and side rail. The end rails of the frame and exposed surfaces of the pedestal and legs are veneered. The side rails and the undersides of the legs are painted a dark red-brown color. The frame rails are tenoned between L-shaped corner pieces and vertical blocks that are glued in each corner. The leaf supports are doweled within cutouts in the side rails. Reinforcing blocks of wood are glued below these supports on the inside of the side rails. A medial brace is screwed into cutouts in the undersides of the side rails and the reinforcing blocks.

The medial brace rests on two thin rectangular strips applied to the top of the pedestal. The shaft stands on a small square base which in turn stands on a rectangular plinth with incurving sides and canted corners. An iron rod runs through the pedestal's center and is bolted to the medial brace and peened on the underside of the plinth. The plinth and the four scroll-shaped legs are each shaped from a single piece of wood. The plinth fits into a rabbet on the top of each leg, and the two are screwed together from the underside. The legs have casters.

Inscriptions: "Repaired by / N J Stewart / Coconut Grove Florida / Jan 25 1923" is written in pencil on the upper surface of the medial brace. "Property of / Millicent Bingham" is written in ink on a paper label glued to the underside of the top.

Condition: The hinges broke out and the center section of the top has been repaired and pieced in those areas. Both leaves have plugged holes in their upper surfaces at the hinges. The present hinges are replacements. Small stops for the leaf supports have been screwed to the undersides of the leaves.

This table is an extremely rectilinear interpretation of the architectonic Classical style popular after 1830. The frame, molding at the pillar's base, and upper ends of the feet all have square profiles. These elements are given a more lively treatment in the designs published by John and Joseph Meeks of New York City in 1833 and John Hall of Baltimore in 1840, as they are on the other two tables in this style in the Art Gallery's collection (cats. 9, 14).[1] Hall did not illustrate a table with two falling leaves, but the example included in the Meeks broadside of 1833 was called a "Breakfast Table."

1. The Metropolitan Museum of Art, New York, illustrated in Otto 1962, fig. 1; Hall 1840, pls. 19–21.

52

TABLE

Probably New York City, 1929–30

Black walnut, Brazilian rosewood veneer; chestnut

41.1 x 53.3 (130.9 open) x 40.4 (16 1/8 x 21 [51 1/2] x 15 7/8)

Gift of J. Marshall and Thomas M. Osborn in memory of Mr. and Mrs. James M. Osborn, 1977.40.6

Structure: Each section of the top is made of a single board that is veneered over its entire surface and colored dark red. The means by which the center of the top is applied to the frame is not visible; presumably the frame is doweled or tenoned and glued to the top. The hinged leaves fit flush against the center; when open, each leaf rests on a veneered pivot support that is pinned within the leg unit. Small rectangular stops are nailed to the underside of the center section. The two U-shaped leg units are composed of solid strips of wood that are joined together at right angles. A stretcher connects the lower members of these leg units. The parts of the base appear to be butted together and glued, although there may be concealed dowels or other joints. Two metal glides are attached to underside of each leg unit.

Reference: Sands 1983, figs. 7, 10.

Provenance: See text.

Marie-Louise Osborn's interest in modernistic design undoubtedly prompted her to acquire this essential accessory for early twentieth-century living rooms, a low table for use with seating furniture (see p. 94). This table was one of her early purchases, since it appears in a snapshot taken in the summer of 1930 of the living room in the Osborns' Bronxville apartment (Fig. 45). Although most of the other living room furniture changed as the Osborns moved, first to Manhattan and later to New Haven, this table continued to occupy the center of the main seating group.[1]

The table probably was copied from a French prototype by a custom furniture shop in New York City, as was most of the Osborns' modernistic furniture (cats. 15, 140). The immediate inspiration has not been identified, but the use of wood of uniform thickness for all of the table's elements—the top, leaves, pivot supports, leg units, and stretcher—resembles low tables

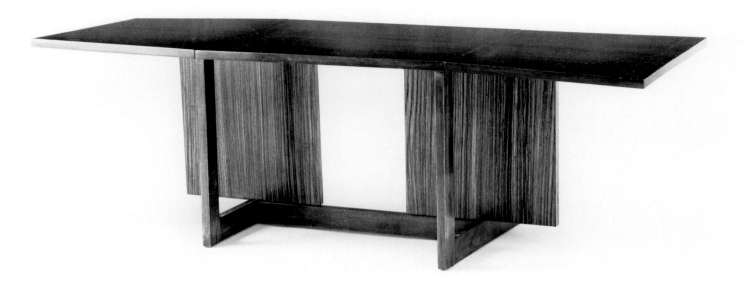

52

52

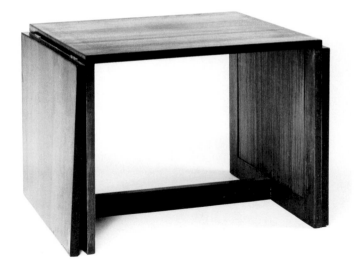

Fig. 45. Living room, James and Marie-Louise Osborn apartment,
Bronxville, New York, Summer 1930.
Photograph. Yale University Art Gallery, New Haven.

designed by Jean-Michel Frank in 1928–30.[2] No counterpart has been found for the square panels that pivot to support the leaves. When the table is opened, the panels and legs create a lively interplay of rectilinear shapes, both solid and void. This sophisticated table clearly is in the idiom of elite French work, particularly its rosewood veneer finished in a rich purple-red color, intended to simulate the more costly Macassar ebony. A sumptuous surface treatment that tempers abstract, linear design elements is characteristic of contemporary French furniture *de luxe* and offers a dramatic contrast to the Bauhaus-inspired use of industrial materials in Alfons Bach's table (cat. 23).

1. Sands 1983, figs. 7, 10; see also Appendix C.
2. Tables of this type by Frank are illustrated in Sanchez 1980, pp. 178–81, 184. One made for the San Francisco apartment of Templeton Crocker is illustrated in Duncan 1984, fig. 82, far left. Frank used the same design in the Paris apartment of the Vicomte de Noailles in 1929 (Sanchez 1980, p. 21) and his own apartment in 1930.

Hinged Leg Supports

A different type of table with falling leaves, first produced in quantity during the second quarter of the eighteenth century, represented a radical new conception. The frame was no longer considered an inviolable element, with movable supports grafted onto it. Instead, frame rails and legs became moving parts, serving the dual functions of supporting the frame when closed and the top when open. The additional leg unit that pivoted between the table frame and stretcher was abandoned in favor of hinging one or more of the table's legs to the frame. A few writing tables made in England at the end of the seventeenth century used this construction with turned legs and stretchers.[1] The advent of the Georgian style and curved or "crooked" legs after 1715 undoubtedly furthered the adoption of this technique, since it eliminated any need for unfashionable stretchers. The joint between the leaves and the fixed center of the top also changed, from the tongue-and-groove joint used in the early eighteenth century (cats. 40–44, 46) to the rule joint.

Tables with hinged legs were made in a greater variety of forms than the earlier tables with pivoting leg supports. Card tables with folding tops (cats. 72–112) were one specialized form employing hinged legs. Tables with falling leaves usually had two leaves, although tables with one leaf or "flap" were included in price books and eventually developed into a component of a dining table set (cats. 54, 60). Surviving American cabinetmakers' price lists from the mid-1750s onward reveal that the cost of producing falling-leaf tables was calculated by

each foot in the frame or "bed." Standard depth dimensions for these tables ranged in 6-inch (15.2cm) intervals from 3 feet (91.4cm) to 5 feet 6 inches (167.6cm), as is evident from the dimensions of tables in the Art Gallery's collection (see cats. 53, 54, 57).[2]

In the later Colonial period (1725–75), terms such as "falling leaf" and "folding table" became less common, perhaps because these forms had grown so pervasive that the distinction was no longer necessary. Cabinetmakers' accounts during this time frequently called them "Rule Joint" tables, to distinguish them from the earlier type with tongue-and-groove joints. A 1756 price list for "Joinery Work" prepared in Providence, Rhode Island, included "Tables at £4:10 pr foot with Rule Joynts, Ditto with old fashioned Joints at £4."[3] Larger tables were generally known as "Dining Tables," although the 1772 Philadelphia price list included a table as small as "3 feet in the bed" under that heading. The same list also mentioned a "Table full frame with 2 Leaves hung with Rule Joynt 4 feet long with 2 Drawers" under the heading "Pine Kitchen Tables."[4]

Subtle changes during the eighteenth century in tables with hinged rails reflected changes in attitudes toward dining and seating guests at tables (see pp. 22–24). Tables made earlier in the century attest to the continuation of the custom of seating large groups at more than one table. Many have oval tops, maintaining the tradition of late seventeenth-century dining tables (cats. 40–44). Although all the late Colonial period dining tables at Yale have rectangular tops, the stylistically earlier examples have shaped edges that were more suitable for use separately (cats. 53–55, 57). In contrast, the tables of later styles have square edges that facilitated butting two tables together (cats. 56, 58–60). As early as 1757, George Washington ordered from London a pair of tables specifically designed for this purpose: "4 [ft]-6 [in] Square two flaps each & all the feet to move, to join with hooks etc."[5]

By the end of the eighteenth century, a single, long table composed of two or more smaller tables had become the most fashionable form for dining. Some were made as a set of matching elements (cat. 60); one of the earliest documented examples was made by John Townsend for John and Rebecca Wood of Newport in 1793.[6] Many less style-conscious Americans in this period probably combined visually disparate tables to create a long dining table. John T. Kirk discovered extensive documentation for this practice in England among the Gillow records.[7] Dining tables with hinged supports continued to be made during the first half of the nineteenth century, but an increasing number of alternatives were developed that offered greater stability. "Pillar and claw," or pedestal base, dining tables appeared in the Philadelphia and New York price books in the 1790s. By 1834, the New York price book listed "Sliding Frame"

(cats. 135, 136), "Sliding Frame . . . with Swivel Top," and "Folding Frame" dining tables as additional options.[8]

1. *DEF*, III, p. 232, figs. 6–7.
2. Rhode Island 1965, p. 174; Weil 1979, p. 185; Wadsworth 1985, p. 472; Fales 1976, p. 286; *London Prices* 1788, p. 60; *New York Prices* 1796, p. 40.
3. Rhode Island 1965, p. 174.
4. Weil 1979, pp. 185, 190; see also *London Prices* 1788, p. 60; *New York Prices* 1796, p. 40.
5. Fede 1966, p. 13.
6. Rhode Island 1965, no. 47.
7. Kirk 1982, pp. 31–43.
8. *Philadelphia Prices* 1795, p. 50; 1796, pp. 76–77; *New York Prices* 1796, p. 49; 1854, pp. 64–74.

53

DINING TABLE

Coastal Massachusetts or New Hampshire, 1735–75

Soft maple; eastern white pine

69.7 x 32.4 (102.5 open) x 106.7 (27 1/2 x 12 3/4 [40 3/8] x 42)

The Mabel Brady Garvan Collection, 1930.2226

Structure: Each part of the top is made of a single board. The hinged leaves fit against the center with rule joints. The center section is pinned to the fixed legs and the end frame rails. The quarter-round moldings at the lower edges of the end rails are applied. One side of each end rail is tenoned and double pinned into a fixed leg. The long sides of the frame have an inner stationary rail and an outer hinged rail. The stationary rails are nailed to the fixed parts of the hinged rail through small filler blocks of wood. The fixed parts of the hinged rails are tenoned and double pinned into the fixed legs. Finger hinges connect the fixed parts of the hinged rails to the fly rails, which are tenoned and pinned into the fly legs. At the corners of the frame opposite the fixed legs, the end rails are dovetailed to the stationary rails with a single glue block reinforcing the corner.

Condition: The frame and legs retain some of the original reddish-brown finish. The iron hinges on the top appear to be original. The leaves of the top are warped, and one large crack in the center section has been repaired with two butterfly cleats. The top has been screwed to the frame. Both the original glue blocks are lost; one has been replaced. A wedge-shaped block has been added between the top and one end rail.

Provenance: This table was owned by the collector Fred Wellington Ayer of Bangor, Maine. Garvan purchased it at the sale of Ayer's collection in New York City on May 4, 1929 (*Ayer* 1929, no. 379).

This table is a classic example of a dining table made and used in both urban and rural New England for almost half a century. Similar tables were owned in Boston by Isaac Smith and in Deerfield, Massachusetts, by Jonathan and Dorothy Ashley.[1] Constructed of native woods, and measuring a standard dimension of 3 feet 6 inches (106.7cm) in the bed, this table would have cost £21 according to the rate established in 1757 by Providence cabinetmakers for "Maple Rule Joynt tables @ 6 £ pr foot." This price was in the same range as a "Stand Table" (cat. 123) or one-drawer chest made of maple, but considerably less than the £38.10s. charged for a mahogany table of the same dimensions or £150 for a mahogany highchest.[2] The maker further minimized the cost of the Art Gallery's table by decreasing the time required to make it. He inserted filler blocks of wood between the side rails before nailing them together, thereby eliminating the need to produce a perfect fit. Despite its inherent weakness, this construction technique was popular in New England, although it was rarely used elsewhere (see p. 174).

The origin of this table can be located with some certainty on the north shore of Massachusetts and the adjacent coastal area in New Hampshire. Sharp, ridged knees and abruptly rounded legs are characteristic of furniture made in the regions of Salem, Massachusetts, and Portsmouth, New Hampshire.[3] The legs on this table are a distinctive variation of this type, with pronounced hocks at their ankles and offset feet. An undocumented maple table at the New Hampshire Historical Society has what appear to be identical legs.[4]

1. Warren 1975, no. 56; Fales 1976, no. 225.
2. Rhode Island 1965, p. 175.
3. Ward 1988, no. 134; Jobe/Kaye 1984, no. 96.
4. New Hampshire 1973, no. 55.

54

DINING TABLE

Eastern Massachusetts, 1750–80

Mahogany (including the hinged rail); eastern white pine

70 x 45.2 (90.3 open) x 91.6 (27 1/2 x 17 3/4 [35 1/2] x 36 1/8)

The Mabel Brady Garvan Collection, 1930.2224

Structure: The two sections of the top are both made of single boards. The hinged leaf fits against the fixed section with a rule joint. The fixed section is attached to the frame with glue blocks, and the frame's long sides are also nailed to it. One end rail and side rail are tenoned and double pinned into the legs. The other end rail is tenoned and pinned to the leg at one side and dovetailed to an inner stationary side rail at the other. A rectangular glue block reinforces this joint. The stationary side rail is nailed

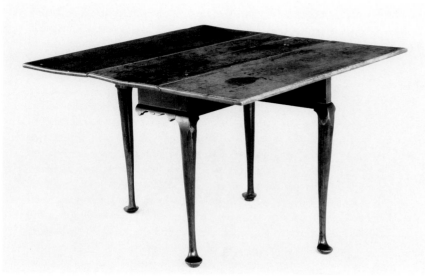

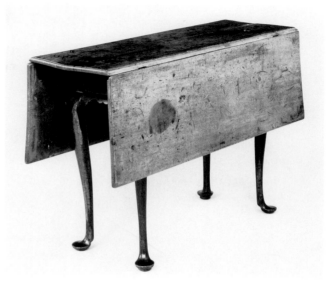

53　53

54 *Inscription*

54　54

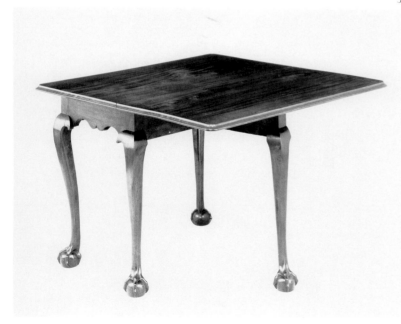

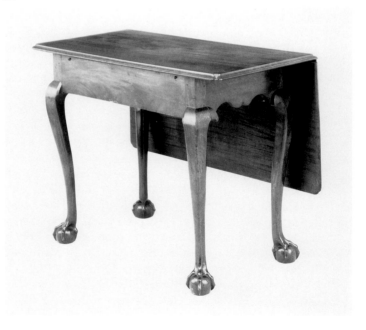

through a filler piece of wood to the fixed part of the hinged rail. The fixed part of the hinged rail is tenoned and double pinned to the leg. A finger hinge connects the fixed part of the rail to the fly rail, which is tenoned and double pinned to the fly leg. The knee brackets are glued to the end rails.

Inscription: "I [or J] Wilder" is written in chalk on the underside of the falling leaf.

Condition: The top has a few minor patches and plugs, and all of the glue blocks have been reattached. The iron hinges appear to be original.

Provenance: Garvan purchased this table from Charles Woolsey Lyon on April 25, 1929.

Tables with one falling leaf were less common than those with two during the eighteenth century, although it is almost impossible to determine the number of a table's leaves from most documentary references. Cabinetmakers' accounts and price books classified this form as a dining table; the Art Gallery's table measures exactly 3 feet (91.6cm) in the bed, the smallest standard size of dining table during the eighteenth century. The 1788 London price book described the basic dining table as "a single table, with plain Marlbo' legs, 1 or 2 flaps, with 1 fly foot to each," and the Gillow accounts of the 1790s illustrated several dining tables with one leaf.[1] Specific descriptions of tables with one leaf are exceptional, such as the 1736 inventory of the estate of Governor Patrick Gordon of Pennsylvania that recorded "a Walnut one leafd Table."[2] The "square dividing Maple Table" valued at 5s. 4d. in Richard Bracket's estate of 1760 in Braintree, Massachusetts, may also have been a table of this type.[3]

When not in use, this table apparently was intended to be placed against the wall with its leaf facing outward. Unlike the short side rails, the long side rail opposite the leaf is unshaped, and the legs have no knee brackets on this side. The hinged rail of this table is made of mahogany. With the falling leaf on the outside, the top could have been opened without moving the table away from the wall. Many single and double falling-leaf tables appear to have functioned in this fashion; at least two related examples also have unshaped side rails.[4] A number of interior views from the later eighteenth and early nineteenth centuries depict the occupants seated at tables positioned at the room's perimeter (Fig. 46).[5] Earlier falling-leaf tables with pivot supports may have been used in the same manner: the table in an English interior of c. 1690 (Fig. 43) was placed beneath a window, which provided light for anyone who wished to use the table without moving it.

American dining tables with one falling leaf survive from every region. The Art Gallery's table exhibits a number of design and construction features typical of eastern Massa-

chusetts during the late Colonial period, including filler blocks inserted between the hinged rail and the stationary inner frame rail (see cat. 53), ridged knees, and side talons on the claws that are swept backwards. A documented table of this type descended in the family of the cabinetmaker Joseph Hosmer of Concord, Massachusetts; another was owned in the Faulkner family of Acton, Massachusetts, and has been attributed to George Bright of Boston.[6] The "I. Wilder" inscribed on the underside of the falling leaf of the Art Gallery's table has not been identified with any cabinetmakers of the period and may be the name of an owner. Two tables that have appeared on the market are almost identical to the Yale example, with only minor differences in dimensions and without indented corners on their tops. All three may have been made in the same shop.[7] An apparently unique example with carved knees descended in the Whipple family of Ipswich, Massachusetts.[8] Other single-leaf dining tables from eastern Massachusetts have been published; three are in the collections of the Winterthur Museum, Historic Deerfield, and The Carnegie Museum of Art, Pittsburgh.[9]

1. *London Prices* 1788, p. 60; Kirk 1982, figs. 71–73.
2. Hornor 1935a, p. 60.
3. Cummings 1964, p. 166.
4. Nutting 1928, I, no. 1068; *Cox* 1984, no. 418.
5. Peterson 1971, pls. 16, 127; Mayhew/Myers 1980, figs. 27, 31. See also p. 24.
6. Fales 1963, fig. 4; the Faulkner family table is owned by the Concord Antiquarian Museum, no. F907.
7. *Antiques* 102 (September 1972), p. 289 (also illustrated in *Antiques* 90 [August 1966], p. 141); *Cox* 1984, no. 418. The latter table has a chalk inscription, "H. Osgood," similar to the inscription on the Art Gallery's table.
8. Sotheby's 1979, no. 1273.
9. Downs 1952, no. 310; Fales 1976, no. 253; Owsley 1976, no. 5; Nutting 1928, I, no. 1068; *Sack Collection*, VI, p. 1452; Sotheby's 1973b, no. 418; *Antiques* 117 (March 1980), p. 458.

55

CORNER TABLE *Color plate 6*

Probably Boston or Salem, Massachusetts, 1740–60

Mahogany; eastern white pine (stationary rear rail), soft maple (fly rail), black cherry (corner blocks)

65.4 x 86 x 44.3 (83.5 open) (25 3/4 x 33 7/8 x 17 1/2 [32 7/8])

Bequest of Doris M. Brixey, 1984.32.34

Structure: Each half of the top is made from a single board. The hinged leaf fits against the fixed section with a rule joint. The fixed section was attached with glue blocks to the inside of the frame. The two front frame rails are tenoned and double pinned into the legs. A block is glued into each corner joint. The

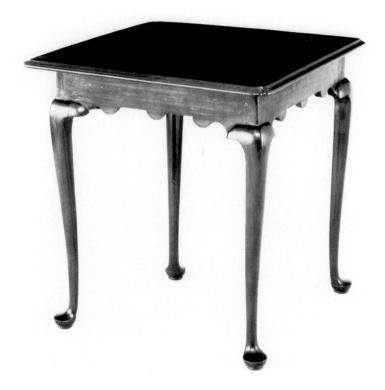

55

55 55

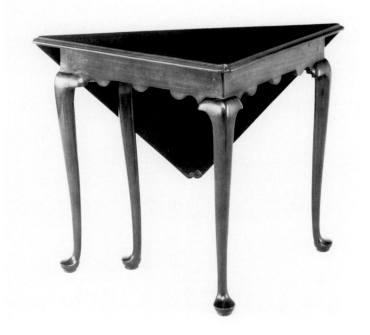

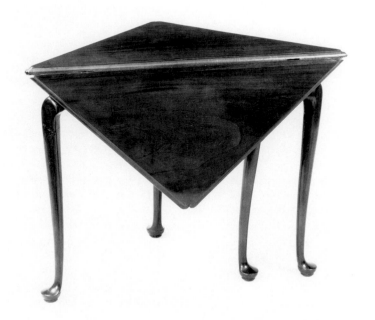

back rail is composed of an inner stationary rail and an outer hinged rail. The fixed part of the hinged rail is tenoned and double pinned into the left rear leg. A finger hinge connects the fixed part of the hinged rail to the fly rail, which is tenoned and double pinned into the fly leg. The inner, stationary rail is nailed flush to the fixed parts of the hinged rail. An additional piece of wood, also nailed to the inner, stationary rail, is tenoned and double pinned into the right rear leg between that leg and the fly leg. The original knee brackets were glued to the legs.

Condition: This table has sustained considerable damage. The indented front corner of the fixed half of the top broke off and has been reattached. The indented corner and rule joint of the falling leaf are replacements. All of the glue blocks holding the top to the frame are replacements, and the top is now screwed on through these new blocks. Three deep mortises have been cut into the underside of the top adjacent to the corners of the frame; their purpose has not been determined. The mortise and tenon joints of both fixed rear legs broke apart and have been repaired. One of the vertical glue blocks securing the front leg to the frame is original; the others appear to be replacements. The back edge of the right fixed leg and part of its foot have been repaired with new pieces of wood. All of the knee brackets are replacements.

References: Nutting 1928, I, no. 1063; Stein 1931, fig. 3; Vandal 1990, p. 152.

Provenance: This table was owned by the collector George Smith Palmer (1855–1934) of Norwich and later New London, Connecticut. In 1928, Palmer sold the contents of "Westomere," his house in New London, to the dealer Israel Sack of Boston. Sack sent the collection to auction in New York, where this table was acquired by Richard de Wolfe Brixey (*Palmer* 1928, no. 258).

A "corner table" was designed to be placed in a corner with the leaf facing outward when not in use, just as other tables with single falling leaves were positioned against the wall (see cat. 54). The practice is documented in an eighteenth-century inventory of Schloss Pillnitz, near Dresden, which catalogued "zwey kleine fournierte Tischgen mit gebrochenen Blättern und zusammen zu legende Gestellen, in die Winkel zu setzen" (two small veneered tables with broken [i.e. falling] leaves attached to the frames, to set in the corners).[1] The Philadelphia price list of 1772 included a "Corner Table Cruked legs or marlbro feet with bases 3 feet sqare [square]"; the last detail apparently refers to the top's dimensions when the falling leaf is raised.[2] Tables of this type may also have been called "triangle" tables. Joshua Delaplaine of New York City made a "mahogany triangle table" for £3 in 1739.[3] In the twentieth century, this form has been called a "handkerchief" table and is usually exhibited with the shaped frame rails facing outward and the leaf hanging in back.

The corner table was a relatively rare form of falling-leaf table. It may be of Continental European origin: in addition to German examples such as those cited above, French gaming tables of this shape—known as *tables à quadrilles brisées*—were made during the mid-eighteenth century.[4] The earliest American example may be a late Baroque corner table with turned legs and a pivot leg support published by Wallace Nutting.[5] During the mid-eighteenth century, relatively simple corner tables with turned legs were made in some quantity in both England and Virginia.[6] In contrast, the few examples from New England and the mid-Atlantic Colonies were high-style, urban products with cabriole legs. A walnut corner table that was probably made in Philadelphia has claw-and-ball feet.[7] The form was ideally suited to the emphasis on geometry in the early Georgian style, particularly the interplay between its triangular shape when closed and its square shape when open. The small size of most surviving examples indicates that they were not intended for dining; the Art Gallery's table is under 91.4cm (36 in.) square and is 65cm (25 5/8 in.) in height, the same size as contemporary tea tables (cats. 18, 20-22).

The Art Gallery's corner table is one of at least five made around the middle of the eighteenth century in eastern Massachusetts, most probably in Boston or Salem. The three most successful tables of this group have similar skirts with opposing cyma curves and may be products of the same shop, although the construction of their hinged rails is different. One of these three descended in the family of Daniel Jewett Perley (1763-1843), who was born in Ipswich, Massachusetts.[8] The skirt of the Art Gallery's table is somewhat less accomplished, but the shaping of its legs and top reveal the hand of an urban craftsman. A corner table with a sliding leg instead of a hinged leg descended to Elizabeth Fuller of Deerfield, Massachusetts, but undoubtedly was made in a coastal city.[9]

1. Haase 1985, p. 95.
2. Weil 1979, p. 187.
3. Johnson 1964, p. 81.
4. Watson 1966, I, p. 223.
5. Nutting 1924, no. 758.
6. Kirk 1982, nos. 1262, 1264–65; Bivins 1988, p. 146.
7. Downs 1952, no. 309; its secondary woods are white oak and yellow-poplar.
8. Greenlaw 1974, no. 134; *Franklin* 1984, no. 421. Landon 1985, p. 38, describes the table that descended from Perley, who undoubtedly inherited it from his parents. This table unfortunately survives in only fragmentary condition. I am grateful to Margaret B. Wise for information regarding its provenance.
9. Fales 1976, no. 251. This table has been reduced in size and undergone other significant alterations.

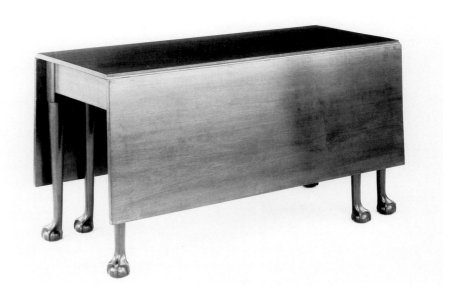

56

56

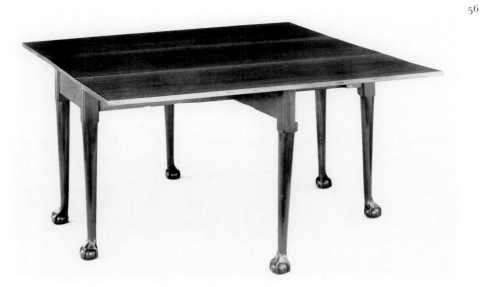

5 6

DINING TABLE

Probably New York, 1750–80

Mahogany; soft maple (hinged rails), eastern white pine (inner
 side rails, medial brace), yellow-poplar (filler blocks), basswood
 (corner blocks)

70.7 x 51.5 (149.4 open) x 129.7 (27 7/8 x 20 1/4 [58 7/8] x 51
 1/8)

The Mabel Brady Garvan Collection, 1930.2620

Structure: The left leaf and center section of the top are single
boards, whereas the right leaf is made of two boards. The
hinged leaves fit against the center with rule joints. The outer
side rails of the frame are screwed to the top from outside, and
the end rails are screwed to the top from inside. The two end rails
and the fixed parts of the hinged side rails are tenoned into the
legs. Small blocks between the fly legs and the fixed legs are ten-
oned into the fixed legs and screwed to the top from outside. An
inner frame consisting of two side rails connected by a medial

brace is nailed to these blocks and the fixed parts of the hinged rails through filler pieces of wood. The medial brace is reinforced with glue blocks. Finger hinges connect the fixed parts of the hinged rails to the fly rails, which are tenoned into the fly legs. Cutouts in the fly legs overlap the inner side rails when closed.

Inscription: "# 718" is written in pencil on two pieces of tape attached to the medial brace and inner right side rail.

Condition: The center section of the top apparently suffered damage at its back end. A strip of wood has been pieced into the underside of the top across its entire width, and the rule joints have been pieced on in this area. Five large cracks in the top have been repaired with butterfly cleats. The hinges are replacements, and the rule joints adjacent to them have been repaired. Two of the glue blocks reinforcing the medial brace are replacements. L-shaped braces were added between the leg posts and the underside of the frame at one point, but are now lost. The joint between the right fly leg and the fly rail has been reinforced with two pins. The feet were once fitted with casters and appear to have been cut down.

Provenance: Garvan purchased this table from Henry Hammond Taylor on September 13, 1929.

A distinctive version of the table with hinged leg supports was developed by New York cabinetmakers during the late Colonial period. Unlike New England or Pennsylvania tables, the four legs at the corners of the frame were fixed, with one or more additional legs to support falling or folding leaves (see cats. 73, 74, 108). Dining tables made in New York frequently were very large, a tradition that continued from the early eighteenth century (Fig. 44). Examples from the second quarter of the eighteenth century have stiffly curved legs with pointed feet.[1] Those made after 1750 with claw-and-ball feet have either cabriole legs or the straight legs seen on this example.[2] A pair almost identical to the Art Gallery's table descended in the Beekman family of New York, and closely related tables were owned on Long Island by the Riker family and in Schaghticoke, New York, by the Knickerbacker family.[3]

1. Downs 1952, no.318; Blackburn 1976, no. 84.
2. A six-leg table with cabriole legs is illustrated in Miller 1956, no. 62. Undocumented examples with straight legs are illustrated in *Antiques* 89 (January 1966), p. 9, and Singleton 1902, p. 75.
3. The Beekman family tables are at The New-York Historical Society, Gift of the Beekman Family Association, no. 1948.552a-b; Levy 1988, p. 108; Rice 1962, p. 41.

57

DINING TABLE

New York City, 1750–80
Mahogany; soft maple
70.5 x 53.4 (155.8 open) x 168.7 (27 3/4 x 21 [61 3/8] x 66 3/8)
Gift of Abraham Bishop, B.A. 1778, 1967.29

Structure: The three sections of the top are each made of a single board. The hinged leaves fit against the center with rule joints. The center section is screwed to the frame rails from inside. A series of long glue blocks reinforces this joint. The end rails of the frame are dovetailed to two inner side frame rails. A medial brace is nailed between the inner side rails and attached to the top with glue blocks. A shaped, quarter-round molding is applied to the end rails. The fixed part of each hinged rail is bolted and peened to the inner side frame rail through a filler block of wood and is also nailed from inside. A fixed leg is double tenoned and pinned into both rails on each side of the frame. Finger hinges connect the two fly rails on each side of the frame to the fixed part of the hinged rail. The fly rails are tenoned and double pinned into the fly legs.

Inscriptions: "T[?] Sloan" is written in chalk on the inside of the left stationary rail. There are also sums of figures in chalk on the underside of the top and on one side of the medial brace.

Condition: This table is one of the best-preserved pieces of furniture in the Art Gallery's collection. One of the glue blocks from the underside of the top is lost, and a few others have been reglued.

References: Lockwood 1926, II, fig. 719; Miller 1937, II, no. 1309.

Provenance: Jonathan (1784–1844) and Stella (d. 1859) Law of Hartford, Connecticut, owned this table by July 19, 1819, when they received a request from Jonathan's brother-in-law, Abraham Bishop (1763–1844) of New Haven: "At your house I

57 Inscription

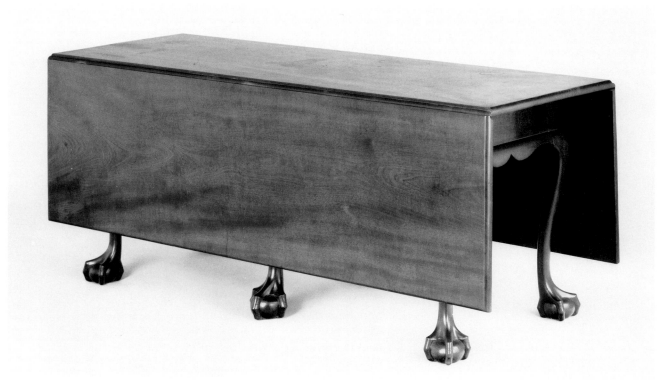

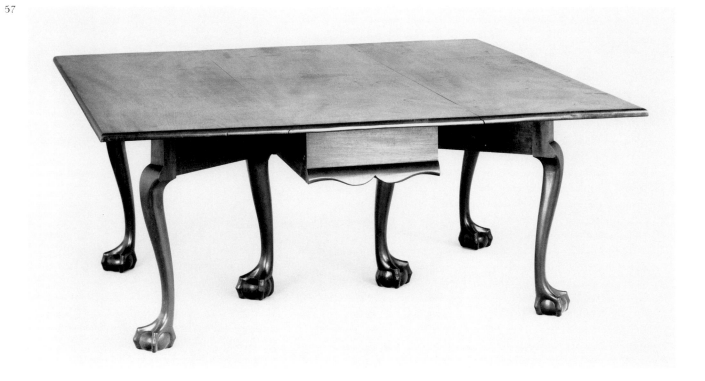

noticed a very cumbrous, backbreaking mahogany table. Whenever your family shall be tired of the glory of lifting it, you may send it to me at cost or such other price as you may choose to charge, and I will introduce it, in a rear room of the Customhouse, to a set of chairs nearly related to it." When he learned that Stella Law "took leave of it [the table] with reluctance," Bishop counseled Jonathan that "Time will sometimes reconcile people to such heavy losses. A new fashionable table may aid time in the effort" (Abraham Bishop to Jonathan Law, July 19 and August 5, 1819, private collection).

Bishop had inherited the position of Commissioner of Customs for New Haven upon the death of his father in 1803. After receiving the table in August 1819, he placed it in his private office in the Customs House at the corner of State and Elm Streets in New Haven. The "old chairs . . . of the same tenor and date" that Bishop used with the table were a set of ten Massachusetts armchairs and two matching side chairs that he had purchased from the estate of Paschal N. Smith of New Haven (Abraham Bishop to Jonathan Law, July 27, 1819, private collection; see Kane 1976, nos. 97–98). Bishop lost his sinecure when Andrew Jackson became President in 1829 and thereupon donated the table and ten side chairs to Yale College for "the use of the Library." He was formally thanked by President Jeremiah Day in April 1829 (Jeremiah Day to Abraham Bishop, April 29, 1829, private collection). The table and chairs remained in the library of Yale University until they were transferred to the Art Gallery in 1967.

Among the large dining tables made in New York, this example is unusually massive; it could have accommodated twelve people, as Abraham Bishop intended (see *Provenance*). It is also distinguished from others made in New York by the arrangement of its hinged rails. Most New York tables, such as cat. 56, had fixed legs at the corners with hinged legs on the inside. In contrast, the legs on this table's corners are hinged, and the stationary legs at the center of each side are fixed. This arrangement positions the opened legs at the top's corners, making it unnecessary for anyone seated at the table to straddle a leg. It also gives the open table a dynamic, anthropomorphic appearance accentuated by the crooked legs and characteristically large New York claw-and-ball feet.

Dining tables of this size and quality were costly investments in the late Colonial period. In 1753 and 1754, the New York cabinetmaker Joshua Delaplaine charged £8.1.0 for a "mahogany Dining table 5 foot 3 In. bed, 8 Legs, 2 draws" and £7.5.0 for a "Large Mahogany dining table . . . 5 foot and 6 bed" for which the customer supplied an existing top; these prices were the same as for a mahogany chest of drawers.[1] The 1772 Philadelphia price list put the same price on bureau tables and large dining tables. A mahogany bureau table with corner columns cost £8.10.0. A dining table with crooked legs that measured 5 feet 6 inches (167.6cm) in the bed, the size of the Art Gallery's table, was the largest standard size listed and cost £8 in mahogany, with an additional 2s. 6d. for each claw foot.[2]

Given what is known of this table's early history (see *Provenance*), it is tempting to propose an identity for the Sloan whose name is inscribed on a frame rail. Jonathan Law was born too late to be the original owner of this table, but he may have acquired it secondhand as part of a business transaction. Sloan is not a common surname in New York City during the eighteenth or early nineteenth centuries; no Sloan is known as a cabinetmaker during the Colonial period. A John Sloan is listed as a cabinetmaker on Bowery Street in the 1806 city directory, and a Robert Sloan appears as a cabinetmaker at 281 Bowery between 1807 and 1812.[3] One of these men could have acquired the table as a piece of used furniture and sold it to Law, perhaps at the time of his marriage in 1807. Another late Colonial New York dining table with a New England provenance was owned by the Swaine family of Rhode Island and given to May Swaine when she married John McLoughlin of Danbury, Connecticut, in 1817.[4]

1. Johnson 1964, pp. 87, 90.
2. Weil 1979, pp. 185, 189.
3. *New York Directory* 1806, p. 384; 1807, p. 421; 1808, p. 289; 1809, p. 331; 1810, p. 356; 1811, p. 267; 1812, p. 284.
4. This table was sold at auction by E. Kathleen Cumerford McLoughlin in 1959 and purchased by Colonial Williamsburg, no. 1959–382.

58

DINING TABLE

Probably Rhode Island, 1770–1810

Mahogany; soft maple (hinged and stationary rails), eastern white pine (glue blocks)

70.7 x 29.4 (103.4 open) x 103.4 (27 7/8 x 11 5/8 [40 3/4] x 40 3/4)

Yale University Art Gallery, 1987.2.2

Structure: All three sections of the top are single boards. The hinged leaves fit against the center with rule joints. The center section of the top is screwed to the frame rails from inside. One side of each end rail is tenoned and double pinned into the upper end of one of the two fixed legs. The long sides of the frame have an inner stationary rail and an outer hinged rail. The stationary rails are nailed flush to the fixed parts of the hinged rails, which are tenoned and double pinned into the two fixed legs. At the corners of the frame opposite the fixed legs, the end rails are

dovetailed to the stationary rails. A rectangular block is glued into the corner behind these joints. Finger hinges connect the fixed parts of the hinged rails to the fly rails, which are tenoned and double pinned into the fly legs. Cutouts in the fly legs allow them to overlap the frame's dovetailed corners when closed.

Inscriptions: "Bed" is written in chalk on the underside of the top's center section. "1" is written in chalk on the inside of one end rail and the adjacent stationary rail; "2" is written on the opposite end and stationary rails.

Condition: When this table was discovered, its surface had been badly bleached by sunlight. Peter Arkell recolored and refinished it at the Art Gallery in 1986. The top's hinges are replacements. The center section has been patched where one hinge broke out, and there are plugged holes around all four hinges. The finger hinges of both side rails have been reinforced with screws, and a small filler piece of wood has been added between the left side rails.

Provenance: This table was found in storage at the Art Gallery in January 1986.

The presence of maple and eastern white pine as secondary woods indicates that this dining table was made in New England, where similar tables were owned. A virtually identical example was made in the Boston area between 1788 and 1800 for John and Betsey Barstow of Hanover, Massachusetts; and a table with six molded legs was ordered in 1771 from Samuel Edgecomb by Thomas Shaw of New London, Connecticut.[1] The Art Gallery's table was probably made contemporaneously in Rhode Island. Its fly legs were constructed to overlap and support the frame's corners when closed, a technique used in New England almost exclusively in Rhode Island during the Colonial and Federal periods.[2] Although the finest straight-leg tables in this style from Newport and Providence were fluted, a Georgian-style sofa made in 1812 by Adam S. Coe of Newport has molded legs similar to those on this table.[3]

1. Jobe/Kaye 1984, no. 65; Myers/Mayhew 1974, no. 88.
2. Moses 1984, pp. 90, 210; Hewitt/Kane/Ward 1982, p. 194, chart XII.
3. Downs 1952, no. 276.

5 9

DINING TABLE

Probably Mid-Atlantic States, 1790–1820

Black cherry; red oak (hinged rails), yellow-poplar (stationary rails)

72.9 x 36.7 (112.6 open) x 119.5 (28 3/4 x 14 1/2 [44 3/8] x 47)

The Mabel Brady Garvan Collection, 1931.2207

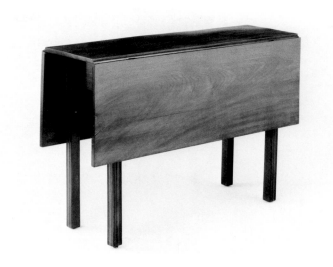

58

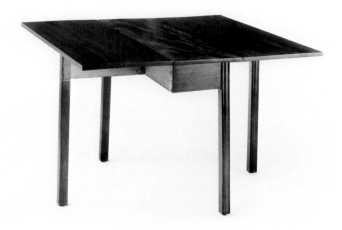

58

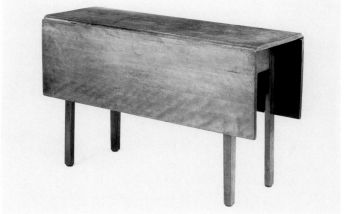

59

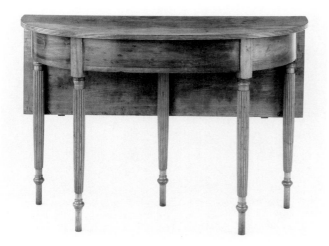
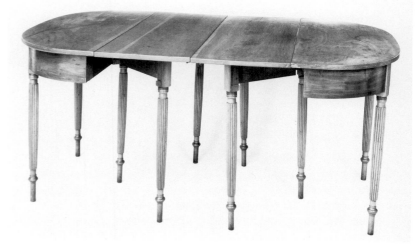

60 60

Structure: The top's center section is made of a single board, whereas each leaf is made of three boards butted together. The hinged leaves fit against the center with rule joints. The center section is pinned to all four frame members. One side of each end rail is tenoned and double pinned into one of the two fixed legs. The long sides of the frame have an inner stationary rail and an outer hinged rail. The stationary rails are nailed through filler pieces of wood to the fixed parts of the hinged rails. The fixed part of the hinged rail is tenoned and double pinned into the two fixed legs. At the corners of the frame opposite the fixed legs, the end rails are dovetailed to the stationary rails. Finger hinges connect the fixed parts of the hinged rails to the fly rails, which are tenoned and double pinned into the fly legs. Cutouts in the fly legs' upper ends overlap and support the frame corners when closed.

Condition: The rule joints have been repaired on both leaves. Pins have been added to the left rear fly leg. The left face of the left rear leg has been patched at the mortise. The wrought-iron hinges appear to be original, although the screws are replacements. The right front hinge has been returned to its original location after an earlier removal to an adjacent position on the top. The old leather glides glued to the undersides of the legs may be original; they have been reinforced with modern nails.

Like the preceding example (cat. 58), this table has overlapping fly legs at its corners. Its secondary woods, however, suggest an origin in one of the mid-Atlantic states, where this construction technique was used with greater frequency than in New England.[1] The influence of the Neoclassical style can be detected in the slightly tapered legs and their champfered

inside edges, but the table is otherwise a simple, utilitarian object.

1. Hewitt/Kane/Ward 1982, p. 194, chart XII.

60
SET OF DINING TABLES

New England, possibly Rhode Island or Connecticut, 1800–25

Cherry, mahogany veneer; soft maple (hinged rail), eastern white pine (curved rails), hickory (pegs on fly rail)

73.1 x 103.8 x 42.3 (79.5 open) (28 3/4 x 40 7/8 x 16 5/8 [31 1/4])

The Mabel Brady Garvan Collection, 1930.2583A

Structure: Each half of the top is one board; the semicircular section has reeded edges whereas the falling leaf has square edges. Three tenons applied to the inside edge of the fixed section fit into three reciprocal mortise holes on the inside edge of the falling leaf. Two leaf-edge tenons are also applied to the falling leaf's outside edge. The top is screwed to the frame rails from inside. The veneered semicircular frame is composed of four horizontal laminates. The rear corners of the rail are dovetailed to the inner back rail, and rectangular glue blocks reinforce these joints. The inner back rail is nailed to the fixed part of the hinged rail through two filler pieces of wood. Two small pieces of wood are nailed to the inner rail behind the fly rail hinges. The two front legs have deep rabbets cut into their upper posts that are glued over the front rail. Finger hinges connect the fixed part of the hinged rail to the two fly rails, which are tenoned and double pinned into the fly legs. Cutouts

in the fly legs' upper ends overlap and support the rear corners of the frame. A stationary leg is tenoned between the fixed part of the hinged rails and is held in place against the inner rail with four pins.

Inscription: "Tooker / Bridgeport / Conn" is painted on the underside of the top in a late nineteenth- or twentieth-century hand.

Condition: The top has been patched in several places, and its hinges are replacements. The hardware connecting the falling leaf to the leaf on the matching table is probably a later nineteenth-century addition; the top on the matching table is a replacement. Both front legs broke out and are now secured by nails driven through their front surface into the rails. The outside front corner of the left fly leg has been reattached. The banding along the frame's lower edge is a replacement. A bead molding was probably nailed to the underside of the frame originally.

Provenance: Garvan purchased this table from Henry Hammond Taylor.

This dining table originally may have had a center section with additional falling leaves, although the "tongues" and mortises on the leaves' edges are designed to be reciprocal. John T. Kirk has found references in the Gillow accounts in England to more than one "Sett of Mahogany Dining Tables" composed only of two circular ends with rectangular falling leaves.[1]

The regional origin of this set is difficult to establish with certainty. It features the same combination of secondary woods and fly leg construction found on cat. 58, attributed to Rhode Island. The use of cherry for this pretentious a form, however, is more typical of Connecticut than of Providence or Newport. The design of the turnings is related to tables made in Philadelphia (cats. 39, 111), a center that had an important influence on Connecticut furniture in the eighteenth century. The inscription painted on one of the tables indicates that they were owned in Bridgeport, Connecticut, prior to the time Garvan purchased them.

1. Kirk 1982, figs. 66–67.

Hinged Fly Supports

The pembroke table was a new type of small table with falling leaves that appeared in England around 1750. It probably evolved to meet the need for a table that was the same height as a dining table but with smaller leaves, making it less cumbersome to move. Pembroke tables also had greater stability, since their shallow leaves required only short, hinged sections of the side rails (known as "flys") for support, leaving all four legs stationary.[1] Hinged flys appear to have been developed for this form. They were used later on tables with pillar-and-claw bases, such as card tables (cats. 113–115) and dining tables.[2]

The term "pembroke table" was used interchangeably with "breakfast table" to describe this form throughout the last quarter of the eighteenth century and first quarter of the nineteenth. According to Sheraton, "pembroke table" was derived "from the name of the lady who first gave orders for one of them, and who probably gave the first idea of such a table to the workmen."[3] "Breakfast table," the earlier of the two terms, was used by Thomas Chippendale in the *Director* and apparently reflected one of the new form's primary purposes.[4] Thomas Sheraton stated the table's function unequivocally: "for a gentleman or lady to breakfast on."[5] "Breakfast table" was the preferred nomenclature in American estate inventories. In contrast, designers after Chippendale and English and American price books prior to 1830 used "pembroke table." The earliest usage in America known to this author dates to 1770, when George Bright of Boston billed Jonathan Bowan for "a Pembroke Table."[6] The 1772 Philadelphia price list headed the section that described this form with "Pembroke Table," using "Breakfast Table" for the subsequent entries, perhaps because the former name was still unfamiliar.[7] "Pembroke table" may have held a type of snob appeal for some Americans. Under the heading "Breakfast Table," the 1792 Hartford price list distinguished between a "plain Breakfast Table, Ditto with stretchers, Ditto with drawer trim'd," and the most elaborate and expensive version of the form, a "Pembroke Table, ends swell'd and scollop'd top."[8] After about 1830, "pembroke table" fell into disuse and the form was known almost exclusively as a "breakfast table."[9]

Despite its nominal association with breakfast, the pembroke table was fashionable for about seventy-five years as a small, easily portable table of sufficient height for a variety of activities. On December 27, 1773, Thomas Elfe of Charleston, South Carolina, charged Peter Stevenson for making "a pembrook tea table."[10] A pembroke table that Duncan Phyfe made for James Lefferts Brinckerhoff of New York in 1816 was described on the bill as a "Tea Table."[11] An 1803 advertisement for Joseph Barry's furniture wareroom in Baltimore listed "Pembroke tables with back gammon boxes included."[12] In the early 1800s, Abraham Russell of New Bedford, Massachusetts, placed his pembroke table beneath a looking glass, where it functioned as a pier table (Fig. 36). In other homes, such tables were positioned under a window to provide the best light for reading, writing, or other work.[13] Like some types of dining

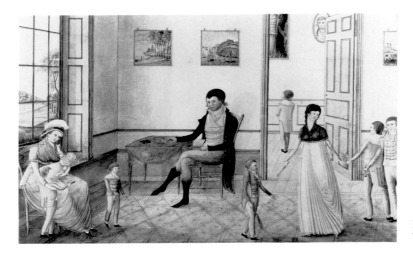

Fig. 46. William Wilkie, *Nathan Hawley and His Family*, 1801. Watercolor. Albany Institute of History and Art, New York.

table (cat. 54), pembroke tables frequently were used in place against the wall, without being moved into the room (Fig. 46). Many Americans owned two or more pembroke tables, which were frequently made in pairs (cat. 61); a few pembroke tables were made to match other furniture (cat. 69). The 1788 inventory of John Penn's Philadelphia town house listed breakfast tables in the dining room, front parlor, and front chamber upstairs; an inventory of "Richmond Hill," Aaron Burr's home in New York City, recorded breakfast tables in the drawing room, white room, and breakfast room.[14] After about 1840, easily portable tables became less desirable, and pembroke tables were superseded in urban homes by sofa and center tables. The name "pembroke table" may have been discarded when the form ceased to be fashionable. Andrew Jackson Downing characterized what he called "*breakfast* or *tea-tables*" in 1850 as "useful and indispensable articles of furniture in a cottage."[15]

The earliest pembroke tables made in America were in the Georgian style with crossed stretchers and carved ornament; documented examples include the one made by George Bright of Boston in 1770 and a more elaborate table made by Adam Hains of Philadelphia between 1788 and 1801.[16] Following the London price book for 1793, the American price books issued during the Federal period listed two categories of pembroke tables: those with four "plain Marlbro' legs" (cats. 61–67) and "Pillar and Claw Pembroke Tables" (cats. 68–70) with pedestal bases.[17] Although this evidence suggests that the two types were made concurrently in this country, few of the surviving pillar-and-claw pembroke tables appear to have been made prior to the second decade of the nineteenth century, when this form superseded the four-leg version. The pembroke tables at Yale illustrate regional design and construction features similar to those found on contemporary card tables (cats. 108,

113–120). The collection contains examples of four-leg pembroke tables made in regions ranging from New England to Maryland as well as metropolitan (cats. 50, 61, 63, 65, 66), micropolitan (cats. 48, 64, 67), and rural (cat. 49) versions of the form. Some tables made outside metropolitan areas have pivot supports rather than hinged flys (see p. 127, cats. 48, 49). Some urban examples made after 1825 also have pivot supports, although these may have been specified by the customer as a cost-saving measure (see p. 127, cats. 50, 51). A pembroke table from the same period has hinged flys (cat. 71). The relatively simple styles of these last tables reflect the form's gradual decline as a piece of fashionable furniture during the second quarter of the nineteenth century.

1. *London Prices* 1788, p. 54, describes the basic pembroke table "with one fly on each side." Exactly the same wording was used in American price books.
2. *London Prices* 1811, p. 210.
3. Sheraton 1803, p. 284.
4. Chippendale 1762, pl. 53.
5. Sheraton 1793, p. 412.
6. Jobe/Kaye 1984, no. 66.
7. Weil 1979, p. 186.
8. Wadsworth 1985, p. 472.
9. *New York Prices* 1834, p. 61; Downing 1850, p. 421; see also cat. 51.
10. Webber 1938, p. 37.
11. Sloane 1987, p. 1110.
12. Weidman 1984, p. 71.
13. Pembroke tables positioned under windows appear in a 1793 portrait by Joseph Steward (Peterson 1971, pl. 10), a 1795 portrait by John Brewster, Jr. (Mayhew/Myers 1980, fig. 27), and an interior by an unknown artist of c. 1850–60 (Peterson 1971, pl. 96).
14. Kimball 1931, p. 378; "Richmond Hill" 1927, pp. 17–19.
15. Downing 1850, p. 421.
16. Jobe/Kaye 1984, no. 66; Downs 1952, no. 314.
17. *London Prices* 1793, pp. 91–94, 259; *Philadelphia Prices* 1795, pp. 34–36; *New York Prices* 1796, pp. 33–34.

PEMBROKE TABLE ONE OF A PAIR

New York City, 1785–1800

Mahogany, mahogany veneer, maple stringing (edges of top and
drawer front); yellow-poplar (back frame rail, drawer interior),
black cherry (hinged rails), eastern white pine (inner side
rails, corner blocks)

71 x 47.5 (102 open) x 80.4 (28 x 18 3/4 [40 1/8] x 31 5/8)

The Mabel Brady Garvan Collection, 1930.2605A

Structure: Each section of the top is a single board. The center
section is screwed to the frame from inside. The hinged leaves
fit against the center with rule joints; when open, each leaf rests
on a support that is hinged to the side rails. The front and back
rails are tenoned into the legs, as are the inner side rails. Small
blocks are glued between the legs and hinged rails. Two-piece
quarter-round blocks are glued into the two rear corners. Fin-
ger hinges connect the flys to the fixed parts of the hinged rails,
which are nailed to the inner side rails. Angled pieces of wood
that fit against the flys are nailed to the inner side rails.

The veneered drawer front and the back are dovetailed to the
sides. The two-piece bottom is nailed to the back and has feath-
ered edges that fit into grooves in the front and sides. Three nar-
row glue blocks reinforce the joint between the sides and bot-
tom. The drawer is supported by side runners nailed to the inner
side rails. Drawer stops are also nailed to the side rails, and a
drawer guide is nailed to the left inner rail near the top.

Inscriptions: "II" is incised on the inside of the two front rails.
"1857," "18," and an illegible inscription in an eighteenth-
century hand are written in pencil on the left drawer side.

Condition: The brasses are replacements. The glue blocks on
the underside of the drawer have been reattached.

Provenance: Jacob Margolis acquired these tables from an uni-
dentified William Moore. Garvan bought them from Margolis
in 1926.

This table is a classic example of the sophisticated inlaid furni-
ture made in New York City during the Federal period. The
legs, which are tapered along their inside edges, provide a taut
framework for the sweeping, rounded lines of the falling leaves
and end rails. Inlays of increasing size are placed on the legs to
enhance their vertical thrust, just as the lightwood stringing
around the edges of the top and drawer front accentuates their
curved lines. These ornamental features accounted for more
than half the table's original cost. In the 1796 New York price
book, a basic pembroke table cost £1.1; the extras on this table
included an oval top (2s.), end rails "swept" to match the oval top

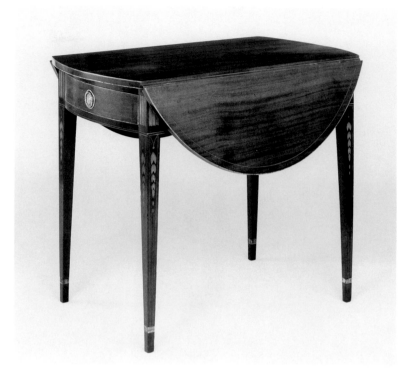

61

(5s.), "pannels with strings" on the end rails (2s. 1d.), stringing
on the legs (10d. per side or 7s. 8d. total) and top (2s. 8d.), "cross
or long banding on the fronts of circular work" (2s.), and a
veneered drawer front and "sham ditto" on the back side (1s.
8d.). Together with charges for larger dimensions than the stan-
dard model, as well as the "flutes" and stylized "husk" inlays,
the extras represented at least £1.5.3 of a total cost of about
£2.6.3 for each table of this pair.[1]

Lavish ornament was characteristic of pembroke tables made
in New York City. A similar pembroke table with inlaid flutes
and shaded, overlapping ovals was made by John Dikeman of
New York between 1794 and 1796.[2] The same inlays were used
by Elbert Anderson of New York on a sideboard made between
1789 and 1796.[3] Pairs of pembroke tables were also common in
New York during this period; labeled pairs by George Shipley
and John Dikeman are known.[4]

1. *New York Prices* 1796, pp. 33–34, charts 6, 8, 9, 18.
2. *Antiques* 105 (May 1974), p. 1019.
3. Comstock 1962, no. 510.
4. Downs 1951, p. 47; the Dikeman tables are discussed in Montgomery
 1966, no. 326.

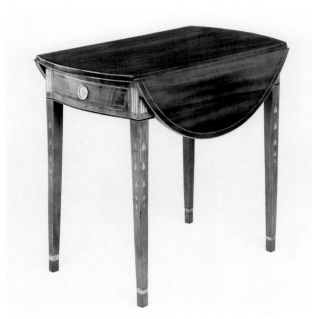
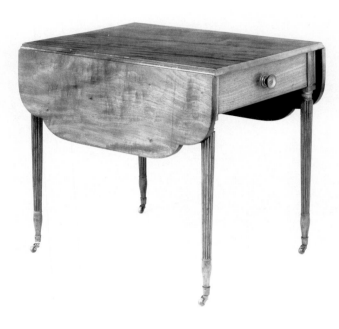

62 63

6 2

PEMBROKE TABLE

Probably New York or New Jersey, 1790–1810

Mahogany, mahogany veneer; eastern white pine (inner side
 rails, rear corner blocks, back frame rail, drawer front), yellow-
 poplar (drawer interior), black cherry (front and hinged rails)

73.3 x 45 (93.3 open) x 80.5 (28 7/8 x 17 3/4 [36 3/4] x 31 3/4)

The Mabel Brady Garvan Collection, 1930.2713

Structure: The three sections of the top are each a single board.
The center section is screwed to the frame rails from inside. The
hinged leaves fit against the center with rule joints. The front,
back, and inner side frame rails are tenoned into the legs.
Quarter-round blocks are glued into the two rear corners. Fin-
ger hinges connect the flys to the fixed parts of the hinged rails,
which are nailed to the inner side rails. Angled pieces of wood
that fit against the flys are also nailed to the inner side rail.
Small angled blocks are glued between the legs and the outside
ends of the fixed part of the hinged rail and the angled piece of
wood.

The veneered drawer front and the back are dovetailed to the
sides. The two-piece bottom is nailed to the back and has feath-
ered edges that fit into grooves in the front and sides. The
drawer is supported by side runners nailed to the inner side
rails, and stops are nailed at the back ends of the side rails.

Inscriptions: "38" is written on a small paper label pasted on
the inside of the drawer bottom, with the same number painted
in red nearby. A chalk drawing on the underside of the top
appears to be a design for fretwork. Chalk cabinetmaker's
marks are drawn on the inner side rails under the flys and on the
fixed part of the left hinged rail.

Condition: A plugged hole is in the right front corner of the top.
The rule joint is repaired where the right rear hinge broke out.
The right front leg broke off at the skirt and has been reattached
with pins. The lower front rail has been reattached to the left
front leg. Triangular blocks have been nailed into both front
corners of the frame. A medial brace has been nailed between
the two drawer runners. Rectangular shims have been nailed to
the underside of each leaf where it rests on the fly. The stringing
on the top may be a later addition; it was repaired by Peter
Arkell in 1981. The brasses are replacements.

Reference: "Annapolis" 1930, p. 427.

Provenance: Garvan's records state that this table was pur-
chased at Jacob Margolis' fifth auction in November 1924 (*Mar-
golis* 1924b), but none of the tables in the catalogue correspond
to this piece. It apparently was no. 115 in Margolis' fourth sale in
April of the same year (*Margolis* 1924a).

This table's design and construction are very similar to the pre-

ceding example (cat. 61), but executed with less finesse. The legs have a less pronounced taper, the falling leaves are shorter, and the thick cuffs and banding around the frame's lower edge interrupt the legs' vertical lines. The table may have been made in New York City by a less accomplished shop or outside the city by a craftsman copying the urban model. Similar husk inlays appear on a pembroke table that was owned in Albany, New York, and a sideboard labeled by Matthew Egerton, Jr., of New Brunswick, New Jersey.[1]

1. *Antiques* 66 (October 1954), p. 252; White 1958, no. 80.

6 3

P E M B R O K E T A B L E

New York City, 1800–20

Mahogany, mahogany and probably rosewood veneers; eastern
 white pine (front and fixed side rails, drawer interior), birch
 (back and hinged side rails), spruce (drawer runners)

70.8 x 54.9 (111.5 open) x 82.3 (27 7/8 x 21 5/8 [43 7/8] x 32 3/8)

Anonymous gift in memory of Mrs. George H. Nettleton,
 1966.165

Structure: Each section of the top is made of a single board. The center section is screwed to the frame from inside. The hinged leaves fit against the center with rule joints. The upper and lower front frame rails are tenoned into the legs and dovetailed to the side rails. The veneered back rail is tenoned into the legs. The inner side rails and the fixed parts of the hinged outer rails are tenoned into the same mortise holes in the legs. Finger hinges connect the flys to the fixed parts of the hinged rails, which are glued to the inner side rails.

 The veneered drawer front overlaps the front frame rails. The drawer front and the back are dovetailed to the sides. The bottom is nailed to the back and has feathered edges that fit into grooves in the front and sides. The drawer is supported by side runners that are nailed to the inner frame rails. A drawer guide is nailed to the right side rail near the top.

Condition: The upper end of the left front leg has been replaced; the original leg has been reglued to this new piece. A screw has been put through the top into the leg's upper end. The upper front frame rail has been replaced. The front side of each leg's upper end originally was veneered; the right front leg has been reveneered to match the replacement on the left. The drawer front and back frame rail have also been reveneered. The drawer knob and casters are replacements. The feet appear to have been cut down. The drawer bottom has been extended to

compensate for shrinkage. The surface was refinished by Robert M. Soule in 1966.

Provenance: This table was purchased by Josephine Setze, curator of the Intra-University Loan Collection, Yale University, from the dealers George and Benjamin Arons of Ansonia, Connecticut, on June 8, 1966. It was acquired for use in the Yale University Faculty Club and was transferred to the Art Gallery when the club was closed in 1977.

Although extensively restored, this table illustrates the great difference between richly inlaid tables with square legs (cat. 61) and austere, monochromatic tables with turned legs made in New York City during the Federal period (see also cats. 108, 116). Identical turnings and double-elliptic tops appear on pembroke tables made in New York by Michael Allison between 1801 and 1816 and George Woodruff between 1808 and 1810.[1] Both the Woodruff and Yale tables were constructed with their inner and outer side frame rails tenoned into the same mortise, a technique that apparently was characteristic of New York workmanship. A later example of this form in the Art Gallery's collection was made with pivot supports instead of hinged flys (cat. 50).

1. *Antiques* 92 (August 1967), p. 153; Montgomery 1966, no. 331.

6 4

P E M B R O K E T A B L E

Matthew Egerton, Jr. (d. 1837)

New Brunswick, New Jersey, 1790–1802

Mahogany, mahogany veneer; eastern white pine (back and inner
 side rails, filler blocks, drawer front), yellow-poplar (front rails,
 drawer interior, runners, guide), southern yellow pine (hinged
 side rails), hickory (hinge pin)

70.7 x 52.3 (100.7 open) x 80.6 (27 7/8 x 20 5/8 [39 5/8] x
 31 3/4)

The Mabel Brady Garvan Collection, by exchange, 1989.35.1

Structure: The front, back, and outside ends of the side frame rails are veneered. A bead molding is applied to the rear rail to simulate a drawer. The rear rail is composed of two vertical laminates. The upper front frame rail is dovetailed to the legs. The lower front, rear, and inner side frame rails are tenoned into the legs. The two rear corner joints are reinforced with glue blocks. The drawer runners, guides, and stops are nailed to the inner side rails. The fixed parts of the hinged rails are glued to the inner side rails, with filler blocks at either end adjacent to the

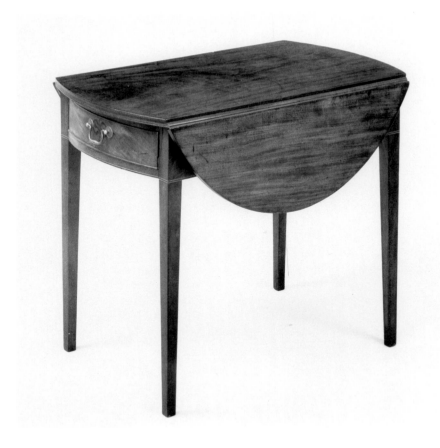

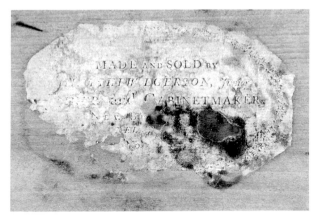

64 *Label*

64

legs. Knuckle hinges connect the flys to the fixed parts of the hinged rails.

The drawer front is veneered and has a bead molding nailed around its outside edges. The sides are dovetailed to the front and back. The bottom is composed of two boards that are nailed to the back and fitted into grooves in the front and sides with feathered edges. Small, square glue blocks reinforce the joint between the bottom and the front; rectangular blocks reinforce the joints between the bottom and the sides.

Inscriptions: "Benjamin/Benjamin" is written in chalk in an eighteenth-century hand on the interior of the rear frame rail. A printed paper label is pasted to the inside bottom of the drawer: "MADE AND SOLD BY / *MATTHEW EGERTON, Junior,* / JOINER AND CABINETMAKER, / NEW-BR[UN]S[WICK,] / NEW-J[ER]SE[Y,] / --No. --."

Condition: The top is not original; it appears to be a very early replacement made for this table. The right front and left rear legs broke off and have been repaired. The left drawer guide and the right drawer stop are lost. The brasses are replacements.

Some of the glue blocks on the underside of the drawer are lost and others have been reattached.

Reference: Garrett 1972, p. 192.

Provenance: Charles F. Montgomery owned this table by 1969. The Art Gallery purchased it from Florence M. Montgomery in 1989.

The son of a cabinetmaker, Matthew Egerton, Jr., apparently worked in the same New Brunswick shop for his entire career. Two different Matthew Egerton labels are known, with and without "Junior" after the name. Most scholars have assigned the former label to the entire career of Matthew, Jr., and the latter to his father, who died in 1802. Observing the great similarity of most labeled Egerton furniture in the Federal style, however, William M. Hornor advanced the theory that both labels were used by the younger man, the label without "Junior" superseding the label with "Junior" after 1802, when the distinction was no longer necessary.[1] Hornor's theory is supported by the fact that the label with "Junior" is found on late Colonial

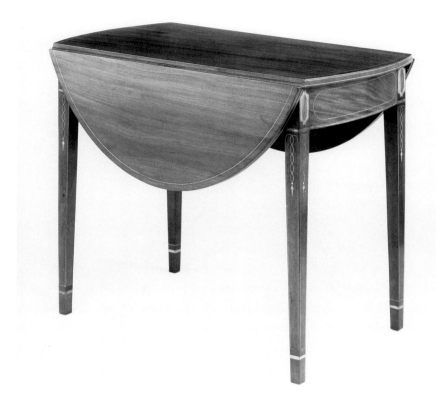

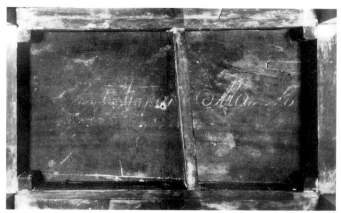

65 *Inscription*

65

style furniture, including *kasten*, clothes presses, and clock cases.[2] In contrast, the label without "Junior" appears on work tables with spiral turnings as well as a desk that probably date after 1820.[3] There are also differences in the type of pembroke table with each label, which probably reflect, as Hornor proposed, the later date of one label rather than the work of different craftsmen. The Art Gallery's table and another with the same label are identical in shape, with oval tops and rounded end rails.[4] In contrast, pembroke tables with the label without "Junior" have square end rails and square tops, two with ovolo corners.[5] Like most documented Egerton furniture in the Federal style, all but one of these other tables are ornamented with stringing and other inlays. The plainness of the Art Gallery's table suggests that it may have been made as stock for the "cabinet warehouse" that Egerton operated as part of his shop. Among the "Stock of Furniture Ready Made in the Ware Room" of his son John B. Egerton's estate in 1838 were "Three Mahogany Breakfast tables" valued at $11 each.[6]

1. Hornor 1930c, pp. 52–53.

2. *Kasten*: Lyle/Zimmerman 1980, fig. 26; *Antiques* 130 (October 1986), p. 692. Clothes presses: Hornor 1930c, p. 52; DAPC 65.1478; DAPC 71.560. Clock cases: *Sack Collection*, III, pp. 642–43; DAPC 69.2232.
3. Work tables: White 1958, no. 78; DAPC 74.5806. Desk: DAPC 65.1470.
4. The other pembroke table with the "Junior" label is in The Newark Museum, New Jersey (no. 75.82; illustrated in *Antiques* 104 [December 1973], p. 977).
5. *Haskell* 1944a, no. 551; Lyle/Zimmerman 1980, fig. 25. A third pembroke table with a square top with ovolo corners, with the Matthew Egerton label, was sold at the 1990 Winter Antiques Show in New York City by Valdemar F. Jacobsen of Cold Spring Harbor, New York.
6. Hornor 1928b, p. 421.

65

PEMBROKE TABLE

Baltimore, 1800

Mahogany (including outer side rails), satinwood veneer (panels on upper ends of legs), black cherry veneer (dark band of

cuffs); yellow-poplar (end and inner side rails), southern yellow pine (medial brace), eastern white pine (corner blocks)

72.7 x 47.5 (108.5 open) x 87.2 (28 5/8 x 18 3/4 [42 3/4] x 34 3/8)

Gift of Benjamin A. Hewitt, B.A. 1943, PH.D. 1952, 1984.101.1

Structure: The top's center section is made of two boards whereas the two falling leaves are made of single boards. The center section is screwed to the frame rails from inside. The hinged leaves fit against the center with rule joints. The veneered end rails are tenoned into the legs, as are the fixed parts of the hinged outer side rails. Inner side rails are nailed to the fixed parts of the hinged rail. A medial brace is glued between the inner side rails. A rectangular block is glued in each corner between the end rail and the inner side rail. Knuckle hinges connect the flys to the fixed parts of the hinged rails.

Inscriptions: "Baltimore March / 29 1800" is written in chalk on the underside of the top. There is an illegible chalk inscription on the inside of one end rail.

Condition: The center section of the top has been patched on both outside edges. There are pairs of screw holes on the undersides of the leaves where shims may have been applied at one time. The lower two-thirds of the left front leg has been replaced. The right rear leg has broken out and been repaired at the juncture with the frame.

Provenance: The donor purchased this table from the dealers Hilbert Brothers of New Canaan, Connecticut, on May 14, 1974.

This table's dated inscription makes it an important document of the Federal style in Baltimore. Its construction and ornamentation follow the norm Benjamin A. Hewitt described for contemporary card tables made in Baltimore: a medial brace, square edges on the top, a facade with a single panel outlined in patterned stringing, and bellflowers with long central petals.[1] The hollow-cornered rectangle with oval center inlaid on the table's pilasters was a popular motif in Baltimore that also appeared on card tables, pier tables, and sideboards.[2]

1. Hewitt/Kane/Ward 1982, p. 171.
2. Other objects with this inlay are discussed in Weidman 1984, no. 115A, n. 5. A heavily restored card table in this group has been described as matching the Art Gallery's pembroke table (Hewitt/Kane/ Ward 1982, p. 183, n. 4), but it lacks a medial brace and has different inlays and secondary woods.

66

PEMBROKE TABLE

Baltimore, 1790–1810

Mahogany, satinwood veneer (cuffs); yellow-poplar (end and inner side rails, medial brace), white oak (hinged side rails)

71.1 x 48.3 (112.9 open) x 91.7 (28 x 19 [44 1/2] x 36 1/8)

Gift of Mary Byers Smith in memory of her brother J. Duke Smith, B.A. 1897, 1946.16

Structure: Each section of the top is made of a single board. The center section is screwed to the frame rails from inside. The hinged leaves fit against the center with rule joints. The veneered end rails are tenoned into the legs. Knuckle hinges connect the flys to the fixed parts of the hinged side rails, which are tenoned into the legs. The inner side rails are nailed to the fixed parts of the hinged rails. A medial brace is glued between the inner side rails.

Inscription: "27" is printed on a paper label affixed to the piece of wood screwed to the underside of the top.

Condition: A piece of wood has been screwed to the underside of the top to stabilize a crack. Stops for the flys were screwed to the undersides of the leaves at one time. The banding on one end rail and the upper end of one leg has been patched. Some of the cuffs and adjacent banding have been replaced.

Reference: "House in Good Taste" 1928, p. 258.

Provenance: This table belonged to the donor's brother, John Duke Smith (1874–1941) of Andover, Massachusetts, who "considered it one of his best pieces of furniture. This opinion was backed up by the late William S. Richardson of McKim, Mead, and White" (Mary Byers Smith to the director, Yale University Art Gallery, November 1945; Art Gallery files). It is not certain whether J. Duke Smith purchased or inherited the table; it was in the Smiths' family home in Andover when it was published in 1928. Smith and his sister were descended from the founders of Smith and Dove Manufacturing Company in Andover, which had business connections with southern states through its production of cotton textiles.

Virtually identical in design and construction to the previous example (cat. 65), this table can be securely attributed to Baltimore. Both of these pembroke tables are larger than contemporary examples from other regions in the Art Gallery's collection, and this size may have been a local characteristic.[1] The table's top measures just over 3 feet (91.7cm) in depth, the dimension given for the form in the 1834 New York price book.[2]

1. Weidman 1984, p. 80.
2. *New York Prices* 1834, p. 61.

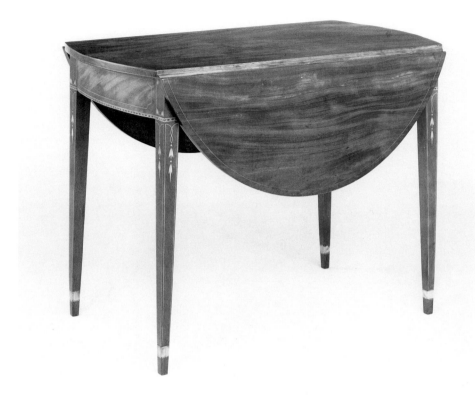

66

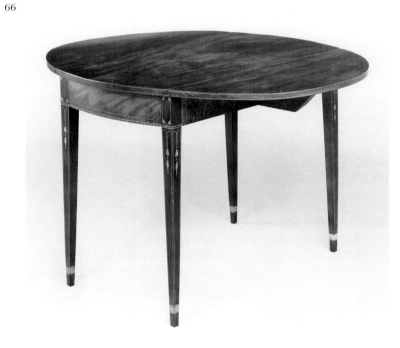

66

67

PEMBROKE TABLE

Possibly by John Shaw (1745–1829)

Annapolis, Maryland, 1790–1810

Mahogany, mahogany veneer; yellow-poplar (end rail, drawer
 front and bottom), red oak (inner side rails, right hinged rail),
 white oak (left hinged rail), redgum (drawer sides, back,
 guides, runners), spruce (strips nailed to undersides of side
 rails)

72 x 49.5 (99.2 open) x 76.5 (28 3/8 x 19 1/2 [39] x 30 1/8)

The Mabel Brady Garvan Collection, 1930.2539

Structure: Each section of the top is a single board. The center
section is screwed to the back rail from inside and the side rails
from outside. The hinged leaves fit against the center with rule
joints. The two front frame rails are solid, and the front knee
brackets are carved from the lower front rail. The back frame
rail is veneered, and its knee brackets and bead moldings that
simulate a drawer are applied. The front, back, and inner side
rails are tenoned into the legs. Knuckle hinges connect the flys
to the fixed parts of the hinged rails, which are nailed to the
inner side rails. Strips of wood are nailed to the side rails' under-
sides. The feet are carved from solid wood.

The drawer front is veneered and has a bead molding applied
around all four sides. The drawer front and back are dovetailed
to the sides. The bottom is made of two boards with feathered
sides. It is fitted into a groove in the front, butted between the
sides, and nailed to the back. The drawer is supported by side
runners nailed to the inner frame rails. Small drawer stops are
nailed above the runners at the rear. Thin drawer guides are
nailed to the side rails below the top.

Condition: The center section of the top is pieced along the
right side where the hinges broke out, and the right leaf has
been pieced along its inside edge. The present hinges are
replacements. There are a number of plugged holes along the
top's left side. All four legs have broken out. The left front leg has
been patched on the front corner adjacent to the drawer open-
ing. The right front leg has been patched below the top. The left
rear leg has been patched on its outer faces. The lower left cor-
ner of the back rail broke off and has been restored with a new
piece of wood; it was stabilized with metal braces by Peter
Arkell in 1981. The drawer stops are replacements. The runners
nailed to the underside of the drawer are also replacements. The
lock is lost. The bail handles and keyhole outlines appear to be
original.

Reference: "Annapolis" 1930, p. 427.

Provenance: Acting as Garvan's agent, R.T.H. Halsey acquired
this table in Annapolis, Maryland, for exhibition in the
Hammond-Harwood House.

A comparison of this pembroke table with the preceding two
examples (cats. 65, 66) illustrates the pronounced differences in
local taste during the Federal period. Unlike the Baltimore
preference for elaborately inlaid furniture, many Annapolis res-
idents ordered objects like this table, embellished only with
architectural moldings. A sideboard table in the Art Gallery's
collection (cat. 11) represents an earlier manifestation of this
taste, which remained strong during the succeeding generation.
A pembroke table identical to the Art Gallery's descended in the
Pinkney family of Annapolis, and a related example originally
was owned in Annapolis by John and Mary Ann Ridout.[1]

The latter two tables have been attributed to the Annapolis
cabinetmaker John Shaw on the basis of design and construc-
tion features found on a labeled pembroke table, including a top
with rounded edges, flys with ogee profiles, and rounded guttae
feet carved from solid wood.[2] All these details are present on the
Art Gallery's table, but it differs from the others in its greater
number of secondary woods and its conventional drawer con-
struction: Shaw's distinctive practice was to extend the drawer
sides beyond the back. Although this table undoubtedly was
made in Annapolis, it may be the work of one of Shaw's
competitors.

1. Weidman 1984, no. 142; Elder/Bartlett 1983, no. 15.
2. Elder/Bartlett 1983, no. 25.

68

PILLAR-AND-CLAW PEMBROKE TABLE

New York City, 1805–20

Mahogany, mahogany veneer; soft maple (hinged rails), eastern
 white pine (rear frame rail, inner side rails, drawer front),
 yellow-poplar (drawer interior), ash (medial brace)

73.8 x 58.9 (119.1 open) x 91.4 (29 1/8 x 23 1/4 [46 7/8] x 36)

The Mabel Brady Garvan Collection, 1930.2028

Structure: Each section of the top is a single board. The center
is screwed to the frame from inside. The hinged leaves fit
against the center with rule joints. The front and back rails are
veneered, and bead moldings are applied to the back rail to sim-
ulate a drawer. Bead moldings are nailed and glued to the
undersides of the back and lower front rails and the corners. The
drops are glued to the bead moldings beneath the corners. The
front rails are dovetailed into the inner side rails and the front
corners. The rear rail is probably tenoned to the rear corners.

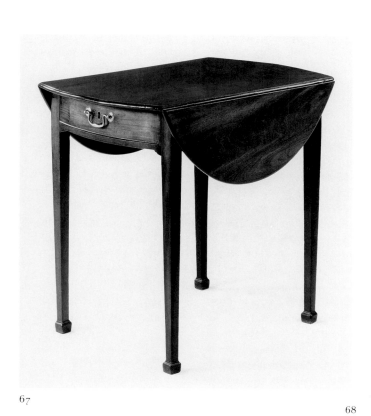

67

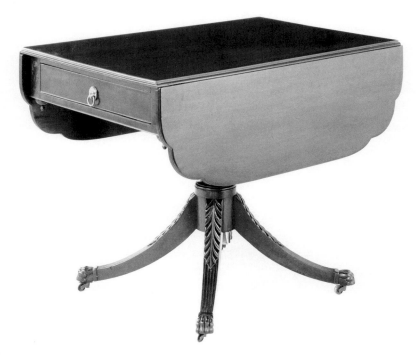

68

68 *Inscriptions*

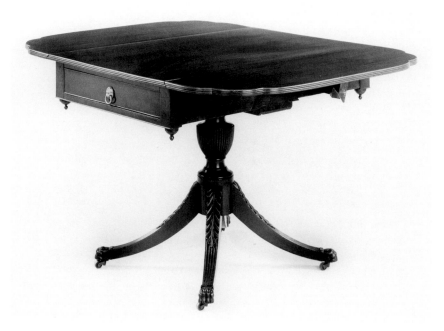

Blocks are glued into the two rear corners of the frame. The fixed parts of the hinged rails are glued to the inner side rails, which are probably tenoned into the rear corners. Finger hinges connect the two flys on each side to the fixed parts of the hinged rail. The sides of the frame are screwed onto rabbeted ends of a rectangular medial brace, and the pedestal is double-tenoned into the medial brace. The legs are blind-dovetailed into the bottom of the pedestal and were secured by a metal plate.

The drawer front is veneered and has bead moldings around its edges. The drawer front and back are dovetailed to the sides. The two-piece bottom is nailed to the back and fits into grooves in the front and sides. The drawer is supported by side runners that are glued to the inner side rails. Small drawer stops are nailed to the sides near the end of the runners and a drawer guide is nailed to the left side rail near the top.

Inscriptions: "I. Sebring" is painted in black on the drawer bottom. "FROM [crossed out] / ERNEST F. HAGEN, / Furniture & Antiques / 213 E. 26th St., / NEW YORK" is printed on a paper label affixed to the drawer bottom, and "Restored for / Mr. R.T.H. Halsey 84 West 55 st. / Nov. 1908 New York." is written in ink next to the label. "H F 11.18" is written in chalk on the drawer bottom.

Condition: The New York cabinetmaker Ernest Hagen (1830–1913) restored this table in 1908. The top has been patched at the left rear corner and right center hinge. The hinges are original. The drop on the right rear corner is a replacement. The drawer runners and guide are replacements, and the left drawer stop is lost. The brass lion-head pulls and casters are replacements. All four legs have broken out and been reattached, and the urn has also suffered major breaks. The drawer bottom has been extended to compensate for shrinkage. The interior of the drawer has been stained and the entire table has been heavily refinished.

Exhibitions: Metropolitan 1909, II, no. 228; Halsey/Cornelius 1922, p. 213.

References: Cornelius 1922, pl. 34; Stillinger 1988, p. 11D.

Provenance: This table was part of the collection Garvan acquired from R.T.H. Halsey, who probably purchased it in 1908. The painted inscription suggests that its original owner may have been Isaac Sebring, who was listed as a merchant in the New York City directories between 1790 and 1822. (*New York Directory*, 1790, p. 89; 1822, p. 397). He may have been the same Isaac Sebring baptized in the Dutch Reformed Church on January 3, 1757, the son of Cornelius and Aaltje Sebring (*IGI*).

With its urn-shaped pillar, reeded legs, and animal-paw feet, this table represented a continuation of the Neoclassical style promoted by Robert Adam and other eighteenth-century designers. All the elements were designed to create a harmonious, balanced form that visually diminished its large size. The top's treble elliptic shape reduces its width, which reaches 119.1cm (46 7/8 in.) when open. Hard, reflective edges and surfaces have been eliminated by carving and reeding on the urn, legs, feet, and edges of the top. The frame's rectilinear lines are offset by the drops applied to its corners. According to the 1817 New York price book, these enhancements cost at least £2.7.9, which more than doubled the basic price of £2.4.6. The drawer, metal plate screwed beneath the pedestal, extra flys, and size of this table further increased its cost.[1]

Pillar-and-claw pembroke tables like the present example were popular in New York City during the first two decades of the nineteenth century. A detailed description of this form and a sketch of a pillar with a reeded urn were recorded in 1809 by the New York cabinetmaker John Hewitt.[2] Similar tables were made locally by Stephen and Moses Young in 1808 and Michael Allison between 1808 and 1816; another was made in Georgetown, District of Columbia, between 1812 and 1819 by Gustavus Beall, who had trained in New York.[3] The same ornamental vocabulary appeared on contemporary pillar-and-claw and swivel-top card tables from New York (cats. 113–119).

1. *New York Prices* 1817, pp. 31–32, 118, 123, 129, 140.
2. Johnson 1968, p. 196, fig. 2.
3. Diplomatic Reception Rooms, United States Department of State, Washington, D.C. (no. 67.55; illustrated in *Antiques* 88 [October 1965], p. 424); Sotheby's 1986a, no. 627; Museum of Early Southern Decorative Arts, Winston-Salem, North Carolina (illustrated in Golovin 1975, fig. 2).

6 9

PILLAR-AND-CLAW PEMBROKE TABLE

Color plate 16

New York City, 1820–30

Mahogany (including front and back frame rails), mahogany veneer; eastern white pine (inner side rails, medial brace, drawer front, filler pieces in plinth), soft maple (hinged rails), yellow-poplar (drawer interior, runners, stops, guide), ash (crossbraces of plinth)

73.6 x 60.3 (121.9 open) x 97.8 (29 x 23 3/4 [48] x 38 1/2)

The Mabel Brady Garvan Collection, 1936.414

Structure: Each section of the top is a single board. The center is screwed to the frame rails from inside. The hinged leaves fit against the center with rule joints. The veneered upper and lower front rails are double tenoned into the front corners, and the veneered back rail is tenoned into the rear corners. A bead

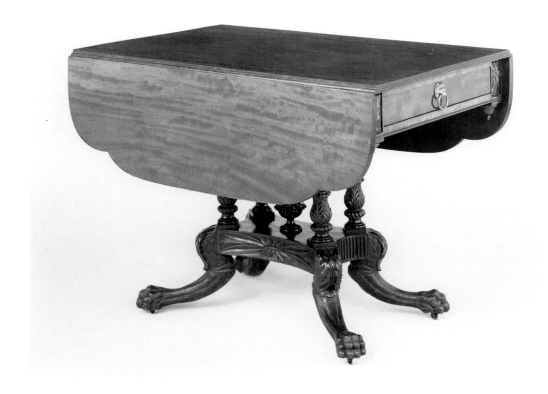

69

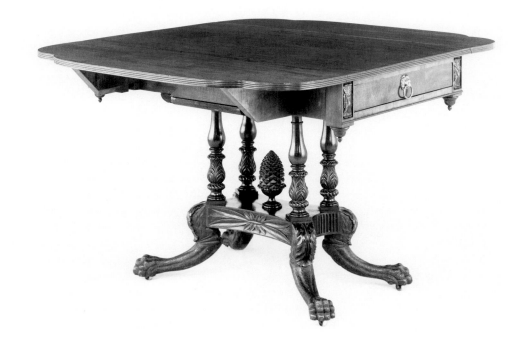

69

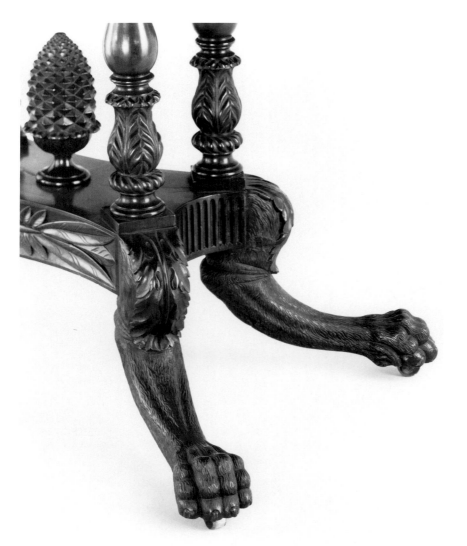

69 *Base carving* 69 *Front corner carving*

molding is nailed to the lower edges of the lower front and back rails and continues across the fronts of the corners. A carved foliate ornament is applied within a rectangular recess on the outside face of each corner, and a turned drop is glued to its underside. The inner side rails and the fixed parts of the hinged rail on each side are glued together and tenoned into the same mortise hole in each corner. Quarter-round blocks are glued in the two rear corners of the frame. Finger hinges connect the two flys on each side to the fixed parts of the hinged rails. A triangular piece of wood is glued between the flys.

The frame's side rails are screwed into rabbets on the ends of a two-layer medial brace. The pillars are tenoned between this brace and the plinth. The plinth is composed of two crossbraces with filler blocks between them and applied side panels. The top of the plinth is veneered. The finial is tenoned into the plinth. The legs are blind-dovetailed to the canted corners of the plinth. Casters are fitted into recesses under the feet.

The veneered drawer front and the back are dovetailed to the sides. A strip of mahogany is glued to the top of the drawer front. The bottom is nailed to the back and has feathered edges that fit into grooves in the front and sides. The drawer is supported in part by side runners that are nailed to the inner frame and in part by the medial brace. Drawer stops are nailed to the side rails, and a drawer guide is nailed to the right side rail near the top.

Condition: The medial brace has four plugged holes that are oriented at ninety degrees from the pillars' present position. The wear and oxidation of the table's underside indicates that these plugged holes represent a mistake corrected at the time the table was made. The brass lion-head pulls are later additions. All four legs broke off at the knee and have been repaired. Part of the finial's base was broken off and reattached. The casters are replacements.

Exhibition: Tracy/Gerdts 1963, no. 44.

Provenance: Acting as Garvan's agent, Henry Hammond Taylor purchased this table and cat. 74 from Ella Hamilton Van Liew of New York City on March 16, 1933. If this table descended in the Van Liew family, the original owner was probably John Randolph Van Liew (b. 1791), who moved to New York City from New Brunswick, New Jersey, during the early 1820s. His son Augustus, later Ella Hamilton Van Liew's father-in-law, was born in New York on November 1, 1825 (membership records of the Holland Society, New York). For further information on the Van Liews' ancestry, see cat. 74.

This imposing pillar-and-claw pembroke table is one of the masterpieces of American Classical Revival furniture. It epitomizes the later phase of Neoclassicism of the early nineteenth century, when an increase in scale and carved, high-relief ornament were combined with motifs copied from archaeological sources. The finial, frequently misidentified as a pineapple, is derived from a colossal ancient Roman pinecone of bronze that was installed in the *nicchione* of the Cortile della Pigna at the Vatican about 1610.[1] Naturalistic, crouching animal legs appeared on various forms of Hellenistic and Roman furniture and were incorporated into designs by Thomas Hope and George Smith.[2] On this table, the different textures of these elements are expertly rendered. In contrast to the preceding example (cat. 68), this table has a bold, energetic quality that is particularly evident in the animated character of its paw feet.

Pembroke tables supported by four pillars on a plinth were probably first introduced in New York about 1810. The first London price book to describe a base with "pillars and a solid block . . . with canted corners, four claws . . . dovetail'd in the cants" was issued in 1811.[3] This type of base is not listed for pembroke tables in the 1810 or 1815 New York price books, but the 1817 edition has a table for calculating the cost of "an octagon block and four pillars."[4] Michael Allison made a table of this type with reeded claws between 1808 and 1816 and an example with carved paw feet after 1816; another documented example with similar paw feet was made by Duncan Phyfe for James Lefferts Brinckerhoff in 1816.[5] The Art Gallery's table is more richly ornamented than all these examples and must have cost above the $60 that Phyfe charged Brinckerhoff for his table. The substantial carver's fees would have been in addition to the cabinetmaker's extra charges for a double elliptic top with reeded edges, carved "stumps" with drops, veneered end rails with sunken panels and bead moldings, a block with "swept" sides, and "preparing and fixing a paw foot."[6]

This pembroke table apparently was made to match a pair of dining table ends also owned by the Van Liews (see *Provenance*). The ends have tops with canted corners and reeded claws instead of paw feet, but the other carved elements appear to be identical.[7] Similar differences in design occur on Baltimore card tables and pembroke tables that were made *en suite*.[8] A pembroke table sold at auction in 1990 is almost identical to the Art Gallery's example, with only minor differences in the carving and applied moldings.[9]

1. See Ackerman 1954, p. 113, fig. 46.
2. Richter 1966, nos. 128–40, 238–44, 250, 286, 491–95, 577; Hope 1807, pls. 15, 22, 26, 33; Smith 1808, pls. 79, 89, 109, 111, 125, 128.
3. *London Prices* 1811, pp. 128–29.
4. *New York Prices* 1817, pp. 33, 125–27.
5. *Flayderman* 1930, no. 421; Ellesin 1974, p. 142; Sloane 1987, fig. 4.
6. *New York Prices* 1817, pp. 31–33, 113, 120, 123, 126, 129, 143.
7. The dining table was sold with the remainder of Ella Hamilton Van Liew's estate in 1934, when it was purchased by the dealers Ginsburg and Levy of New York City (American Art Association 1934, no. 367;

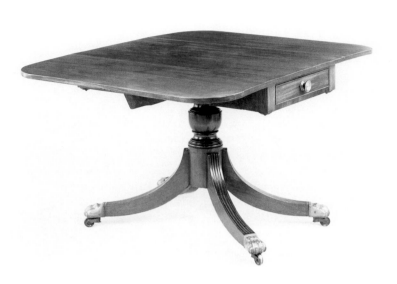

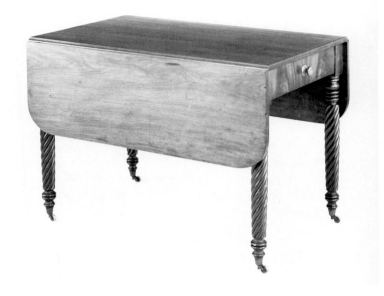

The New York Times, December 20, 1934, p. 21). One of the ends is reproduced in McClelland 1939, pl. 92, where it is identified as coming from the "Van Loo [*sic*] sale." The dining table's present owner is unknown to the author.

8. Baltimore 1947, nos. 6, 22.
9. Christie's 1990, no. 300.

70

PILLAR-AND-CLAW PEMBROKE TABLE

Possibly Baltimore, 1810–30

Mahogany, mahogany veneer; black walnut (front, back, and hinged side rails, medial brace), southern yellow pine (inner side rails), eastern white pine (blocks and backboard of medial brace, drawer front and runners), yellow-poplar (drawer interior and guides)

73.7 x 51.1 (125.9 open) x 99.5 (29 x 20 1/8 [49 5/8] x 39 1/8)

Bequest of Millicent Todd Bingham, 1969.42.8

Structure: Each section of the top is a single board. The center is screwed to the frame from the inside. The hinged leaves fit against the center with rule joints. The front and back rails are veneered, and bead moldings and a gilded stamped-brass knob are applied to the back rail to simulate a drawer. Shallow drops are turned onto the undersides of the frame's corner blocks. The front rails are double tenoned into the front corner blocks. The

back rail and fixed parts of the hinged rails are tenoned into the corner blocks. Finger hinges connect the flys to the fixed parts of the hinged rails, which are nailed to the inner side rails. Cutouts in the inner side rails fit over rabbets on the medial brace and are secured with screws. A pair of blocks is nailed to the inner side rails between the brace and top. A board is nailed to the back of the medial brace and the blocks. The pillar is double tenoned into the medial brace. The legs are blind-dovetailed into the pillar and are secured by a metal plate attached to the underside.

The drawer front is veneered and had bead moldings around its edges. The drawer front and back are dovetailed to the sides. The bottom is nailed to the back and has feathered edges that fit into grooves in the front and sides. Two flat rectangular blocks reinforced the joint between each side and bottom. The drawer is supported by side runners nailed to the inner frame rails. A drawer guide is nailed to the left side rail near the top.

Inscriptions: "R [backwards] ——ench [or k]" is written in chalk on the left side rail. "Property of/Millicent Bingham" is written in ink on a paper label attached to the underside of the drawer bottom.

Condition: The brass lion-paw casters appear to be original. The drawer front has had a hole drilled through it to receive a later lock mechanism. Missing veneer was replaced by Peter Arkell in 1985, when he refinished the top. All the original glue

blocks on the underside of the drawer are lost; one has been restored. The beading on the drawer front has been planed down flush with the front, and the knob is a replacement. The knob on the back rail appears to be original. The table was photographed showing the back rail because of the alterations to the front.

The presence of black walnut and southern yellow pine as secondary woods indicates that this table was made in Pennsylvania or somewhere to the south. The shallow drops on the frame's corners, truncated urn pillar with a high base, and particularly the large, untapered claws with square upper ends and bold reeding appear to be characteristic of pillar-and-claw tables made in Baltimore during the second and third decades of the nineteenth century. A card table with these features was labeled by the Baltimore cabinetmaker John Needles after 1816; similar work tables were signed by Ralph E. Forrester of Baltimore between 1816 and 1819 and John Ray of Shepherdstown, Virginia (now West Virginia) in 1826.[1] Pembroke, dining, center, and work tables of this type have histories of ownership in Maryland as well as eastern Virginia and North Carolina.[2] Unlike most of these examples, the Art Gallery's table has only one ring turning at the urn's base and no oak as a secondary wood.

1. MESDA research file MT-12-145; Elder/Stokes 1987, no. 133; MESDA research file VV-12-27. The John Ray who signed the latter work table may be the same man who advertised as a toolmaker and hardware merchant in Baltimore between 1811 and 1818 (*Federal Gazette and Baltimore Daily Advertiser*, May 27, 1811, p. 3; *Baltimore Patriot and Mercantile Advertiser*, June 2, 1818, p. 2).
2. Weidman 1984, nos. 155–58; MESDA research files S-7718, S-7501, S-12181.

7 1

BREAKFAST TABLE

Probably New England, 1825–50

Mahogany, mahogany veneer; eastern white pine (end and inner side rails), hard maple (hinged rails)

70.1 x 57.3 (124 open) x 99.3 (27 5/8 x 22 1/2 [48 7/8] x 39 1/8)

Gift of Mrs. Glen Wright, 1957.52.1

Structure: Each section of the top is a single board. The center section is screwed to the frame from inside. The hinged leaves fit against the center with rule joints. The end rails are veneered and tenoned into the legs. The inner side rails are glued to the fixed parts of the hinged rails. Finger hinges connect the two flys on each side to the fixed parts of the hinged rails. Triangular blocks are glued between the flys. The fixed parts of the hinged rails and the inner side rails are tenoned into the same mortise in the legs.

Condition: The top was refinished by Emilio Mazzola in 1963. Old knobs have been added to simulate drawer fronts on the end rails. Additional mortises are cut into one leg, apparently by error. The casters are replacements.

Large, simple pembroke tables continued to be made in every region after the form ceased to be fashionable as parlor furniture. This table's twist turnings were popular during the later Classical Revival (see cats. 186–189). The capitals and bases relate to earlier New England turnings on card tables from coastal Massachusetts and New Hampshire (see cats. 83, 88, 105). Similar twist legs appear on work tables made after about 1825 by Rufus Pierce of Boston and Ephraim Blanchard of Amherst, New Hampshire.[1]

1. *Antiques* 118 (October 1980), p. 634; New Hampshire 1979, no. 43.

Folding Tops: Card Tables

Tables in this category have tops composed of two identical leaves, one attached to the frame and the other hinged to the fixed leaf and resting on top of it when closed. This form has been closely associated with gaming in Anglo-American furniture since the beginning of the eighteenth century, perhaps because this type of top was developed from folding game boards. Changes over time in folding-leaf supports paralleled those on tables with falling leaves. Only one American example is known of the earliest version (Fig. 47), which featured a joined frame with a subsidiary, pivot support (see cats. 40–47). The change to hinged leg supports appears to have occurred simultaneously in tables with falling leaves and folding tops in the early eighteenth century (cats. 55, 72). About a century later, the preference for more stable leaf supports inspired pillar-and-claw card tables with hinged flys (cats. 113–115) similar to those on pillar-and-claw pembroke tables (cat. 68–70). Unlike tops with falling leaves, many folding tops made after 1810 were designed to swivel on a stationary frame (cats. 116–122), another means of achieving stability.

Late Colonial Style

The earliest English tables with folding tops appeared at the beginning of the seventeenth century. Victor Chinnery suggested that these tables probably were called a "foulding livery cubberd" or "cubberd table" and were used as side tables for dining.[1] The only American table of this form to survive (Fig. 47) bears out Chinnery's theory, as it is related to contemporary cupboards by the now-lost drawer in the frame, open shelf, and decorative elements such as balusters, turnings, and bosses. After it became obsolete as dining furniture around 1700, this form was adapted to serve as a card table. The shelf was abandoned, the frame made less massive, and the top frequently lined with needlework or fabric, which facilitated play with cards or dice but served few practical purposes for other activities.[2] The first card tables were semicircular or rectangular in shape, with stretchers and hinged rear legs. No American card tables of this type have been identified, although the earliest documentary references, such as the "old Japan Card Table" listed in a Philadelphia inventory of 1727, probably referred to this form.[3]

References to card tables in the Colonies appear with increasing frequency after about 1725 and include the walnut one owned in 1733 by John Jekyll of Boston.[4] Many of these may have been imported from England, as very few American card

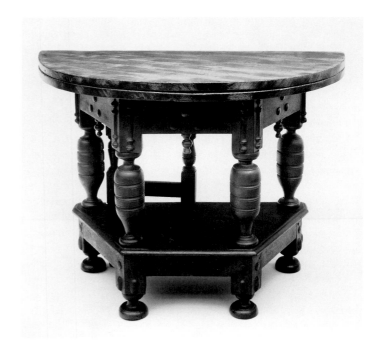

Fig. 47. Cupboard table, Essex County, Massachusetts, 1675–1700. Oak and soft maple. The Metropolitan Museum of Art, New York, Gift of Mrs. J. Insley Blair, 1951.

tables can be securely dated to the first half of the eighteenth century (see cat. 72). After about 1750, there appears to have been a proliferation of card tables among wealthy citizens in all the Colonies (cats. 73–77). By that time card tables were frequently ordered in pairs. John Cadwalader of Philadelphia owned two pairs of card tables, including the "2 Commode card tables" he purchased from Thomas Affleck on October 13, 1770; the 1786 inventory of Cadwalader's house listed card tables in three downstairs rooms.[5] These numbers suggest that card tables were used not only for gaming but as convenient, all-purpose tables that took up little space on the perimeter of a room and could be easily maneuvered when needed. In 1759, George Washington requested Thomas Knox, a factor in Bristol, England, to secure "a neat Make Card Table—w[ch] may serve for a dress[g] one."[6]

1. Chinnery 1979, p. 305.
2. See *DEF*, III, pp. 186–87.
3. Hornor 1935a, p. 12.
4. SCPR, XXXII, p. 308.
5. Wainwright 1964, pp. 44, 72–73.
6. Washington to Thomas Knox, January 1758 (old style), George Washington Correspondence, Washington Papers, Library of Congress.

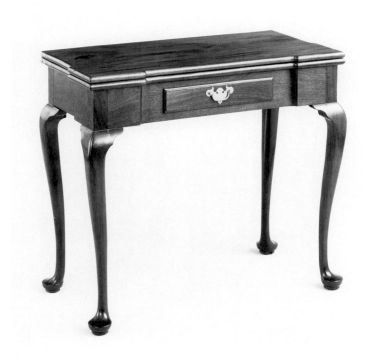
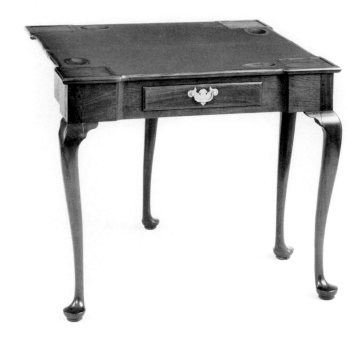

72 72

72

CARD TABLE *Color plate 4*

Boston, 1740–60

Mahogany; eastern white pine (inner rear rail, glue blocks, drawer interior), soft maple (hinged rail)

73.2 x 81.3 x 40 (28 7/8 x 32 x 15 3/4)

Bequest of Olive Louise Dann, 1962.31.20

Structure: The top is attached to the frame with glue blocks. Both leaves are solid boards. A tenon on the back edge of the fixed leaf fits into a reciprocal mortise on the inside edge of the hinged leaf when the top is opened. The top's interior has been carved out to receive a baize lining, with reserved squares at each corner and adjacent oval pockets. The front and side rails and the fixed part of the hinged rail are tenoned and double pinned into the three fixed legs. The right side rail is dovetailed to the inner rear rail, and this joint is reinforced with a glue block. The inner rear rail is nailed to the fixed part of the hinged rail through a filler block and is also nailed to the left rear leg. A finger hinge connects the fixed part of the hinged rail to the fly rail, which is tenoned and double pinned to the fly leg. Knee

brackets are glued to both sides of each leg.

The drawer front and back are dovetailed to the sides. The bottom is a single board nailed into rabbets in the front and sides and to the back. The drawer is supported by two strips of wood tenoned into a strip of wood that is nailed to the inside of the front rail. A drawer guide is glued to the supports.

Condition: The baize has been replaced. All of the blocks below the top have been reglued and some have been replaced. The knee bracket on the fly leg is a replacement. The right front leg broke out and has been repaired. The upper end of the fly leg cracked and was repaired after 1959. The guide on the left drawer runner is a replacement. A spring lock was originally nailed to the drawer bottom. The brass handle is original.

Exhibition: Yale University Art Gallery, New Haven, "The Work of Many Hands: Card Tables in Federal America, 1790–1820," March 25–May 30, 1982.

Reference: Kirk 1982, fig. 1374.

New England card tables in the early Georgian style are uncommon. A small group of Boston-made tables with circular front corners, relatively straight cabriole legs, and accordion-

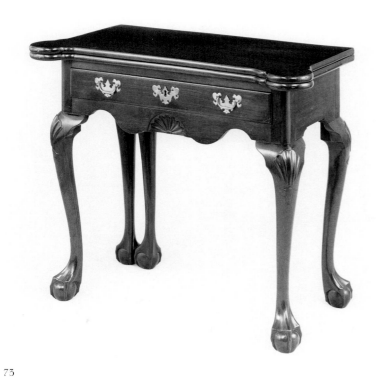

73

hinged side rails includes two of the earliest documented American card tables, a pair purchased by Peter Faneuil of Boston before his death in 1743.[1] The table at Yale, with its square front corners, hinged fly rail, and more robust, curved legs probably represents a later development. The design of the front is similar in effect to contemporary blockfront case furniture. A related table, with a cockbeaded drawer and without pockets in the top, is in the collection of Historic Deerfield.[2] A more attenuated version of the same form with claw-and-ball feet, presumably later than the Yale example, was made by Benjamin Frothingham of Charlestown, Massachusetts, between 1756 and 1790.[3]

1. Warren 1975, no. 57; the mate was sold at auction in 1983 (Sotheby's 1983, no. 358). A card table closely related to this pair is in the Museum of Fine Arts, Boston (Randall 1965, no. 79).
2. Fales 1976, no. 268.
3. Downs 1952, no. 349.

73

CARD TABLE

Probably Hartford or Middletown, Connecticut, 1760–85

Mahogany; black cherry (hinged and inner rear rails), yellow-poplar (drawer interior and runners)

71.9 x 84.1 x 40.9 (28 1/4 x 33 1/8 x 16 1/8)

The Mabel Brady Garvan Collection, 1930.2063

Structure: The top is screwed to the frame rails from inside. Both leaves are solid boards. A tenon on the back edge of the fixed leaf fits into a reciprocal mortise on the inside edge of the hinged leaf when the top is opened. The top's interior has been carved out to receive a baize lining, with reserved circles at each corner and adjacent oval pockets. The front rails are tenoned and pinned into the two front legs. The side and inner rear rails are tenoned and double pinned into the four fixed legs. The fixed part of the hinged rail is nailed flush to the inner rear rail with four nails. A finger hinge connects it to the fly rail, which is tenoned and double pinned to the fly leg. There is a shallow cutout in the inner rear rail into which the upper post of the fly leg is fitted when closed. Knee brackets are glued to both sides of the two front and left rear legs, whereas the two right rear legs each have a knee bracket on their outside corners.

The drawer front and back are dovetailed to the sides. The bottom has feathered edges fitted into grooves in the front and sides and nailed to the back. The drawer is supported by two L-shaped strips of wood nailed to the side frame rails.

Condition: The baize has been replaced. The left rear corner of the fixed top leaf broke off around the hinge and has been repaired. A crack across the upper leaf of the top has been repaired with three butterfly cleats. The right front leg broke off and has been pieced together. A crack in the fly leg has been filled with a new piece of wood. The rear knee bracket on the left rear leg is lost. The lower left corner and both right corners of the drawer front have been broken and repaired. The drawer had interior partitions at one time. The brasses appear to be original.

Reference: Rogers 1931, p. 51.

Provenance: Garvan purchased this table from Charles Woolsey Lyon on April 24, 1929.

Both the style and construction of this table suggest that it may have been made in Connecticut, although this attribution must remain tentative due to the absence of any documented card tables made in Connecticut during the Colonial period. Other examples of this form, which features a top with projecting, rounded corners on a rectangular frame with five legs, have his-

tories of ownership in New York families.[1] The maker of Yale's table was clearly inspired by the urban model, particularly in such refinements as a baize cover and reserves for counters and candlesticks in the top as well as carved knees and feet. The silhouette and carving of this example do not exhibit the liveliness or sophistication associated with New York craftsmanship, however, and none of the New York tables have as deeply arched cyma curves on their skirts. Similar deep curves flanking an intaglio shell appear on a group of case furniture attributed to Hartford or Middletown, Connecticut.[2] Like this table, some of these pieces were made of mahogany, an uncommon wood in Connecticut cabinetmaking. A preference for New York-style card tables is well documented among Connecticut cabinetmakers during the Federal period,[3] and the Yale table may represent an earlier manifestation of this taste.

1. *Antiques* 101 (January 1972), p. 67; *Antiques* 103 (June 1973), p. 1025.
2. See Wadsworth 1985, nos. 99, 107; Kirk 1967a, no. 115; Zea 1985, fig. 7.
3. Hewitt/Kane/Ward 1982, pp. 153–54; Wadsworth 1985, p. 250.

74

CARD TABLE *Color plate 8*

New York City, 1765–85
Mahogany; white oak (hinged rail), redgum (inner rear rail, drawer), eastern white pine (drawer supports)
70.9 x 86.8 x 42.3 (27 7/8 x 34 1/8 x 16 5/8)
The Mabel Brady Garvan Collection, 1936.308

Structure: The top is screwed to the frame rails from inside. Both leaves are solid boards. The interior of the top has been carved out to receive a baize lining, with reserved squares at each corner and adjacent oval pockets. The frame rails are solid boards that are carved into shape. The gadrooning is nailed to the underside of the front and side rails. The front, side, and inner rear rails are tenoned and double pinned into the four fixed legs. The fixed part of the hinged rail is nailed flush to the inner rear rail from outside. A knuckle hinge connects it to the fly rail, which is tenoned and double pinned to the fly leg. Carved knee brackets are glued to the front and side of the two front legs and the sides of the two fixed rear legs. Uncarved knee brackets are glued to the back of the left rear leg and the fly leg.

A small drawer is fitted into an opening cut into the inner rear rail behind the fly leg. The drawer is supported by two L-shaped strips of wood nailed to the front and back frame rails. The drawer sides are dovetailed to the front and back. The bottom is fitted into a rabbet in the front and sides and nailed to all four members. The drawer front fits flush into the inner rail

and the brass knob fits into a reciprocal hole in the fly rail when the table is closed.

Inscriptions: "2" is written in chalk on the inner rear rail. "H. TIBATS" is stamped on the right hinge. An exhibition label for Montgomery/Kane 1976 is attached to the inner rear rail.

Condition: The baize has been replaced. There are two filled cracks in the top's upper leaf. Two dowels have been added to the back edge of the fixed leaf and fit into reciprocal holes on the inside edge of the hinged leaf when the top is opened. The lower leaf was broken near the right hinge and at the right front corner and was repaired by Peter Arkell in 1976. The rear knee bracket on the left rear leg was restored by Arkell at the same time. All of the gadrooning and knee brackets have been reattached with glue. A piece of the right front knee bracket is lost. The inner rear rail broke out of the left rear leg and has been repaired. Two screws have been added to secure the inner rail to the hinged rail. At one time the table had casters, which have been replaced with wooden glides. The drawer bottom has been renailed. The hinges and brass knob are original; the knob retains traces of gilding.

Exhibitions: Montgomery/Kane 1976, no. 116; Yale University Art Gallery, New Haven, "The Work of Many Hands: Card Tables in Federal America, 1790–1820," March 25–May 30, 1982.

References: Rogers 1962a, p. 11; Kirk 1970, fig. 21; Montgomery 1975, p. 65; Cooper 1980, fig. 212 (incorrectly credited to the Museum of Fine Arts, Boston); Prown 1980, fig. 6; Kirk 1982, fig. 26.

Provenance: Acting as Garvan's agent, Henry Hammond Taylor purchased this table and cat. 69 from Ella Hamilton Van Liew (1855–1934) of New York City on March 16, 1933. It is unlikely that the card table descended in her family: her parents were the Reverend William Hamilton of Greencastle, Pennsylvania, and Anna Gage. Hamilton, who was not related to the Hamilton family of New York, entered the Baltimore conference of the Methodist Episcopal Church in 1818 and died in Washington, D.C. (*The New York Times*, February 10, 1872, p. 11). The table may have belonged to the family of Mrs. Van Liew's husband, the silk manufacturer Henry Augustus Van Liew (1857–1933). He was a direct descendant of Frederick Hendrickson Van Leeuwen (b. 1651?), who emigrated in 1670 from Utrecht to Jamaica, Long Island. In 1701, Van Leeuwen moved to Somerset County, New Jersey, where his family remained for over a century before moving to New York City in the 1820s. If the card table was a Van Liew family heirloom, the most likely original owner was either Johannes (1736–1794) or

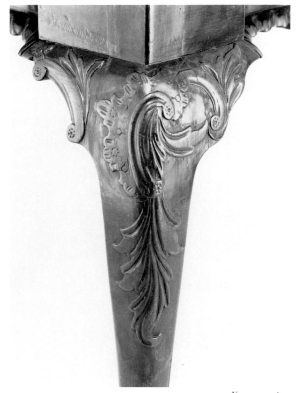

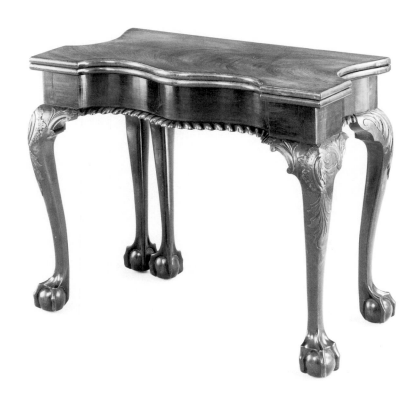

74 *Knee carving* 74

74 74 *Drawer in rear rail*

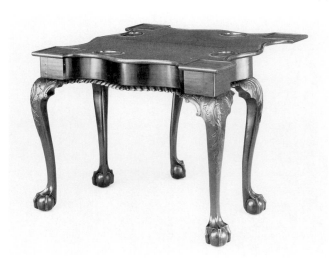

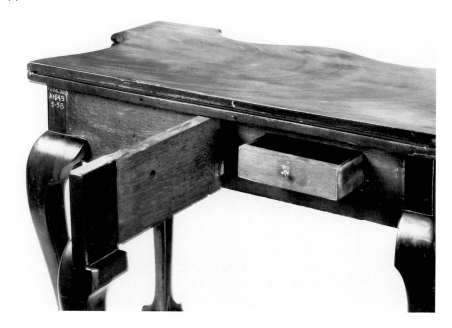

his son Frederick (b. 1760), both of whom lived in New Jersey (*BDSNY* 1900, p. 512; *The New York Times*, April 2, 1933, p. 31; Van Liew 1910, pp. 9–10, 15). It is possible, however, that the table was purchased by a later generation of the family as an antique. The auction of the Van Liews' estate included a variety of eighteenth- and nineteenth-century furniture from New York City, Philadelphia, England, France, and the Netherlands, an assemblage that probably was collected (American Art Association 1934).

This card table is one of the most significant forms of eighteenth-century American furniture. Based on card tables with projecting square corners that were made in the first half of the eighteenth century (see cat. 72), its deep, serpentine rails and richly carved knees are unusually bold statements of the Rococo aesthetic. Documented tables of this type have histories of ownership associated with New York or New Jersey families, although many of these histories are as vague as the one for this table (see *Provenance*). The overall solidity, large gadrooning, and blocklike feet of this example are characteristic features of New York City furniture from the third quarter of the eighteenth century. The origin of this form is uncertain. The contemporaneous production of card tables with projecting, square front corners and serpentine rails in Rhode Island suggests a common, English prototype, although eighteenth-century English examples are extremely rare.[1]

In his systematic study of Colonial New York card tables, Morrison Heckscher distinguished at least two separate shops that produced approximately thirty known examples. This card table belongs to a group of about fifteen he called the "Van Rensselaer type." These tables have deep serpentine rails, bold skirt moldings, and carving on the outside faces of the rear legs, as well as solid serpentine rails shaped on the inside, moldings nailed to the front and side skirts, and tops screwed to the rails from inside.[2] This consistency in style and construction supports Heckscher's contention that all the "Van Rensselaer" tables were produced by the same shop. At least four different carvers executed the carved details of this group; Yale's table was made and carved by the same craftsmen as two other tables, one in the Bayou Bend Collection, Houston, and the other at the Museum of the City of New York.[3] The "2" written in chalk on the inside of the Yale table suggests that it was made as one of a pair, but because they are essentially identical it is impossible to determine if either the Houston or New York table was made as its mate. From the physical evidence of repairs and other alterations on these three tables, they have had separate histories of ownership for a long time.

1. Rhode Island card tables are reproduced in Levy 1977, p. 49, and Rodriguez Roque 1984, no. 147. Heckscher 1973, fig. 11, illustrates an eighteenth-century table that resembles certain New York examples but may be English. Examples of nineteenth-century English origin are illustrated in Gilbert 1978, II, no. 391, and Christie's East 1989b, no. 296.
2. Heckscher 1973, pp. 975–76.
3. Heckscher 1973, pp. 976, 983. The table at Bayou Bend is illustrated in Warren 1975, no. 109.

75

CARD TABLE

New York City, 1765–85

Mahogany (including drawer front), mahogany veneer; soft maple (front and side frame rails), eastern white pine (inner rear rail, drawer runner and guide, strips supporting dustboard), white oak (hinged rail), yellow-poplar (filler pieces, drawer interior, dustboard)

68.6 x 86.3 x 40.3 (27 x 34 x 15 7/8)

The Mabel Brady Garvan Collection, 1930.2618

Structure: The top's lower leaf is nailed to the frame rails beneath the baize cover. Both leaves are solid boards. The top's interior has been carved out to receive a baize lining, with reserved squares at each corner and adjacent oval pockets. The front and side frame rails are carved into shape and have veneered front surfaces. The carved moldings are nailed to the undersides of the front and side rails. The front and side rails and the fixed part of the hinged rail are tenoned into the corner posts of the three fixed legs. The inner rear rail is dovetailed to the right side rail and is nailed through filler pieces of wood to the fixed part of the hinged rail. A knuckle hinge connects the fixed part of the hinged rail to the fly rail, which is tenoned to the fly leg. Carved knee brackets are glued to the front and sides of the front legs; uncarved knee brackets are glued to the back corner of the right side rail and the front side of the left rear leg.

A small drawer is fitted into an opening cut into the inner rear rail behind the fly leg. The front and back are dovetailed to the sides. The bottom is nailed to a rabbet in the drawer front and to the undersides of the sides and back. The drawer is supported by a dustboard that is nailed over strips nailed between the front and inner rear rails. A drawer guide is nailed to the dustboard on the right side. An L-shaped drawer runner is fitted alongside the dustboard on the left side and nailed to the strips. The drawer fits flush into the inner rail. There is a hole in the fly rail to cover the drawer's knob when the rail is closed.

Condition: The baize was replaced and the entire table was cleaned by Peter Arkell in 1973. Arkell also reworked the front rail's finish in 1982. A rectangular piece of veneer has been added to the center of the front rail. The shaped blocks behind

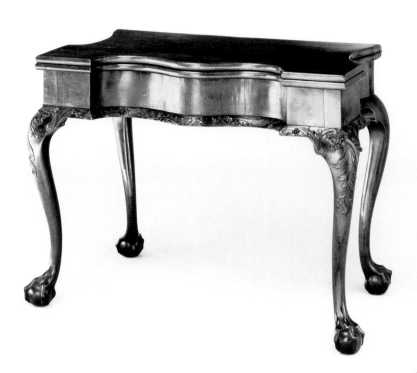

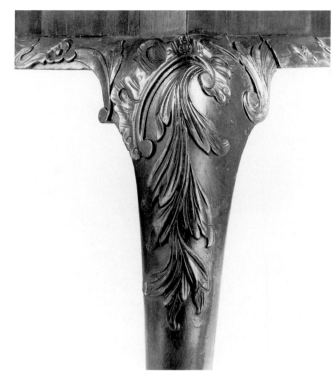

75 75 *Knee carving*

the knee brackets on the front and left rear legs are later additions. The knee brackets on the back side of the two rear legs have been lost. The frame's right rear corner has been reinforced with the addition of two screws. The joint between the fly rail and fly leg has also been reinforced with a screw. New vertical blocks have been glued into both rear corners of the frame. The lower half of the hingepin is lost. A crescent-shaped stop has been added to the drawer back. The drawer's knob is replaced. The feet were once fitted with casters.

Reference: Kirk 1970, fig. 22.

Provenance: Garvan purchased this table from Joe Kindig, Jr., on June 11, 1929.

Four-leg card tables made in New York were purer statements of the Rococo style than most of their five-leg counterparts. In addition to this example, others are at Chipstone and in the Dorothy Scott collection.[1] Just as this table is visually lighter than the preceding table, with thinner, more curvilinear legs and more delicate carving, its construction is much less solid. The front rail is veneered, and the stationary half of the fly rail is

nailed to the inner rear rail through filler blocks of wood. None of the mortise and tenon joints are pinned. Morrison Heckscher suggested that this table was made by a New York City cabinetmaker imitating the two shops producing serpentine front tables on a larger scale.[2]

1. Rodriguez Roque 1984, no. 148; Elder/Stokes 1987, no. 96.
2. Heckscher 1973, p. 978.

76

CARD TABLE

Philadelphia area, 1750–75

Mahogany; white oak (hinged rail), southern yellow pine (inner rear rail, drawer runner), yellow-poplar (drawer sides and back), Atlantic white-cedar (drawer bottom), eastern white pine (glue blocks), hickory (hinge pin)

71.7 x 90.5 x 39.6 (28 1/4 x 35 5/8 x 15 5/8)

The Mabel Brady Garvan Collection, 1930.2628

Structure: The top's lower leaf is pinned to the upper posts of

the legs, and rectangular blocks are glued at the joint between the top and the frame. Both leaves are solid boards. The interior has been carved out to receive a baize lining, with reserved circles and adjacent oval pockets at each corner. The side frame rails are dovetailed to the front and inner rear rails. The projecting front corners are built up with two shaped pieces glued and nailed to the frame on either side of each leg post. The legs appear to be glued in place between these pieces. Small strips of wood are butted against the outside edges of the shaped corner pieces and are glued and nailed to the frame members. The fixed part of the hinged rail is tenoned and pinned to the post of the left rear leg and is nailed flush to the inner rear rail. A knuckle hinge connects it to the fly rail, which is tenoned and double pinned to the fly leg. Knee brackets are glued to both sides of the front legs and the front side of the rear legs.

The drawer front and back are dovetailed to the sides. The upper surfaces of the sides and back are rounded. The bottom is nailed into rabbets cut into the undersides of all four members. The drawer is supported by two L-shaped strips of wood tenoned into the front and back frame rails.

Inscriptions: "# 413 / R" is written in chalk on the left drawer side. A printed paper label is glued to the underside of the top: "Penn [. . .]oo P.M., / J. J. MAGUIRE / 406 MARKET STREET, HARRI[. . .] / [. . .] Scheffer, Printer and Bookbinder, 21 South Second Street, Exclusiv[e . . .]." A printed and typewritten paper label is glued to the exterior of the fixed portion of the hinged rail: "To be detached and fixed on back of object before/ delivery to driver. / NAME OF OWNER Howard Reifsnyder, / STREET 3914 Walnut Street, / CITY Philadelphia, Pa. / NAME OF OBJECT One Folding Card Table." "6" is written in pencil on a piece of paper pasted to the underside of the top.

Condition: The baize is a replacement. Both leaves of the top have been patched around the hinges, which are replacements. The top's lower leaf has been repinned to the frame; the blocks have been reglued and some have been replaced. The edges of both leaves have been patched. The right front leg broke apart and has been repaired: the corner piece attached to the side rail is a replacement screwed on from inside, and nails have been driven through the front of the leg's corner post. The fly leg broke off the fly rail and has been repinned. The incised hatching flanking the shells carved on the knees is a later addition. The knee brackets on both rear legs and the side bracket on the right front leg are replacements. Both upper corners of the drawer front have been restored; the brass handle, keyhole, and lock are all replacements. The right drawer runner is a replacement. The table's surface has been heavily refinished.

Reference: Nutting 1929, I, no. 1026.

Provenance: The fragmentary label on the underside of the top apparently was put on by John J. Maguire, who was listed in Harrisburg, Pennsylvania, directories as a watchmaker at various locations on Market Street between 1900 and 1910 (*Harrisburg Directory*, 1900, p. 378; 1906, p. 467; 1910, p. 498). He may have been the person who sold the table to the collector Howard Reifsnyder of Philadelphia. Garvan acquired the table on April 27, 1929, at the auction of Reifsnyder's estate (*Reifsnyder* 1929, no. 641).

Card tables with projecting, circular front corners (today called "turret" corners) were made in England beginning about 1720, and distinct variations of this form were made in New England, New York, and Philadelphia. In addition to its provenance, the style and construction of this table relate it to other Philadelphia furniture: the use of yellow-poplar, Atlantic white-cedar, and yellow pine as secondary woods; an oak hinged rail nailed flush to the inner rear rail; a knuckle hinge; carved shells and feet that are characteristic of Philadelphia; and frame rails that are taller than those found in New England or New York.[1] This table's deep rails, lipped drawer, and shells with bellflower drops suggest that it was made contemporaneously with mid-century chairs and case furniture with the same features. A later development of this form in Philadelphia is represented by a group of card tables that are richly carved with Rococo ornament on the front corners, apron, and legs.[2]

1. Compare the relative height of this table's rails to the New England card table in Warren 1975, no. 57, and the New York table in Heckscher 1985, no. 105.
2. For example, the card tables at Winterthur (Hummel 1976, p. 114) and Bayou Bend (Warren 1975, no. 110) and in the Kaufman Collection (Flanigan 1986, no. 14).

77

CARD TABLE

Philadelphia, 1765–85

Mahogany; red oak (hinged rail), southern yellow pine (inner rear rail, drawer runners), yellow-poplar (drawer sides and back), Atlantic white-cedar (drawer bottom, vertical corner block)

73.9 x 91.2 x 45 (29 1/8 x 35 7/8 x 17 3/4)

The Mabel Brady Garvan Collection, 1930.2087

Structure: The lower leaf of the top was attached to the frame with a continuous band of rectangular glue blocks. Both leaves are solid boards and have rounded outside edges. Strips of carved gadrooning are nailed to the undersides of the side and lower front rails, extend across the upper ends of the legs, and

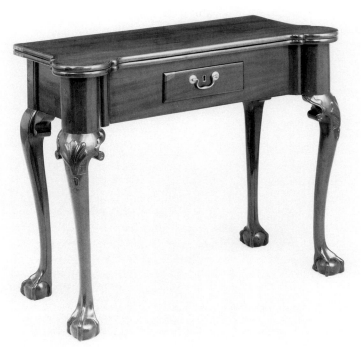
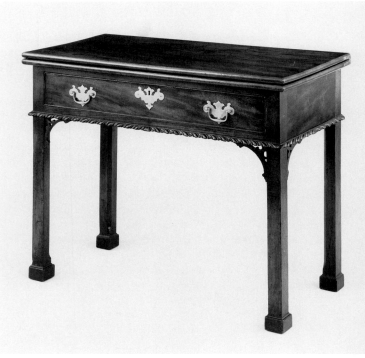

are mitered together at the corners. The two front rails, side rails, and the fixed part of the hinged rail are tenoned into the three fixed legs. The inner rear rail is dovetailed to the right side rail and is nailed flush to the fixed part of the hinged rail. Vertical blocks are glued into the right rear corner of the frame. A knuckle hinge connects the fixed part of the hinged rail to the fly rail, which is tenoned into the fly leg. A cutout in the upper end of the fly leg overlaps the right rear corner of the frame when closed. Each foot is applied around the leg with the side pieces fitted between the front and back. Openwork knee brackets are nailed to both sides of the front legs.

The drawer front and back are dovetailed to the sides. The bottom has feathered edges that fit into grooves in the front and sides; it is nailed to the back. Flat, rectangular strips of wood are glued to the bottom where it joins the front and sides, and runners are glued to the underside of the side members. The drawer is supported by two L-shaped strips of wood nailed to the side rails of the frame.

Inscription: "2" is written in chalk on the fixed part of the hinged rail.

Condition: The upper leaf of the top has been patched around the right hinge. Approximately half of the glue blocks beneath the top have been lost. Both of the side knee brackets are restorations; the right side bracket was made by Peter Arkell in 1973. The right front bracket has been reattached. The molded piece applied to the back side of the right front foot is replaced. The brasses on the drawer front are not original, and a section of the bead molding along its top edge is a replacement. Before Garvan purchased the table, horizontal drawer guides were glued to the frame sides immediately above the runners, and rectangular stops have been glued to the inner rear rail.

Provenance: Garvan purchased this table at auction in New York City on November 21, 1929. The only provenance given in the catalogue was "from Yorktown, Va." (American Art Association 1929, no. 573).

Designs for tables with straight legs, openwork brackets, and applied foot moldings were drawn by Chippendale in 1753.[1] Card tables with these features were made in most of the American Colonies during the second half of the eighteenth century,

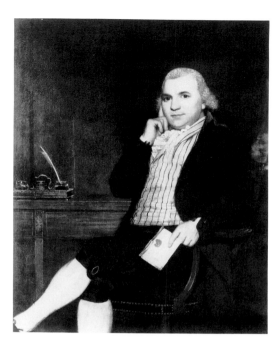

Fig. 48. James Earl, *Humphrey Courtney*, 1794–96.
Oil on canvas. Daughters of the American Revolution
Museum, Washington, D.C.,
Gift of Mrs. Louise Tompkins Parker.

1. Chippendale 1762, pl. 58.
2. A card table of this type labeled by John Townsend of Newport is at the Metropolitan Museum (Heckscher 1985, no. 100), and one signed by Daniel Clay of Greenfield, Massachusetts, is at Historic Deerfield (Fales 1976, no. 276).
3. Weil 1979, p. 186.
4. Philadelphia 1976, no. 79; Hornor 1935a, p. 189, pls. 272–73.
5. See Garvan 1987, pp. 20–21.

Federal Style

So many card tables survive from the Federal period that an immense number must have been produced in this country in the decades after the War of Independence. The rise of new fortunes in the new country and a decline in influence of the traditional Protestant morality have been cited as the cause of this great increase over the number of card tables made during the Colonial period.[1] The increase can also be interpreted as an intensified continuation of the late Colonial practice of using card tables as convenient, all-purpose small tables. A portrait painted by James Earl between 1794 and 1796 shows Humphrey Courtney of Charleston seated at a card table with a letter and inkstand (Fig. 48). Card tables continued to be made in pairs during this period; many single tables in the Art Gallery's collection bear numbers or other inscriptions that suggest they once had a mate. This preference for pairs indicates how much they functioned as part of a furnishing scheme rather than as specialized gaming tables. Sarah Anna Emery described an early-nineteenth century Newburyport, Massachusetts, home: "Stiff looking, slender legged chairs and sofas were primly ranged round the room, with card tables to match in the piers; these sometimes had marble tops. Above them hung large Dutch mirrors."[2]

Card tables were perhaps the most commonly made furniture form after chairs during the Federal period, and they were made in both cities and rural areas of every region. The Art Gallery's collection provides an overview of the regional differences in this common form. There is an impressive group of documented New England tables, although there are no tables in the collection from Vermont, Connecticut, or Newport, Rhode Island. New York and Philadelphia are represented by classic examples, but none of the card tables attributed to these centers are documented. There are no card tables in the collection from Maryland or other southern states.

Because of the large number of tables in this section, it has been organized into more specific regional categories, particularly for the New England tables, than have other parts of the catalogue. The two primary divisions represent the different construction features found in New England as opposed to New

although the New England versions rarely have applied feet.[2] The form was particularly popular in Philadelphia. "Card tables with Malbrough [*sic*] feet" are listed in a manuscript copy of an unidentified Philadelphia price list for furniture that was published in 1772. According to this source, a mahogany table like this one, described as a "Card table with a drawer . . . with braces & bragetes [brackets] . . . with carved moldings" cost £4.[3] Marlborough feet appeared on many documented pieces of furniture made in Philadelphia after 1765, including the suite of upholstered seating furniture made by Thomas Affleck for John Penn about 1766, the case made for David Rittenhouse's orrery in 1771 by John Folwell, and furniture made for the Logan family by Thomas Tufft in 1783.[4] The gadroon moldings, C-scroll brackets, and bases on this table are very similar to those on the Affleck seating furniture, suggesting that this table is contemporaneous. A "Marlborogh" [*sic*] card table made by David Evans for Edward Burd in 1788 eliminated the bases and brackets and substituted a bead-and-reel molding for the gadrooning, creating a more Neoclassical, and presumably later, object.[5]

York and Pennsylvania. These broad categories are subdivided into distinct regional schools, where these have been identified. Documented tables from each region are presented before undocumented examples that are attributed to the same region. Both the construction and style characteristics covered here are based on the pioneering study by Benjamin A. Hewitt (in Hewitt/Kane/Ward 1982), and the reader should consult that volume for the background information from which these conclusions were drawn.

1. Hewitt/Kane/Ward 1982, pp. 15–16.
2. Emery 1879, p. 244.

[NEW ENGLAND]

The majority of the card tables produced in New England, particularly those made in Massachusetts and urban New Hampshire, were much less sturdy but more economically made than their counterparts from the mid-Atlantic states. The rails were thin and the curved rails were constructed from single boards that were bent or sawn to shape or made up from one or two laminates. Filler pieces of wood were inserted between the fixed part of the fly rail and the inner rear frame rail, which permitted the cabinetmaker to assemble the table from parts that were not custom-fitted to each other. The fly legs were rarely shaped to fit over or around the inner rear rail when closed. Most New England tables have finger hinges on the fly rail, which were easier to make but less strong than the knuckle hinges favored outside of New England.

[NORTHERN NEW ENGLAND : MAINE NEW HAMPSHIRE · RURAL MASSACHUSETTS]

In his study of American Federal-period card tables, Benjamin A. Hewitt (in Hewitt/Kane/Ward 1982) found distinct differences between the card tables made in the urban centers of northern New England as opposed to those made in smaller towns. Card tables made in the New Hampshire cities of Concord and Keene have imported woods, sophisticated patterns of veneer, and pictorial inlays (cat. 79). Craftsmen in Portsmouth, New Hampshire's largest city, made card tables that closely resemble Boston products (cat. 83). Tables from rural areas were made more frequently with native primary woods, simpler facade designs, and simpler inlays (cats. 80–82).

78
CARD TABLE

John Caldwell (1746–1813)

Hebron, Maine, 1790–1813

Mahogany, mahogany veneer; eastern white pine (frame rails, glue blocks), hickory (hinge pin)

76 x 95.7 x 46.3 (29 7/8 x 37 5/8 x 18 1/4)

Gift of Benjamin A. Hewitt, B.A. 1943, PH.D. 1952, 1980.87.2

Structure: The top's lower leaf is screwed to the frame rails from inside and the fixed part of the hinged rail from outside. Each leaf is a solid board. The veneered front and side rails are mitered together. The front rail is composed of two horizontal laminates, the lower being only 1 cm (3/8 in.) thick. The front legs are blind dovetailed into the frame's corners. Quarter-round blocks reinforce these joints. The side rails are dovetailed to the inner rear rail. Rectangular blocks with champfered ends are glued into the two rear corners. The inner rear rail is nailed flush to the fixed part of the hinged rail, which is tenoned into the left rear leg. A finger hinge connects the fixed part of the hinged rail to the fly rail, which is tenoned into the fly leg.

Inscriptions: "John Caldwell" is written in chalk on the underside of the top. "No 2 / $10" is written in pencil on the underside of the fly rail. "3" is written in graphite on the underside of the top and the inner rear rail.

Condition: Both front legs broke out from the frame and have been reattached. The front corners of the side rails also broke out and had to be replaced, together with the veneer and stringing in these areas.

Exhibition: Yale University Art Gallery, New Haven, "The Work of Many Hands: Card Tables in Federal America, 1790–1820," March 25–May 30, 1982.

Reference: YUAGB 38 (Winter 1982), p. 67.

Provenance: The donor purchased this table at auction on July 27, 1979 (Skinner 1979, no. 113).

Most of the card tables that can be documented to makers working in Maine are similar to coastal Massachusetts examples in design and construction.[1] The three-unit facade with a contrasting center panel and the shape of Caldwell's table followed a standard form of Boston-area card tables (cats. 103–105). The turnings are a variation of the most common Boston legs (cat. 103), with a simplified capital and an exaggerated swell in the shaft. Unlike urban Massachusetts products, however, this table is made from thick, heavy boards and is constructed to be more sturdy.

78 *Signature*

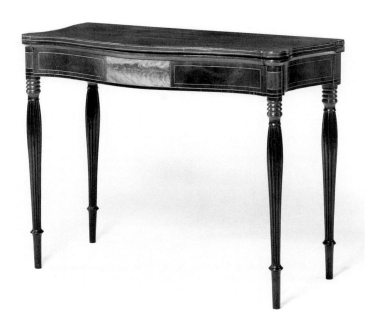

78

What appears to be an original inscription on the fly rail records that it was made as one of a pair at a price of $10 (see *Inscriptions*). This figure is comparable to the cost of similar tables made in New England during Caldwell's working period. A pair of card tables in the estate of Samuel Fisk of Boston was appraised at $15 in 1797; a pembroke table made by Daniel Clay of Greenfield, Massachusetts, cost $5 in 1805.[2]

Like many eighteenth-century settlers in Maine, Caldwell came from Massachusetts, and his early training undoubtedly accounts for the style of his table. John Caldwell was the son of William Caldwell (1708–1758), a joiner and yeoman in Ipswich, Massachusetts, where the family had lived since 1654. Another family member also made furniture: Josiah Caldwell (c. 1784–1864), a cabinetmaker in Salem, Massachusetts, was John's nephew. John Caldwell married Dolly Hoyt of Ipswich in 1771, and they lived in Haverhill before moving to Hebron, Maine, by 1782.[3]

1. A card table attributed to Ichabod Fairfield when he was working in Saco, Maine, was published in Sprague 1987, no. 94, and a card table signed by W.H. Foster of Gorham was illustrated in *Antiques* 133 (May 1988), p. 956. The Portland Museum of Art, Maine, owns a card table signed by Daniel Radford of Portland, who trained in Salem, Massachusetts.

2. SCPR, XCV, p. 44; Wadsworth 1985, no. 139.
3. Caldwell 1873, pp. 4–7, 25–26, 51. The present name of Hebron, Maine, is Oxford.

79
CARD TABLE

Eliphalet Briggs, Jr. (1788–1853)
Keene, New Hampshire, 1810–20
Mahogany, mahogany veneer; eastern white pine
74.6 x 86.3 x 42.1 (29 3/8 x 34 x 16 5/8)
The Mabel Brady Garvan Collection, 1930.2718

Structure: The top's lower leaf is screwed to the frame rails from inside. Each leaf is a solid board. A tenon fitted into the back edge of the lower leaf fits into a reciprocal mortise on the inside edge of the upper leaf when the top is opened. The front and side frame rails are veneered and tenoned into the fixed legs. The rounded front corners are composed of two horizontal laminates that are screwed to the top, the front legs, and the side rails. The right side rail is dovetailed to the inner rear rail. Rounded vertical blocks are glued into the two rear corners. The

inner rear rail is nailed flush to the fixed part of the hinged rail, which is tenoned into the left rear leg. A knuckle hinge connects the fixed part of the hinged rail to the fly rail, which is tenoned into the fly leg.

Inscription: "E Briggs" is written in pencil on the underside of the top.

Condition: The left urn inlay has been damaged and repaired along one side.

Exhibition: Hewitt/Kane/Ward 1982, no. 1.

Reference: Kimball 1931, p. 29.

Provenance: Jacob Margolis acquired this table and its mate in Amenia, New York. He sold them to Garvan in September 1924.

The signature on the underside of this card table is in the same hand as the inscription on a chest of drawers owned by Bertram K. and Nina Fletcher Little: "Eliphalet Briggs j / Keene January 9th 1810 / Made This $19 Doll."[1] Like Caldwell, Briggs produced a table in the Boston style—identical urn inlays appear on Boston-area tables (cats. 98, 99)—that was, however, much more solidly constructed than its metropolitan counterparts. The curved front corners are cut from thick laminated blocks of wood, and the rear rails are nailed together without filler blocks between them, as was common in Boston. Briggs' table and another made in Rhode Island for the New York market (cat. 107) are the only New England tables in Yale's collection with knuckle hinges, which were more characteristic of the mid-Atlantic region.

 This card table is one of a pair. The present whereabouts of the mate is unknown; it was traded or sold by the Art Gallery between 1955 and 1969.

1. New Hampshire 1979, 142, no. 54.

8 0

CARD TABLE *Color plate 11*

John Dunlap II (1784–1869)

Antrim, New Hampshire, 1806–10

Black cherry, black cherry veneer; eastern white pine (front and inner rear rails, glue blocks), birch (hinged rail), ash (hinge pin)

74 x 91.3 x 45.3 (29 1/8 x 36 x 17 7/8)

Gift of Benjamin A. Hewitt, B.A. 1943, PH.D. 1952, 1978.129.1

Structure: The top's lower leaf is screwed to the front and side frame rails from inside. The joint between the top and the frame was reinforced by a few rectangular glue blocks. Both

79 *Signature*

80 *Label*

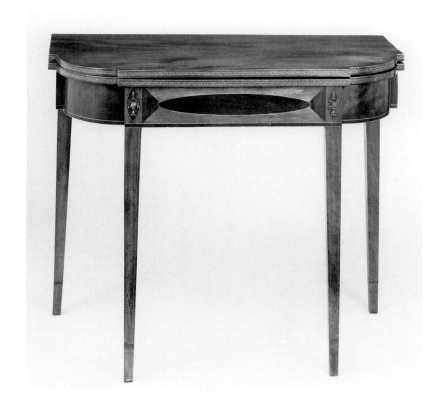

79

80

80 Top

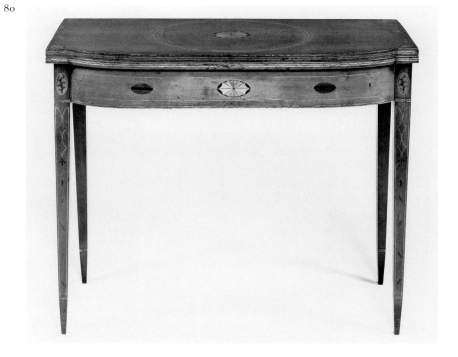

leaves are made of two boards butted together. The veneered front rail is composed of three horizontal laminates. The curved rail's ends are screwed from behind to flat blocks of wood that are tenoned into the front legs. The frame's side rails are solid and are also tenoned into the fixed legs. Vertical blocks reinforce the joints between the side rails and the front legs. The right side rail is dovetailed to the inner rear rail. The inner rear rail is nailed through two filler pieces of wood to the fixed part of the hinged rail, which is tenoned into the left rear leg. A finger hinge connects the fixed part of the hinged rail to the fly rail, which is tenoned into the fly leg.

Inscription: "John Dunla[p . . .]" is written in ink on a strip of paper glued to the underside of the top.

Condition: The left rear corner of the hinged leaf broke off and was reattached by Robert M. Soule in 1981. The top has been removed from the table; some of the blocks have been reglued and others are lost or replaced. A screw connecting the fixed part of the hinged rail to the top is probably a later addition. The front corner blocks are later additions. The patterned banding on the left side rail is damaged at the center.

Exhibitions: New Hampshire 1979, no. 36; Hewitt/Kane/Ward 1982, no. 4.

References: Page 1979, pl. 12; *YUAGB* 37 (Summer 1979), p. 59; Kane 1980, fig. 11; Hewitt 1982, pl. 5.

Provenance: The donor purchased this table from the dealer John P. Cotter, Jr., of West Hartford, Connecticut, on April 26, 1975.

This richly decorated card table is a superlative example of John Dunlap's work. The legs, skirt, and particularly the top illustrate his love for small-scale, inlaid ornaments that added a lively quality to primary woods without a bold figure. Dunlap was also adept at manipulating the materials available to him to simulate more sophisticated effects; the oval inlays at the top of the legs have been scorched with hot sand in a floral design similar to pictorial inlays (see cats. 86, 108).

 Dunlap is first recorded as living in Antrim in 1806, and two card tables very similar to this one have labels dated 1807.[1] At least three other tables, including cat. 81, can be attributed to him on the basis of their idiosyncratic decoration and construction. According to Benjamin A. Hewitt, the most distinctive feature of this group is a weak inner rear rail, which is dovetailed to the right side rail but falls short of the left rear corner and is nailed through filler blocks to the fixed part of the hinged rail.[2] The identical inlays, legs, and rail construction on this group of tables suggest that Dunlap made them all at about the same time.

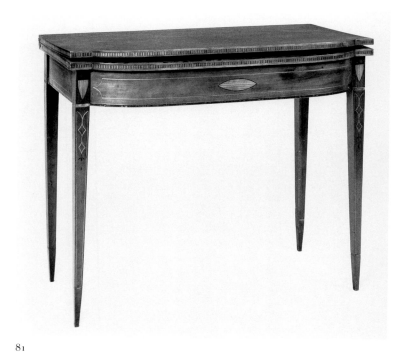

81

1. Currier 1970, no. 90; New Hampshire 1979, p. 144. The second table is in a private collection.
2. Hewitt/Kane/Ward 1982, p. 120. Aside from the other Dunlap table at Yale, the two other card tables attributed to Dunlap are in private collections. I am indebted to Benjamin A. Hewitt for this information on the privately owned Dunlap card tables.

81

CARD TABLE

Attributed to John Dunlap II (1784–1869)

Antrim, New Hampshire, 1806–10

Birch (top), black cherry (side rails, legs), black cherry veneer; eastern white pine (front and inner rear rails), soft maple (hinged rail)

74.2 x 90.6 x 43.2 (29 1/4 x 35 5/8 x 17)

Gift of Benjamin A. Hewitt, B.A. 1943, PH.D. 1952, 1978.129.2

Structure: The top's lower leaf was attached to the frame with closely spaced rectangular glue blocks. Each leaf is a single board. The veneered front rail is composed of two horizontal laminates. Its ends are screwed from behind to flat blocks of wood that are tenoned into the front legs. The frame's side rails are solid and are also tenoned into the fixed legs. Vertical glue blocks reinforced the joints between the siderails and the front

82 *Brand*

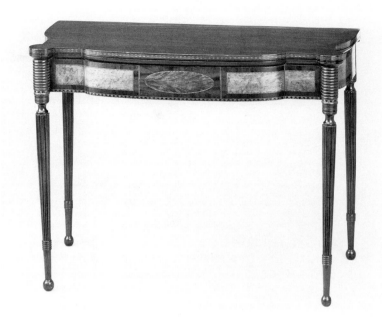

82

legs. The right side rail is dovetailed to the inner rear rail. The inner rear rail is nailed through two filler pieces of wood to the fixed part of the hinged rail, which is tenoned into the left rear leg. A finger hinge connects the fixed part of the hinged rail to the fly rail, which is tenoned into the fly leg.

Inscription: "5" is impressed on a metal disk nailed to the underside of the front rail.

Condition: The top has been removed from the frame; all of the blocks along the front rail have been lost and the remainder have been replaced. Two screws now secure the top to the front rail. The vertical corner blocks are also lost. A deep gouge in the front rail to the left of the center has been filled. Losses in the patterned banding, particularly on the front legs, were restored by Peter Arkell in 1982.

Exhibition: Yale University Art Gallery, New Haven, "The Work of Many Hands: Card Tables in Federal America, 1790–1820," March 25–May 30, 1982.

Provenance: The donor purchased this table from the dealer Wayne Pratt of Marlboro, Massachusetts, on September 10, 1976.

See cat. 80 for a discussion of the attribution to John Dunlap II. In a characteristically creative use of limited resources, Dunlap

made the shield-shape inlays on the legs from a pointed oval similar to the one inlaid at the center of the skirt.

82

CARD TABLE

Alden Spooner (1784–1877)

Athol, Massachusetts, 1807–45

Black cherry with mahogany, black cherry, and maple veneers; eastern white pine (all rails), hickory (hinge pin)

73.1 x 94.8 x 46.4 (28 3/4 x 37 3/8 x 18 1/4)

Gift of Benjamin A. Hewitt, B.A. 1943, PH.D. 1952, in memory of Charles F. Montgomery for inspiring *The Work of Many Hands*, 1981.71

Structure: The top's lower leaf is screwed to the frame rails from inside. Each leaf is composed of two boards. The front and side rails are veneered; the projecting sections are separate pieces glued to the rails. The front and inner rear rails are dovetailed to the side rails. The frame's front corners are screwed into cutouts in the front legs. The left rear leg is butted and glued to the left side rail. The inner rear rail is glued flush to the fixed part of the hinged rail, which is tenoned into the left rear

leg. A finger hinge connects the fixed part of the hinged rail to the fly rail, which is tenoned into the fly leg.

Inscription: "SPOONER / ATHOL" is branded on the outside of the fixed part of the hinged rail.

Condition: The two front legs broke out at one time and have been reattached to the frame. The upper edge of the front frame rail adjacent to the left front leg was broken off and a new screw has been added to secure the top in this area.

Exhibition: Hewitt/Kane/Ward 1982, no. 8.

References: Hewitt 1982, fig. 2; *YUAGB* 38 (Winter 1983), p. 73.

Provenance: The donor purchased this table from the dealer Robert E. Cleaves of Groton, Massachusetts, on November 21, 1974.

As the product of a rural cabinetmaker, this card table stands in sharp contrast to the following example (cat. 83), which was made in a coastal city. The construction of the two tables is very similar, although Spooner used an unusually short fly rail. He also imitated the shape and overall design of the urban model. Much more individualistic are Spooner's distinctive, attenuated turnings and his fondness for boldly patterned inlay. Another card table branded by Spooner is identical in design and construction to the Art Gallery's example, with the exception of minor differences in the patterned inlays.[1]

Born in Petersham, Massachusetts, Alden Spooner was working in Athol as early as July 1807, when he signed and dated a chest of drawers.[2] The "SPOONER" and "ATHOL" brands on this table were also used to mark furniture made by Spooner in partnership with George Fitts, as well as a Windsor chair marked "SPOONER & THAYER ATHOL."[3] Philip Zea has published the dates of Spooner and Fitts' partnership as 1808–13, which seems more in keeping with the style of their furniture than the starting date of 1826 proposed in a history of Athol.[4] It is not known if Spooner made furniture independently when he was in partnerships, or if furniture marked with his name alone was made when he was working without a partner.

1. Zea 1985, fig. 14.
2. Harlow 1979, pl. 5.
3. Furniture by Spooner and Fitts includes a candlestand and chest of drawers at Old Sturbridge Village, Massachusetts (Harlow 1979, pls. 6–7, fig. 2) and Windsor chairs at Historic Deerfield (no. 68-179) and the Pocumtuck Valley Memorial Association, Deerfield, Massachusetts (Fales 1976, no. 181). The Windsor chair by Spooner and Thayer is in a private collection (DAPC 78.727).
4. Zea 1985, p. 661; Lord 1953, p. 282.

83

CARD TABLE

Portsmouth, New Hampshire, or Boston area, 1800–25

Mahogany (including the filler block), mahogany and satinwood veneers; eastern white pine (frame rails, glue block), birch (hinged rail)

75.4 x 94 x 45.9 (29 5/8 x 37 x 18 1/8)

The Mabel Brady Garvan Collection, 1930.2519

Structure: The top's lower leaf is screwed to the frame rail from inside. Each leaf is a solid board. A tenon in the back edge of the fixed leaf fits into a reciprocal mortise on the inside edge of the hinged leaf. The front and side rails are veneered; the projecting sections are separate pieces applied to the rails. The front and inner rear rails are probably dovetailed to the side rails. Quarter-round blocks are glued into each corner of the frame. The front corners are fitted into cutouts in the legs. The left side rail may be tenoned into the left rear leg. The inner rear rail and the fixed part of the hinged rail are glued together with a filler piece of wood between them. The fixed part of the hinged rail is tenoned into the left rear leg and connected to the fly leg by an unusual finger hinge with rounded ends. The fly rail is tenoned into the fly leg, and there is a small block glued behind this joint.

Inscriptions: "B & T No 1" is written in pencil on the underside of the top. "1" is stamped on the upper surface of the front rail and the underside of the top. "41" is written on a paper tag attached to the outside of the fly leg; "41" is also painted in red on the fly leg adjacent to the tag.

Condition: Both corner blocks on the table's left side have been replaced; both corner blocks on the right side have been reattached. A small block has been inserted between the inner rear rail and the fixed rail at the hinge.

Exhibition: Yale University Art Gallery, New Haven, "The Work of Many Hands: Card Tables in Federal America, 1790–1820," March 25–May 30, 1982.

Provenance: Garvan purchased this table from Charles Woolsey Lyon.

The small number of documented card tables from Portsmouth makes it difficult to attribute this example to that city with certainty. This shape was apparently popular in Portsmouth; it was used by Judkins and Senter of Portsmouth for a pair of card tables they made in 1816 for the merchant Jacob Wendell.[1] The same shape, however, was one of two illustrated for card tables by Thomas Sheraton in the 1793 *Appendix to the Cabinet-Maker*

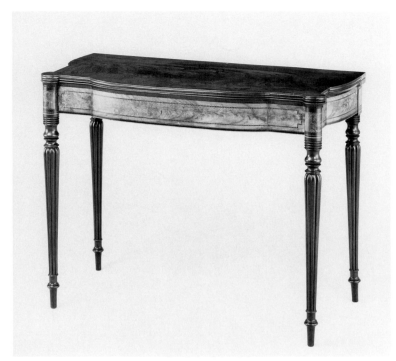

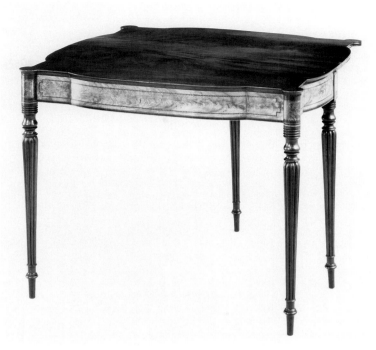

83 83

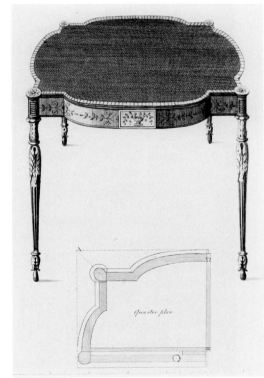

Fig. 49. G. Terry after Thomas Sheraton, *Card Tables* (detail),
from *Appendix to the Cabinet-Maker and Upholsterer's Drawing-Book*, 1793.

and Upholsterer's Drawing-Book (Fig. 49), and card tables of this shape were made in Massachusetts and Vermont as well as New Hampshire during the Federal period.[2] A card table very similar in appearance to the Art Gallery's was owned in the family of Dr. Josiah Bartlett (1729–1795) of Kingston, New Hampshire, and another similar pair was purchased by the merchant James Rundlet of Portsmouth between about 1800 and 1820.[3] Most of Rundlet's furniture was acquired from local cabinetmakers, although his tables might have been made in Boston for the coastal trade. The construction and design of the Art Gallery's card table suggest that it was an urban product. The turnings are of a type associated with Boston,[4] but details such as the heavy reeding of the legs and the molded edge on the upper leaf of the top suggest an origin outside of that city.

1. New Hampshire 1979, no. 9. I am grateful to Brock Jobe for his observations on the Portsmouth characteristics of this card table.
2. Hewitt/Kane/Ward 1982, p. 70; *Sack Collection*, VIII, p. 2195; Hosley 1987, p. 266.
3. Sander 1982, no. 58. The Bartlett family table was sold at auction in Kingston on June 24, 1989; it was illustrated in *Maine Antique Digest* 17 (July 1989), p. 3f.
4. Hewitt/Kane/Ward 1982, pp. 65–66.

84

CARD TABLE

New Hampshire or Massachusetts, 1810–30

Mahogany, maple veneer; eastern white pine (frame rails, glue blocks), birch (hinged rail)

74.9 x 91.5 x 44.8 (29 1/2 x 36 x 17 5/8)

The Mabel Brady Garvan Collection, 1930.2700

Structure: The top's lower leaf is screwed to the frame rails from inside. Each leaf is a solid board. A tenon in the back edge of the lower leaf fits into a reciprocal mortise on the back edge of the hinged leaf. The veneered front and side rails are mitered together. The front legs are blind dovetailed to the front corners. The side rails are dovetailed to the inner rear rail. Quarter-round blocks are glued into the frame's corners. The front blocks are also secured by angled nails driven through the undersides of the side rails. The inner rear rail is nailed through a filler board to the fixed part of the hinged rail, which is tenoned into the left rear leg. A finger hinge connects the fixed part of the hinged rail to the fly rail, which is tenoned into the fly leg.

Condition: The hinge on the left side of the top broke out, and the top has been repaired in that area.

Inscription: "C 12 39" is written in crayon on the underside of the top.

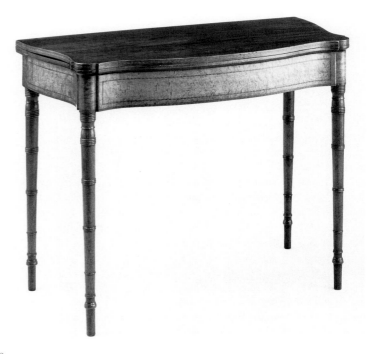

84

References: Halsey 1930, p. 429; Miller 1937, II, no. 1525; Battison/Kane 1973, p. 163.

Provenance: Garvan purchased this table from Charles Woolsey Lyon.

This simple card table was probably made in southern New Hampshire or a town in Massachusetts that was removed from the direct influence of one of the large coastal cities. The uninterrupted expanse of veneer on the facade, the legs ornamented with a series of stacked rings, and the shape all resemble two card tables made between about 1820 and 1840 by Isaiah Wilder, who worked in Hingham, Massachusetts, and Surry and Keene, New Hampshire.[1] Another closely related card table was branded by an unidentified "T. Green," whose use of veneer was influenced by eastern Massachusetts styles.[2] Turnings with evenly spaced, stacked rings also appear on a sideboard signed in 1815 by Anson T. Fairchild of Northampton, Massachusetts, and a sofa made by Judkins and Senter of Portsmouth, New Hampshire, in 1816.[3]

1. Hewitt/Kane/Ward 1982, no. 7; New Hampshire 1979, no. 55.
2. Fales 1976, no. 288.
3. "Collectors' Notes" 1959; New Hampshire 1979, no. 10.

85 *Label*

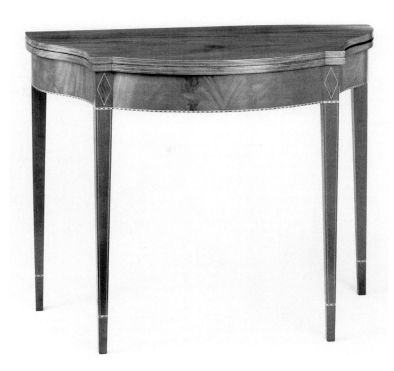

[NEWBURYPORT, MASSACHUSETTS]

Card tables made in Newburyport, Massachusetts, during the Federal period were distinguished by the frequency of rare or unique shapes employed by the makers (cat. 88) and by equally distinctive turnings (cats. 87, 88). Relatively plain facades were usually complemented by ornamental inlay or carving on the pilasters of the front legs, a feature found on all the Newburyport tables at Yale.[1]

1. Hewitt/Kane/Ward 1982, pp. 124–25.

85

CARD TABLE

Joseph Short (1771–1819)

Newburyport, 1806

Mahogany, mahogany veneer; eastern white pine (frame rails, filler pieces, glue blocks), birch (hinged rail), hickory (hinge pin)

72.6 x 90.3 x 44 (28 5/8 x 35 1/2 x 17 3/8)

Gift of Benjamin A. Hewitt, B.A. 1943, PH.D. 1952, in honor of Patricia E. Kane for making *The Work of Many Hands* a reality, 1981.82

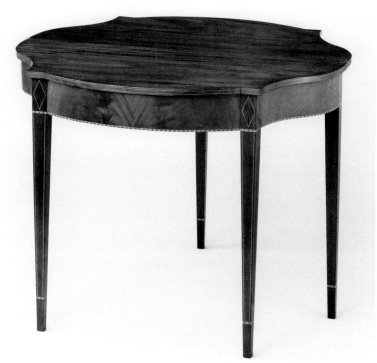

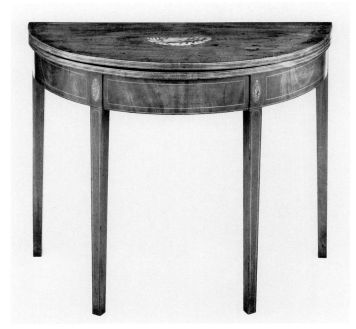
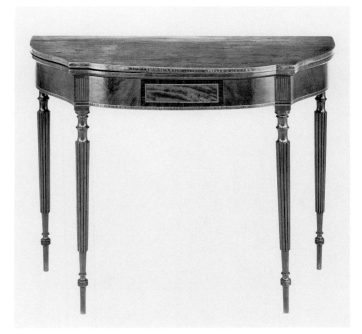

86 87

86 *Top inlay*

Structure: The top's lower leaf is screwed to the frame rails from inside. Each leaf is made of two boards. The front and side frame rails are veneered. The curved front rail is cut from a solid board and screwed to an inner rail through three filler blocks of wood. The side rails are cut from solid boards. The inner front rail and the side rails are tenoned into the front legs. The side rails are dovetailed to the inner rear rail. Rounded vertical blocks are glued behind both ends of each side rail; rectangular vertical blocks are glued at either end of the inner front rail. The inner rear rail is nailed through two filler pieces of wood to the fixed part of the hinged rail, which is tenoned and double pinned into the left rear leg. A finger hinge connects the fixed part of the hinged rail to the fly rail, which is tenoned and double pinned into the fly leg.

Inscriptions: A printed paper label is glued to the underside of the top: "WARRANTED / *CABINET WORK* / OF ALL KINDS, MADE AND SOLD BY, / JOSEPH SHORT, / At his Shop, Merrimack Street, between / Market-Square and Brown's Wharf, / NEWBURYPORT. / [hand pointing to right] ALL orders for Work will be gratefully / received and punctually executed." The notation "Next below Mr. John Boardman's" is handwritten in ink between the label's sixth and seventh lines, and the date "1806" is written at the end of the last line. "1" is written in pencil on the inner rear rail.

Condition: The hinged rail is a replacement, although the nails that secured the inner rear rail to the original fixed part appear to have been retained. The pins securing the new rail to the rear legs appear to have been added when the rail was replaced.

Exhibition: Hewitt/Kane/Ward 1982, no. 9.

Provenance: The donor purchased this table at an auction held by Richard W. Oliver of Kennebunk, Maine, on July 3, 1977.

Like other furniture produced by Short during his brief career, this card table is a masterpiece of restrained ornament on a superbly designed form.[1] The patterned inlay of lightwood lozenges on a dark ground sets up a subtle interplay with the lozenge shapes of dark veneer outlined in lightwood stringing on the pilasters. In comparison to other tables of the same shape (cats. 87, 99–101, 106), this table has front and side rails that are more deeply curved, creating a lively overall silhouette that is particularly apparent when the top is open.

1. A labeled card table and candlestand by Short are at Winterthur (Montgomery 1966, nos. 294, 371); another labeled card table was published in Fales 1965, no. 39.

86

CARD TABLE

Coastal Massachusetts, probably Newburyport, 1790–1810

Mahogany, mahogany and maple veneers; chestnut (front, side, and inner rear rails), soft maple (hinged rail), eastern white pine (blocks), hickory (hinge pin)

72.7 x 92.7 x 45.7 (28 5/8 x 36 1/2 x 18)

The Mabel Brady Garvan Collection, 1936.311

Structure: The top is screwed to the frame rails from inside. The leaves of the top are solid boards. The back edge of the fixed leaf has a tenon that fits into a reciprocal mortise on the hinged leaf's inside edge when the top is opened. The curved front and side rails are sawn into shape and veneered. Tenons on the ends of these rails are butted together inside a channel cut into the upper end of each front leg. These joints are reinforced by screws, which may be later additions. The side rails are dovetailed to the inner rear rail, and an angled block is glued behind each joint. The fixed center part of the hinged rail is screwed and nailed to the inner rear rail through a filler piece of wood. Finger hinges connect the fixed part of the hinged rail to the two fly rails, which are tenoned into the fly legs. An angled block is glued behind each of these joints.

Inscription: "1790 'PAUL REVERE OWNED THIS TABLE / MR. GARVAN BOUGHT IT FROM PR'S / GREAT GREAT GRAND-DAUGHTER'" is written on an adhesive label attached to the underside of the top.

Condition: The inlay on the top was repaired by Emilio Mazzola in 1963 and recolored by Peter Arkell in 1972.

Exhibition: Hewitt/Kane/Ward 1982, no. 11.

Provenance: According to family tradition, this table originally was owned by the silversmith Paul Revere II (1735–1818) of Boston. It descended from Revere's granddaughter, Deborah Lazelle Revere (1799–1845), who married Alexander Lincoln (1806–1879) in 1827 (*Hingham* 1893, II, pp. 485–86). By his second wife, NinEva Aldrich, Alexander Lincoln fathered Alexander Randolph Lincoln (b. 1871). A. R. Lincoln's wife, Marjorie, sold the table on September 23, 1936 to John Marshall Phillips, curator of silver at the Art Gallery, who was acting as Garvan's agent.

The design and construction of this card table indicate that it was made in Newburyport, which seems at odds with its supposed ownership by Paul Revere (see *Provenance*). Benjamin A. Hewitt has noted, however, that the large number of surviving tables that can be attributed to the relatively small town of Newburyport may be evidence of an export trade.[1] This table's inlays may have been chosen to satisfy the Boston market. Similar thistle inlays appear on a pair of tables originally owned by the merchant Perrin May (1767–1844) of Boston, and the large shell inlaid at the center of the top is reminiscent of the shell inlay on the pair of card tables made for Elizabeth Derby West of Salem, Massachusetts, around 1809.[2] Undoubtedly imported, perhaps from Boston, the shell inlay on Yale's table is awkwardly placed, suggesting that the maker only imperfectly understood the style he was imitating.

1. Hewitt/Kane/Ward 1982, p. 124.
2. Sander 1982, no. 54; Hipkiss 1941, no. 64.

87

CARD TABLE

Coastal Massachusetts, probably Newburyport, 1790–1810

Mahogany, mahogany veneer; eastern white pine (frame rails, glue blocks), hard maple (hinged rail)

72.6 x 91.3 x 43 (28 5/8 x 36 x 16 7/8)

The Mabel Brady Garvan Collection and the Gift of C. Sanford Bull, B.A. 1893, by exchange, 1966.64

Structure: The top's lower leaf is screwed to the frame rails from inside. Each leaf is a solid board. The veneered front and side rails are composed of two horizontal laminates. The curved front rail is glued or nailed to an inner, flat front rail that is tenoned into the front legs. Rectangular blocks are glued behind this joint. The side rails are nailed or glued to the front legs and dovetailed to the inner rear rail. Quarter-round blocks are glued behind these joints. The inner rear rail is nailed through two

filler pieces of wood to the fixed part of the hinged rail, which is tenoned into the left rear leg. A finger hinge connects the fixed part of the hinged rail to the fly rail, which is tenoned into the fly leg.

Condition: The crudely executed reeding on the pilasters appears to be a later addition. Peter Arkell restored the center strip of the banding on the fly leg in 1975. The corresponding strips on the other legs appear to be earlier replacements.

References: Sack Collection, I, p. 258; Kirk 1982, fig. 377.

Provenance: The Art Gallery acquired this table from the dealer Israel Sack, Inc., of New York City on September 29, 1966.

The turnings on this card table are identical to those on another attributed to Newburyport, but variations in the construction of these two tables make it likely that they were produced in different shops.[1]

1. Hewitt/Kane/Ward 1982, no. 13.

88

CARD TABLE

Probably Newburyport, 1800–20

Mahogany, mahogany and zebrawood veneers; basswood (front
 frame rail), eastern white pine (side and inner rear rails),
 birch (hinged rail)

74.7 x 91.1 x 45.5 (29 3/8 x 35 7/8 x 17 7/8)

The Mabel Brady Garvan Collection, 1931.1234

Structure: The top's lower leaf is screwed to the frame rails from inside and the inner rear rail and fixed part of the hinged rail from outside. Each leaf is a solid board. A tenon in the back edge of the lower leaf fits into a reciprocal mortise on the back edge of the hinged leaf. The veneered front and side rails have a bead molding nailed to their undersides. The projecting part of the front rail is a separate piece glued to the rail, and the projecting parts of the side rails are each made of two separate pieces of wood glued to the rail. The front rail is butted and glued between the side rails. The side rails are dovetailed to the inner rear rail. Rectangular blocks are glued in all four corners. The front corners of the frame are glued into cutouts in the front legs; these joints are secured with screws through the upper surface of the frame rails. The inner rear rail is nailed through two filler pieces of wood to the fixed part of the hinged rail, which is tenoned and double pinned to the left rear leg. A finger hinge connects the fixed part of the hinged rail to the fly rail, which is tenoned and double pinned to the fly leg.

Inscription: "27" is written in pencil on the upper surface of the front rail.

Condition: The surface was refinished by Emilio Mazzola in 1964. At one time the legs were fitted with casters.

Exhibition: Yale University Art Gallery, New Haven, "The Work of Many Hands: Card Tables in Federal America, 1790–1820," March 25–May 30, 1982.

Provenance: Garvan purchased this table from Henry Hammond Taylor in December 1930.

The carved vertical leaves with a star-punched ground on this table's pilasters traditionally have been associated with Salem, Massachusetts; a pair of side tables with similar carving was labeled by the Salem cabinetmaker William Haskell.[1] This motif, however, was popular throughout northern New England. Carved leaves appear on a bed probably made in 1816 by Daniel Wise of York, Maine, and a card table made in 1827 by John Dunlap II in Antrim, New Hampshire.[2] The present table was probably made in Newburyport, as its complex shape was used almost exclusively by cabinetmakers in that city.[3]

1. Montgomery 1966, no. 343. See also cat. 152.
2. Sprague 1987, no. 96; New Hampshire 1979, no. 46.
3. Hewitt/Kane/Ward 1982, pp. 68, 70.

[SALEM, MASSACHUSETTS]

The variety of card tables made in Salem during the Federal period rivaled that of Boston and reflected Salem's great prosperity at this time. The Art Gallery's collection includes documented examples that range from austere and monochromatic (cats. 89, 90) to richly ornamented with veneers and patterned inlay (cats. 91, 92).

89

CARD TABLE

Mark Pitman (1779–1829)

Salem, 1800–29

Mahogany, mahogany and rosewood veneers; eastern white pine
 (frame rails, glue blocks), birch (hinged rail)

74.2 x 91.6 x 43.9 (29 1/4 x 36 1/8 x 17 1/4)

Gift of Mr. and Mrs. Charles F. Montgomery, 1976.121

Structure: The top's lower leaf is screwed to the frame rails from inside. Each leaf is made of a single board. The veneered front rail is composed of two horizontal laminates; the ends of

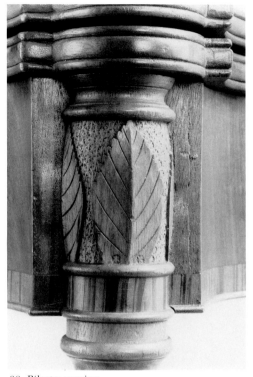

88 *Pilaster carving*

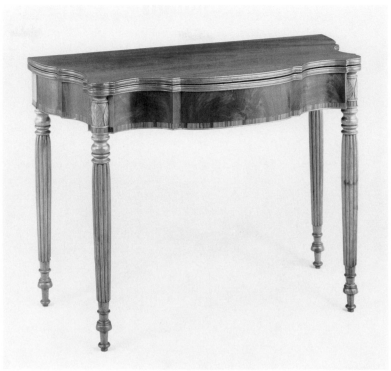

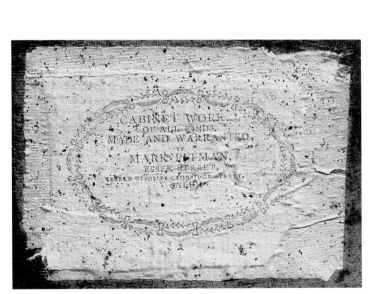

CABINET WORK,
OF ALL KINDS,
MADE AND WARRANTED,
BY
MARK PITMAN,
ESSEX STREET,
NEARLY OPPOSITE CAMBRIDGE STREET,
SALEM.

89 *Label*

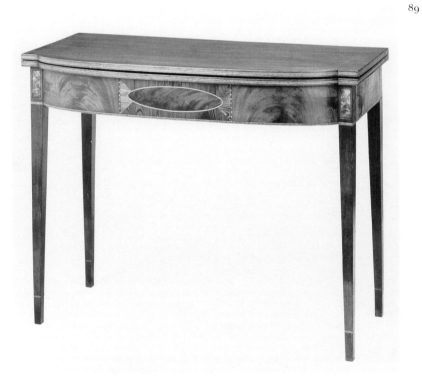

this rail are laminated, wedge-shaped pieces of wood that are butted and glued in place. The veneered side rails are single boards. The frame rails are tenoned into the fixed legs; the right side rail is dovetailed to the inner rear rail. Two-piece, rounded blocks are glued into the frame's front corners to reinforce these joints. Similar blocks were also glued into the rear corners. The inner rear rail is nailed through a filler piece of wood to the fixed part of the hinged rail, which is tenoned into the left rear leg. A finger hinge connects the fixed part of the hinged rail to the fly rail, which is tenoned and double pinned into the fly leg.

Inscription: A printed paper label is glued to the underside of the top: "CABINET WORK, / OF ALL KINDS, / MADE AND WARRANTED, / BY / MARK PITMAN, / ESSEX STREET, / NEARLY OPPOSITE CAMBRIDGE STREET, / SALEM."

Condition: The blocks are lost from both rear corners. The patterned inlay on the fly leg was restored by Peter Arkell in 1982.

Exhibitions: Yale University Art Gallery, New Haven, "Recent Acquisitions," December 19, 1979–February 10, 1980; Hewitt/Kane/Ward 1982, no. 14.

Reference: Hewitt 1982, fig. 1.

Provenance: Montgomery purchased this table on October 19, 1963.

Over the course of thirty years, Pitman used at least four different labels with the same address and essentially the same text. What are almost certainly the earliest appear on a small sideboard and chest of drawers.[1] This table, with the most sophisticated use of veneer and patterned inlay in Pitman's documented work, stylistically belongs to the early part of his career. The closest variant of its label, however, is pasted to the frame of a printed silk ribbon commemorating the deaths of John Adams and Thomas Jefferson in 1826.[2]

1. Montgomery 1966, no. 358; Fales 1965, no. 33.
2. Fales 1965, no. 34.

90

CARD TABLE

Thomas Needham III (1780–1858)

Salem, 1800–20

Mahogany, mahogany and maple veneers; eastern white pine

74.6 x 91.4 x 45 (29 3/8 x 36 x 17 3/4)

Gift of Benjamin A. Hewitt, B.A. 1943, PH.D. 1952, 1980.87.1

Structure: The top's lower leaf is screwed to the frame rails from inside; the joint with the inner rear rail is reinforced with three angled glue blocks. Each leaf is a solid board. The veneered frame rails are presumably tenoned into the fixed legs. The rounded front corners are composed of two horizontal laminates screwed to the top, the front legs, and the side rails. The right side rail is dovetailed to the inner rear rail. Champfered blocks are glued into the two rear corners. The inner rear rail is nailed flush to the fixed part of the hinged rail, which is tenoned into the left rear leg. A finger hinge connects the fixed part of the hinged rail to the fly rail, which is tenoned into the fly leg. The hinge pin has a wedge driven into its center.

Inscription: A printed paper label is glued to the inner rear rail behind the fly leg: "*Cabinet Work of all kinds* / MADE & SOLD BY / Thomas Needham, / Charter-Street, Salem."

Condition: A crack in the top's lower leaf has been repaired. At the time this was done, the top was removed from the table, and the three horizontal interior blocks were reglued. The left front leg and the section of the curved rail behind it broke out; this joint has been reconstructed. There is a square plug on the back side of the leg below the bead molding, and its front edges immediately below the bead molding have been patched. An organic coating, probably animal-hide glue, was brushed over the label when it was applied; this coating has inhibited oxidation.

Exhibition: Hewitt/Kane/Ward 1982, no. 16.

Reference: Hewitt 1982, fig. 11.

Provenance: The donor purchased this table from the dealers The Sergeants of Shrewsbury, New Jersey, on October 4, 1980.

Thomas Needham's furniture is plain in appearance. Documented examples include a bed at the Essex Institute; a mechanical table and couch at Winterthur; and a card table, lap desk, basin stand, and chest of drawers in private collections.[1] The labels he used are identical except for minor variations in the printer's flowers at the corners.

1. Fales 1965, no. 27; Montgomery 1966, nos. 199, 282; card table owned by John Walton in 1987, illustrated in *Maine Antique Digest* 15 (March 1987), p. 38a; lap desk owned by W.M. Schwind, Jr., in 1987, illustrated in *Maine Antique Digest* 15 (August 1987), p. 35c; *Sack Collection*, VIII, p. 2210; Fales 1965, no. 28.

91

CARD TABLE *Color plate 1*

Attributed to Samuel Barnard (1776–1858)

Salem, 1800–20

Mahogany with mahogany, rosewood, and maple veneers; eastern white pine

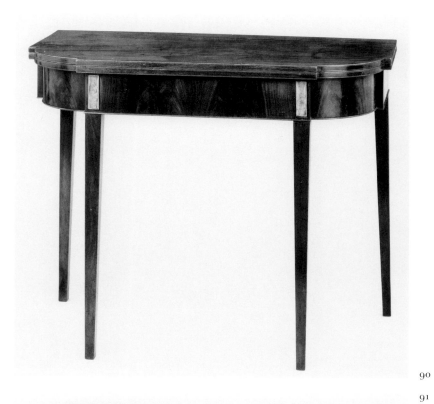

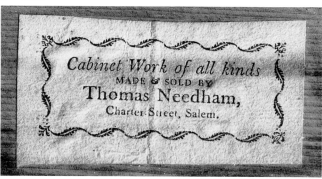

90 *Label*

91 *Brand*

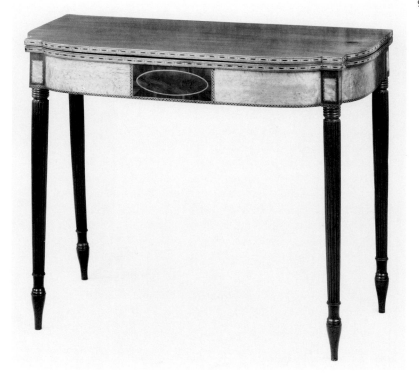

90

91

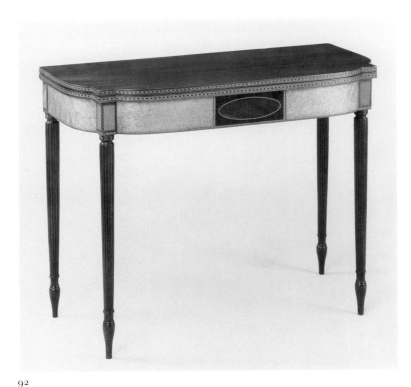

92

73.3 x 89.8 x 43.5 (28 7/8 x 35 3/8 x 17 1/8)
Gift of Benjamin A. Hewitt, B.A. 1943, PH.D. 1952, in memory of
Patrick M. Spadaccino, Jr., 1986.113.1

Structure: The top's lower leaf is screwed to the frame rails
from inside. Each leaf is a solid board. The veneered front and
side rails are tenoned into the front legs. Two-piece triangular
blocks are glued between the front and side rails to form a con-
tinuous surface behind the legs. The front rail is composed of
two horizontal laminates. The left side rail is tenoned into the
left rear leg; the right side rail is dovetailed to the inner rear rail.
Small triangular blocks are glued into the frame's rear corners.
The inner rear rail is nailed flush to the fixed part of the hinged
rail, which is tenoned into the left rear leg. A finger hinge con-
nects the fixed part of the hinged rail to the fly rail, which is ten-
oned into the fly leg.

Inscriptions: "s . b" is branded on the upper surface of the fly
rail. "A . B" is written in ink on the inside surface of the fly rail.

Condition: The top's lower leaf is patched on the right side. The
triangular blocks behind the front legs have been reattached
with nails. The left rear corner block is a replacement.

Exhibition: Hewitt/Kane/Ward 1982, no. 19.

Reference: Hewitt 1982, pl. 6.

Provenance: This table had been owned in Portsmouth, New
Hampshire, prior to being sold at an auction held by Ronald
Bourgeault of Hampton, New Hampshire, in August 1977. It
was purchased by the collector Patrick M. Spadaccino, Jr., of
Danbury, Connecticut, from whom the donor acquired it in
1984.

The SB brand on this table's fly rail has been attributed to Sam-
uel Barnard on the basis of an 1805 invoice for a furniture ship-
ment, which documents Barnard's use of his initials to mark the
packing cases.[1] Documented objects by other Salem craftsmen
support this attribution. Similar turned legs and inverted bal-
uster feet appear on a sideboard made in 1808-09 by William
Hook.[2] Related turnings on a card table have water-leaf carving
that is associated with both Hook and Joseph True.[3]

No other furniture marked with this brand or documented to
Barnard is known to the author. Given this lack of a direct link
between Samuel Barnard and the SB brand, the possibility that
it represented either an owner or another cabinetmaker with the
same initials cannot be ruled out. A possible candidate in the
latter category is the Boston-area cabinetmaker Stephen Bad-
lam, Sr. (1751–1815), who worked in Dorchester Lower Mills.
Badlam is not known to have used an initial brand, although he
employed at least two different full-name brands.[4] Four of the
pieces he marked have additional initial brands, which may
have identified journeymen working in his large shop.[5] Styl-
istically, however, the Art Gallery's card table bears little resem-
blance to any of the furniture branded "s. BADLAM," which
features carved ornament, square legs, and few contrasting
veneers.

1. Hewitt/Kane/Ward 1982, p. 136.
2. Randall 1965, no. 70.
3. Rodriguez Roque 1984, no. 152.
4. For a discussion of Badlam's career, see Swan 1954. The first "S.
 BADLAM" brand has a slanted S, a diamond between the S and B,
 and a conjoined BA. It appears on a set of side chairs, one of which is
 at Winterthur (Montgomery 1966, no. 30; brand illustrated, p. 475);
 a looking glass (*Antiques* 115 [February 1979], inside front cover); a
 clock case (private collection); and a stand (DAPC 76.3). The second
 "S. BADLAM" brand has an upright S, a pellet between the S and B,
 and widely spaced letters. It appears on a pair of lolling chairs, one of
 which is at Winterthur (Montgomery 1966, no. 110; the second
 armchair and brand are illustrated in Swan 1954, p. 381); a card table
 (Swan 1954, p. 383); and a dining table (*Antiques* 73 [January 1958],
 p. 15). A duck decoy owned and probably made by Stephen Badlam III
 (1822–1892) is marked with a SB initial brand that is different from
 the brand on the Art Gallery's card table. Stephen III was a clerk by
 profession, and there is no evidence that he made furniture or owned
 any tools belonging to his forebears (Moir/Parker 1989, p. 521, pl. 9).

I am grateful to Jackson Parker for information on this decoy and its descent in the Badlam family.

5. Montgomery 1966, p. 87. The card table has the initials "WH," a side chair and a lolling chair have the initials "SF," and the clock case has the initials "IC." The initial brand on the card table is recorded in *Sack Collection*, III, p. 829.

92

CARD TABLE

Attributed to Samuel Barnard (1776–1858)

Salem, 1800–1820

Mahogany with mahogany, rosewood, and maple veneers; eastern white pine (frame rails, blocks), birch (fly rail)

71.9 x 90 x 43.1 (28 1/4 x 35 3/8 x 17)

Gift of Benjamin A. Hewitt, B.A. 1943, PH.D. 1952, in memory of Patrick M. Spadaccino, Jr., 1986.113.2

Structure: The top's lower leaf is screwed to the frame rails from inside. Each leaf is a solid board. The veneered front and side rails are tenoned into the front legs. The front rail is composed of three horizontal laminates. The left side rail is tenoned into the left rear leg; the right side rail is dovetailed to the inner rear rail. Beveled blocks are glued into the frame's rear corners. The inner rear rail is nailed through a filler piece of wood to the fixed part of the hinged rail, which is tenoned into the left rear leg. A finger hinge connects the fixed part of the hinged rail to the fly rail, which is tenoned into the fly leg. A vertical block is glued behind this joint.

Condition: The joints between the frame rails and the three fixed legs appear to have been reglued. The two-piece blocks glued behind the front legs appear to be later additions.

Provenance: The donor purchased this table at auction on March 30, 1984 (Skinner 1984, no. 57).

The design of this card table indicates that it was a product of the same shop as cat. 91, which has been attributed to Samuel Barnard. Their respective constructions, however, reveal that they were produced by two different craftsmen within Barnard's shop. The unmarked table has thicker rails with three instead of two laminates, larger dovetails, flush construction of the rear rail instead of filler, a smaller finger hinge, and champfered blocks instead of triangular. Its turnings are also less refined than those on the marked example. Similar differences in construction can be found on nearly identical-looking work tables produced in Henry Connelly's shop in Philadelphia (cat. 162).

[BOSTON AND ENVIRONS]

Cabinetmakers working in Boston, the largest city in New England, produced card tables that ranged from relatively plain (cats. 93–96) to highly ornamented (cats. 97, 99, 100). Many of the tables at Yale feature the pictorial inlays and patterned banding that were characteristic of Boston production. Tripartite facades composed from contrasting veneers were also very popular (cats. 97, 99, 100, 102–105). Benjamin A. Hewitt determined that the squat, double-taper leg on cat. 93 and the base turnings on cat. 103 are unique to the Boston area.[1]

1. Hewitt/Kane/Ward 1982, pp. 61, 65.

93

CARD TABLE

Jacob Forster (1764–1838)

Charlestown, 1786–1820

Mahogany, mahogany veneer; eastern white pine (frame rails, glue blocks), soft maple (hinged rail), hickory (hinge pin)

74.6 x 88.1 x 43.4 (29 3/8 x 34 5/8 x 17 1/8)

Gift of Benjamin A. Hewitt, B.A. 1943, PH.D. 1952, 1977.183.1

Structure: The lower leaf of the top is screwed to the frame rails from inside. Both leaves are solid boards. The curved front and side rails are composed of two horizontal laminates and veneered. They are dovetailed into the three fixed legs. The fixed part of the hinged rail is tenoned into the left rear leg. The inner rear rail is dovetailed to the right side rail and nailed flush to the fixed part of the hinged rail. Triangular blocks are glued into both rear corners of the frame. A finger hinge connects the fixed part of the hinged rail to the fly rail, which is tenoned into the fly leg.

Inscriptions: A printed paper label is glued to the underside of the top: "JACOB FORSTER, / *Cabinet Maker*, / CHARLESTOWN, *Massachusetts*, / Where are Made, / Tables of all kinds, / In the newest and best mode, / Desks, Book Cases, Mahogany Chairs, Sofas, / Lolling & Easy Chairs, Clock Cases, &c. / BOSTO [N Printed by N,] Coverly." (For an intact label, see *Antiques* 89 [June 1966], p. 775.) "T:H" is branded into the outside surface of the fly rail.

Condition: Both leaves of the top have been patched in the area where a pair of replacement hinges broke out at the back edge. These hinges were replaced with side hinges following the originals. The top has been reattached to the frame forward to its original position. The back edges of both leaves have been

planed. The right front leg broke away, and the back side of the upper one-fifth of its height has been replaced with a new piece of wood. A square block of wood has been screwed behind both the leg and frame rails to hold them together. Glue blocks have been added underneath the top above this leg.

Exhibition: Hewitt/Kane/Ward 1982, no. 24.

Reference: YUAGB 37 (Fall 1978), p. 73.

Provenance: The donor purchased this table from George Kent of Rumney, New Hampshire, on July 20, 1974. Kent claimed that it had descended through three generations of his family.

At least three other card tables with the identical label of Jacob Forster are known.[1] Like the table at Yale, these are semicircular in shape and ornamented with rectangles of stringing on the rails and geometric inlays on the pilasters, although their construction varies to the same degree as the card tables attributed to Samuel Barnard (cats. 91, 92). A semicircular card table at Historic Deerfield is unlabeled but features the same curved rail construction, two-tone paterae, and squat, double-taper legs as the Yale example.[2] Hewitt theorized that these distinctive legs, which appeared only in the Boston area, were produced in Forster's shop and sold to other cabinetmakers.[3] They appear on only one of the other documented Forster card tables.[4]

Forster moved to Charlestown in 1786 and lived there until his death. He used at least two labels during his career. One has the incomplete date "179–" printed below his name; the longer label on Yale's table describes his wares in detail and is signed by the printer, either Nathaniel Coverly, Sr. (c. 1744–1816) or Nathaniel Coverly, Jr. (c. 1775–1824).[5] No evidence from either the labels or the objects indicates that one label was used before the other. The label dated 179– would logically have been used only in that decade, although two examples are inscribed with the date "1814."[6] This shorter label appears on chests of drawers, work tables, and a chair, whereas the longer label was used on card tables, a lap desk, and a basin stand; it is possible that Forster used one label for chairs and case pieces and the other for tables and related forms.[7]

The "TH" brand on this table may have been the mark of either the original owner or a journeyman in Forster's shop. A variety of initial brands appear on furniture made in the large shop of Stephen Badlam, Sr., of Lower Dorchester Mills, which suggests that such brands were used to identify different journeymen's work (see cat. 91).

1. Montgomery 1966, no. 287; *Antiques* 16 (December 1929), p. 481; *Antiques* 89 (June 1966), p. 775.
2. Fales 1976, no. 278.
3. Hewitt/Kane/Ward 1982, pp. 141–42.
4. *Antiques* 16 (December 1929), p. 481.

5. Nathaniel Coverly, Sr., could have printed the label during one of three periods of residence in Boston: between 1788 and 1794, in 1800, and from 1803 until his death. Nathaniel Coverly, Jr., did not work independently of his father until about 1796 and worked in Boston after 1800 (see Franklin 1980, pp. 76-77, 81). Between December 1803 and February 1804 the *Columbian Centinel* announced a dividend of the property of Nathaniel Coverly, Jr., "of Salem, now resident in Charlestown . . . a Bankrupt" (*Columbian Centinel & Massachusetts Federalist*, December 14, 1803, p. 3; February 1, 1804, p. 1). The younger Coverly could have printed the label while resident in Charlestown, which would make this label later than the one dated 179–.
6. *Sack Collection*, II, p. 498; Sotheby's 1973a, no. 712.
7. Chests of drawers: *Antiques* 7 (June 1925), p. 316; *Antiques* 89 (June 1966), p. 841. Work tables: *Sack Collection*, II, p. 498; Sotheby's 1973a, no. 712. Chair: Montgomery 1966, no. 32. Lap desk: *Antiques* 46 (October 1944), p. 205. Basin stand: Montgomery 1966, no. 361.

94

CARD TABLE

John Smith and Samuel Hitchings, in partnership, c. 1803–04
Boston, c. 1803–04
Mahogany, mahogany veneer; eastern white pine
75.1 x 88.2 x 42.6 (29 5/8 x 34 3/4 x 16 3/4)
Gift of Mr. and Mrs. Charles F. Montgomery, 1974.118.1

Structure: The top's lower leaf is screwed to the frame from inside. Each leaf is a solid board. A tenon fitted into the back edge of the lower leaf fits into a reciprocal mortise on the inside edge of the upper leaf when the top is opened. The veneered front and side rails are tenoned into the fixed legs. The rounded front corners are composed of two horizontal laminates. The corners are nailed to the front and side rails and are also screwed to the top, cutouts in the front legs, and the side rails. The right side rail is dovetailed to the inner rear rail. Blocks are glued into the two rear corners. The inner rear rail is nailed flush to the fixed part of the hinged rail, which is tenoned into the left rear leg. A finger hinge connects the fixed part of the hinged rail to the fly rail, which is tenoned into the fly leg. The hinge pin has a wedge driven into its center.

Inscriptions: A printed paper label is glued on the outside of the fixed part of the hinged rail: "SMITH & HITCHINGS, / Cabinet-makers, / At STORE No. 40, MIDDLE-STREET, / BOSTON, / MAKE AND OFFER FOR SALE AT THE LOWEST CASH PRICES, / A General Assortment of / CABINET WORK AND WINDSOR / CHAIRS, &c." "E M D" is written in pencil on the inside of the front rail.

Condition: The left rear corner of the top's upper leaf is patched. The hinges are replacements. The screws through the

93 *Label*

93 *Brand*

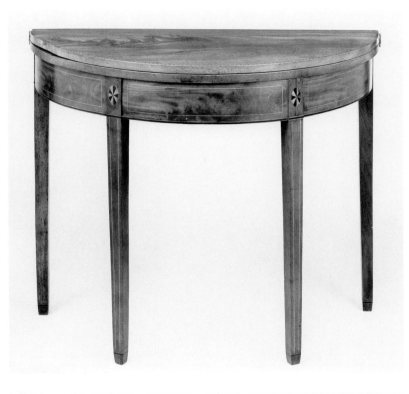

94 *Label*

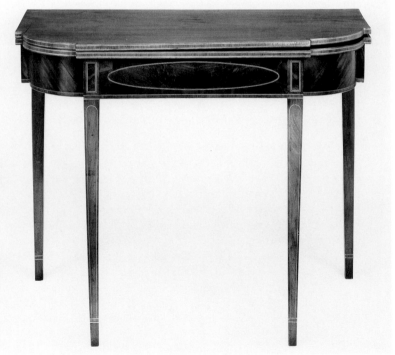

93

94

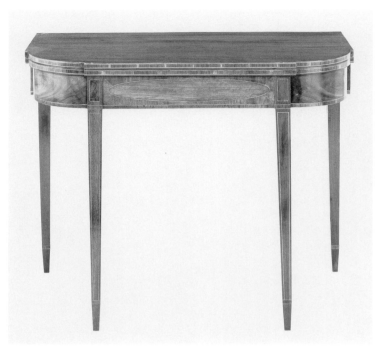

95

95 *Brand*

curved rails are old but may be later additions. There is a vertical crack in the fly leg below the joint with the fly rail. One side of the cuff on the left rear leg was never carved out for inlay.

Exhibition: Hewitt/Kane/Ward 1982, no. 23.

Reference: Garrett 1972, p. 189.

Provenance: Harry Arons owned this table in June 1963; Charles Montgomery purchased it from him in 1966.

In 1803, the cabinetmakers John Smith and Samuel Hitchings first appeared in the Boston city directories as a partnership at 40 Middle Street. They advertised anonymously in December for journeymen and apprentices, noting that they had for sale "a fashionable assortment of Cabinet Work, and Chairs."[1] Less than one year later, on November 7, 1804, they announced that "the Copartnership of Smith & Hitchings, is this day dissolved by mutual consent."[2] The following week, John Smith advertised "a general and fashionable assortment of Cabinet Work and Windsor Chairs" at 58 Back Street.[3] He was listed as a cabinetmaker in the city directories on Back Street in 1805 and on Charles Street in 1807 and 1809. He formed a short-lived partnership with Robert Low on Cambridge Street in 1810, although he continued to reside on Charles Street. In 1813, Low is listed as the partner of Thomas Spencer, and Smith's final listing shows him working independently on Cambridge Street, with his home on Charles Street. Samuel Hitchings worked briefly as a cabinetmaker at 40 Middle Street, the site of the Smith and Hitchings shop; he was listed independently in the Boston city directories only between 1805 and 1807.[4]

This table may have been made as one of a pair; an identical card table labeled by Smith and Hitchings is in the Museum of Fine Arts, Boston.[5] A later nineteenth- or early twentieth-century brand, "M.G. DOUGLAS," has been put on the Boston Museum's table, presumably at a time when it was separated from the Art Gallery's table. The handwritten initials on the Yale table possibly may refer to a different line of descent in the Douglas family, whose identity is unknown.

1. *Columbian Centinel & Massachusetts Federalist*, December 7, 1803, p. 4.
2. *Columbian Centinel*, November 7, 1804, p. 2.
3. *Columbian Centinel*, November 14, 1804, p. 3.
4. *Boston Directory*, 1805, pp. 67, 115; 1806, p. 66; 1807, pp. 87, 137; 1809, p. 126; 1810, pp. 178-79; 1813, pp. 117, 229. This evidence contradicts Bjerkoe 1957, p. 204, which cites an untraced advertisement for John Smith "on Back St. in former shop of Smith & Hutchins [*sic*]."
5. The table (no. 67.966) was acquired by the Museum of Fine Arts from the dealer Brian E. Palmiter of Bouckville, New York.

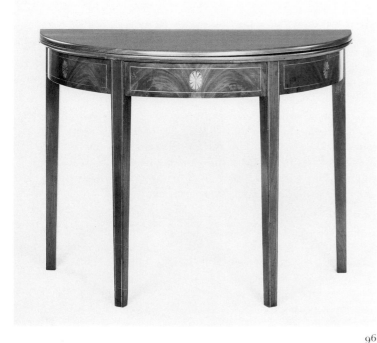

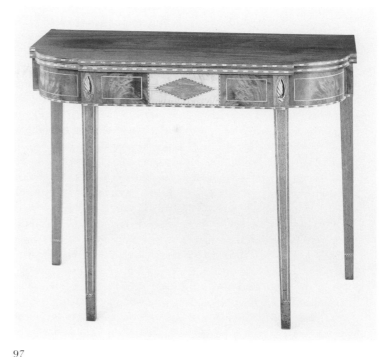

96

97

95

CARD TABLE

Boston, 1803–11

Retailed by William Leverett (1760–1811)

Mahogany, mahogany veneer; eastern white pine (frame rails, glue blocks), black cherry (hinged rail)

74 x 90.7 x 44.3 (29 1/8 x 35 3/4 x 17 1/2)

Gift of Benjamin A. Hewitt, B.A. 1943, PH.D. 1952, 1984.101.2

Structure: The top's lower leaf is screwed to the frame rails from inside. Each leaf is a solid board. The veneered frame is a single board with the projecting front and sides formed by applied pieces of wood. This board is fitted into channels cut into the upper ends of the front legs. The rounded front corners are formed by a series of vertical kerfs in the board that permits the corners to be bent into shape. Strips of muslin are glued behind each front corner to reinforce the bond. The board's back ends are dovetailed to the inner rear rail. Vertical blocks with champfered corners are glued into the two rear corners. A medial brace is nailed between the board's front and the inner rear rail. The inner rear rail is screwed through two filler pieces of wood to the fixed part of the hinged rail, which is tenoned into

the left rear leg. A finger hinge connects the fixed part of the hinged rail to the fly rail, which is tenoned into the fly leg. A vertical block with a champfered corner is glued behind this joint.

Inscription: "W. LEVERETT" is branded on the underside of the inner rear rail.

Condition: Both rear corners of the top's upper leaf have been patched. The right front leg is a replacement. Both left legs broke out and have been reattached to the frame. The fly leg broke out and has been reattached with a screw through the top of the fly rail. The block in the left rear corner and the hinge pin are replaced.

Reference: Ostergard 1987, fig. 1–31.

Provenance: The donor purchased this table from the dealer W. Torrey Little, Inc., of Marshfield Hills, Massachusetts, on September 5, 1983.

The retailer of this card table probably was the William Leverett born in Boston on March 3, 1760, the son of John and Mary Leverett. He married Charlotte Whiting on November 7, 1793, in Roxbury and died at some point between February 20 and

September 28, 1811, when his successor, Joseph Hay, informed Bostonians that he had "served his apprenticeship with the late Mr. William Leverett."[1] In 1937, Mabel M. Swan described William Leverett as the "most formidable competitor" of Thomas Seymour, whose shop was on Common Street at the opposite end of the Mall from Leverett.[2] Leverett's newspaper advertisements, however, make clear that he was an entrepreneur rather than a craftsman. In 1803, he announced the opening of his warehouse for "the Sale Exchange of all Kinds of new and second hand Furniture, Glasses, Pictures, Books, & c. & c. at Private and Public Sale."[3] As part of this enterprise, he apparently supervised a cabinet shop; he repeatedly offered his customers "Cabinet Work of all Kinds executed with neatness and dispatch, at the above Warehouse."[4]

It is unclear whether the furniture branded by William Leverett, including this card table, was produced by his workmen or simply sold through his warehouse. With a single large oval inlaid across its facade, double-tapered legs, and extensive use of crossbanding and lightwood stringing, the table was undoubtedly made in Boston; a similar table was labeled by John Smith and Samuel Hitchings (cat. 94). Another card table branded by Leverett is clearly a Boston product, differing from the Yale example in the eagle inlaid at the center of the facade and the shells on the pilasters.[5] Most construction features of the Art Gallery's table are equally characteristic of Boston, particularly the curved front rails formed by kerf construction (see cat. 98).

1. *IGI*; *Columbian Centinel*, September 28, 1811, p. 2.
2. Swan 1937, p. 177.
3. *Columbian Centinel & Massachusetts Federalist*, June 1, 1803, p. 3.
4. *Columbian Centinel & Massachusetts Federalist*, December 7, 1803, p. 3.
5. *Sack Collection*, VI, p. 1446.

9 6

CARD TABLE

Attributed to Samuel Fisk (1769–1797) and/or William Fisk (1770–1844)

Roxbury or Boston, 1792–1800

Mahogany, mahogany veneer; eastern white pine (frame rails, glue blocks, drawer runners), soft maple (hinged rail)

72.1 x 90.5 x 44.1 (28 3/8 x 35 5/8 x 17 5/8)

Gift of Mr. and Mrs. Henry E. Bartels in honor of Benjamin A. Hewitt, B.A. 1943, PH.D. 1952, 1983.23

Structure: The lower leaf of the top is screwed to the frame rails from inside. Both leaves of the top are solid boards. The back edge of the fixed leaf has a tenon that fits into a reciprocal mortise on the hinged leaf's inside edge when the top is opened. The curved front and side rails are sawn into shape and veneered. The side rails are dovetailed to the front and the inner rear rails, and a rounded block is glued in the two rear corners. The fixed center part of the hinged rail is screwed to the inner rear rail through a filler piece of wood. Finger hinges connect it to the two fly rails, which are tenoned into the fly legs. A rectangular block is glued behind each of these joints. Each front leg is fitted over the front rail and secured by a vertical tenon fitted into a mortise in the rail's underside. A small drawer was fitted flush into an opening cut into the inner rear rail behind the right fly leg. Two L-shaped drawer supports are tenoned between the front and inner rear frame rails. A rectangular drawer stop is glued at the back of the left drawer runner.

Condition: The table has been heavily refinished. The top has been rescrewed to the frame. The upper leaf is cracked and patched at the right hinge. Lightwood stringing was originally inlaid along the lower edge of the frame rails. Sections of the center patera appear to be replacements. The left front leg broke away from the rail, and sections of the veneer and curved rails on either side of it have been pieced. Both front legs have been secured with screws. The right hinged rail broke out and has been replaced. The adjacent hinge on the fixed rail and the upper end of the right fly leg have been pieced. The drawer is a twentieth-century replacement.

Reference: *YUAGB* 39 (Fall 1984), p. 62

Provenance: The donors purchased this table in May 1982 from the dealer Kenneth Hammitt of Woodbury, Connecticut.

This card table is identical in dimensions and most of its design and construction features to a table branded by both Samuel and William Fisk.[1] On that table, the curved rails are composed of two laminates instead of being sawn to shape. The table branded by the Fisks also differs from this piece in having paterae composed of alternating light and dark pieces and a top with square edges. More striking than these differences, however, is the presence on both tables of the same unusual rear rail with two swing legs and a cutout for a hidden drawer.

Benjamin A. Hewitt published the documented Fisk table in 1982 as a product of Salem, Massachusetts, having based his information on an inaccurate entry in Ethel Hall Bjerkoe's *The Cabinetmakers of America*.[2] The Fisks, who were brothers, were born in Watertown, Massachusetts, and first set up their cabinetmaking shop in Roxbury in 1792. Between 1796 and Samuel's death in 1797, they moved to Washington Street in Boston Neck, where William worked for the rest of his life.[3] The inventory of Samuel Fisk's Boston shop and home, taken by Stephen Badlam, Isaac Vose, and Nehemiah Munroe, listed "4 patras"

valued at 66¢ as well as two card tables in the shop valued at $15.[4] The fact that the Fisks worked in Roxbury and Boston rather than Salem discounts Hewitt's finding that no straight-leg card tables with two fly legs were made in the Boston area. It does not, however, challenge his conclusion that this type of rail construction was more popular in Salem than elsewhere in Massachusetts.[5]

1. Hewitt/Kane/Ward 1982, no. 15.
2. Bjerkoe 1957, p. 93.
3. Willard 1911, pp. 117–18; *Boston Directory*, 1798, p. 48: "Fisk, William, cabinet-maker, on the neck"; 1800, p. 44: "Washington Street"; 1805, p. 49: "on the Neck" (same for 1806–09); 1810, p. 76: "Washington St." (same for 1816, 1820, 1823); 1825, p. 282: "841, h[ome] 839 Washington" (same for 1826–44). Bjerkoe confused Samuel Fisk with his father, a deacon, and located the Washington Street address in Salem rather than Boston. This erroneous information was cited in Randall 1965, p. 198, and Montgomery 1966, p. 88. The fact that the Fisks never worked in Salem corroborates both Randall's and Montgomery's arguments that William Fisk's work was for Boston patrons in a Boston style.
4. SCPR, XCV, pp. 43–44.
5. Hewitt/Kane/Ward 1982, pp. 93, 151, 194, chart XII.

9 7

CARD TABLE

Probably Boston area, 1790–1810

Mahogany with mahogany, birch, and satinwood veneers; eastern white pine (frame rails, filler block), birch (hinged rail)

74.7 x 90.1 x 44.1 (29 3/8 x 35 1/2 x 17 3/8)

The Mabel Brady Garvan Collection, 1930.2068

Structure: The top's lower leaf is screwed to the frame rails from inside. Each leaf is a solid board. The veneered front and side rails are tenoned into the fixed legs. The rounded front corners are composed of two laminates screwed to the front and side rails and into rabbets in the front legs. The right side rail was dovetailed to the inner rear rail. Blocks with champfered corners were glued into the two rear corners. The inner rear rail was nailed through a filler piece of wood to the fixed part of the hinged rail, which is tenoned into the left rear leg. A finger hinge connects the fixed part of the hinged rail to the fly rail, which is tenoned and double pinned into the fly leg. A block is glued behind this joint.

Condition: The right rear corner of the top's upper leaf has been patched. A crack in the lower leaf has been repaired with two strips screwed to the underside. Peter Arkell made minor patches to the veneer and inlay in 1980. The right front leg broke out and the section of the curved rail behind it is a replacement. Many screws have been added to secure the curved rails to the legs. The fly rail's hinge has been extensively repaired. Three-quarters of the inner rear rail has been replaced, as have all the glue blocks.

Exhibitions: Yale University Art Gallery, New Haven, "A Wide View for American Art: Francis P. Garvan, Collector," May 8–September 28, 1980; Yale University Art Gallery, New Haven, "The Work of Many Hands: Card Tables in Federal America, 1790–1820," March 25–May 30, 1982.

References: Furniture Buyer 1929; Rogers 1931, p. 43.

Provenance: This table was owned by the collector Fred Wellington Ayer of Bangor, Maine. Garvan purchased it at the auction of Ayer's collection in New York City on May 3, 1929 (*Ayer* 1929, no. 170).

This card table exhibits such Boston characteristics as a tripartite facade, contrasting veneers, and a variety of patterned and pictorial inlays; identical shell inlays appear on the pilasters of a card table branded by William Leverett.[1] A card table of the same design, with different construction features and inlays, was sold at auction in 1989.[2]

1. *Sack Collection*, VI, p. 1446. For information on Leverett, see cat. 95.
2. Christie's 1989b, no. 357. This table has lost approximately 2cm (3/4 in.) in height.

9 8

CARD TABLE

Probably Boston area, 1790–1810

Mahogany, mahogany veneer; eastern white pine (frame rails, blocks), birch (hinged rail)

74.7 x 86.9 x 45 (29 3/8 x 34 1/4 x 17 3/4)

The Mabel Brady Garvan Collection, 1930.2080

Structure: The top's lower leaf is screwed to the frame rails from inside. Each leaf is a solid board. The frame rails are veneered and tenoned into the fixed legs. The rounded front corners are part of a single board that is glued behind the other frame rails and into cutouts in the back sides of the front legs. Each rounded corner is formed by a series of vertical kerfs in the board that permits the corner to be bent into shape. Strips of muslin are glued in back of each corner to reinforce the bond. The right end of this board is dovetailed to the inner rear rail. Two-piece, rounded blocks are glued into the two rear corners of the frame. The inner rear rail is glued to the fixed part of the hinged rail with a filler piece of wood between them. The fixed part of the hinged rail is tenoned into the left rear leg, and a block is glued behind this joint. A finger hinge connects the

98 *Kerf construction*

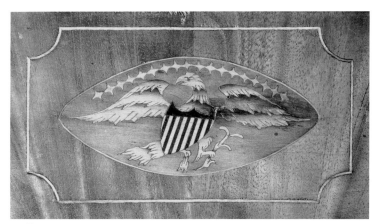

98 *Front rail inlay*

fixed part of the hinged rail to the fly rail, which is tenoned into the fly leg and reinforced with a glue block.

Inscription: "Mr R T Haines Halsey / 64 W 55 Street" is written in red crayon on the back side of the fixed portion of the hinged rail.

Condition: Garvan's records indicate that this table was repaired by Umberto Bongianni, although the major structural repairs may have been done when Halsey owned it. The rear corners of the top's upper leaf have been patched near the hinges. The left front leg broke out and has been repaired. The hinge on the fly rail has been reinforced with screws, and the hinge pin has been replaced. The eagle inlay has sustained a deep gouge and abrasion in the area of the eagle's left wing.

Exhibition: Hewitt/Kane/Ward 1982, no. 22.

References: Miller 1937, II, no. 1511; Rogers 1960, no. 16; Rogers 1962a, p. 14; Comstock 1962, no. 550; Prown 1980, fig. 7.

Provenance: Garvan acquired this table as part of the collection he purchased from R.T.H. Halsey.

The patriotic eagle and Neoclassical urn inlays on this card table were popular ornaments for Federal-period tables in several regions. Identical urn inlays were employed by Eliphalet Briggs of Keene, New Hampshire (cat. 79), and similar eagle inlays appear on tables made in New York City.[1] The eighteen-star eagle inlay on this card table and another one at Yale (cat. 99) was unique to the Boston area and was probably the work of a local inlay maker.[2] The only documented card table with this inlay is branded by William Leverett of Boston, although Leverett was the retailer rather than the maker.[3]

The curved rails of the Art Gallery's table are made with kerf construction, a relatively rare method that was also used on a similar eagle-inlaid card table in the Diplomatic Reception Rooms, United States Department of State.[4] Apart from minor differences in the patterned banding and veneers, the State Department's table is nearly identical in design, ornament, and construction. The two tables were almost certainly made in the same shop. Closely related card tables with identical eagle and urn inlays are in the collections of the Henry Ford Museum and Eddy G. Nicholson.[5] Although the Art Gallery's table marked by Leverett (cat. 95) has kerf-constructed front corners, it is different from these others in most other construction features.

1. Two different New York City card tables with what appear to be identical eagle inlays are illustrated in *Antiques* 93 (June 1968), p. 707, and *Antiques* 99 (April 1971), inside front cover.
2. Hewitt/Kane/Ward 1982, p. 84.
3. *Sack Collection,* VI, p. 1446. For information on Leverett, see cat. 95.
4. Illustrated in Conger/Pool 1974, pl. 5.
5. Henry Ford Museum (no. 63.124); *Sack Collection,* VIII, p. 2268.

99

CARD TABLE

Probably Boston area, 1790–1810

Mahogany with mahogany, maple, and rosewood veneers; eastern white pine (frame rails, glue blocks), birch (hinged rail)

75.5 x 91.3 x 45.4 (29 3/4 x 36 x 17 7/8)

The Mabel Brady Garvan Collection, 1930.2777

Structure: The top's lower leaf is screwed to the frame rails from inside. Each leaf is a solid board. A tenon in the back edge of the fixed leaf fits into a reciprocal mortise on the inside edge

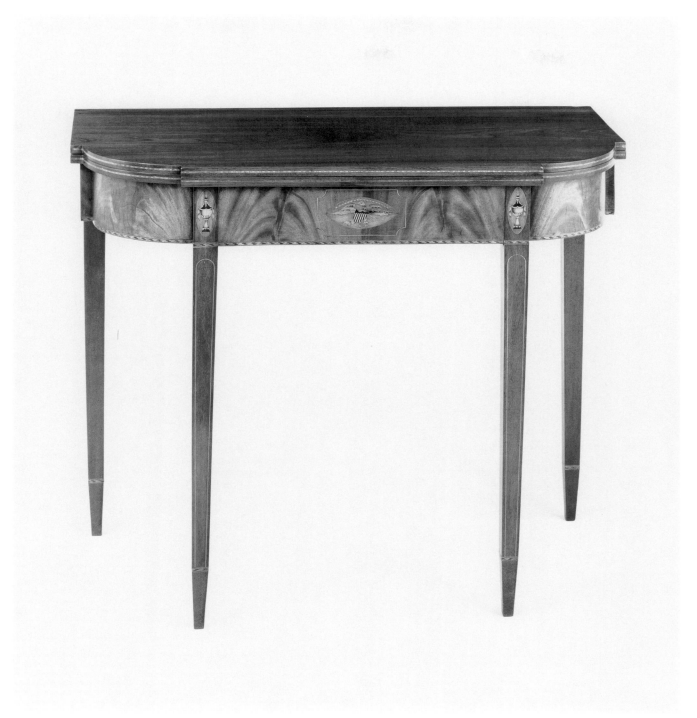

98

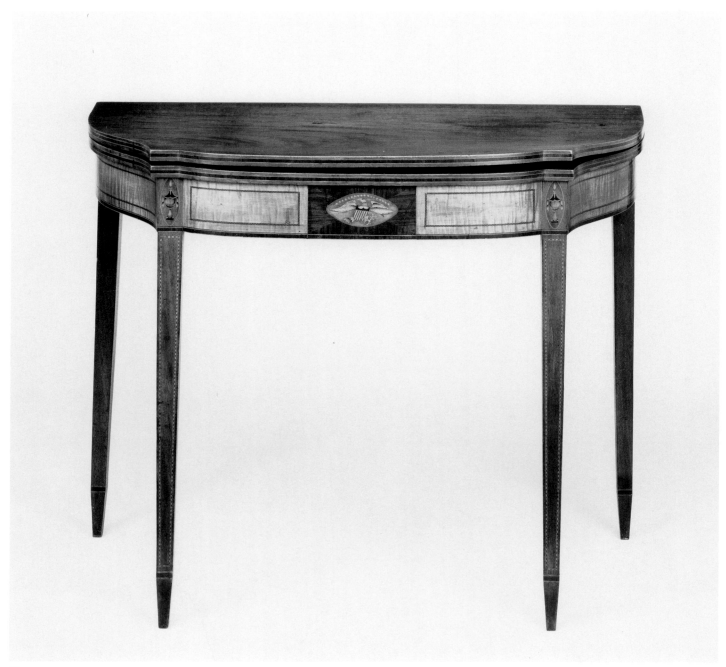

99

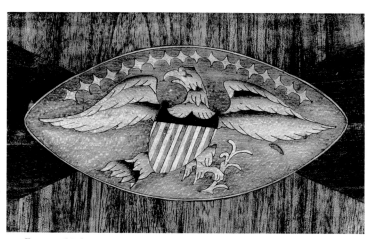

99 *Front rail inlay*

99 *Pilaster inlay*

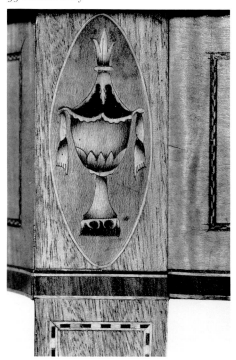

of the hinged leaf when the top is opened. The front and side rails are veneered. The front rail is composed of three horizontal laminates and is tenoned into the front legs. The side rails are composed of two horizontal laminates and are glued around the front legs. The left side rail is butted and glued to the left rear leg. Two vertical blocks are glued behind each front leg. The right side rail is dovetailed to the inner rear rail. Triangular vertical blocks are glued into the two rear corners. The inner rear rail is nailed through one filler piece of wood to the fixed part of the hinged rail, which is tenoned and double pinned into the left rear leg. A short finger hinge with champfered edges connects the fixed part of the hinged rail to the fly rail, which is tenoned into the fly leg.

Inscriptions: "R.T.H. Halsey" is written in ink on a paper tag glued to the underside of the top. "ADDISON GALLERY / PHILLIPS ACADEMY / ANDOVER, MASSACHUSETTS" is printed on a second paper label attached to the underside of the top; "No. 612.b.1932" is typed on this label.

Condition: The top's lower leaf has been patched at the right hinge. Both of the rear corner blocks have been reattached and may be old replacements.

Exhibitions: Girl Scouts 1929, no. 728; Hewitt/Kane/Ward 1982, no. 21.

Reference: Miller 1937, II, no. 1512.

Provenance: Garvan acquired this table as part of the collection he purchased from R.T.H. Halsey.

A superb example of the Neoclassical style in Boston, this table exhibits the local taste for eagle and urn inlays (see cat. 98) as well as patterned inlay, used here instead of light wood stringing to outline panels on the legs. It also has a distinctive type of finger hinge that may represent the work of a local specialist (see cat. 104).

Two scribe lines drawn on the inside of the inner rear rail indicate that this table is one of a pair. The mate, marked with a single scribe line and with a reversed eagle inlay, was owned by Israel Sack, Inc.[1]

1. *Sack Collection*, VI, p. 1560; *Sack Collection*, IX, p. 2429.

100
CARD TABLE

Coastal Massachusetts, probably Boston area, 1790–1820
Mahogany, mahogany and satinwood veneers; eastern white pine
74.2 x 91.2 x 43.5 (29 1/4 x 35 7/8 x 17 1/8)
The Mabel Brady Garvan Collection, 1930.2597

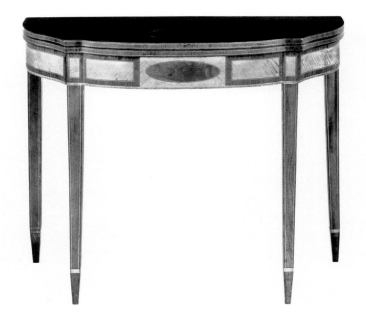

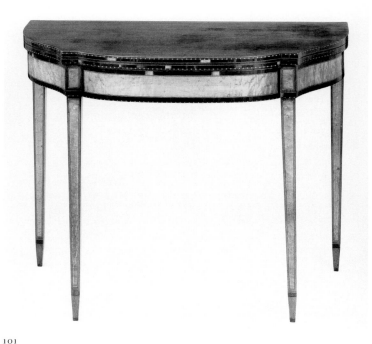

Structure: The top's lower leaf is screwed to the frame rails from inside. Each leaf is a solid board. A tenon in the back edge of the fixed leaf fits into a reciprocal mortise on the inside edge of the hinged leaf when the top is opened. The veneered front and side rails are composed of two horizontal laminates. The ends of the front rail are glued to pieces of wood tenoned into the front legs. The side rails are nailed to the front legs and dove-tailed to the inner rear rail. Quarter-round blocks are glued behind the joints on each front leg and in the two rear corners. The inner rear rail is nailed flush to the fixed part of the hinged rail, which is tenoned into the left rear leg. A finger hinge con-nects the fixed part of the hinged rail to the fly rail, which is ten-oned into the fly leg.

Inscriptions: "TOP" is written in pencil on the underside of the top. "37" is painted in red on the back side of the fly rail.

Condition: The top's lower leaf has been repaired at the left rear corner. The fly leg has been reattached to the fly rail with a metal brace. Two blocks have been reattached. The finish is badly deteriorated, but the table itself seems to be well preserved.

Reference: Miller 1937, II, no. 1506.

Provenance: Garvan purchased this table from Jacob Margolis on September 4, 1925.

Both the design and construction of this card table relate to examples made in Boston or the north shore of Massachusetts. Card tables of identical shape and very similar veneers were made by Elisha Tucker of Boston about 1810 and retailed by William Leverett between 1803 and 1811.[1] A similar table was made in 1814 by Emery Moulton of Lynn, Massachusetts; another at Winterthur has "I + S" painted on the underside of the top, which Montgomery attributed to Jacob Sanderson of Salem.[2]

1. Montgomery 1966, no. 302; DAPC 74.6227. For information on Leverett, see cat. 95.
2. *Sack Collection*, IX, p. 2419; Montgomery 1966, no. 300.

101
CARD TABLE

Probably Boston, 1790–1820

Mahogany, mahogany and maple veneers; spruce (inner rear rail, front corner blocks), eastern white pine (front and side rails, rear corner blocks), soft maple (hinged rail)

74.7 x 91.6 x 44.7 (29 3/8 x 36 1/8 x 17 5/8)

The Mabel Brady Garvan Collection, 1930.2314

Structure: The top's lower leaf is screwed to the frame rails

from inside. Each leaf is a solid board. A tenon in the back edge of the fixed leaf fits into a reciprocal mortise on the inside edge of the hinged leaf when the top is opened. The veneered front and side rails are composed of two horizontal laminates. The front rail is tenoned between the front legs. The side rails are apparently nailed or screwed into the front legs and dovetailed to the inner rear rail. Quarter-round, two-piece blocks are glued behind the front legs, and rectangular blocks are glued in the rear corners of the frame. The inner rear rail is screwed to the fixed part of the hinged rail through a filler board and is tenoned into the left rear leg. A finger hinge connects the fixed part of the hinged rail to the fly rail, which is tenoned into the fly leg. This joint is reinforced with a block.

Condition: This table has been heavily refinished. All of the vertical crossbanding flanking the maple panels on the rails has been replaced. Considerable repairs have been made to the crossbanding and stringing on the right side rail. The left rear leg broke out and has been reattached to the rear rails with nails. The rear rails were detached from the frame and have been reglued and rescrewed in place. The fly leg has been reattached to the fly rail with nails; the block behind this joint has been damaged and reglued. The hinge pin in the fly rail and the glue block in the right rear corner of the frame are replacements. The other corner blocks have been reglued but appear to be original.

Exhibition: Hewitt/Kane/Ward 1982, no. 20.

Reference: Kirk 1970, fig. 125.

Provenance: Garvan purchased this table from Jacob Margolis in 1925.

This characteristic Boston-area card table is distinguished by the maple panels inlaid on three sides of its front legs and two sides of its rear legs. Similar panels appear on a number of high-style Neoclassical chairs, desks, sideboards, and work tables made in Boston.[1] The overall effect of the decoration is marred, however, by the clumsy design of the crossbanding and inlaid panels on the pilasters, which interrupts the flow of veneer normally found on such tables (cat. 100).

The use of spruce, here employed in the inner rear rail and blocks, is extremely uncommon in a piece of American furniture from this period. The only other table in the Art Gallery's collection on which spruce was used for a major structural element is the card table by Joseph Rawson and Son of Providence (cat. 106). Small strips of spruce appear on two pembroke tables (cats. 65 and 67). Except for the sounding boards of two pianos and the secondary wood of a clock case, this wood has not been identified in any other piece of American-made furniture at

Yale.[2] Many looking glasses were made of spruce, although none of those at Yale have been conclusively identified as American. Spruce boards were sold in large quantities in American cities during this period, which makes its infrequent use in furniture difficult to explain (see p. 295).

This table may have been made as one of a pair; an apparently identical card table is in the Maine State Museum, Augusta.[3]

1. Flanigan 1986, no. 35; Montgomery 1966, nos. 38–39, 344; Randall 1965, nos. 65, 173; Hipkiss 1941, no. 30; Stoneman 1959, nos. 144–45.
2. Ward 1988, nos. 231–32; Battison/Kane 1973, no. 13.
3. No. 83.52.86. No history of ownership accompanied this table, which was donated by a collector. I am grateful to Edwin A. Churchill for bringing it to my attention.

102

CARD TABLE ONE OF A PAIR

Coastal Massachusetts, probably Boston area, 1800–20
Mahogany, mahogany and satinwood veneers; eastern white pine (frame rails, glue blocks), soft maple (hinged rail)
75.8 x 91.8 x 44.3 (29 7/8 x 36 1/4 x 17 1/2)
The Mabel Brady Garvan Collection, 1934.401B

Structure: The top's lower leaf is screwed to the front and side frame rails from inside and to the fixed part of the hinged rail from outside. Each leaf is a solid board. A tenon in the back edge of the fixed leaf fits into a reciprocal mortise on the inside edge of the hinged leaf. The veneered front and side rails are tenoned into the front legs. Two-piece, quarter-round blocks reinforce both joints. The front rail is composed of three horizontal laminates, the lowest laminate being much narrower than the other two. The side rails are dovetailed to the inner rear rail. Rectangular blocks are glued into the two rear corners. The left rear corner of the frame is butted and glued to the left rear leg. The inner rear rail is nailed through a filler board to the fixed part of the hinged rail. The fixed part of the hinged rail is tenoned into the left rear leg.

Inscriptions: "2" is written in crayon on the inside of the rear rail. There is an indecipherable inscription in red crayon on the fixed part of the hinged rail.

Condition: The joints between the frame rails and the three fixed legs appear to have been reglued. The fly rail and one-half of the fixed part of the hinged rail have been replaced.

References: Miller 1937, II, no. 1523; Kirk 1970, fig. 160.

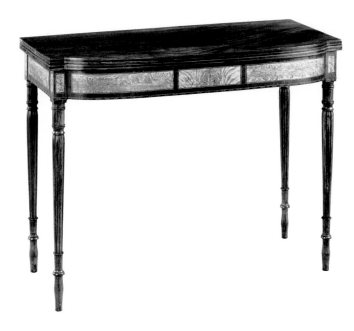

102

Provenance: Jacob Margolis acquired this pair of tables "out of the Marblehead house," the King Hooper House that was operated as a branch of Israel Sack's Boston shop (A.W. Clarke to Garvan, March 8, 1927, Clarke file, FPG—AAA). Garvan purchased the tables from Margolis on March 9, 1927.

Although frequently associated with Salem, Massachusetts, turned feet similar to these were found on tables from Boston and other cities on the North Shore.[1] This card table exhibits several features that suggest a Boston origin, including a tripartite facade composed of panels of contrasting veneer and reeded legs that are rounded at their juncture with the capital.

1. Hewitt/Kane/Ward 1982, pp. 64–65; a pair of card tables with identical feet was owned by Miriam Thurlow of West Newbury, Massachusetts (Watkins 1966, p. 205).

103

CARD TABLE ONE OF A PAIR

Coastal Massachusetts, probably Boston area, 1800–20

Mahogany, mahogany and maple veneers; sylvestris pine (front, side, and hinged rails), eastern white pine (inner rear rail, glue blocks), hickory (hinge pin)

76.1 x 92.8 x 44.9 (30 x 36 1/2 x 17 5/8)

Gift of Mrs. Clark McIlwaine in memory of Margaret Tyler Clark, 1946.3B

Structure: The top's lower leaf is screwed to the frame rails from inside. Each leaf is a solid board. A tenon in the back edge of the lower leaf fits into a reciprocal mortise on the inside edge of the upper leaf. The veneered front and side rails are solid boards that are butted and glued together. The front legs are blind dovetailed to the frame's front corners. The side rails are dovetailed to the inner rear rail. Large rectangular blocks with champfered outside corners are glued into the four corners of the frame. The inner rear rail is nailed through a filler board to the fixed part of the hinged rail, which is tenoned into the left rear leg. A finger hinge connects the fixed part of the hinged rail to the fly rail, which is tenoned into the fly leg. A small rectangular block with champfered ends is glued behind this joint.

Inscriptions: "2" is written in pencil on the underside of the top and the upper surfaces of the front rail and the fixed part of the hinged rail.

Condition: The top's original side hinges broke out and were replaced with hinges that were attached to the top surface of the upper leaf and the underside of the lower leaf. Cuts were made in both parts of the hinged rail to accommodate these hinges, which were subsequently removed and replaced with new side hinges. Both leaves of the top are patched and repaired around the various sets of hinges. Peter Arkell refinished the top in 1975. The left front leg broke out and has been reattached with a screw through the corner block. There is a large patch to the veneer on the left side rail.

Exhibition: Hewitt/Kane/Ward 1982, no. 27.

Reference: Kirk 1970, fig. 158.

Card tables with tripartite facades, serpentine frame rails, and turned, reeded legs were made in large numbers in eastern Massachusetts during the Federal period. Documented examples include a card table at Historic Deerfield labeled by Samuel Adams and William Todd of Boston between 1798 and 1800 and a card table branded "J S / BOSTON."[1] All three of the Art Gallery's tables of this type (see also cats. 104, 105) have turnings associated with Boston or Salem. This card table is superior in design to the other two examples at Yale, with the large oval and bold turnings complementing the serpentine shape.

The frame rails of this card table are made of sylvestris pine, a wood whose North American species were rarely used by American cabinetmakers during the eighteenth and early nineteenth centuries. The other three pieces of furniture in the Art

Gallery's collection with sylvestris pine as a secondary wood were made, as was this card table, in eastern Massachussetts: a clock case with works by David Wood of Newburyport, a chest-on-chest by Stephen Badlam, Sr., of Lower Dorchester Mills, and a chest of drawers.[2] Looking glasses made of sylvestris pine traditionally have been indentified as European, although one pillar frame (cat. 184) is very similar to documented New England examples and possibly represents the same regional preference for this secondary wood as does the present table.

1. Hewitt/Kane/Ward 1982, no. 25; Stoneman 1965, no. 40. Information concerning the brand on the latter table is recorded in DAPC 74.6231.
2. Battison/Kane 1973, no. 15; Ward 1988, nos. 54, 82.

104

CARD TABLE

Coastal Massachusetts, probably Boston area, 1800—20

Mahogany with mahogany, satinwood, ebony, rosewood, and maple veneers; eastern white pine (frame rails, glue blocks), birch (hinged rail)

77.5 x 98.3 x 44.2 (30 1/2 x 38 3/4 x 17 3/8)

The Mabel Brady Garvan Collection, 1930.2151

Structure: The top's lower leaf is screwed to the frame rails from inside. Each leaf is a solid board. The veneered front and side rails are fitted around the square back sides of the front legs' upper posts. Large stepped blocks are glued into the front corners. The projecting section of the front rail is a separate piece that is butted and glued to the rail. The side rails are dovetailed to the inner rear rail, and rectangular blocks with champfered ends are glued into the frame's rear corners. The inner rear rail is glued to the two filler blocks that separate it from the fixed part of the hinged rail, which is tenoned into the left rear leg. A short finger hinge with champfered edges connects it to the fly rail. A rectangular block is glued behind the joint between the fly leg and fly rail.

Inscription: Illegible letters are written in chalk on the underside of the top.

Condition: The upper surface of the top's hinged leaf has a filled area near the center of its back edge. A piece of the inner rear rail is broken off near its joint with the left rear corner of the top. The left front leg broke out and has been reattached with two screws through its front. The fly rail and hinge pin are replacements; the fly leg and the block behind it appear to be original. The casters are later additions.

References: YUAGB 5 (1931), p. 49; Kirk 1970, fig. 159.

Provenance: Garvan purchased this table at Jacob Margolis' tenth auction on November 5, 1926 (*Margolis* 1926, no. 102).

The distinctive finger hinges on this table, cat. 99, and cat. 105 have short teeth with champfered edges. They may represent the work of a Boston-area specialist who supplied cabinetmakers with ready-made hinged rails. See also cat. 103.

105

CARD TABLE

Coastal Massachusetts, probably Boston area, 1800—20

Mahogany, mahogany and satinwood veneers; eastern white pine (frame rails, glue blocks), birch (hinged rail)

74.8 x 92.7 x 46.6 (29 1/2 x 36 1/2 x 18 3/8)

The Mabel Brady Garvan Collection, 1930.2511

Structure: The top's lower leaf is screwed to the frame rails from inside. Each leaf is a solid board. The veneered front and side rails are butted and glued together. The projecting part of the front rail is a separate piece that is glued to the rail. The front legs are blind dovetailed to the canted front corners. Large blocks that are stepped in section are glued into the front corners. The side rails are dovetailed to the inner rear rail. Rectangular blocks with champfered corners are glued into the frame's rear corners. The inner rear rail is nailed through a filler board to the fixed part of the hinged rail, which is tenoned into the left rear leg. A short finger hinge with champfered edges connects the fixed part of the hinged rail to the fly rail, which is tenoned into the fly leg. A rectangular block was glued behind this joint.

Condition: The right front leg broke out and has been reglued. The veneer on either side of it has been reattached and one piece is a replacement. The glue block behind the fly leg is a replacement. There are three screw holes in line on the underside of the top whose function cannot be explained.

Exhibitions: Downs 1928, p. 18; Hewitt/Kane/Ward 1982, no. 26.

References: Nutting 1928, I, no. 1039; Stoneman 1959, no. 119; Comstock 1962, no. 556 (incorrectly credited to the Philadelphia Museum of Art); Hewitt 1982, fig. 3.

Provenance: Garvan purchased this table from Henry V. Weil in December 1924.

Although there are no inscriptions on this card table to indicate that it was made as one of a pair, a table that appears to be its

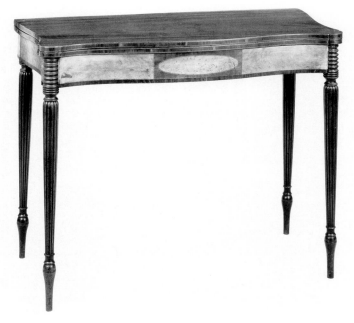
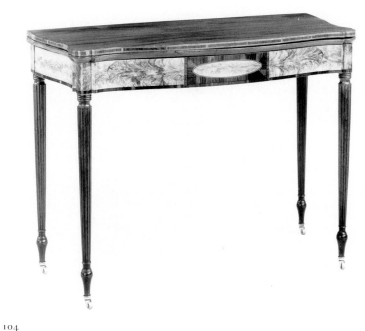

<div align="center">103 104</div>

mate was advertised by the Priscilla Shop of Weston, Massachusetts, in 1925.[1] See also cats. 103 and 104.

1. *Antiques* 15 (February 1929), p. 105.

[PROVIDENCE, RHODE ISLAND]

The card tables made in Providence and Newport after the War of Independence form a distinct group within New England furniture. Providence cabinetmakers tended to make their tables more sturdy than did those in Massachusetts, using flush construction for the rear rails and fly legs that overlapped and supported the rear corner of the frame.[1]

1. Hewitt/Kane/Ward 1982, pp. 148–49.

106

CARD TABLE

Joseph Rawson and Son (partnership of Joseph Rawson, Sr. [1760–1835] and Samuel Rawson [1786–1852], 1808–28)
Providence, 1808–15
Mahogany, mahogany and soft maple veneers; spruce (front rail),

hemlock (side rails), eastern white pine (inner rear rail, glue blocks), hard maple (hinged rail), hickory (hinge pin)
73.4 x 93.5 x 45 (28 7/8 x 36 3/4 x 17 3/4)
Gift of Benjamin A. Hewitt, B.A. 1943, PH.D. 1952, 1977.183.2

Structure: The top's lower leaf is screwed to the frame rails from inside. Each leaf is a solid board. The front and side rails are cut from solid boards and veneered. A rectangular piece of wood with decorative inlays is applied to the center of the front rail. The frame rails are tenoned into the front legs with quarter-round and rectangular blocks glued behind these joints. The side rails are dovetailed to the inner rear rail with champfered vertical blocks glued into the two rear corners. The inner rear rail is glued to the fixed part of the hinged rail with a filler piece of wood inserted between them. The fixed part of the hinged rail is tenoned into the left rear leg. A finger hinge connects it to the fly rail, which is tenoned into the fly leg. A vertical block is glued behind the latter joint.

Inscriptions: " + JR [monogram], Nº / 1" is written in chalk on the underside of the top. A paper label is glued inside the fly rail: "JOSEPH RAWSON & SON, / *Cabinet and Chair Makers*, / NEAR THE THEATRE...........SUGAR-LANE, / PROVIDENCE, / Rh[ode Is]land."

105 *Hinge*

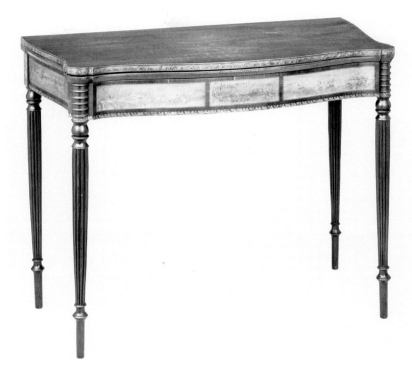

105

106

106 *Label*

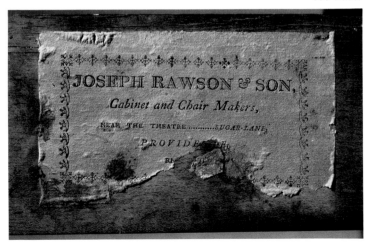

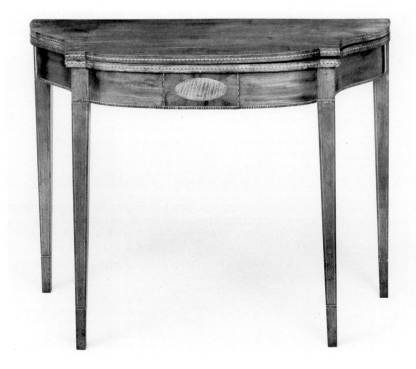

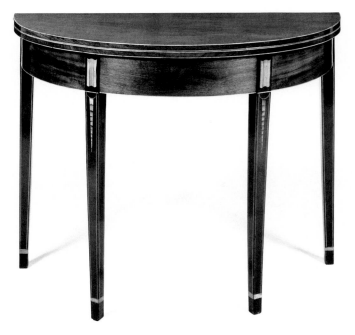

107 Label

107

Condition: The patterned banding on the left side of the applied front panel is a replacement. The block in back of the fly leg is also a replacement. The right front corner block has been reglued.

Exhibition: Hewitt/Kane/Ward 1982, no. 31.

Reference: Monahon 1980, fig. 13.

Provenance: The donor purchased this table from Mrs. Ray Carmichael of Hamden, Connecticut, on April 9, 1976.

Both the shape and ornament of this card table were influenced by contemporary examples from coastal Massachusetts (cats. 85, 100), and turned-leg tables made by the Rawsons were equally close to Massachusetts styles.[1] More than one authority has theorized that a Massachusetts-trained workman in the Rawsons' shop was responsible for this relationship.[2] These tables all feature monochromatic veneers and a restrained use of patterned inlay, however, suggesting that there was a consistent shop style, deliberately subtler than the Massachusetts work that inspired it.

As the inscription on the underside of the top indicates, this table is one of a pair; the mate is in a private collection.[3]

1. Monahon 1980, pl. 5; Monkhouse/Michie 1986, no. 80; Sotheby's 1989, no. 353.
2. Hewitt/Kane/Ward 1982, p. 149; Monkhouse/Michie 1986, p. 143.
3. Monahon 1980, p. 141.

107

CARD TABLE

Probably Providence, 1790–93

Retailed by George Shipley (d. 1803), New York City

Mahogany, mahogany veneer; eastern white pine (frame rails, glue blocks), black cherry (hinged rail)

72.3 x 91.5 x 45.3 (28 1/2 x 36 x 17 7/8)

Gift of Benjamin A. Hewitt, B.A. 1943, PH.D. 1952 in memory of Sarah and Attmore Tucker, 1983.96

Structure: The top's lower leaf is screwed to the frame rails from inside. Two rose-head nails are driven at an angle into the top lamination, possibly to secure the top. Both leaves are solid boards. The back edge of the lower leaf has a tenon that fits into a reciprocal mortise on the hinged leaf's inside edge when the top is opened. The curved front rail is composed of three hori-

zontal laminates and veneered. The two front legs are fitted over the rail, and possibly also tenoned into it from below. The curved rail's right end is dovetailed to the inner rear rail, which is nailed flush to the fixed part of the hinged rail. Two rounded blocks are glued into the rear corners. The fixed part of the hinged rail is tenoned into the left rear leg. A knuckle hinge connects it to the fly rail, which is tenoned into the fly leg. The fly leg's upper end is cut out to overlap the right rear corner of the frame when closed. The left rear leg has a similar cutout that is glued over the left end of the curved rail.

Inscriptions: A printed paper label is glued to the inner rear rail behind the fly leg: "*A large Assortment of* / CABINET FURNI-TURE / *of the newest Fashion at* / *G. Shipley's Manufact^y.* / *N^o 161 Water Street* / NEW YORK. / Mahogany for Sale. / Rollinson Sculp.t" "STINSON / 176727" is written on an adhesive tag applied to the underside of the curved rail.

Condition: The right front leg broke out and has been reattached with a spline; two laminates behind it have been replaced. The cuff inlay on the left front leg and the hinge pin are also replacements. During the early 1970s, the table was refinished by Richard Slee of Marblehead, Massachusetts, who may have made the other repairs.

Exhibitions: Ward 1977, no. 9; Hewitt/Kane/Ward 1982, no. 32.

Reference: *YUAGB* 39 (Fall 1984), p. 62.

Provenance: The dealer Carl W. Stinson of Reading, Massachusetts, acquired this table in the early 1970s from an estate in Marlboro, Massachusetts. Stinson consigned the table to auction in New York City, where the donor purchased it on January 29, 1977 (Sotheby's 1977, no. 1067).

Based on distinctive features of this card table's construction and decoration, including the overlapping fly leg, monochromatic veneer, and glyph and "icicle" inlay, Benjamin Hewitt proposed that it was made in Providence and retailed by George Shipley of New York City.[1] Shipley may have had a wholesale connection with a craftsman in Providence. A pair of pembroke tables with Shipley's label has inlays identical to those on this table, indicating that Shipley sold a number of Providence-style pieces.[2] Shipley advertised that he was "from LONDON,"[3] and it is unlikely that a English-trained cabinetmaker would have produced furniture with Rhode Island characteristics. In the same advertisements, however, Shipley announced that "he has in employment a number of excellent workmen," and it is possible that one of these craftsmen had been trained in Providence.

George Shipley arrived in New York prior to September 29, 1789, when he advertised as a cabinetmaker, house carpenter, and retailer of hardware and other metal goods. He was listed in the city directories at 161 Water Street between 1790 and 1793; from 1794 until 1798 he was located at 195 Water Street. In the 1801 directory, Shipley was listed at 191 Water Street; he had announced in March 1801 that he "has again commenced the Cabinet making business in all its branches." Shipley died sometime in 1803 before November 9, when his widow offered for sale the stock of his shop as well as the lease on 191 Water Street.[4] During his first three years of business at 161 Water Street, Shipley used at least two different labels, both engraved by William Rollinson (1762–1842).[5]

1. Hewitt/Kane/Ward 1982, p. 150.
2. One of these tables is illustrated in Downs 1951, p. 47. A photocopy of the original photograph from which this illustration was taken, showing both tables, is in the comparative files in the Furniture Study, Yale University Art Gallery.
3. *New York Daily Advertiser*, March 15, 1790, p. 3; May 18, 1792, p. 3.
4. *New York Daily Advertiser*, September 29, 1789, p. 2. *New York Directory*, 1790, p. 90; 1791, p. 115; 1792, p. 121; 1793, p. 137; 1794, p. 167; 1795, p. 192; 1796, p. 288; 1797, p. 291; 1798, n.p.; 1801, p. 274; 1802, p. 314; 1803, p. 260. *New York Daily Advertiser*, March 31, 1801, p. 3; November 9, 1803, p. 3.
5. The other label is illustrated in Rogers/Fales 1961, p. 374.

[THE MIDDLE ATLANTIC STATES]

The aesthetic preferences governing the design and ornament of card tables made in New York City and Philadelphia were distinct from those in New England. There were fewer popular shapes, and the only square leg used had a single-taper. Although tables with square leg frequently were decorated with contrasting veneers (cats. 108, 109), turned-leg tables from both cities were almost invariably monochromatic (cats. 111, 116). Card tables made in New York, New Jersey, Pennsylvania, and Maryland during the Federal period were also much more sturdily constructed than their New England counterparts: curved frame rails were made with multiple laminates, rear rails were assembled without filler pieces of wood, and tenons were usually inserted into the back edges of the top.[1]

1. Hewitt/Kane/Ward 1982, pp. 89, 93–95, 97–98.

[NEW YORK CITY]

The price books published in New York City between 1796 and 1817 provide considerable information concerning the styles of card tables made there during the Federal period. The great majority had four fixed legs and a fifth fly leg that supported the rear corner of the frame, a feature included as part of the basic model in every price book.[1] The number of available shapes

remained constant at about a dozen, but the more complex shapes changed with time. Tables with "ovalo" corners (cat. 108) are listed in the 1796 and 1802 price books, but not in 1810 or 1817; conversely, "eliptic" card tables as well as the "eliptic pillar and claw card table" (cats. 113–115) first appear in 1810.[2] During the 1790s and first decade of the 1800s, card tables were frequently embellished with stringing, banding, and pictorial inlays; one rare pair has inset panels of reverse-painted glass.[3] These ornamental techniques declined in popularity by 1810, when they were calculated in much less detail. In 1810 and 1817, carving, reeding, and brass stringing and inlay were the favored enrichments.[4]

Although New York tables are similar in construction to those produced in other areas of the mid-Atlantic region, most New York falling-leaf and card tables at Yale have finger hinges like those on New England tables (see p. 174). The exceptions are the two Colonial card tables (cats. 74, 75) and one pillar-and-claw card table (cat. 115).

1. *New York Prices* 1796, p. 35; 1802, p. 20; 1810, p. 24; 1817, p. 34; Hewitt/Kane/Ward 1982, pp. 91–92, 95.
2. *New York Prices* 1796, pp. 35–37; 1802, pp. 20–23; 1810, pp. 24–25; 1817, pp. 34–36; Hewitt/Kane/Ward 1982, pp. 46–47.
3. Montgomery 1966, no. 297. The mate to this table was sold at auction in 1986 (Sotheby's 1986a, no. 644).
4. *New York Prices* 1796, tables 6–8, 14; 1802, pp. 57–59; 1810, pp. 59, 66–67, 71; 1817, pp. 111, 122.

108

CARD TABLE *Color plate 30*

New York City, 1790–1805

Mahogany (including blocks on either side of hinged rail), mahogany veneer; eastern white pine (front and straight side rails, corner blocks), yellow-poplar (laminates of curved rails, inner rear rail), black cherry (hinged rail)

74.6 x 91.2 x 44.9 (29 3/8 x 35 7/8 x 17 5/8)

The Mabel Brady Garvan Collection, 1930.2009

Structure: The top's lower leaf is screwed to the frame rails from inside. Both leaves of the top are veneered; each leaf is composed of two boards with batten ends. A tenon on the back edge of the hinged leaf fits into a reciprocal mortise on the inside edge of the fixed leaf when the top is opened. The frame rails are veneered. A projecting, rectangular block with an inlaid oval is fitted into the center of the front rail. The semi-circular front corners are composed of four vertical laminates screwed and nailed to the square side rails and to cutouts in the back of the front legs. The frame rails are tenoned into the fixed legs. Vertical blocks are glued into the frame's two rear corners.

108 *Front rail inlay*

108 *Pilaster inlay*

108 *Side rail inlay*

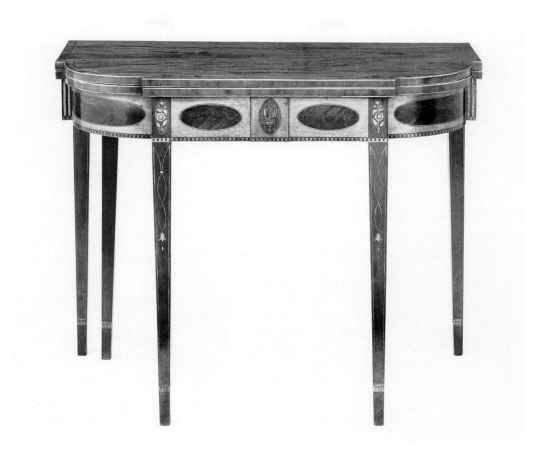

108

108 *Vertical laminations*

The inner rear rail is nailed flush to the fixed part of the hinged rail, which is connected to the fly rail with a finger hinge. The fly rail is tenoned into the fly leg, which overlaps the inner rear rail when closed. Vertical blocks are glued between the fixed rear legs and the hinged rail.

Inscriptions: "2" is written in chalk on the inside of the inner rear rail and both square side rails.

Condition: Horizontal cracks in both leaves of the top have been repaired with new strips of veneer. Peter Arkell refinished the surface in 1981.

Exhibitions: "Georgian Art" 1931, p. 12; Hewitt/Kane/Ward 1982, no. 37.

References: YUAGB 5 (1931), p. 49; Ostergard 1987, fig. 1–29.

Provenance: Garvan may have acquired this table from Jacob Margolis. An early catalogue card listed its provenance as "Margolis? 1923" (card no. 732,box 27, FPG–AAA). The table was not included in Margolis' auction of that year, although he may have sold it privately to Garvan. Later catalogue cards for this table record that it was purchased at Margolis' November 5, 1926, sale at the American Art Association, but no table matching its description appears in the catalogue or in the list of twenty-one lots that Garvan acquired at that sale. This later version of the provenance probably was confused with that of cat. 104.

This card table is an outstanding example of American Neoclassical furniture. Its smooth, planar surface is enlivened by a series of sophisticated interplays between light and dark veneers, naturalistic and geometric inlays, and vertical and horizontal ovals. The inlaid ovals on the frame rails, stringing on the top leaf, interlaced stringing with pendant bellflowers on the legs, and vertically striped veneers on the ends of the straight side rails adjacent to the curved front rails were all characteristic of card tables made in New York City. A similarly ornamented table has been attributed to William Whitehead of New York, who worked between 1792 and 1800.[1] The pictorial inlay of an urn with flowers apparently was a favorite motif in New York during this period. A similar inlay appears on a New York card table at Winterthur, and the New York silversmith John Burt Lyng used a swage with an urn of flowers to ornament the backs of spoons made about 1785.[2] The Art Gallery's table is also constructed in a manner characteristic of New York City. The curved frontrails were formed from vertically laminated pieces of wood, a rare technique used only in New York.[3]

This card table's lavish ornament represented more than one-third of its total cost. As described in the 1802 price book, the basic version was listed at £2.10s.:

Veneer'd Ovalo Corner Card Table. Three feet long; straight middle and ends; the rails veneer'd; four fast legs, and one fly; three joints in each top; clamp'd and veneer'd; the edges of tops cross or long beaded; an astragal or five strings round the frame.

A rough calculation of the extras that were added to this table yields approximately £1.0.4 of additional ornamentation exclusive of the pictorial inlays. These included a "pannel" of stringing on three sides of the top (6s.), banding on the edges of the leaves (4s. 6d.), a tablet on the front rail (1s.), the six oval panels let into the frame rails (5s. 10d.), and the double lines of stringing on eight sides of the legs with "round diamond ends" on four of them (36d.).[4]

As the chalk inscriptions indicate, this table was made as one of a pair; what appears to be its mate was published in 1948.[5] A pair of card tables with similar inlaid ornament was sold at auction in 1990.[6]

1. Hewitt/Kane/Ward 1982, no. 38.
2. Montgomery 1966, no. 284; Yale University Art Gallery, Gift of Carl R. Kossack (no. 1985.84.560).
3. Hewitt/Kane/Ward 1982, p. 89.
4. *New York Prices* 1802, pp. 22, 57–58.
5. Sack 1948, fig. 6.
6. Sotheby's 1990a, no. 1190.

[PHILADELPHIA]

The price books published in Philadelphia during the Federal period, like those from New York, document local styles and construction features. To a lesser degree than in New York, the books reflect a shift from the inlaid ornament popular in the 1790s to the monochromatic, reeded ornament of the 1810s.[1] Each edition of the Philadelphia price book listed about nine different shapes for card tables, most of which followed the shapes in London price books.[2] The 1811 price book included two shapes, "kidney end . . . with serpentine middle" (cats. 109, 110) and "serpentine corners, straight front, and end rails," made almost exclusively in Philadelphia and areas under its influence. The turnings of many Philadelphia card tables, including cats. 39 and 111, were equally distinctive.[3] Additional fly legs were listed as extras but rarely selected.[4]

Knuckle hinges are found on every Philadelphia-area card table in the Art Gallery's collection (cats. 76, 77, 109–112) as well as the Federal-style pembroke tables made in New Jersey and Maryland (cats. 64–67). More sturdy and labor-intensive than the finger hinges popular in New England and New York, knuckle hinges may be of German or Continental European origin.[5]

1. *Philadelphia Prices* 1795, tables 6–12; 1811, pp. 83–84, 88–89, 95, 97, 101.

2. *Philadelphia Prices* 1795, pp. 36–38; 1796a, pp. 48–51; 1811, pp. 33–37. Hewitt/Kane/Ward 1982, pp. 46–47.
3. Hewitt/Kane/Ward 1982, pp. 65–67.
4. *Philadelphia Prices* 1795, p. 36; 1796a, p. 50; 1811, p. 33. A Philadelphia card table with five legs is illustrated in Hewitt/Kane/Ward 1982, no. 49.
5. Knuckle hinges appear on harlequin tables made between 1745 and 1765 by Abraham and David Roentgen of Neuwied, Germany (Huth 1974, pls. 2, 124).

109

CARD TABLE

Philadelphia, 1800–15

Mahogany, mahogany and satinwood veneers; eastern white pine (frame rails, glue blocks), beech (hinged rail)

75.4 x 90.2 x 45.7 (29 5/8 x 35 1/2 x 18)

Bequest of Doris M. Brixey, 1984.32.33

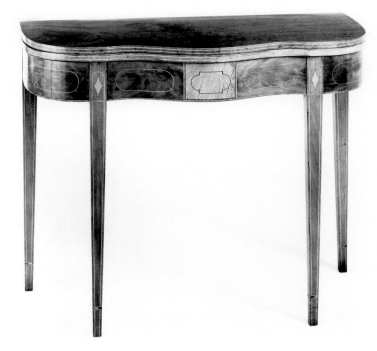

109

Structure: The top's lower leaf is screwed to the frame rails from inside; it has a 3cm (1⅛ in.) overhang at the back. Each leaf is a solid board. Two tenons in the back edge of the fixed leaf fit into reciprocal mortises on the back edge of the hinged leaf when the top is opened. The veneered front and side rails are a single unit composed of four horizontal laminates. Narrow sections of the frame rail fit into channels cut into the front legs, which are designed to fit into wedge-shaped slots on either side of the narrow sections of the rail. At one time the joints between the legs and rails were secured from behind with screws. The frame rail is dovetailed to the inner rear rail. Champfered vertical blocks are glued into the two rear corners. The inner rear rail is nailed through a filler piece of wood to the fixed part of the hinged rail, which is tenoned into the left rear leg. A knuckle hinge connects the fixed part of the hinged rail to the fly rail, which is tenoned into the fly leg.

Condition: All the interior surfaces have been covered with a thick coat of red paint. A series of nail holes on the upper surface of the curved rail suggests that the joints between the horizontal laminations may have been reinforced with nails at one time. Both front legs broke out and have been reattached with angled dowels through the top of the frame. The veneer around the front legs has been repaired. The cuff inlay is a twentieth-century replacement. Both corner blocks are replacements.

American card tables of this shape were made almost exclusively in the Philadelphia area; the shape apparently was unknown in England.[1] It was first listed in the 1811 Philadelphia price book as "kidney end . . . with serpentine middle," although it probably was made before that date.[2] Many tables of this shape were lavishly ornamented, with geometric stringing

on the rails and contrasting pilasters and center panels that were sometimes embellished with pictorial inlays. Based on the figures in the 1811 price book, the ornament on these tables represented between one-third and one-half of their total cost.[3] The basic model of the Art Gallery's table, described as "three feet long, three fast and one fly leg, solid top, the rails veneered," cost $4.68; its ornament represented an additional $2.10, exclusive of stringing. The extras included the projecting legs (2¢ apiece), the "string panel with astragal top and hollow bottom" inlaid on the pilaster of each leg (14¢ apiece), the inlaid diamond panels (11¢ apiece), the lightwood panel at the center of the skirt (2¢, with an extra charge of two-thirds for "sweep work"), the rectangle with astragal ends inlaid on the skirt (14 1/2¢), and the six ovals inlaid on the rails (12¢ apiece with an additional 2¢ for inlaying into "round work").[4] The conceit of continuing the stringing on the legs around the lozenges echoes the astragals inlaid on the facade and adds distinction to this table.

1. Hewitt/Kane/Ward 1982, p. 67.
2. *Philadelphia Prices* 1811, p. 36.
3. Among the many similar card tables are those reproduced in Hewitt/Kane/Ward 1982, no. 44; Garrett 1985, no. 118; Warren 1975, no. 153. Patricia E. Kane's analysis of the first table calculated the price of its ornament at one-third the total cost (Hewitt/Kane/Ward 1982, p. 43).
4. *Philadelphia Prices* 1811, pp. 36, 88, 95, 97.

110

CARD TABLE

Probably Philadelphia, 1800–15

Black walnut, black walnut veneer; yellow-poplar (curved and hinged rails), eastern white pine (inner rear rail, glue blocks), hickory (hinge pin)

73.1 x 92.8 x 45.1 (28 3/4 x 36 1/2 x 17 3/4)

The Mabel Brady Garvan Collection, 1930.2081

Structure: The top's lower leaf is screwed to the frame rails from inside. Each leaf is a solid board. The veneered front and side rails are a single unit composed of two horizontal laminates. Narrow sections of the frame rail fit into channels cut into the upper ends of the front legs. The frame rail is dovetailed to the inner rear rail. Rectangular blocks are glued into the frame's rear corners. The inner rear rail is nailed flush to the fixed part of the hinged rail, which is tenoned into the left rear leg and connected by a knuckle hinge to the fly rail. The fly rail is tenoned into the fly leg, which has a cutout that overlaps the inner rear rail.

Inscriptions: There is an indecipherable chalk inscription on the inner rear rail; the second part appears to begin with "De" "5" is written in pencil on a piece of brown paper glued to the underside of the top.

Exhibitions: White 1958, no. 86; Hewitt/Kane/Ward 1982, no. 45.

Provenance: Garvan purchased this table from Frances Wolfe Carey on January 7, 1929.

This table was included in a landmark exhibition of New Jersey furniture in 1958, undoubtedly because it was made of walnut instead of mahogany and was purchased from a New Jersey dealer. Every detail of its construction is consistent with Philadelphia practice, however, and it is essentially identical to the preceding example (cat. 109), without the projecting legs and other additional ornamentation. Although mahogany and satinwood were specified in descriptions of furniture in Philadelphia price books from 1795 on, walnut had been a less expensive alternative to mahogany since the second quarter of the eighteenth century and continued to be used as such into the Federal period. A retail price book published in Philadelphia in 1796 gave prices for furniture in mahogany and walnut, as did a 1772 price list.[1] The use of walnut and the overall lack of embellishment on this card table suggest that it was made in Philadelphia as a less ostentatious and less expensive model.

1. *Philadelphia Prices* 1796b, pp. 3–25; Weil 1979, p. 176.

111

CARD TABLE

Philadelphia, 1790–1815

Mahogany, mahogany veneer; eastern white pine (frame rails, glue blocks), red oak (hinged rail)

74.4 x 91.6 x 43.2 (29 1/4 x 35 5/8 x 17)

Gift of Benjamin A. Hewitt, B.A. 1943, PH.D. 1952, 1979.103.1

Structure: The top's lower leaf is screwed to the frame rails from inside. Each leaf is a solid board. Two tenons in the back edge of the upper leaf fit into reciprocal mortises on the back edge of the lower leaf. The veneered front and side rails have a bead molding nailed to their undersides. The front and side rails are a single unit composed of four horizontal laminates that are apparently nailed together from the upper surface. Narrow sections of the rail unit are fitted into channels cut into the upper ends of the front legs. The back ends of the rail are dovetailed to the inner rear rail. Rectangular blocks with champfered outside edges are glued into the two rear corners. The inner rear rail is nailed flush to the fixed part of the hinged rail, which is tenoned into the left rear leg. A knuckle hinge connects the fixed part of the hinged rail to the fly rail. The fly rail is tenoned into the fly leg, which overlaps a cutout in the frame's right rear corner. The left rear leg overlaps the left rear corner of the frame and is glued in place.

Inscription: "2" is written in chalk on the inner rear rail.

Condition: The right front leg broke out from the frame and has been reattached. The upper left corner of the left front leg's upper end is broken off, and the right side of the right front leg's upper end has been repaired with a new strip of wood. Deep vertical scratches have been drawn out from the reeding onto all the legs. The veneer around both front legs has been cracked and repaired. Both rear legs broke off the tenons on the hinged rail and have been reattached; the fly leg is now held in place with metal braces.

Exhibition: Hewitt/Kane/Ward 1982, no. 46.

Provenance: The donor purchased this table from the dealer Kenneth Hammitt of Woodbury, Connecticut, on August 30, 1979.

In contrast to the lavish ornament found on many Philadelphia card tables with square legs, tables made with turned legs were relatively plain in appearance. This austerity might be no less expensive than a prodigal use of veneer and inlay, however. Both the total cost of this card table and the relative value of its ornamentation are very similar to an elaborately decorated, square-

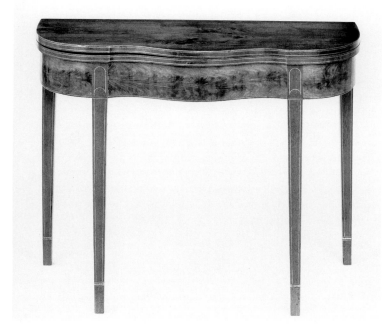

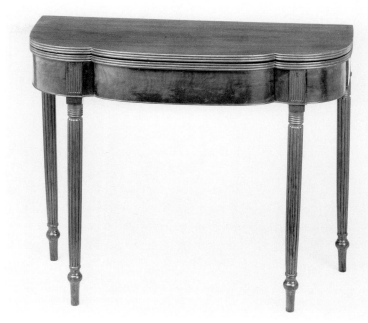

110 111

leg table (cat. 109). Based on the figures in the 1811 Philadelphia price book, the total cost of this turned-leg table would have been approximately $7. Between one-third and one-half of this amount represented embellishments on the standard "kidney end" form, including the bead molding on the skirt (40¢), four projecting legs (8¢), and "reading" the edges of the top (97¢), the shafts of the legs (80¢), and the pilasters (20¢). The double elliptic top, on the other hand, represented a 26¢ reduction in the cost of the table.[1] A few card tables of this type were further enriched with carved capitals and pilasters.[2]

A card table almost identical in appearance to the Yale example descended in the Somers family of Haddonfield, New Jersey.[3]

1. *Philadelphia Prices* 1811, pp. 56, 101. The "eliptic" shape is first listed as an extra under "A Circular Card Table" in *Philadelphia Prices* 1796a, p. 50.
2. A double elliptic-top card table with carved capitals and pilasters and an additional fly leg is illustrated in Hornor 1935a, pl. 428.
3. Hopkins/Cox 1936, no. 21.

112

CARD TABLE

Philadelphia area, 1800–25

Mahogany, rosewood (pieces nailed to underside of frame rails), mahogany veneer; eastern white pine (inner rear rail, medial brace, glue blocks), white oak (hinged rail), yellow-poplar (inner front rail, side rails, filler board between inner rear and hinged rails)

74.6 x 101.5 x 49.4 (29 3/8 x 40 x 19 1/2)

The Mabel Brady Garvan Collection, 1930.2024

Structure: The top's lower leaf is screwed to the frame rails from inside. Each leaf is a solid board. Three tenons in the back edge of the upper leaf fit into reciprocal mortises on the back edge of the lower leaf. The veneered front and side rails have pieces of rosewood glued to their undersides to simulate banding. The front rail is composed of two shaped pieces with a flat central piece glued to an inner rail that flares out from the center to the outside corners. Each side rail is composed of a shaped outer layer glued to an inner rail that tapers from the back corner to the front. The side rails are dovetailed to the inner rear rail; the method by which the front corners of the frame are joined is not visible. Two-piece, quarter-round corner blocks reinforce the front corner joints. Smaller quarter-round blocks are glued in the back corners. A medial brace is dovetailed between the inner front and inner rear rails. The inner rear rail and the fixed part of the hinged rail are glued together with a filler strip of wood between them. The fixed part of the hinged

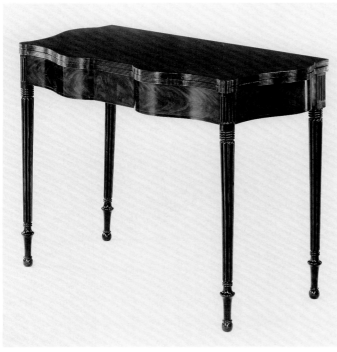

112

distinctive shape cannot be identified in any contemporary Philadelphia price books.[2] The table is also 4 in. (10.2cm.) wider than the standard "three feet long" card tables described in the price books and represented at Yale (cats. 109–111).[3] The leaf-edge tenons, medial brace, fly leg that overlaps and supports the frame, and use of oak as a secondary wood are all characteristic of Philadelphia work, but the tapered frame rails and the use of applied pieces of wood to simulate banding are unusual. At least three other tables of this shape are known, all without the corner columns but with turnings that are variations on the standard Philadelphia type. Two of these tables are even larger than the Yale example.[4] Identical feet appear on a card table of a different shape but with similar secondary woods and construction features that descended in the Chapman family of Charles County, Maryland.[5]

1. Hewitt/Kane/Ward 1982, p. 65.
2. Ibid., p. 71, for a description of this shape as "square with serpentine and round middle front, serpentine ends, ovolo corners, and three quarter colonnettes."
3. *Philadelphia Prices* 1795, pp. 49–51; 1796a, pp. 49–51; 1811, pp. 33–36.
4. Parke-Bernet 1969, no. 83; the larger tables are illustrated in *Sack Collection,* VIII, p. 2214, and Christie's 1991, no. 346.
5. MESDA research file S-7807.

rail is tenoned and pinned to the left rear leg. A knuckle hinge connects it to the fly rail, which is tenoned into the fly leg. The fly leg overlaps a cutout in the right rear corner of the frame.

Inscriptions: "N⁰ 1" is written in chalk on the right side of the medial brace. "1" is incised on the underside of the fixed part of the hinged rail.

Condition: The upper end of the left front leg is cracked. The fly leg has been broken and repaired and has been reattached to the fly rail.

Provenance: This table was part of the collection Garvan acquired from R.T.H. Halsey.

Several features of this card table suggest that it was made by a craftsman working outside of Philadelphia in Pennsylvania or New Jersey. Its design and construction were influenced by Philadelphia models, although the execution departed from standard urban practice. The legs were patterned after a common Philadelphia type that was rarely used elsewhere: capitals with four ring turnings over a hollow and feet with a hollow over a bulb and taper.[1] The flattened bulb and attenuated taper of the feet are an unusual interpretation of this form. The table's

Pillar-and-Claw Card Tables

Pillar-and-claw card tables, known today as "trick-leg" tables, were a uniquely American response to the problem of eliminating hinged leg supports in early nineteenth century furniture (see p. 135). The form combined hinged flys from pembroke tables (cats. 61–70) with bases from three-leg, center pedestal tables (cats. 6, 123–133). Two flys on the back of the frame are connected by hinged iron braces and rods to the two rear legs, which rotate backwards when the flys are pulled out (see cat. 113). The relationship between such seemingly disparate forms as mid-eighteenth century tea tables and early nineteenth-century pillar-and-claw card tables is indicated by the similarity between the urn on a card table in the Art Gallery's collection (cat. 115) and the urns on mid-eighteenth-century New York tea tables (see cat. 125). Both forms were also commonly known by the same name, "pillar-and-claw table."

Pillar-and-claw card tables were made in New York and Philadelphia for a relatively brief period, perhaps because the form's complicated mechanism did not create a table of greater stability than those with fly legs. Pillar-and-claw card tables were listed only in the New York City price books for 1810 and 1817 and the Philadelphia price book for 1811.[1] The large

number surviving attests to their popularity, despite the high cost. The price of a basic "Veneered Eliptic Pillar and Claw Card Table" was £5.8.0 in the 1810 New York price book, nearly three times the cost of a five-legged table with the same amount of ornament; the "Serpentine Cornered Pillar and Claw Card Table" listed in the 1811 Philadelphia price book cost $16.38, almost four times the price of a serpentine cornered table with four legs.[2] The pillar-and-claw card tables made in Philadelphia exhibit the same regional characteristics as four-leg card tables; no example from this city is in the Art Gallery's collection.[3]

Pillar-and-claw card tables made in New York City have been consistently associated with Duncan Phyfe, although without any firm documentation. The only labeled tables known to the author are a pair at the Henry Ford Museum, made by Michael Allison between 1807 and 1815.[4] The New York cabinetmaker John Hewitt wrote a detailed description of this form in his account book in 1809 and recorded selling several pairs over the following three years.[5] The New York tables have had a special appeal for collectors since the early part of this century. With the same elements as contemporary tables with falling leaves (see cat. 68)—reeded saber legs with paw feet, a central urn, corner drops, and double or treble elliptic leaves—pillar-and-claw card tables were composed with an economy that places them among the most graceful and successful designs in American Neoclassical furniture. On some examples, even the frame rail was discarded.[6] The three pillar-and-claw card tables in the Art Gallery's collection indicate the range in quality and price that was available in New York.

1. *New York Prices* 1810, pp. 25–26; 1817, pp. 36–37; *Philadelphia Prices* 1811, pp. 36–37.
2. *New York Prices* 1810, pp. 25–26; *Philadelphia Prices* 1811, pp. 35–36.
3. A pillar-and-claw card table attributed to Joseph Barry of Philadelphia is illustrated in Fennimore/Trump 1989, pl. 16.
4. McClelland 1939, pl. 187.
5. Johnson 1968, pp. 196–97.
6. Montgomery 1966, no. 315.

113

CARD TABLE

New York City, 1810–20
Mahogany, mahogany veneer; eastern white pine (frame rail)
75.1 x 90.3 x 45.1 (29 5/8 x 35 1/2 x 17 3/4)
The Mabel Brady Garvan Collection, 1930.2155

Structure: The veneered frame rail is composed of three horizontal laminates. A bead molding is glued to the rail's under-side, and three projecting tablets are glued to the front. The back ends of the frame are tenoned into blocklike corners; turned drops are tenoned into these corners and the frame rail. The inner rear rail has reverse-curved ends that are screwed to the top's underside. Two reverse-curved support braces are blind-dovetailed into the inner rear rail and screwed to the top. A trapezoidal piece of wood is glued to the inner rear rail between the support braces. A shallow trapezoidal compartment box is nailed into cutouts in the support braces and a rabbet in the trapezoidal piece of wood. The iron mechanism that connects the hinged flys to the legs is fitted within the compartment. The fixed center section of the hinged rail is glued to the back of the inner rail. Finger hinges connect it to the two flys, which have the same reverse-curved shape as the inner rear rail and the support braces. The square plinth of the pedestal is double-tenoned into the center of the inner rear rail. The front leg probably is blind-dovetailed to the pedestal. A short extension in the metal plate covering the pedestal's underside is screwed to the underside of the front leg. The two rear legs are fitted into the pedestal with metal strips attached to rods extending through the pedestal. Metal braces screwed to the legs' undersides also connect them to the mechanism for the flys.

Inscription: "ADDISON GALLERY / PHILLIPS ACADEMY / ANDOVER, MASSACHUSETTS" is printed on a paper label attached to the underside of the top; "612a.1932" is typed on the label.

Condition: The top is old but not original to this table. The two rear drops probably are replacements. The lower end of the right leg is pieced.

Reference: Nagel 1949, p. 93.

Provenance: This table was owned by the cabinetmaker and antiques dealer Ernest F. Hagen of New York City, from whom it was acquired by the collector Alexander M. Hudnut of Princeton, New Jersey. Garvan purchased the table at the auction of Hudnut's collection in New York City on November 19, 1927 (*Hudnut* 1927, no. 63).

Of the three pillar-and-claw card tables at Yale, this example has the most expensive ornamentation. Its "extras" include a treble elliptic top (6s.), a raised panel at the center of the rail and four projecting "stumps" (10s. total), four drops (10s. total), and a bead molding along the edge of the elliptic frame (14s.), making a cost of £8, exclusive of carving.[1] The attention to detail did not end on the exterior, as this table has interior supports that are shaped as reverse curves. The carving on the legs and the tall neck on the urn create a perfect visual equilibrium between base, frame, and top.

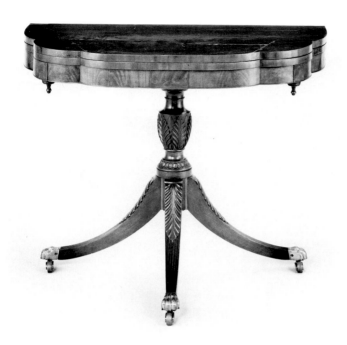

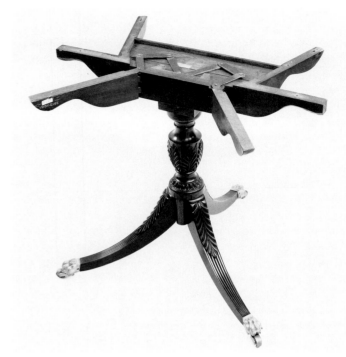

This table may have been made as one of a pair; what appears to be an identical table, retaining its original top, was published in 1922.[2]

1. *New York Prices* 1810, p. 26.
2. Cornelius 1922, pl. 35. The same table is illustrated in Halsey/Tower 1925, fig. 119. At that time it may have belonged to R.T.H. Halsey; its present owner is unknown.

114

CARD TABLE

New York City, 1810–20
Mahogany, mahogany veneer; eastern white pine (corner blocks)
75 x 92.2 x 45.1 (29 1/2 x 36 1/4 x 17 3/4)
The Mabel Brady Garvan Collection, 1930.2776

Structure: The top's lower leaf is screwed to the frame rails from inside. The veneered leaves are each composed of four boards with batten ends. The back edge of the lower leaf has a mortise at its center and tenons at either end; these correspond to a reciprocal tenon and mortises on the back edge of the upper leaf. The veneered frame is composed of three horizontal laminates. A bead molding is nailed to the rail's underside. The inner rear rail has shaped ends that are tenoned between the frame rail's rear ends. A champfered corner block reinforces each of these joints. Two shaped support braces are blind-dovetailed into the rear rail, screwed to the top, and glued into cutouts in the front rail. A trapezoidal piece of wood is glued to the inner rear rail between the support braces, and a trapezoidal compartment box is fitted within cutouts in the support braces. The iron mechanism that connects the hinged flys to the legs is fitted within this compartment. The fixed center section of the hinged rail is glued to the back of the inner rail. Finger hinges connect it to the two shaped flys, which have veneer glued over the metal strips screwed into their upper surfaces. Angled blocks are dovetailed to the rear corners of the rail unit. The pedestal is tenoned into the center of the inner rear rail. The front leg is probably blind-dovetailed to the pedestal. A metal plate covering the pedestal's underside has an extension that is screwed to the underside of the front leg. The two rear legs are fitted into the pedestal with metal strips, attached to the rods that extend through the pedestal. Metal braces screwed to the undersides of the legs also connect them to the mechanism for the flys.

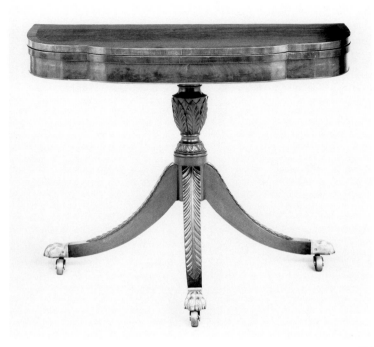
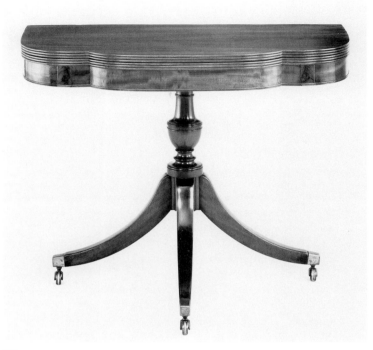

114 115

Condition: The casters appear to be original. A section of the bead molding on the right front corner is a replacement. There are deep shrinkage cracks in both leaves of the top, which was refinished by Peter Arkell in 1974.

Reference: Miller 1937, II, no. 1548.

Provenance: This table was part of the collection Garvan acquired from R.T.H. Halsey.

In contrast to the preceding example (cat. 114), this card table has longer carved leaves and a truncated urn that create an awkward relationship between the base and top. It was made with less costly options, such as veneered panels or "flush stumps" on its rails and a double elliptic top, and its interior supports were curved but not shaped into reverse curves.

115
CARD TABLE

New York City, 1810–20

Mahogany, mahogany veneer; eastern white pine (frame
 laminates), white oak (front supports, inner and hinged rails),
 yellow-poplar (box for mechanism)

74.9 x 92.1 x 45.1 (29 1/2 x 36 1/4 x 17 3/4)
The Mabel Brady Garvan Collection, 1930.2534

Structure: The top's lower leaf is screwed to the frame rails from inside. Both leaves are solid boards. Two tenons in the back edge of the upper leaf fit into reciprocal mortises in the back edge of the lower leaf. The veneered frame rail is composed of two horizontal laminates. A double-bead molding is nailed to the rail's underside. Projecting tablets are applied to the frame and to the shaped corners glued to the frame rails' back ends. The inner rear rail has angled ends that butt against these corners. Two angled support braces are blind-dovetailed into the inner rail and butted against the front rail. A trapezoidal piece of wood is fitted between these braces and nailed to the inner rear rail. A shallow trapezoidal compartment box is nailed into cutouts in the support braces. The iron mechanism that connects the hinged rails to the legs is fitted in this compartment. The fixed center section of the hinged rail is glued to the back of the inner rear rail. Knuckle hinges connect it to the two hinged flys, which have the same angled shape as the inner rail and the front supports. The pedestal is tenoned into the center of the inner rear rail and the trapezoidal block. The front leg is probably blind-dovetailed to the pedestal. An extension from the

metal plate covering the pedestal's underside is screwed to the underside of the front leg. The two rear legs are fitted into the pedestal with metal strips that are attached to the rods extending through the pedestal. Metal braces screwed to the undersides of the legs also connect them to the mechanism for the flys.

Condition: Peter Arkell refinished the top in 1985. The pedestal broke in half below the base of the urn and has been repaired. The feet appear to have been reduced slightly to accommodate new casters.

Provenance: Louise Barrett acquired this table in Washington, Georgia. Garvan purchased it from her on August 14, 1929.

This card table was a considerably less expensive alternative to tables like the two preceding examples (cats. 113, 114). The solid top, absence of carving, and angled rail supports could be produced with a minimum of work time, and the table was probably made as a stock piece instead of on commission. This table was found in Georgia in 1929, which suggests that it was made for export to the southern market. Considerable quantities of furniture were shipped from New York to southern ports in the early nineteenth century. Equally plain furniture labeled by Duncan Phyfe has been found in Georgia and South Carolina; the labels may have been intended as advertisements for distant consumers.[1]

1. Brown 1978, pp. 24–26. A work table labeled by Phyfe that descended in the Dearing family of Albany, Georgia, is now at Winterthur (Montgomery 1966, no. 408).

Swivel-Top Card Tables

Hinged legs on card tables, as on falling-leaf tables, were gradually abandoned after the first decade of the nineteenth century (see pp. 135, 216). The most popular alternative for card tables was the swivel-top form, on which the folding top rotated 90 degrees and was supported by the table frame when opened (see cat. 118). A detailed description of the form appeared in the London price book for 1811:

A square card table, on pillar and claws. All solid.—Three feet long; square edges to the tops; on a pillar and four claws (as No. 1); the frame three and a half inches deep, lap dovetail'd together; . . . the rail under the frame nine inches wide, dovetail'd in to the front and back rails; the top clean'd on the under side, and made to turn round on an iron center, fix'd to a cross rail; or a turn'd wood center in ditto, screw'd to the under side of the top.[1]

The rotating top combined the space-saving, folding top with a more stable supporting frame. It also permitted the adaptation of the card table form to the pedestal base favored by later Neoclassical designers, who embellished them with the full repertoire of motifs from Greco-Roman sources (cats. 117–121). Some of these card tables are among the most sculptural forms in American furniture (cat. 119).

Swivel-top card tables were introduced into the United States in the first decade of the nineteenth century and may represent the impact of immigrant European-trained craftsmen and designers. Among the earliest documented examples are card tables made in New York City by Charles-Honoré Lannuier, who arrived from Paris in 1803 and worked in New York until his death in 1819. Lannuier probably made swivel-top tables from the beginning of his American career. Not only are no hinged-leg card tables by him known, but the designs of his swivel-top tables show a progression from four legs in the Federal style (see cat. 116) to sculptural caryatid bases, which suggests that he made this form over an extended period of time. The caryatid-base card tables with histories of ownership all date after 1810: one pair was made for Isaac Bell of New York after 1810; separate pairs were purchased by Philip Hone of New York and George Harrison of Philadelphia about 1815; and another pair was commissioned by Stephen Van Rensselaer IV of Albany in about 1817.[2] Another early use of the swivel-top form by an immigrant designer is the pair of card tables designed in 1808 by Benjamin Henry Latrobe as part of a suite of furniture made by Thomas Wetherill for William Waln of Philadelphia.[3] Latrobe, having arrived from England in 1805, treated the Waln commission as an opportunity to introduce the latest European Neoclassical style, including furniture forms, to America.

The majority of documented American card tables with swivel tops date after about 1810. An exception is the pair of swivel-top card tables from the fifty-six pieces of furniture ordered from Duncan Phyfe in 1807 by William Bayard of New York; this commission also included a pair of card tables with fixed tops and hinged legs.[4] In 1816, Phyfe made another pair of swivel-top card tables for James Brinckerhoff of New York.[5] A lyre-base card table with a swivel top was made by Elisha Learnard of Boston between 1813 and 1821; a four-leg pair was produced about 1820 by James Rockwood of Richmond, Virginia, for the Stewart family.[6] A pair of card tables with pedestal bases and swivel tops was purchased from Henry Connelly by Stephen Girard of Philadelphia in 1817.[7] In the same year, the first listing in an American price book appeared in New York as an option under the standard card table: "A swivel top, with pieces framed between the rails for ditto, extra from the fast top."[8] By the second quarter of the nineteenth century, swivel tops had almost completely supplanted hinged-leg card tables in every regional center.

1. *London Prices* 1811, p. 141.
2. Miller 1956, no. 124; Tracy 1970, no. 44; Downs/Ralston 1934, nos. 214–15; Rice 1962, pp. 31–32.
3. Garvan 1987, pp. 90–93.
4. Hornor 1930a, p. 38; McClelland 1939, pl. 246.
5. Sloane 1987, fig. 6.
6. Talbott 1975, fig. 8; MESDA research file S-6156.
7. Philadelphia 1976, no. 173c.
8. *New York Prices* 1817, p. 34.

116

CARD TABLE

New York City, 1810–20

Mahogany, mahogany veneer; eastern white pine (front and side frame rails, glue blocks), black cherry (back frame rail, medial brace, stop pin), ash (pivot block)

76.5 x 90.2 x 45.3 (30 1/8 x 35 1/2 x 17 7/8)

Gift of Benjamin A. Hewitt, B.A. 1943, PH.D. 1952, in honor of Florence M. Montgomery, 1984.102

Structure: The top's lower leaf is bolted through a block and a medial brace and pivots 90 degrees to open. Two dowels attached to the underside serve as stops. The interior and exterior the underside serve as stops. The interior and exterior surfaces of both leaves are veneered. The strips of veneer on the outside edges of each leaf are fitted together with an unusual tongue-and-groove joint at the canted corners. Each leaf is composed of three or four boards with narrow batten ends. A .5cm (¼ in.)-thick strip of mahogany is applied to the back edges of both leaves. Three tenons in this strip on the lower leaf fit into reciprocal mortises on the upper leaf. The frame rails are solid boards veneered on their outer surfaces. A bead molding is nailed to the underside of the frame, and the upper surface of the rails is veneered. The canted corners are dovetailed between the front and side rails. A narrow section of each corner rail is fitted into a channel cut into the upper end of each front leg. The side and back rails are tenoned into the rear legs. Two triangular glue blocks are used to reinforce the joints at the rear legs and line up with the leg post to create an interior canted corner. A medial brace is dovetailed between the front and back rails. This brace supports both the pivot block and the right side board of the compartment in the frame's left side. The joint between the brace and the compartment side is secured by a continuous row of champfered glue blocks. The bottom of the compartment was held in place with a continuous row of champfered glue blocks.

Inscription: "121" is written in chalk on the underside of the medial brace.

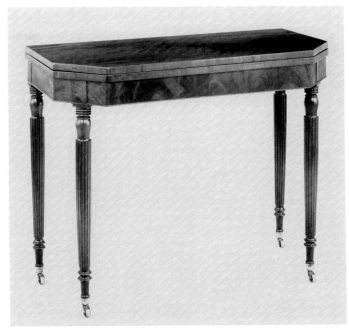

116

Condition: The top is patched at the rear corners where the hinges broke out; there is another patch on the left side of the hinged leaf. A hole from an earlier stop on the underside of the lower leaf has been plugged and may represent a cabinetmaker's error. The bottom of the interior compartment is a replacement, and most of the original glue blocks are lost. A fragment of the purple felt that originally lined the compartment survives on the medial brace. At a later time a different purple felt was glued to the upper surfaces of the frame rails. Both front legs broke out from the frame and have been reattached with screws; the back side of the left leg's upper end has been reshaped. The left rear leg broke off above the capital and has been repaired. The two front legs were broken and repaired above the casters.

Provenance: The donor purchased this table from The Farm of Wells, Maine, on May 25, 1983.

The four fixed legs give this card table the appearance of a hinged-leg table and may indicate that it is an early example of the swivel-top form. Although similar in its overall appearance to a pair of card tables labeled by Charles-Honoré Lannuier, this table has enough differences in its design and construction to discourage an attribution.[1] The labeled tables have standard New York legs with ring-turned capitals and bulbous feet. The

Art Gallery's table has legs with bulbous capitals and tapering, cylindrical feet. The frame rails on the Yale table are shallower than those on the labeled tables, and the unusual joints in the veneer on the outside edges of its top do not appear on the labeled examples.

1. The labeled tables are at Winterthur (Montgomery 1966, no. 306).

117

CARD TABLE ONE OF A PAIR *Color plate 14*

New York City, 1810–20

Mahogany (including boards of top, strip glued to top of frame rails, glue blocks), mahogany veneer; eastern white pine (frame rails, lower laminate of medial brace), black cherry (upper laminate of medial brace), yellow-poplar (compartment bottom)

76 x 91.3 x 46.1 (29 7/8 x 36 x 18 1/8)

The Mabel Brady Garvan Collection, 1930.2004B

Structure: The top's lower leaf is bolted through a medial brace and pivots 90 degrees to open. A rectangular stop is screwed to the underside. Each leaf is composed of three boards with batten ends and half-round moldings applied to the outside edges. All surfaces and edges on both leaves are veneered. A .5cm (1/4 in.)-thick strip of mahogany is applied to the back edges of both leaves. Three tenons in this strip on the hinged leaf fit into reciprocal mortises on the lower leaf. This arrangement is reversed on the mate to this table. All six frame rails are veneered; the front, corner, and side rails have bead moldings nailed and glued to their undersides. A carved, rectangular tablet is inset into the center of the front rail. Carved rosettes are glued within rectangular reserves in the legs' upper ends. All six rails have a strip of wood applied to their upper edges behind the veneer. The corner rails are dovetailed between the front and side rails. A narrow section of each front corner rail is fitted into a channel cut into the upper end of each front leg and is screwed from behind. The side rails and the rear rail are tenoned into the rear legs with small vertical blocks glued behind the joints. A thick medial brace composed of two horizontal laminates is tenoned between the front and rear rails. This brace forms the fourth side of the compartment, lined with green wool felt, that is uncovered when the top is pivoted open. The compartment's bottom is nailed to rabbets on the undersides of the front, left side, and rear rails, and an L-shaped piece of wood glued to the medial brace. The outside toes of each foot are pieced.

Condition: At one time the feet were fitted with casters. A second set of holes was drilled into the underside of the fixed leaf for the rectangular stop; this appears to have been a mistake made at the time of fabrication. There are also a number of inexplicable nail holes in the underside of the fixed leaf. One of the center toes on the left rear foot is lost. Repairs to the veneer were made by Otto Hoepfner and Sons in 1952. The green wool felt lining the compartment appears to be original.

Exhibition: *Girl Scouts* 1929, no. 774.

References: "Long Text" 1929, p. 369; Miller 1937, II, no. 1530; McClelland 1939, pl. 132; Kane 1980, fig. 12.

Provenance: According to the text of the catalogue that accompanied the Girl Scouts' Loan Exhibition, "These tables came, only recently, into the possession of the present owner by inheritance" (*Girl Scouts* 1929, no. 774). Francis Garvan's files record that this pair of tables was presented to him by an unidentified "Mrs. Cowdrey," who apparently was a friend of the family rather than a relative.

This superb pair of tables is among the finest examples of New York furniture in the Neoclassical style. All parts of the table were designed with a taut economy of mass that is particularly evident when the tops are opened. The ornamentation was conceived as a subtle interplay between planar and relief decoration. The top side of each upper leaf was crossbanded around its outside edge, which was shaped as a bold, half-round molding. Deeply carved ornaments gave the appearance of applied bronze mounts against the veneered frame rails. On the legs, the boldly modeled leaves and paws contrasted with the more subtly carved shanks.

Curved legs terminating in animal paws were rare in American Neoclassical furniture and appeared almost exclusively in New York, where they were adapted to chairs, window benches, work tables, a dressing table, and a pier table as well as these card tables.[1] The legs ultimately were derived from a Greek table form with a circular top and three animal legs of the fourth century B.C. that became popular throughout the Mediterranean world.[2] First-century Roman versions of bronze and marble, which had been reproduced in such volumes as the Comte de Caylus' *Recueil d'Antiquités* of 1756–67, Giovanni Battista Piranesi's *Vasi* of 1778, and Charles Heathcote Tatham's *Etchings Representing the Best Examples of Ancient Ornamental Architecture* of 1799, served as the models for Neoclassical designers.[3] Most European designers working in the first decade of the nineteenth century created tables with this type of leg, but these were mostly circular tables or stands that closely resembled classical prototypes.[4]

This pair of tables has been associated with Duncan Phyfe in several sources.[5] A dressing table with similar curved legs descended in the family of Phyfe's grandniece, Emily Phyfe Dunham.[6] No other American card table of this form, docu-

117 *Foot*

117 *Pilaster carving*

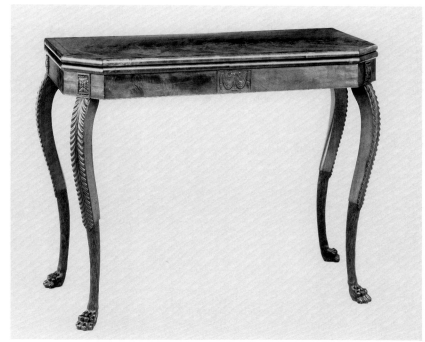

117

117

117 *Front rail carving*

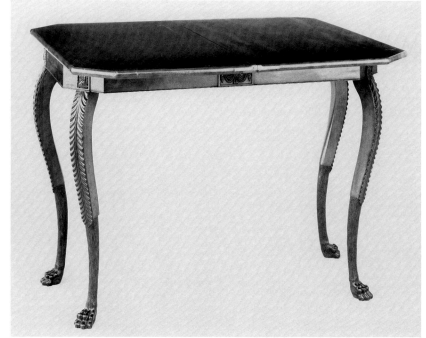

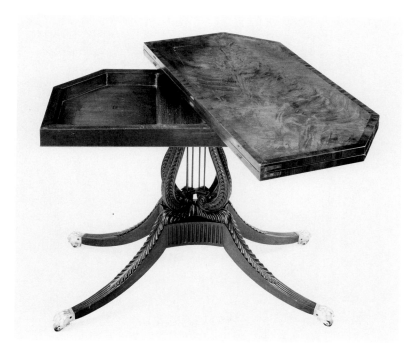

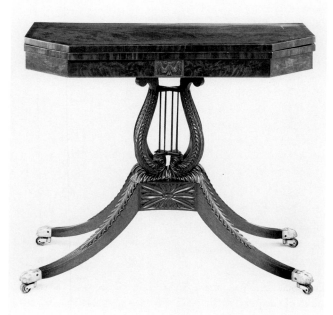

118 118

mented or undocumented, is known to the author. The combination of this leg with either a dressing table case or the standard, canted-corner card table frame does not relate to any documented work by Charles-Honoré Lannuier, whose only table with this leg was a version of the French *guéridon*.[7]

1. Cornelius 1922, pls. 2, 3, 11; *Antiques* 83 (March 1963), inside front cover; Otto 1965, fig. 243; McClelland 1939, pl. 152; Farnham 1972, p. 438.
2. Richter 1966, pp. 70–71.
3. Caylus 1756–67, III, pl. 38; *Piranesi* 1905, I, pls. 31–33; II, pls. 54, 68, 106. The plates in Tatham 1799 were issued without numbers; in the copy at the Yale Center for British Art, the relevant plates are 15, 24, and 28.
4. Hope 1807, pls. 15, 19, 22, 25, 32; Percier/Fontaine 1812, pls. 33, 40.
5. These tables are discussed but not illustrated in Cornelius 1922, p. 74, in addition to the sources listed above in the Reference section.
6. McClelland 1939, pl. 152.
7. Conger 1979, pl. 35.

118

CARD TABLE

New York City, 1810–25

Mahogany, mahogany veneer; yellow-poplar (compartment bottom), eastern white pine (medial brace)

77.9 x 91.2 x 45.2 (30 5/8 x 35 7/8 x 17 3/4)
The Mabel Brady Garvan Collection, 1930.2005

Structure: The top's lower leaf is bolted through the medial brace and pivots to open. The leaves are veneered; each is composed of four boards with batten ends. Three tenons in the back edge of the lower leaf fit into reciprocal mortises on the back edge of the upper leaf. A rectangular strip of wood is screwed to the lower leaf's underside as a stop. The veneered frame rails have a bead molding nailed to their undersides and a .5cm (1/4 in.)-thick strip applied to their upper edges behind the veneer. A carved rectangular tablet is applied to the front rail. The canted corners are dovetailed between the front and side rails. The side rails are dovetailed to the rear rail. A wide medial brace is double tenoned between the front and rear rails. Its left side forms one side of the compartment that is uncovered when the top is pivoted. The brace's top and left side are veneered. The compartment bottom is nailed to rabbets on the undersides of the frame rails and the medial brace. The pedestal supports are tenoned into the underside of the medial brace and the plinth. The supports are connected by rectangular crosspieces lapped to each other and applied to each support at the neck and the lower end. The plinth is a solid block into which the legs are blind-dovetailed.

Inscriptions: "N⁰ 1" is written in pencil on the stop screwed to the underside of the top. "F W Ayer" is written in pencil on the underside of the compartment's bottom.

Condition: There are shrinkage cracks in the veneer on the top. The stop has been rescrewed to the top. The left rear lyre string was replaced by Emilio Mazzola in 1962. The age of the cross-pieces is difficult to determine; they do not appear to be original. At one time the upper pair of crosspieces was screwed in place through the front of the supports. The upper ends of two scrolled supports broke off and have been repaired. Two of the legs broke out and all four have been reinforced by metal braces screwed to their undersides. The back face of the plinth broke off with the left rear leg and has been reattached with nails.

Reference: Furniture Buyer 1929.

Provenance: This table was owned by the collector Fred Wellington Ayer of Bangor, Maine. Garvan purchased it at the auction of Ayer's collection on May 4, 1929 (*Ayer* 1929, no. 444).

The vocabulary of ornament on this card table, including the tablet of drapery, stylized flower, and legs with leaves and animal paws, is similar to the preceding pair of tables (cat. 117). Pedestal bases became popular in the early nineteenth century with the increasingly archaeological interest in ancient furniture forms, although lyres, the emblem of Apollo and the arts of music or poetry, were not used as table supports in antiquity. French cabinetmakers adapted them to this purpose during the classical revival under Louis XVI; a work table with lyre supports at either end was made by Jean-Henri Riesener for Queen Marie-Antoinette about 1785.[1] Thomas Sheraton published a design for a "Horse Dressing Glass and Writing Table" with similar lyre supports in 1793, and English cabinetmakers working after 1800 used lyre supports for a wide variety of forms, including tables with falling leaves, dumbwaiters, and writing tables.[2] Lyre supports became equally popular in America: designs for them were published in New York price books (Fig. 51). John Banks of New York City made a work table with a lyre support in 1824, and many other cabinetmakers in that city used them on tables with falling-leaves and card tables.[3]

The lyre base and other rich ornament on this card table accounted for more than half of its cost. In the 1817 New York price book, a "square, swivel top, pillar and claw card table" was priced at £3.7.0:

Three feet long, three feet wide when open, on four claws, . . . the tops with three joints, clamped, slipped, and veneered on three sides; or inside lipped for cloth; framed with flush stumps or mitre dovetailed, front and ends veneered, top edge of frame slipped, the rail and tops polished, a half bottom in the frame.

A crossed-lyre base with ebony strings cost approximately £2.13.0, and together with such embellishments as canted corners (£1.1.0), crossbanding on the top (1s.6d.), a tablet in the rail (1s.), a bead molding around the skirt (1s.), crossbraces for the pedestal (2s.6d.), an octagonal plinth with swept sides (5s. 6d.), and lion-paw casters (3s.2d.), the ornamental features on this table cost about £4.8.8, exclusive of the carving.[4]

1. Watson 1973, no. 120.
2. Sheraton 1802, pl. 17; Sheraton 1803, pl. 38; Jourdain 1965, figs. 133, 209.
3. McClelland 1939, pl. 190; Cornelius 1922, pls. 44–46.
4. *New York Prices* 1817, pp. 35, 37, 111, 115, 123, 125–26, 145.

119

CARD TABLE *Color plate 17*

New York City, 1810–25
Mahogany, mahogany veneer; eastern white pine
74.9 x 90.2 x 45.8 (29 1/2 x 35 1/2 x 18)
The Mabel Brady Garvan Collection, 1930.2002

Structure: The veneered front and side rails of the frame are a continuous unit composed of three horizontal laminates. They have a square brass molding with an indented center applied to their lower edge. The back ends of the rail unit and the rear rail are tenoned into angled corner blocks. An angled two-piece block is glued in the right rear corner. Two medial braces are dovetailed between the front and rear rails. The lower leaf of the top is bolted through the right medial brace, and a lateral brace is nailed between the right brace and the right side rail. A compartment within the left side of the frame is formed by a board nailed into rabbets on the undersides of the front, side, and back rails. It is also nailed to the underside of a board glued to the inside face of the left medial brace. The carved eagle's wings are screwed to the undersides of the compartment bottom and the lateral brace, and the head is screwed to the underside of a block glued to the front rail. The eagle's neck, body, and the half-sphere are carved from a single block. The eagle's head is tenoned into the neck, and the wings are screwed onto the shoulders. An iron brace is screwed between the eagle's back and the rear frame rail. The base is bolted to the eagle pedestal from the underside. A brass bead molding is nailed over the outside edges of a disk fitted between the eagle and the base. The legs are blind-dovetailed into the plinth and are fitted with casters.

Inscription: "c 1308" is written in pencil on the back of the top's lower leaf.

Condition: The top is an old replacement made of two mahog-

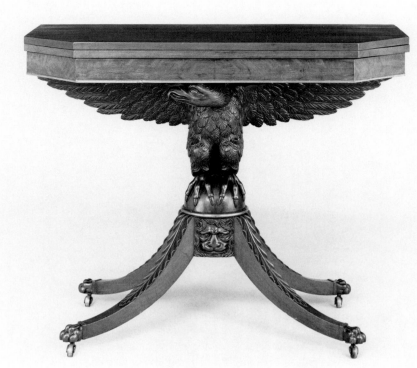

119

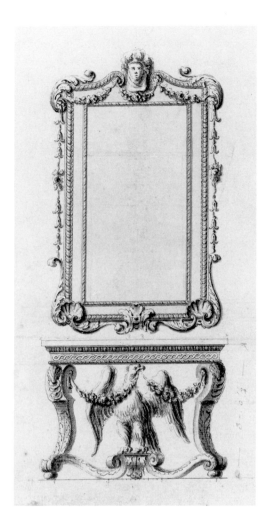

Fig. 50. John Vardy, Design for a pier table and looking glass, c. 1745. Ink and wash. The British Architectural Library, Royal Institute of British Architects, London.

119 *Eagle*

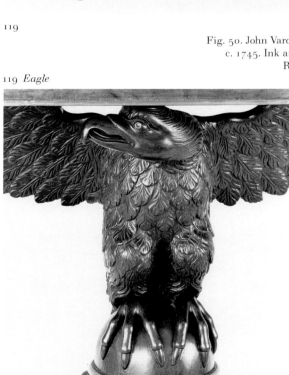

119 *Lion mask*

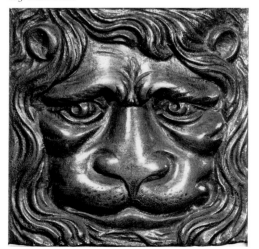

any boards; the leaves of the original top were veneered and composed of two boards without battens. The brass moldings on both sides of the frame have been restored. The rust colored velvet glued inside the compartment appears to be original and is identical to the velvet on a similar table in a private collection (see below). The iron brace behind the eagle is not original. An identical brace is on the table in the Museum of Fine Arts, Boston (see below), which suggests that the two tables were together when this repair was made. The eagle has been reattached to the frame. One feather on the eagle's right wing has been broken off and reattached; the tip of one feather on the left wing has been reattached and another is lost.

Exhibition: "Georgian Art" 1931, p. 14.

References: Nutting 1928, I, no. 1052; Sizer 1930, p. 109; *YUAGB* 5 (1931), p. 61; *YUAGB* 8 (February 1938), p. 45; McClelland 1939, pl. 128; Montgomery 1957, p. 72; Isaacson 1975, fig. 181; Norton 1984, p. 92.

Provenance: This table was owned by the collector Louis Guerineau Myers (1874–1932) of New York City. Garvan purchased it at an auction of objects from Myers' collection on February 26, 1921 (*Myers* 1921, no. 655).

The eagle supporting this card table frame is one of the most sculptural elements known on a piece of American furniture made prior to the Victorian period. The dramatic effect this life-size carving must have had in its original setting was heightened by a matching table (now in the Museum of Fine Arts, Boston) with its eagle facing in the opposite direction.[1] Although the use of an eagle may well have been dictated by patriotic sentiments of the client, the craftsman's inspiration came from pier tables made in England during the second quarter of the eighteenth century from designs by William Kent, John Vardy, and others, on which both eagle supports and lion masks were standard devices (Fig. 50).[2] At least one table of this type was in America during the Colonial period; among the furnishings to be sold in 1758 from the carver John Welch's house in Boston was "a Marble Table supported by carv'd Eagles."[3] The ultimate inspiration for these table frames were the sculptural pier tables made in the late seventeenth century for Continental European palaces.[4] The same reliance on a Baroque prototype informs another card table produced contemporaneously in New York (cat. 120) and supports Richard Randall's observation that the vocabulary of some Neoclassical American furniture owed as much to late seventeenth- and early eighteenth-century sources as it did to antiquity.[5]

Apart from the eagle and lion mask, this card table follows a standard form in New York City during the second and third decades of the nineteenth century (see cat. 118). Although no history was recorded for this table, its mate reportedly descended in the Demarest family of New York and New Jersey. A very similar pair of card tables was owned in the Denniston family of New York City.[6] The latter pair of tables has more detailed, high relief carving and several extra refinements of construction but is otherwise identical to the Yale-Boston pair and undoubtedly was made in the same cabinet shop. Another card table from this shop, identical in design, carving, and construction to the Denniston family pair, is in a private collection. Among the few surviving pieces of American furniture with eagle supports of a similar scale are the speaker's desk from Federal Hall in New York, supposedly designed by Pierre-Charles L'Enfant about 1789; a work table apparently made by the unidentified J. and F. Burkhart and dated 1824; and a monumental collector's cabinet that was probably made in Philadelphia.[7]

1. Randall 1965, no. 102.
2. Ward-Jackson 1958, no. 42; Symonds 1930; Randall 1963, p. 453.
3. *Boston Gazette*, April 24, 1758, p. 2.
4. Hayward 1965, pp. 129–30.
5. Randall 1963.
6. Collection of Richard and Gloria Manney, illustrated in Sotheby's 1983, no. 223.
7. *Age of the Revolution* 1977, no. 58; *Haskell* 1944b, no. 183; Montgomery 1966, no. 349.

120

CARD TABLE

New York City, 1810–20

Eastern white pine (front supports, drapery; frame rails, top), soft maple (rear supports), mahogany (plinth corners), ash (legs; central medial brace), ebony (molding along lower edge of frame), rosewood veneer; black cherry (left and right medial braces, compartment bottom), yellow-poplar (plinth block)

82.5 x 91.5 x 46 (32 1/2 x 36 x 18 1/8)

The Mabel Brady Garvan Collection, 1966.127

Structure: The top's lower leaf is bolted through a brace tenoned between the front and back frame rails and pivots 90 degrees to open. The leaves are veneered; each is composed of two boards with batten ends. Paired brass stringing is inlaid along the outside edges of both leaves. The inside surface is covered with baize. Two tenons in the back edge of the upper leaf fit into reciprocal mortises on the back edge of the lower leaf. The veneered frame rails have a gilt molding applied to their upper edges and an ebony molding inlaid with paired brass stringing applied to their lower front edges. The canted corners are dovetailed between the front and side rails. The side rails are dove-

tailed to the rear rail. Two medial braces are dovetailed between the front and rear frame rails below the central brace for the top. The left medial brace supports the bottom of the compartment that is uncovered when the top pivots open. The sections of the frame rails enclosing the compartment have a channel cut into their upper surfaces into which strips of green velvet are glued. The compartment's interior is lined with early nineteenth-century wallpaper. The compartment's bottom is glued to the inside surface of the frame rails and supported by a series of evenly spaced glue blocks. It is also nailed to the underside of the central brace through which the top is bolted.

The eagles' wings are screwed to the bodies from behind and nailed to the undersides of the frame. The eagles' heads are screwed to a block screwed into the corners of the frame. The front supports' lower ends are screwed to the plinth from the underside and are reinforced with inset pieces of wood. The two rear supports are tenoned between the frame and the plinth. The plinth is made from a horizontally laminated block of wood. The canted front corners are separate blocks tenoned into the plinth. The back corners of the plinth are made from a single piece of wood butted and glued to the main block. The plinth's top is veneered. The legs are double-tenoned into the underside of the corners. A carved double swag of drapery is glued to the underside of the plinth between the front legs. A small block is glued behind this drapery at the center.

Condition: There were originally forty-five rosettes or stars nailed to the inset sides of the plinth. Most of the painted and gilded surfaces have been overpainted. The lower feathers of the eagles' wings have been damaged. A stop was once nailed to the underside of the top's lower leaf. Some of the blocks glued to the compartment's bottom have been lost. At the time this table was acquired by the Art Gallery, the beaks of both eagles were replaced and losses in the brass stringing were replaced with wood filler.

References: Aronson 1965, no. 1273; *Sack Collection*, I, p. 212.

Provenance: According to tradition, this table and a cellarette (Ward 1988, no. 229) were made for Stephen Ball Munn (1766–1855), who moved to New York City in 1791 and became wealthy as a dry goods merchant and speculator in western land. In September 1814 Munn moved from rooms above his store at 226 Pearl Street into a newly constructed house at 483 (later renumbered 503) Broadway between Broome and Spring Streets; it is possible that this table and the cellarette were purchased for his new residence (Cornell 1941, pp. 7–11). (A somewhat different and less accurate account of Munn's life is given in Barrett 1889, II, pp. 20–21, which states that Munn moved to Broadway in 1813 and into the new house at 503 Broadway in

1823. Barrett also incorrectly gives 1856 as the year of Munn's death; he died on September 11, 1855.) The two pieces of furniture descended in Munn's family until they were acquired by the dealer Paul Cooley of Hartford, who sold them in 1962 to Israel Sack, Inc. The Art Gallery acquired both pieces from Israel Sack, Inc., in 1966.

This table belongs to a group of about a dozen tables with similar winged-eagle supports, including four card tables, two tables with falling leaves, a pair of side tables, a tea table, a center table, and a pier table.[1] The shape of the frames, turnings, and applied ornament on the different examples are standard New York City forms; the carved legs on the Art Gallery's table are very similar to the feet on a table made by Duncan Phyfe in 1816.[2] The histories of the documented examples indicate that they were made during the second decade of the nineteenth century (see *Provenance*). One of the falling-leaf tables was owned by Ebenezer Denny of Pittsburgh, who died in 1822; a card table, tea table, and center table originally belonged to Robert Smith of Baltimore, who returned to a new home in that city in 1811 after ten years in Washington.[3]

None of the tables with winged-eagle supports has a documented connection to a maker, although almost all of them have been associated with Charles-Honoré Lannuier, presumably on the basis of his use of winged-caryatid supports. Tables marked by Lannuier, however, exhibit a more refined design and execution than the somewhat coarse quality of the eagle tables.[4] Winged-eagle supports of this type must have been made by many different craftsmen, as designs for them were included in New York price books from 1817 on (Fig. 51). The eagles cost 19s., more than double the price of other "standards" illustrated.[5] Variations in the carving and overall design of tables with eagle standards indicate that they were not all the product of one shop. The card table at Yale appears to have been made in the same shop as the cellarette with which it descended from Stephen Ball Munn (see *Provenance*). The identical square ebony molding with two inlaid brass lines was applied around the table's skirt and the cellarette's body, and the profile of the table's plinth is very similar to the cellarette's top. The two pieces were also carved by the same hand. The schematic, almost perfunctory rendition of the feathers on the eagles' wings is identical to the winged volutes on the cellarette's feet, and the leaf-and-paw carving on the two pieces is the same. Among the other winged-eagle furniture, the example closest in design to Yale's table is the card table at the Henry Ford Museum, although it was carved by a different craftsman.

Table supports with winged bird or animal heads were ultimately derived from Roman tables of the first century A.D. and were widely used by leading French and English designers and

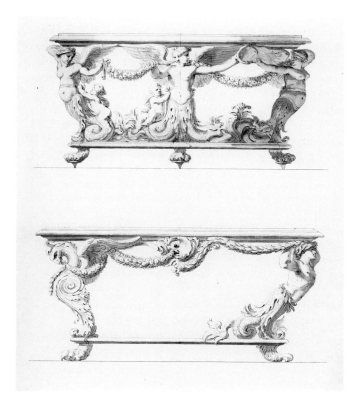

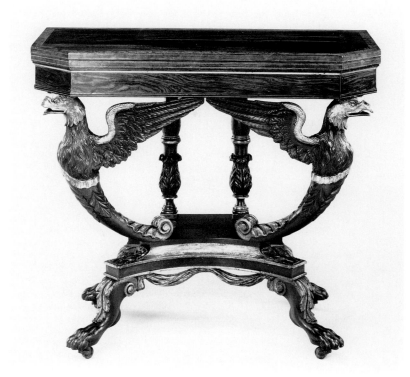

Fig. 52. Attributed to Nicolas de Launay or Claude Ballin,
Designs for console tables, 1670–80. Pencil and wash.
Nationalmuseum, Stockholm, Cronstedt Collection.

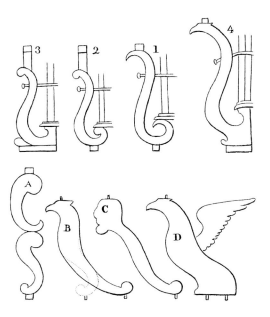

Fig. 51. Detail of plate 5
from *The New-York Book of Prices
for Manufacturing Cabinet
and Chair Work*, 1817.

craftsmen of the early nineteenth century.[6] However, the prototype for the supports on Yale's table appears to be one of the silver console tables made between 1670 and 1680 for the *Galerie des Glaces* at Versailles (Fig. 52). Not only were the supports similarly conceived as a combination of eagles' heads and wings with foliate volutes, but this design also incorporated swags and a plinth supported by animal-paw feet. Pier tables of this design were popular in England during the Palladian revival of the second quarter of the eighteenth century.[7] As with the preceding card table (cat. 119), the classical elements of this table appear to owe more to the mid-eighteenth-century English interpretation of Baroque sources than to antiquity.

1. The card tables are in the Henry Ford Museum (Fales 1972, no. 257), the Maryland Historical Society (Weidman 1984, no. 161), a private collection (Ralston 1945, fig. 5), and formerly in the collection of Elisabeth Babcock (*Babcock* 1985, no. 650). One table with falling leaves and the pair of side tables are in the Museum of Fine Arts, Boston (Tracy/Gerdts 1963, no. 15; Fairbanks/Bates 1981, p. 271). The second table with falling leaves was sold at auction in 1987 (Christie's 1987, no. 266). The tea table and center table are part of the same set as the card table in the Maryland Historical Society (Weidman 1984, nos. 162–63). The pier table descended from Thomas and Margaret Livingston Tillotson and was sold at auction in 1982 (DAPC 82.1103).
2. Sloane 1987, fig. 6.
3. Christie's 1987, no. 266; Weidman 1984, nos. 161–63.
4. Rice 1962, pp. 32–34; Sotheby's 1988b, no. 421; see also p. 220, above.
5. *New York Prices* 1817, p. 146.
6. Richter 1966, p. 113, nos. 573, 578–79; Grandjean 1966, pls. 44, 52–53; Percier/Fontaine 1812, pls. 19, 21, 33, 39; Cornu, pl. 24; Sheraton 1803, pl. 55; Smith 1808, pls. 12, 91, 120, 126.
7. *DEF*, III, p. 262; Gilbert 1978, II, no. 447.

121

CARD TABLE

Eastern Massachusetts, probably Boston area, 1810–25

Mahogany, mahogany and maple veneers

77.5 x 92 x 45.2 (30 1/2 x 36 1/4 x 17 3/4)

The Mabel Brady Garvan Collection and Gift of C. Sanford Bull, B.A. 1893, by exchange, 1965.117

Structure: The top's lower leaf is bolted through a brace and pivots 90 degrees to open. Each leaf is a solid board. A tenon in the back edge of the lower leaf fits into a reciprocal mortise on the inside edge of the hinged leaf. The veneered frame rails have a triple-reeded molding nailed to their undersides. The side rails are dovetailed to the front and rear rails. The frame has a full bottom composed of three boards. The center bottom board is butted against the front rail above the applied molding and is screwed to the underside of the rear rail. On either side is

a two-piece board fitted into grooves in the side rail and the center board and nailed to the underside of the rear rail. The brace that secures the top is tenoned between the front and rear rails and runs along the right side of the center bottom board. Black felt, which appears to be original, is glued to the upper surfaces of the frame and the medial brace. The two lyre-shaped boards are double tenoned into a two-piece block that is screwed to the center bottom board. The boards' lower ends are tenoned into the veneered circular plinth. The legs are blind-dovetailed into the plinth and reinforced by iron braces screwed to their undersides.

Condition: The top's upper leaf is patched at the left and right rear corners. The stop on the underside of the top is a replacement. Three brass strings inlaid on the pedestal were replaced at the Art Gallery by Emilio Mazzola in 1966. The carved terminal on the left side of the rear lyre support is a replacement; the carved terminal on the right side of the front support has been reattached. An area of the veneer on the plinth's front side is patched. Asphaltum was apparently used to create the blacks in the painted decoration; it has created an "alligatored" surface in those areas. The casters appear to be original.

References: Sack Collection, I, p. 260; *YUAGB* 31 (Spring 1966), p. 40.

Provenance: The Art Gallery acquired this table from Israel Sack, Inc., in 1965.

Lyre supports were used extensively for tables made in Boston and Philadelphia as well as New York (cat. 118).[1] This table is related to a similar group of tables that descended in Boston-area families by its square frame with an elliptic front, ormolu mounts on the front corners, parallel lyre supports cut from boards, inlaid brass strings, and long, reverse-curved legs. One of these tables was owned in the family of James Swan (1754–1830) of Boston, and another descended in the Bartlett family of Roxbury, Massachusetts.[2] On the Art Gallery's table, the simple moldings, painted leaves, and maple veneer on the frame and plinth were inexpensive alternatives to carved and inlaid ornament. These features may also indicate that the table was made in a small shop or in a less urbanized center where specialized work was not readily available. A similarly modest version of this form was labeled by Elisha Learnard of Boston between 1813 and 1821.[3]

1. See Hawley 1988 for Philadelphia tables of this type.
2. Randall 1965, no. 105; Nutting 1928, I, no. 1059. An undocumented example is owned by The Newark Museum, New Jersey (Tracy 1961, p. 3).
3. Talbott 1975, fig. 8.

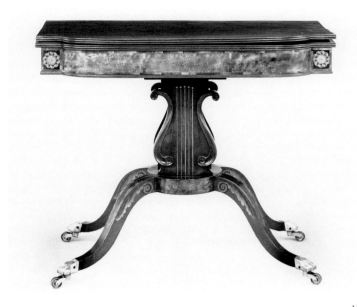
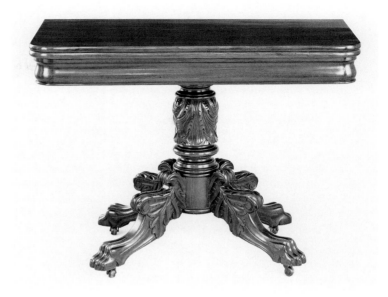

122

CARD TABLE

Northeastern United States, 1850–75

Mahogany; yellow-poplar (frame rails, medial brace, glue blocks, compartment bottom), ash (brace for top)

75.4 x 101.2 x 50.7 (29 5/8 x 39 7/8 x 20)

Bequest of Millicent Todd Bingham, 1969.42.4

Structure: The top's lower leaf is screwed to a cylindrical piece of wood that is fitted into a medial brace and pivots 90 degrees to open. Each leaf is a solid board. Two tenons in the back edge of the lower leaf fit into reciprocal mortises on the inside edge of the upper leaf. Two dowels are fitted into the underside of the lower leaf to serve as stops. An ogee molding with a bead along its lower edge is applied over the exterior of the front and side rails. The side rails are dovetailed to the rear rail and butted and glued to the front rail. Triangular blocks reinforce the joints in the two front corners. The medial brace is tenoned between the front and rear rails. The compartment bottom is nailed to rabbets on the undersides of the frame rails and a second medial brace. This second brace is screwed into rabbets in the undersides of the front and rear rails. The pedestal is presumably tenoned into the second brace. The legs are presumably tenoned into the lower end of the pedestal.

Condition: The table bears traces of a very dark finish that was probably original. A series of nails and nail holes have been added around the underside of the frame. The pivot and the stops on the top are replacements. Holes from two earlier stops have been plugged and may represent a cabinetmaker's error. The casters are original.

Pillar-and-claw card tables with leaf-carved balusters and legs carved with lion paws were made throughout the northeastern United States during the second and third quarters of the nineteenth century. Documented examples of this form include one with the stenciled label of Reuben Sykes of New York City, who is recorded as working between 1826 and 1828; another made by Samuel and Joseph Rawson of Providence between 1835 and 1850; and a table signed by John Needles of Baltimore, who worked between 1810 and 1852.[1] The flat, stylized carving on the baluster and legs of this card table appears to have been influenced by the "neo-Grec" taste that developed in the late 1850s as a reaction to the deep, naturalistic carving favored during the Rococo Revival. The table's ample size also suggests that it was made after 1850, when the scale of most domestic furniture greatly increased.

1. DAPC 77.1246; Monahon 1980, fig. 19; Weidman 1984, p. 191n.

Tops That Turn Up

Tops that pivoted on pintle hinges from a horizontal into a vertical position represent another response to the eighteenth-century demand for tables that could be stored on a room's perimeter in a minimum amount of space. The same mechanism had been used for joined chair tables during the sixteenth and seventeenth centuries and was first adapted to a pedestal table base in Holland about 1700.[1] Some of these tables had tops with "scalloped," or shaped, edges derived from "waiters," or trays, on which tea, food, and other items were carried (see cat. 124); similar references to less permanent antecedents were found in other eighteenth-century table forms (see pp. 89, 164).

Large, perfectly flat tops of this type required considerable skill to make and apparently became a specialty of some craftsmen. Turners who made the "pillar and claws" could acquire tops from master cabinetmakers or sell the pillars to them. In 1754, Joshua Delaplaine of New York City made "a top for a tea table of french mahogany" for his former apprentice John Parsons, who supplied Delaplaine on another occasion with "2 pillers Mahogany."[2] Samuel Williams of Philadelphia advertised "mahogany and walnut tea table columns" in 1767, and Elijah and Jacob Sanderson purchased large numbers of "stand pillars" from Salem, Massachusetts, turners in the 1790s and early 1800s.[3]

Tables with tops of this type did not become common in England or its colonies until the second quarter of the eighteenth century. The iron and brass "Tea Table ketches" sold prior to 1741 by the Philadelphia hardware merchant Joseph Paschall provide the earliest evidence that this type of table was being made in America.[4] The tables most commonly made in the eighteenth century with tops that turned up were tea tables and stands, which represented larger and smaller sizes of the identical form. In most regions the difference in their respective diameters was consistently about 12 in. (30.5cm). The 1772 Philadelphia price list did not specify a size for "Tea Table" tops, normally 3 feet (91.4cm) in diameter; a "folding stand" top was 22 in. (55.9cm) in diameter. On the same list, a stand with a "fixed" (stationary) top was only 18 in. (45.7cm) in diameter.[5] The 1795 Philadelphia and 1796 New York price books distinguished between a "Pillar and Claw Table" with a top 27 in. (68.6cm) in diameter and "a stand from 18 to 22 inches in diameter."[6] The Hartford, Connecticut, price list of 1792 included a "small Tea Table, top 26 inches" and a "plain Tea or Stand Table, top 3 feet 2 inches."[7] The "Stand Table" in the Hatfield, Massachusetts, price list of 1796 had a top 3 feet in diameter, whereas the "Candle Stand" was 17 in. (43.2cm) in diameter.[8]

This form is known today by such names as "tilting" or "tilt-top" table, although these terms do not appear in eighteenth-century sources. References to tables with tops that turn up in contemporary documents are difficult to separate from references to similar forms with stationary or folding tops (cat. 6; see also p. 216) or different forms with the same nomenclature (cats. 18–22). Few descriptions are as specific as the "Mohogony [sic] Turn up Table" listed in the estate of Peter Minot of Boston in 1757 or the "Jointed" tea table repaired by Thomas Elfe of Charleston in 1772.[9] Some late eighteenth-century English sources used the term "Snap Table," from the brass or iron "snap" or catch that secured the top in a horizontal position.[10] Earlier cabinetmakers' accounts, such as those of Joshua Delaplaine, contain numerous references to "a bras tea table Snap" and "mending a tea table with a new cap [block with pintles] and snap," but the name "snap table" was never common in America.[11] Tables and stands with this type of top can also be distinguished by the presence of a "box." Known today as a "birdcage," this mechanism revolved on the pillar when the top was horizontal and also held the pintles on which the top was raised. Boxes were listed as standard features on tea tables in the Hartford and Hatfield price lists, although most New England tea tables were made without them (cat. 123).[12] The box was more common on tables made in the mid-Atlantic states (cats. 124, 130–132) and apparently was considered so elementary that no mention of it appeared under tea tables in the 1772 Philadelphia price list. It appeared as an extra in the Philadelphia price book of 1795.[13]

Tables and stands with tops that turn up traditionally are placed in the corners of reconstructed eighteenth-century rooms, and there is considerable documentation to support this practice. A portrait painted about 1745 by the English artist Joseph Nollekens depicted a table with its top turned up in the corner of the room (Fig. 53). John Fanning Watson's reminiscences of eighteenth-century Philadelphia interiors, written in 1830, included "round tea tables, which, being turned on an axle underneath the centre, stood upright, like an expanded fan or palm leaf, in the corner."[14] The feet or "claws" of three tables in the Art Gallery's collection are oriented in such a way that they fit easily into a corner when the tops are upturned (cats. 123, 127, 133), and those with a box could be moved into this position. Evidence from some of the tables at Yale, however, indicates that the practice of placing these tables in corners apparently was not universal. The feet of one stand without a box are arranged to fit against a flat wall when the top is vertical (cat. 129), and two others have feet set at an angle that makes either placement difficult (cats. 126, 128).

Unlike other eighteenth-century forms designed for mobility, tables with tops that turned up continued to be made during

the nineteenth century. Throughout the nineteenth century, successive English design books, beginning with those of Thomas Sheraton and George Smith, featured "loo tables" and other tables with tops that turned up on central pedestals.[15] American price books from the late 1820s and 1830s listed "top to turn up" or "top made to turn down" as features of loo, center, and pillar-and-claw dining tables (cat. 134); documented examples were made by Joseph True of Salem, Massachusetts, about 1845 and George J. Henkels of Philadelphia in 1865.[16] Smaller tables with this type of top were less popular than they had been in the eighteenth century, and during this period the tops of many earlier tables and stands, including most of the examples in the Art Gallery's collection, were nailed to the caps or boxes to maintain a horizontal position. Some smaller tables of this type were made to feature tops with elaborate marquetry, needlework, or inlaid ornament, and two different "tip tables" in the Arts & Crafts style appeared in a catalogue issued after 1912 by L. and J.G. Stickley of Fayetteville, New York.[17]

With one exception (cat. 134), the Art Gallery's collection of tables with tops that turn up is limited to tea tables and stands from the second half of the eighteenth century. Both forms were made in every region during the eighteenth century. The Art Gallery owns three tea tables (cats. 123–125) and four stands (cats. 126–128, 133) made outside the major style centers. Urban versions of these forms are represented by a group of stands made in Philadelphia (cats. 129–132).

1. Lunsingh Scheurleer 1976; Thornton 1978, p. 230.
2. Johnson 1964, p. 28.
3. Prime 1929, p. 185, states that the Samuel Williams advertisement appears in the *Pennsylvania Chronicle* for September 9, 1767. This newspaper was issued weekly, so no edition of that specific date exists. Attempts to locate the original advertisement in this newspaper have been unsuccessful. The Sanderson accounts are cited in Swan 1934, pp. 14, 31.
4. Hornor 1935a, p. 143.
5. Weil 1979, p. 187.
6. *Philadelphia Prices* 1795, p. 50; New York Prices 1796, pp. 49–50.
7. Wadsworth 1985, p. 472.
8. Fales 1976, p. 286.
9. Downs 1952, no. 385; Webber 1935, p. 83.
10. Kirk 1982, nos. 1435, 1437.
11. Johnson 1964, pp. 84, 89.
12. Wadsworth 1985, p. 472; Fales 1976, p. 286.
13. *Philadelphia Prices* 1795, p. 50.
14. Watson 1830, p. 184.
15. Sheraton 1803, pl. 58; Smith 1808, pp. 12–13, pl. 69; *Victorian* 1853, p. 44, pl. 55; Joy 1977, pp. 481, 488, 492, 499.
16. Garrett 1975, p. 893; *Philadelphia Prices* 1828, pp. 30–31; *New York Prices* 1834, p. 67; Clunie/Farnam/Trent 1980, no. 41; DAPC 81.2169.
17. Gray 1985, p. 172.

Fig. 53. Joseph Francis Nollekens, *Two Children of the Nollekens Family, Probably Jacobus and Maria Joanna Sylvia*, c. 1745. Oil on canvas. Yale Center for British Art, New Haven, Paul Mellon Collection.

123

TEA TABLE

Theodosius Parsons (dates unknown)
Scotland Society, Windham, Connecticut, 1787–93
Black cherry
69.6 (120 top up) x 92 diameter (27 3/8 [47 1/4] x 36 1/4)
The Mabel Brady Garvan Collection, 1930.2458

Structure: The top is made of three boards. The cleats dovetailed to the top's underside are fitted over pintles on one end of the square block. The catch is screwed to the underside of the top and latches over an iron pin attached to the block. The pillar is tenoned and wedged into the block. The legs are blind-dovetailed into the pillar and secured with an iron triangle.

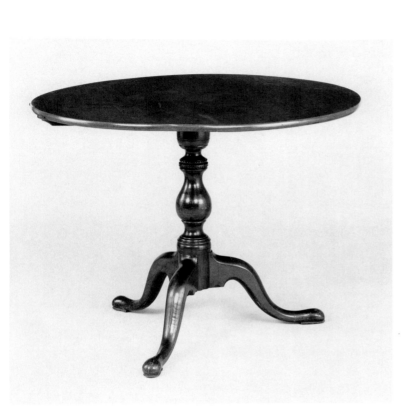

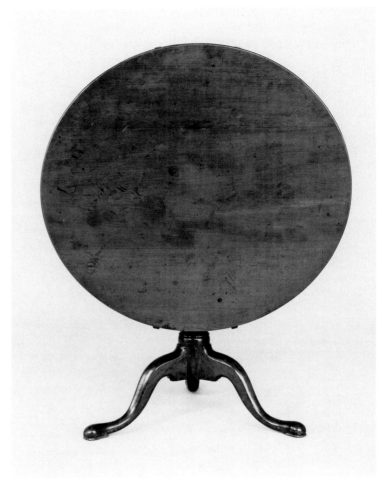

123 123

123 *Label and catch*

Inscription: "Theodosius P[arsons] / CHAIR-MAKER and JOINER; / WINDHAM." is printed on a paper label pasted to the center of the underside of the top.

Condition: At one time the top was nailed to the block. Screws have been added to the cleats. Modern casters were on the feet when the table was acquired. The iron catch and triangle are original.

Exhibitions: Kirk 1967a, no. 166; Mayer/Myers 1991, no. 40.

Reference: Nagel 1932, p. 139.

Provenance: Garvan purchased this table from Frank Mac-Carthy on January 17, 1930.

This tea table is the only documented work by Theodosius Parsons, an obscure cabinetmaker who advertised intermittently for journeymen joiners and Windsor chair makers in Connecticut newspapers between 1787 and 1792.[1] Parsons apparently was not from the Windham area, as the surname does not appear in local church or public records. He may have moved to the Scotland Society, a parish within Windham township, in 1787; on April 3 of that year he purchased land with a house and other buildings for £120. He described this as "the parcel of land . . . where I now dwell" in the 1788 deed wherein he sold the property for a profit of £33.[2] This sale may have been prompted by a lack of success at his trade. In the 1788 tax assessments for Scotland Society, his property was valued at £25, within the middle range of the community. By 1790, his assessment had dropped to £20, a relatively low valuation at that date.[3] Between 1789 and 1793, Parsons received loans of money and gifts of produce from the Reverend James Cogswell, minister of the Scotland Society, who described the Parsons family in his diary as "poor folk."[4] "Theodotious Persons" was recorded in the 1790 Windham County census with a household of one male under sixteen years of age and four females. A "Theoph. Parsons" aged forty-five years or older appeared in the 1800 Windham census and may be the same individual, although this man's family consisted of three females under twenty-five years old.[5] No records, however, have been discovered to confirm the cabinetmaker's residence in Connecticut after 1793.

A "plain Tea or Stand Table . . . with turn'd top" in the 1792 Hartford price list cost £1.18.0, equal to the most elaborate card and pembroke tables and the smallest size dining table with falling leaves.[6] This table's simple forms followed a popular design from the last quarter of the eighteenth century. A drawing of a "Mahogany Snap Table" with a baluster-shaped pillar and uncarved, rounded feet was entered in the estimate book of the Gillow firm in Lancaster, England, in 1788.[7] Tables with similar bases were made contemporaneously in New York and Pennsylvania; documented examples include stands and tea tables labeled by Thomas Burling of New York City, who worked from 1769 to 1797, and a tea table attributed to George Fitzsimmons (1780–1830) of West Whiteland Township in Chester County, Pennsylvania.[8] Parsons may have based his table on more sophisticated Connecticut interpretations of the New York form, such as the mahogany and cherry tea table that probably was made in Hartford for Ursula Wolcott Griswold.[9] The rounded outside edge on the top of Parsons' table resembles the standard treatment in New York (see cat. 125), but the scalloped rings above the baluster pillar add a whimsical quality more characteristic of rural Connecticut workmanship. The labor-intensive technique of dovetailing cleats to the top's underside is also atypical of urban practice.

1. "Connecticut Cabinetmakers" 1968, p. 5.
2. Deed Book R, p. 511; Deed Book S, p. 364; Windham Deed records, Town Hall, Willimantic, Connecticut.
3. Windham Tax Assessor's Record Book, 1788–93, Manuscripts and Archives, Yale University Library, New Haven.
4. Mayer/Myers 1991, pp. 21–22.
5. Population schedules: 1st Census (1790), Connecticut, III, p. 228; 2nd Census (1800), Connecticut, II, p. 870. Records of the Bureau of the Census, National Archives, Washington, D.C.
6. Wadsworth 1985, p. 472.
7. Kirk 1982, fig. 1435.
8. A labeled Burling stand is illustrated in Failey 1976, no. 110. A similar tea table labeled by Burling is reproduced in *Antiques* 114 (December 1978), p. 1212; another is in The Fine Arts Museums of San Francisco (no. 1983.22d–c). The Fitzsimmons tea table is illustrated in Schiffer 1966, pl. 41.
9. Johnston 1979, fig. 4.

124

TEA TABLE

Philadelphia area, 1760–90

Black cherry

73.9 (122.5 top up) x 90.7 diameter (29 1/8 [48 1/4] x 35 3/4)

Bequest of Olive Louise Dann, 1962.31.23

Structure: The top is made of two boards with an outside molding carved on its upper surface. A pair of cleats screwed to the underside of the top are fitted over pintles on the box's upper block. A brass catch screwed to the underside of the top latches into a catch plate on the box. The box is composed of four uprights tenoned and wedged between two square blocks. A circular opening in the lower block fits over the pedestal, which has a turned tip that fits into a small hole in the underside of the upper block. A wooden key fits into a cutout in the pedestal's upper end and locks into a slot in an ogee-molded ring that fits

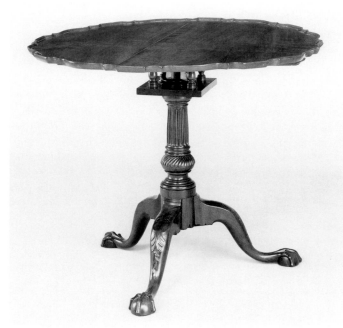

124

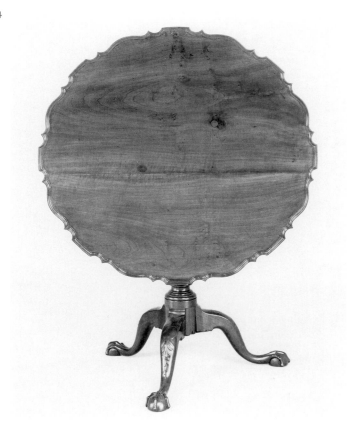

over the shaft and rests on the lower block of the box. The legs are blind-dovetailed into the pedestal.

Condition: The top has been patched with three circular plugs and a 32cm (12 5/8 in.) strip. Two shrinkage cracks in the top have been repaired with butterfly cleats. A small piece of the raised molding has been patched. Some of these repairs were made by Emilio Mazzola in 1963. The catch on the underside of the top has been moved but appears to be original; the cleats have been rescrewed to the top. The pintles on the box broke out and have been repaired with a new piece of wood. Two legs broke out from the pillar; the piece of the pillar between the legs has been reattached and both legs have been repaired. The original metal triangle on the underside of the base is lost. The carving on the knees is very worn. A mahoganized finish was removed in 1963 by Emilio Mazzola; in 1973, Peter Arkell attempted to color the surface to match the underside of the top, which has survived with an old finish intact.

Exhibition: Ward/Ward 1979, no. 85.

References: Antiques 21 (March 1932), p. 110; *YUAGB* 29 (April 1963), p. 21.

Provenance: This table was owned by Joe Kindig, Jr., in 1932. Olive Dann, the donor, was a regular customer of Kindig's and undoubtedly acquired it from him.

This tea table is closely patterned on high-style, Rococo tea tables made in Philadelphia during the 1760s and 1770s. An example now at The Henry Francis du Pont Winterthur Museum has the same scalloped top mounted on a box, pillar with a fluted shaft above a compressed sphere, claw-and-ball feet, and cartouche design on the knees formed by paired C-scrolls.[1] In contrast to the superb carving and richly figured mahogany found on Philadelphia tables, the Art Gallery's table is made of cherry and carved with schematic interpretations of the urban patterns. It almost certainly was made outside of the city, probably in southeastern Pennsylvania, southern New Jersey, or northern Maryland or Delaware. The unusually close relationship to Philadelphia models indicates that the maker either trained in the city or copied a locally owned Philadelphia table. A mahogany tea table with "top scalloped, claw feet, [and] leaves on knees" was ordered from James Gillingham of Philadelphia in 1769 by James Bordley of Queen Anne's County, Maryland.[2]

A cherry tea table of this type with equally ambitious carving has been attributed to Connecticut, where a considerable amount of furniture was made in imitation of Philadelphia forms (see cat. 48).[3] Cherry was far more acceptable in Connecticut than elsewhere for high-style furniture, but it fre-

quently was used in Pennsylvania as a less expensive alternative to mahogany or walnut.[4] The Art Gallery's tea table is distinguished from Connecticut work by its extremely close relationship to its Philadelphia counterparts. Connecticut cabinetmakers imitated the overall form of Philadelphia models but rarely copied carving motifs as carefully as did the maker of this table. In addition, the thin ankles and flat balls under the claws resemble the Philadelphia interpretation of these details more than the thick ankles and blocklike claws found on tables made in Connecticut.[5]

1. Downs 1952, no. 380.
2. Weidman 1984, p. 44.
3. Jones 1977, pl. 3. I am grateful to Philip D. Zimmerman for sharing with me his manuscript entry on this table for a forthcoming catalogue of the Milwaukee Art Center's furniture collection. For a discussion of Philadelphia influence in Connecticut, see Zimmerman 1988, pp. 26–28.
4. Less elaborate Pennsylvania tea tables of this type made of cherry are illustrated in *Antiques* 95 (June 1969), p. 795, and *Antiques* 101 (June 1972), p. 984. Cats. 1, 32, and 49 are all examples of Pennsylvania furniture made of cherry.
5. *Barbour* 1963, pp. 32–33; *Bartlett* 1985, no. 1017.

125

TEA TABLE

Possibly eastern Maryland, Virginia, or North Carolina, 1760–80

Mahogany

72.3 (115 top up) x 75.5 diameter (28 1/2 [45 1/4] x 29 3/4)

The Mabel Brady Garvan Collection, 1930.2064

Structure: The top is made of two boards. A pair of cleats screwed to the underside is fitted over pintles on the box. A brass catch screwed to the underside of the top latches into a catch plate on the box. The box's uprights are tenoned between two square blocks. A circular opening in the lower block fits over the pillar, which has a turned tip that fits into a small hole in the underside of the upper block. A wooden key locks the box to the pillar. The legs are blind-dovetailed into the pillar.

Condition: A crack in the top has been repaired with a butterfly cleat. At one time the top was screwed to the upper block of the box. The catch is a replacement. Two of the legs broke out from the base and have been reattached; one has been pinned diagonally through the underside. Both upper corners of this leg are patched. The foot on the third leg broke off and has been reattached with a replacement ankle section. The left talon on this foot is lost. The surface was refinished by Emilio Mazzola in 1962.

Provenance: This table was in Irving W. Lyon's collection. Garvan acquired it as part of the collection he purchased from Irving P. Lyon in 1929.

This table has a top with rounded edges, a box and key without a collar, and an urn pillar, all characteristics of tea tables made in New York City or Albany.[1] Several distinctive features suggest, however, that it may have been made by a Southern craftsman following a New York model. The unusual symmetrical uprights on its box appear on a group of similar stands and tea tables found in Maryland and North Carolina. These tables all exhibit the attenuated proportions, thick ankles, and delicate, deeply undercut talons of the Art Gallery's table. An almost identical tea table originally was owned by Robert Whitehurst Snead of New Bern, North Carolina.[2]

1. Documented examples descended in the Verplanck family of New York City (Heckscher 1985, no. 125) and the Haslett family of Brooklyn (Peirce 1979b, pl. 6); another was made prior to 1765 for Robert Sanders of Albany (Blackburn 1976, no. 38).
2. The table and a related stand owned by Snead are illustrated in Bivins 1988, figs. 7.15–16. A tea table very similar to both the Yale and Snead examples was discovered in Frederick, Maryland (MESDA research file S-9294), and a related stand descended in the Thomas family of Georgetown, District of Columbia (MESDA research file S-6979).

126

STAND *Color plate 21*

Probably central Massachusetts, 1801

Black cherry, maple inlay; eastern white pine (drawer interior)

70.9 (106.8 top up) x 44.9 (62.9 across corners) x 44 (27 7/8 [42] x 17 5/8 [24 3/4] x 17 3/8)

The Mabel Brady Garvan Collection, 1930.2225

Structure: The top is a single board. The cleats screwed to the underside are fitted over pintles on the block. The catch is screwed to the underside of the top and latches into a catch plate on the block. The block is a small box whose top and bottom are dovetailed to the sides. A drawer is fitted into one end, and the back is attached to the other members with glue blocks. A bead molding is incised around the drawer front. The drawer front and back are dovetailed to the sides. The bottom is fitted into grooves in the front and sides and nailed to the back. The pillar is tenoned into the bottom of the box. The legs are blind-dovetailed into the pillar.

Inscription: "E H / 1801" is scratched into the urn inlaid on the top.

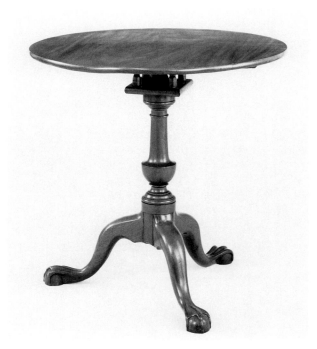

125

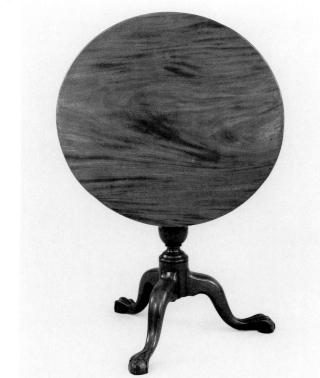

125

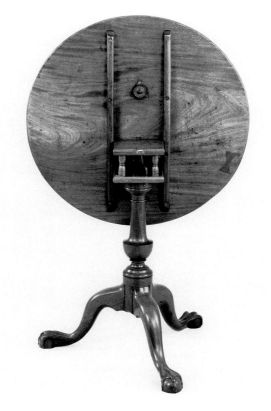

125

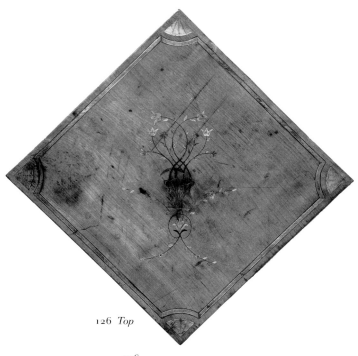

126 *Top*

126 126

126

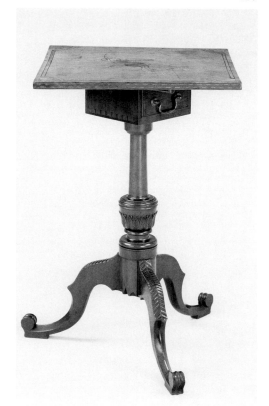

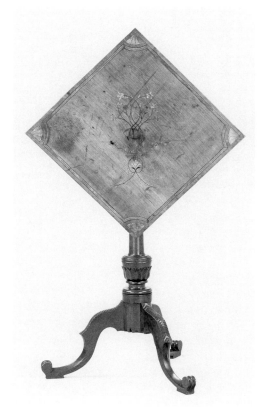

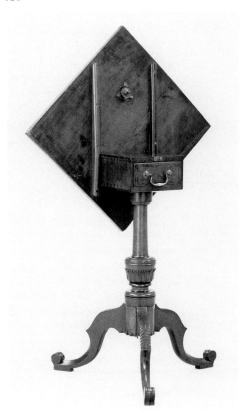

Condition: The top has been bleached by exposure to sunlight. One of the pintles broke out and has been reattached. The left cleat is a replacement. Repairs to the veneer were made by Otto Hoepfner and Sons in 1953. The hardware, including the gilt brass drawer handle, appears to be original.

Reference: Miller 1937, II, no. 1363.

Provenance: Garvan purchased this stand from Charles R. Morson on January 18, 1929.

This extraordinary stand is an exuberant, original interpretation of the Neoclassical style by a craftsman working outside the major urban centers. Its basic form was derived from tea tables and stands with square tops and urn pillars made in Boston and Essex County, Massachusetts; a documented example was made by Jonathan Gavet of Salem in 1784.[1] Gavet's stand is a unified statement of curved lines and unembellished surfaces. The maker of the Art Gallery's stand deliberately contrasted the pedestal's sculptural elements with the planar surfaces of the top and drawer front. The former have complicated silhouettes embellished with carving; the latter are simple, geometric shapes ornamented with inlay. Because of the craftsman's skillful manipulation of form and ornament, this dichotomy enlivens the stand's impact. The three-dimensional case for the drawer is the same square shape as the two-dimensional top. The exaggerated, broken curves of the legs and scroll feet are repeated in the flowering vine inlay on the top. The stylized patterns of the leg and urn carving are echoed by the quarter paterae on the top and the patterned stringing on its outside edges.

 This stand's maker and precise place of origin remain unidentified. It was produced in the same shop as a fire screen, two desks and bookcases, and at least four chests of drawers.[2] Constructed of cherry and pine, with identical dark-and-light diagonal stripe stringing and similar carved details, all of these objects are lively interpretations of urban Massachusetts forms. The base of the fire screen is identical to the stand's, with legs cut from the same template. Urn and flowering vine inlay composed of the same elements was used in slightly different configurations on the stand, fire screen, both desks, and one chest of drawers. This chest, still privately owned, originally belonged to Simeon and Susanna Clark of Hardwick, Massachusetts. The original owner of the fire screen and another chest of drawers was Ezra Allen (1773–1866) of Holland, Massachusetts, from whom they descended to the present owner. The desk and bookcase at the Connecticut Historical Society was purchased in the 1950s from a collector who lived in Brookfield, Massachusetts, and the Winterthur desk and bookcase apparently was acquired in Boston.[3] Hardwick, Holland, and Brookfield are all located within central Massachusetts, about halfway between Worcester and Springfield. Given these histories of ownership and the craftsman's familiarity with coastal Massachusetts forms, it seems logical to assume that he worked in an inland Massachusetts town. Similar, although less sophisticated, objects probably made in the same area include a stand with an inlaid top and two desks and bookcases. One of the latter is the now-unlocated desk labeled by Adrian Webb and Charles Scott of Providence, Rhode Island, whose authorship has been questioned in recent research.[4]

1. Randall 1965, no. 106.
2. The fire screen and one chest of drawers is in a private collection. The desks are at The Henry Francis du Pont Winterthur Museum, Delaware (Montgomery 1966, no. 177), and The Connecticut Historical Society, Hartford (*Barbour* 1963, pp. 68–69). The second chest of drawers is in the Bybee Collection at the Dallas Museum of Art (Venable 1989, no. 37); the third was owned by John Walton, Inc. (*Antiques* 133 [May 1988], p. 940); the fourth is in a private collection. I am indebted to Nancy E. Richards for bringing the last chest to my attention and sharing her extensive research on Massachusetts furniture from this region.
3. I am grateful to Elizabeth Pratt Fox for the information from Frederick Barbour's records. The Winterthur desk and bookcase was purchased from Charles Woolsey Lyon, Inc., which later reported that the desk had been acquired from a Boston family descended from the cabinetmaker Eliphalet Chapin of East Windsor, Connecticut (memorandum by Milo M. Naeve, August 5, 1960, file 57.885, Registrar's Office, The Henry Francis du Pont Winterthur Museum). Montgomery published the desk's provenance as "Wheelwright Family of Boston" (Montgomery 1966, p. 221), perhaps on the basis of personal knowledge. No documentation survives for this connection, and Houghton Bulkeley was unable to find any relationship between a Wheelwright and Chapin's descendants (letter from Bulkeley to Charles F. Montgomery, February 20, 1965, file 57.885, Registrar's Office, The Henry Francis du Pont Winterthur Museum).
4. The stand is at The Henry Francis du Pont Winterthur Museum (Montgomery 1966, no. 376) and one desk is in a private collection (*Antiques* 90 [October 1966], inside front cover). The Webb and Scott desk is reproduced in *Flayderman* 1930, no. 431, and discussed in Emlen/Steiner 1985.

1 2 7

STAND

Northeastern Massachusetts, New Hampshire, or Maine,
 1790–1820
Mahogany, mahogany and birch veneers; birch (cleats and block)
72.6 (105.9 top up) x 41.3 x 61.1 (28 5/8 [41 3/4] x 16 1/4 x 24)
Bequest of Charles Stetson, B.A. 1900, 1954.37.26

Structure: The top is a single board. A pair of cleats screwed to its underside is fitted over pintles on the block. The legs are blind-dovetailed into the pillar, which is tenoned into the block.

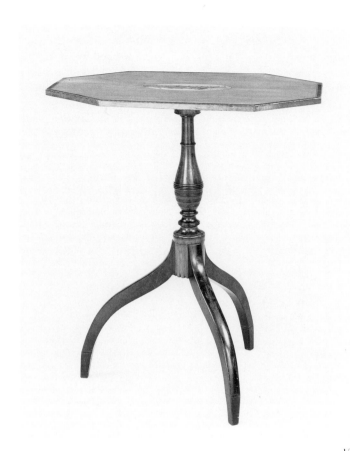

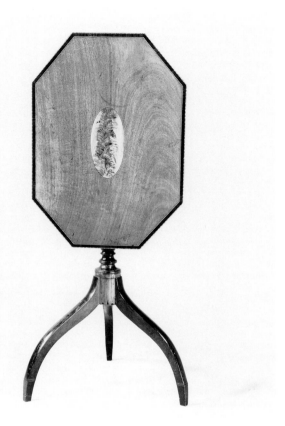

127 127

Condition: The block broke in half and has been repaired. The top of the pillar was sawn apart and reassembled when the tenon was repaired. The pillar also has been repaired where one leg broke out and was reattached. The catch is a replacement.

Provenance: Charles Stetson (1878–1953) was a lawyer in Boston, Massachusetts. It is not known if he collected or inherited the fifteen pieces of furniture he bequeathed to the Art Gallery, some of which were made in northeastern New England and may have been family possessions (Battison/Kane 1973, nos. 40, 41; Kane 1976, no. 225; Ward 1988, no. 168). His parents, Charles Pierce Stetson and Annie Sawyer Stetson, were from Bangor, Maine.

Stands with inlaid, geometrically shaped tops and tapering "claw" legs were made throughout New England during the Federal period. Several features indicate that this stand was produced north of Boston. Legs with a gradual taper above the

cuff inlay and a sharper, pointed taper below it are characteristic of this region,[1] as is the use of birch for both inlay and secondary elements. The same patterned stringing around the top's outside edge is found on desks and bookcases from northeastern Massachusetts.[2] The overall shape of the Art Gallery's stand is akin to an oval top stand attributed to Benjamin Radford of Portland, Maine.[3] Clustered, evenly spaced rings like those on the pillar appear on furniture made in Massachusetts and New Hampshire (see cat. 84). An undocumented stand with a similar baluster pillar has been published.[4]

1. Hewitt/Kane/Ward 1982, p. 61.
2. Montgomery 1966, nos. 190, 193, inlays nos. 16, 18.
3. Shettleworth 1974, fig. 4.
4. Stoneman 1959, no. 201.

128

STAND

New York City area or possibly New Haven, Connecticut,
1800–20

Mahogany (top, pillar), cherry (legs, block)

67.9 (102.2 top up) x 37.6 x 60.7 (26 3/4 [40 1/4] x 14 3/4 x
23 7/8)

Gift of Malcolm P. Aldrich, B.A. 1922

Structure: The top is a single board. Cleats screwed to its
underside are fitted over pintles on the block. The legs are blind-
dovetailed into the pillar, which is tenoned and pinned to the
block.

Inscriptions: A typed paper label is pasted to the underside of
the top: "This Candlestand was owned by / Ezra Stiles who was
born in 1727. / He graduated from Yale College in / 1746 and
became President of Yale / in 1778. It was purchased from his /
great grandaughter [*sic*] in New Haven, Ct." "CANDLESTAND
OF / PRESIDENT EZRA STILES / GIFT OF / MALCOLM ALDRICH"
is engraved on a brass plate nailed to the underside of the plinth.

Condition: The cleats and catch are replacements. Two addi-
tional cleats have been added to the underside of the top at right
angles to the originals, presumably to prevent the top from
warping. The block broke apart and has been pinned together.
The right front leg and the lower half of the left front leg are
replacements. The rear leg appears to be original but has been
reattached. A metal triangle has been added to secure these
repairs.

Provenance: According to the typed label attached to this
stand, it was purchased in New Haven from a great-
granddaughter of Ezra Stiles (1727–1795), seventh president of
Yale. Amelia Leavitt Jenkins Foote (b. 1827), the granddaugh-
ter of Stiles' daughter Emilia Stiles Leavitt (1762–1883), was
his only third-generation, female descendant to live in New
Haven (Stiles 1895, p. 209). The donor, who was born in 1900,
could not have purchased it from Amelia Foote. The "great-
granddaughter" mentioned in the stand's label may actually
have been a fourth-generation descendant, most likely Amelia
Foote's daughter Sarah Wells Foote (1859–1955), who lived in
North Haven from 1914 until her death in a house furnished
with family heirlooms. She is probably the same person who
provided a pembroke table in the Garvan collection (cat. 50),
which was purchased from an unidentified New Haven woman
who claimed to be a descendant of Ezra Stiles.

 The origin of the label itself is unclear. A similar typed label
is attached to one of a pair of side chairs associated with Ezra
Stiles and given to Yale by Mrs. Edward S. Harkness (Kane

1976, no. 135). This label may have been applied when the
chairs were exhibited in a memorabilia room in Sterling
Memorial Library, and it is possible that the stand was also part
of that collection at one time. The stand is now among the fur-
nishings of the Master's Residence of Ezra Stiles College.

Despite its association with Ezra Stiles (see *Provenance*), this
stand probably was made after his death in 1795. Rectangular
tops with canted corners as well as tops and claws with reeded
edges were characteristic of New York furniture from the first
two decades of the nineteenth century (cats. 68, 116–119). The
pillar's unusual, egg-shaped turning appears on the capitals of
a New York card table made about 1810 (cat. 116). The lack of
finesse in the pillar's turnings and the use of cherry for the legs
indicate that this stand was made outside of the city. Its pur-
ported history of ownership in New Haven raises the possibility
that it was locally made. A somewhat later pembroke table with
a Stiles association and a New Haven provenance (cat. 50) is
also a simplified version of a New York City prototype and may
be another New Haven product.

129

STAND

Probably Philadelphia, 1740–80

Mahogany

74.5 (101.1 top up) x 48.3 diameter (29 3/8 [39 3/4] x 19)

Bequest of Olive Louise Dann, 1962.31.4

Structure: The top is a single board. The cleats screwed to its
underside are fitted over pintles on the block. A catch screwed to
the top's underside latches into a catch plate on the block. The
legs are blind-dovetailed into the pillar, which is tenoned and
wedged into the block.

Condition: Part of the block's back edge and one of the pintles
was repaired by Emilio Mazzola in 1960 with a new piece of
wood. The entire surface was refinished by Peter Arkell in 1975.
The pillar is cracked at the juncture with the legs; two legs broke
out and have been reattached with pins. One foot broke off and
has been reattached. The metal triangle that secured the legs to
the pillar is lost. The catch is original.

Reference: Montgomery/Kane 1976, fig. 29.

An immense number of stands similar to this one and the three
following (cats. 130–132) were made in Philadelphia and envi-
rons during the second and third quarters of the eighteenth
century. A basic component of most interiors, these stands were

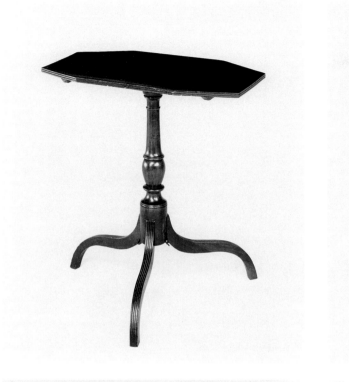

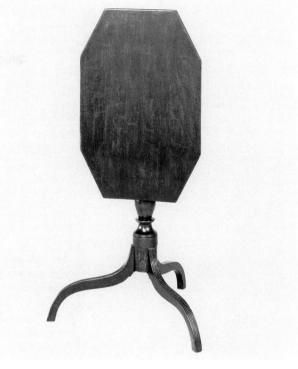

128

128

129

129

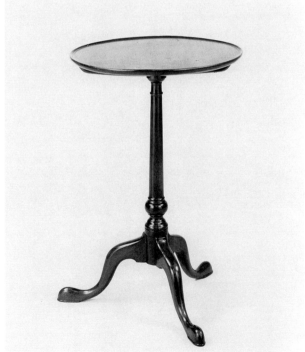

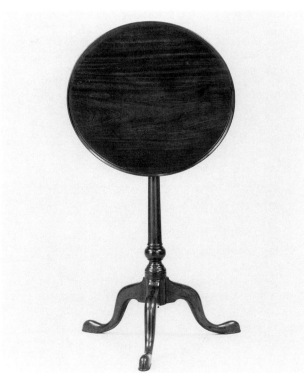

among the least expensive pieces of furniture included in the 1772 price list. A "folding Stand 22 Inches [diameter] with A box plain top and feet" cost £1.15.0 in mahogany and £1.5.0 in walnut, the same as another essential furnishing, a cabriole leg side chair "with plain feet & bannester [and] with leather Bottoms."[1] The demand for this form led to a considerable degree of standardization. As noted above, p. 232, some turners apparently specialized in making pillars, most of which follow the same pattern with a compressed sphere between a tapered shaft and a concave spool. Morrison Heckscher discovered that the legs on some examples were not shaped to fit the pillar's curvature, indicating that the stands were assembled from component parts made by specialists.[2]

Despite this use of component parts, stands with tops that turn up were available in Philadelphia with a wide range of options in decoration and construction. The most elaborate versions had scalloped tops, fluted pillars, claw-and-ball feet, and carved knees that more than doubled the base price.[3] Even similar stands show considerable variety. The four examples at Yale, all with "plain tops and feet" and tops close to the standard 22 in. (55.9cm) in diameter, exhibit subtle differences in the quality of their proportions, turnings, and legs. Three of these tops are mounted on boxes, and one has the less expensive alternative of a "cap," or block (cat. 129). Although less versatile than a box, the cap is invisible to the viewer, and the resulting interplay of simple, graceful lines makes this stand a superb statement of the early Georgian style.

1. Weil 1979, pp. 182, 187.
2. Heckscher 1985, nos. 119–20.
3. Stands of this type are illustrated in Downs 1952, no. 283, and *Antiques* 88 (July 1965), inside front cover. The prices of the extras are listed in Weil 1979, p. 187.

130
STAND

Probably Philadelphia, 1740–80
Black walnut
72.1 (104.1 top up) x 58.5 diameter (28 3/8 x 41 x 23)
Bequest of Olive Louise Dann, 1962.31.7

Structure: The top is a single board. The cleats screwed to its underside are fitted over pintles on the box's upper block. The box is composed of four balusters tenoned between two blocks. A brass catch screwed to the top's underside latches into a catch plate on the upper block. A circular opening in the lower block fits over the pillar, which has a turned tip that fits into a small hole in the upper block. A wooden key fits into a cutout in the

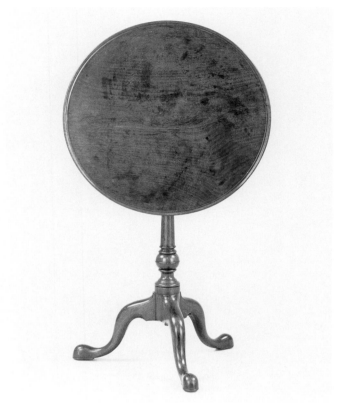

130

pillar's upper end and locks into the ring that fits over the shaft and rests on the box's lower block. The legs are blind-dovetailed into the pillar.

Condition: At one time the top was nailed to the box's upper block. The pillar is repaired where the legs broke out. The triangle on the underside of the pillar and legs is a replacement.

Reference: Kirk 1970, fig. 156.

See cat. 129.

131
STAND

Probably Philadelphia, 1740–80
Black walnut
72 (101.1 top up) x 54.8 diameter (28 3/8 [39 3/4] x 21 5/8)
Bequest of Doris M. Brixey, 1984.32.36

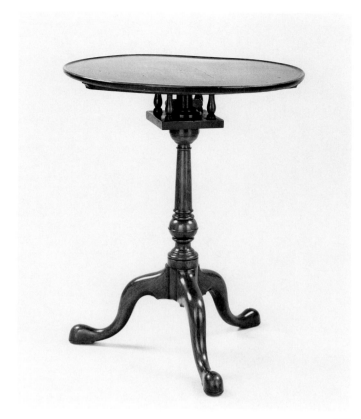

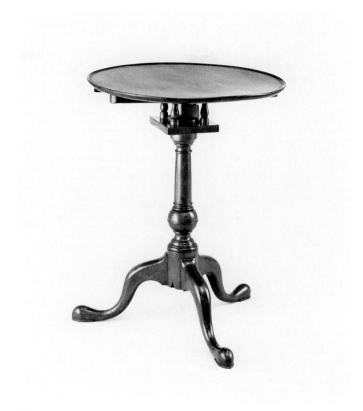

Structure: The top is made of two boards. The cleats screwed to its underside are fitted over pintles on the upper block of the box. The box is composed of four balusters tenoned and wedged between two blocks. A brass catch screwed to the top's underside latches into a catch plate on the upper block. A circular opening in the lower block fits over the pillar, which has a turned tip that fits into a small hole in the upper block. A wooden key fits into a cutout in the pillar and locks into the ring that fits over the pillar and rests on the box's lower block. The legs are blind-dovetailed into the pillar.

Condition: The cleats are replacements, attached at a slightly different angle than the originals. The catch and wooden key are also replacements. At one time the top was nailed to the box's upper block. A crack in the upper block has been repaired with a new piece of wood. One leg broke out and has been reattached to the base, which was repaired in that area. A small piece on the lower edge of this leg is a replacement. A metal triangle nailed to the undersides of the pedestal and legs is lost.

See cat. 129.

132
STAND

Probably Philadelphia, 1740–80
Black walnut
71.3 (104.1 top up) x 60.3 diameter (28 1/8 [41] x 23 3/4)
The Mabel Brady Garvan Collection, 1930.2607

Structure: The top is made of two boards. The cleats screwed to its underside are fitted over pintles on the box's upper block. The box is composed of four balusters tenoned and wedged between two blocks. A brass catch screwed to top's underside latches into a catch plate on the upper block. A circular opening in the lower block fits over the pillar, which has a turned tip that fits into a small hole in the upper block. A wooden key fits into a cutout in the pillar and locks into the ring that fits over the shaft and rests on the box's lower block. The legs are blind-dovetailed into the pedestal. Three iron strips are nailed to the underside of the pillar and legs as reinforcements.

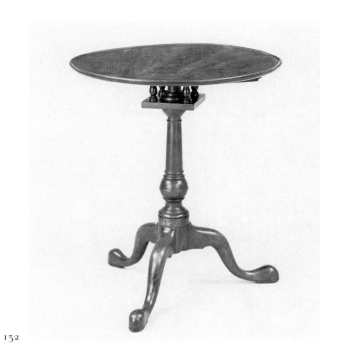

132

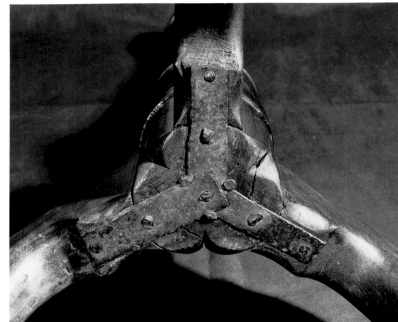

132 *Underside of base*

133

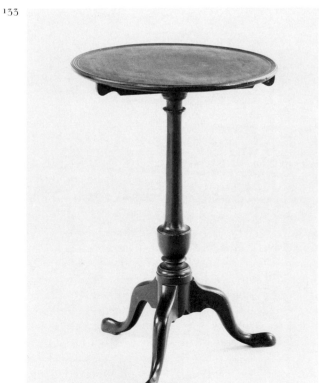

133

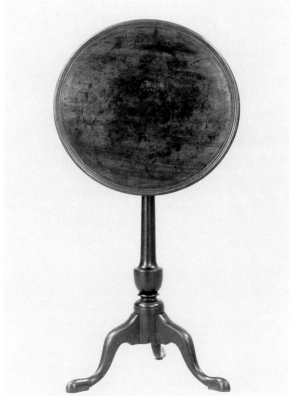

Condition: The top is old but may not be original to the pillar, since the cleats, box, and key are replacements. The ring appears to belong with the pillar, since both are extremely worn and have similar scraped surfaces. Shrinkage cracks in the top and one of the legs have been repaired with new pieces of wood. The catch appears to be original to the top, and the iron strips are original to the base.

Reference: Kirk 1970, fig. 157.

Provenance: Garvan purchased this stand from Frances Wolfe Carey on October 3, 1927.

See cat. 129.

133
STAND

Probably central Maryland or northeastern Tidewater region of
 Virginia, 1760–80
Mahogany
67.6 (93.4 top up) x 44.6 diameter (26 5/8 [36 3/4] x 17 1/2)
The Mabel Brady Garvan Collection, 1930.2041

Structure: The top is a single board. The cleats screwed to its underside are fitted over pintles on the block. A brass catch screwed to the top's underside latches into a catch plate in the block, which is beveled on the underside. The legs are blind-dovetailed into the pillar, which is tenoned and wedged into the block.

Condition: The finish is very old and has darkened. At one time the top was nailed to the block. The catch is a replacement.

Provenance: This stand was among the furnishings of "Audley," the Clarke County, Virginia, home of Lorenzo Lewis (1803–1847). According to family tradition, it belonged to his mother, Eleanor Parke Custis Lewis (1779–1852), the grand-daughter of Martha Dandridge Custis, whose second husband was George Washington. After the death of her husband, "Nelly" Lewis moved from "Woodlawn," her home in Fairfax County, to live with her son. The stand presumably accompanied her to "Audley" at this time. Lorenzo Lewis's estate was divided between four of his sons; the house at "Audley" was inherited by H.L. Daingerfield Lewis (1841–1893). After his mother's and brothers' deaths, Daingerfield Lewis appears to have owned most of the family furniture and other heirlooms, which he and his heirs sold in a series of auctions and private sales from 1890 onward. The house at "Audley" was sold in 1902 to Archibald Cummins, who in turn sold it to B.B. Jones in 1921

(Wayland 1944, pp. 201–10). The Art Gallery's stand was acquired from an unidentified source by the collectors Harry H. and Bertha Benkard of New York City. Garvan purchased it at an auction of objects consigned by Mrs. Benkard on April 20, 1929 (*Benkard* 1929, no. 83).

This stand may have been owned by Eleanor Lewis, George Washington's granddaughter by marriage, but it probably was made for the preceding generation of the Custis or Lewis families. Stands of this type from the late eighteenth and early nineteenth century usually have oval, unmolded tops and elongated urns.[1] This stand's circular top with a molded edge, cuplike urn, and scalloped edge on the pillar are characteristic of tables and stands made in the third quarter of the eighteenth century (cats. 125, 129–132). A mahogany tea table with an almost identical pillar and ridged legs descended in the Chase family of Annapolis, Maryland.[2] Unlike the tapered cleats on stands and tables made in northeastern cities, this stand's untapered cleats have bold cyma curves at their ends that play an important part in the object's overall design.

1. Documented stands of this type include examples by Joseph Short of Newburyport, Massachusetts (Montgomery 1966, no. 371); William King of Salem, Massachusetts (*Sack Collection*, I, p. 305); Ebenezer Smith of Beverly, Massachusetts (*Flayderman* 1930, no. 261; illustrated in *Antiques* 16 [December 1929], p. 452); and John Janvier, Jr., of Cantwell's Bridge (now Odessa), Delaware (deValinger 1942, fig. 6).
2. Elder 1968, no. 25.

134
DINING TABLE

Jacob Margolis (c. 1870–?)
New York City, 1929
Mahogany
74.2 (131.4 top up) x 122.1 x 87.3 (259.3 fully assembled)
(29 1/4 [51 3/4] x 48 1/8 x 34 3/8 [102 1/8])
Gift of Francis P. Garvan, B.A. 1897, 1987.46.1

Structure: The entire table is composed of three sections. The two end sections are identical; the center section is constructed in the same manner, but has four legs instead of three. The top of each section is composed of three boards. Three leaf-edge tenons on the inside edges of one end section and one side of the center section fit into reciprocal mortises in the center section and the other end section. U-shaped brass clips fit into brass sleeves screwed to the undersides of the tops and hold the sections together. Rectangular pieces of wood are screwed to the

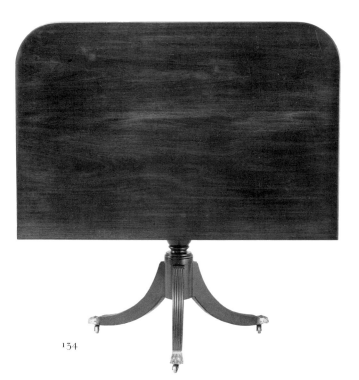

134

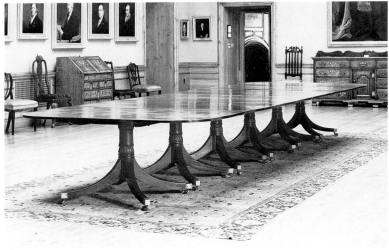

Fig. 54. Dining table, England, 1801–20. Mahogany.
Yale University Art Gallery, New Haven,
The Mabel Brady Garvan Collection.

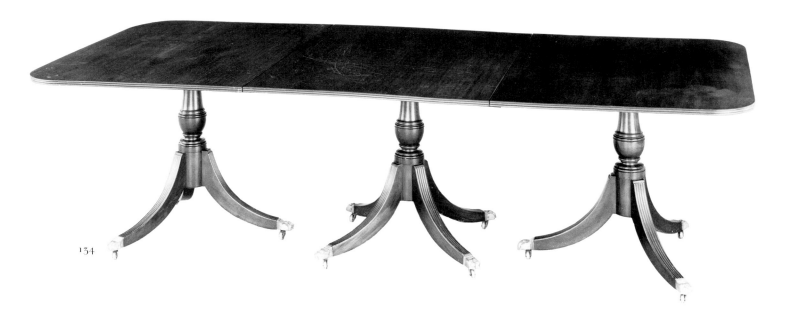

134

underside of each top near its inside edge and pivot to support the joined sections. The cleats screwed to the top's underside fit over metal pintles on the block, which is composed of three horizontal laminates. Two catches screwed to the top's underside latch into catch plates screwed to the block. The legs are blind-dovetailed into the pillar, which is double tenoned into the block. A metal plate is nailed to the underside of the pillar and legs.

Provenance: Garvan commissioned this table for the Art Gallery in August 1929. It is still used as office furniture.

The Colonial Revival style (see pp. 342–44) had become so pervasive in American interiors during the 1920s that reproductions of late eighteenth- and early nineteenth-century American furniture were chosen to furnish Egerton Swartwout's Italian Gothic-style Art Gallery building. This dining table was one of ninety reproductions that Francis P. Garvan commissioned for the Art Gallery from Jacob Margolis in August 1929, including forty-eight chairs, eighteen easy chairs, eighteen "tavern tables," two candlestands, and three mirrors (including cat. 199). Most of this furniture was to be made of maple, although the dining table and one mirror were made of mahogany.[1]

The son of a cabinetmaker, Jacob Margolis was born in Jonava, Lithuania, a furniture-making center. With a large part of his family, he immigrated first to England and in 1892 to Hartford, Connecticut, where he and his kin worked in custom furniture shops. His brother, Nathan Margolis (1873–1925), founded an extremely successful firm in Hartford that made reproductions of early American furniture. Jacob moved to New York City in 1898–99, where he repaired and sold antiques (see Appendix D). He also made reproductions of early American furniture and greatly expanded this facet of his business after 1927. Between 1928 and 1930, Garvan ordered from Margolis a number of reproductions, including copies of furniture in his own collection.[2]

This table was derived from early nineteenth-century pillar-and-claw dining tables composed of two or more sections with tops that turned up. Margolis may have been inspired by an immense English table of this type in Garvan's collection that was among the objects chosen for the inaugural exhibition of the collection at the Art Gallery in 1929 (Fig. 54). The table's simple forms and uncarved surfaces accorded with early twentieth-century taste (see also cat. 199). Like most of his peers who made reproductions, Margolis' claims of "authenticity" were justified by his adherence to the Arts & Crafts tenets of traditional, labor-intensive techniques and "honest" materials. He wrote Garvan in 1927:

I could far outstrip, in workmanship, concerns like Sloane, Erskine Danforth, who have commercialized their reproductions to the loss of exactness and true feeling. My furniture would be made mostly by hand—mortising, carving and finishing—not like furniture made by Wallace Nutting . . . [who uses] the cheapest type of lumber and machine carving . . . which is'nt [sic] even a true reproduction.[3]

Margolis was particularly proud of using "old wood," by which he may have meant wood salvaged from earlier objects; he noted that the tops of his dining tables came from "old bar-room tops" and described a table similar to the Art Gallery's as having a "Hand made top—made from wood 150 years old."[4]

1. Bill from Jacob Margolis to Garvan, August 27, 1929, Margolis file, FPG–AAA. It is not certain that the entire commission was completed.
2. Jacob Margolis to Garvan, April 26, 1928, Margolis file, FPG–AAA; Marion Clarke to Garvan, August 14, 1929; A.W. Clarke to Garvan, December 4, 1929; Marion Clarke to Garvan, May 20, 1930; Clarke file, FPG–Y.
3. Jacob Margolis to Garvan, November 2, 1927, Margolis file, FPG–AAA.
4. Jacob Margolis to Garvan, November 13, 1929, and March 31, 1930; undated (c. 1929) photograph; all Margolis file, FPG–AAA.

Extension Tops

Tables with extension tops were made to divide in half and extend on sliding or folding side frame rails that supported separate, auxiliary leaves. An English invention, this form first appeared at the beginning of the nineteenth century, contemporaneously with other tables that dispensed with hinged legs and falling leaves (see pp. 135–36). Thomas Sheraton noted "three or four different kinds" of extension dining tables in 1803, all of them patented.[1] One of these patents was taken in 1800 by Richard Gillow of Lancaster, whose firm became renowned for its "Imperial Extending Dining Table."[2] J.C. Loudon illustrated tables of this type in 1833 that were "invented in the manufactory of Mr. [William] Dalziel," a London cabinetmaker who had supplied most of the furniture designs for the *Encyclopaedia*.[3] The nineteenth-century fascination with patented, mechanical furniture made extension tables immensely popular. Almost every English furniture design book issued after 1830 included extension dining tables, some of which had falling leaves at the ends in addition to the extension mechanism.[4] These tables were also referred to by the English as "telescope tables."[5]

Americans appear to have made and used extension dining tables almost immediately after their appearance in England. A "dining draw table with five leaves (patent)" made by William Camp of Baltimore was offered for sale in 1815, and Thomas Jefferson owned an extension dining table that he probably purchased before 1809.[6] These early versions were extremely expensive. The "folding frame dining table" in the New York price book for 1834 cost $15.50, almost three times as much as the next most expensive type of dining table, which cost $5.82.[7] This elite character diminished as the century progressed, and a number of innovations were made in the extension mechanism. In 1843, Cornelius Briggs of Roxbury, Massachusetts, received the first American patent for this form to be put into production (Fig. 55); Andrew Jackson Downing praised it as "more easily managed and cheaper than the common form."[8] By the second half of the nineteenth century, huge numbers of tables with extension tops were being made in a variety of styles and sizes in every major furniture center. Elizabethan-style extension dining tables were made by Daniel Pabst of Philadelphia in the 1860s, and a reform-Gothic version was made by Cottier and Company of New York about 1878.[9] In 1881, A.W. and S.D. Ovitt of Chicago advertised no less than "6 Styles and sizes of Pat. Pillar Extension [tables]; 16 Ditto, Common Extension; 8 Ditto, Breakfast Extension; 4 Ditto, Kitchen Extension, 2 Ditto, Saloon; 3 Ditto, Restaurant; 3 Ditto, Office; 50 Ditto, Centre and Parlor."[10] By the end of the century, extension tables were the preferred form for dining tables. In a guide to inexpensive furnishings in 1915, Ekin Wallick of *The Ladies' Home Journal* illustrated matching falling-leaf and extension dining tables, which cost $18 and $27, respectively. He commented: "I feel that the extension table will give greater satisfaction for general use."[11] The form has maintained its popularity to the present day, as an example still in use at the Art Gallery attests (cat. 136).

1. Sheraton 1803, p. 282.
2. *DEFM*, p. 341.
3. Loudon 1833, figs. 1884–86; *DEFM*, p. 225.
4. *Victorian* 1853, pl. 18–20; Joy 1977, pp. 512, 518–28. Examples with falling leaves are illustrated in Loudon 1833, figs. 1882–83; Joy 1977, p. 515.
5. *Victorian* 1853, p. 19; Eastlake 1878, p. 74.
6. *Federal Gazette and Baltimore Daily Advertiser*, August 26, 1815, p. 30; Sotheby's 1988a, no. 1887.
7. *New York Prices* 1834, p. 72.
8. Stamm 1986, p. 8; Downing 1850, p. 421.
9. Hanks/Talbott 1977, fig. 7; Sotheby's 1990b, no. 255; Cook 1878, fig. 76.
10. Hanks 1981, fig. 23.
11. Wallick 1915, pp. 61–62.

135

EXTENSION DINING TABLE

Northeastern or midwestern United States, 1890–1910

White oak; ash (sliding rails), birch (L-shaped blocks), hard maple (two corner blocks), eastern white pine (corner block), yellow-poplar (corner block)

75.6 x 122.2 x 130.5 (303.4 open) (29 3/4 x 48 1/8 x 51 3/8 [119 1/2])

Yale University Art Gallery, 1973.123.1

Structure: Each half of the top is made of three boards. There are six additional leaves. Four dowels along the inside edge of one half of the top fit into reciprocal holes on the inside edge of the other half. Each half of the frame is composed of three shaped rails mitered together at the corners, with a triangular glue block reinforcing each joint. Three L-shaped blocks are glued into a channel on the inside of each rail and are screwed to the underside of the top.

The mechanism for extending the top consists of three parallel sliding rails on each side of the frame. The rails are connected by six U-shaped metal braces fitted into slots cut into the upper surface and underside of each rail. The metal braces permit the rails to slide past one another but stop them when each one reaches its end. The innermost rail of each group is screwed

Fig. 55. Briggs' extension dining table,
from Andrew Jackson Downing,
The Architecture of Country Houses, 1850.

135

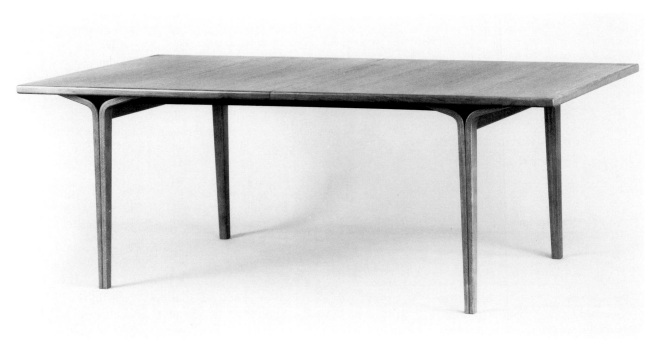

to one half of the top, the outermost to the other half, and the center rail to a rectangular supporting brace that runs parallel to the end. A fifth leg is attached with five dowels to the brace.

Rectangular braces on each half of the frame are screwed to the tops of two legs, running parallel to the inside edge of the top. They are screwed and nailed to three shaped pieces of wood that are screwed to the underside of the top.

Inscription: "2" is branded twice on the upper surface of the central brace.

Condition: The casters are original. One block from the underside of the top is lost, and two others are replacements. Peter Arkell removed a deteriorated finish from the top in 1973.

Reference: Kane 1976, fig. 11.

Provenance: In 1973 this table, together with a set of six side chairs and two armchairs (Kane 1976, nos. 257–58), was transferred to the Art Gallery from the former Yale Infirmary at 276 Prospect Street. Designed by J.C. Cady and Company, the Infirmary was built in 1892 and enlarged in 1906. The date at which this furniture was acquired by the Infirmary is unknown.

The choice of oak, simple form, and use of ornamental moldings on this table were reactions to the rich carving and exotic woods of mid-century revival styles (see cats. 35, 138). Ironically,

Charles Locke Eastlake, the most influential critic of high Victorian furniture, also disapproved of the extension table:

Such a table cannot be soundly made in the same sense that ordinary furniture is sound. It must depend for its support on some contrivance which is not consistent with the material of which it is made. . . . When it is extended it looks weak and untidy at the sides; when it is reduced to its shortest length, the legs appear heavy and ill-proportioned. It is always liable to get out of order, and from the very nature of its construction must be an inartistic object.[1]

Elite criticism did little to diminish the popularity of mass-produced extension tables in a variety of reform styles with either manufacturers or consumers. The dining table of "solid quarter sawed oak" was the second most expensive piece of furniture that Walter and Ulilla Post purchased in 1894 for their first home in St. Paul, Minnesota.[2] Tables similar to the Art Gallery's were illustrated in trade catalogues issued by Bardwell, Anderson, and Company of Boston in 1889; the Rockford Union Furniture Company of Rockford, Illinois, in 1890; Montgomery Ward and Company of Chicago in 1895; and the Stickley-Brandt Furniture Company of Binghamton, New York, in about 1902.[3]

1. Eastlake 1878, pp. 74–76.
2. Clark 1987, p. 165.
3. Dubrow/Dubrow 1982, pp.143–48; *Montgomery Ward* 1895, pp. 611–12.

136

EXTENSION TABLE

Designed 1970 by Robert DeFuccio (b. 1936)

Manufactured by Knoll International (founded 1938)

East Greenville, Pennsylvania, c. 1972

Black walnut (edge of top, fixed rails), white oak (legs, sliding rails), black walnut veneer

72.5 x 101.5 x 193.2 (289.9 open) (28 1/2 x 40 x 76 1/8 [114 1/8])

Millicent Todd Bingham Fund, 1972.78.1

Structure: The top separates into two parts and has two removable rectangular leaves. Each half of the top is composed of three boards that are veneered and have solid outside edges attached with tongue-and-groove joints. Four metal dowels along the inside edge of one half of the top fit into reciprocal holes on the inside edge of the other half. The legs are screwed into the underside of the top at the corners. Each leg is composed of two laminated pieces of wood joined together at their lower ends with a spline. A painted block of wood is inserted in the opening at the top of each leg. A rail is screwed to the top and butted between the legs at both ends of the table.

The mechanism for extending the top consists of two sets of three sliding rails. The rails have dovetail-shaped grooves cut into each side, and are connected by butterfly-shaped splines that permit the rails to slide past each other. The innermost rail of each group is screwed to one half of the top, and the outermost is screwed to the other half. Fixed rails are glued to the outside of each outermost sliding rail and butt against the end rail when the table is closed. A metal catch screwed to the underside of one half of the top latches into a metal catch plate screwed to the other half.

Inscriptions: "Knoll International / 320 Park Avenue / New York, N.Y. 10022. K [encircled]" is printed on a paper label affixed to the underside of the top. "JEFFERSON E-Z [in a shield] TABLE SLIDE / MFG. BY / THE JEFFERSON WOOD WORKING CO. / LOUISVILLE, KENTUCKY" is stamped in ink on one of the sliding rails. "8 1" is stamped on the inside edges of one half of the top and the first leaf, "8 2" is stamped on one inside edge of both leaves, and "8 3" is stamped on the inside edges of the other half of the top and the second leaf.

Provenance: This table was purchased from Knoll International on August 2, 1972, as Art Gallery office furniture. A set of two armchairs and six side chairs designed for Knoll by William Stephens was acquired for use with this table; the same chair design is illustrated in Kane 1976, no. 271.

Beginning in 1970, Knoll's production of Robert DeFuccio's tables was a departure that reflected the increasing importance of postwar studio furniture. Unlike Knoll's best-known designers, DeFuccio was trained as a craftsman at the School for American Craftsmen in Rochester, New York. Influenced by the School's successive directors, Tage Frid and Wendell Castle, DeFuccio rejected the modernist, Bauhaus principles that Knoll had made ubiquitous and conceived of his furniture as an expression of the wood from which it was made.[1] The organic qualities of wood are heightened in DeFuccio's table by the elimination of sharp angles: the top's corners and edges are rounded, and the legs are curved to flow into the top. The shape of the legs evokes a branching tree. These aesthetics, however, had to be reconciled with the requirements of factory production and competitive pricing. The top is veneered instead of solid, and the extension mechanism was made by a specialist manufacturer and not as an integral part of the object. Like most Knoll products (see cat. 10), DeFuccio's basic design was adapted to more than one form; this design was also used for coffee tables and stationary-top tables in two different sizes.[2]

1. For a discussion of the School for American Craftsmen, see Cooke 1989, pp. 11–14.
2. *Defuccio* 1970.

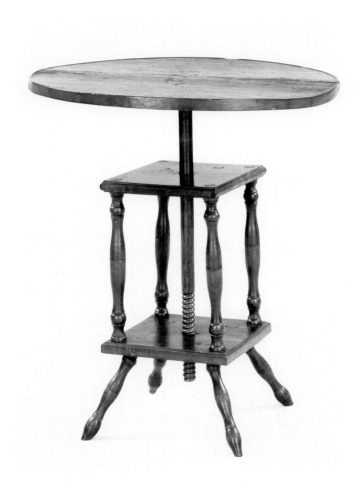

Other Table Forms

The tables in this section represent a variety of solutions to the problem of providing a horizontal surface that can be increased in size or height and stored conveniently when not in use.

137

ADJUSTABLE STAND

Probably northern Piedmont region of North Carolina,
 1790–1820
Black walnut
57.1 (72.4 maximum) x 53.3 diameter (22 1/2 [28 1/2] x 21)
The Mabel Brady Garvan Collection, 1930.2045

Structure: The top is made of two boards. The shaft's upper end is tenoned into the cleat that originally was nailed to the top's underside. The shaft's threaded lower end fits into a counter-threaded hole in the pedestal's lower block. The pedestal is composed of four uprights tenoned and wedged between two square blocks. Four legs are tenoned through the lower block.

Condition: The joint between the two halves of the top has separated and been repaired with nails. The cleat has been reattached with screws; at one time nails were driven through the top's upper surface to secure it.

Provenance: According to Fred Bishop Tuck, an antiques dealer in Pinehurst, North Carolina, who found this stand in November 1929, it had been owned in 1805 in the household of Henry Moore of Guilford County, near Greensboro, North Carolina, and descended through four generations of the Moore family (Tuck to Henry Hammond Taylor, November 22, 1929, FPG-Y). Although Moore was a common surname in Guilford County, no Henry Moore has been located in county or U.S. Census records. A Henry Moore was listed in every census between 1810 and 1840 in Rockingham County, directly north of Guilford County; this man's estate was probated in 1843 (*NCCI*, 1810, p. 96; 1820, p. 102; 1830, p. 131; 1840, p. 141. Will Book B, pp. 285–87, Rockingham County Superior Court, Wentworth, North Carolina). Tuck sold the stand to Henry Hammond Taylor, who sold it to Garvan.

Turned stands with elements that could be moved up and down on threaded shafts were a Continental European form made as early as the second half of the sixteenth century. A design for a book stand of this type by Jacques Besson was published in Lyons, France, in 1569.[1] Candle arms were the most popular

adjustable element in the eighteenth century, and one version of this form incorporated an adjustable, circular top below the candle arms. Known in France as *serviteurs-fidèles*, stands of this type were made by leading eighteenth-century Parisian cabinetmakers, such as Martin Carlin.[2] Much simpler stands of the same form were made contemporaneously in America.[3] The terms "Stand Candlestick," "Standing Candlestick," and "candlestick with a screwed top" that appear in inventories may have referred to this form, although the same terminology was used for iron and brass candlestands.[4]

Instead of candle arms and a top that move up and down on a fixed shaft, in this stand the top is mounted on a moving shaft. The unusual base, which resembles boxes on contemporary tea tables (see p. 232), provides this stand with greater stability than most turned stands with adjustable elements. The stand almost certainly was improvised in response to a specific customer's requirements. It probably was intended for activities such as eating or writing in a household with members of many different ages. The height of the top is variable between the standard table height of 72cm to 58cm (28 3/8 in. to 22 7/8 in.), well below the height of eighteenth- or early nineteenth-century tables intended for adults.

The stand's construction and the style of its turnings suggest that the craftsman was a Windsor chair maker. He may have trained as a turner in Pennsylvania, as the leg terminals are reminiscent of the earliest type of foot on Pennsylvania Windsors, and similar elongated turnings with incised rings are found on later eighteenth-century Windsor chairs from that state.[5] The compressed spheres on the uprights are related to pillar and leg turnings on high-style Philadelphia furniture (cats. 39, 111, 124, 129–132), although this motif apparently is English in origin.[6] Turnings with these features are found on at least two examples of Windsor seating furniture with histories of ownership in the Piedmont region of North Carolina: an armchair owned in the Davidson family of Mecklenburg County and a settee that descended in the Harris family of Cabarrus County.[7] The use of walnut is uncharacteristic of adjustable stands or Windsor furniture made in the Northeast and suggests that this stand was made in a southern state where the wood was plentiful.

1. Jervis 1974, pl. 172.
2. Watson 1973, p. 131, pl. 127; Rieder 1984, pp. 16–17.
3. Rodriguez Roque 1984, no. 155; Nutting 1924, nos. 892, 918, 930, 935, 939. See also cat. A41.
4. Cummings 1964, pp. 59, 172, 235.
5. Santore 1981, no. 105.
6. A pillar with a compressed sphere is illustrated in Sheraton 1803, pl. 65.
7. MESDA research files S-13235, S-13208.

138

RISING SIDE TABLE

Northeastern United States, 1850–70

Black walnut; yellow-poplar

78.5 (116.4 open) x 122.3 x 55.6 (30 7/8 [45 7/8] x 48 1/8 x 21 7/8)

Yale University Art Gallery, 1972.139

Structure: The top is made of a single board with a frame screwed to its underside. The frame's end rails and medial brace are tenoned into its side rails. A reverse-ogee molding is applied to its outside edges below the top. The center and bottom shelves of the table are constructed in the same manner as the top. The frame of the center shelf has a raised reverse-ogee molding applied to its outside edges and is fixed to the upper ends of the leg units. The bottom shelf has oval cutouts in its top to fit over the leg units, and has a square molding with a bead on its upper surface applied to the outside edges of its frame. The underside of the top is mounted on narrow rectangular boards that fit inside the table's leg units. These boards are attached to the cord that is threaded over a pulley at the top of the leg unit and nailed to the underside of the bottom shelf. As the top is raised, the weight of the bottom shelf pulls the cord downward and holds the top in place. A spring-action catch on the underside of the center shelf locks the shelves in place when they are fully opened. Each hollow leg unit is composed of two panels fitted between posts. The volute brackets are screwed or doweled to the posts, and the posts are tenoned or doweled into the base. The stretcher is tenoned between the bases. The raised moldings and bosses are glued to the leg units.

Condition: The casters are original; the glazed cord appears to be a replacement. There are deep cracks across both the center and bottom shelves. Four of the bosses on the legs were restored by Peter Arkell in 1981.

Provenance: This table was found in 1972 in a late nineteenth- or early twentieth-century Colonial Revival style house at 285 Prospect Street in New Haven, Connecticut. This house was bequeathed to Yale University by Ralph G. VanName, Class of 1899, who had lived there from 1934 until his death in 1961.

Rising side tables were mechanical versions of tables with two or three fixed shelves used for serving food. Side tables with fixed shelves (*commodes-servantes*) had been introduced in France during the late Louis XVI period[1] and became popular in England and America during the first quarter of the nineteenth century. Charles-Honoré Lannuier made a Louis XVI style commode-servante in New York between 1803 and 1819;

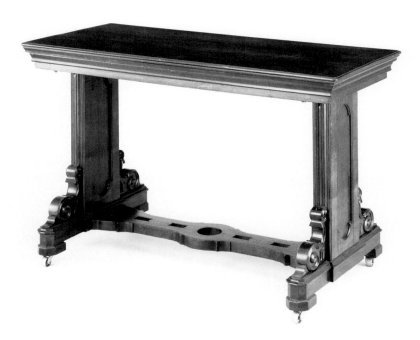

138

138

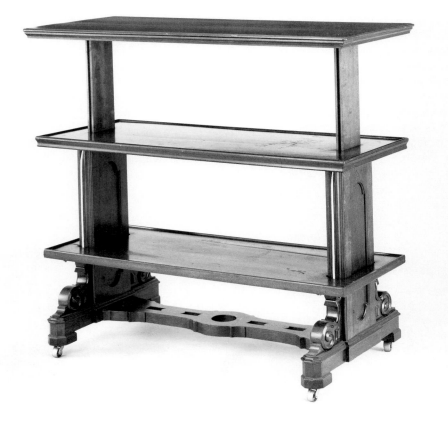

designs for this form were published in England by George Smith in 1808, J.C. Loudon in 1833, and Thomas King in 1834-35.[2] Fitted with casters for greater mobility, side tables functioned as practical auxiliaries to the sideboard. Loudon described their function as "holding the dessert, the plate, the glasses, and other articles in use, while the top of the principal sideboard is covered with articles for display."[3] About 1845, this practicality was enhanced by a mechanism that raised and closed the shelves, making the table less cumbersome to move and store when not in use. In 1850, Andrew Jackson Downing praised the rising side table, which he called a "moving sideboard," as "a very convenient piece of furniture . . . as, being light, and upon castors, they [sic] may be wheeled from one part of the room to another."[4]

The scrolled brackets, applied bosses, and recessed panels with apsidal ends on this table were elements of what was called the "Elizabethan" style. Most English and American designs for rising side tables were in this style, perhaps because the mechanism's invention coincided with the height of the style's popularity.[5] In contrast to the Art Gallery's richly carved library table (cat. 35), the Elizabethan elements on this side table are realized as simplified, largely two-dimensional patterns. A comparison of such details as their stretchers illustrates this difference in quality as well as what must have been a significant difference in cost. The side table's modest character may reflect its function as a practical accessory rather than a static object for display.

1. Watson 1973, p. 31, pls. 145–46; Owsley 1972, fig. 6.
2. Montgomery 1966, no. 346; Loudon 1833, figs. 1876–77; Joy 1977, pp. 415–16.
3. Loudon 1833, p. 1045.
4. Downing 1850, pp. 420–21.
5. *Victorian* 1853, pl. 22; Joy 1977, pp. 417, 509; Downing 1850, p. 420.

1 3 9

BRIDGE TABLE *Color plate 27*

Northeastern or midwestern United States, 1920–40

Decorated by Catherine A. Smith (1888–1956), Block Island, Rhode Island

Sweetgum (including medial brace), oilcloth with paper appliqués; paperboard

65.6 x 72.7 x 72.7 (25 7/8 x 28 5/8 x 28 5/8)

Gift of Mr. and Mrs. W. Scott Braznell, PH.D. 1987, 1987.84.15

Structure: The four frame rails are mitered together and secured with corrugated fasteners. Metal mounts are nailed over the corners. A medial brace with tapered ends is tenoned between two rails. The paperboard top is nailed or glued to rabbets in the frame rails. Paper cutouts are glued to an oilcloth cover that is glued over the top. Each leg moves on a pin inserted through the outside of the frame rail and secured by an L-shaped bracket pinned through the adjacent rail. A two-part, folding hinge is pinned to the leg and the frame rail. Metal glides are nailed to the legs.

Inscriptions: "Cassie Smith" is written twice on the underside of the top, once in chalk and once in pencil.

Condition: One paper appliqué on the top is a replacement.

Provenance: Catherine A. Smith, who decorated this table, almost certainly was its original owner. The daughter of Horace and Catherine Dogerty Dickens, she was descended from a family that had lived on Block Island since the eighteenth century. She married a Block Island fisherman, Louis E. Smith (information courtesy of Helen Cullinan). The donors purchased this table at the Block Island Exchange, a firm selling consignments and secondhand goods, in August 1987.

Tables with hinged legs that fold up under the top are ubiquitous in the twentieth century, although this form was developed during the preceding two centuries. The earliest versions probably were tables made in the eighteenth century for use in military campaigns and other situations where portable furniture was required. Thomas Sheraton illustrated a design for a simple "trussel [trestle] camp table" with hinged, folding legs in 1803.[1] Many tables with hinged, folding legs were patented by American furniture manufacturers during the nineteenth century. Edward W. Vaill, a folding-chair manufacturer in Worcester, Massachusetts, advertised a "Patent Folding and Revolving Table" in 1878 with an elaborate ebonized and gilt central pedestal.[2]

By the 1890s, simple, rectangular "Folding Tables" with yard measures stamped on their tops were advertised in mail-order catalogues as "indispensable to families where considerable sewing is done; also makes a nice card table."[3] The square card table, commonly called a "bridge table" during the 1920s and 1930s, is undoubtedly the most familiar form of folding-leg table in the twentieth century. The invention of bridge in the 1890s coincided with a new respectability for card playing, particularly for women, and the bridge table became an essential furnishing for American homes. Tables with folding legs, however, were ignored by designers, decorators, and authors of advice books directed to an elite audience. The merits of bridge tables with fixed legs were extolled in decorating manuals: "A permanent game group is . . . an immense improvement over the folding bridge table and chairs which must be dragged out from some hiding place The permanent groups are substantial

and better looking."[4] Modernist designers such as Louis Sog-not, Gilbert Rohde, and Warren MacArthur created fixed-leg tables, often with legs of chromium-plated metal tubes and tops of unusual new materials.[5] In contrast, the Art Gallery's table was intended to be a simple, utilitarian object. It had no decorative feature other than its metal corner mounts and was made of inexpensive materials, sweetgum and paperboard. Some manufacturers offered more elaborate folding bridge tables, including examples with ornamental tops and matching sets of tables and chairs made of novel forms.

This table was transformed from an unremarkable into an extraordinary object by Catherine Smith's ornamental top. Although the manufacturer probably did not intend the table to be decorated, this unprofessional embellishment of a ready-made form is in the same tradition as early nineteenth-century work tables decorated by young women (cats. 4, 150, 151, 155). The top is also reminiscent of patchwork "crazy quilts" made by American women beginning in the 1870s as an imitation of Japanese *kirihame*.[6] Just as odd-sized pieces of silk, velvet, and other fabrics used for crazy quilts frequently were chosen for their sentimental associations, the brightly colored gift-wrapping papers used by Smith, some with Christmas motifs, undoubtedly had similar meanings for her. The sophistication of Smith's design, however, indicates a wider range of influences than domestic quilting. According to one acquaintance, Smith was not only an accomplished seamstress who worked on quilts but also an amateur artist who made watercolor and pencil sketches.[7] The selection of papers with active, abstract patterns and particularly the pieces' jagged shapes suggest that she was aware of Cubist painting and contemporary modernist textiles (Fig. 56). The visual similarity between Cubism and crazy quilts that Smith exploited had been noted at the time of the Armory Show in New York City in 1913 (Fig. 57), and American modernist artists and their patrons played a central role in the discovery and collecting of American folk art during the ensuing decades.[8] Smith's interests in quilts, art, and bridge (she was a lifelong member of an island bridge club) came together in her work on this tabletop, a dynamic, personal synthesis of traditional and modernist elements.

1. Sheraton 1803, p. 125, pl. 8.
2. Hanks 1981, fig. 22.
3. *Montgomery Ward* 1895, p. 611.
4. Fales 1936, pp. 125–26; see also Post 1930, p. 344; Gillies 1940, p. 199.
5. Post 1930, pl. 63; Frankl 1928, fig. 56; Sironen 1936, pp. 163, 183. A bridge table designed by Warren MacArthur was owned by Fifty/50, a dealer in New York City, in 1986.
6. Metropolitan 1986, p. 105.
7. Helen Cullinan to Alice Kane, August 19, 1987, Art Gallery files.
8. For a discussion of the connection between folk art and modernism, see Rumford 1980.

Fig. 56. Ruth Reeves for W.& J. Sloane, textile, "Electric" pattern, designed 1930. Block-printed linen. Yale University Art Gallery, New Haven, Gift of Wilma Keyes.

Fig. 57. Briggs, *The Original Cubist*, from *The Evening Sun*, New York, April 1, 1913.

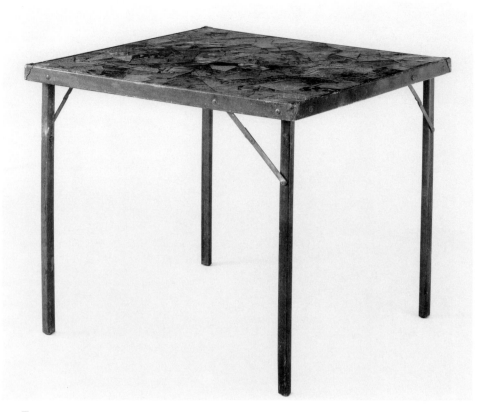

139 *Top*

139 *Underside with inscriptions*

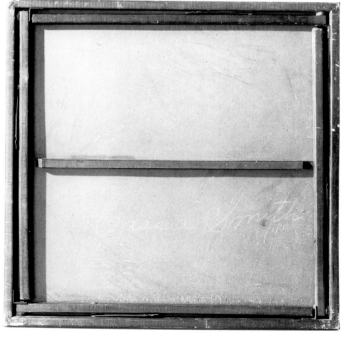

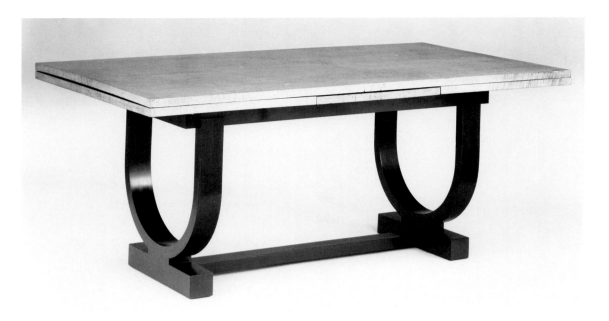

140

Fig. 58. Side chair,
probably New York City, c. 1930.
Birch; wool upholstery
by Dan Cooper, 1954.
Yale University Art Gallery,
New Haven,
Gift of J. Marshall
and Thomas M. Osborn
in memory of
Mr. and Mrs. James M. Osborn.

140

DINING TABLE

New York City, c. 1930

Birch (including sliding rails), hard maple veneer; hard maple
(underside of top), red oak (cleats)

76.5 x 96.5 x 173.2 (295 open) (30 1/8 x 38 x 68 1/4 [116 1/8])

Gift of J. Marshall and Thomas M. Osborn in memory of Mr.
and Mrs. James M. Osborn, 1977.40.5

Structure: The rectangular top is veneered on all its surfaces.
Two cleats screwed to its underside fit into a rectangular frame
that supports the top at its center. Strips of felt are glued to the
underside at either end where it touches the leaves. The rect-
angular frame beneath the top is made of four rails and two
medial braces that are doweled together and screwed to the
base. The two leaves are screwed to long sliding rails that fit into
cutouts in the end rails of the table frame. Two recesses are cut
into the underside of each leaf at the outside edge. The sliding
rails permit the leaves to be pulled out from underneath the top
and butt against its ends. Two blocks are screwed to the under-
side of the center frame as guides for the sliding rails. The base
is composed of four rails mitered together at the corners and
secured with splines. The U-shaped leg units are composed of
seven laminates. The upper ends of the legs are rabbeted and
glued to the outside of the frame. The lower ends are screwed
from the underside to the plinths. The stretcher is presumably
doweled between the plinths.

Inscriptions: A monogram that appears to be composed of the
letters "L T" is drawn in pencil on the outside face of one of the
sliding rails.

Condition: The black paint on the frame, legs, and base has
been renewed. Cracks in the laminations were filled by Peter
Arkell in 1982.

References: Fairbanks/Bates 1981, p. 508 (as by Dan Cooper);
Sands 1983, fig. 4 (as by Lord and Taylor).

Provenance: Mr. and Mrs. James M. Osborn purchased this
table and a set of six side chairs (Fig. 58) for the dining room of
their apartment at 14 Sutton Place, New York City, where they
lived from September 1930 to June 1932. A photograph taken in
this apartment shows one of the side chairs in the hall outside
the living room (Art Gallery files).

Like other furniture that Marie-Louise Osborn acquired in the
years following her marriage (cats. 15, 52), this table was a copy
of a French prototype, less expensive than the original. The
model was the burl-veneer dining table designed in 1925 by
Émile-Jacques Ruhlmann for the Hôtel Ducharne in Paris and

first told. It is 8' 8 by 12 which seems huge after the one to which we are accustomed. I finally convinced Marshall that our little table would look too dinky, and besides any guests would see only the living room and dining room. There is a stunning set at Lord and Taylor, but since there is no hurry I can take my time looking. My idea is to get a table, six chairs, and a serving table, reserving the side board for some time in the future when we are in a big apartment.[5]

Over the summer, however, the Osborns decided to move to the apartment on Sutton Place instead of remaining in Bronxville. Marie-Louise followed through with her plan to acquire a table and six chairs, but it is not certain that those she purchased were the set she had seen at Lord and Taylor. It is possible that the pier table (cat. 15) was acquired as the serving table Marie-Louise mentioned; its curved, black supports are related to those of the dining table.

The top of this table can be extended by pulling out leaves that are fitted below it at either end. Known as a "draw table," this form first appeared in Continental Europe about 1550 and was popular until the third quarter of the seventeenth century.[6] Draw tables appear in seventeenth-century American inventories, although only one American-made example from this period is known (Fig. 18). Twentieth-century French designers revived the draw table action, which Ruhlmann used on the table for the Hôtel du Collectionneur, and such American modernists as Louis Rorimer and Gilbert Rohde designed tables with draw leaves.[7]

featured in the Hôtel du Collectionneur at the Paris Exposition.[1] Not only was the Osborns' table made of less expensive materials, but subtle details in Ruhlmann's design, including flared ends on the U-shaped supports and cyma profiles on the bases below them, were eliminated to reduce its cost. The contrast between the ebonized base and figured-maple veneer on the top was not present on Ruhlmann's table but appeared on other American interpretations of this model, including glass and chrome-plated metal tables by Donald Deskey.[2]

The designer and retailer of this table remain unidentified. It has been incorrectly published as the work of Dan Cooper (see References), whose association with the Osborns did not begin until the 1950s; fabric of his design was chosen to reupholster the matching set of chairs in 1954 (Fig. 58).[3] Another writer associated this table with Lord and Taylor (see *References*), which has proved impossible to verify. The table was purchased by the Osborns after their move to Sutton Place in September 1930. During March of that year, Marie-Louise Osborn had informed her mother that they intended to move to a new apartment in Bronxville with a large dining room, unlike the "dinette" in their first apartment.[4] One month later, Marie-Louise wrote to her mother:

I also looked at dining room sets for next year, as I discovered our dining room [in the proposed new apartment] *is larger than we were*

1. Camard 1984, p. 144; McClinton 1972, p. 18.
2. Hanks/Toher 1987, pl. 45
3. Marie-Louise Osborn to Dan Cooper, Inc., September 22 and October 8, 1954, Family correspondence, Osborn Collection, The Beinecke Rare Book and Manuscript Library, Yale University, New Haven. See also Ward 1988, no. 227.
4. Marie-Louise Osborn to Mrs. J.F. Montgomery, March 19, 1930, Family correspondence, Osborn Collection, The Beinecke Rare Book and Manuscript Library, Yale University.
5. Marie-Louise Osborn to Mrs. J.F. Montgomery, April 15, 1930, Family correspondence, Osborn Collection, The Beinecke Rare Book and Manuscript Library, Yale University.
6. Thornton 1978, pp. 226, 378.
7. Davies 1983, no. 7; Christie's East 1989a, no. 289.

Related Forms

Objects in this section of the catalogue include specialized forms related to tables (cats. 142, 145–149). Also catalogued here are a globe (cat. 141) with a turned stand related to table legs, a folding screen (cat. 144) related to other art furniture (cats. 142–43), and work tables (cats. 150–162) that are hybrids of table and case furniture forms.

141

TERRESTRIAL GLOBE

Elizabeth Mount (1806–1850)
Setauket, New York, 1822
Soft maple (legs), black cherry (horizon ring, stretchers)
72.5 x 69.5 diameter (28 1/2 x 27 3/8)
The Mabel Brady Garvan Collection, 1930.2540

Structure: The gores and zodiac are executed in pen and ink on paper, highlighted with watercolor and embellished with applied cutouts. The gores are glued to the globe, which appears to be a type of *papier-mâché* incorporating a coarsely woven fabric. The globe turns on a central rod fitted into sockets that are screwed to the engraved brass meridian. The meridian is fitted into notches in the horizon ring and supported by a pin screwed through a circular disk above the center joint of the stretchers. The stretchers are lapped together and tenoned into the legs, which are tenoned into the horizon ring. The zodiac is glued over the top of the horizon ring, which is composed of four semicircular sections joined with splines.

Inscription: "Elizabeth Mount/MAKER/SETAUKET/1822.[within an archway framed by the words 'A NEW TERRESTRIAL GLOBE']" is inscribed in ink on the gores.

Condition: The stand retains its original light-brown paint applied in imitation of wood grain. The red paint on the outside edge of the horizon ring also appears to be original. The surface of the globe is abraded and the watercolor has faded. The zodiac is badly discolored and is lifting off the horizon ring, whose joints have separated. The central lapped joint of the stretchers has broken, and all of the stretchers have been repaired and reglued to the legs.

Reference: Yonge 1968, p. 48 (as by Elizabeth "Monns").

Provenance: Elizabeth Mount was the only child of Judge John S. Mount (1780–1853) of Setauket by his first wife, Dorothy Hawkins (1788–1843). The globe was given or bequeathed to the family of her father's brother Thomas and her mother's sister Julia Ann, whose five children included the painters William Sidney Mount and Shepherd Alonzo Mount. All the family's property, including the painters' house in Stony Brook, descended to Evelina Mount (1837–1920), the daughter of Thomas and Julia Ann Mount's eldest son, Henry Smith Mount (1802–1841). When the antiquarian Charles J. Werner of Huntington first visited the house in 1904, he saw the globe in William Sidney Mount's studio and mistakenly assumed it was painted by the artist. Werner later purchased the globe from Charles Q. Archdeacon, who had been appointed the guardian of Evelina Mount (Werner, p. 12). In 1918 Charles Woolsey Lyon wrote Francis Garvan that the globe was "purchased by me from a Mr. Werner . . . who purchased it from the Mont [*sic*] family with a great many other paintings etc. done by Mont, the painter. This Elizabeth Mont was a sister of the painter, Mont." Garvan purchased the globe from Lyon on November 1, 1918 (Lyon to Garvan, November 1, 1918, Lyon file, FPG-AAA).

Literary sources record the use of globes in ancient Greece; the earliest surviving terrestrial globe was made in 1482 by Martin Behaim of Nuremberg, Germany.[1] By the seventeenth century, terrestrial and celestial globes had become emblems of erudition and were used as decorative elements in domestic libraries and studies, a practice that continued through the eighteenth and early nineteenth centuries in both Europe and America.[2] Globes also played an important role in the curriculum of American elementary and secondary schools during the early nineteenth century. In 1794 the Englishman Henry Wansey recorded seeing "a very good pair of Globes" at an academy in rural Flatbush, Long Island, and an 1803 advertisement for Susanna Rowson's Female Academy in Medford, Massachusetts, listed "Geography and the Use of Globes" as part of the curriculum.[3] In 1807, the looking-glass maker John Doggett of Roxbury, Massachusetts, provided a "frame for the Globe" at the "Ladies' Academy" operated by Judith Saunders and Clementina Beach in Dorchester.[4] Small, embroidered silk globes were made by young women at the Westtown School in Westtown, Pennsylvania, during the 1810s and 1820s.[5]

Elizabeth Mount's purpose in making this globe is uncertain. Its large size and precise detail are exceptional for the handiwork of a sixteen-year-old girl. She may have been a schoolteacher and made this globe for her pupils, although its descent in her cousins' family suggests that it was a more personal possession.

1. For a history of early globes, see Stevenson 1921.
2. Thornton 1978, p. 315, figs. 115, 299–300, 303; Jobe/Kaye 1984, p. 307.

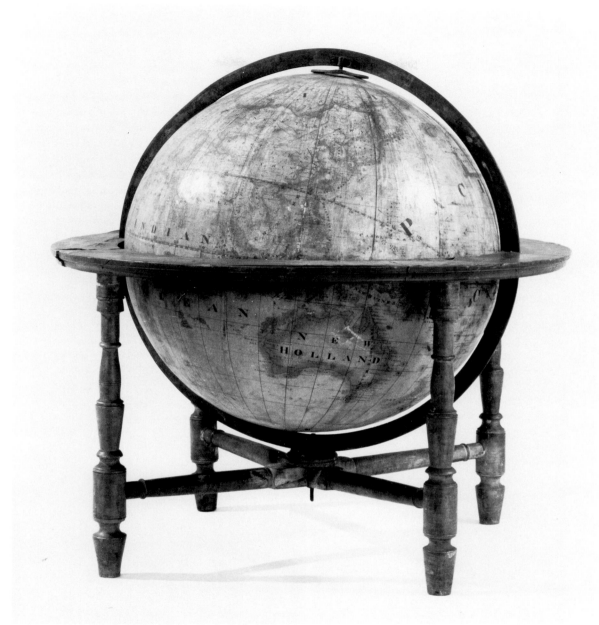

141 *Inscription*

141

3. Wansey 1798, p. 197; Giffen 1970, p. 438.
4. Doggett Daybook, p. 163.
5. Garrett 1985, no. 77.

142

PEDESTAL *Color plate 23*

Northeastern United States, 1870–90

Black cherry (top, upper plinth, side posts, top of base, exterior
 facing of base), yellow-poplar (central pedestal, facing on
 interior of base); eastern white pine (frame of base), birch
 (dowel between pedestal and base)

108 x 80.5 x 51.7 (42 1/2 x 31 3/4 x 20 3/8)

Gift of Theodore E. Stebbins, Jr., B.A. 1960, 1985.114.4

Structure: The top is made of two boards and revolves on a cen-
tral pin in the plinth. The drops are glued to the top's underside.
The central pedestal and two side supports are doweled
between the plinth and base. The top board of the base is
screwed to the frame, which is composed of boards butted and
glued together. The square ends of the base are veneered. The
scalloped projections are shaped blocks glued to triangular
frames butted against the base.

Condition: The ebonized surface and gilt highlights are origi-
nal. The top retains its original upholstery, a plum-colored vel-
vet and gold, burgundy, and plum-colored gimp that are tacked
over a piece of white cotton fabric. The upper surface of the
plinth has a deep shrinkage crack. One piece of the half-round
molding at the bottom of the pedestal is a replacement. Small
pieces of the carved capitals and birds' heads and feathers are
missing and some have been restored. One glue block from the
underside was replaced by Peter Arkell in 1980.

Exhibition: Yale University Art Gallery, New Haven, "A Cen-
tury of Tradition and Innovation in American Decorative Arts,
1830–1930," September 8, 1979–January 20, 1980.

Provenance: The donor purchased this stand in 1975 from Post
Road Antiques of Larchmont, New York.

In response to the recommendations of Charles Locke Eastlake,
Clarence Cook, and other critics of mid-Victorian interiors,
middle- and upper-class Americans in the last thirty years of
the nineteenth century collected works of art to elevate the aes-
thetic and moral quality of their domestic environment.[1] The
ensuing demand for cabinets, shelves, stands, pedestals, and
easels to display artwork gave rise to a new branch of the furni-
ture industry, "Fancy Cabinet Ware." Chicago alone had thirty
manufacturers specializing in this type of furniture by 1884.[2]
This pedestal's massive scale and revolving top indicate that it

was intended for a large, heavy sculpture that could not be easily
moved to exhibit different sides. Similar pedestals supported
life-size marble busts at the home of Charles D. Mathews in
Norwalk, Connecticut, during the 1880s.[3]

Artistic furniture of the superlative quality of this pedestal
was conceived as a statement of the owner's refinement. Its
eclectic ornamental vocabulary—Ionic capitals and animal
monopodia taken from antiquity, baluster support and turned
drops from Renaissance architecture, ebonized surface with
gilt accents evoking Asian lacquer—suggested familiarity with
a wide range of cultures. The upholstered top would have been
interpreted as a "softening" detail emblematic of modern civili-
zation.[4] A leading maker of art furniture, such as Herter
Brothers of New York City, must have been responsible for this
pedestal. The designer took a standard form of the period, a
pedestal supported by two addorsed birds, and created an
abstract design of volutes incorporating birds as well as sun-
flowers.[5] The repeated, stylized plant forms highlighted with
gilding show the influence of Christopher Dresser's *The Art of
Decorative Design*, first published in 1862.[6] An identical stand
is in the collection of Mr. and Mrs. Richard Manney of
Irvington, New York.

1. Metropolitan 1986, pp. 111, 128–33.
2. Darling 1984, pp. 145–54.
3. Findlay/Friend 1981, p. 35.
4. Grier 1988, pp. 129–62.
5. A typical example of a pedestal supported by birds is illustrated in a
 catalogue issued by Bardwell, Anderson, and Company of Boston in
 1884 (Dubrow/Dubrow 1982, p. 69).
6. Dresser 1862, especially pp. 22–33, 84–94.

143

EASEL

Northeastern or midwestern United States, 1870–90

Black cherry

183 x 72.5 x 68.2 (maximum) (72 x 28 1/2 x 26 7/8)

Gift of Herman W. Liebert, B.A. 1933, 1976.99.2

Structure: Turned and square crosspieces are tenoned or dow-
eled between the side uprights. The center upright is tenoned or
doweled between two crosspieces. All projecting elements,
including the legs, are glued to the uprights. A drop is glued to
the underside of the lowest crosspiece. The shallow shelf has an
applied front molding and is locked into holes in the central
upright by a spring-tension lock. The brace is hinged to the sec-
ond crosspiece and secured with a key to the brass strut
attached to the central upright.

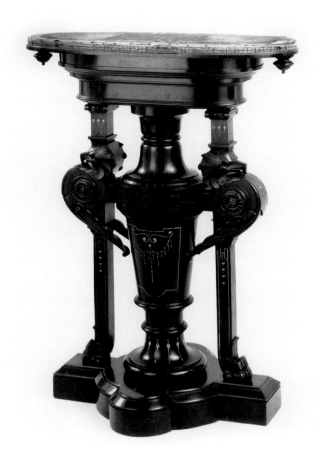

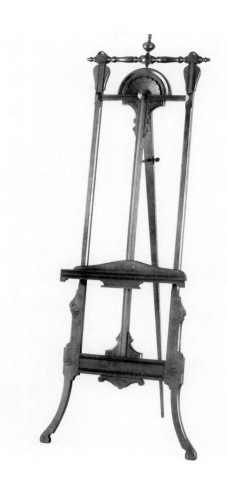

142 143

Provenance: The donor purchased this easel from an unidentified antiques dealer in the 1960s.

Ornamental easels for displaying paintings or prints in domestic interiors were made in America as early as the first quarter of the nineteenth century. A Classical Revival style easel with ormolu mounts descended in the Sargent family of Boston and may have belonged to the painter Henry Sargent.[1] The form did not become common until the rapid proliferation of furniture for displaying artwork during the 1870s (see cat. 142). Unlike the preceding pedestal, this easel was designed to be mass-produced, although its simple form and incised, turned, and molded decoration followed the guidelines established for artistic furniture by Eastlake and other reformers. An easel of this type was purchased from Field, Leiter, and Company of Chi-

cago between 1873 and 1881 by Lura Bailey Gonsalves for her home in Richland Center, Wisconsin.[2] Another was made about 1885 by George Burrill Rawson of Providence, Rhode Island.[3]

1. Randall 1965, no. 216.
2. Darling 1984, p. 147.
3. Monahon 1980, fig. 27.

144

FOLDING SCREEN *Color plate 25*

Max Kuehne (1880–1968)

New York City, 1924–28

Tempera, gold and silver leaf on Douglas-fir plywood; Ponderosa
 pine (frame members)

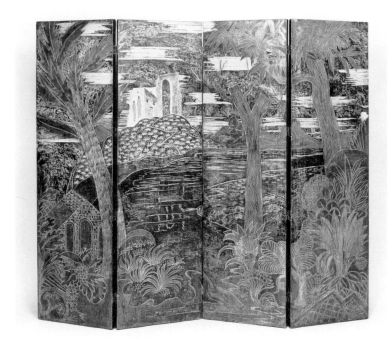

144 *Signature*

144

182.5 x 204.4 (flat) (71 7/8 x 80 1/2)
Gift of Mr. and Mrs. Richard E. Kuehne, 1990.29.2

Structure: Each panel is composed of a four-member frame covered with plywood on the front and back. The panels are hinged together.

Inscription: "Max Kuehne" is incised at the lower right of the composition.

Provenance: This screen remained in the artist's possession and was inherited by his son, the donor.

An ancient Asian form, the folding screen was introduced to Europe with the opening of trade with China and Japan during the sixteenth century. Both Asian and European screens became popular domestic furnishings in America during the ensuing centuries; a screen "containing six folds" was listed in a Philadelphia inventory as early as 1693.[1] The majority of folding screens owned in America before 1850 probably were imported, although their origin is difficult to determine from the imprecise terminology used in contemporary records. The 1759 inventory of the estate of Peter Leigh of Charleston, South Carolina, included "1 large 6 leaved Japan Screen" and "1 four

leaved India Screen" valued at £15 and £10, respectively.[2] The terms "Japan" and "India" may have referred to places of origin, techniques of decoration, or simply to the folding as opposed to the non-folding screen form. Two screens that can be documented as Asian products were among the cargo brought from Japan to Salem, Massachusetts, on the *Margaret* in 1802.[3]

Large numbers of folding screens were made in this country beginning in the 1870s, when the craze for Japanese decoration swept both Europe and the United States.[4] Until World War II, screens in a variety of styles enjoyed widespread popularity in middle- and upper-class American homes. Designers of period-revival style interiors used screens to mask service doors and provide dressing alcoves in bedrooms.[5] Folding screens with bold patterns and irregular shapes appealed to modernist designers, who used them to subdivide large, open-plan interiors.[6] A screen of the latter type appears in a 1930 photograph of Marie-Louise Osborn in her apartment in New York City.[7] Prior to its donation to the Art Gallery, the Kuehne screen was used in Richard Kuehne's dining room as a cover for the door to the kitchen.

Born in Essen, Germany, Max Kuehne trained as a painter in New York under Kenneth Hayes Miller and Robert Henri and

was self-taught as a gilder and woodworker. His best-known works were European and New England landscapes executed in a modified Post-Impressionist manner. Although he regarded furniture-making as a secondary career, sales of his furniture provided a steady income that enabled him to paint. As early as 1917, he made mirror frames in collaboration with his friend and fellow student Rockwell Kent (cat. 202). In addition to frames for his own paintings, Kuehne also made picture frames after about 1920 for the artists Jack Beal, Leon Kroll, Maurice Prendergast, Charles Sheeler, and Eugene Speicher; the art dealers Durand-Ruel and Wildenstein; and the collector Alfred Barnes. He exhibited furniture in 1921 at the Architectural League in New York. Between 1938 and 1946, Kuehne's furniture was sold through the prominent New York decorating firm of Charles Gracie and Sons. Most of his later furniture was made for personal friends.[8]

Kuehne's frames and furniture were simply constructed to provide surfaces for his decoration. After drawing the outlines of his design in a gesso layer, he added the metal leaf and paint, scratching through these layers to create white lines that defined the composition. This technique, known as *sgraffito*, had been employed with gilding in Western art since the Middle Ages.[9] Its resemblance to the incised lacquer technique used on so-called Coromandel screens must have had additional appeal for Kuehne, whose designs frequently drew upon Islamic and Asian sources. This screen also shows his awareness of modernism. Its large areas of metal leaf and its stylized composition are similar to screens of the 1920s and 1930s by Gaston Priou, Jean Dunand, and Armand-Albert Rateau in France and Donald Deskey in the United States.[10] The absence of traditional perspective in the landscape takes on a Cubist quality as the panels of the screen are arranged to create different advancing and receding planes. The screen's rich tempera colors are unusual in Kuehne's furniture; he apparently used them on only three or four screens because customers preferred silver leaf with subdued tones.[11] A screen by Kuehne with more monochromatic decoration was purchased in 1939 by the Worcester Art Museum, Massachusetts.[12] The Art Gallery's screen also represents an aspect of Kuehne's decorative art that is later than his frames and furniture of the early 1920s, which combined non-Western influences with a deliberately primitive style of execution similar to the contemporary work of Charles Prendergast.[13]

1. McElroy 1970, pp. 63–64.
2. Charleston County Wills, LXXXV A-B, pp. 436–43, Charleston County Courthouse, Charleston, South Carolina. I am indebted to Bradford L. Rauschenberg for this reference.
3. Clunie/Farnam/Trent 1980, p. 51.
4. Komanecky/Butera 1984, pp. 14–39, 54–57, 99–109; Metropolitan 1986, p. 137.
5. de Wolfe 1913, pp. 38, 162, 181, 217; Post 1930, pp. 331–32, 349; Burris–Meyer 1937, pp. 8–9.
6. Frankl 1928, fig. 38; Reynolds 1930, p. 41; Fales 1936, p. 184; Means 1941, p. 21.
7. Sands 1985, fig. 7. For information on James and Marie-Louise Osborn, see Appendix C.
8. Information on Kuehne's life and career was taken from his obituary in *The New York Times*, March 16, 1968, p. 31, and *Who's Who*, 1936, p. 246; 1962, p. 346. I am grateful to Richard E. Kuehne for further information concerning his father's career, recorded in a letter to me dated August 15, 1990, Art Gallery files. An account book documenting Max Kuehne's frame orders is in Richard Kuehne's possession. Fifteen paintings by Kuehne are reproduced in Gallatin 1924.
9. Cennini 1960, pp. 86–89.
10. Duncan 1984, fig. 191; Komanecky/Butera 1984, nos. 25–27.
11. Richard E. Kuehne to the author, August 15, 1990.
12. Worcester Art Museum (no. 1939.69).
13. Gallatin 1924, p. 8, pl. 16. A screen by Prendergast is illustrated in Komanecky/Butera 1984, no. 18.

Basin Stands

Basins and ewers were used for personal hygiene from the Middle Ages until the advent of indoor plumbing in the middle of the nineteenth century.[1] During the seventeenth century, basins and ewers in affluent English and American homes were customarily placed on chamber tables, a type of chest on frame.[2] Small, multipurpose stands (cats. 6, 126–133) were more commonly used for this purpose; Randall Holme noted in 1688 that "a little round table, set vpon one pillar . . . is used for to set a Bason on whilest washing Some call it a dressing table."[3] In addition to the significant difference in cost between a chamber table and a stand, the forms required different postures for using the basin. The tops of surviving chamber tables average about 85cm (33 1/2 in.) in height, appropriate for a standing individual, whereas the stands are usually 12cm (4 3/4 in.) lower and probably were used when their owners were seated.

Special stands for basins first appeared in England and America as part of the multiplication of new forms during the second quarter of the eighteenth century. The earliest type was a low, three-leg table with features that remained constant on the form for the following century: a top just large enough to hold a basin, a small drawer for soap, small towels, or other accessories, and a shelf to hold the ewer or "water bottle" (cat. 145). By the middle of the century, this form had been developed into taller versions, with such refinements as a circular opening in the top that secured the basin and "holes for cups," as they were described in the price books. These cups apparently were intended for such items as soap and toothbrushes; a matched set of porcelain including "1 Grecian Patern Ewer & Bowl, 1

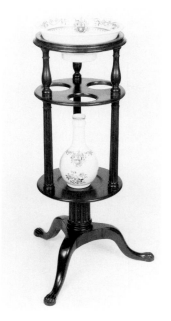

Fig. 59. Basin stand,
Newport, Rhode Island, 1760–80.
Mahogany with Chinese export
porcelain basin and water bottle.
Collection of
Mr. and Mrs. Philip Holzer.

145

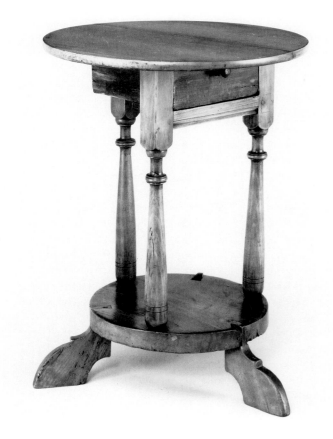

Chamber [pot] & Cover, 1 Soap Box & Brush tray," purchased in 1808 by Elizabeth Corne Dyckman of New York, may have been intended to outfit a basin stand.[4] Mid-eighteenth-century basin stands were made in either square or circular versions, the latter being particularly graceful statements of the Rococo style (Fig. 59). Thomas Chippendale illustrated designs for both types of "Bason Stands" in the *Director*, and the 1772 Philadelphia price list included a "Bason Stand with three pillers & 2 drawers" as well as "Ditto Square with 2 drawers."[5] The circular stand was almost twice as expensive as the square version in the Philadelphia price list, although surviving examples are usually the same size. Their height, about 78cm (30 3/4 in.), suggests that basin stands continued to be used by seated individuals. Basin stands apparently were made in every major American cabinetmaking center, but a paucity of documentary references and the rarity of surviving examples suggests that they were uncommon even in wealthy homes prior to the War of Independence.

As the form became more popular during the last quarter of the eighteenth century, the circular version was superseded by the corner basin stand (cat. 146). George Hepplewhite promoted this form as "a very useful shape, as it stands in a corner out of the way."[6] Describing a bedchamber in Newburyport, Massachusetts, during the 1790s, Sarah Anna Emery commented, "There was a novelty, the first wash-stand I ever saw, a pretty triangular one of mahogany, a light graceful pattern to fit into a corner of a room."[7] An early documented stand of this type was made in 1796 by Jacob Wayne of Philadelphia; another was purchased from Duncan Phyfe by William Bayard of New York in 1807.[8] Despite attempts by a few designers to create circular basin stands in the Classical Revival style, which influenced at least one American example, this form's decline in popularity is reflected by its absence from every price book published in America or England after 1788.[9] Well into the nineteenth century, square basin stands (cat. 147) appeared in both design and price books as the basic version of the form, consistently priced at about half the cost of a corner basin stand.[10]

Both square and corner basin stands were available in "enclosed" versions, with folding or tambour covers for the basin and a cupboard instead of a shelf for the ewer. This feature signaled the trend toward more substantial "wash stands," "wash tables," and "wash sinks" that supplanted the basin stand during the second quarter of the nineteenth century. As early as 1793, Sheraton praised an enclosed basin stand by noting, "The advantage of this kind of bason-stand is, that they [*sic*] may stand in a genteel room without giving offence to the eye, their appearance being somewhat like a cabinet."[11]

1. *DEF*, III, pp. 328–32.
2. Forman 1987, pp. 150–54.

3. Holme 1688, p. 18.
4. Tracy 1981, p. 84.
5. Chippendale 1762, pls. 54–55; Weil 1979, p. 188.
6. *London Prices* 1788, pl. 12; Hepplewhite 1794, p. 15.
7. Emery 1879, p. 32.
8. Hornor 1930b, p. 43; Hornor 1930a, p. 40.
9. Designs for circular basin stands are illustrated in Sheraton 1803, pl. 10; Percier/Fontaine 1812, pls. 6, 19; Joy 1977, pp. 70–71. A New England basin stand of this type in the Neoclassical style is in the Essex Institute, Salem, Massachusetts (Clunie/Farnam/Trent 1980, no. 32).
10. *London Prices* 1788, pp. 70–72, 76; *Philadelphia Prices* 1795, pp. 52–53; *New York Prices* 1796, pp. 51–52; *New York Prices* 1834, pp. 102–07.
11. Sheraton 1793, pp. 393–94. Designs for wash sinks, stands, and tables of the later nineteenth century are illustrated in Downing 1850, figs. 194–95, 268, 284; *Victorian* 1853, pl. 92; Joy 1977, pp. 72–83.

145

BASIN STAND

Possibly New York, 1725–50

Sweetgum; eastern white pine

63.1 x 48 diameter (24 7/8 x 18 7/8)

The Mabel Brady Garvan Collection, 1930.2468

Structure: The two-piece top is pinned to the legs. The legs are tenoned into the shelf. The feet are blind-dovetailed into the shelf. The front rail is tenoned and pinned into the legs. A triangular shelf supporting the drawer is nailed to the rear leg and into a rabbet on the front rail. The drawer sides are nailed to rabbets on the sides of the front, and the back is nailed to rabbets at the rear of the sides. The sides are also nailed to the back. The drawer bottom is nailed to the undersides of the sides and back and to a rabbet on the underside of the front.

Condition: This stand originally was stained a dark color. The drawer retains its original turned knob. The top has been reversed and heavily refinished. The two pieces of the top split apart and have been repaired on what is now its underside with two metal cleats. The left rear foot is a replacement.

Provenance: Garvan purchased this stand in April 1929 from Charles Woolsey Lyon, who called it a "shoemaker's stand."

At least four other basin stands of this early type survive, none with a reliable history of ownership.[1] The other four appear to be more sophisticated products, with shaped tops, dovetailed drawers, and cyma-curved legs. The Yale example was probably constructed by a turner rather than a joiner or cabinetmaker, as its drawer is nailed together and only the front rail is tenoned and secured with pins. Production in a turner's shop may indicate a rural origin, which seems unlikely for so rare a form, or it may indicate an early date of manufacture in the eighteenth century, when many tables were produced by turners (see p. 119). The shape of the feet also suggests an early date, as it is similar to the pivot supports on contemporary small tables with falling leaves (cat. 46).

This stand is also distinguished from the other four in being made of sweetgum. Known as "bilsted" in the eighteenth century, this wood was frequently used for less expensive furniture in New York and may indicate that the stand was produced in that colony.[2] The "round 3 Legged walnut table with a draw and a lock to ditto" made in 1737 by Joshua Delaplaine of New York City may have been a basin stand of this type.[3]

1. Brooklyn Museum (no. 35.1042, illustrated in Schwartz 1968, fig. 47); *Flayderman* 1930, no. 124; Sotheby's 1974, no. 746: Levy 1988, p. 23 (formerly in the Henry Ford Museum, Dearborn, Michigan).
2. Downs 1952, p. xxxiii; Johnson 1964, pp. 44, 50–51.
3. Johnson 1964, p. 32.

146

CORNER BASIN STAND

Northern coastal Massachusetts or New Hampshire, 1790–1810

Black cherry, black cherry veneer; eastern white pine

93.9 x 55.1 x 37.1 (37 x 21 3/4 x 14 5/8)

The Mabel Brady Garvan Collection, 1930.2694

Structure: The two halves of the backboard are dovetailed together and nailed to the top. A small shelf is glued into a groove in the backboard's inside corner. The top is nailed to the legs and the two back frame rails. The veneered front rail, which is composed of two horizontal laminates, has tapered ends fitted in mortises in the legs. The side rails are tenoned into the legs. The top and bottom of the shelf are nailed to the side rails, which are tenoned into the legs. The two front rails have tapered ends fitted into mortises in the legs. Three rectangular strips are glued and nailed inside the compartment as a drawer stop and guides.

Condition: The drawer is a replacement. The patterned inlay along the lower edge of the upper front rail and the inlaid bands at the cuffs are also replacements.

Inscriptions: "2" is written on a paper label glued inside the drawer bottom, and the same numeral is painted in red adjacent to the label. Illegible pencil notations are written on the drawer's underside.

Provenance: This basin stand was owned in the early twentieth century by the antiquarian Wallace Nutting (1861–1941) and

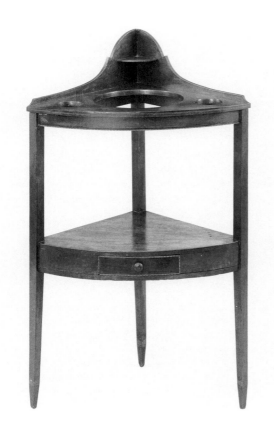

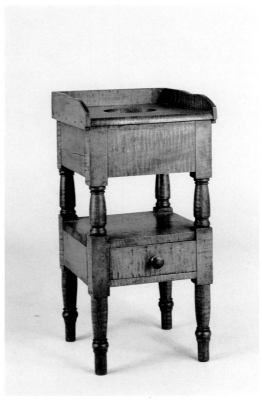

146 147

was displayed in the Cutler-Bartlet House in Newburyport, Massachusetts, one of five historic houses he owned. In 1918, Nutting sold the furnishings from these houses to *Au Quat-rième*, the antiques department at John Wanamaker's department store in New York City. Garvan purchased the stand from Wanamaker's in September 1918 (*Nutting* 1918, no. 1261).

Made of cherry, this corner basin stand was a simple, inexpensive version of a form newly fashionable in the coastal towns of northern Massachusetts and New Hampshire. More elaborate corner basin stands were made contemporaneously by the Massachusetts cabinetmakers Archelaus Flint and Jacob Forster of Charlestown and William Hook of Salem; another was owned by John Richardson of Concord, Massachusetts.[1] The herringbone-pattern inlay on the front of the Art Gallery's stand is very similar to inlays on a card table from Boston (cat. 99), and its long, pointed feet are also a distinctive characteristic of this region (see cats. 80–81, 95, 98–101, 127). These feet must have contributed to the object's instability when it supported a

basin and ewer full of water. Sheraton noted the advantage of designing the legs so that "the two front ones . . . spring forward, to keep them from tumbling over," a feature found on the four documented stands cited above.[2]

1. Randall 1962, fig. 5; Montgomery 1966, no. 361; Randall 1965, no. 101; Stoneman 1965, no. 62.
2. Sheraton 1803, p. 36.

1 4 7

MINIATURE BASIN STAND

Possibly eastern Pennsylvania, 1825–50

Soft maple (including outer drawer front); eastern white pine (inner drawer front, drawer bottom and runners, lower filler strips), black cherry (left drawer side), mahogany (right drawer side, upper filler strips), walnut (drawer back)

39.9 x 18.8 x 18.8 (15 3/4 x 7 3/8 x 7 3/8)

The Mabel Brady Garvan Collection, 1931.312

Structure: The top is nailed to the legs, and the wash boards are nailed to the top. The upper and lower frame rails are tenoned to the legs. The shelf is nailed to the lower side and back frame rails. The drawer front is composed of two vertically joined pieces of wood, with the inner piece nailed to the outer piece. The drawer front and back are dovetailed to the sides; the rear dovetails are reinforced by nails. The bottom has feathered edges fitted into grooves in the front and sides. The drawer is supported by side runners nailed to a pair of filler strips glued to the frame's side rails.

Inscription: "3" is written in chalk on the left drawer side.

Condition: The right rear leg broke off below the shelf and has been reattached. The brass knob appears to be original.

Reference: Schiffer/Schiffer 1972, no. 273.

Unlike corner basin stands (cat. 146), eighteenth-century square basin stands usually did not have washboards applied to their tops, indicating that they were moved away from the wall when in use. Sheraton published a design for a square basin stand with washboards in 1803, but this feature did not appear in an American price book until 1834.[1] Documented American basin stands with this feature include one made by Kimball and Sargent of Salem, Massachusetts, between 1821 and 1830 and another labeled by Anthony Van Doorn of Brattleboro, Vermont, between 1815 and 1847.[2]

 This basin stand's distinctive feet with compressed spheres are characteristic of Philadelphia and its environs (see cats. 39, 111, 129–132). A related, full-size stand, also of figured maple, was purchased from Eneas P. John of Chester County, Pennsylvania, about 1849.[3] The variety of secondary woods suggests that the Art Gallery's stand was made from scraps in a cabinetmaker's shop, probably as a toy.

1. Sheraton 1803, pl. 10; *New York Prices* 1834, p. 102.
2. Fales 1965, no. 24; *Maine Antique Digest* 14 (September 1986), p. 32-B.
3. Schiffer 1966, no. 59.

Carts

Low carts with wheels and two or more shelves first became popular in American homes about 1900. Known by such names as "tea trolley" (cat. 148), "tea wagon," and "portable server," the form apparently was adapted from restaurant trolleys for serving tea or dessert and was used domestically for the same purposes.[1] Guardians of upper-class propriety like Emily Post dismissed them as inappropriate: "In proper serving, not only of tea but of cold drinks of all sorts, even where a quantity of bot-

tles, pitchers and glasses need space, everything should be brought on a tray and not trundled in on a tea-wagon!"[2] The cart had its greatest appeal in homes with open plans and without servants, capturing the interest of such modernist designers as Alvar Aalto (cat. 148) and Marcel Breuer.[3] Tea trolleys seem to have gone out of fashion during the 1960s, and carts used in domestic interiors since that time have a wider range of forms and functions. Advertisements from the 1970s and 1980s show them as stands for stereo equipment or personal computers as well as for serving food or liquor (see cat. 149).[4] Bruce Beeken is one of a few contemporary craftsmen to have produced what he called a "tea cart."[5]

1. Wallick 1915, p. 118; *Modern Priscilla* 1925, p. 153; Ford/Ford 1942, p. 120; Morton 1953, p. 105; Schoenfeld 1960, p. 21.
2. Post 1923, p. 171.
3. Wilk 1981, fig. 79.
4. Conran's 1986, n.p.; Louie 1987.
5. Monkhouse/Michie 1986, no. 76.

148

TEA TROLLEY

Designed c. 1936 by Alvar Aalto (1898–1976)

Retailed by Artek-Pascoe, New York City (founded 1940)

Probably Wisconsin, 1941–42

Hard maple (laminates of leg elements, edge moldings on top and shelf), birch (handle), laminated plywood with hard maple surface veneers (top, shelf); yellow-poplar (top and shelf frames)

55.5 x 89.3 x 45.2 (21 7/8 x 35 1/8 x 17 3/4)

Gift of Keith Smith, Jr., B.A. 1928, 1981.73.2

Structure: The top is a plywood board nailed and glued to a frame, whose end rails and two medial braces are glued into grooves in the long side rails. The raised molding is glued to the frame's outside edges. The two leg elements are each a single piece composed of five laminates. The legs are screwed to the frame's end rails and medial braces. The handle is screwed to the legs. The shelf is made in the same way as the top; one end is glued to the legs and the other is screwed to them. The wheels' metal axles are fitted into channels cut into the shelf's side rails and one of its medial braces. The axles are secured by a metal brace and by the leg element. Each wheel is a wooden disk with rubber strips nailed into grooves on its outside edge.

Inscriptions: A series of numbers is written in pencil on the trolley: "8" on the underside of the top, "22" on the underside of the shelf, and "6" or "9" on the underside of each leg element. "A" is written in pencil on the underside of the top.

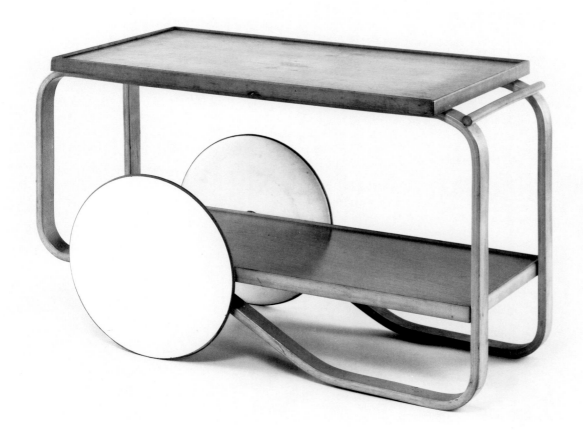

149 *Adhesive label*

148

Provenance: The donor purchased this tea trolley from Artek-Pascoe in 1941 or 1942; it was part of a large order of Aalto furniture for a new house, including two upholstered armchairs, four upholstered side chairs, two low-back side chairs, and a stool, as well as a webbing-upholstered chair and bench designed by Ewald Holtkamp (see Appendix C).

Alvar Aalto's designs of the early 1930s for bent plywood furniture immediately challenged German steel tube furniture as icons of orthodox modernism. In 1935, Aalto founded Artek in Finland to control the production and marketing of his furniture; but the furniture did not become widely available in the United States until after a 1938 exhibition at The Museum of Modern Art. This exhibition inspired Wallace Harrison, Harmon Goldstone, and Laurance Rockefeller to establish the firm of New Furniture in 1939 as a distributor of Aalto's designs. In

the following year, Aalto and Clifford Pascoe of New York City formed the firm of Artek-Pascoe to manage sales in the United States.[1] Pascoe was unable to import furniture from Finland with the outbreak of World War II; according to at least two sources, he found a manufacturer in Wisconsin to supply copies of Aalto's designs, without the approval of either Aalto or Artek.[2]

Made partly of yellow-poplar, a wood found only in North America, this tea trolley apparently is an example of the furniture made in Wisconsin. Keith Smith, Jr., saw Aalto's designs when he visited the New York World's Fair in 1939 and subsequently purchased this trolley and several other pieces from Artek-Pascoe in 1941 and 1942 (see *Provenance*), when Pascoe was having reproductions made. This trolley lacks the dark-colored handles and top surfaces seen in some contemporary illustrations of trolleys made in Finland, although these features may have been optional in both countries.[3]

149

1. Pallasmaa 1985, p. 82; Ostergard 1987, pp. 160–61, 173 n. 92.

2. See Pallasmaa 1985, p. 82, where Göran Schildt, Director of the Aalto Archives, Munkkiniemi, Finland, states: "Aalto furniture was produced by Eggers in Wisconsin beginning in 1940." Schildt's information apparently came from documents in the Aalto Archives; it has not been possible to further identify the Eggers firm, which may have been a small workshop. According to Christopher Wilk, Pascoe's reliance on a company in Wisconsin was confirmed by the recollections of Harmon Goldstone (Wilk to the author, April 5, 1991, Art Gallery files). I am grateful to Wilk for his observations on American-made versions of Aalto's designs.

3. Ostergard 1987, no. 108, illustrates a tea trolley made at the Turku, Finland, factory with a dark-colored handle; Pallasmaa 1985, fig. 123, illustrates a trolley with a dark-colored top and shelf. The trolley illustrated in Artek-Pascoe 1941, no. 7–98, has no dark-colored elements.

149

UTILITY CART

Designed 1968 by Louis Maslow (1908–1973)

Manufactured by InterMetro Industries Corporation (founded 1929)

Wilkes-Barre, Pennsylvania, c. 1985

Chrome-plated steel tube and wire, plastic, rubber

99.2 x 66.3 x 51.4 (39 x 26 1/8 x 20 1/4)

Stewart G. Rosenblum, J.D. 1974, M.A. 1974, M.PHIL. 1976, Fund, 1986.19.1

Structure: The cart is built around two U-shaped elements that form the uprights. The uprights' sides are horizontally grooved at 2.5cm (1 in.) intervals. Three adjustable open wire shelves are fitted over the uprights and locked in place by cylindrical black plastic sleeves that fit into the grooves. The shelves are welded together. The casters are doweled into the uprights with a rubber disk fitted between them.

Inscriptions: "Metropolitan Wire Corporation / [monogram], MODEL / METRO, NSF [encircled by the words 'NSF TESTING LABORATORY ANN ARBOR MICH.'] / Wilkes-Barre, Pa. Cucamonga, Calif. Mississauga, Ont. Canada" is printed on an adhesive label attached to one of the flared handles. "SUPER / ERECTA SHELF / U.S. PATENTS 3,757,705 / 3,424, 111–3,523,508–4,285,783 / D215,773 AND RELATED / FOREIGN PATENTS—OTHER / PATENTS PENDING / METRO, NSF [encircled by the words 'NSF TESTING LABORATORY ANN ARBOR, MICH.']" is cast into the cylindrical corner pieces of each shelf. "METRO" is printed in white on the small black plastic triangles fitted into the shelves' outside edges; it is also molded twice on the the rubber disks above the casters. The casters are marked "J&J."

Provenance: The Art Gallery purchased this cart from West Town House, a housewares store in New York City, on January 30, 1986. The donor had provided funds to acquire a contemporary, American-made object available in retail stores. The cart was chosen by a team of curators from the Art Gallery and graduate students from Yale University.

Carts such as this one appeared in domestic environments during the 1970s and early 1980s when "high-tech" decorating became fashionable. A reaction to the colorful, fanciful interiors of the 1960s, this aesthetic exposed structural and mechanical systems and used commercial equipment of metal, porcelain, and glass as furnishings.[1] Steel wire carts and shelves of different forms were popular in high-tech interiors; a floor model of this cart was set up as a bar at the housewares store where the

Art Gallery acquired it (see *Provenance*).[2] This cart and its component shelves originally were designed as a sturdy, hygienic storage and transport system for the food service industry.[3] The same cart was included in a computer supplies catalogue for transporting paper and magnetic media within office buildings, and a variation of the model is currently used at The Beinecke Rare Book and Manuscript Library at Yale for moving books.[4] Several functional features of the Art Gallery's cart were exploited as stylish details, such as the zigzag wire supports on the shelves, regularly spaced lines on the legs, matte surface on the handles, and the plastic labels and sleeves.

1. Kron/Slesin 1978.
2. Ibid., pp. 55, 60–62, 98–99, 114–15; Brewer 1988.
3. *Metro* 1981.
4. MISCO 1986, p. 27.

Work Tables

The work tables catalogued in this section are a hybrid form perhaps more properly classified as case furniture. Their capacity for storage was at least as important as the working surface they provided, and on some examples (cats. 160, 162) the storage compartment was the table's largest and most elaborately ornamented feature. Hinged tops (cats. 160–162) and fixed tops with fragile painted decoration (cats. 150, 151, 156) were not intended to provide working surfaces, unlike most table forms. The strong personal associations of many work tables with a specific individual, usually a woman, is more characteristic of case furniture than tables, which were used primarily for social interaction (see also p. 16).

Small tables used by women for writing, drawing, and sewing were first produced by Parisian cabinetmakers about 1750, a manifestation of the important role women played as arbiters of taste at the French court during the eighteenth century.[1] One type of work table, known as a *tricoteuse*, had a top with raised outside edges and no storage compartments. Thomas Sheraton illustrated this form as a "French Work Table" in 1793 (Fig. 60), but no example made or used in America before the second quarter of the nineteenth century is known to the present author. American women preferred the form known in France as *table à ouvrage*, which was a more substantial version of the lap desk or "traveling box" (Fig. 61) and the sewing box, basket, or bag previously used by women for writing, drawing, and sewing equipment (Fig. 42).[2] Work tables with hinged tops (cats. 160–162) replicated traveling or sewing boxes, just as others were made with bag-shaped elements (cats. 150, 151, 153). A French work table of about 1784, attributed to Martin Carlin, has a basket-shaped compartment.[3] The different types of work

table were most frequently called a "Lady's Work Table" in American sources. Those with fabric bags occasionally were called "pouch" or "purse tables," but this terminology was more common in England than America.[4]

Work tables apparently did not become fashionable in America until the end of the eighteenth century. The "Sattin Wood Oval Purse Table" ordered in 1797 by the Baltimore merchant Hugh Thompson from Seddon, Sons and Shackleton of London is an early documentary reference to the form.[5] Square and oval versions were listed in the 1788 London price book; the Philadelphia and New York price books of 1795 and 1796, respectively, also described a model with canted corners.[6] Despite this evidence, no surviving American work table known to the author can be dated prior to 1800 by either its maker's working dates or its history of ownership. The earliest securely dated American examples were made in 1808 by Robert McGuffin of Philadelphia (cat. 162) and in 1810 by Nehemiah Adams of Salem, Massachusetts; another stylistically early table was labeled by Oliver Parsell of New Brunswick, New Jersey, who worked between 1802 and 1818.[7] Work tables made by other craftsmen active before 1810 nevertheless appear to date from the second decade of the nineteenth century, when the form was made in every regional center from Maine to South Carolina.[8]

As the Art Gallery's collection indicates, work tables were available in a variety of forms at a wide range of prices. The basic "Square Work Table" (cat. 155) was inexpensive, costing only 8s. in price books from the 1790s and 10s. or $2.25 in the 1810–11 price books, about the same as the least expensive type of chair.[9] Many surviving work tables were probably ordered by indulgent relatives who chose more elaborate versions with such extras as fitted drawers (cat. 158) or "a sliding frame, with a loose bottom to form a silk bag" (cat. 150).[10] During the early nineteenth century, both plain and more richly ornamented tables were placed in the parlor (Fig. 62). Other tables could be used for sewing or drawing (Fig. 31), but work tables, as emblems of their owners' accomplishments, were exhibited where visitors and suitors could admire them.[11] A few work tables had idiosyncratic features indicating a different usage, such as one by Duncan Phyfe with a marble top, usually found on objects used for serving food or drink.[12] Sliding frames for bags were added to other furniture forms, including chairs and chests of drawers.[13]

Different regional interpretations of the work table are well represented in the Art Gallery's collection. Those made in New England (cats. 150–155) were usually either square or square with canted corners; sliding frames with bags were more popular in this region than elsewhere. Hinged tops were more common on tables from the mid-Atlantic region, many having the "astragal end" shape (cats. 160, 162). Oval work tables were

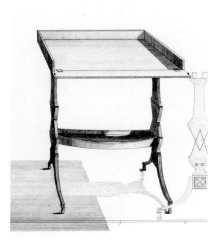

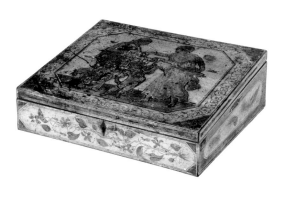

Fig. 60. G. Terry after Thomas Sheraton, *A Lady's Work Table,* from *The Cabinet-Maker and Upholsterer's Drawing Book,* 1793.

Fig. 61. Traveling box, England, 1770–1800. Satinwood; pine. Yale University Art Gallery, New Haven, The Mabel Brady Garvan Collection.

Fig. 62. John Collins, *Nathaniel Coleman and His Wife* (detail), 1854. Watercolor. Whereabouts unknown; formerly Burlington County Historical Society, Burlington, New Jersey.

particularly popular in Pennsylvania, Maryland, and the South (cat. 159). Although the collection does not contain any examples dating after about 1840, work tables have continued to be made to the present. Documented later nineteenth-century examples include Grecian style tables made by Anthony G. Quervelle of Philadelphia between 1825 and 1849; Rococo Revival style tables made in 1846 by Charles Baudouine of New York and between 1857 and 1868 by Mitchell and Rammelsberg of Cincinnati, Ohio; and a Reform style table patented by George Hess of New York in 1876.[14] More commonly known as a "sewing table" or "sewing stand" in the twentieth century, the form became more utilitarian and was used in such private spaces as the bedroom or "sewing room."[15] The authors of a 1916 decorating guide stated, "Every bedroom planned for a woman, young or old, calls for a work table, work basket, or work bag, or all three."[16]

1. Watson 1973, pp. 15, 24–25.
2. Portraits of American women with sewing boxes and baskets are reproduced in Deutsch 1989, pls. 6, 7, 9, 10.
3. Watson 1973, pl. 124.
4. Sheraton 1803, p. 292.
5. Hill 1967, I, p. 12.
6. *London Prices* 1788, pp. 81–83; *Philadelphia Prices* 1795, pp. 62–64; *New York Prices* 1796, pp. 61–62.
7. Kimball 1933b, fig. 2; DAPC 64.1394.
8. Documented work tables were made by Elam Williams of New York City between 1799 and 1840 (DAPC 78.1514); Matthew Egerton of New Brunswick, New Jersey, between 1802 and 1837 (White 1958, no. 78); Vose and Coates of Boston between 1808 and 1818 (Montgomery 1966, no. 477); Duncan Phyfe of New York between 1811 and 1816 (Montgomery 1966, no. 409); John Sailor of Philadelphia in 1813 (Montgomery 1966, no. 424); Jacob Forster of Charlestown, Massachusetts, in 1814 (*Sack Collection,* II, p. 498); Isaac Young of Charleston, South Carolina, in 1814 (*Antiques* 87 [June 1965], p. 633); Ralph E. Forrester of Baltimore between 1816 and 1821 (Elder/Stokes 1987, no. 133); and Thomas Seymour of Boston in 1817 (Stoneman 1959, no. 151). Examples from Maine are discussed in cat. 150.
9. *Philadelphia Prices* 1795, p. 62; *New York Prices* 1796, p. 61; *New York Prices* 1810, p. 29; *Philadelphia Prices* 1811, p. 64.
10. *Philadelphia Prices* 1811, p. 66.
11. For a discussion of the display of women's handiwork, see Deutsch 1989.
12. Montgomery 1966, no. 409.
13. Loudon 1833, figs. 660, 669, illustrates chairs with "workbags" under their seats. A Massachusetts chest of drawers with a sliding bag frame is owned by The Art Institute of Chicago (no. 1970.36), and an English version of the same form is illustrated in *Antiques* 1 (January 1922), p. 37.
14. Smith 1973, figs. 2, 4, 12; Franco 1973, fig. 2; Peirce 1979a, fig. 5; Dietz 1983, no. 44.
15. Wallick 1915, p. 117; *Modern Priscilla* 1925, p. 179; Koues 1948, p. 92.
16. Wood/Burbank 1916, p. 104.

150 *Side rail painting*

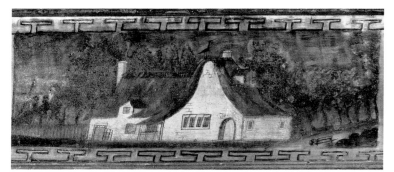

150 *Rear rail painting*

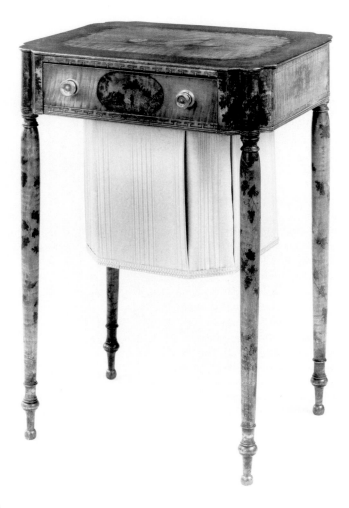

150

150 *Top*

150

WORK TABLE

Massachusetts, New Hampshire, or Maine, 1810–25
Mahogany (top), soft maple (legs, veneer); eastern white pine
73.9 x 50.8 x 38.2 (29 1/8 x 20 x 15)
The Mabel Brady Garvan Collection, 1930.2654

Structure: The top is a single board with a maple tablet inlaid at its center. The top is glued to the frame with small rectangular glue blocks. The back and outer side rails of the frame have a reeded molding applied to their undersides. The outer side rails are glued into rabbets in four triangular corners, whereas the back rail is glued between the rear corners. Inner side rails are dovetailed to the back frame rail and are glued between the front corners. The front frame rail is fitted into rabbets cut into the inner side rails, and the front drawer support is tenoned between them. The legs are fitted into semicircular cutouts in the corners. The drawer front overlaps the front drawer support.

The drawer front and back are dovetailed to the sides. The bottom is nailed to the back and has feathered edges that fit into grooves in the front and sides. The drawer runners are nailed to the inner side rails of the frame. A drawer stop is nailed to the back of the frame. The side rails of the bag frame are dovetailed to the front and back rails, and triangular blocks are glued into the inside corners to create a canted-corner opening for the bag. The bag frame is hung on side runners nailed to the inner side rails.

Condition: The table has been disassembled and glued back together. All of the blocks beneath the top are replacements. Gaps between the corner blocks and the back rail have been filled. The antique yellow silk bag and its birch plywood bottom were restored by Karl Derbacher in 1986. The brass knobs are replacements.

Exhibition: Cullity 1987, no. 13.

Reference: Miller 1937, II, no. 1605.

Provenance: Garvan acquired this table from Charles Woolsey Lyon.

The simple form and construction of this table and cats. 151 and 155 are typical of a large group of New England work tables intended to receive painted decoration. Almost all were made of maple or birch, relatively inexpensive native woods that resembled east Asian satinwood, which was used in England for Neoclassical painted furniture. Most work tables of this type were ornamented by students at female academies rather than by professional decorators such as John Ritto Penniman in Boston or John and Hugh Finlay in Baltimore. Documented tables from Massachusetts were painted at Susanna Rowson's Academy in Boston by Sarah Eaton of Dedham about 1810, at a Newburyport academy by Mary Ann Poor of Danvers in 1820, in Newbury by Nancy Pearson Huse in 1822, and in Northampton by an unidentified "Sarah" in 1814.[1] Three similar chamber tables were decorated in 1815–16 by students at the Bath Female Academy in Bath, Maine.[2] Neither of the Art Gallery's painted work tables can be connected with a specific school, but both the nature and quality of their painted decoration are characteristic of the products of these academies. The vines encircling the legs of the Art Gallery's table, the trophies of musical instruments and imaginary landscapes on its rails, and the shells on its top were popular ornamental motifs during the early nineteenth century, appearing on contemporary ceramics, textiles, and wallpaper as well as painted furniture. A group of exotic shells on seaweed similar to the decoration on this table's top was painted by John Ritto Penniman on a commode made by Thomas Seymour of Boston in 1809.[3]

1. Giffen 1970, fig. 9; Essex Institute, Salem, Massachusetts (no. 135,590); Fales 1965, no. 58; Biddle 1963, no. 88.
2. Montgomery 1966, nos. 478–79; Churchill 1983, no. 1, pp. 11–12.
3. Hipkiss 1941, no. 42.

151

WORK TABLE

Massachusetts, New Hampshire, or Maine, 1810–25
Hard maple, hard maple veneer; eastern white pine
74.5 x 50.4 x 38.3 (29 3/8 x 19 7/8 x 15 1/8)
The Mabel Brady Garvan Collection, 1930.2659

Structure: The veneered top has an ovolo molding applied to its outside edges. It was made of two boards that were glued together and screwed to the frame. The veneered frame rails are tenoned into the legs. The upper front rail appears to be dovetailed between the legs. Blocks are glued into the joints between the legs and the side rails.

The drawer front and back are dovetailed to the sides. The bottom is nailed to the back and has feathered edges that fit into grooves in the front and sides. Blocks are glued to the underside of the bottom along the sides. The front end of the drawer is divided into nine small square compartments; the remainder of the interior was divided in half. The drawer is supported by the lower front rail, a runner nailed to the right side rail, and a strip nailed to the back frame rail. Drawer stops are glued to the back of the frame, and drawer guides are nailed to the side rails.

The front and back members of the bag frame are tenoned

between the sides. The frame is pulled out from the left side of the table; it was supported by runners nailed to the undersides of the front and back table frame rails. Two small supports are wedged into the upper ends of the legs.

Inscriptions: "Cracked" is written in chalk in an early nineteenth-century hand on the underside of the drawer bottom. "Copley Society Exhibition, 1911 / NAME / F H Bigelow [handwritten in ink] / ADDRESS / Cambridge [handwritten in ink]" is printed on a gold bordered paper label attached to the underside of the drawer bottom. "534" is printed on a small paper label pasted inside the drawer.

Condition: The two pieces of the top broke apart, apparently due to warpage, and the veneer cracked. When the top was removed for repair, some of the blocks were reattached or replaced; the blocks on the back and front sides and all of the screws were discarded. One half of the top is charred and may have been flattened by exposure to heat. The halves of the top were planed along their inside edges before being reattached to the table frame, and deep lines were scored on their undersides to prevent further warping. The center divider from the drawer interior is lost. One runner for the bag frame is lost and the other is a replacement. The casters and the ivory keyholes on the drawer and bag frame appear to be later additions. The glass knobs are replacements. Peter Arkell partially refinished the surface in 1981. The simple bag, made from a Brunschwig & Fils reproduction damask by Karl Derbacher in 1986, was designed to complement the amateur quality of the painted decoration.

Exhibition: Copley Society 1911, no. 590 or 591.

Provenance: The antiquarian Francis Hill Bigelow (1859–1933) of Cambridge, Massachusetts, owned this table when it was exhibited in 1911.

The evenly spaced rings on the table's turnings are associated with north coastal Massachusetts and New Hampshire, and its painted decoration is characteristic of documented tables from that region (see cats. 84, 150). Similar, undocumented work tables have been published; one of these has a bag frame that pulls out from the side and turnings characteristic of the north shore of Massachusetts.[1] At least two painters appear to have worked on the Art Gallery's table: the detailed landscapes and shells on the top, bag frame, and back frame rail appear to be by a different and possibly earlier hand than the brightly colored foliage and borders on the top, drawer front, and side rails.

1. Lockwood 1926, II, fig. 794; *Sack Collection,* IX, p. 2438.

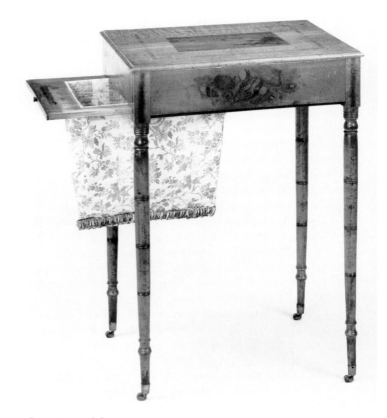

151 *Rear view with bag open*

152
WORK TABLE

Essex County, Massachusetts, 1810–25
Mahogany, mahogany veneer; eastern white pine
71.2 x 52.6 x 45.8 (28 x 20 3/4 x 18)
The Mabel Brady Garvan Collection, 1930.2481

Structure: The top is a single board glued to the case. The veneered case is composed of four thick canted corners. The top and bottom front rails are dovetailed to the two front corners, whereas the center rail is tenoned between them. The side boards are either glued or nailed to the corners. The backboard is dovetailed between the two rear corners. Four small blocks are glued inside the two rear corners of the case to reinforce this joint. A bead molding is applied to the case's undersides. The case is fitted into rabbets cut into the legs.

The two drawers have veneered fronts and bead moldings glued to their outside edges. Each drawer's front and back are

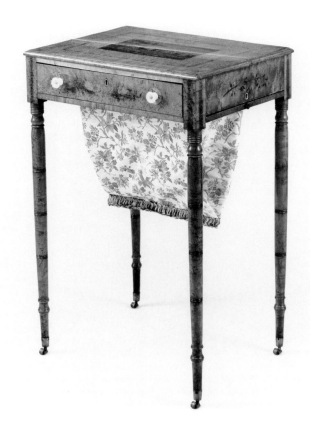

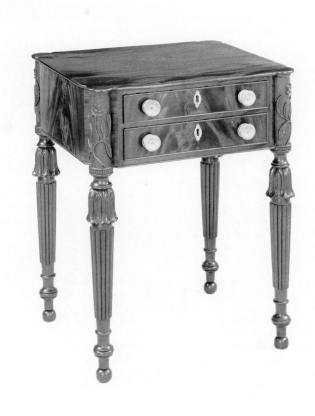

151 152

dovetailed to the sides. The bottom is nailed to the back and has feathered edges that fit into grooves in the front and sides. The front half of the upper drawer is divided into a central square compartment with a smaller square and rectangular compartment on either side. The dividers are joined to each other and to the drawer sides by dado joints reinforced with nails. Drawer runners and guides are glued to filler pieces of wood glued to the case's sides.

Condition: The top is cracked in several places and has been reattached to the case. The brass knobs and escutcheons are replacements. The veneer on the front rails has been patched. There are shrinkage cracks in the back of the case. The right rear leg broke out and has been reattached. The surface was refinished by Emilio Mazzola in 1968.

Provenance: Acting as Garvan's agent, Henry Hammond Taylor purchased this table from Harry Arons.

This table's distinctive legs identify it as a product of Essex County, Massachusetts. Posts with carving on a star-punched

ground; bell-shaped, foliate capitals; tapered, fluted shafts; and feet with compressed rings, frequently above ball feet, are found on furniture made in Salem. Documented examples include a chamber table by Nehemiah Adams, working between about 1790 and 1840; work and card tables by Nathaniel Appleton, working between 1805 and about 1840; a chamber table by John Mead, working between about 1805 and 1824; and a card table by Elijah Sanderson, working between about 1780 and 1825.[1] In addition to numerous examples of the forms cited above, this leg is also found on sideboards and chests of drawers.[2] The carving on this large group of furniture has been attributed to the short-lived Samuel Field McIntire (1780–1819) because flowers and foliage similar to those on the legs of these tables are found on architectural carving by McIntire and his father.[3] No documented example of this type of furniture carving by either McIntire is known to the author, however, and the presence of other specialist carvers in Salem, as well as the wide variation in the quality of the carving, make any specific attribution difficult. The carving on the Art Gallery's table is stiff and uninspi-

red, suggesting that it may have been executed outside of Salem by a less accomplished craftsman trained or influenced by that city's carvers.

1. *Antiques* 100 (August 1971), p. 145; Fales 1965, no. 4; Lockwood 1926, II, fig. 780; Worcester Art Museum, Massachusetts (no. 1952.38); Bivins 1990, pl. 13.
2. Kimball 1933a, figs. 5, 7.
3. Kimball 1933a; Fales 1957, pp. 65–66.

153
WORK TABLE

Eastern Massachusetts, 1810–30

Mahogany (top), black cherry (legs, drawer fronts, sides, and backs, bag frame), mahogany and maple veneers; eastern white pine (side- and backboards, drawer bottoms, runners, and guides), soft maple (front frame rails), yellow-poplar (bag frame bottom)

71.7 x 42.2 x 36.6 (28 1/4 x 16 5/8 x 14 3/8)

The Mabel Brady Garvan Collection, 1930.2679

Structure: The top is a single board glued to the case. The case's sides and back and the bag frame's front edge are veneered. The side boards are trapezoidal in section. The backboard is butted and glued between the sides, and the three front rails are tenoned between the sides. The case is screwed into cutouts in the legs.

The veneered drawer fronts overlap the front rails. The front and back of each drawer is dovetailed to the sides. The bottoms have feathered edges nailed to the back and fitted into grooves in the front and sides. The bag frame's four uprights are tenoned between the frame and bottom board. The sides of the frame are tenoned to the front, and the back is tenoned to the sides. The drawer runners and bag frame supports are nailed to the case's sides. Drawer guides are nailed to the sides, and stops for the bag frame are nailed to the back.

Inscription: "375" is written in chalk on the inside of the upper drawer bottom.

Condition: In 1985, the bag frame was recovered by Karl Derbacher with a twentieth-century green silk fabric and gimp. The unmatched brass knobs are replacements.

Provenance: Garvan purchased this table on January 20, 1928, at an auction of objects assembled by the dealer Gertrude H. Camp of Whitemarsh, Pennsylvania (*Camp* 1928, no. 38).

Constructed with a sparing use of expensive woods, this table was probably made by a craftsman working outside the major coastal cities of eastern Massachusetts. The same turning pat-

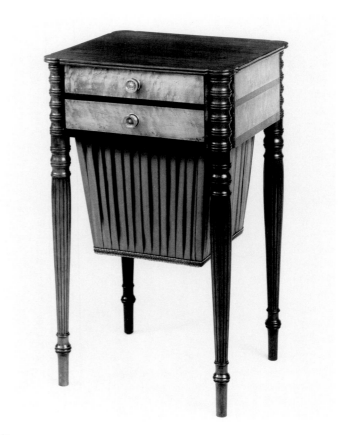

153

terns and contrasting veneers appeared in Salem and Boston (cat. 105), although executed with greater finesse than on this example.[1] The use of cherry as a primary wood and yellow-poplar as a secondary wood is also atypical of urban furniture from this region.

1. Hewitt/Kane/Ward 1982, pp. 64–66.

154
WORK TABLE

Eastern Massachusetts, 1810–30

Mahogany, mahogany veneer; eastern white pine

72.7 x 52.2 x 45.6 (28 5/8 x 20 1/2 x 18)

Bequest of Olive Louise Dann, 1962.32.100

Structure: The top is a single board that is probably pinned to the legs beneath the applied, turned disks. The case is veneered. The backboard is dovetailed to the sides, and the front rails are

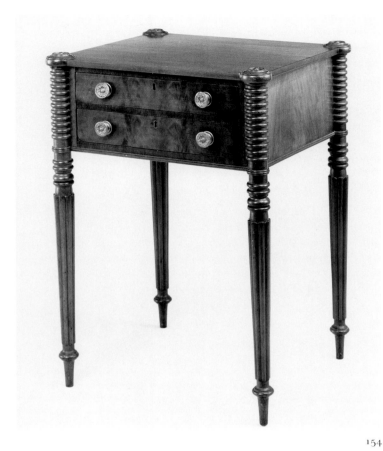
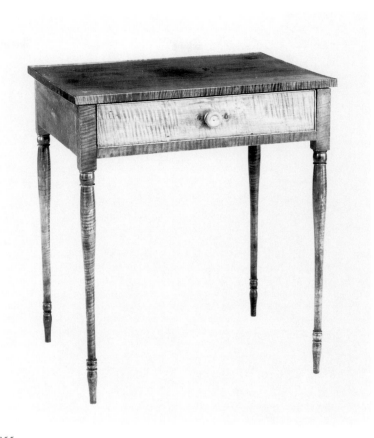

<div style="text-align:center">154 155</div>

fitted into cutouts in the front ends of the sides. The reeded molding is nailed to the case's underside. The case is glued into cutouts in the legs.

The drawers have veneered fronts. A 1cm (3/8 in.)-thick strip of mahogany forms the upper edge and top dovetail of each drawer front. The drawer front and back are dovetailed to the sides. The bottom is nailed to the back and has feathered edges that fit into grooves in the front and sides. The front of the upper drawer is divided into a central rectangular compartment flanked by two square compartments on each side. The dividers are joined to each other and to the sides by dado joints. Drawer runners are nailed to the sides of the case.

Inscriptions: "Hall" is written in ink on the inside bottom of the upper drawer; "2. / 25 / 43" is written in pencil on the upper edge of the left drawer side. "1186 / Scq [Sep?] 6 - 1926" is written in pencil on the right side of the lower drawer; "1" and "т в" are written in pencil on the back.

Condition: Glue blocks have been added to the underside of the top. The top is attached to the front rail with a new screw. The brass knobs are replacements.

This work table and cat. 153 demonstrate ornamental alternatives for the form in eastern Massachusetts during the first quarter of the nineteenth century. Instead of a colorful surface with contrasting veneers and fabric bag, this table was embellished with monochromatic veneers, reeded moldings, and turned and reeded legs. Work tables similar to this example were labeled by Jacob Forster of Charlestown in 1814 and John A. Ellis of East Cambridge between 1851 and 1859.[1]

1. Sotheby's 1973a, no. 712; *Sack Collection*, II, p. 498; *Antiques* 93 (April 1968), p. 452.

155
WORK TABLE

Probably Connecticut or Rhode Island, 1810–25

Soft maple; eastern white pine (glue blocks, drawer guides),
 yellow-poplar (drawer sides and back), chestnut (drawer bottom)
73 x 63.8 x 47.7 (28 3/4 x 25 1/8 x 18 3/4)
The Mabel Brady Garvan Collection, 1930.2091

Structure: The frame rails are tenoned into the legs. Blocks are
glued and nailed at both ends of each side rail. Bead moldings
are nailed to the drawer front's outside edges. The drawer front
and back are dovetailed to the sides. The bottom is nailed to the
back and has feathered edges that fit into grooves in the front
and sides. The joints between the sides and bottom are rein-
forced with glue blocks. Side runners and drawer guides are
nailed to the sides of the frame, and stops are glued in its back
corners.

Condition: The top and drawer knob are replacements added
after 1930. Holes in the drawer front from a bail handle present
in 1930 have been plugged. The drawer bottom has been
renailed.

Provenance: Garvan purchased both this table and an almost
identical mate from Henry V. Weil in March 1925. The other
table was put up for auction as a duplicate in 1931 (*Garvan* 1931,
no. 98).

Made of figured maple, this work table is an undecorated ver-
sion of the simple form intended for painted decoration by
schoolgirls (cats. 150, 151). The existence of an almost identical
mate, with two knobs instead of one on its drawer (see *Prove-
nance*), suggests that these two tables were produced for a
school; identical chamber tables were provided for students in
painting classes at the Bath Female Academy in Bath, Maine.[1]
The Art Gallery's table was probably made in Rhode Island or
Connecticut, where chestnut and yellow-poplar were frequently
used as secondary woods.

1. Montgomery 1966, nos. 478–79.

156
WORK TABLE

Possibly New York City or Albany, New York, 1800–20

Soft maple, maple veneer; eastern white pine (frame rails, drawer
 front and bottom), yellow-poplar (drawer sides, back, runners,
 and bead moldings)
75.5 x 41.5 x 37.8 (29 3/4 x 16 3/8 x 14 7/8)
Gift of A. Pennington Whitehead, 1977.135

Structure: The top is a single board pinned to the legs. The
frame rails are veneered and painted. The side and back rails
are composed of a board with out-curving triangular corner

pieces glued to the ends. The upper and lower front rails are ten-
oned between the side rails and have out-curving triangular
pieces of wood glued at the ends. The dividers between these
rails are nailed to the legs. The corners of the frame are mitered
together. The legs are screwed into cutouts in the corners.

The drawer has a veneered front with bead moldings nailed
to its outside edges. The in-curved drawer front is bent to shape.
The drawer front and back are dovetailed to the sides. The bot-
tom is nailed to the back and has feathered edges that fit into
grooves in the front and sides. The drawer is supported by side
runners nailed to the sides of the frame rails. Drawer stops are
glued in the frame's rear corners.

Condition: This table is extremely well preserved, retaining an
old finish that may be original. The gilt-brass pulls and casters
are original. The top has been reattached to the frame with
screws from the underside. Veneer on the right side of the front
has been patched. All four corners and both side pieces of the
drawer's bead molding were restored by Peter Arkell in 1985.

Provenance: This table descended in the Campbell family of
Cherry Valley, New York. The donor inherited it from his mater-
nal uncle, Douglas A. Campbell.

Made of inexpensive woods, this work table has a sophisticated
shape, turnings, gilt-brass elements, and painted decoration
that create the effect of a more costly object. Unlike cats. 150
and 151, the painted ornament probably was executed by a pro-
fessional. Its finish has darkened, diminishing the intended
contrast between reserved areas of figured maple and simu-
lated rosewood banding. The history of ownership in the Camp-
bell family suggests an origin in New York, although no close
parallels to this table have been identified as New York work. Its
form, decoration, and primary wood are more characteristic of
New England work tables, although yellow-poplar was not com-
monly used as a secondary wood in urban New England furni-
ture, and the quality of the table's turnings and painted decora-
tion indicates an urban origin. Some New York Neoclassical
furniture was made with contrasting veneers (cat. 108), and the
foot turnings are identical to those on a New York City card table
in the Art Gallery's collection (cat. 116).

157
WORK TABLE

Eastern New York or New Jersey, 1820–40

Mahogany, mahogany veneer, ivory inlay; black cherry (frame
 rails, drawer fronts), yellow-poplar (drawer interiors, blocks,
 and runners), eastern white pine (drawer guides)

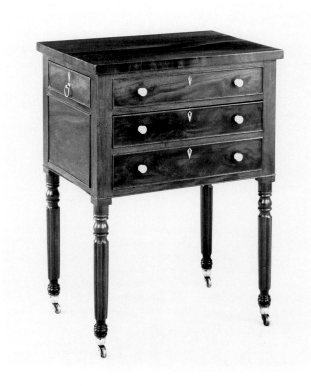

157

157

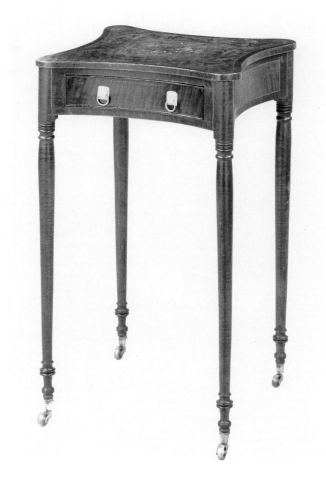

156

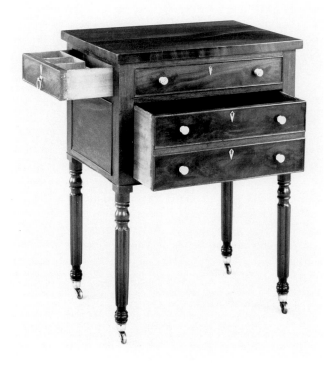

156 *Top*

74.4 x 53.4 x 37.7 (29 1/4 x 21 x 14 7/8)
The Mabel Brady Garvan Collection, 1931.1238

Structure: The top is composed of a frame made of four pieces of wood mitered together at the corners. The outside edges of these strips are veneered and the top is covered with a thick sheet of veneer. The top's frame is screwed to the case and secured with angled blocks. A series of blocks has been glued to the underside of the top piece of veneer. The front and sides of the case are veneered. Bead moldings are applied to the case and drawer fronts. The front rails are tenoned into the legs. The sides are fitted into the legs with tongue-and-groove joints. The back is composed of a panel framed by the legs and upper and lower horizontal rails that are tenoned into the posts.

Both drawers are made in the same manner. The front is veneered, and the front and back are dovetailed to the sides. The bottom is nailed to the back and has feathered edges fitted into grooves in the front and sides. Small rectangular blocks are glued to the underside of the drawer bottom at the sides. The upper drawer has three small square compartments at its front end. The runners that support the upper drawer are fitted with a tongue into a groove in the case's right side and nailed to the left legs. Drawer guides are nailed to the upper surfaces of these runners, and stops are nailed to the left side panel. The runners that support the lower drawer are nailed to the sides through filler pieces of wood that act as a drawer guide. Stops are nailed to the lower back rail.

Condition: The top has several deep shrinkage cracks and has been reattached to the frame with nails. The veneer on the top's outside edge and the veneer and beading along the case's lower edge have been patched in several areas. When Garvan purchased the table in 1930, the original knobs had been replaced by mid-eighteenth-century bail handles. Peter Arkell plugged the holes from the bails in 1985 and put on Ball and Ball reproduction brass knobs. The ring pull on the side drawer is original.

Provenance: Acting as Garvan's agent, Henry Hammond Taylor purchased this table from an otherwise unidentified Mrs. William A. (Susan) Miller on September 29, 1930.

Mahogany work tables with large, rectangular cases on turned legs were a popular form in New York City and areas under its influence; the more elaborate versions incorporated a shelf above the feet. Documented examples were made by such New York City cabinetmakers as John Budd between 1817 and 1837, Duncan Phyfe about 1820, Edward Holmes and Simeon Haines about 1826, and James H. Cooke between 1845 and 1850.[1] The form was produced contemporaneously by craftsmen working outside the city, including Matthew Egerton, Jr.,

Albert Bonnell, and A.E. Noe in New Jersey, and Amariah Taft Prouty in upstate New York.[2] The Art Gallery's work table is a simple, foursquare version of this type. Its maker added such refinements as the simulated drawers, bead moldings, and ivory keyhole escutcheons to mitigate the blocklike quality of the case.

1. Comstock 1962, no. 497; McClelland 1939, pl. 110; Scherer 1984, nos. 58, 78.
2. White 1958, no. 78; Dietz 1985, nos. 3, 12; Scherer 1984, no. 66.

158
WORK TABLE

Possibly New York, New Jersey, or Pennsylvania, 1815–40

Soft maple (top, corner posts, pedestal, veneer), hard maple (bead moldings, legs); eastern white pine (frame members, drawer runners, writing surface, interiors of lower two drawers; front, back, and bottom of upper drawer), mahogany (sides and partitions of upper drawer, veneer on writing surface), birch (lateral brace), white oak (braces under top)

91.6 x 48.1 x 48.4 (36 1/8 x 18 7/8 x 19 1/4)
The Mabel Brady Garvan Collection, 1930.2113

Structure: The top originally was a single board glued to the case. All four sides of the case are veneered, and a bead molding is nailed to their undersides. The backboard is one piece, whereas both side boards have 5cm (2 in.) strips glued to their front ends. The three front rails are tenoned between these strips. The sides and back are probably dovetailed together. Two-piece corner posts are fitted over the corners of the frame. The base is double tenoned to a lateral brace that is screwed into cutouts in the case. The legs are blind-dovetailed into the base.

The drawers have veneered fronts with bead moldings applied around their outside edges. The interior of the top drawer is covered by a writing board that is hinged to the front. The writing surface is covered with baize and the outside edges are veneered. It is made of a board glued between two side strips. The left side of the top drawer has three small, square compartments with a rectangular compartment at the rear that contained a penholder. The bottom drawer is divided into four equal-sized compartments by two lapped partitions. The drawer fronts and backs are dovetailed to the sides. The feathered bottoms are nailed to the backs and fitted into grooves in the front and sides. The drawers are supported by side runners nailed to the sides of the case. Small stops are glued to the backboard.

Inscriptions: "Boon" is inscribed in chalk on the underside of the bottom drawer. "RO 80 / 7667 / L [encircled]" is written in red crayon on the underside of the same drawer.

Condition: The top split in half and has been pieced at its center with a strip of mahogany painted to resemble maple. Three rectangular blocks have been added to reinforce the joint between the top and the back, and four reinforcing boards are glued to the underside of the top. Deep shrinkage cracks in the sides and back of the frame have been filled. The acorn drop on the left front corner broke off and has been reattached. The brass knobs on the drawers were replaced in 1963. Three of the front rails were gouged out when the locks were replaced and have been repaired. The pen tray and the hinged supports for the writing surface in the top drawer are lost. At one time the writing surface was hinged to the back of the drawer instead of the front. The baize on the writing surface is not original. The center drawer has a checkerboard drawn and painted on the underside. The insides of all three drawers have been stained. Three of the legs broke off and have been pinned to the base. The pedestal's moldings have been repaired in areas where they were damaged when the legs broke off.

Provenance: Garvan purchased this table from Charles R. Morson in 1926.

The regional origin of this work table is difficult to establish. Maple and birch are typical woods in New England furniture, but this example's large size and pillar-and-claw base are more characteristic of work tables from the mid-Atlantic region. The maker of this table and an almost identical example probably worked outside the major cabinetmaking centers.[1] The oversize base and the awkward angle at which it joins the case reveal the hand of a less skilled craftsman attempting to imitate a sophisticated, urban form.

1. *Antiques* 54 (November 1948), inside front cover.

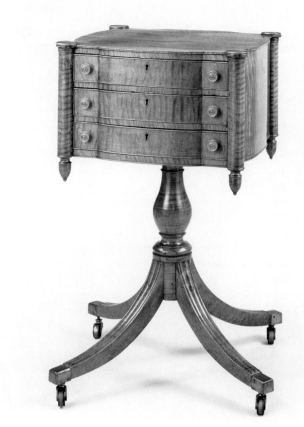

158

158 *Signature*

159

WORK TABLE

Eastern Virginia, probably Norfolk, 1800–10

Mahogany (including lowest laminate of frame, upper laminate of drawer front, drawer runners), mahogany veneer, satinwood inlay; eastern white pine (other frame laminates, lower laminate of drawer front), white oak (drawer sides), southern yellow pine (drawer bottom and back), hickory (pins supporting shelf)

65.8 x 56.9 x 43.4 (25 7/8 x 22 3/8 x 17 1/8)

Bequest of Doris M. Brixey, 1984.32.38

Structure: The veneered top is made of two boards and is glued to the frame. The veneered frame rails are composed of four horizontal laminates. The legs are rabbeted over the laminated

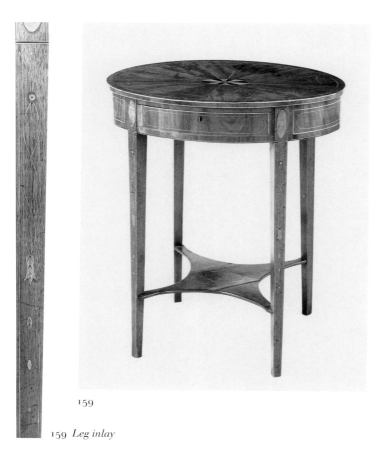

159

159 *Leg inlay*

later addition. There are numerous repairs to the stringing and banding, some made by Peter Arkell in 1985. The legs have been reduced in height by approximately 7cm (2 3/4 in.); traces of the original lightwood cuffs survive on the bottoms, and the legs undoubtedly continued below the cuffs. The joints between the shelf and the legs have been repaired. Two of the glue blocks from the underside of the drawer bottom are lost. The right drawer stop is a replacement.

Described in the 1795 Philadelphia price book as "An Oval Work Table . . . [with] a drawer . . . [and] a plain shelf sweep'd and fix'd . . . with a cross stretcher to support it," this type of work table was most popular in Maryland and the South, although some were made in the Northeast.[1] The secondary woods and multiple laminations used in constructing the Art Gallery's table are also characteristic of furniture from Maryland and the South.[2] The distinctive circle, leaf, and concave bellflower inlays on the table's legs, which have incised lines filled with mastic or pitch, appear on furniture made in Norfolk, Virginia.[3] Despite the alterations it has suffered, this work table is an important example of the superb furniture produced by Norfolk cabinetmakers in the Neoclassical style. The patera outlined in stringing on the top adds definition to the oval shape, which is repeated in stringing and inlays on the frame and legs.

1. *Philadelphia Prices* 1795, p. 63. Examples of this form made and owned in Baltimore are illustrated in Baltimore 1947, nos. 25–27. An oval work table branded by John Wells of Hartford, Connecticut, is at The Connecticut Historical Society (*Barbour* 1963, p. 29), and an example made in New York City is owned by The Metropolitan Museum of Art (no. 35.27).
2. Hewitt/Kane/Ward 1982, p. 171.
3. Hurst/Priddy 1990, pp. 1146–48, pls. 12, 12a, 17. I am grateful to Ronald Hurst and Sumpter Priddy for their observations in relating this table to other Norfolk furniture.

rails and secured by a short tenon that fits into a mortise in the lowest laminate. The shelf is made of two pieces lapped together at the center. Each end is butted against the inside face of the leg and supported by a pin. Splines are fitted onto the ends and nailed to both the shelf and the leg.

The veneered drawer front is made of three horizontal laminates. The front and back are dovetailed to the sides. The bottom is nailed to the back and has feathered edges fitted into grooves in the front and sides. Two small glue blocks reinforce the joint between each side and the bottom. The drawer is supported by side runners that are tenoned and nailed between the front and back of the frame. Two small stops are nailed onto the runners.

Inscriptions: "A TAYLO / R / 10th / JANUARY / 1803" is incised into the underside of the top. "MRS. BIXEY [*sic*]" is written in ink on an adhesive tag attached to the underside of the frame.

Condition: The incised inscription appears to be spurious. The light-and-dark patterned oval inlaid in the center of the top is a

160

WORK TABLE

New York City, 1805–20
Mahogany with mahogany, rosewood, and satinwood veneers
79.6 x 65 x 32.8 (31 3/8 x 25 5/8 x 12 7/8)
The Mabel Brady Garvan Collection, 1930.2507

Structure: The top is a single board hinged to the back frame rail. The frame is built around four corner blocks tenoned through the bottom and secured with screws. The bottom originally was a single board. The veneered frame rails are tenoned into the corner blocks. The curved side rails are composed of six

vertical laminates; the reeded sides below them are mounted on canvas backing and fitted into grooves in the frame and the bottom board. The sliding tambour door in the front is similarly constructed. The back panel is a solid board with a reeded surface. The pillar-and-claw base is double tenoned into a block screwed to the underside of the case. The legs are blind-dovetailed into the block with an iron plate screwed to the underside. The turned feet presumably are tenoned into the legs.

The interior is divided into three compartments by "upright cheeks" or panels butted between the corner blocks and screwed to the bottom. Each compartment has an incised bead molding around its upper edge and is divided into two levels. Removable trays with partitioned interiors are fitted into the upper levels of the side compartments. The curved side of each tray is composed of three vertical laminates and is dovetailed to the flat side. The bottom is glued flush to the sides. A double-bead molding is incised on the upper surface of the sides. The trays are supported by very small, shaped blocks of wood that are glued to the curved frame sides and the cheeks. A writing flap is hinged to the inside of the front rail and covers the upper center compartment. The flap is composed of four boards fitted between the top and bottom frame members with tongue-and-groove joints. A horse hinged to the underside of the writing surface fits into ratchetted strips glued to the compartment's side panels. A rectangular block is glued in the compartment's left rear corner.

The bottom of the upper center compartment is fitted into a groove in the right cheek and supported on the left by a second cheek panel. This second side panel creates the channel into which the tambour door covering the lower compartment slides when it is opened. The front and back of the drawer in this compartment are dovetailed to the sides. The bottom is nailed to the back and fitted into grooves on the sides and a rabbet on the lower edge of the front. The drawer is supported by side runners fitted into grooves in the cheeks.

Inscription: "C.1313 -" is written in pencil on the inside bottom of the upper center compartment.

Condition: The bottom board cracked in half and was repaired with a filler strip. The base has been reattached to the case, and the original screw holes have been plugged. Wedges have been added to reinforce the tenons of the two rear corner blocks. The knob on the tambour door is a later addition, and the reeding around it has been patched. Two reeds on the back side have been replaced. The reeding on the left front leg has been patched. The knobs and casters appear to be old but are not original to the table. The leather covering and tab on the writing flap have been replaced. The horse has been repaired with new

pieces of wood and rehinged to the flap. There probably was a second drawer in the case, which is now lost.

References: Cornelius 1922, pl. 33; Nutting 1928, I, no. 1180.

Provenance: Garvan purchased this table from Charles Woolsey Lyon.

This "astragal end work table" is a superlative example of a form popular in New York City during the first quarter of the nineteenth century. The shape, which was named for its projecting, semicircular ends, appears to have been an innovation of cabinetmakers working in the mid-Atlantic states. As Charles Montgomery noted, the shape was not described in contemporary London price books.[1] It first appeared in New York and Philadelphia after 1805; an early documented example is a Philadelphia work table dated 1808 (cat. 162). The form was described in the 1810–11 price books published in New York and Philadelphia and continued to be included in price lists for the next two decades.[2]

Many New York work tables of this type have been published; documented examples were made in 1813 for Victorine du Pont of Delaware at the time of her marriage to Ferdinand Bauduy and in 1816 by Duncan Phyfe of New York for H.G. Clopper of New Brunswick, Nova Scotia.[3] The Art Gallery's work table is one of the most distinguished examples in this group. Its semicircular rails and their removable "lifts" are made of vertically laminated wood, a technique used only in New York City.[4] Its monochromatic surface is subtly ornamented with carving, reeding, and an interplay of different veneers. The case's function is underscored by its hinged top, which evokes the chest or box traditionally used for storing textiles and needlework, and its reeded sides, which are a stylized representation of pleated fabric used on other tables (cats. 153, 162). To counteract the case's solid, horizontal mass, the sweeping, vertical lines of the claws were accentuated by being raised off the floor on turned feet, ornamented with reeding, and topped with a truncated urn.

An analysis of this table using the 1810 New York price book underscores its exceptional character. The base price of an astragal end work table was £1.15.0, three times the cost of a square work table. The Art Gallery's table was loaded with almost every extra feature listed in the price book: a hinged top with a lock, a drawer concealed by a tambour door, a writing flap with a horse support, and two "lifts" or removable trays with interior partitions and a "hollow for pins or pens . . . [made] to tilt." The decision not to use any secondary woods must have represented additional cost. Despite its monochromatic surface, this table was lavishly ornamented, with banding on the top and frame, satinwood panels framed by crossbanding on the corner

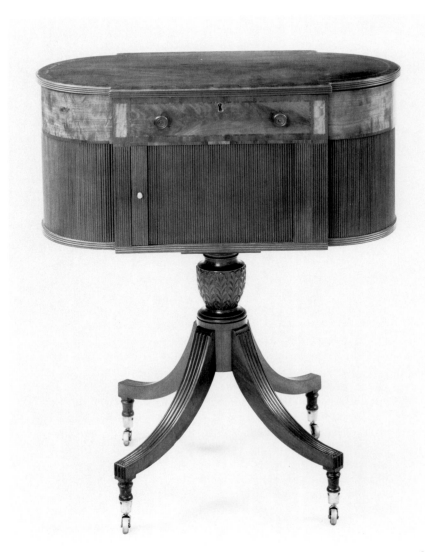 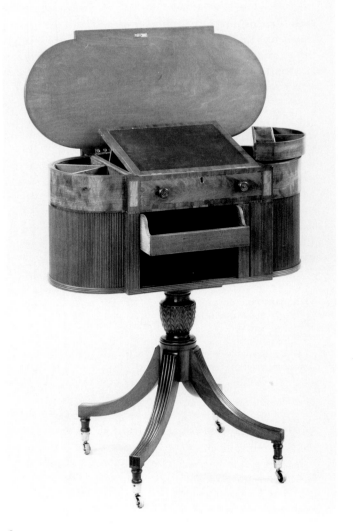

160 160

posts, reeded edges on the top and bottom of the case, and a carved and reeded pillar-and-claw base. The most expensive extra, "inclosing with reeds," cost an additional £1.4.0, almost as much as the base price for the form. Exclusive of the carving, these ornamental and structural features cost approximately £5.15.7, raising the object's price to £7.10.7, the same as that of a secretary or wardrobe.[5]

1. Montgomery 1966, p. 415.
2. *New York Prices* 1810, p. 30; 1817, p. 55; 1834, pp. 89–90; *Philadelphia Prices* 1811, pp. 65–66.
3. Quimby 1973, p. 555; McClelland 1939, pl. 256. Undocumented examples are reproduced in McClelland 1939, pl. 90; Hipkiss 1941, no. 71; Montgomery 1966, no. 421.
4. Hewitt/Kane/Ward 1982, p. 89; see also cat. 108.
5. *New York Prices* 1810, pp. 15–16, 19, 30, 62, 64, 69, 71.

161

WORK TABLE

New York City, 1810–25

Mahogany (including corner posts, drawer fronts, partitions in upper compartments, sides of writing surface frame), mahogany veneer; eastern white pine (sides and back of frame, lateral brace, underside of writing surface), yellow-poplar (inner side panels, drawer interiors and runners, bottom of upper compartments)

77 x 56 x 37.8 (30 3/4 x 22 x 14 7/8)

The Mabel Brady Garvan Collection, 1930.2067

Structure: The top is veneered on its upper and lower surfaces, and half-round moldings are nailed to its outside edges. The top is hinged to the back frame rail. The exterior of the case is veneered. Square moldings are applied around all four sides of the canted corners and flanking the sides of the case. A bead molding is nailed to the underside of the case. The frame is built around four corners that are trapezoidal in section. The method by which the side and back panels are joined to the corners is not visible. Reinforcing strips have been glued into the joints between the sides and the corners. The front rails are tenoned into the corners. Two inner panels are nailed to rabbets cut into the corners. The case is supported by a lateral brace fitted into cutouts in the outer and inner side panels; it is screwed to the outer side panels and was nailed to the inner ones. The pedestal is double tenoned into this brace. The legs are blind-dovetailed into the pedestal.

Beneath the top the interior is divided into three compartments by thin strips of wood fitted between the front and back frame rails. The tops of these strips have bead moldings, and the upper edges of the case are veneered. The rectangular center compartment is covered by a writing flap hinged to the front rail. The writing surface is covered with baize and the outside edges are veneered. It is composed of a board fitted between two side strips with tongue-and-groove joints. Supports for the flap are screwed to the compartment sides. The trapezoidal side compartments are fitted with interior partitions. The right compartment has a removable pen tray. The bottom for these three upper compartments is a single board supported by the inner panels and fitted into the sides and back of the case.

The two drawers have veneered fronts. The fronts and backs are dovetailed to the sides. The bottoms are nailed to the back and have feathered edges fitted into grooves in the front and sides. The interior of the upper drawer is partitioned into eight compartments of varying sizes. The drawers are supported by side runners nailed to the inner panels; small rectangular stops are glued to the back panel.

Inscription: "Front" is incised on the underside of the compartments' bottom.

Condition: There are large shrinkage cracks on the top and sides. Sections of the molding on the outside edge of the top are replacements. The right rear corner of the bead molding on the lower edge of the case is restored. Two of the partitions in the left interior compartment are lost. The lateral brace supporting the case cracked in half and has been reattached. Both front legs broke off the pedestal and have been reattached with metal braces. The baize, brass knobs, and locks are replacements. The casters are original.

References: *YUAGB* 4 (December 1930), p. 106; Rogers 1931, p. 55.

Provenance: This table was owned by the collectors Harry H. and Bertha Benkard of New York City. Bertha Benkard had inherited some Neoclassical New York furniture from her forebears. Garvan purchased the table at an auction of objects consigned by Mrs. Benkard on April 20, 1929 (*Benkard* 1929, no. 87).

Less opulent and expensive than the preceding form (cat. 160), the base price for a "canted corner work table" in the 1817 price book was 16s. less than that for an astragal end table. The maker of this table dispensed with such extras as exotic veneers and a door covering the drawers, using instead recessed or "sunk" panels on the corners and reeding on the pillar and claws as the principal ornamental features. Based on the listing in the 1817 price book, this table's total cost would have been approximately £4.15.8, considerably less than cat. 160 and about the same as a veneered pillar-and-claw card table (cats. 113–115).[1]

Many work tables with canted corners were made in New England (cats. 150, 152, 153); the shape apparently enjoyed less popularity in New York. It was listed in the 1796 New York price

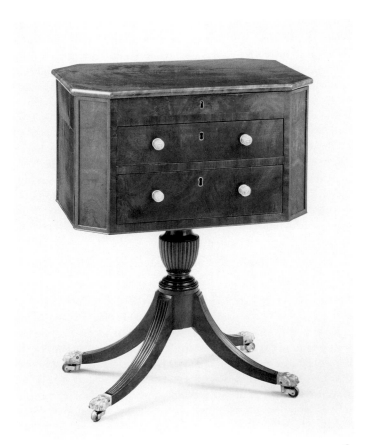

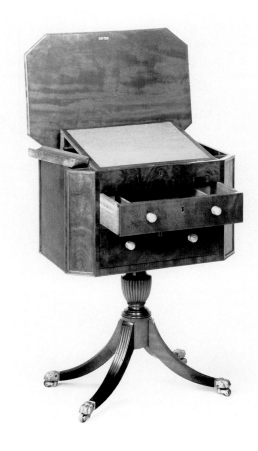

161 161

book and omitted from the 1802 and 1810 editions.[2] Surviving examples of the form made in New York, including the Art Gallery's table, appear to date after 1810. The pillar-and-claw bases used on most examples became popular during this decade (see cat. 69). One or possibly two work tables of this type were made by Joel Curtis of New York between 1821 and 1823.[3] A more elaborate canted corner work table made by Duncan Phyfe between 1811 and 1816 has a marble top, brass banding, tapered sides, and a base with four pillars mounted on a block.[4]

1. *New York Prices* 1817, pp. 19, 53–55, 120, 137, 140.
2. *New York Prices* 1796, p. 62.
3. McClelland 1939, pl. 183; Tracy 1981, no. 73. Although Tracy claimed that the Boscobel table was also the example illustrated in McClelland, the latter appears to have an uncarved pillar and different veneers.
4. Montgomery 1966, no. 409.

162

WORK TABLE *Color plate 12*

Robert McGuffin (active c. 1806–11)

Retailed by Henry Connelly (1770–1826)

Philadelphia, 1808

Satinwood with satinwood, rosewood, and ebony veneers; eastern white pine (top, drawer bottoms), mahogany (shelf supports, drawer fronts, sides, backs, and knobs), yellow-poplar (frame rails)

73.1 x 66.5 x 33.1 (28 3/4 x 26 1/8 x 13)

The Mabel Brady Garvan Collection, 1936.306

Structure: The veneered top is made of a rectangular center board with semicircular ends butted to its sides. The veneered frame rails are made of three horizontal laminates and are screwed to the legs. The upper surfaces of the frame rails are also veneered. The lower shelf is supported by rails tenoned

between the front and back legs. The fabric sides are tacked to a rabbet along the lower edge of the frame rails and over the lower shelf. Fabric-covered sheets of paperboard separate the inner and outer layers of fabric. The dividers for the side compartments are fitted between the front and back frame rails.

Small drawers beneath the side compartments are suspended on two L-shaped supports nailed to the compartments' bottoms. The sides of each drawer have an applied overhanging lip that fits into these supports. The drawer front and back are dovetailed to the sides, and the bottom is glued into rabbets in the front and sides and nailed to the front and back.

Inscription: "Made by / Robert McGuffin / 1808 / 72 4th Street / Philad" is written in ink on the underside of the left side compartment.

Condition: Edward Hoepfner made some minor repairs to the stringing and veneer in 1953. The lock and hasp are replacements. The underside of the top almost certainly was covered with fabric although no trace of it remains. The watered blue silk glued in the side compartments and the bottom of the large compartment is probably original. The sides of the large compartment are lined with a later nineteenth-century blue cotton. The exterior covering was created by Joseph LiVolsi in 1953, following a design in plate 26 of the 1793 *Appendix* to Thomas Sheraton's *Drawing-Book.* Although based on a contemporary English design for an equally sophisticated work table, LiVolsi's restoration may be less appropriate than a covering of narrowly pleated fabric sides without swags. Closely spaced, sharp-edged pleats were characteristic of contemporary work table bags and frequently were simulated by the reeded sides on tables of the same shape (cat. 160). The green color chosen in 1953 also seems inappropriate, since the original exterior fabric probably matched that of the interior. Fragments of what appears to be the original blue silk cover survive on the related work table at Winterthur (Montgomery 1966, no. 426).

Exhibition: Carson 1953a, no. 45.

Provenance: This table was made for Susan Theresa Pratt (d. 1822) of Philadelphia, who married Charles Frederick Mayer of Baltimore in 1819. The table descended to her only surviving child, Henry Christian Mayer (1821–1846) of Rochester, New York; to his son, Henry Christian Mayer (b. 1844) of Philadelphia; to his daughter, Christine Stevens Mayer Polk (b. 1870) of Germantown, Pennsylvania (Mayer 1878, p. 51; Christine S. Polk, memorandum, January 22, 1936, accession file 1957.914, The Henry Francis du Pont Winterthur Museum). Joe Kindig, Jr., acquired the table from Polk in January 1936 and sold it to Garvan on May 5, 1936 (Kindig to Garvan, January 30, 1936, and May 5, 1936, Kindig file, FPG–AAA. Records

in the Winterthur archives reveal that Kindig offered the table simultaneously to Henry Francis du Pont and Francis Garvan, sending a photograph and Polk's memorandum to du Pont while shipping the table to Garvan. At some later time, the memorandum was mistakenly associated with the similar table du Pont acquired from Ella Parsons' collection [Montgomery 1966, no. 426], perhaps because that table was also offered by Kindig).

Made of satinwood imported from Ceylon or India and covered with silk, this work table is an extraordinarily sumptuous statement of the Neoclassical style. Such opulence was characteristic of Henry Pratt (1761–1838), who probably commissioned the table for his daughter. Son of the painter Matthew Pratt and grandson of the goldsmith Henry Pratt, the younger Henry became an extremely wealthy merchant. At his country house, Lemon Hill, Pratt created elaborate gardens that became a famous attraction for visitors to Philadelphia and were described in 1829 as a "grand pleasure grove."[1] The house itself is one of the finest Neoclassical houses in America, and the same quality is apparent in the work table. The legs have sculptured surfaces and dark inlays that contrast with the smooth planes of veneer above them. The rails and top are shaped into exaggerated curves accented by delicate stringing and banding, particularly the hollow-corner rectangles evoking the table's hollow front. The table's considerable mass is visually reduced by the fabric-covered sides, which originally may have been pleated to echo the reeding on the legs (see *Condition*).

Further evidence of the table's exceptional character is provided by a comparison with the much more modest "astragal end work table" listed in the 1811 Philadelphia price book. Susan Pratt's table is 4 in. (10.2 cm) wider and 1 in. (2.5 cm) deeper than the basic model and had such additional refinements as a "sweeped shelf with two lower rails to support ditto" and two interior drawers and compartments. These extras added $3.14 to the base price of $4.[2] The veneer, inlay, carving, upholstery, and use of satinwood probably raised the cost of this table to about $15, equal to a desk or double chest of drawers.

The recently discovered inscription on this work table documents it to the shop of Henry Connelly, one of the leading Philadelphia cabinetmakers during the first quarter of the nineteenth century, and its provenance adds another wealthy family to his roster of clients.[3] Robert McGuffin apparently was a journeyman in Connelly's shop, which had moved to 72 South 4th Street in 1808, the year this table was made. The Philadelphia tax assessment ledgers for 1808 and 1809 listed McGuffin together with Connelly and two other cabinet makers.[4] McGuffin had worked for Connelly since at least 1806, when he signed and dated a sideboard labeled by Connelly that was pur-

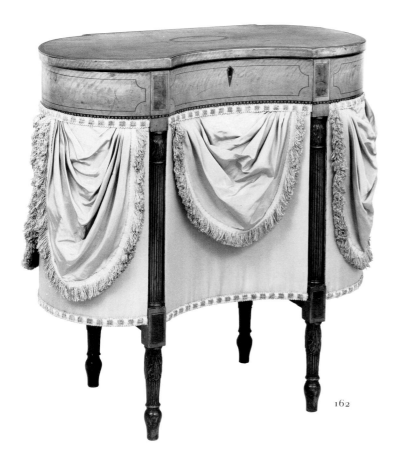

162

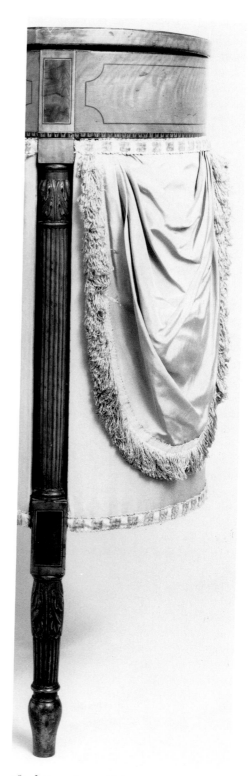

162 *Interior*

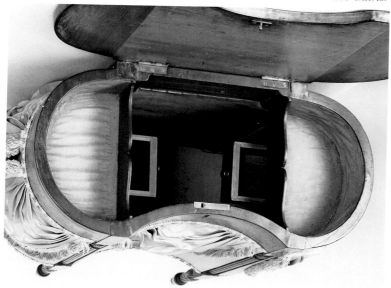

162 *Leg carving and inlay*

162 Inscription

chased by Henry Hollingsworth of Philadelphia.[5] It may have been customary for journeymen in Connelly's shop to sign their work. A secretary bookcase inscribed "Made . . . for Henry Connelly" is signed in three places by Daniel Monroe, with different dates in 1808 and 1809.[6] The obscure location of the workmen's signatures, however, suggests that they were added without the proprietor's or purchaser's knowledge. In 1811 McGuffin appeared in the city directory as a partner in McGuffin and Anderson, cabinetmakers, at 12 South 5th Street; the tax ledgers of the same year grouped McGuffin with the cabinetmakers Samuel Anderson, Jacob Eglee, and William Morrison.[7]

This work table is closely related to three other tables made of satinwood with hollow fronts and semicircular ends: a work table at Winterthur, and two card tables in private collections.[8] The card tables have square legs but in both construction and ornamentation are closely related to the Winterthur work table. All three have rails composed of four horizontal laminates, rectangular panels created by rosewood crossbanding on the rails, pointed oval inlays on the pilasters, and inlaid paterae designs on the top. In contrast, the Art Gallery's table has rails with three laminates, hollow-corner panels created by stringing on the rails, rectangle inlays on the pilasters, and a crossbanded edge and inlaid oval on the top.

Although McGuffin's inscription establishes the Art Gallery's table as the product of Connelly's shop, it raises a number of questions concerning the roles he and Connelly played in its production. The pattern used for the carved and fluted legs on both the Yale and Winterthur work tables is identical to that on the ebony seating furniture made under Ephraim Haines' direction for Stephen Girard in 1806–07, with Barney Schumo as the turner and John R. Morris as the carver.[9] If Schumo and Morris worked independently, as seems likely given their separate charges in Haines' accounts, they probably produced identical turnings and carving for many cabinetmakers, including Connelly. The carving on the Art Gallery's table is loose and naturalistic, clearly by a different hand than the stylized foliage found on the Winterthur table or the Girard furniture. It is possible that McGuffin executed the carving on the table he signed, although more likely he was responsible for the cabinetwork, veneer, and assembly, using legs made by specialists. The differences noted above in the construction of Yale's and Winterthur's work tables suggest that McGuffin did not make the other tables, and the use of the same design by at least two different craftsmen may indicate that it was a shop design, perhaps created by Connelly himself. Two closely related card tables made in Salem, Massachusetts, exhibit the same reliance on an identical design by two different craftsmen (cats. 91, 92).

1. Philadelphia 1976, pp. 185–86.
2. *Philadelphia Prices* 1811, pp. 10, 65–66.
3. Philadelphia 1976, pp. 211–12.
4. Ducoff-Barone 1991, pp. 988, 991.
5. Carson 1953a, no. 1. The inscription, which had not been discovered at the time of the 1953 exhibition, is on the underside of a drawer: "Robert McGuffin / Maker / 1806."
6. *Antiques* 117 (March 1980), p. 493. The inscriptions, as recorded in DAPC 81.1400, are "September the . . . 1809 / Henry Connelly No. 72 South fourth Street" (on the bottom board of the lower center cabinet), "Made January the 10 1808 / for Henry Connelly, Daniel Monroe" (inside the secretary drawer), "Made April 6 / by Daniel Monroe / 1089 [*sic*]" (on a drawer bottom), "Henry Con . . . Monr . . ." (support for top of lower case). No listing for a cabinetmaker named Daniel Monroe has been found in Philadelphia directories.
7. *Philadelphia Directory* 1811, p. 207; Ducoff-Barone 1991, pp. 986, 989, 991–92. I am grateful to Beatrice B. Garvan for sharing the results of her attempts to track McGuffin in a variety of sources. No birth, marriage, or death records have been found for him; he apparently did not ever own property in Philadelphia and is not on any surviving passenger lists for ships arriving in Philadelphia between 1800 and 1806. No record of anyone by this name has been found in southern or midwestern states.
8. Montgomery 1966, no. 426; Flanigan 1986, no. 63. The second card table has not been published.
9. Carson 1953b, p. 345.

Looking Glasses

Looking glasses present many special challenges to scholars and collectors of American furniture. Although they have been important components of American homes from the seventeenth century onward, it was not until the early nineteenth century that significant numbers were made in this country. Eighteenth-century looking glasses made abroad traditionally have been included in collections of American furniture that otherwise excluded European-made objects, and the English and European looking glasses at Yale are included in this catalogue as a continuation of that tradition.

In the eighteenth and early nineteenth centuries, the stylistic development of looking glasses followed a different chronology from that of most other furniture forms, being more closely related to changes in architecture and interior woodwork. Specific types of frames continued to be made long after their inception, albeit with modifications to suit changes in style. This practice created a greater diversity of contemporaneous looking-glass types than that for other furniture: for example, frames as varied as cats. 170, 180, and 182 were all made in the first two decades of the nineteenth century. The Art Gallery's collection has been classified according to these different formal types and includes most of the styles popular in America between about 1720 and 1850. There are, however, no glass, entirely gilt, or complete japanned frames in either the early Georgian or Rococo styles. Apart from Colonial Revival examples, there are only five looking glasses to illustrate the plethora of styles after 1850 (cats. 15, 202, 203, 209, 210). Two of the most important forms from the eighteenth and nineteenth centuries, sconce glasses and mantel glasses, are not represented, nor are there any frames dating earlier than the second quarter of the eighteenth century.

Terminology

During the eighteenth and early nineteenth centuries, the term "looking glass," or simply "glass," was the common name for the objects known since about 1860 as "mirrors." "Looking glass" was used 153 times in 109 probate inventories from rural Suffolk County, Massachusetts, between 1675 and 1775, whereas "mirror" did not appear at all.[1] Both terms had been in use since the sixteenth century, however, and Samuel Johnson considered them synonymous in his 1755 Dictionary of the English Language.[2] During the early nineteenth century, "mirror" was sometimes used to distinguish convex or concave reflective glass (cat. 181) from ordinary looking glasses, as in

Paul Mondelly's advertisement in an 1810 Boston newspaper for "Superb Convex Mirrors; [and] Looking Glass Plates."[3] Thomas Sheraton defined "mirror" in his Cabinet Dictionary of 1803 as "a circular convex glass in a gilt frame," although he also noted that "all polished bodies which are impervious, or which repel or reflect light, may be called mirrors."[4] In eighteenth-century sources, "mirror" occasionally was used in the latter sense, as an alternative to "looking glass." In 1756 Lewis Evans of Philadelphia gave his daughter "a Concave Mirror"; six years later, William Ince and John Mayhew published designs in London for "Convex or Concave Glasses."[5] A 1797 inventory of George Washington's furniture mentioned "2 Brackets & oval Mirrors," which probably were flat plates of glass.[6]

Connoisseurship

It is difficult to establish the national origin of most eighteenth-century looking glasses in American museum collections. Documentary evidence indicates that the majority of looking glasses owned by eighteenth-century Americans were imported, primarily from England. The enormous quantities of looking glasses shipped to America can be determined from R.W. Symonds' research in the Public Record Office in London, where he found specific valuations for each year's exports between 1697 to 1780. Between 1697 and 1704, £1,582 worth of looking glasses were exported to the American Colonies, £3,969 between 1720 and 1728, and £1,402 between 1740 and 1747. The value of exported looking glasses in these years was considerably higher than that of other furniture forms, although much lower than that for pewter, tinware, and textiles.[7] The evidence for the large-scale importation of English looking glasses during the Colonial period is confirmed by the advertisements and shop records of Americans who sold them. Merchants repeatedly advertised English frames: Sidney Breese of New York City announced "just imported from London . . . Looking Glasses, framed in the Newest Taste" in 1761, and "Sconce and Pier Looking Glasses" were among the goods "Imported from London" by Ziphion Thayer of Boston between about 1765 and 1777.[8] Between 1719 and 1722, the silversmith Francis Richardson of Philadelphia bought forty-two looking glasses in London for resale in America.[9] Even craftsmen who made looking glasses, such as James Foddy of New York and James Reynolds of Philadelphia, sold imported frames together with their own.[10] Independence from England apparently did little to slacken the pace of importation. Families such as the Derbys of Salem, Massachusetts, renowned for their patronage of American craftsmen, acquired looking glasses directly from

Looking Glasses

London.[11] Between 1825 and 1837, Isaac L. Platt of New York City called himself a "Looking-Glass Manufacturer and IMPORTER."[12]

A number of factors explain this large-scale importation. Imported goods undoubtedly were considered more stylish. Large English shops were able to undersell American craftsmen because of the scale and specialization of their craft. Nor did shipping present a great problem: in March 1718, James Logan of Philadelphia requested "A handsome black looking glass for a Parlor" from England and received it in October of the same year.[13] The American craftsman's frustration with English domination of the market is suggested by the statement made in 1773 by Martin Jugiez of Philadelphia, who claimed that he could make "frames of any kind, to come nearly as cheap as can be imported."[14]

The most significant reason for the importation of looking glasses during the Colonial period was the inability of American glassmakers to produce glass plates of sufficient smoothness and clarity for silvering. The process was complicated and required skilled workmen for each stage: creating the plate by blowing or casting, followed by polishing, silvering, and "diamond cutting," or beveling. From the surviving documentary evidence, it is difficult to separate the quantities of framed and unframed plates imported during the Colonial period. Unframed plates were rarely mentioned in Colonial newspapers, and the numerous notices to buy old or broken plates suggest that they were in short supply.[15] After the War of Independence, in contrast, immense numbers of unframed plates were imported and advertised. Henry Bradshaw Fearon reported on a visit to New York City in 1817, "Plate-glass is imported from France, Holland, and England, the latter bearing the highest price."[16] Spencer and Gilman of Hartford, Connecticut, announced in 1818 that they "have lately received, 30 Cases English Looking Glass plates, of all sizes."[17] Americans remained dependent on European glass plates well into the nineteenth century. One of the leading American looking-glass makers and importers of glass plates, John Doggett of Roxbury, Massachusetts, wrote to Senator James Lloyd of Massachusetts in 1826 urging a reduction in the duty on imported, unsilvered plates, as it would "give some encouragement for Silvering here, and would not interfere with any Manufactory as there is none in the Country." Doggett purchased plates from Manchester, Paris, and Bremen, and sold them to fellow craftsmen, includ-

ing James Todd of Portland, Maine, and Isaac L. Platt and Elias Thomas of New York City.[18] As late as 1872, it was reported in *The Great Industries of the United States* that, "The making of mirrors . . . [is] not yet carried on in this country, and we have to depend still upon Europe for the supply of many articles of glassware to meet the demands of artistic cultivation."[19]

Microanalysis of the woods used in looking glasses yields little conclusive evidence that a frame is European or American. The most frequently used woods in the Art Gallery's Colonial-period looking glasses are spruce (*Picea* spp.), whose American and European species cannot be distinguished, and pines of the sylvestris group (including *Pinus sylvestris* and *Pinus resinosa*), whose American and European species can be separated only with difficulty.[20] These woods were very rarely employed by American furniture makers (see cats. 101, 103), nor were they used in any of the labeled American looking glasses in the Art Gallery's collection. Native spruce was advertised for sale in Boston during the early nineteenth century as a building material.[21]

Combinations of woods on looking glasses in the Art Gallery's collection raise a number of different possibilities as to their origin. Eastern white pine (*Pinus strobus*, the only white pine species likely to have been used on Yale's looking glasses) and yellow-poplar (*Liriodendron tulipifera*) are easily identified North American woods that were used for the carved elements of labeled English looking glasses of spruce and sylvestris pine (cats. 172, 181). A pair of looking glasses at Winterthur has a similar combination of spruce frames with carved elements made of eastern white pine.[22] These examples suggest either that the frames were made in America of native spruce, or that European-made spruce frames were imported with the glass and ornamented after their arrival, or that English craftsmen preferred to use American softwoods for carved work when they were available. American woods were exported to England and other European countries in the eighteenth century, so their presence on a looking glass offers no guarantee of an American origin. A 1721 Act of Parliament permitted the importation of timber from the Colonies without duty, as a means of encouraging British cabinetmakers to use "mahogany and various sorts of American wood ∴ . . to the improvement of the manufactures."[23] American lumber merchants frequently promoted their wood as "fit for the European market," and one New York City merchant observed in 1785 that "the encouragement given

by British [sic] to import lumber of all kinds from America is much greater than from any other country."[24] Eastern white pine is by far the most common wood used in Yale's post-Revolutionary period looking glasses, but this fact can be interpreted as representing either an increase in American production or an increase in exports of the wood to Europe. A looking glass (cat. 184) that resembles documented examples made in the Boston area has three frame members of sylvestris pine and the fourth of eastern white pine; it may have been made in America of native woods or it may have been made in England with an imported wood.

This quandary is complicated further by the possibility that ornaments made from European woods were imported by American craftsmen. The crest ornament on a frame of eastern white pine labeled by James Todd of Portland, Maine, is made of alder (Alnus spp.), almost certainly one of the European species.[25] Todd may have purchased an imported, ready-made ornament, or simply imported the entire frame. Gilded alder ornaments also appear on a cellarette made in New York City.[26] Microanalysis of a significant group of documented English looking glasses must be completed before more definitive conclusions concerning woods can be drawn.

The quality of a looking glass and the techniques used in its manufacture also offer few clues as to national origin. Looking glasses made of native woods by the Philadelphia carver James Reynolds for the Cadwalader, Chew, and Fischer families are the equal of contemporary English products of similar scale.[27] Most looking-glass frames used in America could have been made by any skilled local woodworker. As early as 1712, the joiner William Branson of Philadelphia made "fframes [sic] for 5 Prints," which at that date would have been similar to most looking-glass frames.[28] Edward Weyman of Charleston, South Carolina, advertised in 1766 that he performed "grinding, polishing, Diamond cutting [beveling], SILVERING and FRAMING . . . to as great Perfection as in Europe."[29] This may not have been an exaggeration, since the quality of looking glasses imported from England occasionally disappointed American customers. George Washington expressed the frustration of many Americans when he wrote to his factor in London:

Instead of getting things good and fashionable in their several kin[d]s we often have Articles sent Us that coud only have been usd by our Forefathers in the days of yore—'Tis a custom, I have some Reason to believe, with many Shop keepers, and Tradesmen in London when they know Goods are bespoke for Exportation to palm sometimes old, and sometimes very slight and indifferent Goods upon Us.[30]

A retailer of imported looking glasses, John Elliott, Sr., of Philadelphia, felt it necessary to note in an advertisement of 1765 that he had "the greatest Choice in Town, and so good in Quality as

can be imported."[31] As a challenge to the imported looking glasses that were often sold at vendue sales when they arrived in a port, Edward Lothrop, a looking-glass maker in Boston, announced that his "Elegant, Burnished Gilt Looking-Glasses . . . will be found vastly superior to those that are urged upon the Public every day at Auction and by others not acquainted with the trade."[32] Some people, however, insisted that imported frames were superior to native products—during a visit to New York in 1817, the Englishman Henry Fearon observed, "Glass-mirrors and picture-frames are executed with taste and elegance; but still the most superior are imported from England."[33]

The problem of distinguishing between English- and American-made looking glasses is compounded by the difficulty in identifying with certainty any styles or types of frames that are specifically American. It seems reasonable to assume that the same regional preferences and styles that affected other American furniture forms would also extend to looking glasses, and some regional types do seem to have appeared after 1800 (see cats. 170, 171, 175, and p. 325). The task of sorting out these types is complicated by the extensive trade in looking glasses among the American centers of manufacture. D. Williford of Savannah, Georgia, advertised in 1819 "an invoice of well made N.Y. Furniture, consisting of . . . Looking Glasses of Various descriptions."[34] In 1809, Caleb Greene of Newport, Rhode Island, asked Daniel Lamson of Hartford, Connecticut, "whether it would not be best to select 1 or 2000 dollars worth of your most unsaleable goods and take them to New York and sell them at auction or otherwise. . . . Looking glasses will sell best in New York."[35] In the early 1800s, John Doggett shipped looking glasses on consignment to merchants in Portland, Maine, Portsmouth, New Hampshire, Hartford, Connecticut, Troy, New York, New Orleans, and Montreal; he also sold frame components to other Boston-area craftsmen, including Paul Cermenati (cats. 182, 183), William Leverett (cat. 95), Stillman Lothrop (cat. 186), James M'Gibbon, and Charles and Spencer Nolen, as well as Peter Grinnell and Son of Providence, Rhode Island.[36]

The looking-glass trade in this country was dominated by a few cities on the Eastern seaboard, where framed and unframed glass plates were imported from abroad. A survey of 140 looking-glass makers working before 1860 revealed that eighty-nine, or approximately two-thirds, worked in Boston, New York City, or Philadelphia.[37] Half the remaining makers were based in other coastal cities. Makers or retailers working elsewhere were dependent on these Eastern establishments for both the imported glass plates and apparently for the styles demanded by their customers. William Jones of Cincinnati announced in 1816 that he was "now prepared to frame Look-

ing Glasses . . . after the latest Philadelphia and Baltimore patterns."[38] The large urban shops could clearly control the type of goods they sent out: Edward Lothrop advertised both "Elegant, Burnished GILT LOOKING-GLASSES" and "ALSO . . . low-priced Gilt & Mahogany-framed GLASSES, Well-suited to the Country Market."[39] Some of the larger firms marketed their products through agents in smaller, inland towns, such as Bray and Bailey of St. Louis, who sold looking glasses made by W. Neal of Philadelphia.[40]

Assessing the quality and condition of a given looking glass raises as many problems as does the question of national origin. A number of factors peculiar to the manufacture of looking glasses make the degree of acceptable repair and inconsistency of fabrication much higher than on other furniture. It is often very difficult to determine whether parts of a frame are original. Little of the ornament applied to these frames was an inherent part of their structure or design. The more elaborate looking glasses were often a basic frame with added decoration. The ornamentation of looking glasses was in fact an additive process, as described in a 1770 bill of sale for a "Walnut framed Looking Glass . . . Ornamented with Side peices [sic] and Bird on the top."[41] Because the ornament is not an intrinsic part of the frame, it is frequently impossible to be certain whether it was made by the maker or retailer, or ordered by a later owner to enhance a plain object.

Determining the integrity of the ornamentation is also complicated by the fact that all but the most expensive frames were produced from component parts. Many looking-glass makers acquired these components from carvers, inlay makers, glass painters, or other specialists. One such specialist, John M'Elwee of Philadelphia, advertised in 1789 "a quantity of elegantly gilt, black and gilt, and white, carved and plain mouldings, of different sizes, for looking-glass and picture frames" and in 1800 "a Quantity of Composition Ornaments, and Moulds of every pattern necessary for the Looking Glass business."[42] As noted above, large looking-glass manufactories, such as John Doggett's, not only employed their own specialists to produce these parts but also sold them to other makers. Any inconsistency among the parts of a given frame, therefore, may simply indicate that they were obtained from different sources.

The question of the integrity of parts is made even more difficult by the fact that looking glasses were constantly repaired during the eighteenth and nineteenth centuries. Almost every English and American looking-glass maker advertised that he repaired old frames in addition to making new frames for existing glass, resilvering glass, and even taking old looking glasses in exchange for new ones. Makers and owners went to great lengths to conserve glass plates because they accounted for as much as two-thirds of the object's total cost. In the 1822 inven-

tory of the shop of George Smith of Baltimore, forty-two empty mahogany frames were valued at $9, whereas forty-four unframed glass plates received the valuation of $22.[43] As noted above, the glass plates were costly not only because they were made by difficult, labor-intensive processes, but also because they had to be imported. Most frames of the period covered by the Art Gallery's collection tended to be rather slight in relation to the size of the glass they were intended to protect, and some looking-glass makers seem to have devoted the largest part of their time to repairs.[44] In 1771, Charles Carroll of Carrollton, Maryland, complained to his English agent about the fragility of looking glasses, ordering him to obtain frames "of a solid kind, it has been found by experience that slight carving will neither endure the extremes of heat and cold nor the rough treatment of negro servants."[45] Reattached or remade ornament could represent a repair made during the lifetime of the original owner or retailer or at a later date.

It is, in sum, difficult to assess looking glasses using the criteria developed for other furniture forms. The frames' fragility and the additive character of their ornament suggests that a far greater degree of replacements and restorations must be considered acceptable than would be for other objects. More important, the problems in ascertaining national or regional origin suggest that in the case of looking glasses such questions should become secondary. A label or history of ownership cannot determine with certainty whether the object was made locally, by another American maker, or abroad. But labels and provenances do record the presence of specific looking glasses in specific places at specific times, thereby making them important documents in the history of American taste.

1. The inventories are those published in Cummings 1964.
2. Johnson 1755, s.v. "looking-glass," "mirror"; see also *Oxford English Dictionary*, ed. 1989, s.v. "looking-glass" and "mirror."
3. *Columbian Centinel*, July 18, 1810, p. 1.
4. Sheraton 1803, p. 271.
5. Hornor 1935a, p. 280; Ince/Mayhew 1762, pl. 77.
6. Fede 1966, p. 46.
7. Symonds 1935, p. 156.
8. Gottesman 1938, p. 133; Thayer's trade card is illustrated in Whitehill/Fairbanks/Jobe 1974, fig. 174.
9. Fales 1974, pp. 17, 274.
10. *New-York Gazette*, October 6–13, 1729, p. 3; *Pennsylvania Chronicle*, November 28–December 5, 1768, p. 396; Philadelphia 1976, p. 120.
11. Clunie/Farnam/Trent 1980, p. 35.
12. *Antiques* 92 (November 1967), p. 633.
13. McElroy 1970, pp. 32–33.
14. *Supplement to the Pennsylvania Gazette*, March 24, 1773, p. 5.
15. Advertisement of Stephen Whiting, Sr., *The Boston Weekly News-Letter*, September 29, 1748, p. 2; advertisement of Minshull's Looking Glass Store, *New-York Journal*, March 16, 1775, p. 3.
16. Fearon 1818, p. 30.
17. *Connecticut Courant*, April 28, 1818, p. 3.

18. Doggett Letterbook, pp. 6, 25, 29, 36, 37, 40, 135.

19. *Great Industries* 1872, p. 897.

20. R. Bruce Hoadley at the University of Massachusetts, Amherst, recently has devised a means of separating the American and European species of sylvestris pine, based on the measurement of ray heights in microscopic samples. Although the presence of rays of a certain length is conclusive, their absence may only characterize the specific samples taken. To be accurate, this method requires taking numerous samples and averaging measurements.

21. *Columbian Centinel and Massachusetts Federalist*, May 9, 1804, p. 3; *Columbian Centinel*, June 1, 1811, p. 4.

22. Downs 1952, no. 258.

23. Joy 1965, pp. 2–3.

24. Advertisement for Abiel Wood and Company, *New-York Gazette and Weekly Mercury*, April 8, 1771, p. 4 (see also the advertisement for Joel Davis, in Gottesman 1965, p. 198); Gottesman 1954, p. 197.

25. Montgomery 1966, no. 230.

26. Ward 1988, no. 229.

27. Beckerdite 1984, frontispiece, figs. 8, 9, 10.

28. Hornor 1935a, p. 272.

29. *South Carolina Gazette and Country Journal*, December 2, 1766, p. 2.

30. George Washington to Robert Cary Esq. and Company, September 1760, Washington Papers, Library of Congress, Washington, D.C.

31. *Pennsylvania Gazette*, May 9, 1765, p. 3.

32. Comstock 1968, p. 120.

33. Fearon 1818, pp. 29–30.

34. Theus 1967, pp. 90–91.

35. Ott 1969, p. 15.

36. Doggett Daybook, pp. 70, 71, 95, 98, 107, 122, 125, 143, 146, 148, 157, 166, 170, 215, 220, 242, 261; Doggett Letterbook, p. 163.

37. The sample used for this survey comprises the makers listed in Ring 1981.

38. Sikes 1976, p. 133.

39. Comstock 1968, p. 120.

40. Van Ravenswaay 1958, p. 241.

41. Jobe/Kaye 1984, no. 147.

42. *Pennsylvania Packet and Daily Advertiser*, November 6, 1789, p. 3; *Philadelphia Gazette and Universal Daily Advertiser*, May 7, 1800, p. 2.

43. Hill 1967, I, p. 217.

44. Ibid., p. 228.

45. Elder 1975, p. 278.

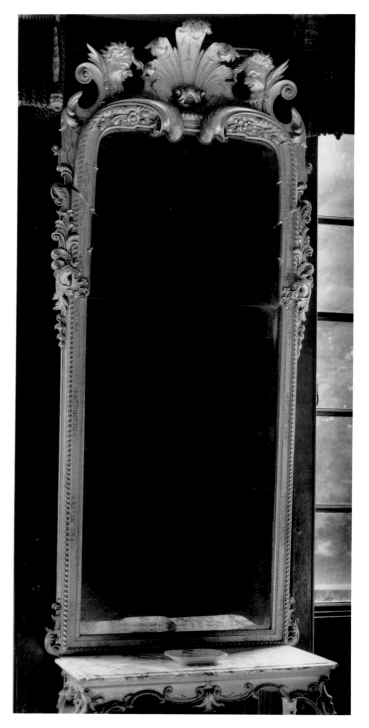

Fig. 63. Attributed to James Moore and John Gumley, Looking glass, 1722–26. Pine. Erthig Park, Denbighshire, England.

EIGHTEENTH- AND EARLY-NINETEENTH CENTURY
Looking Glasses

Looking Glasses with Crests with Arched Centers

Looking glasses with an arched crest flanked by scrolls appeared in England at the end of the seventeenth century. Although the symmetrical broken curves of the sight edge of this type of frame were a carryover from the Baroque style, the veneered surface and limited use of carving and gilding represented a departure from the elaborately ornamented looking-glass frames that had been produced in the latter part of the seventeenth century. The scrolled crest in particular appears to be an abstraction of the three-dimensional forms found on aristocratic carved and gilt frames (Fig. 63). The emphasis on outline, characteristic of much early Georgian furniture, was reinforced by the flat, veneered surface. Frames of this type were popular in America for at least a century after their first appearance. The examples in the Art Gallery's collection illustrate the basic form (cat. 163) as well as later modifications made to suit the Rococo (cats. 166–168) and Neoclassical styles (cats. 169–171).

163
LOOKING GLASS

Probably England, 1730–70
Walnut veneer; spruce
143.1 x 52.2 (56 3/8 x 20 1/2)
Bequest of Olive Louise Dann, 1962.31.28

Structure: The top frame rail is lapped between the side rails, which extend above it. The bottom and side rails are mitered together and secured with two splines at each corner. The front ogee molding is applied. The gilt sight edge is built up on a lip projecting from the side and bottom frame members. The lip is butted and glued to the top frame member. The veneered crest is glued to a shallow rabbet in the top frame member and to the upper ends of the side rails. The two backboards, composed of pieces of wood with feathered outside edges glued together, are nailed in place.

Condition: A vertical strip glued to the back of the crest is now

lost. At one time an ornament was nailed to the front of the crest. The sides of the frame were veneered or reveneered in the twentieth century. Both pieces of glass are replacements. A cross-brace fitted into cutouts in the side rails of the frame once secured the lower piece of glass. The backboards appear to be original.

Looking glasses of this large size first became available in England at the beginning of the eighteenth century, when the English glass houses routinely produced plates more than 91.5cm (3 feet) in height.[1] Such a looking glass might have been called a "pier glass," a term used in some eighteenth-century sources to denote looking glasses over a certain size rather than any looking glass hung on the pier between the windows of a room. There appears to have been a fairly consistent standard for separating pier glasses from looking glasses: a 1754 inventory of frames offered for sale by Charles Willing of Philadelphia described glasses less than 26 x 15 inches (66 x 38.1cm) as "Small Looking Glasses" and those over this size as "Pier Glasses"; Sheraton's 1803 *Cabinet Dictionary* similarly gave the smallest size of "Glasses for piers" as 28 x 16 inches (71.1 x 40.6 cm).[2] By this standard, cats. 167 and 168 as well as this example would have been called pier glasses. It is difficult, however, to ascertain how rigidly this distinction was applied. Advertisements such as one for "all sorts of peer Glasses, Sconces, and dressing Glasses" in the *South-Carolina Gazette* in 1732 suggest a less specific application of the term.[3]

The restrained ornamentation of this looking glass apparently represented an aesthetic preference rather than a desire to cut costs. The size of the glass alone would have made it very expensive. Carved and gilded frames of the same type were available in Colonial America; one example was reportedly brought to New York by William Cockcroft about 1750.[4] Many Americans seem to have deliberately chosen the simpler type of frame. On July 10, 1739, Thomas Hancock of Boston placed an order with his London agent for a looking glass that may have been nearly identical to Yale's: "1 Looking Glass the Lower plate four foot Long & 22 Inches wide the top plate in proportion to the bigness of ye Lower plate. The frame to be Veneer'd Engh Walnutt Dark van'd with a handsome Carved Gilt Edge."[5] This style of frame remained popular for more than three decades with American customers in all the major cities. Almost identical looking glasses were owned by Jeremiah Cresson of Philadelphia about 1740 and sold by Joseph Grant, Jr., of Boston between 1750 and 1758.[6] John Elliott, Sr., of Philadelphia apparently began importing and selling looking glasses of this type in 1762. Based on the surviving looking glasses labeled by Elliott, this type of simple arched crest was the second most popular style he sold.[7]

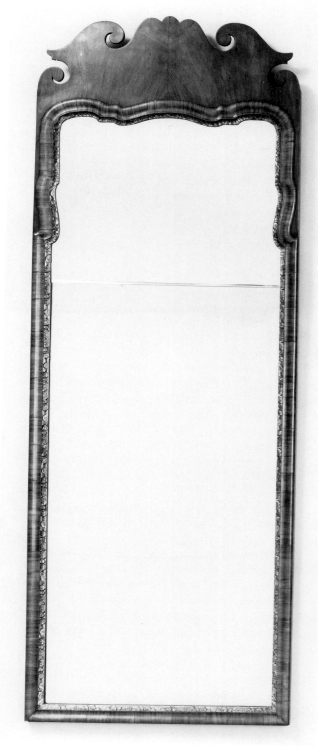

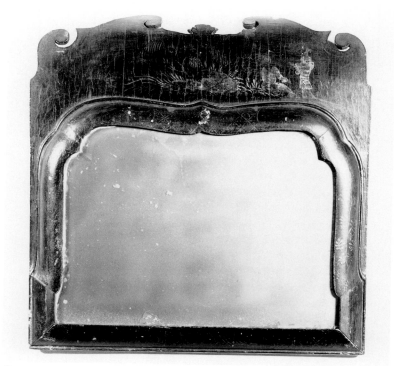

164

165

163

1. *DEF*, II, pp. 310, 516–17.
2. Hornor 1935a, p. 283; Sheraton 1803, pp. 235–36.
3. Advertisement for Broomhead and Blythe, *South-Carolina Gazette*, August 12–19, 1732, p. 4.
4. Barquist 1991, pl. 4.
5. Jobe/Kaye 1984, p. 450.
6. Schiffer 1983, no. 90; Jobe/Kaye 1984, no. 144.
7. Hayward 1971, pp. 145, 150.

164

FRAGMENT OF A LOOKING GLASS

Probably England, 1725–50
Spruce
53.7 x 51.4 (21 1/8 x 20 1/4)
The Mabel Brady Garvan Collection, 1931.1217

Structure: The front surface of the frame is japanned; two of the figures have silver faces and hands. The crest is butted and glued to the top frame member. The frame members are composed of two laminates; the top is lapped to the sides. The inside edges of the frame members are shaped to follow the applied ogee molding. The glass is secured with blocks.

Condition: This frame is the surviving upper portion of a looking glass, preserved by the addition of a lower frame member. The ogee molding applied to this new piece appears to be a reused section from the lost lower frame. Two small strips of mahogany were pieced into the side members when the lower rail was added. The backboard is a replacement. Only two of the interior glue blocks survive. The beveled glass is original.

This fragment undoubtedly was adapted to its present form when the larger piece of glass in a frame like cat. 163 broke. The character of the repairs and the fact that the lower part of the frame was sacrificed to salvage the glass suggests that this conversion took place when the glass was more valuable than its japanned frame, thus most probably before the second half of the nineteenth century. Odd pieces of glass were considered precious even on a royal level: the upper part of a seventeenth-century looking glass remounted in an elaborate Rococo frame is preserved at Drottningholm Palace outside of Stockholm. That even part of the old frame on Yale's example was retained can be attributed to economy or to the fact that the glass plate's distinctive shape did not lend itself easily to an updated frame. Most looking-glass makers advertised that they reframed old glass; James Foddy of New York City announced in 1729 that "He also undertakes to square Diamond Cut and Polish Old Looking-Glasses, and converts them to the best Use."[1]

1. *New-York Gazette*, October 6–13, 1729, p. 3.

165

CREST FROM A LOOKING GLASS

Probably America, 1750–80
Eastern white pine
23.8 x 36.4 (9 3/8 x 14 3/8)
Gift of Mr. and Mrs. Charles F. Montgomery, 1972.113

Structure: The japanned crest is a single board with two tapered and champfered strips nailed to its back.

The lively, foliate silhouette of this crest indicates that it is a relatively late example of eighteenth-century japanned furniture. The splines nailed to its back are extremely unusual; most crests composed of thin boards were butted to the top of the frame and secured with glue blocks.

166

LOOKING GLASS

Probably England, 1750–80
Walnut veneer, spruce
85.9 x 35.7 (33 7/8 x 14)
Bequest of Olive Louise Dann, 1962.31.3

Structure: The top frame rail is lapped between the side rails. The bottom rail and side rails are mitered together and secured with a thin, angled spline at each corner. The ogee molding is applied to the front of the frame and the gilt sight edge is built up on a lip projecting from the frame members. Small pieces of wood are inserted behind the applied molding at the upper corners. The veneered crest is butted and glued to the top frame member and this joint is secured by two angled blocks. Two additional vertical blocks reinforce the larger scrolls. A carved shell is fitted within the circular opening at the crest's center. The glass plates are held in place by small blocks. The backboard has feathered edges and is secured with nails.

Inscription: "Joseph Riley" is written in chalk on the backboard.

Condition: The applied molding and the carved gesso on the bottom frame member are replacements. The glass plates and backboard are original.

On this looking glass and the following two examples (cats. 167, 168), a carved and gilded openwork shell has been inserted into the center of the crest. Frames with similar carved shells, birds, or foliage were made after about 1745 as a response to the Rococo style. These features became eponymous: contempor-

ary documents used such terms as "Walnut Sconce Gilt Edge & Shell," and two frames of this type were inscribed "Edge & Bird."[1] The differences among the Art Gallery's frames demonstrate some of the options available in terms of expense and ornamentation, ranging from this small example without side scrolls or base to larger looking glasses with both of these features (cats. 167, 168). The shell-in-crest looking glass was widely owned in eighteenth-century America. Documented examples were acquired by Jonathan Sayward of York, Maine, between 1761 and 1767; labeled by Stephen Whiting, Sr., of Boston between about 1765 and 1773; and owned by Mary Miller Annin of Elizabethtown, New Jersey, in 1780.[2]

1. Hayward 1971, p. 123; *Sack Collection*, IV, p. 1018. See also Hornor 1935a, p. 275; invoice of Frederick William Geyer to Paul Revere, September 20, 1783, Invoice Book 1785–91, pp. 13–15, Revere Family Papers, Massachusetts Historical Society, Boston.
2. Jobe/Kaye 1984, no. 146; *Sack Collection*, IV, p. 950; New Jersey 1976, no. 34. Stephen Whiting's label locates his shop "Opposite the Corn Field," a phrase used in his newspaper advertisements between 1765 and 1773 (see Barquist 1991, p. 1117, n. 22).

1 6 7

LOOKING GLASS *Color plate 5*

Probably England, 1750–80
Walnut veneer, spruce
115.5 x 62.8 (45 1/2 x 24 3/4)
The Mabel Brady Garvan Collection, 1950.718

Structure: The frame members are mitered together at the lower corners; the top is butted between the sides. The bead and ogee molding with a gilt inner edge is applied to the frame. The veneered crest is a single board that is butted against the top of the frame. This joint is reinforced by two horizontal blocks. The shell is carved from a piece of wood glued behind the crest's center. Vertical braces are glued behind the crest's outside scrolls. Each corner scroll is a single piece nailed and glued to the frame's sides and the crest or base and is reinforced by small glue blocks. The frame's sides are veneered between these scrolls. The veneered base is butted against the lower frame member. This joint is reinforced by two horizontal blocks and three vertical braces. The glass is held in place by glue blocks. The backboard, composed of four pieces, is held in place with nails.

Condition: The bottom left half of the gilt inner molding is a replacement, as are the right brace behind the crest and all three braces behind the base. The outer right scroll on the base broke off and has been reattached. The backboard is original.

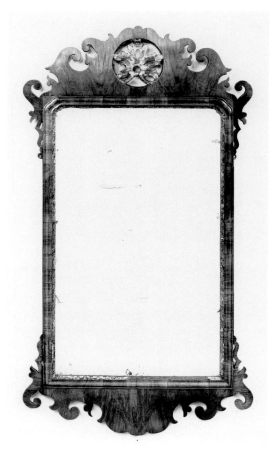

167

The glass may also be original, although all the blocks securing it are replacements. Some or all of these repairs may have been done by Otto Hoepfner and Sons, who worked on this frame at some point prior to 1960.

See cat. 166.

1 6 8

LOOKING GLASS

Probably England, 1750–80
Walnut veneer, spruce
116.2 x 63.6 (45 3/4 x 25)
The Mabel Brady Garvan Collection, 1950.719

Structure: The frame members are mitered together at the corners. The crest is constructed from horizontally joined pieces of

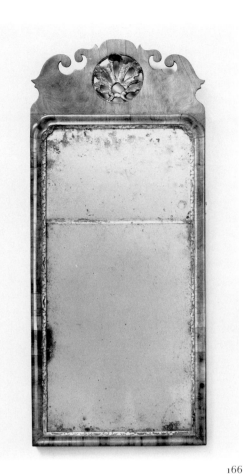

166

166 *Inscription*

168

wood and is butted against the top of the frame. This joint is reinforced by two horizontal blocks. Vertical braces were glued behind the outside scrolls. The shell is carved from a piece of wood attached to the back of the crest. A bead and ogee molding is applied to the front of the frame. The sight edge is an extension of the frame members. The scrolls glued to the frame's sides are each a single piece reinforced by a small glue block. The frame's sides are veneered between these scrolls. The veneered base is a single board butted against the bottom member of the frame. This joint is reinforced by two horizontal blocks with angled ends. The glass is held in place by small blocks that are glued to the inside of the frame. The backboard is composed of four horizontally joined pieces with feathered outside edges. The backboard is held in the frame with nails and was covered with layers of newspaper and brown paper.

Inscription: "2" is written in eighteenth-century script on the inside of the backboard.

Condition: The crest's center broke in half horizontally; the veneer cracked and the shell fractured into several pieces. This break was repaired with two vertical braces added on either side of the shell. One of the vertical braces behind the crest is now lost and the other is a replacement. The shell and sight edge have been repaired and overpainted with gold paint. Three of the corner scrolls have been repaired; the two glue blocks behind the upper right scroll are replacements. A central vertical brace behind the base is now lost. The backboard and glass are original. Three blocks securing the glass appear to be original. The original hanger probably was a wrought-iron loop screwed to the top frame member at the center.

Provenance: Two pages from what appears to be an Augusta, Maine, newspaper of 1810 were applied to the back of the frame, which suggests that this looking glass was in Maine at that time.

See cat. 166.

169

169

LOOKING GLASS

Possibly America, 1790–1820
Mahogany veneer, eastern white pine
95.3 x 50.7 (37 1/2 x 20)
Bequest of Olive Louise Dann, 1962.31.34

Structure: The frame members are mitered together at the corners and secured with splines. Their front surfaces are veneered and inlaid with stringing. The gilt sight edge is glued inside the frame and mitered together. The veneered crest is a single board butted and glued to the top frame member. This joint is reinforced by three horizontal blocks and five vertical braces that are nailed and glued behind the projecting scrolls. The bird is carved from a block inserted behind the crest. The scrolls glued to the sides are each a single piece reinforced by a small glue block. The veneered base is a single board butted and glued to the lower frame member. Two horizontal blocks and a central vertical brace are glued and nailed behind the base. The original backboard was nailed over the back of the frame.

Inscription: "Clara E. Bradley / North Haven / Conn." is written in late nineteenth-century script on the back of the base.

Condition: The bird's feet are lost and its head has been incorrectly restored as an eagle; the long neck indicates that it originally was a phoenix. Both the glass and backboard are replacements.

Provenance: At one time this looking glass belonged to Clara E. Bradley (b. 1865) of North Haven, who served as Librarian of the Bradley Public Library in her native town from 1900 to 1933 as well as Librarian of the New Haven High School beginning in 1911 (Thorpe 1901, pp. 96–97; Brusic 1986, p. 153). The looking glass may have descended from her parents, Rowe and Margaret Bradley of North Haven.

This looking glass exhibits the changes made to the arched-crest form to suit the Neoclassical style during the last quarter of the eighteenth century. The overall silhouette and carved crest ornaments of earlier frames were retained, but the carved sight edge was replaced by a square, veneered molding inlaid with stringing. Looking glasses of this type probably did not appear in America until after the War of Independence. Examples similar to this one were purchased from William Wilmerding of New York City in 1791 and labeled by Kneeland and Adams of Hartford, Connecticut, between 1792 and 1795.[1] After the beginning of the nineteenth century, arched-crest frames underwent further simplification (cats. 170, 171).

The Kneeland and Adams frame and all three of the Art Gallery's frames of this type are made of eastern white pine and probably were manufactured in the United States. Glass plates measuring 22 x 13 in. (55.9 x 33cm), the dimensions of the plate in the Art Gallery's looking glass, were advertised by Cermenati and Bernarda of Boston in 1807.[2] These frames may have been imported from England, however (see p. 295). The one sold by Wilmerding could have been among the "gilt and wooden framed Looking-Glasses, and a variety of other articles, of the latest importation" that he advertised in 1789.[3]

1. Downs 1946; Montgomery 1966, no. 218.
2. *Columbian Centinel*, January 3, 1807, p. 1.
3. *New-York Daily Gazette*, August 13, 1789, p. 1.

170

LOOKING GLASS

Joseph Del Vecchio (1778–1815) and John Paul Del Vecchio (d. 1815), in partnership 1803–15

New York City, 1805–15

Mahogany veneer; eastern white pine (crest, base, and backboards, side scrolls, frame members), yellow-poplar (glue blocks)

86 x 46.8 (33 7/8 x 18 3/8)

The Mabel Brady Garvan Collection, 1930.2537

Structure: The frame members are mitered together at the corners and reinforced with splines. The veneered crest is a single board butted and glued to the top frame member. This joint is reinforced by two horizontal glue blocks and three vertical braces nailed behind the center and the side scrolls. Additional diagonal braces are glued behind the crest's foliate projections. The single-piece brackets are butted and glued to the frame. Each joint is reinforced with a single glue block. The veneered base is a single board butted and glued to the lower frame member. This joint is reinforced by two horizontal glue blocks. Two backboards with champfered edges are nailed over the back of the frame. A brass hanging ring is screwed into the top frame member.

Inscriptions: "8" is written in chalk on the outside of both backboards. A printed paper label is glued to the outside of the upper backboard: "JOS. & JNO. VECCHIO, / LOOKING GLASS & PRINT STORE, / WHOLESALE AND RETAIL, / No. 136, BROADWAY, / New-York, / MANUFACTURERS of Looking-Glasses, Picture-Frames, / & c. & c.—Plain, Fancy, and Ornamental Gilding executed / in the best manner, on the most reasonable terms, and at / the shortest notice.—Spy-Glasses, Quadrants, Survey-ing / Compasses, Thermometers, Reeves Water Colours, & c. / N.B.—Ladies' Needle Work, & c. framed and glazed / with neatness and dispatch."

Condition: The crest's left scroll was restored in 1964 by Emilio Mazzola, who also replaced the veneer on the upper right and lower left side scrolls. The vertical braces behind the crest's side scrolls and the flared end of the lower left bracket are replacements. The base cracked below the left glue block and has been glued back together. Recent braces have been glued on either side of the original vertical brace that was nailed behind its center. The resilvered glass is old but was added to the frame after 1930. The backboards and brass hanger are original.

Provenance: Acting as Garvan's agent, Henry Hammond Taylor purchased this looking glass from Harry Arons on March 24, 1930.

Arched-crest looking glasses made in the early nineteenth century, such as this example, had simpler ornament and distinctly narrower and less top-heavy proportions than their eighteenth-century counterparts. Base sections were larger in relation to the crest, and scrollwork on the crest and base tended to be more attenuated and somewhat smaller in relation to the total frame. The 49.5 x 29.2cm (19 1/2 x 11 1/2-in.) glass plate in this frame appears to have been a standard size; two other frames in the Art Gallery's collection have plates of identical dimensions (cats. 179, 193). Plates measuring 20 x 12 in. (50.8 x 30.5cm) were included in lists of looking glasses offered for sale by Charles Willing of Philadelphia in 1754 and Cermenati and Bernarda of Boston in 1807.[1] In 1829 John Doggett ordered four hundred 20 x 12-in. "Green Glass silverd" plates from F. and E. Delius of Bremen.[2] Thomas Sheraton, however, did not include either the 19 1/2 x 11 1/2 or 20 x 12-in. sizes in the *Cabinet Dictionary*'s detailed catalogue of glass plate dimensions.

The brothers Joseph and John Paul Del Vecchio came to New York City in 1800 as partners in Corti, Vecchio, Donegani, and Company, "carvers, gilders, glass manufacturers." Large numbers of Italian craftsmen immigrated to Great Britain, Canada, and the United States at the beginning of the nineteenth century; Paul Cermenati, G. Monfrino, and John Bernarda (cats. 182, 183) presumably were also part of this migration. At least three other Del Vecchio brothers left Moltrasio on Lake Como to pursue the looking-glass trade: James Sr. (active 1797–1848) established himself in 1797 as a successful "Print Seller and Looking-Glass Manufacturer" in Dublin; Charles (c. 1786–1854) apparently traveled to Ireland with James before coming to New York in 1810; and Francis (c. 1772–1810) worked in Montreal.[3] Joseph and John Del Vecchio worked with the otherwise unidentified P. Corti until 1803; a barometer

made by this partnership is in the Bayou Bend Collection.[4] The Del Vecchios moved to Albany, New York, in 1804 but returned to New York City the following year, working at 136 and 138 Broadway until their deaths in 1815. Their brother Charles continued the firm until his death in 1854.[5]

Although Joseph and John Del Vecchio must have trained in Italy, their labeled looking glasses are Neoclassical versions of the Anglo-American arched-crest form.[6] The Art Gallery's looking glass is identical to the work of other early nineteenth-century New York City makers, including Bartholomew Plain, Elias Thomas, and John A. Butler.[7] It is possible that this frame design represents a New York City type. Examples are also known with the labels of Nicholas Geffroy of Newport, Rhode Island, and George E. Smith of Baltimore, but they may have been imported from New York.[8] The Del Vecchios also sold looking glasses they imported from England. A partial bill of lading records four framed mirrors, framed pictures, looking-glass and mirror plates, and a thermometer that they imported from London in 1810.[9]

1. Hornor 1935a, p. 283; *Columbian Centinel*, January 3, 1807, p. 1.
2. Doggett Letterbook, p. 1
3. Ring 1981, p. 1182; Fitz-Gerald 1981; Van Cott 1989, pp. 222–23.
4. Van Cott 1989, fig. 1.
5. Ring 1981, p. 1182.
6. Other looking glasses by Joseph and John Paul Del Vecchio are illustrated in Van Cott 1989, figs. 2–4.
7. Downs/Ralston 1934, no. 102; Birmingham 1982, no. 110; private collection (DAPC 63.994).
8. The Geffroy looking glass is in the Los Angeles County Museum of Art (reproduced in *Antiques* 54 [September 1948], p. 187); *Burke* 1970, no. 157.
9. Bill of lading from the ship *Weymouth* for J. and J. Del Vecchio, September 11, 1810, Joseph Downs Manuscript Collection, The Henry Francis du Pont Winterthur Museum, Delaware.

171

LOOKING GLASS

Probably New England, possibly Boston, 1800–40
Mahogany, mahogany veneer; eastern white pine
83.1 x 41.7 (32 3/4 x 16 3/8)
The Mabel Brady Garvan Collection, 1930.2243

Structure: The frame members are lapped together at the corners. The crest, brackets, and bottom board are each a single piece of mahogany. The crest is butted and glued to the frame with two thin, horizontal blocks reinforcing the joint. The molded, composition eagle is glued to the front of the crest. The brackets are glued to the crest and frame sides; each joint is

reinforced by a thin rectangular block. The backboard has feathered edges and is nailed over the back of the frame.

Inscription: An illegible inscription and numeral are written in pencil on the outside of the backboard near the top.

Condition: The crest cracked in half horizontally and damaged the eagle; this damage has been repaired. The crest's right scroll has broken off and been reattached. The eagle originally may have been gilded. The lower right bracket broke off and has been either replaced or reattached with a new brace behind it. The base has been reglued to the frame; the original blocks have been lost, and the blocks securing the brackets have been trimmed. Two vertical braces doweled into the frame have been added to the back of the base. The base's left scroll broke off and has been reattached with a brace; a similar brace has been added behind the right scroll. The glass is a replacement. The backboard is original.

Provenance: Garvan acquired this looking glass as part of the collection he purchased from R.T.H. Halsey.

This looking glass is one of a large group with crests, brackets, and base sections cut from thin mahogany boards following the same pattern. The majority of these frames also has a sight edge with notches instead of carving, an ogee molding on the inner frame, and a molded composition ornament applied to the crest's center. Many looking glasses of this type are labeled, primarily by Boston makers working during the first four decades of the nineteenth century: Cermenati and Monfrino, Cermenati and Bernarda, Elisha Tucker, Samuel Bradlee, Spencer Nolen, and Edward Lothrop.[1]

These looking glasses may represent a Boston form, although there are frames of this type documented to other parts of New England. The original owners of two examples lived in Concord, Massachusetts, and Hill, New Hampshire.[2] Frames of the same design were also labeled by Luke C. Lyman of Middletown, Connecticut, and James Todd of Portland, Maine.[3] These looking glasses could have been made in Boston and sent to more rural areas for sale; at least one Boston maker advertised that he had goods "Well-suited to the Country Market."[4] Both Lyman and Todd described themselves as "manufacturers" of looking glasses, however, and as Charles Montgomery pointed out, the simple scroll patterns of this frame could have been duplicated easily by any woodworker without special skills in gilding or carving.[5] The 18 x 12-in. (45.7 x 30.5cm) glass plate in the Art Gallery's frame was listed by Sheraton as a standard size "of Dutch Manufacture," and plates of this size were available from Cermenati and Bernarda in 1807.[6] Even in Boston the composition ornaments were undoubtedly purchased by the framemaker from a specialist.

171

170

170 *Label*

The eagle on the documented New Hampshire frame is identical to the one on the Yale example.

Frames of this simple type, with crest, base, and sides sawed from thin mahogany boards, were also imported. An example similar to the Art Gallery's looking glass, although without an applied ornament, was labeled by George Kemp and Son of London between 1785 and 1797.[7] A larger, more elaborately ornamented version with eastern white pine as the secondary wood has pieces of a Dutch newspaper dated 1794 glued between the blocks and the glass plate.[8] It is not impossible that an American maker would have used a foreign newspaper as scrap material, but this frame's large size, gilded phoenix and leaf ornaments, and additional scrolls in the crest and base distinguish it from the group described above. It may have been a more expensive version of a popular form made in both Europe and the United States, or it may have been an import that served as the prototype for simpler, American-made imitations.

1. Montgomery 1966, no. 224; private collection (DAPC 66.290); *Antiques* 104 (October 1973), p. 539; Schiffer 1983, nos. 422–24, 428–29.
2. The Concord looking glass is in the Concord Antiquarian Museum, Massachusetts; the Hill looking glass is illustrated in New Hampshire 1973, no. 45.
3. Both in private collections (DAPC 77.324 and 65.827).
4. Comstock 1968, p. 120.
5. Montgomery 1966, p. 268.
6. Sheraton 1803, p. 235; *Columbian Centinel*, January 3, 1807, p. 1.
7. Wood 1968, fig. 1; *DEFM*, p. 504.
8. Jobe/Kaye 1984, no. 148.

Pediment Looking Glasses

A new type of looking glass was introduced in England about 1730. The crest was shaped as a scrolled pediment with a central plinth, separated from the lower part of the frame by a carved molding. The carved and gilt sight edge often had rounded, indented upper corners; the main part of the frame was outlined by a carved molding with crossetted upper corners and lower corners shaped like trusses. Chains of carved and gilded foliage or husks frequently were applied to the frame's sides. The base was designed as a pair of reverse curves flanking a rounded center.

In contrast to the intricate silhouettes and frequently japanned surfaces of arched-crest frames, pediment frames had simple forms, planar surfaces, and distinct compartments separated by moldings. These frames were a product of the interest in classical and Renaissance architecture that transformed English design during the second quarter of the eighteenth century, influenced primarily by the work of Andrea Palladio and Inigo Jones. Designs for doorways, windows, and overmantels in books by William Kent, James Gibbs, Isaac Ware, and other Palladian architects appear to have been the primary inspiration for these looking glasses (Fig. 64). The names used to describe this type of frame—"tabernacle," "architectural," and "pediment"—underscored its relationship to architectural forms.[1]

Many pediment looking glasses had richly carved surfaces that were entirely gilded, and frames of this type were owned in America by the Reverend John and Dina Van Bergh Frelinghuysen of Raritan, New Jersey, after 1750 and the Reverend Thomas Smith (1703–1795) of Falmouth (now Portland), Maine.[2] As with the arched-crest form, however, most pediment looking glasses with histories of ownership in America are of a less costly variety: only the moldings and carved ornament were gilded, and the surface was veneered with mahogany. This type of frame remained popular in England and America for more than a century and was modified to suit changes in style during that time. The Art Gallery's collection includes a late example of the earliest form of pediment looking glass (cat. 172); versions in the Rococo (cats. 173, 174) and Neoclassical styles (cat. 175) are also represented.

1. Jones 1739, pls. 41–50; Ince/Mayhew 1762, pl. 79; advertisement of James Reynolds, *Pennsylvania Chronicle*, November 28-December 5, 1768, p. 396.
2. New Jersey 1974, no. 51; Barquist 1991, pl. 9.

172

LOOKING GLASS

Thomas Aldersey (active 1754–81)

London, 1765–81

Yellow-poplar (carving), mahogany veneer; spruce

129.5 x 58.5 (51 x 23)

Bequest of Olive Louise Dann, 1962.31.31

Structure: The top and bottom frame members are tenoned between the sides. The front surface of the frame is veneered. The crest is a single board butted and glued to the top of the frame. The upper ends of the scrolls are separate pieces glued to the crest. The frame's upper and lower corners are composed of projecting, shaped pieces of wood glued to the side members. The carved vines are nailed to the frame's sides. The rounded end is butted and glued to the base. The glass originally was held in place by small glue blocks.

Inscription: "THOMAS ALDERSEY, / Looking-Glass Maker, / IN / LONDON." is printed on a paper label glued to the backboard.

Condition: All of the gilding appears to have been renewed.

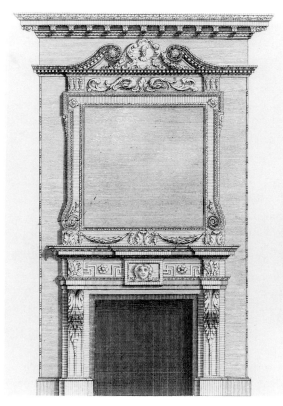

Fig. 64. P. Fourdrinier after William Kent,
Chimney Piece of the Honourable Mr. Pelham,
Secretary at War, from *Designs of Inigo Jones*, 1727.

172 *Label*

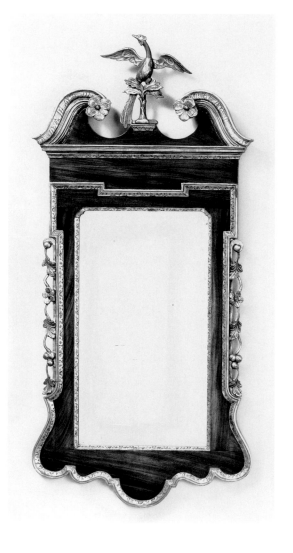

172

The crest moldings and rosettes are now screwed to the crest from behind. Both the phoenix finial and the carved molding applied to the plinth are replacements. The joint between the crest and top frame member separated in the past and caused a crack across the veneer; the two pieces have been reglued together with vertical braces. Peter Arkell filled the crack in the veneer in 1985. The mortise for the original finial has been plugged, and two strips have been added to secure the replacement. The carved vines on the frame's sides have been renailed and may be replacements. The three-piece backboard appears to be original. The glass has beveled edges and may be original, although it has been resilvered.

With forms and moldings derived from classical sources, pediment looking glasses such as this one were perfectly suited to Georgian houses of the second and third quarters of the eighteenth century and were popular throughout the American Colonies. One of the earliest documented importations is a frame labeled by John Elliott, Sr., of Philadelphia between about 1758 and 1762.[1] The Boston merchant William Bowes advertised "a fine Assortment of Pedment Sconce Looking Glasses" he had imported from London in 1763.[2] Similar pediment frames were owned by the tanner Jonathan Heywood of Concord, Massachusetts, who died in 1774, and by Philip Van Rensselaer of Albany, New York, who died in 1798.[3]

Thomas Aldersey worked as a cabinetmaker, upholsterer, and "glass grinder" at four different addresses in London over a period of about thirty years.[4] Although none of his labeled looking glasses are known to have histories of ownership in America, they are types that were imported in large quantities into this country, including a simple arched-crest frame and a Rococo-style pediment frame similar to cat. 174.[5] The delicately carved vines of fruit, flowers, and foliage and the narrow proportions of the Art Gallery's looking glass suggest a date of manufacture at a time when the Rococo style was being modified by the growing enthusiasm for Neoclassicism. A looking glass with similar features was owned by George Washington and probably was purchased in 1783 or 1784.[6]

1. Downs 1952, no. 255. The dates for Elliott's use of this label were established in Hayward 1971, pp. 34, 38.
2. *Boston Gazette*, June 27, 1763, p. 1.
3. Benes 1982, no. 119; Blackburn 1976, no. 48.
4. *DEFM*, p. 6.
5. Wood 1968, fig. 2; Skinner 1987, no. 72.
6. Fede 1966, pp. 30–31.

173

LOOKING GLASS *Color plate 9*

Possibly America, 1750–80
Mahogany veneer, eastern white pine
170.1 x 76.9 (67 x 30 1/4)
The Mabel Brady Garvan Collection, 1930.2593

Structure: The top and bottom frame members are butted and glued between the sides, which extend above and below these junctures. The crest section is a single board fitted against rabbets on the extensions of the frame's side rails. Shaped vertical braces are glued behind the large scrolls. Diagonal braces are glued behind the smaller, inside scrolls. The frame's front surface is veneered with the molding glued on and the carved scrollwork nailed in place. A thin molding with a carved vine is nailed to each side of the frame. The extensions to the sides above and below these carvings are single pieces glued in place. The base is glued to the bottom of the frame and to rabbets in the extensions of the frame's sides. Three pieces of wood are glued behind the base as reinforcements. A wrought-iron loop hanger is screwed to the frame's top member. The glass is held inside the frame by small blocks. This looking glass apparently never had a backboard. It retains an old piece of burlap whose outside edges are folded under and nailed to the back of the frame.

Condition: The majority of the gilded surfaces on this frame are original, although they have been retouched in places with gold paint. Peter Arkell removed discolored varnish from the gilded surfaces in 1986 and colored damaged areas. At the same time, he refinished the veneered surfaces. The carvings applied to the crest's scrolls are replacements. The finial appears to be contemporary with the frame but was added after 1928. The finial support is probably original. The two leaves and cluster of berries on the left side have been restored. The brace behind the crest's left scroll is a replacement. Both of the carved vines on the sides have modern nails added to reinforce the original nails but do not appear to have been removed from the frame. A later horizontal brace has been screwed across the bottom of the frame. The glass may be original, although the blocks securing it are replacements.

Reference: Nutting 1928, II, no. 2957

Provenance: Garvan acquired this looking glass from Henry V. Weil between 1928 and 1930.

As with arched-crest looking glasses, the pediment form was modified in response to the Rococo style (see cat. 166). On this frame and the following example (cat. 174), the architectural components of earlier pediment frames were dissolved into Rococo ornament: classical moldings were eliminated or replaced by carved scrolls and foliage, and a series of reverse curves was substituted for rectangular sight edges. Abraham Swan made similar alterations to Palladian architecture in designs he published in 1745 (Fig. 65). These frames were undoubtedly what James Reynolds described in 1768 as "mock Pediment and Raffle ornamented," a name that expressed this playful transformation of the earlier form. A looking glass of this type sold to Jonathan Bowman of Maine by William Jackson of Boston in 1770 was similarly inscribed "Sham Pediment flewer pott & Sprigs."[1]

Several unusual features of this looking glass suggest that it may be of American manufacture. A coarse fabric is nailed over its back instead of a backboard, which would have made transatlantic shipment impossible unless it was sent without glass.[2] Two pillar looking glasses that were probably made in Boston and purchased before 1818 by Daniel and Sarah Cleaves of Biddeford, Maine, also have fabric backings instead of backboards.[3] The only secondary wood present in this frame is eastern white pine, and on the documented English frames known to the author this wood is used primarily for carved elements. The technique of extending the frame's vertical members to support the crest and base sections differs from standard English practice, which supports these parts with separate glue blocks or braces. A possible clue to this frame's origin is another

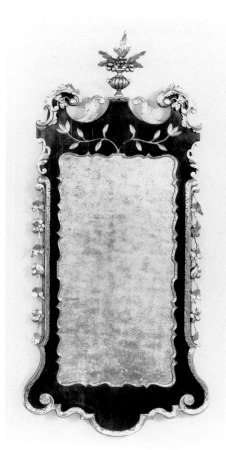

173

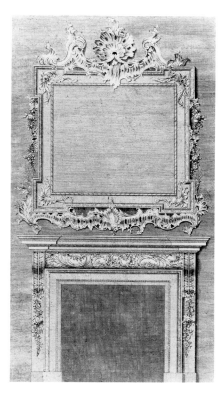

Fig. 65. Edward Rooker
after Abraham Swan,
*Chimney-Piece
with a very rich Frame over it,*
from *The British Architect*, 1745.

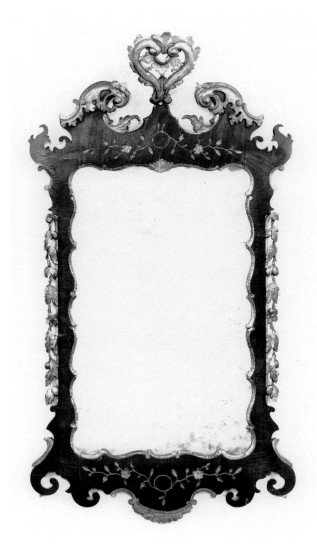

174

looking glass, identical except for the applied carving on the crest (a replacement on the the Art Gallery's frame); its present location is unknown.[4]

1. Advertisement of James Reynolds, *Pennsylvania Chronicle*, November 28-December 5, 1768, p. 396; Jobe/Kaye 1984, no. 147.
2. This fabric is composed of an aggregate fiber that is not cotton, wool, or flax.
3. Sprague 1987, no. 111.
4. Hinckley 1987, no. 167.

174

LOOKING GLASS

Probably England, 1750–80

Scots pine (applied carvings; braces), mahogany veneer; spruce (crest and bottom boards, frame members, backboard)

125 x 66 (49 1/4 x 26)

The Mabel Brady Garvan Collection, 1930.2169

Structure: The frame's top and bottom members are glued between the sides. The sides extend slightly above and below

these junctures. The crest is a single board with the upper ends of the scrolls pieced on at the top. The crest is butted against the top of the frame and glued to the sides' upper extensions. A vertical brace is glued behind each scroll and a central brace is glued behind the plinth. The brackets are glued to the sides with glue blocks reinforcing these joints. The front surface of the frame is veneered. The carved moldings are nailed to the crest. The gilt molding with a carved vine is nailed to each side of the frame. The base is a single board butted against the bottom member of the frame and fitted against the sides' lower extensions. The glass is held in place with small blocks. The backboard is composed of three horizontally joined pieces with feathered outside edges.

Condition: The edges of the carved moldings on the crest have suffered numerous losses, and all the gilding has been retouched. The finial is a replacement. The carved vines have also suffered losses and have been repaired in a few places. The tip of the upper left bracket was restored by Emilio Mazzola in 1964. The center brace once glued behind the base is now lost. The backboard and glass appear to be original. Some of the blocks securing the glass are lost and others are replacements.

Provenance: This looking glass was owned by the antiques dealer and collector Morris Berry of Plainville, Connecticut. It apparently was purchased at an auction of Berry's collection in 1928 by the dealer C. Edward Snyder of Baltimore. Garvan purchased the looking glass from Snyder on January 12, 1929 (*Berry* 1928, no. 23; Snyder file, FPG-Y).

This looking glass represents a particularly successful transformation of the pediment form into the Rococo idiom. In contrast to the preceding example (cat. 173), almost every straight line in the frame has been transformed into scrolls and curves. Corner scrolls and a base section like those on arched-crest frames (cats. 167, 168) undoubtedly were chosen for this type of looking glass because of their lively silhouettes. The rich carving on the finial, flanking scrolls, and chains of foliage on the sides is contrasted with the delicate, incised sprays of flowers on the sham pediment and base. Together with the gilded accents on the edges of the frame, this creates a visually complex and exciting surface. According to contemporary sources, the 30 x 18-in. (76.2 x 45.7cm) glass plate was a standard size that would have classified this frame as a "pier glass."[1] Thomas Aldersey of London labeled a similar looking glass between 1754 and 1781 (see cat. 173).

When this looking glass was in Morris Berry's collection, it was copied by the Nathan Margolis Shop of Hartford and thereafter offered as one of the firm's standard reproductions. The Margolis version was made with a Prince of Wales feathers fin-

ial. Responding in 1932 to an inquiry from Garvan concerning what reproductions were available, Harold Margolis sent "illustrations of some of our very choicest pieces."[2] Among these was their copy of this object, which by that time had been purchased by Garvan.

1. Hornor 1935a, p. 283; Sheraton 1803, pp. 235–36. See also cat. 163.
2. Harold Margolis to Garvan, May 23, 1932, Margolis file, FPG-AAA. For further information on the Margolis family, see cat. 134.

175

LOOKING GLASS

Probably America, possibly New York City, 1790–1820

Eastern white pine (carvings; crest and bottom boards, frame members), mahogany veneer; yellow-poplar (backboards, blocks)

121.6 x 60.2 (47 7/8 x 23 3/4)

Bequest of Olive Louise Dann, 1962.31.32

Structure: The frame members are mitered together at the corners with two angled splines reinforcing the joint at each upper corner and one angled spline at each lower corner. A bead molding is applied to the frame members' outside edges, and a gilt sight edge is glued to their inside edges. The front surface is veneered and the gilt moldings are nailed and glued to the crest. The crest is composed of two horizontal boards glued together. The scrolls are reinforced by thin diagonal braces originally nailed in place. The crest is butted and glued to the top frame member. This joint is reinforced by horizontal glue blocks. Two strips of wood are nailed behind the plinth to form a reciprocal space for the triangular block on the lower end of the finial. A thin piece of wood is nailed to the crest beneath the finial. The brackets glued to the frame's lower corners are each secured by a single glue block. The base is a single piece butted and glued to the lower frame member. This joint is reinforced by horizontal glue blocks.

Condition: The braces behind the crest have been reattached. The upper end of the right scroll broke off and has been reattached to the crest. The finial is contemporary with the frame but does not appear to be original to it. The vines attached to the sides of the frame are twentieth-century replacements. The lower half of the base broke off and has been reattached with two diagonal braces reinforcing the repair. The backboards and all but one of the glue blocks that originally held the glass in place are replacements. The glass appears to be original.

The advent of Neoclassicism in England after about 1765 inspired changes in the pediment looking-glass form. A pedi-

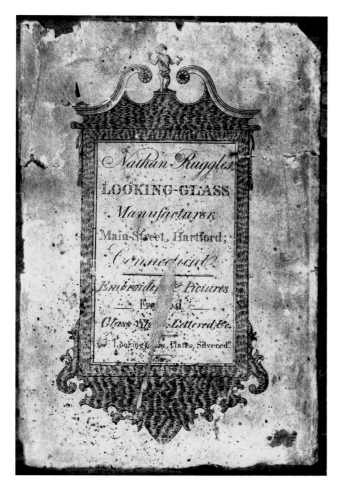

Fig. 66. Abner Reed,
Label of Nathan Ruggles,
1806–08. Engraving.
The Henry Francis du Pont
Winterthur Museum, Delaware.

175

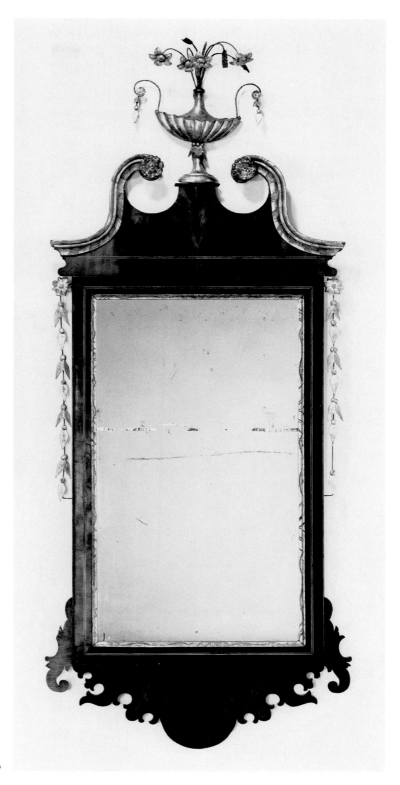

ment crest and side pendants were combined with the schematically carved sight edge, rectangular inner frame, and elaborate, attenuated base and side brackets found on contemporary arched-crest frames (cats. 169, 170). The pediment was redesigned with a more delicate appearance and was ornamented with geometric moldings or pictorial inlays instead of carving. Moldings were reduced in scale or replaced with stringing, and composition ornament was used instead of carved decoration. Neoclassical pediment looking glasses probably were not imported to or made in America until after the War of Independence; the earliest documented examples date from the 1790s. An example, probably imported, with the indented corners and molded sight edge found on mid-eighteenth-century arched-crest frames, was purchased from the New York City merchant William Wilmerding in 1794.[1] A version with a rectangular sight edge was illustrated on the label used between 1792 and 1795 by the Hartford, Connecticut, cabinetmakers Samuel Kneeland and Lemuel Adams.[2] An American-made looking glass of this latter type was labeled by Nathan Ruggles of Hartford, Connecticut, between about 1806 and 1810.[3]

The present looking glass is of one of a group that represents a further modification of the Palladian pediment form to suit the Neoclassical style. Frames in this group are taller and narrower, and often have small reverse-painted panels inserted above the glass. The scrolled pediments are more attenuated and graceful, and any vestigial horizontal moldings are eliminated. The upper corner brackets are also eliminated, and the carved wood vines are replaced by thin wires with gilt composition leaves and flowers. The finials frequently resemble Greek and Roman vase forms.

Many scholars have identified looking glasses of this type as products of New York City or Albany. The most firmly documented example known to the present writer is recorded as being purchased in New York City on July 7, 1807.[4] Two labeled frames are problematic: one bears the label used by Charles Del Vecchio after 1831, seemingly too late a date of manufacture; the other is heavily restored and has an unusual stenciled mark.[5] Evidence also suggests that such Neoclassical pediment frames may have been made in New England. The label engraved between 1806 and 1808 for Nathan Ruggles of Hartford, Connecticut, depicts a "New York" pediment looking glass (Fig. 66), although this label has not been found on a frame of this type. A similar looking glass, owned by the Bushnell family of New Haven, may have been purchased locally, although no looking-glass makers worked in New Haven during this period.[6] Another looking glass of this type has been attributed to Massachusetts because of the eagle inlay on its pediment, although subsequent research by Benjamin A.

Hewitt could not determine whether such eagle inlays were unique to a specific region.[7]

Charles Montgomery advanced the theory that this "New York" type of Neoclassical pediment looking glass, like later eighteenth-century highchests, was a uniquely American design that updated a form out of fashion in England.[8] No documented European version of this exact form is known to the present author. The Art Gallery's looking glass and all the related frames at Winterthur have eastern white pine as a secondary wood, which suggests an American origin.[9] The possibility that they are English cannot be excluded, however. Neoclassical pediment looking glasses sold by importers such as William Wilmerding, however, indicate that the pediment frame was still fashionable in England as late as the 1790s.

1. Downs 1946. As noted in cat. 169, looking glasses sold by Wilmerding were advertised as imported; a closely related example at Winterthur is made of Scots pine and is probably English (Montgomery 1966, no. 212).
2. Montgomery 1966, p. 476, no. 218.
3. Montgomery 1966, no. 213.
4. Tracy 1981, no. 75.
5. Van Cott 1989, figs. 8, 9. For the former example, see also Ormsbee 1944; for the Del Vecchio family, see cat. 170.
6. Reproduced in *Antiques* 87 (January 1965), p. 57.
7. Montgomery 1966, no. 216; Hewitt/Kane/Ward 1982, pp. 82–84.
8. Montgomery 1966, p. 253.
9. Montgomery 1966, nos. 214–16; see also p. 295, above.

Neoclassical Looking Glasses with Openwork Crests

Among the radical changes in English furniture design that accompanied the advent of Neoclassicism after 1765 was an entirely new form of looking glass. The frame enclosing the glass plate was reduced to a narrow molding in a simple geometric shape, primarily rectangular or oval. The crest and base were visually separated from the frame and conceived as openwork designs based on Roman and High Renaissance grotesques. The surfaces of these looking glasses were gilded or painted, with extensive carved or molded ornament and no veneer or natural wood. The terms "plume" and "single-plume looking glass" used during the late eighteenth century probably referred to these frames and their vertical, feathery crest and base elements.[1] Robert Adam had created several pier glasses of this type by 1768, and Matthias Lock published several similar designs in 1769 (Fig. 67).[2] They became widespread in England and America during the last quarter of the eighteenth century; George Hepplewhite, Thomas Sheraton, William and John Linnell, and many others produced designs for them.

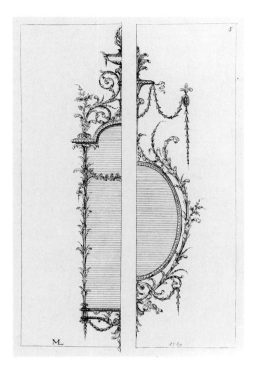

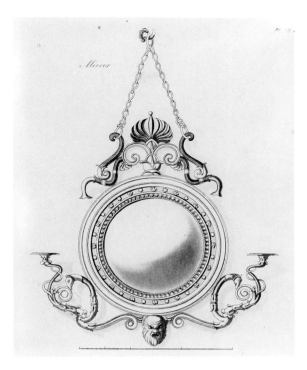

Fig. 67. *Left*, Matthias Lock, plate 5 from *A New Book of Pier-Frames*, 1769. Victoria and Albert Museum, London.

Fig. 68. *Right*, George Smith, *Mirror*, from *A Collection of Designs for Household Furniture and Interior Decoration*, 1808.

As Neoclassicism entered a more archaeological phase at the beginning of the nineteenth century, the delicate, earlier versions of this form (cats. 176–179) were superseded by bolder examples that nevertheless maintained the format of a geometric frame with distinct crest and base elements (cats. 180, 181). Published designs for these later frames were surprisingly rare: George Smith issued two in 1804 (Fig. 68), and a partial view of another appeared in Ackermann's *Repository* in April 1810.[3]

1. Montgomery 1966, p. 269.
2. Harris 1963, p. 17, pls. 58, 83.
3. Smith's second design is illustrated in Smith 1808, pl. 135; for Ackermann, see Agius 1984, p. 50.

176

LOOKING GLASS

Probably Philadelphia, 1791–1804

Retailed by James Stokes (c. 1755–1831)

Eastern white pine (frame members, core of twist moldings); Atlantic white-cedar (backboard)

86.7 x 53.9 (34 1/8 x 21 1/4)

Charles F. Montgomery Collection, 1989.57.3

Structure: The four frame members are mitered together; each joint is secured with a diagonal dowel. The leaf border was stamped in the gesso, whereas the beaded sight edge was applied in ready-made strips before gilding. The twist is nailed into the cavetto. The beveled glass is secured with glue blocks. The two backboards are each composed of two pieces of wood glued together and are nailed to the frame.

Inscriptions: A printed paper label is glued to the upper backboard: "JAMES STOKES. AT THE CORNER OF MARKET AND FRONT STREETS. [in a frame surrounding the following text] HAS / FOR SALE A / General Assortment / OF LOOKING GLASSES / HARD WARE / DRY GOODS &c / whole Sale / AND / RETAIL. [PHILADELP]HIA [at bottom of label, below frame]." A fragment from a printed book in German is glued to the left side of the upper backboard; the text reads: " 215. / . . . bracht worden. Diese les- / . . . Die Erhaltung der / . . . ttes."

Condition: The gilding is original, as are the glass and glue blocks that secure it. Some of the original nails that secured the backboards also survive in place. At one time this frame was hung horizontally.

Although made without an openwork crest or base, this handsome looking glass followed the conventional design for this type

of frame: an outer leaf or gadroon border and a beaded sight edge. Its strict rectilinearity is relieved by the textural contrasts of stamped leaves, beading, and twists. Unlike their turned counterparts on New England frames (cats. 180, 183, 185, 186), the twist moldings on this looking glass are composed of a fiber wrapped around a wooden rod. This frame is also distinguished because it is one of the few in the Art Gallery's collection that definitely retains its original glass. The beveled edges were cut following arcs rather than straight lines, as was the glass in the frame labeled by Thomas Aldersey of London (cat. 172).

James Stokes sold a wide variety of looking glasses at the "fancy hardware and dry goods store" that he established at the corner of Front and High Streets in 1791. In addition to the type of frame at Yale, arched-crest, pediment, and pillar frames survive with his labels. Of varying sizes and sophistication, the frames of each type appear to be made from different component parts, indicating that Stokes sold looking glasses from a variety of sources.[1] Stokes' store was listed in the Philadelphia directories between 1791 and 1804. In 1805, his business was taken over by Thomas and James Fassitt, who used an identical label with their names replacing that of Stokes. Stokes appeared as a "gentleman" in the directories until 1810, when he was listed again as a merchant and printed a new label. In the following year, management of the store was taken over by his sons-in-law, Caleb Perry Wayne (1776–1849) and Charles Biddle, Jr. (1787–1836). This partnership dissolved in 1822, and Biddle continued to operate a store on that site until 1826.[2]

1. Looking glasses labeled by Stokes include arched-crest frames (Montgomery 1966, no. 221; Strickland 1976, fig. 1; *Antiques* 110 [July 1976], p. 63), pediment frames (DAPC 65.1626; *Parsons* 1939, no. 85), and pillar frames (Fig. 75; Hinckley 1953, no. 1100).
2. Ring 1981, pp. 1184, 1192, 1194.

177

LOOKING GLASS ONE OF A PAIR

Probably England, 1770–1800

Sylvestris pine (frame members, finial); spruce (splines)

85.7 (71 without finial) x 50.2 (33 3/4 [28] x 19 3/4)

The Mabel Brady Garvan Collection, 1946.405A

Structure: The frame is composed of four curved pieces with rabbets cut into either end. The pieces are butted together and a curved spline is glued over the rabbets. A curved strip of wood is glued on the backs of the top and bottom splines. The glass was held in place by blocks glued to the frame.

Condition: The exterior surface of the frame originally was gilded and is now covered with gold paint. A section of the frame's front surface has been replaced at the bottom center. The finial is contemporary with the frame but probably not original to it. All of the blocks securing the glass have been removed. The glass has been resilvered and may be original. The backboard is a replacement.

Reference: Davis 1947, p. 73.

Provenance: According to Orlando Ridout IV, this looking glass and its mate are the "two antique gilt oval mirrors . . . which were hung between the two pairs of library windows at Whitehall" (Ridout to George J. Corbett, August 26, 1949, Ridout correspondence file, Box 17, FPG-AAA). One of the grandest houses in Colonial Maryland, "Whitehall" was built near Annapolis between 1765 and 1775 by Governor Horatio Sharp. It was acquired in 1790 by the Ridout family, which sold the house and most of its contents in 1894. Garvan purchased furniture remaining at "Whitehall," including the two oval looking glasses, in 1931.

The provenance of this pair of looking glasses suggests that it was acquired by the Ridout family after they purchased "Whitehall" in 1790. An almost identical frame was labeled by William Duffour of London between about 1770 and 1784.[1] Oval looking glasses, introduced during the Colonial period, became primary emblems of the Neoclassical style in the United States during the Federal period. In 1775, one New York City looking-glass maker announced: "Any Lady or Gentleman that have Glass in old fashioned frames, may have them cut to ovals or put in any pattern that pleases them best."[2] John Parkinson of Charleston, South Carolina, advertised in 1783, "Large square glasses cut so as to make a pair of ovals or girandoles, of the newest fashion."[3] A pair almost identical to the Art Gallery's was imported from France by Stephen Girard of Philadelphia in 1798; another pair was depicted in Ralph Earl's 1790 portrait of the Angus Nickelson family of New Milford, Connecticut.[4] More elaborate oval frames with composition crests were purchased in 1790 and 1791 by George Washington for use in his homes at Philadelphia and Mount Vernon, and in about 1800 by Charles Phelps, Jr., of Hadley, Massachusetts.[5]

1. Wood 1968, fig. 3; *DEFM*, p. 258.
2. Advertisement of Minshull's Looking Glass Store, *New York Journal*, March 16, 1775, p. 3.
3. *The South-Carolina Weekly Gazette*, April 12, 1783, p. 1.
4. Schiffer 1983, no. 490; Mayhew/Myers 1980, pl. 7.
5. Fede 1966, pp. 46–47; Wadsworth 1985, no. 158.

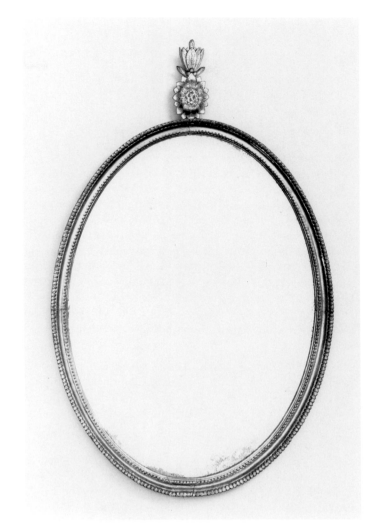

176 177

176 *Label*

178

LOOKING GLASS *Color plate 13*

Probably England, possibly America, 1790–1810

Spruce (frame members), sylvestris pine (frame moldings), eastern white pine (crest and bottom ornaments)

128.7 x 61 (50 5/8 x 24 1/8)

The Mabel Brady Garvan Collection, 1930.2784

Structure: The four frame members are lapped together at the corners. A gadrooned molding is applied over the frame's outer edge. The beaded inner molding is carved on strips nailed to the frame's inside edge. The eight rectangular sections of glass covering the front of the frame are fitted between the beaded and gadrooned moldings. The crest and base are composed of carved wood ornaments applied with wax to a wire framework that was tightly wrapped with twine before being worked into shape. The central elements of the crest and base are glued to blocks glued into slots in the frame. The scrolled side pieces are attached to the frame with wire loops. The pendant vines of molded composition are anchored with wires to the frame's side members.

Condition: At one time the back of the frame was covered with block printed wallpaper that subsequently was covered with a layer of newspaper. The glass is original and has crizzled due to its high alkali content. All of the interior glue blocks and the backboard are replacements.

The frame was cleaned and stabilized by Larry Price in 1987. Price reproduced the tip of the right leaf on the top plume, the left scrolled leaf supporting the drapery, the individual leaves on the left vertical branch in the crest, two of the leaf elements on each pendant vine, and the terminating leaf of the left base scroll. He also regilded the front moldings.

This superb looking glass was created from three different designs in George Hepplewhite's *Cabinet-Maker and Upholsterer's Guide*, first published in 1788. The crest is a combination of the urn from one design and the flanking scrollwork from the adjoining illustration (Fig. 69); the base was derived from a design in the preceding plate (Fig. 70). The fact that the maker used elements from these three adjacent images suggests that he was working directly from a copy of Hepplewhite's book. Far from being a jumble of elements, the resulting looking glass epitomizes the harmonious balance, delicacy, and "movement" that Adam and other early Neoclassical designers sought to create.

Although the maker's skill is apparent, his nationality is not. The moldings enclosing the glass plates are spruce and sylvestris pine, whose European and American species cannot be distinguished, whereas the carved elements of the crest and base are North American white pine. These woods raise three different possibilities as to the frame's origin: it could have been made in England by a craftsman who preferred to use imported white pine for carving; the rectangular frame could have been made in England and the carving added after its arrival in the United States; or the entire frame could have been made in America of native woods and imported glass. Looking glasses of similar if less sophisticated design were labeled by P. Vannuck, who worked in Salem, Massachusetts, between 1808 and 1809 and James Todd of Portland, Maine, between 1820 and 1831.[1]

1. Rodriguez Roque 1984, no. 121; Montgomery 1966, no. 230.

179

LOOKING GLASS

Probably England, 1790–1820

Scots pine (frame members; brace behind crest), unidentifiable wood of the genus *Tilia* (crest ornaments)

80.7 x 39.3 (31 3/4 x 15 1/2)

The Mabel Brady Garvan Collection, 1930.2598

Structure: The four frame members are lapped together at the corners. The carved molding is applied to the front of the frame. The crest is composed of carved wood ornaments glued to a wire framework that was wrapped with twine before being worked into shape. A rectangular brace applied to the column's back is glued into a slot in the top frame member. This joint is reinforced by a small glue block on either side of the brace. The scrolled side elements are attached to the frame with gesso.

Inscriptions: "2 1/4 Books" is written in pencil in a late nineteenth- or twentieth-century hand on the outer strip at the back of the frame's upper right corner. "The Litchfield/Historical/Society/=" is printed on a label applied to the outer strip at the frame's lower left corner, and "B/38" and "5165" are written on it in ink. "# 457.R" and "560" are written in chalk on the backboard, and "# 74" is typed on a gummed label affixed to the backboard.

Condition: The frame has been regilded, and the surfaces of several leaves have been reworked. The leaf at the center top of the crest is a replacement, and the wire loop may not be in its original configuration. The left block securing the crest ornament is lost. The interior blocks are replacements. Thick wooden strips with champfered outside edges were nailed to the back of the frame at a relatively late time in its history. The beveled glass is possibly original. The backboard is a replacement.

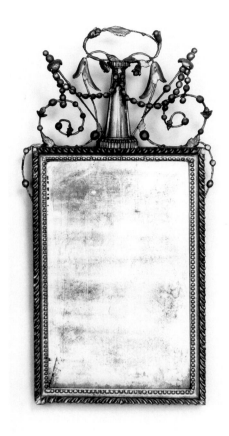

179

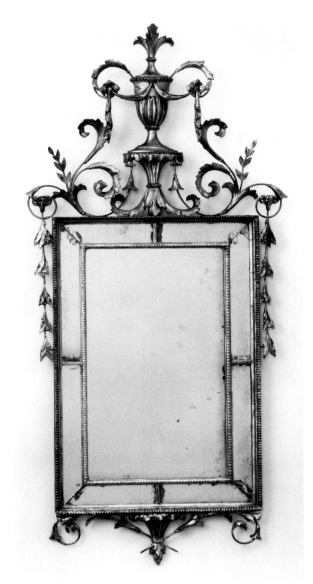

178

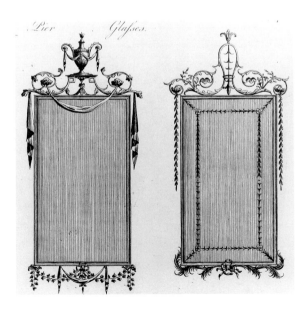

Fig. 69. *Left*, George Hepplewhite, *Pier Glasses* (detail), from *The Cabinet-Maker and Upholsterer's Guide*, 1788.

Fig. 70. *Right*, George Hepplewhite, *Pier Glasses* (detail), from *The Cabinet-Maker and Upholsterer's Guide*, 1788.

This looking glass is a less expensive version of the type exemplified by cat. 178. Using stock moldings, with the gadrooning facing in one direction, the maker built the frame around a standard-size glass plate of 49.5 x 29.2cm (19 1/2 x 11 1/2 in.; see cat. 170).

180

LOOKING GLASS *Color plate 15*

Attributed to John Doggett (1780–1857)

Roxbury, Massachusetts, 1802–25

Eastern white pine (carved ornaments, frame members; backboard, glue blocks, braces behind leaf carving), birch (rope molding; braces behind eagle and dolphins)

184.2 x 97.1 (71 1/2 x 38 1/4)

The Mabel Brady Garvan Collection, 1931.316

Structure: The frame comprises four laminates. The back layer is composed of four identical curved pieces joined by wedge-shaped pieces at the top, bottom, and centers of the sides. The next layer appears to be composed of at least five randomly fitted curved pieces. A third layer appears to be composed of curved, uniform pieces butted together; the construction of the front molding is probably the same but cannot be verified. The stepped inner molding and raised bead molding are applied to the front. A twist that may possibly be made from a single piece of mahogany is nailed into the cavetto. The central crest ornaments are screwed onto a vertical brace screwed into the back layer of the frame. The scrolled foliage is screwed to semicircular strips of wood screwed onto the top of the frame. The base is screwed to a vertical brace screwed into the frame's back layer. The backboard is nailed over the frame.

Inscription: "LYMAN ALLYN / MUSEUM / —" is printed on a paper label pasted onto the back of the eagle's neck; "1932.19" is written in ink on the label.

Condition: All of the braces behind the crest and base ornaments are replacements. Two pieces of the foliage have been broken and repaired with metal strips, and the lower end of the left piece of foliage is lost. The glass is probably original, although all the glue blocks securing it are replacements.

References: Fales 1958, pl. 40b; Comstock 1962, no. 505.

Provenance: Garvan purchased this looking glass from Henry V. Weil. A copy of his catalogue card is inscribed "Derby Family—Salem," together with Weil's name and the price paid for it ("Mantels Mirrors & Miscellaneous" Book, Box 23, FPG-AAA). The Derby family of Salem, Massachusetts, included

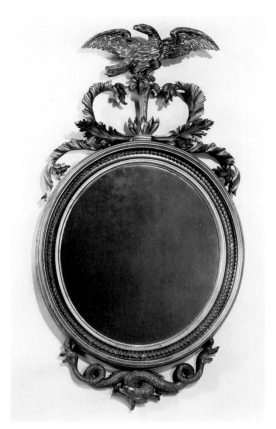

180

Fig. 71. John Ritto Penniman, Label of John Doggett, 1802–17. Engraving. Private collection.

several members of sufficient wealth to commission this looking glass (see cat. 12); as noted below, John Doggett did extensive work for Elizabeth Derby West, including at least two large looking glasses with carved eagles. Garvan purchased an equally imposing looking glass with associated pier table (cats. 12, 186) from Weil that had equally vague Derby provenances.

At the turn of the nineteenth century, the Neoclassical "plume" frame was developed into a form with larger moldings, bolder carving, and more archaeologically accurate classical motifs. Based on English prototypes (see cat. 181), this looking glass is not only an outstanding example of the later type, but one of the greatest looking glasses of probable American manufacture before 1850. The large scale of the crest and base are designed to suit the frame's monumental size. The contrasting textures of the eagle's feathers, dolphins' scales, and foliage are rendered with exceptional skill. The eagle's spread wings, the dynamically curled foliage, twist molding, and tightly entwined dolphins all create a sense of energetic movement around the frame.

This looking glass can be attributed with some certainty to John Doggett of Roxbury, Massachusetts. Two equally large oval looking glasses with eagle crests are documented as his work: one is labeled and the other is almost certainly the "Ovel Looking glass with carved ornaments" that Elizabeth Derby West purchased from Doggett on May 27, 1809, for the substantial price of $110.[1] Mrs. West commissioned five looking glasses from Doggett in 1809, another of which probably was the circular looking glass for a chest of drawers with twist and frame moldings identical to those on the Art Gallery's frame.[2] Very similar carved foliage is found on the case for a gallery clock that Doggett and his partner Samuel Doggett, Jr., presented to their church on March 20, 1820.[3] Moreover, a design of a circular looking glass with the identical eagle and entwined dolphins was used on Doggett's label (Fig. 71). Charles Montgomery suggested that this illustration was intended to show the type of technically sophisticated work, such as the curved frame and twist molding on the Art Gallery's looking glass, that Doggett's shop could produce.[4]

John Doggett's "Looking Glass and Picture Frame GILDING FACTORY" was one of the largest such enterprises in the United States. A surviving daybook for the years 1802 to 1809 documents a shop of carvers and gilders who made looking glasses, picture and embroidery frames, clock cases, and bed and window cornices; like many craftsmen, Doggett also sold such diverse goods as frame components, glass plates, artist's supplies, pewter, prints, furniture, and casks of beer.[5] The crest and base of the Art Gallery's looking glass were executed by different carvers, as would be typical for a shop of this size. In 1817, Dog-

gett formed the partnership of John Doggett and Company with Samuel S. Williams and Samuel Doggett, Jr., which continued until 1854. Imported carpeting became a major element of the business after the early 1820s, as documented in a letterbook for the years 1825 to 1829.[6]

1. Owned by Israel Sack, Inc., in 1955 (DAPC 1961.1); Hipkiss 1941, no. 142; Doggett Daybook, p. 243.
2. Doggett Daybook, pp. 231–36, 243; Clunie/Farnam/Trent 1980, no. 29.
3. Reproduced in Husher/Welch 1980, fig. 5.18.
4. Montgomery 1966, p. 256.
5. Doggett Daybook, pp. 39, 77, 85, 139, 163, 183, 189, 234. See also pp. 295–96, above; Swan 1929.
6. Doggett Letterbook; Ring 1981, p. 1183.

181

MIRROR

Edward Willton (active c. 1823–c. 1850)

Portsea, Portsmouth, England, 1823–30

Sylvestris pine (frame moldings; backboard), spruce (inner ring around glass), eastern white pine (carved drapery, dolphins, anchor), alder (turned crest ornaments)

125.7 x 89.3 (49 1/2 x 35 1/8)

The Mabel Brady Garvan Collection, 1946.403

Structure: The deep outer frame is composed of four layers, each of which is made up of four or more curved pieces butted together. A vertical brace for the carved crest ornaments has been fitted into the frame's back layer at the top. The coronet and shield are nailed and glued to blocks screwed to the brace from behind. The ornaments on either side are glued and nailed to replacement blocks on either side of the central brace. The carved drapery is nailed and glued to both sides of the frame. The base ornament was originally supported by a vertical brace fitted into the bottom of the back layer. The shallow inner frame is composed of six laminates and nailed to the outer frame's inside edge. The glass is secured with blocks glued to the inner frame. The original backboard is composed of four pieces of wood butted together vertically and is nailed to the outer frame.

Inscriptions: "Top" is painted into the silvering on the back side of the glass. An indistinct chalk drawing and a small fragment of a printed paper label survive on the backboard's inside surface. Two different coronets and several reverse curves are drawn in chalk on the outside surface. Above these drawings are the remnants of the center and right thirds of a paper label: "[. . .G]OLDEN HOPE, / [. . .]*Street, corner of White's Row, Portsea. /*

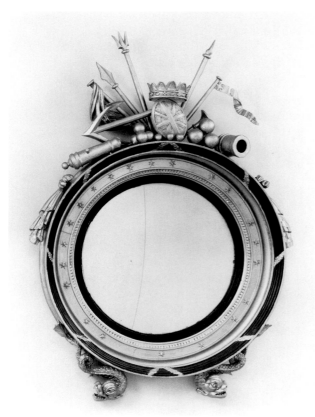

181 *Backboard*

181

181 *Label*

[. . .] WILLTON, / [. . .*Gi*]*lder, Looking Glass & Picture Frame* / [. . .] *M*[*an*]*ufa*[*cturer?*] / [. . .] *Needle W*[*ork*] [. . .] n [. . .] and *Prints* / [. . .] and p[. . .] Old Paintings / [. . .] and [. . .] care, Drawings / [. . .]ur man [. . . .] / / E[. . .] ca[. . .]erve to his Friends th[. . .] / is a [. . .]r, having serve [. . .] / ship [. . .]e[. . .] London; and to [. . .] / mor[. . .]ly o[. . .]racity of the ab[. . .] / inspect his C[. . .] in the different st[. . .] / must necess[ari]lly pass in Manufactu [. . . .] / / Frames [. . .]aments of every d[. . .] / equal [. . .] looking [gl]asses re-polis[hed] / with [. . .] or exp[ens]e of sending to / [. . .]e first [st]yle, on the sh[. . .] / [. . . t]erms, for ready Money."

Condition: The original gilding is almost entirely covered with gold paint. Apart from the shield and coronet, the crest ornaments have been reattached and do not appear to be in their original arrangement. A carved patera with a bow knot, formerly attached above the coronet, is not original and has been removed. Eight of the stars applied to the front surface are now missing. The carved drapery is either reattached to the sides or a later addition. The frame probably had sconce arms when it

was made; two pairs of scrolled sconce arms added to the frame in the twentieth century have been removed. The brace behind the base ornament has been cut off, and it seems probable that part of this ornament is now missing. The dolphins may be original but have been reattached to the frame. The glass appears to be original. Most of the surviving blocks have been reattached with nails.

Provenance: Henry Hammond Taylor acquired this mirror in Portland, Maine, "where it had been in a private family as long as anyone could remember" (card files, FPG-Y). Taylor sold the mirror to Garvan on September 16, 1929.

The most popular version of later looking glasses with openwork crests was the circular mirror made in enormous numbers beginning in the 1790s, when English glass houses discovered the technique of making convex glass.[1] In addition to the heavier moldings and three-dimensional carving typical of the later Classical Revival, mirrors such as this example were distinguished by their reeded and ebonized sight edges, sconce arms, and applied ornaments within the frame moldings. Many

frames of this type were owned in the United States, but very few can be connected to American makers. Two bear labels used by Isaac L. Platt of New York City between 1815 and 1821, although they may have been imported.[2] Another New York City maker, John A. Butler, illustrated this type of mirror on the label he used in 1818–19.[3] Among the documented examples are a pair purchased by Solomon Etting of Baltimore between 1803 and 1842, a pair acquired by Stephen Van Rensselaer IV of Albany around 1817, and a more elaborate version owned about 1816 by the Kettell family of Charlestown, Massachusetts.[4]

The dolphins, tridents, cannon, and other naval emblems on this mirror were popular motifs on English furniture during the first quarter of the nineteenth century, inspired in part by Lord Nelson's victories at sea. As early as the 1760s, however, Matthias Lock had designed looking-glass frames with the same nautical devices.[5] The crowned shield with the Union Jack on this frame is an explicit reference to the British navy that makes the mirror's purported history of ownership in the United States seem unlikely. It is possible, however, that this symbolism did not matter to some American customers, whose primary interest probably was in the mirror's size, the major factor affecting its cost. Patriotic English terminology was used in the United States without alteration: the spheres applied to Neoclassical frames were called "Nelson Balls" in an 1805 advertisement of John and Hugh Finlay of Baltimore.[6] This association of the spheres with Lord Nelson's cannon balls persisted in the United States into the twentieth century.[7]

1. Wills 1965, pp. 34–35. See p. 294, above, for a discussion of the term "mirror."
2. Ring 1981, pp. 1190–91.
3. Private collection (DAPC 63.994).
4. Weidman 1984, no. 105; The Metropolitan Museum of Art, New York (no. 1974.365.1–2); Kettell 1929, no. 201.
5. Victoria and Albert Museum, London, Lock drawings nos. 43, 87, and 167.
6. *Federal Gazette and Baltimore Daily Advertiser*, November 8, 1805, p. 3.
7. Carrick 1922a, p. 165; Carrick 1922b, p. 11.

Pillar Looking Glasses

Pillar looking glasses represent a facet of the Neoclassical style different from the fanciful frames with openwork crests (cats. 176–181) of the late eighteenth century. Many early nineteenth-century English designers found the latter type of frame inconsistent with the style's emphasis on decorum and rationality. J.C. Loudon wrote in 1833:

Chimney and pier glasses, being comparatively fixtures, and belonging more to the permanent or constructive Architecture of the room, *than to the furniture, ought, in our opinion, to be treated in a different manner from what they generally are. Their frames ought to be plainer, and more architectural; and rather to harmonise with the architraves of the doors and windows, and the marble of the chimneypieces, than, as they now do, chiefly with the gilt frames of the pictures. . . . Perhaps there is no piece of furniture, put up by the London upholsterers, which is more generally in bad taste than lookingglasses; and this arises, as it appears to us, from . . . an excessive love of ornament.*[1]

On pillar looking glasses, the glass plate was framed at the top by a carved or painted panel with a projecting cornice, on the sides by pilasters with classical capitals, and on the bottom by a narrow molding with projecting corners beneath the pilasters. All these parts embodied the architectural qualities praised by designers such as Loudon, and the name by which these looking glasses were known—"pillar" or "pillared"—underscored this architectural character.[2] The pilasters on the frame suggested those of a room, just as the cornice molding mimicked a ceiling's cornice. The carved or reverse-painted glass panels below the cornice were equated with the frieze of a classical entablature; William Voight of New York City announced in 1803 that he had imported "Elegant Gilt Frames, with pillars, balls, enamelled frieze and eagle-tops of all sizes."[3] The trusses that frequently flank the frieze were taken from door and window frames in books of architectural designs published by James Gibbs, Batty Langley, Sir William Chambers, and others.[4] Even the spheres applied to the cornices of many examples, known as "balls" in contemporary sources, are suggestive of the dentils in a Doric entablature.

Pillar looking glasses first appeared in England during the last decade of the eighteenth century. The earliest designs known to the writer were published by Thomas Sheraton in 1793 (Fig. 72), but within five years the form had achieved sufficient popularity to be included in an illustration for *The Ladies New Memorandum Book*, a magazine of fashion and romantic fiction.[5] Documented English examples were sold by the London looking-glass makers Thomas Fentham, who labeled one frame between 1794 and 1820, and William Gould and Son, who worked together from 1796 to 1840.[6] A pillar looking glass labeled by James Stokes of Philadelphia between 1791 and 1804 (Fig. 73) is among the earliest frames of this type with a history in the United States. The form appears to have achieved its greatest popularity in this country after 1800. Most labeled American examples were made after that date (see cats. 182, 183), and many others have reverse-painted glass panels commemorating events of significance in the early nineteenth century, such as the death of George Washington on December 14, 1799.[7] Pillar looking glasses from the first two decades of the nineteenth century (cats. 182–185) have the delicate propor-

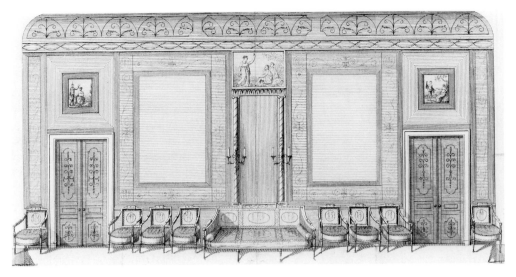

Fig. 72. G. Terry after Thomas Sheraton, *A Plan & Section of a Drawing Room* (detail), from *The Cabinet-Maker and Upholsterer's Drawing Book*, 1793.

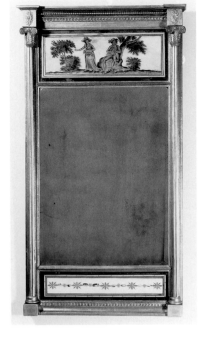

Fig. 73. Looking glass, sold by James Stokes, Philadelphia, 1791–1804. Pine. Private collection.

tions and low relief ornament characteristic of earlier Neoclassical frames with openwork crests (cats. 176–179). After about 1820, pillar looking glasses were made with heavier moldings and more sculptural ornament (cats. 187–191), reflecting the preference for bolder forms and more explicit references to ancient sources characteristic of the second phase of the Classical Revival, as seen on other Neoclassical frames (cats. 180, 181). The inventory of Horace Jones' looking glass shop in Troy, New York, taken in 1828, included "heavy gilt frames ball tops," and his label illustrated this type of looking glass.[8]

Pillar looking glasses in the earlier and later Neoclassical styles were made with both gilt and natural hardwood surfaces. The label on a hardwood pillar frame by Nicholas Geffroy of Newport between 1800 and 1810 described "LOOKING-GLASSES, of the newest fashions, in gilt and mahogany frames, double and single pillar, gilt frames, pillar and plain; mahogany do [ditto]."[9] The inventory of the looking-glass maker William I. Tillman of New York City, taken by his fellow craftsman Bartholomew Plain in 1815, listed both gilt frames, including seven "Twisted Pillar frame Glass[es]" and one "Double pillar Double Cornice Glass," as well as mahogany frames, such as one "Piller frame Glass" and five "Pillester fram[es]."[10] Hardwood frames were considerably less expensive than their gilded coun-

terparts; a mahogany pillar looking glass was purchased for $7 from Elias Thomas of New York on March 29, 1820, whereas a gilt frame on the same invoice cost $17.[11] The inventory of George Smith's shop in Baltimore, taken two years later, valued one gilt looking glass at $10 and a dozen mahogany frames at $9.[12] In addition to economy, hardwood frames undoubtedly were popular because they harmonized with Neoclassical furniture with monochromatic hardwood surfaces and gilt accents.

English pillar looking glasses were exported to the United States, as indicated by the advertisement of William Voight cited above. An elaborate pillar frame made of sylvestris pine, with a painted glass frieze commemorating Washington's death, was owned by Kirk Boott (1755–1817), an English-born dry goods merchant in Boston who may have ordered it from England through his mercantile connections.[13] Unlike earlier styles of looking glasses, however, a high percentage of pillar frames appears to have been made in this country. A sizable quantity survives with the labels of American "Looking Glass Manufacturers," and the documented frames that have been microanalyzed are usually made of North American eastern white pine. The inventories and accounts of American looking-glass makers include large stocks of the moldings, "twists," and balls used to make frames.[14] Perhaps most indicative of Ameri-

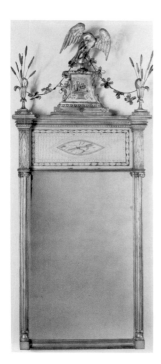

Fig. 74. Looking glass, probably New York City, c. 1800. Pine. Museum of the City of New York, Gift of Mrs. Giles Whiting.

type; a similar frame probably was made in New York City or Albany soon after 1806.[17] Philadelphia pillar frames have narrower cornices and more attenuated proportions than those made in New England or New York. They are generally more embellished with surface carving and applied decoration than New England examples but do not have the crest ornaments found in New York. Some frames have reverse-painted glass panels inserted above and below the mirror plate, such as the one sold by James Stokes between 1791 and 1804 (Fig. 73). A large pillar looking glass of this type was owned by Louis Clapier (d. 1837) of Philadelphia.[18] There appears to have been a greater preference for hardwood pillar looking glasses in Philadelphia, as a majority of the documented examples were labeled by makers or retailers in Pennsylvania and Maryland.[19]

1. Loudon 1833, p. 1073.
2. The advertisement of John Fondey and Jellis Winne in *The Albany Gazette*, June 23, 1808, referred to "Twisted, single and double Pillared Gilt LOOKING GLASSES."
3. *Mercantile Advertiser* [New York], November 25, 1803, p. 2. Reverse-painted glass panels were called "enameled Glass" in some contemporary sources; on the label affixed to cat. 182, Cermenati and Monfrino advertised "enamelling" by inserting the word in the upper panel of a looking glass.
4. Gibbs 1728, pl. 105; Langley 1750, pl. 46; Chambers 1791, pl. facing p. 110.
5. Reproduced in Rothstein 1987, n.p. Another design by Sheraton is illustrated in Sheraton 1802, pl. 52.
6. Schiffer 1983, no. 566; PB Eighty-Four 1980, no. 641. Another labeled Fentham frame is illustrated in *Antiques* 137 (January 1990), p. 145. For Fentham and Gould and Son, see *DEFM*, pp. 296, 360. English pillar frames, one with a painted frieze featuring Britannia, are illustrated in Cescinsky 1929, p. 226.
7. Montgomery 1966, no. 240.
8. Ring 1981, fig. 7.
9. Rhode Island Historical Society, reproduced in *Antiques* 118 (September 1980), p. 418.
10. Montgomery 1966, p. 257.
11. *Antiques* 32 (July 1937), p. 42.
12. Hill 1967, II, p. 216.
13. Skinner 1991, no. 160.
14. Doggett Daybook, pp. 1, 198, 220; Montgomery 1966, pp. 256–57, 280.
15. Montgomery 1966, p. 257.
16. *Mercantile Advertiser* [New York], November 25, 1803, p. 2; *The Albany Gazette*, June 23, 1808.
17. Rice 1962, p. 48. The association of Fig. 74 with Joseph Yates was questioned by the late Margaret Stearns. It apparently was purchased by Mrs. Giles Whiting from an auction of objects consigned by the dealer Harry Arons of Ansonia, Connecticut, who had acquired several pieces of furniture from a descendant of Yates (Deborah Dependahl Waters to the author, January 11, 1991, Art Gallery files). Arons sold at least two other, similar looking glasses with the same provenance to different clients (Montgomery 1966, no. 235; Flanigan 1986, no. 96).
18. Philadelphia 1976, no. 181.
19. Strickland 1976, figs. 4–6.

can manufacture, however, are the differences that exist among pillar looking glasses made in the New England, New York, and Philadelphia regions between 1800 and 1820. Although not every frame made or owned in each of these areas is similar in appearance, specific regional preferences appear to have governed the frames' production or purchase.

The characteristic New England pillar frame is represented by five looking glasses in the Art Gallery's collection (cats. 182–186). Fewer labeled frames survive from the mid-Atlantic states, but distinct types for the New York and Philadelphia regions emerge from the documented examples. Pillar looking glasses made or owned in New York frequently have carved surface decoration and elaborate crests composed of carvings, composition foliage, garlands of balls, and reverse-painted panels in geometric shapes. These richly ornamented frames were probably what Bartholomew Plain described in his 1815 inventory of William Tillman's shop as "Double pillar Double Cornice Glass" and "Plum[e] Pillar frames."[15] Crest ornaments were also referred to as "tops," as in William Voight's listing of "eagle-tops" or John Fondey and Jellis Winne's advertisement for looking glasses "with and without tops."[16] A pillar looking glass purportedly owned by Joseph C. Yates (1768–1837) of New York City (Fig. 74) is characteristic of this

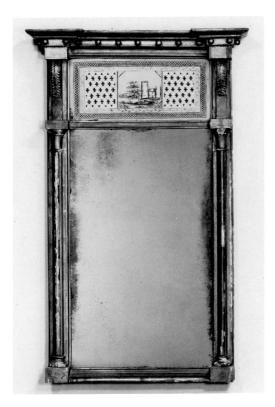

182

182 *Label*

Fig. 75. Batty and Thomas Langley,
A Gothick Colonade (detail),
from *Gothic Architecture
Improved by Rules and Proportions,*
1747.

182

LOOKING GLASS ONE OF A PAIR

Paul Cermenati and G. Monfrino (in partnership, 1806)
Boston, 1806
Eastern white pine
102.2 x 61.3 (40 1/4 x 24 1/8)
The Mabel Brady Garvan Collection, 1930.2725A

Structure: The top and bottom members of the frame proper are tenoned into the sides. The cornice is built up out of several superimposed moldings, with the projecting corners built up over rectangular blocks nailed to the side frame members. A molding with a cavetto and projecting square profile is glued to the top frame member. The balls are attached with wires to strips glued over the projecting square molding, and an ogee molding is applied at the top. The divider between the plates of glass is fitted into a slot cut into each side member. The consoles, pilasters, capitals, and bases are applied to the side frame members. Rectangular blocks are nailed from behind to the side members. An ogee molding with carved beading is applied to the bottom member's front surface. The glass plates are secured

with blocks. The backboard has feathered edges and is nailed over the back of the frame.

Inscriptions: "X 233 / — / 2" is written in crayon in twentieth-century script on the outside of the backboard. A printed paper label is pasted onto the backboard: "Ladies needle work fram'd and Glaz'd in the neatest manner. / *Cermenati & Monfrino,* / CARVERS, GILDERS, PICTURE FRAME and / *Looking Glass Manufacturers* / No. 2. STATE STREET / *South side of the old State House* / Boston / *Where they keep constantly for sale a large and / elegant Assortment of Looking Glasses, Prints / & c, from the best Masters in Europe. / Also* Telescopes, Barometers and Thermometers / *made and Repaired in the / best manner.* / Old Looking Glass new Silvered."

Condition: The backboard and glass plates are original, as are the blocks securing the glass. Attempts have been made to regild damaged areas of the surface, particularly on the capitals.

Reference: Nutting 1928, II, nos. 2964, 3074–75.

Provenance: In 1925, what appears to be this looking glass was illustrated in an advertisement for Israel Sack (*Antiques* 8

[November 1925], inside front cover). When the pair was published in Nutting's *Furniture Treasury* three years later, it was credited to the Boston antiques dealers Flayderman and Kaufman. Garvan purchased the looking glasses from Charles Woolsey Lyon on March 5, 1929 (Lyon file, FPG-AAA).

This pair of looking glasses and the following three examples (cats. 183–185) are characteristic New England pillar frames: they are relatively plain in appearance, with reverse-painted glass panels and thin twist moldings as the dominant decorative details. A great number of nearly identical frames were labeled by other New England craftsmen, including Barnard Cermenati of Newburyport, James M'Gibbon of Boston, and Nathan Ruggles and Azell Dunbar of Hartford.[1] This widespread similarity is undoubtedly due in part to the fact that most of these makers purchased the component parts of their frames from the same sources. John Doggett of Roxbury was one of the leading suppliers of such parts (see cat. 180); he sold Cermenati and his partners frame moldings and balls in four different sizes.[2] Reverse-painted glass panels were executed by specialists such as John Ritto Penniman, who painted seven "tablets" for Doggett in 1803 and ten in 1805.[3] The labels used in Boston by both Cermenati and Monfrino and Cermenati and Bernarda advertised "Enamelling," which suggests that the tablets in their looking glasses were executed in their shops.[4]

The clustered-column pilasters used on this pair of pillar looking glasses are reminiscent of those on medieval buildings. Designs for "five new Orders of Columns . . . in the Gothick manner," all featuring clustered columns, were published in London by Batty and Thomas Langley in 1747.[5] The Langleys' design of the same date for a colonnade with a flat cornice, balls in the frieze, and clustered columns on high bases (Fig. 75) anticipates these pillar looking glasses by almost half a century. Although "Gothick" pillars may seem incongruous with the Neoclassical style, their presence may be explained by the same taste for the picturesque that inspired the landscapes with medieval castles in the reverse-painted panels. According to Sheraton's *Cabinet Dictionary* of 1803, the 28 x 16-in. (71.1 x 40.6cm) glass plates in this pair of frames were the smallest size of "Glasses for piers" that "are made up for sale," and the partnership of Cermenati and Bernarda advertised ready-made looking glasses of the same size.[6]

Paul Cermenati, John Bernarda (see cat. 183), and the otherwise unidentified G. Monfrino were probably Italian immigrants skilled as carvers and gilders.[7] Over a three-year period, John Doggett acquired large quantities of gold size and books of gold leaf from Paul Cermenati, which suggests that he had established a reputation as a gilder.[8] Like the Del Vecchio family in New York City (cat. 170), the different partnerships formed by these Italians produced English-style looking glasses to suit their clients. The chronology of these partnerships is documented by Doggett's daybook, newspaper advertisements, and other records. John Bernarda was listed as the proprietor of a "picture shop" in the 1803 Boston directory, where he probably made frames and kept a stock of prints.[9] In February 1805, Bernarda had Paul Cermenati as his partner in a shipment from London of looking glasses and "a large assortment of PRINTS, by the best artists in Europe."[10] One year later, Cermenati announced the formation of a partnership with G. Monfrino; Doggett's accounts with this partnership began on February 26, 1806.[11] The partnership of Cermenati and Bernarda was established by the beginning of 1807, and they made their first purchase from John Doggett on January 8.[12] Sometime after March 1807 they moved to Salem. On April 13, 1808, an announcement of the partnership's dissolution was published, although their account with Doggett was not closed until October 18.[13] The business in Salem was taken over by P. Vannuck, who left Salem by the end of 1809.[14] Cermenati returned to Boston and worked briefly on his own as a carver and gilder, continuing to purchase balls from Doggett. His final entry in Doggett's daybook, on May 19, 1809, is headed "Paul Cermenati & Co.", and at least two different labels of "P. Cermenati and Co." are known.[15]

1. Private collection (DAPC 65.875); Lyman Allyn Museum, New London, Connecticut (no. 1937.61); Western Reserve Historical Society, Cleveland (DAPC 82.234).
2. In the Doggett Daybook, accounts with Cermenati begin on p. 98 and conclude on p. 242, with numerous transactions in between.
3. Doggett Daybook, pp. 5, 8, 11, 86.
4. Cermenati and Bernarda's Boston label is identical, other than the partners' names, to the label used by Cermenati and Monfrino. A looking glass bearing this label is at Winterthur (Montgomery 1966, no. 224).
5. Langley/Langley 1747, pls. 1–16.
6. Sheraton 1803, pp. 235–36; *Columbian Centinel*, January 3, 1807, p. 1.
7. Although the nature of their kinship is unknown, Paul Cermenati undoubtedly was related to the looking-glass maker Barnard Cermenati, who worked between 1807 and 1818 in Newburyport, Salem, Boston, and Portsmouth, New Hampshire (see Ring 1981, pp. 1180–81).
8. Doggett Daybook, pp. 107, 118, 126, 135, 162, 174, 188, 206.
9. Ring 1981, p. 1181.
10. *Columbian Centinel*, February 6, 1805, p. 4.
11. *Columbian Centinel*, February 12, 1806, p. 1; Doggett Daybook, p. 104.
12. *Columbian Centinel*, January 3, 1807, p. 1; Doggett Daybook, p. 144.
13. *Essex Register*, April 13, 1808, p. 3.
14. *Essex Register*, November 15, 1809, p. 3.
15. Doggett Daybook, p. 242; *Boston Directory*, 1809, p. 35. One of the labels is illustrated in *Antiques* 107 (May 1975), p. 834.

183

LOOKING GLASS

Paul Cermenati and John Bernarda (in partnership, 1807–08)

Salem, Massachusetts, 1807–08

Eastern white pine (cornice, frieze board, frame members), birch (twist moldings, blocks behind capitals)

121.2 x 75.5 (47 3/4 x 29 3/4)

Charles F. Montgomery Collection, 1989.57.1

Structure: The four inside members of the frame are lapped together. The cornice is built up out of several superimposed moldings, with the projecting corners built up over blocks that are nailed to the side frame members. The balls are attached to the cornice with wires. The horizontal divider between the glass and the frieze board is made of a molded front surface nailed to a narrow strip of wood. This divider is fitted into notches in the side frame members. The sides are composed of three layers: the side frame member proper; a secondary strip with ogee moldings on either side that forms the sight edge on the inside; and the pilasters, capitals, and bases that are applied to this secondary layer. The capitals and leaf molding are composition, whereas the twists, balls, and bases are wood. The carved, lozenge-pattern tablet and the surrounding ogee molding are nailed to the frieze board, which is secured in the frame with nails. The twists are nailed into the tablet, cornice, pilasters, and base.

Inscriptions: "Miss Dunlap— / Hardy Street / Salem" is written in ink in an early nineteenth-century hand on the top surface of the cornice. A printed paper label is glued and nailed to the back side of the upper frame member: "CERMENATI & BERNARDA, / *Carvers, Gilders, Picture Frame and Looking Glass* / MANUFACTURERS—ESSEX STREET, *SALEM*, / Keep constantly for sale, at the most reduced prices, a / complete assortment of LOOKING GLASSES...PICTURE / GLASSES... PRINTS . SPY GLASSES...THERMOMETERS...draw- / ing PAPER...PAINTS . PENCILS, &c. &c.—with all kinds of / FRAMES in their line. / / ALSO, / *Ladies* Needle Work *handsomely framed in the most / modern style, and at the shortest notice.* / OLD FRAMES new gilded."

Condition: The original burnished gold leaf has been repaired and covered with a transparent varnish, creating a dark, matte surface. The section of twist in the projecting right front corner of the cornice is lost. The glass, backboard, and blocks are replacements; the original backboard was nailed over the back of the frame.

Reference: Ring 1981, fig. 1.

Provenance: The ink inscription on this frame identifies its original owner as either Sarah Stone Dunlap (1773–1855) or her daughter, Anstiss Stone Dunlap (b. 1799), of Salem, Massachusetts. After the death of her husband, the merchant James Dunlap (1767–1800), Sarah and her two children moved to the home of her parents, Captain Robert Stone (1744–1817) and Anstiss Babbidge Stone (1750–1834), on Hardy Street. In early nineteenth-century usage, "Miss Dunlap" could have referred to either the widowed Sarah or her unmarried daughter. In 1808, the year when this looking glass presumably was made, the eight-year-old Anstiss Dunlap was included on the list of tax valuations for the first ward of Salem, where her grandparents' house was located. No valuations were assigned to any income or real or personal property under her name, however (Tax valuations, 1808, p. 6v, City Clerk's Office, Salem, Massachusetts). It is possible that she received some kind of inheritance in this year, which may have occasioned the purchase of a new looking glass. Anstiss Dunlap married Benjamin Barstow in Salem on June 10, 1822. (Biographical information on the Stone and Dunlap families was drawn from *Salem* 1916, p. 267; *Salem* 1924, p. 318; Bentley 1881, p. 132; Bentley 1882, p. 28.) Nothing further is known of this looking glass' history until it was acquired by Charles F. Montgomery sometime prior to 1964; he apparently purchased it from the dealer Carl Jacobs of Deep River, Connecticut (DAPC 64.1007).

Almost all the surviving looking glasses labeled by Paul Cermenati and John Bernarda during their different partnerships were pillar frames. Excluding the present example, these pillar frames were very similar, with relatively modest proportions and reverse-painted glass panels in the frieze.[1] This consistency contrasts with the varied styles and quality of frames labeled by retailers such as James Stokes (cat. 176) and indicates that Cermenati and Bernarda probably made the looking glasses they labeled. Although the Art Gallery's looking glass is made from some of the same components as Cermenati and Bernarda's other frames, it is more elaborately ornamented, enlivened by textural contrasts between the twists, balls, capitals, and leaf molding. The lozenge-pattern panel creates a bold, architectonic effect that may reflect the influence of large-scale frames such as cat. 186. The present looking glass is also the only one known to the author with this particular label, one of two used by Cermenati and Bernarda during their residence in Salem.[2] Both Cermenati and Bernarda and their successor, P. Vannuck, advertised looking glasses with 34 x 20-in. (86.4 x 50.8cm) glass plates, the size used in this example, "mounted in the *best burnished* GILT FRAMES."[3] Looking glasses of this size were expensive; in 1808, John Doggett of Roxbury charged Edward Howe $100 for a pair of frames with 32 x 18-in. (81.3 x 45.7cm) plates.[4]

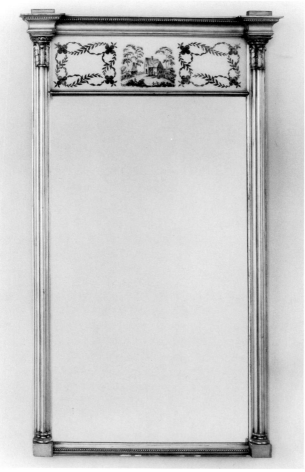

184

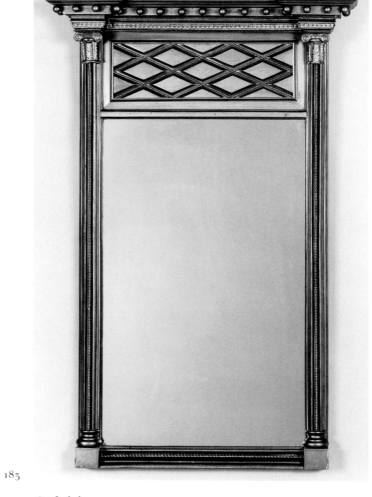

183

1. A Neoclassical arched-crest looking glass labeled by Cermenati and Bernarda is at Winterthur (Montgomery 1966, no. 224). Pillar frames by Paul Cermenati and Company are illustrated in *Antiques* 108 (July 1975), p. 15, and *Antiques* 123 (May 1983), p. 977. For information on the different partnerships formed by Paul Cermenati and John Bernarda, see cat. 182.

2. A looking glass with their other Salem label is reproduced in *Flayderman* 1930, no. 405.

3. *Columbian Centinel*, January 3, 1807, p. 1; *Essex Register*, April 13, 1808, p. 3.

4. Doggett Daybook, p. 206.

184

LOOKING GLASS

Probably New England, possibly England, 1805–20

Eastern white pine (side members of frame; backboard), sylvestris pine (top and bottom frame members, divider between pieces of glass)

108.9 x 62 (42 7/8 x 24 3/8)

Bequest of Millicent Todd Bingham, 1969.44.4

Structure: The side frame members are tenoned into the top, whereas the sides and bottom are lapped together with small pieces glued over the outside. The cornice moldings appear to be glued to the top frame member. A strip of beading is applied to the cornice. The projecting corners are built up over blocks applied to the top frame member. Small rectangular blocks are glued on top of the frame. A divider is fitted into slots cut into the side frame members. Pilasters are screwed to the sides from behind. The carved capitals and bases are probably glued to the sides. The projecting corners at the base are screwed to the bottom frame member, whereas the molding is glued to it. The strip of beading is applied to the molding. A three-piece backboard is nailed over the back of the frame.

Inscriptions: "Miss E M Goodwin / Care of / W.A. Merill [Morill?] / N[. . . H]aven / Conn." is written in ink on a piece of paper pasted on the top piece of the backboard. "FOSTER BROS., / Pictures & Frames, / 4 Park Square, / BOSTON." is printed on a paper label glued to the top frame member, and "163" is written in pencil on the same label. "163 Regild water gold slightly Ant" is written in pencil on the top frame member. "163" is also written on the back of the reverse-painted panel and the bottom backboard. "HTG / CO [encircled, within a square]" is stamped on the back of the glass. "34" is written in ink on the divider and the top, side, and bottom frame members. "34 x 19" is written in ink on the top and both side members. "3671" is written in ink on the top and left side members, and "3672" is written on the right side member. "670" is written in crayon and pencil on the bottom piece of the backboard.

Condition: The blocks of wood attached to the top may have anchored crest ornaments, although there is no evidence that anything was ever attached to them. The reverse-painted panel may be original, although the blocks securing it are replacements. The glass is a replacement, but the backboard is original. As the inscriptions indicate, this looking glass was taken apart, regilded with a "slightly Ant[ique]" finish, and reassembled. The work apparently was done at Foster Brothers, a firm specializing in prints and picture frames that was listed at the 4 Park Square address in city directories from 1903 until at least 1935. A Foster Brothers sales catalogue from the early twentieth century advertised "regilding of old mirrors and repairing and restoring of old frames" (Foster Brothers, inside back cover).

Provenance: At one time this looking glass apparently belonged to Eliza M. Goodwin of New Haven, who lived at the Trinity Church House, a home for the elderly at 165 George Street, from 1872 until her death in 1882 (*New Haven Directory*, 1872, p. 254; 1882, p. 141).

Both this frame and the preceding example were made for 34 x 20-in. (86.4 x 50.8cm) glass plates, a standard size during the early nineteenth century (see cat. 183). Although similar in size and design, these two looking glasses are markedly different in quality. The attenuated proportions, narrow moldings, and limited ornament of the present example seem inadequate to the object's overall scale, in contrast to Cermenati and Bernarda's frame. See also cat. 182.

This looking glass demonstrates the unreliability of using woods to determine an object's national origin. The frame appears to be a New England interpretation (see cat. 182) of an English design, with structural members made of both eastern white pine, an American wood, and sylvestris pine, which may be either an American or European species. The presence of sylvestris pine in an object has been cited traditionally as evidence of European origin; however, a table, clock, and two chests from eastern Massachusetts in the Art Gallery's collection have sylvestris pine as a secondary wood (see cat. 103). The present frame could have been made in Europe by a craftsman using imported American wood, or it could have been made in America by a craftsman using a native species familiar from his European training (see also pp. 295–96).

185

LOOKING GLASS

Probably New England, 1805–20

Eastern white pine

92.1 x 46.1 (36 1/4 x 18 1/8)

The Mabel Brady Garvan Collection, 1930.2069

Structure: The top and bottom members of the frame are tenoned into the sides. A molding with a twist nailed into it is applied to the top frame member. Rectangular blocks that are pieced out on the sides are applied to the side frame members. A molding is applied around the blocks' upper ends. Vertical moldings are applied to the side frame members. A divider with a molded strip nailed over it is fitted into a groove cut into each side member. Blocks are nailed to the frame's lower corners. A molding is applied to the bottom frame member. A brass ring hanger is screwed onto the back of the top frame member at its center. The glass plates are secured with blocks. The backboard is composed of two vertically joined pieces of wood with feathered outside edges and is nailed over the back of the frame.

Condition: The gilding, glass plates, and hanger are original. Most of the original blocks securing the lower plate survive; only two blocks securing the reverse-painted glass appear to be original.

Provenance: This looking glass was part of the collection Garvan acquired from R.T.H. Halsey.

This looking glass is identical, except for its reverse-painted panel, to one labeled by Barnard Cermenati while he was working in Newburyport between 1807 and 1809.[1] See also cat. 182.

1. Fales 1965, no. 50.

186

LOOKING GLASS *Color plate 18*

Possibly by Stillman Lothrop (d. 1853)
Salem, Massachusetts, 1804–06; Boston, 1806–c. 1832
Eastern white pine
190.8 x 99.4 (75 1/8 x 39 1/8)
The Mabel Brady Garvan Collection, 1930.2662

Structure: Tenonlike projections on the top and bottom frame members are fitted into grooves cut into the upper and lower ends of the four side members. A divider is rabbeted between the two inner side members. Both the cornice and the base are built around two rectangular blocks that are nailed to the ends of the side frame members from behind. The pillars' capitals and bases are attached to the corner blocks. The center of the cornice is a flat board that is glued to the top frame member. Flat pieces of wood are inserted between the vertical frame members and blocks at the top and bottom. A projecting square molding is applied at the top. A molding with a twist nailed into it is applied to the top of the cornice and the bottom frame member. The pillars are screwed to the side members from behind. The panel

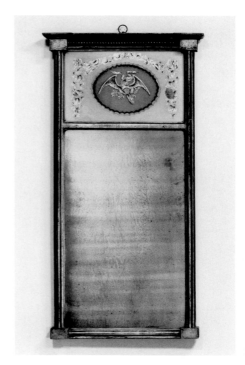

185

186

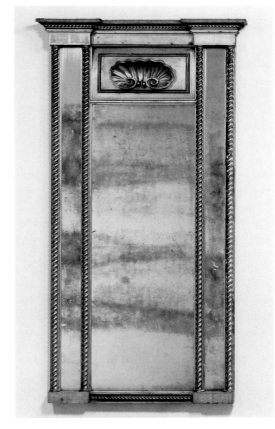

nailed into the upper section of the frame has a twist nailed around its edges and a carved shell screwed to its center. The three glass plates are held in place by glue blocks. A strip of wood is nailed across the back of the frame at the lower edge of the central plate. Two small backboards are nailed over the upper ends of the side glass plates. The lower part of the frame has a four-section backboard nailed over it.

Inscriptions: "Top," "Kemp [?]," and "JH" are painted into the silvering on the center glass plate.

Condition: The glass is original. A few glue blocks are missing but the remainder appear to be original. Early nineteenth-century wallpaper was pasted over the edges of the backboards and the inset panel.

Provenance: See cat. 12.

This imposing looking glass and at least four others appear to be made from the same component parts. A frame in the Bowdoin College Museum of Art is similar in composition to the Art Gallery's frame, with the same carved shell and molding of overlapping quatrefoils and rosettes on the outside edge of the cornice. The three other frames are similar to those at Yale and Bowdoin, although they have carved grapes instead of shells in their upper panels and lack the bases and capitals at either end of the twists. One of these looking glasses, purchased after 1900 in northern New England, has acorn-shaped drops on its cornice. Another has balls applied to the cornice and lacks the molding on the cornice's outside edge; it is labeled by George Dean of Salem, Massachusetts, who was the "AGENT IN SALEM, for S. Lathrop's [sic] Looking-Glass Manufactory." A similar frame labeled by Dean, with narrower twists set within cove moldings, is part of the furnishings of the Alexander House in Springfield, Massachusetts.[1]

The two documented frames suggest that this group of looking glasses were made by Stillman Lothrop, but the attribution of the Art Gallery's looking glass is tentative. George Dean, who operated a hardware store, may have retailed looking glasses made by many firms, advertising his connection with Lothrop because of the latter's renown. Lothrop's work, moreover, may not have had a distinct look, since he repeatedly purchased glass plates, balls, tablets, and even finished looking glasses from John Doggett of Roxbury over the six years covered in the latter's account book. On March 28, 1806, for example, Doggett billed Lothrop $26.90 for twelve looking glasses.[2] However, a looking glass of this example's exceptional size could only have been produced by one of a few large-scale shops. Lothrop noted on one of his labels that he "manufactures looking glasses upon an extensive scale." The size of his shop was similar to Doggett's, and at the time of Lothrop's death his estate was valued at over $20,000.[3] He advertised in 1810 that he "Has just finished two pair of LOOKING-GLASSES, at 2 and 300 Dollars per pair—the largest and most superb, it is presumed, of any now for sale in Boston."[4] The highest price for a looking glass in John Doggett's accounts was $327, charged to Andrew Cunningham in 1807 for a pair of frames whose glass plates measured 57 x 31 in. (144.8 x 78.7cm).[5] Given the fact that the Art Gallery's pier glass is roughly the same size, its original price was probably about $150, in the range of prices Lothrop advertised.

Although it may lack a firm attribution to a maker, this pier glass is a superb example of the Neoclassical style in early nineteenth-century looking glasses. Many designers promoted large pillar frames that complemented the architectural details of an interior by creating a windowlike appearance (see p. 323). A chimney glass of this type was published by Thomas Hope in 1807.[6] The "twist pillars," reminiscent of those supposedly brought from the ruins of Solomon's Temple to St. Peter's in Rome, were widely used in English Regency furniture.[7] A number of smaller frames made in the United States at this time combined twist pillars with a carved shell at the center of the cornice, including examples labeled by Peter Grinnell and Son of Providence, who were in business from 1809 to 1828, and John Dixey, who worked in New York City between 1801 and 1820.[8] The Art Gallery's looking glass also exhibits the restrained ornamentation advocated in the early nineteenth century. Although the carved shell is three-dimensional, the molded pattern on the cornice's outside edge is in low relief. The overall rectilinearity of the frame is enlivened by the twist pillars and the two smaller sizes of twist moldings that echo them. The gilding on each twist of the pillars is alternately burnished or matte, which subtly heightens their spiral movement. This technique may be the one described as "twist & bronzed pillars" in an 1812 advertisement for Robert Willis of Baltimore.[9] The rectangular blocks above and below each pair of pillars are similarly decorated with a pair of burnished rectangles surrounded by a matte frame.

1. Bowdoin 1974, no. 20; Carrick 1922b, fig. 4; Comstock 1968, no. 77; *Antiques* 42 (October 1942), p. 216.
2. Doggett Daybook, p. 108. Lothrop's first transaction with Doggett was recorded on April 5, 1803, and his last on December 12, 1809 (Doggett Daybook, pp. 5, 265). There may be more transactions with Lothrop in Doggett's accounts than with any other individual.
3. Ring 1981, p. 1188.
4. *Columbian Centinel*, July 18, 1810, p. 3.
5. Doggett Daybook, p. 144. A pair of looking glasses of similar size, both labeled by Doggett, is in the Bybee Collection at the Dallas Museum of Fine Arts (Venable 1989, no. 42).
6. Hope 1807, pl. 6.
7. Lavin 1968, pp. 14–15.
8. Both frames are in private collections (DAPC 65.3358 and DAPC 73.95). The Grinnell label is mentioned in the owner's description

Fig. 76. George Smith, *Window Curtain*,
from *A Collection of Designs for Household Furniture
and Interior Decoration*, 1808.

of the frame but has not been documented by a photograph or
transcription.

9. Hill 1967, I, p. 217.

187

LOOKING GLASS

John H. Williams (active 1820–1866)

New York City, 1820–35

Mahogany (corner blocks, turnings), Spanish-cedar (cornice,
bead moldings, sight edge, divider between glass plates),
mahogany veneer; eastern white pine (frame rails, backboard)

141.8 x 71.9 (55 7/8 x 28 1/4)

Charles F. Montgomery Collection, 1989.57.4

Structure: The frame members are veneered. The frieze board
and bottom frame member are tenoned into the sides, which
probably are tenoned into the cornice. The cornice moldings are
mitered together and glued to the top frame member; the top
molding is nailed. The capitals, bases, and pilasters are glued to

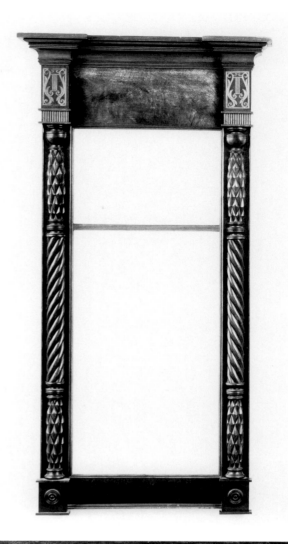

187

187 *Label*

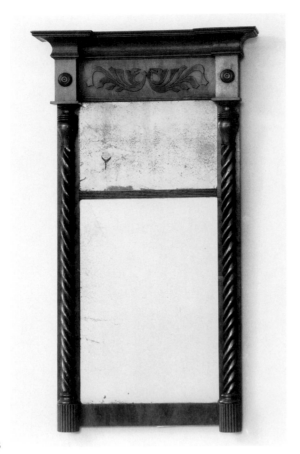

188

188 *Label*

the side frame members. Strips of mahogany are glued to the sides of the frame. The sight edge is nailed to the frame members. The backboard is nailed over the back.

Inscriptions: "56 1 / 4 28 1 / 2 / 5 alfe" is written in pencil on the back of the frame at the upper right corner. A printed paper label is glued to the back side of the upper frame member: "Looking-Glass Warehouse. / JOHN H. WILLIAMS, / NO. 315, PEARL-STREET / OPPOSITE PECK-SLIP, / Offers for Sale, a general assortment of / LOOKING-GLASSES, / [IN THE NEWEST] PATTERNS OF / GILT AND MAHOGANY FRAMES, WARRANTED OF THE BEST / QUALITY, AT THE LOWEST PRICES. / Prints, Drawings, and Needlework neatly framed. / Looking-Glass Plates re-Silvered and Framed at the Shortest [notice.] / WHOLESALE DEALERS SUPPLIED AS [USUAL]. / D. McD . . . Murray St. near Broadway."

Condition: The glass plates and all of the blocks securing them are replacements. The original upper plate was smaller, and the divider between the plates has been moved 2.5cm (1 in.) below its original position to accommodate the replacements. The lower base molding on the right pilaster is a replacement; the front edges of the upper and lower base moldings on the left pilaster are restored. The backboard is original.

Reference: Garrett 1972, p. 189.

Provenance: Charles F. Montgomery acquired this looking glass before December 1969 (DAPC 69.3158).

This looking glass and the three following examples (cats. 188–190) have the heavier proportions, bolder turnings, and reeded moldings characteristic of pillar frames made after about 1820. On many of these, the pillars were replaced with split turnings that evoked the profile of an Ionic capital's volute, as Peter L.L. Strickland has observed.[1] A design for a curtain valance with a similar turning was published by George Smith in 1808 (Fig. 76). Looking glasses made by Horace Jones of Troy, New York, between 1820 and 1828 are among the earliest documented American frames of this type.[2] On some frames the base molding was also replaced by a turning (cats. 189, 190). Looking glasses with this feature were labeled by many American makers during the second quarter of the nineteenth century, including Wells M. Gaylord of Utica, New York, between 1826 and 1838.[3]

The vertically reeded rectangular panels above the turnings of the present looking glass are typical of a large group of hardwood frames with carved, reeded, or twist-turned pillars; many of these frames also have acorn-shaped drops and applied scrollwork in the frieze. Most of the documented examples were made in New York City in the 1820s and 1830s: in addition to

this example by Williams, others were labeled by Elias Thomas between 1820 and 1850, George Dixey between 1821 and 1833, John Sweeney between 1823 and 1828, and Duncan Fraser between about 1825 and 1831.[4] Frames of this type were also labeled by Adna Treat of Troy between 1827 and 1830 and Wells M. Gaylord of Utica between 1826 and 1838.[5] Treat and Gaylord may have purchased these looking glasses from such New York City makers as John Sweeney, who specifically invited the patronage of "Country Merchants and Dealers."[6] A looking glass of this type with a colored print commemorating George III's death in 1820 may have been made in England or Canada, or the print may have been inserted into an American frame.[7]

John H. Williams had an extremely successful career, operating one shop at 315 Pearl Street for forty-four years. In 1843, he opened a second store on Broadway, which he ran with a partner, Linus W. Stevens. Two of Williams' sons also entered the business, taking it over in the 1860s.[8] Williams sold looking glasses in a succession of styles from gilt and mahogany pillar frames to Rococo Revival pier mirrors.[9] A looking glass made by Williams with some of the same components as the present example is in the New York State Museum, Albany.[10] The openwork, lightwood lyres on the cornice of the Art Gallery's looking glass contrast with the dark ground and mimic the effect of brass inlays or gilt mounts on other furniture (see cats. 120, 121). Metal inlays and gilt mounts were used on only a few American looking glasses, such as a mahogany chimney glass at the Maryland Historical Society.[11]

1. Strickland 1976, p. 790.
2. Both owned by dealers (DAPC 67.1514 and 68.3265).
3. *Antiques* 18 (July 1930), p. 66.
4. *Antiques* 44 (September 1943), p. 98; Downs and Ralston 1934, no. 219; Lyman Allyn Museum, New London, Connecticut (no. 1970.190); The White House, Washington, D.C. (DAPC 65.1381).
5. Scherer 1984, no. 59; private collection (DAPC 73.98).
6. Sweeney's label is reproduced in Gaines 1972, p. 881.
7. Schiffer 1983, no. 595.
8. Ring 1981, p. 1195.
9. Scherer 1984, nos. 46, 92; Smith 1976, fig. 11.
10. Scherer 1984, no. 47.
11. Weidman 1984, no. 109.

188

LOOKING GLASS

Probably northeastern United States, possibly Philadelphia, 1820–40

Mahogany, mahogany veneer; eastern white pine

86.8 x 46.7 (34 1/8 x 18 3/8)

Promised gift for the Charles F. Montgomery Collection

Structure: The top and bottom frame members are butted and nailed between the sides. The cornice board is butted and glued to the top frame member. All of these elements are veneered. The cornice moldings are mitered and glued around two square blocks that are glued to the cornice and the sides of the frame. The scrollwork, bosses, and turnings are glued to the frame. A triple-reeded molding is glued to the cornice board's lower edge. The divider is tenoned between the side frame members. The backboard is glued and nailed over the back of the frame. Strips of fabric have been glued over the top and bottom ends of the backboard and the adjacent parts of the frame.

Inscriptions: "2" is written in crayon on the top of the cornice. "2250" is written in crayon on the back of the cornice, and "20" has been scratched over it. A printed paper label is glued to the backboard: "JAPANNED WARE / The Subscriber respectfully informs his customers and the Public / in general, / THAT HE STILL CONTINUES TO MANUFACTURE / COMBS / OF EVERY DESC[RIPT]ION / IN AN EXTENSIVE [MAN]NER. / He has them put in a correct [mann]er, and finished superior / to any hitherto offe[red] to the Public. / ALSO FOR SALE / A large assortment of / LOOKING GLASSES, CUTLERY, JAPANNED WARE, and FANCY ARTICLES / Which he is determined to sell at a [r]educed price / what they have bee[n] sold at hitherto. / Any Orders forwarded to him shall be punctually executed. / John Elliot / [No. 82, Market Street], 4 doors below 3rd. St. South Side Philadelphia."

Condition: The molding on the cornice's left side is a replacement, and the molding on the left front corner has been re-attached. The fabric strips glued over the backboard appear to be original and have never been disturbed. The glass is original. As discussed below, the spurious label was added to this frame in the twentieth century.

Reference: Gaines 1967a, p. 519.

Provenance: Charles F. Montgomery acquired this looking glass prior to April 1963 (DAPC 64.889).

Although this looking glass, with its exaggerated cornice moldings, large frieze section, and bold twists, is a characteristic pillar frame of the type made after 1820 (see cat. 187), the label affixed to its backboard is fraudulent. The text was copied from a label used by the Philadelphia hardware merchant John Elliott between 1811 and 1814.[1] Not only are these dates too early for the looking glass, but careless, nonsensical omissions were made in the wording. The label probably was printed between about 1915 and 1925; the type is a form of Cheltenham, a typeface designed by Bertram Grosvenor Goodhue in 1896.[2] A Philadelphia origin for the looking glass itself is suggested by

the faker's choice of maker from that city, although Elliott may also have been selected because his name was confused with the better known John Elliott, Sr. (1713–1791), to whom he was unrelated. Looking glasses labeled by the earlier Elliott had been published as early as 1923 and quickly became desirable to collectors.[3]

1. Ring 1981, p. 1183. An original label with this text is illustrated in Gaines 1967a, p. 518.
2. Berry/Johnson 1953, p. 120. I am indebted to Roland A. Hoover and Greer Allen for this observation.
3. Hayward 1971, pp. 1–9.

189

LOOKING GLASS

Probably northeastern United States, 1825–50
Eastern white pine
79.7 x 52.7 (31 3/8 x 20 3/4)
Yale University Art Gallery, 1987.2.3

Structure: The four frame members are mitered together at the corners. A divider with an applied reeded molding is fitted into slots in the side members. The cornice is a separate board nailed from behind to the ends of the side turnings. A rectangular panel with an applied composition sunflower is glued to the cornice's center. Composition panels are glued to the cornice on either side. A stepped molding is applied across the upper end of the cornice. The balls are applied with wires to a piece of wood fitted over the cornice board and corner posts; a stepped molding is applied to its outside edges. Split turnings are applied to the side frame members, with reinforcing strips nailed behind them. Composition ornaments are applied to the turnings' ends. A split turning is applied to the bottom frame member and doweled through the square lower ends of the sides. A reinforcing strip is nailed behind it below the bottom frame member. The glass is secured with blocks.

Inscription: An illegible inscription is painted in the silvering on the glass plate.

Condition: The balls have been reattached to the cornice, and some may be replacements. The backboard has been replaced with two old boards. The reverse-painted panel is a twentieth-century replacement but the mirror glass is original. All the blocks that originally secured the upper panel are lost. Three of the blocks securing the glass plate survive in place; the others are replacements.

Provenance: This looking glass was found in 1985 at Saybrook College, one of the twelve undergraduate residential colleges at Yale University.

The composition ornaments on this looking glass provided the appropriate classical symbolism for its function. In Greek mythology the sunflower was the symbol of Clytie, a nymph associated with the sun god Apollo; the sunflower at the cornice's center is therefore an emblem of light. The masks at either side may represent either Clytie or water nymphs, which the English designer Richard Brown suggested in 1820 as a motif for looking glasses, "that element [water] being first discovered to reflect."[1]

In contrast to larger frames with two pieces of glass, the upper plate in this frame is unusually large in relation to the lower plate. The two glass plates in this frame were standard sizes in the early nineteenth century, 8 x 10 in. (20.3 x 25.4cm) and 10 x 14 in. (25.4 x 35.6cm). According to Sheraton, small plates of these sizes were imported from the Netherlands.[2] Many of the frames in the Art Gallery's collection with standard-size plates are small and inexpensive (cats. 170, 171, 179, 191, 193), indicating that the use of stock glass was an important consideration in the cost of a looking glass.

See also cat. 187.

1. Brown 1820, p. 34.
2. Sheraton 1803, p. 235.

190

LOOKING GLASS

Possibly New York City, 1825–50
Black cherry, mahogany veneer; eastern white pine
95.9 x 55.7 (37 3/4 x 21 7/8)
Bequest of Millicent Todd Bingham, 1969.44.2

Structure: The four frame members are veneered and have a reeded sight edge nailed to their inside edges. The side members are butted and glued between the top and bottom pieces. The split turnings are nailed to the side and bottom members. The cornice is a veneered board nailed to the turnings from behind. The pair of foliate scrolls is glued to its center. A reeded strip of wood is nailed to the cornice board's underside. The top board is nailed to the cornice, and the drops are glued to its underside. Stamped brass rosettes and small reeded panels are applied to the turnings' ends. A reinforcing strip is nailed across the bottom turning and the lower ends of the side turnings.

Inscription: "Property of / Millicent Bingham" is written in ink on a gummed paper label applied to the backboard.

Condition: The divider fitted between the glass plates is a replacement; the original divider probably had a triple-reeded front surface. Several of the flared projections on the applied

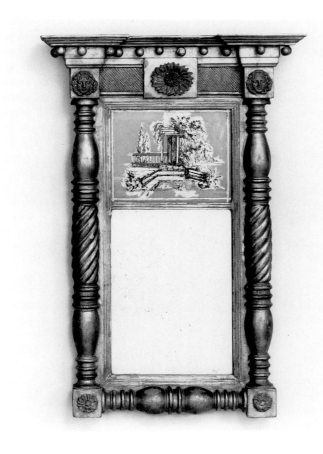

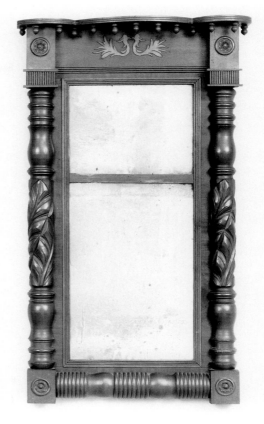

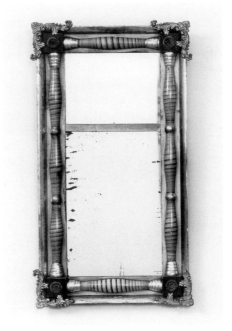

189 190

191

foliate scrolls are lost. A section of the single ring on the left split turning cracked off and has been reattached. The glass is probably original. All of the glue blocks securing it are replacements, as is the backboard.

In comparison with other pillar looking glasses of the second quarter of the nineteenth century (cats. 187, 188), the heavy turnings and angled leaf carving on this frame suggest that it is a relatively late example of the form.

191

LOOKING GLASS *Color plate 20*

Possibly New York State, 1830–50

Eastern white pine

64.1 x 33.6 (25 1/4 x 13 1/4)

Charles F. Montgomery Collection, 1989.57.2

Structure: The frame members are mitered together, probably with splines. The outer molding, sight edge, balusters, and composition ornaments are all nailed to the frame. The backboard and glass are secured with nails.

Condition: Apart from losses to the composition ornaments, this frame is extremely well preserved. The backboard and glass are original.

Reference: Garrett 1972, p. 188.

This looking glass probably was a relatively inexpensive, factory-made product. It was mitered and nailed together from wood cut with circular saws, and the 14 x 9-in. (35.6 x 22.9cm) glass plate in its lower section was a standard size in the early nineteenth century.[1] Its vibrantly painted, gilded, and grained surface would have appealed to purchasers of the grained and stenciled "fancy" furniture that became popular in the 1820s. Even on such modest frames, different decorative options were available. A very similar looking glass with a yellow-painted frame, grained and gilded turnings, and dark-painted corner blocks with stamped rosettes was made by Wells M. and Edwin Gaylord's "looking glass factory" in Utica, New York, between 1839 and 1844; the Gaylords' frame had a reverse-painted panel in the upper section instead of the gilded outer molding and corner ornaments.[2]

Despite its similarities to the documented frame, the Art Gallery's looking glass cannot be attributed to this factory. The turnings and rosettes are similar but not identical. The number and variety of frames labeled by the Gaylords suggest that they also retailed looking glasses purchased from makers in larger eastern cities, such as New York or Albany.[3] Any of the looking glasses that survive with their labels could have been produced in their factory, but their claim to "have on hand the most complete assortment of fashionable styles of looking glasses with which this quarter has ever been supplied" and that "merchants in Central, Western, and much of Northern, New York, would do well to supply themselves from this establishment" indicates that they were handling a larger volume of goods than they made themselves.[4]

Stylistically, the Art Gallery's looking glass is an amalgam of two types of frame that were popular during the second quarter of the nineteenth century. The split turnings around all four sides and the corner blocks with bosses were taken from pillar frames (see cat. 187). Its more stylish features, the gilded quarter-round molding and the gilded, foliate ornaments made of composition, were derived from the looking glasses with simple architectural moldings and sculptural corner elements that became popular in the 1830s. A high-style example of this type of frame, with cornucopias at the corners, was made by John H.

Williams of New York City.[5] A large gilded looking glass that similarly combined four split turnings with carved corner elements was labeled by Isaac L. Platt of New York City between 1825 and 1837.[6] Looking glasses with split turnings on all four sides have been described as a later development than those with turnings and a cornice (cats. 189, 190), but documented examples of both types were contemporaneous, indicating that they were stylistic alternatives.[7]

1. Sheraton 1803, p. 235.
2. Scherer 1984, no. 77.
3. In addition to the example cited above, at least four different types of pillar frames with Gaylord labels are known (private collection [DAPC 73.98]; *Antiques* 18 [July 1930], p. 66; Scherer 1984, no. 61; *Made in Utica* 1976, no. D67). Other looking glasses labeled by the Gaylords include an arched-crest frame and a rectangular frame with an unusual fretwork border (DAPC 67.2158; Montgomery 1966, no. 225).
4. Scherer 1984, no. 77.
5. Smith 1976, fig. 11.
6. Munson-Williams-Proctor Institute, Utica, New York; reproduced in Smith 1976, fig. 10.
7. See Smith 1976, p. 352, for his chronology of looking glasses with split turnings. An example with turnings on all four sides was made by Joseph Stowers, who began working in Salem, Massachusetts in 1824; another was labeled by Caleb Wayne of Philadelphia, who worked between 1823 and 1834 (Fales 1965, no. 66; Strickland 1976, p. 785). See cat. 187 for comparative information on documented looking glasses with split turnings and cornices.

Looking Glasses from Northern Continental Europe

The three looking glasses in this section belong to a large group of frames with tall crests and short bases designed as a series of symmetrical curves. Gilded, openwork carving is applied to both the crest and base, which frequently have pierced outside edges. Apart from the crest and base, these looking glasses are rectilinear in form and do not have side brackets. The frames often have front moldings with an ogee profile and beaded or bead-and-reel moldings at the sight edge. Several looking glasses of this type have histories of ownership in this country, including one presented to Joseph and Mary Fuller of Suffield, Connecticut, in 1796.[1] None of these frames, however, have been attributed to an American craftsman, and two of the frames at Yale (cats. 192, 194) definitely were made of Scots pine, a European species of the sylvestris pine group.

This type of looking glass does not appear to be English. Judith Hughes proposed that they could be identified with the ones imported in large numbers from Continental Europe, particularly after the War of Independence.[2] Carved and gilt frames that are more elaborate than the Art Gallery's examples

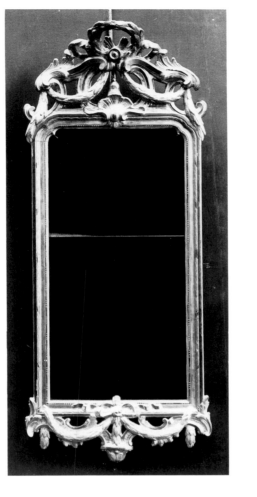

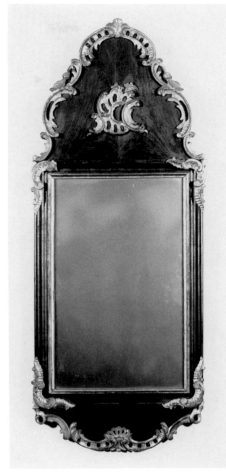

Fig. 77. Nicolas Meunier,
Looking glass, Stockholm, 1772.
Deal and birch.
The Royal Collections, Gripsholm Castle, Sweden.

192

but with strikingly similar tall crests, short bases, rectangular sight edges, and Rococo ornament were made in Denmark and Sweden. A documented looking glass of this type was delivered to the Royal Palace in Stockholm by Nicolas Meunier in 1772 (Fig. 77).[3] Direct trade links between the United States and Northern Europe became common after 1790: a silver spoon made in Copenhagen in 1807 descended in a Portland, Maine, family whose ships traded in Baltic ports.[4] Many American newspaper advertisements in the second half of the eighteenth century made distinctions between English and Continental European looking glasses, such as the Boston newspaper advertisement in 1760 that mentioned "a good Assortment of English goods" together with "Dutch Looking Glasses" or James Reynolds' announcement of "English, French and Dutch Looking-Glasses" in 1784.[5] It is uncertain, however, whether these adjectives refer to a frame's country of origin or to its style,

or to the origin of the glass plates. A few advertisements were more specific: J. Billard of Philadelphia offered looking glasses "just received from *France*" in 1784, and De Blok and De Vos of Baltimore in 1792 had "a small Assortment of elegant gilt and painted framed Looking-Glasses" among the wares they had "imported, in the last Vessels, from HOLLAND and GERMANY."[6]

1. Bissell 1956, pl. 19.
2. Hughes 1966.
3. Vahlne 1986, pp. 64–65, 218–19. Danish looking glasses of this type, all dated c. 1750, include one at the Kunstindustriemuseet, Copenhagen (no. A69/1911), and three illustrated in *Rokoko* 1961, nos. 3, 40, 46.
4. Sprague 1987, no. 17.
5. Advertisement of John, Robert, and John Gould, *Boston Gazette*, September 15, 1760, p. 3; *Pennsylvania Gazette*, May 12, 1784, p. 3.
6. *Pennsylvania Packet*, May 22, 1784, p. 3; *The Maryland Journal and Baltimore Advertiser*, May 1, 1792, p. 3.

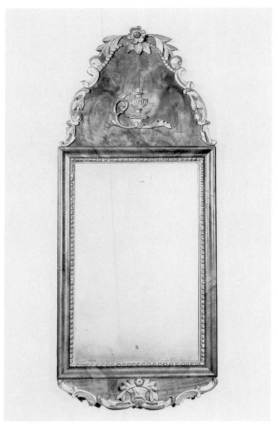
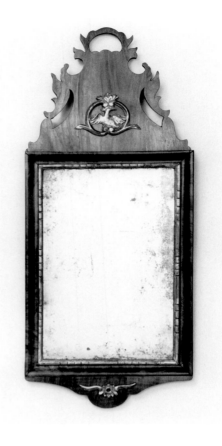

193 194

192

LOOKING GLASS *Color plate 10*

Probably Northern Continental Europe, 1760–80

Unidentifiable wood of the genus *Tilia* (applied carvings), walnut
 veneer; Scots pine (crest and bottom boards, frame members,
 backboard, vertical brace)

86.7 x 33.9 (34 1/8 x 13 3/8)

The Mabel Brady Garvan Collection, 1930.2270

Structure: The top and bottom members of the frame are fitted
between the sides with modified lap joints. The veneered crest
is a single board butted and glued to the frame with a vertical
brace glued behind the center. The veneered base is a single
board butted and glued to the frame. The ogee molding with a
gilt sight edge is glued to the frame members. Gilt carvings are

glued to the crest and base. The carved corner scrolls are nailed
to the front of the frame. The glass is secured with glue blocks.
The backboard is a single board with feathered edges, held in
place with nails.

Inscriptions: "All of 125 years old in 1894./given to Katie E.
Coley by my grand-/mother Mary H. Coley" is written in pencil
on the base. "K E Coley" is painted on the back side of the back-
board, and "Katie E. Cs" is written in ink on the crest. There is
also an illegible pencil inscription on the top frame member.

Condition: The veneer originally was painted with black grain-
ing. At one time the crest cracked horizontally across the center,
although the thick veneer was unaffected. The brace behind the
crest has been reattached. The backboard is original; the glass
has been resilvered but appears to be original.

Provenance: If the inscription "all of 125 years old in 1894" accurately reflects this looking glass' history of ownership, it probably was purchased by Ebenezer (1741–1811) and Abigail Morehouse Coley (1744–1797) of Fairfield, Connecticut, a few years after their marriage in 1763. It descended from their son and daughter-in-law, Levi (1777–1859) and Mary Hide Coley (1790–1871) of Weston, Connecticut, to the latter couple's granddaughter, Catherine ("Katie") E. Coley Hewitt (1868–1925), the daughter of David (1816–1900) and Catherine Sherwood Coley (1820–1889). The looking glass could have belonged to Mary Hide Coley's parents, David (1743–1820) and Lydia Sturges Coley (1755–1823), who were married in 1786 (Jacobus 1930–32, II, pp. 246, 251–52; Baptismal register, Weston Congregational Church Records, Connecticut State Library, Hartford; Will of Catherine E. Hewitt, Westport Probate Court, Connecticut). Frank MacCarthy, from whom Garvan purchased this looking glass on October 4, 1929, apparently acquired it from Catherine Hewitt's heirs; he noted on his bill to Garvan, "This mirror has always been in the possession of the Coley Family of Fairfield, Connecticut" (Mac-Carthy file, FPG-AAA).

193

LOOKING GLASS

Probably Northern Continental Europe, 1770–1800

Walnut veneer, sylvestris pine

93.1 x 37.1 (36 5/8 x 14 5/8)

Bequest of Olive Louise Dann, 1962.31.5

Structure: The frame members are lapped together at the corners. An ogee molding with a carved and gilt sight edge is glued to the front of the frame. The veneered crest and base are single boards butted and glued to the frame, with gilt carvings nailed to them. The glass is secured with glue blocks, and the one-piece backboard is nailed to the frame.

Condition: The parts of the central crest ornament missing when the photograph was taken were partially restored by Emilio Mazzola in 1965. A vertical brace once attached to the center of the crest's back is lost. The gilt sight edge is a replacement. The backboard has been trimmed and renailed to the frame. The glass is possibly original; all of the blocks securing it appear to be replacements.

A Swedish looking glass of c. 1770 has an urn surrounded by Rococo foliage almost identical to the ornament on the crest of this frame.[1] The 20 x 12-in. (50.8 x 30.5cm) glass plate in the Art Gallery's looking glass was a standard size in the late eighteenth and early nineteenth centuries; in 1807, Cermenati and Bernarda of Boston advertised plates with these dimensions in both gilt and mahogany frames.[2] Two disparate looking glasses of this period in the Art Gallery's collection have plates of the same size (cats. 170, 179).

1. Vahlne 1986, pp. 94–95.
2. *Columbian Centinel*, January 3, 1807, p. 1. Sheraton does not include this size in his list of glass plate dimensions (Sheraton 1803, pp. 255–36).

194

LOOKING GLASS

Probably Northern Continental Europe, 1770–1800

Walnut veneer; Scots pine (crest, base, and backboard), spruce (frame members)

75.5 x 31.9 (29 3/4 x 12 5/8)

Bequest of Olive Louise Dann, 1962.31.12

Structure: The frame members are lapped together at the corners. An ogee molding with a carved and gilt sight edge is glued to the front of the frame. The veneered crest and base are single boards butted and glued to the frame; the carved and gilt ornaments are nailed to them. The backboard is a single board with feathered edges, held in place with nails. The glass is secured with glue blocks.

Condition: Black ink has been streaked over patches and imperfections in the veneer. The semicircular loop at the top of the crest is a restoration. The crest ornament appears to be old but probably is not original; the base ornament appears to be a replacement. The crest cracked in half horizontally but the thick veneer on the front is undisturbed. A central vertical brace behind the crest is now lost. The glass is old and possibly original, but all of the glue blocks are replacements. The backboard is original.

Mirrors

Rococo Revival Style

195
MIRROR

Probably England, possibly America, 1835–65
Eastern white pine
67 diameter (26 3/8)
Bequest of Edward P. Eggleston, B.A. 1900, 1966.76

Structure: The frame's exterior surface is covered with molded composition painted to resemble mahogany with gold accents. The frame proper is made in two layers. The back layer, which includes the sight edge, is composed of four curved pieces joined with splines. The front layer is also made of four pieces and forms the deep cavetto molding. Between the glass and the backboard are four pieces of wool and cotton fabric. The glass is held in place by the backboard, which is secured with nails.

Condition: All parts of this mirror, including the glass, fabric, and backboard, appear to be original.

Provenance: Edward Porter Eggleston (1876–1956) of New London and later Bethlehem, Connecticut, owned this mirror before 1931. He may have inherited it from ancestors who lived in New London.

Glass plates with multiple concave or convex reflectors probably were not made in England until after 1780, when the technique of producing convex glass was developed in that country. This type of mirror had been made in France as early as the mid-seventeenth century and was imported into both England and the American Colonies.[1] A small example appears in the garret setting of William Hogarth's 1741 engraving *The Distressed Poet*, and a hand mirror with a similar plate purportedly belonged to Isaac Franks (1759–1822) of Philadelphia.[2] The Rococo sight edge on the Art Gallery's frame, which is otherwise in the Classical Revival style, suggests that it was made when the "modern French" style became popular during the second quarter of the nineteenth century. A larger mirror with its concave reflectors also arranged in multiples of seven, and with a similar verd-

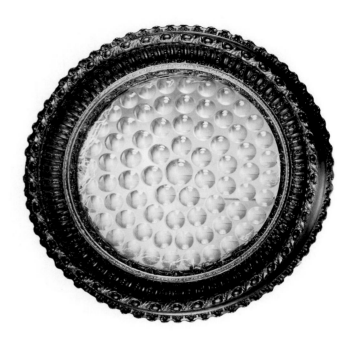

195

antique frame, was purchased in England by Dr. John Cheesman (1788–1862) of New York City, who was married in 1814.[3]

1. See Larmessin, "Le costume du miroitier," in Havard, III, p. 914.
2. Independence National Historical Park, Philadelphia (Milley 1980, p. 58).
3. Museum of the City of New York (no. 56.152).

Colonial Revival Style

Old looking glasses were among the first objects to be collected as the enthusiasm for early American furniture grew during the second half of the nineteenth century. Virginia Robie observed in 1916, "They are important accessories in furnishing a house in Colonial style. A well-placed mirror gives a certain charm to an old-fashioned room that nothing else will"[1] Francis P. Garvan apparently shared this opinion; he acquired three mirrors now in the Art Gallery's collection not for exhibition in the museum, but as decorative components of interiors furnished with "Colonial" furniture (cats. 199, 200). Most types of eighteenth- and early nineteenth-century looking glasses were reproduced and frequently were chosen to accompany furnishings of a different style. The trade card used between 1872 and 1875 by Sypher

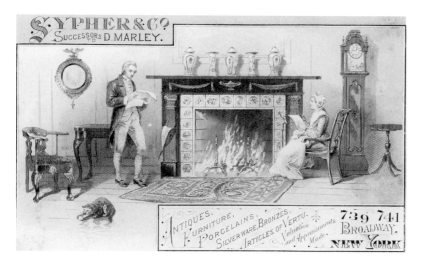

Fig. 78. Baldwin and Gleason,
Trade Card of Sypher and Company,
New York City, 1872–75.
Lithograph. Collection of Marilynn Johnson.

Fig. 79. Francis Lathrop,
Things New and Old,
from Clarence Cook,
The House Beautiful, 1878.

and Company, a decorating and antiques company in New York, illustrated an early nineteenth-century convex mirror with furniture primarily in the late Colonial style (Fig. 78). Many of the designers, dealers, and writers were fully aware of the anachronistic character of this type of association. Carl Dreppard observed:

What the American looking-glass makers did was to produce a style of our own, and after 1812 the style literally screams America. . . . And among them, thanks to the good and tasteful styling of the makers, one can find mirrors that are quite at home with the furniture of any period of Colonial or Federal history, not even excepting the seventeenth century.[2]

An illustration of a room from a house restored by Charles Follen McKim in the 1870s prominently featured a mid-eighteenth-century style looking glass together with a mantelpiece ornamented with balusters and split spindles, an early eighteenth-century style armchair, and an early nineteenth-century fancy chair (Fig. 79). When this illustration was published in *The House Beautiful* of 1878, Clarence Cook entitled it "Things New and Old," and commented, "The old was kept wherever it was sound enough, and suited to a new lease of life, and whatever new was added kept true to the spirit of the old time, though without any antiquarian slavishness."[3] It is impossible to know whether the looking glass

fell into the category of new or old, but reproductions of exactly this type were available at the time (cat. 196).

The group of Colonial Revival mirrors in the Art Gallery's collection indicates the range of forms that were popular as reproductions. After the beginning of the twentieth century, certain types became more popular than others. As part of a general trend away from the aesthetic approach to furniture collecting of the later nineteenth century, early twentieth-century collectors valued pieces that embodied traditional "American" characteristics and values.[4] Most writers particularly extolled mirrors with eagle crest ornaments, and the names assigned to some of these—"Washington" and "Constitution" mirrors—made explicit the importance such patriotic emblems (see cat. 198). Because the eagle was not adopted as the national emblem until 1782 and the majority of looking glasses in use during the early national period were imported from Europe, genuine eagle ornaments were rare. By 1934, the supply had became so abundant that the author of a basic layman's guide to antiques felt it necessary to caution, "Spread-eagles should be looked at with a wary eye for fakes."[5] In some cases, such as cat. 200, reproductions of looking glasses with eagle crests were made to supply the demand. In a larger number of instances, arched-crest and pediment frames were copied with an eagle substituted for the phoenix or other crest ornaments that would have appeared on the

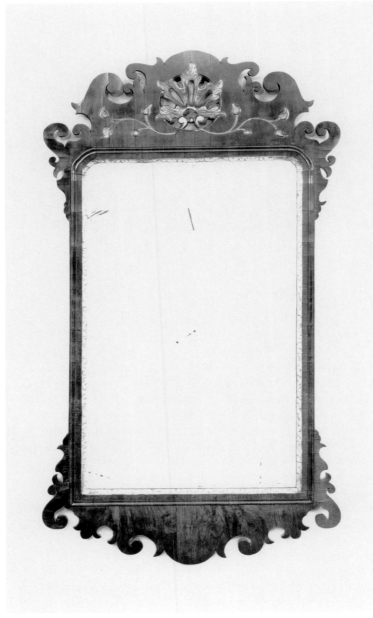

196

196 *Label*

original (cat. 198). Genuine frames were also altered to meet the need for eagles. On one late eighteenth-century looking glass, a damaged long-necked bird was given an eagle's head, perhaps as an honestly intentioned attempt to reconstruct what was assumed to be an eagle (cat. 169). On another frame, an old eagle inlay may have been added during restoration in 1907 (cat. A17).

1. Robie 1916, p. 190.
2. Dreppard 1945, p. 65.
3. Cook 1878, p. 190.
4. Stillinger 1980, pp. 188–203.
5. Lockwood 1934, p. 134.

196
MIRROR

Probably England, possibly Hartford, Connecticut, 1879–89

Retailed by A.D. Vorce and Company (1856–c. 1909–10), Hartford

Walnut veneer, spruce

102.7 x 56.7 (40 3/8 x 22 3/8)

The Mabel Brady Garvan Collection, 1930.2263

Structure: The frame members are mitered together. The veneered crest and base are butted against the frame and each

is secured by two horizontal glue blocks. Vertical braces are glued and nailed behind the crest's scrolls. The corner brackets are glued to the frame's sides, crest, and base, with small glue blocks reinforcing the joints. The frame's sides are veneered between the brackets. The present backboard is nailed over the back of the frame; the original backboard was secured inside the frame with nails.

Condition: The scroll on the lower right corner is a replacement, as is the backboard. The glass appears to be original although the blocks securing it are replacements.

Inscription: "FINE ARTS / 276 / A.D. VORCE & CO. / MAIN ST. / HARTFORD, CONN." is printed on a paper label glued to the back of the base.

Provenance: Irving W. Lyon of Hartford probably purchased this mirror from A.D. Vorce and Company between 1879, when the firm was incorporated, and 1889, when his son Irving P. Lyon moved to New Haven as a freshman at Yale. The younger Lyon later wrote to Francis P. Garvan that it "was my own glass at home in Hartford, at Yale, & here in Buffalo" (notation on photograph, Lyon file, FPG-Y). Garvan purchased it from Irving P. Lyon in 1929. It is described in Garvan's records as one of a pair, although only one such frame was acquired from the Lyon family.

Several of this mirror's stylistic features, which are similar to those of the following example (cat. 197), appear to be characteristic of later nineteenth-century frames made in eighteenth-century styles. The openwork shell does not project beyond the front surface of the frame, and the incised carving on both the crest and base is equally two-dimensional. The silhouette is stiff and uninspired when compared with those of period examples (cats. 167, 168). Details of construction are also consistent between the two nineteenth-century frames, but atypical of eighteenth-century practice. The upper corners of earlier looking glasses were almost always lapped together instead of mitered. It is not common to find veneer on the sides of early examples of this size.

 A.D. Vorce and Company dealt in imported paintings and prints and supplied room moldings, cornices, picture frames, wall brackets, and other artistic accoutrements. The business may have been an American branch of an English firm, as Allen D. Vorce identified himself in advertisements as "Secretary of the London and Scottish Art Unions." Vorce first opened a store in 1856; when the business was incorporated in 1879, Silas and Elisha Robbins of Hartford were named as his partners. With spruce as the only secondary wood, it is difficult to determine whether Vorce made or imported this mirror. An 1886 advertisement for Vorce and Company announced that they were "Direct Importers of . . . FRENCH AND GERMAN PLATE MIRRORS," but also noted that they were "Manufacturers of and Dealers in Pier & Mantel Mirrors."[1] There are many surviving frames identical to this one, which suggests that they were manufactured on a large scale, most probably in England. At least one other was owned in the Hartford area, however, which could indicate that these frames were a specialty of the firm.[2]

1. *Hartford Directory*, 1878, p. 153; 1879, p. 199; 1886, p. 225; 1889, p. 258.
2. Nutting 1928, II, no. 2940.

197

PIER MIRROR ONE OF A PAIR

Probably England, 1870–1900

Sylvestris pine (applied carving on sides), mahogany veneer; spruce (crest and bottom boards, frame members, glue blocks, backboard)

189.8 x 74.7 (74 3/4 x 29 3/8)

The Mabel Brady Garvan Collection, 1930.2223B

Structure: The frame members are mitered together with splines. The veneered crest and base are butted and glued to the frame with horizontal glue blocks reinforcing the joints. The scrolls on the crest and base have narrow braces glued behind them; wider braces are screwed to the crest on either side of the central shell. The corner brackets and adjacent side pieces are butted and glued to the sides with glue blocks reinforcing each joint. Additional small blocks are glued behind each bracket. The frame's sides are veneered between the brackets. The backboard is composed of horizontally joined pieces with feathered outside edges. These pieces were held together by strips of mid-nineteenth-century wallpaper.

Condition: The frame has been heavily refinished, and some of the gilding has been covered with gold paint. The lower edge of the top frame member has been cut away to accommodate the replacement glass plate. A central brace behind the base has been lost. The tips of the upper left and right brackets and three of the C-scrolls on the base are restorations. The carved and gilt pendant leaves are replacements. The backboard is now held in place by small pieces of cork nailed to the frame's inside edge. A horizontal brace has been added across the back of the frame at the center.

Provenance: Garvan purchased this pair of looking glasses from Charles Woolsey Lyon on April 22, 1929.

In addition to the stylistic and construction details that indicate a date of manufacture in the later nineteenth century (see cat.

196), this frame was made for a single glass plate larger than those found in eighteenth-century looking glasses of this relatively modest type (cat. 163). Eighteenth-century English looking glasses with plates more than 122cm (48 in.) in height usually had much more elaborate, high-style frames.[1] In America, references to looking glasses of this large size do not occur until after the War of Independence, by which time the frames for these costly objects were in the current Neoclassical taste (cat. 186).[2]

1. *DEF*, II, pp. 317–19; Wills 1965, pp. 55–59.
2. For descriptions of large looking glasses in late eighteenth-century America, see the advertisement of Gifford and Scotland, *The Diary; or Evening Register*, as cited in Gottesman 1954, pp. 119–20; advertisement of A. Pettit and Company, *Claypoole's Daily Advertiser*, November 18, 1805; Hill 1967, I, p. 215.

198

MIRROR

Probably northeastern or midwestern United States, 1920–50

Yellow-poplar (eagle finial, crest moldings; shaped side pieces at lower corners), mahogany veneer; mahogany (frame side members, shaped side pieces at upper corners), eastern white pine (crest, bottom, and back boards)

144.1 x 70.5 (56 3/4 x 27 3/4)

Yale University Art Gallery, 1987.2.4

Structure: The crest and base are single boards fitted between the side members, thereby forming the frame for the glass. The frame's front surface is veneered. The pediment moldings are screwed to the crest and the upper ends of the sides from behind. The gilt molding extending across the crest is also screwed to the crest from behind. A gilt composition molding is applied around the frame's outside edges. The gilt composition flowers and clusters of acorns and oak leaves are molded over wire and suspended from the frame's projecting corners. A separate strip of wood with a gilt, molded front surface is applied to the frame's sight edge. The glass is secured by small blocks nailed to the sight edge. The backboard is composed of three separate, horizontal pieces nailed and glued over the back of the frame.

Condition: The plinth and finial broke off the crest and have been reattached with a vertical brace screwed to the back. The glass probably is original.

Provenance: This mirror was found in 1982 in the Peletiah Perit House, which was built in 1861 at 55 Hillhouse Avenue in New Haven.

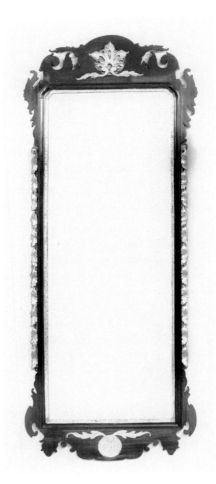

197

Based on mid-eighteenth-century pediment looking glasses (cat. 172), this mirror illustrates the dramatic changes made to earlier forms to suit the aesthetics and ideology of the Colonial Revival. Its carving and silhouette have been simplified: in particular, the pediment moldings are left unornamented. The other moldings, rosettes, and pendant foliage have been executed in low-relief, molded composition similar to that on looking glasses in the Neoclassical style (cats. 178, 183), undoubtedly because this composition was better suited to large-scale factory production than hand carving. In this instance, the Colonial style has become synonymous with a rather bland, flaccid form.

The significant exception to this aesthetic is the mirror's focal point: the boldly carved, oversize eagle finial. A replacement for the phoenix or other birds found on eighteenth-century pediment frames, such finials simultaneously created and justified the nationalistic appeal that the form acquired during the Colo-

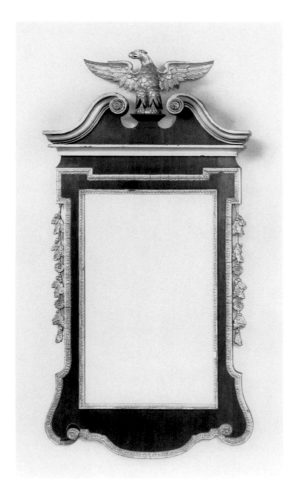

198

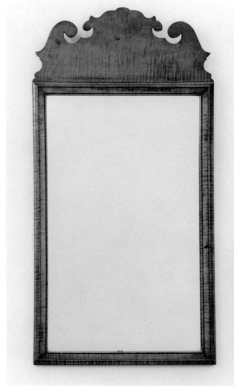

199

nial Revival. The names assigned to this type of frame, partic-ularly "Constitution" and "Washington," evoked patriotic asso-ciations, although they also implied an impossible connection between the early national period and a looking-glass form inspired half a century earlier by English Palladianism. The term "Constitution mirror" was used without any explanation as early as 1906 and has persisted up to the present.[1] The term "Washington mirror" appears to have followed the same course. An exhibition catalogue of 1909 explained, "This type of mirror is called 'Washington,' from the fact that one hangs in Mount Vernon."[2] The vagueness of these historical associations did nothing to diminish the tremendous popularity of pediment frames with Colonial Revival enthusiasts. One writer declared, "Genuine 'constitutions' are valuable and are perhaps as desir-able as any eagle mirror that an American collector could have."[3]

1. Shackleton/Shackleton 1913, p. 90; see also Hornor 1935a, pp.

279–80; Dreppard 1945, p. 213; Hinckley 1987, p. 145; *Sack Collection*, IX, p. 2493.
2. Metropolitan 1909, II, p. 70; see also Hinckley 1987, p. 146.
3. Robie 1916, p. 186. For a discussion of eagles on Colonial Revival mirrors, see pp. 343–44.

199

MIRROR

Jacob Margolis (born c. 1870)

New York City, 1929

Soft maple; eastern white pine (brace, glue blocks). The backboard is plywood made from an unidentified species of *Ocotea*, the genus of numerous tropical hardwoods from Africa and South America.

84.3 x 41.1 (33 1/4 x 16 1/8)

Gift of Francis P. Garvan, B.A. 1897, 1987.46.2

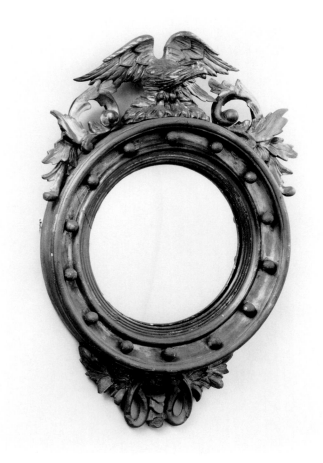

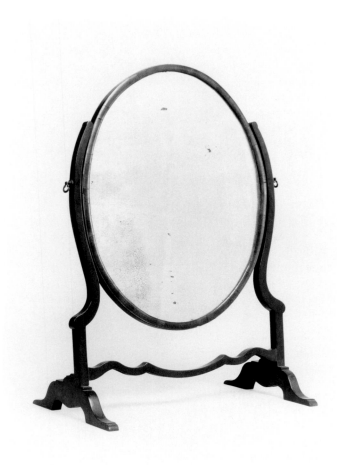

<div style="text-align:center">200 201</div>

Structure: The top and bottom frame members are tenoned into the sides. The crest is butted and glued to the frame; this joint is reinforced by a central vertical brace flanked by horizontal strips of wood. The glass is secured by the backboard, which is held in place with nails. A piece of cardboard is inserted between the glass and the backboard.

Inscription: "Y / DEC 13 1928" is stamped in black ink on the back of the glass.

Condition: All parts of this frame, including the glass, are original.

Provenance: See cat. 134. This mirror was made as one of a pair; the present location of its mate is unknown.

Margolis repeatedly described the furniture he made as "artis-tic reproductions" and "absolute copies" (see cat. 134). Although based on eighteenth-century prototypes (cat. 163), this mirror is equally a product of the Arts & Crafts Movement. Margolis used solid rather than veneered wood, and the simple crest and the shallow frame moldings were influenced by the early twentieth-century taste for simplified forms.

200

MIRROR ONE OF A PAIR

Probably northeastern United States, 1875–1900
Eastern white pine
82.5 x 55.4 (32 1/2 x 21 3/4)
The Mabel Brady Garvan Collection, 1930.2720A

Structure: Four curved pieces are butted together to make the frame. The deep cavetto molding and a smaller, raised cavetto molding are pieced together over the frame. The half-round molding on the outside edge of the frame is applied. The crest and base ornaments are attached by curved iron strips screwed to the backs of the ornaments and the frame members. The glass is secured with blocks. The backboard is nailed over the back of the frame.

Inscription: "72A" is stamped in black ink on the back of the glass.

Condition: The badly deteriorated gilt surface of this frame has been covered with gold paint, as has the quadruple-reeded sight edge, which originally was ebonized. Losses in the gesso layer have been repeatedly treated at the Art Gallery, by Otto Hoepfner in 1951 and Peter Arkell in 1981 and 1986. Given the date and quality of this object, the decision was made in the most recent treatment not to regild the frame. Pieces from both the crest and bottom ornaments have broken off and been reattached. The glass is original.

Provenance: Garvan purchased this pair of mirrors from Jacob Margolis on September 16, 1929.

This mirror was acquired to decorate the Yale University Faculty Club, another building that Francis P. Garvan outfitted with Colonial style antiques or reproductions (see cats. 134, 199). Although the frames appear to have been made as reproductions, Jacob Margolis sold them, probably unwittingly, as dating from the early nineteenth century. Marion Clarke noted on the bill of sale: "These are two old mirrors which I bought instead of new ones which would have cost about the same and would not have looked half as well."[1] Convex mirrors were promoted as desirable additions to artistic or Colonial Revival interiors as early as the 1870s. One was illustrated on Sypher and Company's trade card of 1872–75 (Fig. 78), and another was featured in Walter Crane's frontispiece to Clarence Cook's *The House Beautiful* of 1878.

1. Bill from the Margolis Shop to Garvan, September 16, 1929, Margolis file, FPG-AAA.

201

DRESSING MIRROR

Probably northeastern United States, 1875–1925

Mahogany, mahogany veneer; eastern white pine

59.8 x 42.4 x 26.6 (23 1/2 x 16 3/4 x 10 1/2); mirror frame, 46.8 x 37.4 (18 3/8 x 14 3/4)

The Mabel Brady Garvan Collection, 1930.2794

Structure: The veneered frame is composed of two inner pine laminates that are bent to shape. The inside edge of the veneer forms the sight edge for the glass. The glass and backboard are secured with nails driven into the frame. The frame is suspended between the vertical supports on brass screws with stirrup ends. The crosspiece is glued and may be tenoned between the supports; the supports are tenoned into the feet. Shaped blocks are glued behind the supports to reinforce the latter joints.

Inscriptions: "IV" is inscribed on the underside of the left foot, and "V" is incised onto the underside of the right foot. "5" is written in crayon on the inside of the backboard.

Condition: The crosspiece has been nailed to the right upright. As noted below, the glass almost certainly predates the frame by approximately seventy-five years.

Dressing glasses with oval frames were made in large numbers in the late eighteenth and early nineteenth centuries. Although the glass plate in this frame may date from that period, both the frame and stand were made at least half a century later. The stand's design is stiff and attenuated in comparison to genuine examples.[1] No attempt was made to suggest age or wear, or to disguise the wire nails, circular saw marks, and other evidence of later nineteenth- or twentieth-century manufacture. This dressing mirror may have been made to preserve an old piece of glass.

1. See Montgomery 1966, no. 249.

Modernist Style

202

MIRROR

Rockwell Kent (1882–1971) and Max Kuehne (1880–1968)

New York City, 1917

Eastern white pine

84.8 x 28.6 (33 3/8 x 11 1/4)

Gift of Mr. and Mrs. Richard E. Kuehne, 1990.29.1

Structure: The four frame members are mitered together; the crest is part of the top frame member. The entire frame is covered with gesso and gilded.

Inscriptions: "MIRROR PAINTING ON GLASS—ROCKWELL KENT / FRAME DESIGN—MAX Kuehne c 1925 / RESTORED BY / RICHARD KUEHNE 1987" is scratched into the gesso on the back

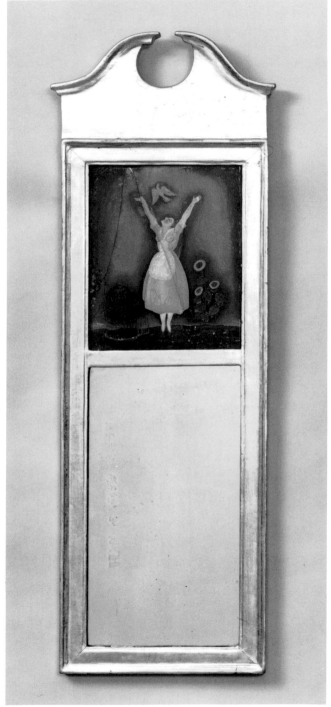

202

Fig. 80. Rockwell Kent, Cartoon for glass panel, 1917. Pencil. Rockwell Kent Collection, Rare Book and Manuscript Library, Columbia University, New York.

Fig. 81. Rockwell Kent, Sheet with study for mirror frame (detail), c. 1917. Pencil. Rockwell Kent Collection, Rare Book and Manuscript Library, Columbia University, New York.

of the crest. "J.M.W.'s SON [illegible letter or numeral] 17" is stenciled onto the back of the mirror glass.

Condition: As noted in the inscription, the gilding was restored in 1987. The painted glass panel is cracked and was retouched by Richard Kuehne when he regilded the frame (Richard E. Kuehne to Patricia E. Kane, September 28, 1989, Art Gallery files). Both glass plates are original. There apparently was never a backboard for the painted glass panel, which originally was secured with nails. The backboard for the mirror glass is lost.

Provenance: Max Kuehne owned this mirror, probably from the time of its fabrication; it was inherited by his son, the donor.

This mirror was an outgrowth of the strong friendship and shared artistic sensibilities of Rockwell Kent and Max Kuehne. Both artists painted in a similar, representational style and derived their greatest inspiration from extensive travel abroad. In addition, both did work in other media to support their painting: Kuehne made frames and furniture (cat. 144), and Kent designed ceramics, textiles, metalwork, and other objects. In 1917, Kent created a series of reverse-painted glass panels, some of which were incorporated in mirror frames made by Kuehne. At least twenty-two of Kent's designs for these glass panels survive, including the one used to trace the image on the Art Gallery's mirror (Fig. 80). This panel was the largest of the three different sizes Kent used for these paintings.[1] It is unclear who designed the frames; Kent made a sketch of a mirror (Fig. 81) similar to the Art Gallery's on a sheet with one of his panel cartoons. His description of this project in his autobiography suggests that Kuehne was not involved in either the design or marketing of the mirrors.

[Painting on glass] *is an old-fashioned art, in vogue in the time of our great-great-grandmothers and familiar to many of us in the decorative panels at the head of the small wall mirrors of that period. Pictures painted on what was to become the rear side of the glass, and viewed from the front, had a surface quality comparable to the finest lacquer. Moreover—and this was of particular interest to me—the art lent itself to multiple production in that one key design could serve as the basis of innumerable replicas. . . . My friend, the painter Max Kuehne, . . . made my mirror frames. The mirrors and the small glass paintings, retailing, according to size, at from twenty to forty or fifty dollars, met with but limited success. At the exhibition staged at Wanamaker's in the late spring of 1918 I sold but one; a year was to pass before they paid me for it.[2]*

The labels Kent prepared for what he called his "Hogarth mirrors" similarly downplay Kuehne's collaboration.[3]

This mirror is characteristic of many early twentieth-century modernist designs that reinterpreted past forms in a new way. As Kent noted in his autobiography, his paintings on glass were inspired by the "enameled" panels in early nineteenth-century pillar frames (cats. 182, 184, 185). The frame's crest, ultimately derived from mid-eighteenth-century pediment looking glasses (cat. 172) but probably more directly influenced by the contemporary enthusiasm for "Constitution" mirrors (cat. 198), reinforced this connection to the past. These older forms have been grafted onto a new type of mirror, with a narrow shape suited to the smaller rooms in urban apartment buildings. Mirrors of this type became popular during the first decades of the twentieth century; one decorating guide praised a similar example by noting, "The slender, vertical lines of . . . the mirror add to the appearance of height in this low-ceilinged room."[4] The simplified forms of Kuehne's frame as well as the deliberately naive quality of Kent's painting reflect the influence of European modernism, particularly the Wiener Werkstätte. The image of a blond woman releasing a bird from a cage also had personal significance for Kent: she undoubtedly symbolizes his mistress, called "Gretchen" in his autobiography, and the freedom she offered him during this time from the constraints of his marriage.

1. The sizes were 12.7 x 10.2cm (5 x 4 in.); 15.2 x 20.3cm (6 x 8 in.); 25.4 x 20.3cm (10 x 8 in.). Kent's drawings are preserved in the Rockwell Kent Collection, Rare Book and Manuscript Library, Columbia University. Two unframed glass panels from this series are in the Ferdinand Howald Collection, The Columbus Gallery of Fine Arts, Ohio (Tucker 1969, nos. 83, 84); the drawing for one of these is also at Columbia.
2. Kent 1955, p. 313.
3. A label is reproduced in Johnson 1982, p. 33.
4. Reynolds 1930, p. 30.

203

MIRROR *Color plate 24*

Bernard W. Fischer (1900–1986)

New York City, 1925–30

Brass (frame strips, applied ornaments), copper (applied ornaments); Douglas-fir plywood (backboard), lead (strips securing backboard), sheet iron (cross brace)

76.6 x 61.7 (30 1/8 x 24 1/4)

Gift of the Estate of Bernard W. Fischer, 1986.115.2

Structure: The frame is composed of four strips mitered and soldered together at the corners. The applied ornaments are soldered together and screwed and bolted to the frame. The decoration on the glass appears to be acid-etched. Strips of felt inserted behind the frame members protect the glass from the frame. The glass is held in place by the backboard, which is

Fig. 82. Bernard W. Fischer, Studies for mirror frames, 1925–30.
Pencil. Yale University Art Gallery, New Haven,
Gift of the Estate of Bernard W. Fischer.

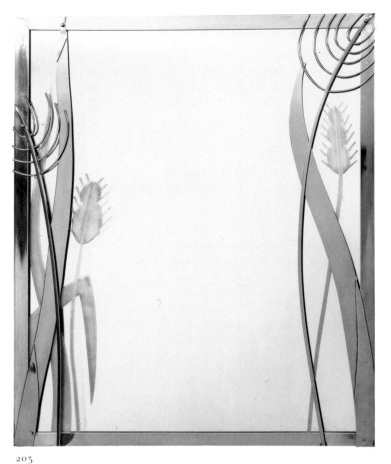

203

203 *Label*

secured by strips of lead soldered to the inside of the frame. A crossbrace is bolted between the frame sides, and its top is folded over to form a lip for the hanging wire.

Inscriptions: "Bernard Fischer / space 17 / 80°°" is written in ink on a fabric tag glued to the backboard. "31067 / 56" is written in crayon on the backboard.

Condition: All parts of this frame are original. When this mirror was received by the Art Gallery, its surface was tarnished. Protected areas beneath the applied ornaments revealed that the original finish had been highly polished with a protective coating. The decayed coating was removed, and the frame was cleaned and lacquered in 1988 by Linda Merk of Fine Arts Conservation, Inc.

Provenance: This mirror was in Fischer's home in Wingdale, New York, at the time of his death.

Unlike Rockwell Kent and Max Kuehne (cat. 202), Bernard Fischer conceived this mirror as an outright challenge to the Colonial Revival frames that dominated popular taste during the late 1920s and early 1930s (cat. 198). On many modernist mirrors, including a wrought-iron example also in the Art Gallery's collection (cat. 15), the frame is subordinated to the glass plate. Fischer, however, created a far more subtle relationship between the two parts. The overlapping plant forms in glass and metal dissolve any clearly defined boundary between glass and frame. This composition and the use of two colors of metal create a sense of spatial recession in which the glass plate's actual distance from the viewer is ambiguous. Instead of functioning as an enclosure, Fischer's frame is something to look through.

The dramatic composition and stylized forms of this mirror were characteristic of many American furniture designs influenced by the 1925 Paris Exposition.[1] Fischer's study for this frame is on a sheet with sketches for another mirror with an equally stylized bird, suggesting a date in the late 1920s (Fig. 82); identical rounded branch forms appear in his drawings of leaping deer from this period.[2] A similar mirror and wastepaper basket by Fischer were shown in an exhibition at The Newark Museum in 1929; another related mirror by Fischer was included in one of Gilbert Rohde's interiors in 1930.[3] Viewed by many as a "mechanistic" material, metal was a popular material for modernistic household furniture (cats. 23, 37). Fischer's use of different metals to create color was a popular means of avoiding too sterile an appearance. "Copper and brass supply definite color notes to a medium somewhat restricted in this respect," wrote the critic Helen Sprackling, "and combine with other metals to accent the beauty of all of them."[4] Despite its reliance on contemporary ideas and models, this mirror reveals that Fischer, like Rockwell Kent and many other American designers, drew on some influences from the past. The etched design on the glass plate undoubtedly was inspired by seventeenth- and eighteenth-century looking glasses with etched or engraved decoration (cat. 205).

Born in Louisville, Kentucky, Bernard ("Ben") Fischer studied painting and sculpture at the Albright Art School in Buffalo, New York. Shortly after his marriage in 1923 to a fellow artist, Phyllis Potter, Fischer moved to New York, where he studied at the National Academy of Design and the Grand Central School of Art and taught art and crafts in public schools from 1923 to 1946. The Fischers became affiliated with leading modernist artists and designers. A number of sculptures, mirrors, and other metal objects by Bernard Fischer were featured in interiors designed by Gilbert Rohde in 1929–30.[5] During this period, Fischer also designed glass and metal tablewares for the National Silver Deposit Company in New York and exhibited sculpture and watercolors. In 1946, the Fishers moved to Traverse City, Michigan, where Bernard worked for Burwood Products, setting up a department for the manufacture of domestic metalwares, such as lamps and small sculptures. The Fischers returned to New York City in 1949; Bernard designed domestic metalwares for the Heifetz Company between 1949 and 1955 and taught art in public schools between 1955 and his retirement in 1962. After 1958, the Fischers lived in their former country house in Wingdale, New York. During this period, they worked together in fiber, ceramic, and enamel, producing wall hangings and bowls, trays, and other simple utilitarian forms with modernist decoration.[6]

1. See Davies 1983.
2. Yale University Art Gallery (no. 1986.115.12).
3. "Modern American Design in Metal," The Newark Museum, New Jersey, 1929 (no catalogue). For Rohde's interiors, see Sprackling 1930, pp. 484–85.
4. Sprackling 1929, p. 266.
5. Sprackling 1929, pp. 264–66; Sprackling 1930, pp. 484–85.
6. I am indebted to Norma Kerlin, the Fischers' niece, for information concerning their careers. Bernard Fischer's obituary appeared in *The New York Times*, August 29, 1986, p. D17. Examples of the Fischers' later work are illustrated in *Interiors* 110 (August 1950), p. 56; *Interiors* 112 (March 1953), p. 71; Untracht 1957, pp. 140, 162, 164, 167, 171.

Small Looking Glasses
and Dressing Glasses

In the seventeenth and eighteenth centuries, as today, small looking glasses were used as aids to grooming. Simple, four-piece frames undoubtedly were the most common type (cat. 204), although they were available with a wide range of ornament (cat. 205). Small looking glasses sometimes were hung on the wall, as shown in William Hogarth's *A Harlot's Progress* of 1732 (Fig. 83), but most were brought out as needed with other equipment used in dressing. A looking glass valued at 12s. was inventoried in 1694 in the "Fowerth Drawer" of the chest of drawers belonging to Ursula Cutt of Portsmouth, New Hampshire; it probably was stored in the chest when not in use.[1] Other inventories listed looking glasses in boxes containing cosmetics, combs, jewelry, and other articles related to personal adornment. The estate of John Tatham of Burlington, New Jersey, included a "Japan dressing box" with "1 Japan looking Glass, 4 small Japan boxes, 1 Japan Pincushion, and 3 Japan brushes" in 1701.[2]

Beginning in the last quarter of the seventeenth century, new forms of looking glasses were made to accompany new furniture forms designed specifically for dressing.[3] One type of looking glass used on dressing or toilet tables had a stand hinged to its back. As with other seventeenth- and eighteenth-century accoutrements of dressing, many of these frames were elaborately decorated or made of precious materials, such as silver. In 1729, James Foddy of New York City advertised "Dressing-Glasses . . . of sundry sorts, in Glass-Frames, Glass and Gold Frames, Gold Frames Jappan'd, Wallnutt and Olive Wood Frames."[4] A frame with a hinged stand could be embellished with drapery that integrated it with a fabric-covered toilet table, as shown in an English print of 1772 (Fig. 84). The popularity of this form has continued to the present.

The "swinging glass," with the looking-glass frame suspended on screws between two standards (cats. 206–209), was another type of dressing glass that enjoyed long popularity. The form has been described as Dutch in origin, although no specific evidence for this attribution is known to the author.[5] Swinging glasses first appeared in England and America at the very beginning of the eighteenth century: a "dressing glass in a swinging frame Japan'd with an arched top" was delivered to Queen Anne by Gerrit Jensen in 1703–04, and one "Swinging Glass" was listed in a Philadelphia inventory of 1706.[6] From the beginning, this form was available as a looking glass only (cat. 206) or with the standards mounted on top of a box for dressing accessories (cat. 207). John Philips' advertisement

from the *Boston Newsletter* in 1737 listed "swinging Glasses with Draws and without."[7] Frames for swinging glasses were closely related to contemporary looking glasses of larger size and were made in every style from late Baroque to late Classical Revival. The swinging glass developed over time into several new forms of dressing furniture, including the screen dressing glass (cat. 208) and shaving stand (cat. 209). As with dressing glasses with hinged stands, swinging glasses frequently were draped to match the fabric covers of dressing tables (Fig. 85). Beginning in the late eighteenth century, swinging glasses also were made as integral parts of chests of drawers and dressing tables, which became the most common version of the form in the later nineteenth and twentieth centuries.[8]

1. Cited in Forman 1985, p. 16.
2. McElroy 1970, p. 57.
3. See Forman 1987.
4. *New-York Gazette*, October 6–13, 1729, p. 3.
5. *DEF*, II, p. 351.
6. *DEF*, II, p. 354; McElroy 1970, p. 15.
7. *Boston News-Letter*, September 22–29, 1737, p. 2.
8. One of the earliest designs for a swinging glass incorporated into a larger piece of furniture is Thomas Shearer's design for a "tambour writing table" in *London Prices* 1788, pl. 14. The earliest American objects of this type, such as a chest of drawers with glass that descended in the family of Elizabeth Derby West of Salem, Massachusetts, date from the beginning of the nineteenth century (Clunie/Farnam/Trent 1980, no. 29).

204

LOOKING GLASS

Possibly America, 1725–1800
Eastern white pine
23 x 19 (9 x 7 1/2)
The Mabel Brady Garvan Collection, 1930.2657

Structure: The frame members are mitered and nailed together except at the top left and bottom right corners, which are wedged together. The irregularly shaped glass plate is secured by wooden filler strips glued into the frame's inside corners. The backboard was held in place with nails.

Condition: The brown paint appears to be original. Holes have been drilled through the top and bottom frame members, presumably for some kind of cord or ribbon. The glass is original. One of the strips securing it is now lost; three others were reattached by Emilio Mazzola in 1966. The backboard is a replacement. One of the nails that secured the original backboard survives in place.

Fig. 83. William Hogarth, *A Harlot's Progress*, Plate 5 (detail), 1732 (restrike of 1856). Engraving. Yale Center for British Art, New Haven.

Fig. 84. *Miss Rattle Dressing for the Pantheon* (detail), 1772. Colored mezzotint. The Print Collection, The Lewis Walpole Library, Farmington, Connecticut, a department of Yale University Library.

Fig. 85. *The Utility of Cork Rumps 1777* (detail), 1777. Etching. The Print Collection, The Lewis Walpole Library, Farmington, Connecticut, a department of Yale University Library.

Fig. 84

Fig. 85

204

Fig. 83

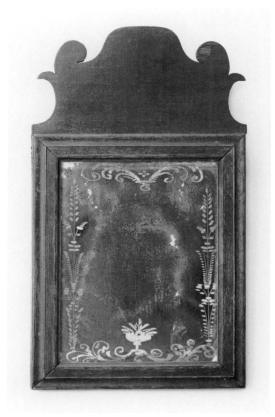
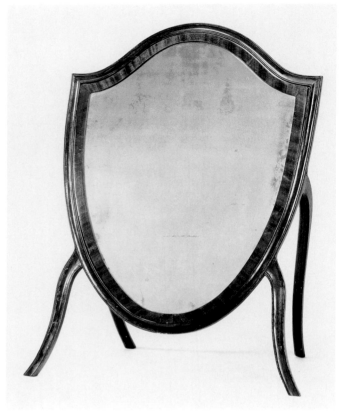

205 206

205

LOOKING GLASS

Possibly America, 1730–1800

Eastern white pine

45.9 x 26.2 (18 1/8 x 10 3/8)

The Mabel Brady Garvan Collection, 1930.2141

Structure: The frame members are mitered and nailed together. The crest is butted against the top of the frame and secured by two narrow glue blocks. A page from Johann Hartmann's *Syntagma pathologicotherapeuticum*, published in Nuremberg in 1727, is inserted between the glass and backboard, which are secured with nails.

Inscription: An arrow is incised on both the upper end of the backboard and the top frame member.

Condition: The left scroll of the crest is a restoration. The brown paint and glass are original.

Reference: McClelland 1936, fig. 129.

Provenance: Garvan purchased this looking glass from Henry V. Weil in 1924.

Like larger and more expensive frames, small looking glasses were available with a variety of optional ornament. The simple, mitered inner frame of this looking glass, which is identical to the preceding example (cat. 204), was embellished with a crest and an engraved glass plate. The maker reduced the cost of this decoration by sawing the crest from a thin board and decorating it with paint instead of veneer. The wheel-engraved glass plate apparently was another relatively inexpensive addition, as plates with identical engraving survive in numerous small mirrors of this type, indicating a wide availability.[1]

The use of eastern white pine for this frame suggests that it may have been made in this country for a glass plate imported from the Netherlands, Germany, or Bohemia.[2] The plate's small size would have made it easy to ship unframed. The book page may have been retained from packing used to protect the plates

during transatlantic shipment. A small looking glass at Chipstone with an almost identical engraved plate is also backed by a page from a German book.[3] Stylistically, this looking glass is a simplified version of the arched-crest form (cats. 163–171) that remained popular in America for almost a century. Similar small, rectangular frames with arched crests were imported by John Elliott of Philadelphia from about 1758 to 1784, and another example was labeled by Wells M. Gaylord of Utica, New York, in 1828.[4]

1. Fales 1976, no. 533; Hughes 1962, p. 70.
2. In 1803, Sheraton reported that glass plates 14 x 18 in. (35.6 x 45.7cm) or smaller—including those that were 8 x 10 in. (20.3 x 25.4cm), the dimensions of this plate—were "generally of Dutch Manufacture," whereas plates 18 x 20 in. (45.7 x 50.8cm) or larger were made in Bohemia and Germany (Sheraton 1803, p. 235). However, both the type of engraved decoration and the use of a page from a German book raise the possibility that this plate was made in a German-speaking country.
3. Rodriguez Roque 1984, no. 109.
4. Hayward 1971, p. 150; owned by Edgar and Charlotte Sittig in 1967 (DAPC 67.2158).

206

SWINGING GLASS

Possibly America, 1790–1810

Mahogany (including backboard), mahogany veneer; eastern white pine (glue blocks)

68.4 x 48.2 x 33.4 (26 7/8 x 19 x 13 1/8); frame, 56.9 x 43.7 (22 3/8 x 17 1/4)

The Mabel Brady Garvan Collection, 1930.2576

Structure: The front surface of the mirror frame is veneered. The top frame member is tenoned into the sides. The side members are butted together at the center bottom. Two shaped reinforcing pieces are glued over this joint behind the veneer and across the frame's back. The glass is secured by glue blocks.

The mirror frame is screwed between the standards. The front legs and sides of the stand are a single element. The side members are tenoned into the top, and the bottom is tenoned into the sides. The two rear legs are tenoned into the side members from behind and secured with nails.

Condition: The frame was refinished by Emilio Mazzola, and the stand was varnished. The glass is original. Some of the blocks securing it are lost and a few are replacements. The backboard is a replacement.

Reference: Nutting 1928, II, no. 3218

Provenance: Early in the twentieth century, this dressing glass

was purchased from the dealers Collings and Collings of New York City by the collector Louis Guerineau Myers (1874–1932), who "just happened along as it was being crated" (Catalogue card no. 1320, Box 28, FPG-AAA). Garvan acquired it at an auction of objects from Myers' collection on February 26, 1921 (*Myers* 1921, no. 567).

"Vase pattern" looking glasses of this shape, derived from classical urns, first appeared in England during the earliest years of the Neoclassical style. A drawing thought to have been done by Matthias Lock about 1760 shows a vase-shaped frame surrounded by Neoclassical openwork ornament, and a set of four similar looking glasses was made for Stowe between 1755 and 1760.[1] This pattern never became as popular for large looking glasses as it did for swinging glasses. It was listed as an option under "box dressing glasses" in the 1788 *London Cabinet Book of Prices*, and Thomas Shearer's design for a writing table in the same volume included a vase-shaped swinging frame.[2] A dressing box with a vase-pattern swinging glass similar to the present example was labeled by Barnard Baker of London between 1778 and 1796.[3] References to this type of frame in America first occur after the War of Independence. John Shaw of Annapolis, Maryland, advertised in 1791 that he had "just received from London . . . URN DRESSING GLASSES, with drawers . . . swing ditto, without drawers."[4] A nineteenth-century version was labeled by Thomas J. Natt of Philadelphia between 1837 and 1853.[5]

The original glue blocks of eastern white pine on the Art Gallery's swinging glass suggest that it may have been produced in this country. A "vase-pattern" frame was listed under the extras for a "Dressing Box and Glass" in the Philadelphia price books for 1795 and 1796 and the New York price books for 1796 and 1802; it cost almost twice as much as an oval frame, with additional charges for "making the standards to fit."[6] Although listed in cabinetmakers' price books, this form probably involved both a cabinetmaker to make the stand or dressing box and a looking-glass maker to produce the frame, as did the dressing box with swinging glass by Jonathan Gostelowe and James Reynolds of Philadelphia (cat. 207). The stand on the present example is similar in scale and made in exactly the same way as a "vase-back" chair of the period, suggesting that it may be the work of a chairmaker.

1. Victoria and Albert Museum, London, Lock drawing no. 31; for the Stowe looking glasses, see Jackson-Stops 1985, no. 263.
2. *London Prices* 1788, p. 107, pl. 14.
3. Wood 1968, fig. 5.
4. *Maryland Gazette*, December 15, 1791, p. 3.
5. DAPC 66.819; the dressing glass is illustrated in *Antiques* 77 (May 1960), p. 446.
6. *New York Prices* 1796, p. 67; 1802, p. 52; *Philadelphia Prices* 1795, p. 69; 1796a, p. 107.

207 *Backboard* 207 *Pincushion*

207

DRESSING BOX WITH SWINGING GLASS

Color plate 7

Jonathan Gostelowe (1744–1795) and probably James Reynolds
 (c. 1736–1794)

Philadelphia, c. 1789

Mahogany (including tops of compartments in upper drawer),
 ivory (finials on standards, knobs on covers), yellow-poplar
 (looking-glass frame); Atlantic white-cedar (drawer bottoms),
 eastern redcedar (drawer sides, runners, interior dividers of
 upper drawer), spruce (backboard of looking glass)

83.2 x 49.6 x 35.4 (32 3/4 x 19 1/2 x 13 7/8); frame, 63.5 x 29.7
 (25 x 11 3/4)

The Mabel Brady Garvan Collection, 1930.2504

Structure: The inner frame appears to be carved from a single
piece of wood. The carved crest, side husks, and base are nailed
to the frame. The glass is backed with a piece of laid paper. The
backboard is held in place with nails.

The frame is screwed between the standards, which were
carved into shape and are tenoned and wedged through the top
of the case. The top is a single board glued to the front and sides
of the case. It is also nailed to the backboard, which is nailed
over the ends of the sides. The two horizontal drawer blades are
nailed between the sides. The bottom is nailed to the sides,
backboard, and the vertical drawer divider, which is tenoned
into the lower drawer blade and screwed to the case's bottom.

The bracket feet are each made of two pieces mitered together
and are nailed and glued to the case. One vertical brace and two
shaped blocks are glued behind each foot.

All three drawers are constructed in the same manner. The
front and back are dovetailed to the sides. The bottom is nailed
into a rabbet on the sides and directly to the back; its cham-
pfered front edge is fitted into a groove in the drawer front. The
upper drawer is supported by side runners that are fitted into
grooves in the case's sides and glued and nailed in place. The
compartments in this drawer are created by strips of wood that
are notched or slotted together. The four square compartments
are fitted with removable boxes that are butted and glued
together. These boxes support the compartments' covers; the
covers along the front of the drawer rest on small pieces of wood
glued into the compartments' corners.

Inscriptions: "A q y" is written in pencil in eighteenth-century
script on the backboard of the looking glass. The monograms
"JG" and "ET" are formed with cut-steel pins on the pincushion
fitted into the large drawer. Each box and its cover in this drawer
is numbered on the underside in an eighteenth-century hand,
corresponding to numbers written on the compartment's
bottom.

Condition: A photograph taken of this object at the time of its
discovery in 1926 documents many changes in its condition.
The thin layer of white plaster covering the frame in 1926 was
removed after the Camps purchased it (see *Provenance*), and
the frame was regilded. The three husks at the top of the left

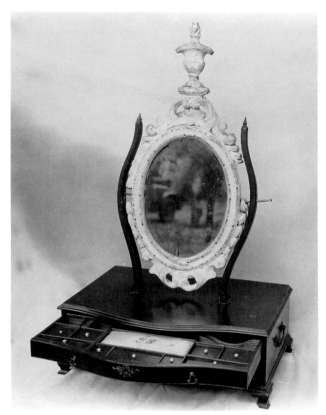

207 *1926 Photograph*

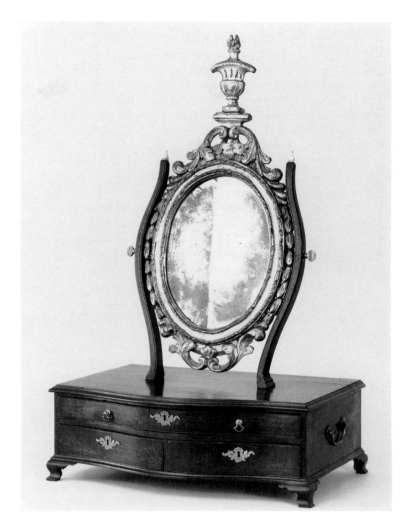

207

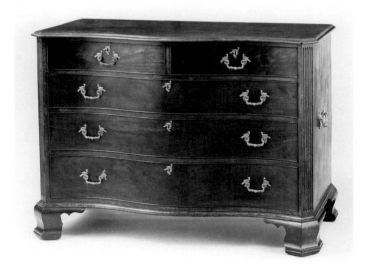

Fig. 86. Jonathan Gostelowe, Chest of drawers, Philadelphia, c. 1789.
Mahogany; yellow-poplar, Atlantic white-cedar, southern yellow pine.
Yale University Art Gallery, New Haven,
The Mabel Brady Garvan Collection.

side, the center husk on the right side, and sections of the outer bead-and-reel moldings were restored at this time. The urn finial was on the frame in 1926 and appears to be original, although its back has been scraped down. The glass and its paper backing appear to be original, as does the backboard, although it does not fit the frame exactly. It has split into two pieces. The screws supporting the frame are replacements. The standards' ivory finials were stained a mahogany color before 1926 and were cleaned at the Art Gallery prior to 1980. Both standards have been reattached to the top of the case; the top itself has been removed from the case and reattached. A large shrinkage crack in the top's left rear corner was repaired with a rectangular patch on the underside. A lateral brace glued to the underside of the top probably is a later addition. The vertical brace behind the left front foot has been reattached horizontally, and the side blocks have been reattached behind it. One of the glue blocks behind the right front foot is a replacement. All of the blocks behind the feet appear to have been reglued. The cast escutcheon on the upper drawer is original; the other two are casts made from the original by Ball and Ball in 1984. The stirrup pulls on the upper drawer are replacements. All of the fittings in the upper drawer are original. The surviving pins are positioned in original holes in the pincushion, but they have been rearranged since 1926.

Although the integrity of this dressing box and glass seems virtually certain, C.W. Brazer recorded that the frame was missing and considered lost when he first saw the box at "The Cheyneys" early in 1926 (Brazer 1926a, p. 386). In a subsequent article, Brazer wrote, "There can be no doubt that the smaller oval frame was carved to fit into the supports of Jonathan's dressing glass" (Brazer 1926b, pp. 108, 130), but he does not explain how the frame was reunited with the stand within a few months. Brazer had purchased a larger, related looking glass (see below), presumably from Eliza Fraser's heirs (see *Provenance*); his frame had been covered with white plaster at some point during the nineteenth century. As noted above, the frame belonging to the dressing box had also been covered with white plaster, which suggests that it had the same history of ownership as the larger looking glass. Presumably the smaller frame was owned by Eliza Fraser's heirs at the time that the other looking glass was discovered, and either they or Brazer were able to link it to the box that they had sold earlier to "The Cheyneys."

Exhibitions: Independence Hall, Philadelphia, "Loan Exhibition of Colonial Antiquities" (Gertrude H. Camp Collection), June-December 1928; Hornor 1935b, no. 58; Philadelphia 1976, no. 121; Yale University Art Gallery, New Haven, "A Wide View for American Art: Francis P. Garvan, Collector," May 8-September 28, 1980.

References: Brazer 1926a, figs. 3, 4; Brazer 1926b, p. 108; *Antiques* 10 (July 1926), p. 10; *Antiques* 14 (October 1928), inside back cover; Ormsbee 1934, fig. 26; Fales 1958, pl. 39b; Rogers 1962a, p. 11; Davidson 1967, fig. 280; Kane 1980, fig. 5; Kirk 1982, fig. 499; Ward 1988, p. 147.

Provenance: The monograms on the pincushion indicate that Gostelowe made this dressing glass and the associated chest of drawers about the time of his marriage on April 19, 1789, to his second wife, Elizabeth Towers. Gostelowe died on February 3, 1795; his wife died on June 23, 1808. Neither Gostelowe nor his wife had children from either of their marriages (she remarried after his death), and Elizabeth's property was inherited by her sister, Sarah Towers Evans. The dressing glass and chest of drawers descended to Sarah's son, Robert Towers Evans, in 1815; to his daughter, Martha P. Evans, in 1858; to her adopted niece, Eliza Ferguson Evans Fraser, in 1895; to Eliza's children after her death on January 10, 1920 (Philadelphia 1976, p. 152). In June 1926, Brazer published the dressing glass as the property of "The Cheyneys," an antiques shop near Media, Pennsylvania. One month later, the glass and its matching chest were advertised in *Antiques* by the antiques dealers Frank and Gertrude Camp, owners of the "Hayloft" in Whitemarsh, Pennsylvania. Both objects were purchased by Garvan on January 19, 1929, at an auction of objects consigned by Gertrude Camp (*Camp* 1929, frontispiece, no. 173).

This dressing box with swinging glass is one of the most elaborate with a history of ownership in this country and one of the few that can be documented as the work of eighteenth-century American craftsmen. As with other looking glasses during the Colonial period, imported examples of this form dominated the market. In 1718 James Logan purchased "1 Swinging Glass with a draw" from a cargo from England; another English example was owned by Samuel Allyne Otis (1740–1814) of Boston.[1] The importations continued during the Federal period: an English dressing box with swinging glass was purchased about 1786 by Elizabeth Van Rensselaer of New York, and in 1798 John Hurlburt of Wethersfield, Connecticut, acquired a lacquer dressing box with swinging glass in Canton, China.[2] An increasing number of examples made after 1800, however, represented the work of American craftsmen, such as Charles Del Vecchio of New York between 1812 and 1820, James Evans of Richmond, Virginia, between 1817 and about 1830, and Thomas Natt of Philadelphia in 1829.[3]

Made about 1789, this dressing box with swinging glass is a synthesis of the styles current in Philadelphia at the end of the War of Independence. Its overall design is Rococo, as are such details as the ogee bracket feet and the chased and gilded brass escutcheons that echo the gilded frame. Despite its bold, three-

dimensional carving, however, the frame shows the influence of Neoclassical looking glasses surrounded by openwork ornament (cats. 176–181). The serpentine front and frame standards, which related the box to the chest of drawers it accompanied (Fig. 86), exhibit a Neoclassical attenuation.[4] Another characteristic feature of urban furniture from the Federal period are delicate, light colored accents on dark mahogany, created here by the standards' ivory finials and the ivory knobs on the interior compartment covers.

Gostelowe's dressing box with swinging glass was a labor of love, as befits an object made for himself and his second wife at the time of their marriage. A comparison of this object with the basic form detailed in the 1788 *London Cabinet Book of Prices* indicates that Gostelowe treated himself and his wife to a number of "extras" that would have significantly increased the cost of the dressing glass had it been made for sale. The case is 5 1/2 in. (14cm) wider and deeper than the standard 14 x 8-in. (35.6 x 20.3cm) model. By "making the front serpentine with straight ends," the most expensive extra listed, he increased the box's cost by almost fifty percent. Gostelowe also added two smaller drawers and provided the upper drawer with a pincushion, twelve small compartments, nine loose covers, four "powder boxes," and five "division[s] for a razor." These embellishments would have cost approximately £1.3.3, more than four times the basic model's price of 5s. 6d.[5] The carved and gilded frame, ivory knobs and finials, and chased and gilded brass escutcheons would have further increased its total cost to well over £2, making this relatively small object equal in value to a desk or chest of drawers.[6]

The carved and gilded looking-glass frame distinguishes this dressing box from the majority of contemporary examples, which had veneered frames like the "Mahogany Swingers, Walnut Tree Ditto" advertised by Robert Stott of Charleston, South Carolina, in 1781.[7] One of the few contemporary descriptions of a dressing box similar to Gostelowe's is the "Dressing Glass Mahoy Stand & Gilt Frame" included in the 1774 inventory of Stephen Carmick of Philadelphia.[8] The frame Gostelowe chose for his dressing box very probably was made by the carver and gilder James Reynolds, who worked in close proximity to Gostelowe throughout his career. Prior to the War of Independence, they both had shops on Front Street near Chestnut; at the time the dressing box was made, Reynolds' shop was on Third Street near the entrance to Church Alley, where Gostelowe's shop was located. There are close similarities between documented examples of Reynolds' work and details of the carving on the Art Gallery's frame. The addorsed, foliate S-scrolls and the tripartite leaves between them at the base and top of the dressing glass are shaped and veined in the same way as their counterparts at the top of the pier glass Reynolds made for John

Cadwalader of Philadelphia in 1770.[9] The dressing glass frame apparently was discovered at the home of the same Gostelowe-Towers family descendants who owned a larger oval looking glass of almost identical design, reportedly signed "James Reynolds of Philadelphia."[10]

The visual similarity between this dressing box with swinging glass and the chest of drawers it accompanied reflected a conception of dressing boxes as a miniaturized versions of case furniture used for storing apparel. As noted in the introduction, seventeenth-century dressing boxes had hinged lids and functioned as chests, containing small looking glasses and other accessories.[11] With the swinging glass mounted on top of the dressing box, the box was transformed from a chestlike container into a small-scale case of drawers with access from the front. On some of the earlier English examples the box is shaped like a portable desk,[12] but on the majority of the later examples the box was clearly designed to imitate a chest of drawers, presumably one on which it was intended to stand. A dressing box with swinging glass with a blocked front similar to those on chests of drawers was made in Boston about 1740.[13] An inlaid oval dressing box with swinging glass probably was created by John and Thomas Seymour and John Doggett in 1809 to match an inlaid semicircular bureau.[14] A dressing box with swinging glass made after 1847 by Duncan Phyfe is a diminutive four-drawer chest of drawers and mirror.[15]

Gostelowe's dressing box with swinging glass represented one significant change in the traditional usage of this form. Dressing boxes owned by men in the seventeenth and early eighteenth centuries were usually kept on a chest of drawers, whereas women's dressing boxes stood on a dressing or toilet table.[16] These gender-related placements apparently had ceased by the 1780s. John Parkinson of Charleston, South Carolina, advertised "Toilet Glasses with Drawers for Ladies Commodes" in 1781.[17] Gostelowe's dressing box with swinging glass similarly was associated with a chest of drawers and intended for a woman's use as well as a man's. The box's upper drawer was designed to accommodate items used by men and women; as described in the 1788 London price book, these compartments were for razors, a hone and oil bottle for the razors, combs, brushes, toothbrushes, tweezers, knives, essence bottles, and pomatum.[18] The pincushion in this drawer, however, was specifically feminine in character. Satin-covered pincushions with pins arranged in initials, floral designs, or sentimental phrases were a common gift to women after the birth of a child in the eighteenth century.[19] The pincushion inserted in Gostelowe's dressing box may have been an expression of hope for children from his second marriage.

1. McElroy 1970, p. 36; Jobe/Kaye 1984, no. 142.
2. Colonial Williamsburg, Virginia (no. 1964–244); Wadsworth 1985, no. 159.

3. Parke-Bernet 1942, no. 128; Bivins 1989, fig. 27; MESDA research file no. S-6935.
4. The chest of drawers is catalogued in Ward 1988, no. 66.
5. *London Prices* 1788, pp. 107, 119–20.
6. *London Prices* 1788, pp. 29–30.
7. *Royal Gazette*, April 11, 1781 (Prime 1929, p. 197).
8. Hornor 1935a, p. 282.
9. See Beckerdite 1984, pp. 1121, 1123–24.
10. Brazer 1926b, pp. 108, 130; the present whereabouts of this looking glass are unknown. From the photograph in Brazer's article, this frame does not appear to exhibit any characteristics of Reynolds' carving style as seen on either the Cadwalader or the Art Gallery's frames.
11. Forman 1987, pp. 155–56.
12. *DEF*, II, pp. 352–54.
13. The Art Institute of Chicago (no. 1944.423).
14. Hipkiss 1941, no. 136.
15. McClelland 1939, pl. 108.
16. Forman 1987, pp. 163–64.
17. *Royal Gazette*, August 15, 1781 (Prime 1929, p. 223).
18. *London Prices* 1788, pp. 127–28.
19. Garrett 1985, pp. 72–73.

208

SCREEN DRESSING GLASS

Probably England, possibly America, 1810–25

Mahogany, mahogany veneer; spruce (glue blocks)

179.8 x 78.2 x 59 (70 3/4 x 30 3/4 x 23 1/4); frame, 111.6 x 63.3 (43 7/8 x 24 7/8)

The Mabel Brady Garvan Collection, 1930.2521

Structure: The side frame members are dovetailed to the top and bottom. The veneered front surface of the frame serves as the sight edge. The backboard is a frame with four rectangular panels. The top and bottom members of this frame are fitted into the sides with tongue-and-groove joints. The center horizontal member is tenoned between the sides; two additional vertical members are tenoned between this central piece and the top and bottom. The backboard's side members have rabbeted outside edges that fit into grooves in the sides of the mirror frame. The backboard is screwed to the mirror frame at the bottom. The glass is secured by rectangular glue blocks. Brass knobs are screwed through the standards into the frame's side members. The stand's horizontal members probably are tenoned between the standards. The legs are tenoned into the standards; this joint is reinforced by iron strips screwed to the legs' undersides.

Condition: Sections of the veneer on the front of the mirror frame are replacements. The black paint on the turnings probably is a later addition. The knobs originally had circular back-plates that are now lost. The beveled glass appears to be original. One of the blocks securing the glass is new; the others have been reglued and possibly are replacements. The brass animal-paw casters are original.

Provenance: This screen dressing glass was owned by the collector Louis Guerineau Myers (1874–1932) of New York City. Garvan purchased it at an auction of objects from Myers' collection on February 26, 1921 (*Myers* 1921, no. 597).

At the end of the eighteenth century, improved technology in the manufacture of looking-glass plates made possible this greatly enlarged form of swinging glass. It was known by a variety of names, including "screen dressing glass," "horse dressing-glass," and the French translation of the latter term, "cheval dressing-glass."[1] The earliest versions of the form, as listed in the 1788 London price book and illustrated in the 1793 appendix to Thomas Sheraton's *Drawing-Book*, were suspended on weights that moved up and down within the standards.[2] By the beginning of the nineteenth century, when screen dressing glasses became more popular, they also were "made to swing"; Charles Percier, Thomas Hope, George Smith, Richard Brown, and Peter and Michael Angelo Nicholson created elaborate, classically inspired designs for frames of this type.[3] In 1827, Ackermann's *Repository* reported: "These moving glasses are now generally introduced in the sleeping-apartments and dressing-rooms of our nobility and persons of distinction."[4]

Screen dressing glasses were owned in America throughout the nineteenth century. The 1817 *New-York Book of Prices* contained the first description of the form in an American price book, although few examples made before 1850 can be identified conclusively as American in origin.[5] Two similar Neoclassical screen glasses may have been made in New York City: one has candle-arm sockets marked by the New York brazier Harmon Hendricks between about 1804 and 1812, and the other may have been purchased before 1819 from Charles-Honoré Lannuier of New York by James Bosley (c. 1779–1843) of Baltimore.[6] A small screen glass with baluster turnings more like the standards of the Art Gallery's frame was labeled by the looking-glass maker Charles N. Robinson of Philadelphia between 1813 and 1822.[7] Screen glasses in a later Classical Revival style were purchased from the cabinetmaker John Meads of Albany, New York, in 1831 and sold at the 1847 auction of Duncan Phyfe's shop in New York City.[8]

1. *London Prices* 1788, p. 157; Sheraton 1803, pp. 255–56; Loudon 1833, p. 1085.
2. *London Prices* 1788, p. 157; Sheraton 1802, pp. 24–25, pl. 17.
3. *London Prices* 1811, p. 299; Percier/Fontaine 1812, pl. 22; Hope 1807, pl. 14; Smith 1808, pls. 125–27; Brown 1820, p. 35; Nicholson/Nicholson 1826, pl. 44.

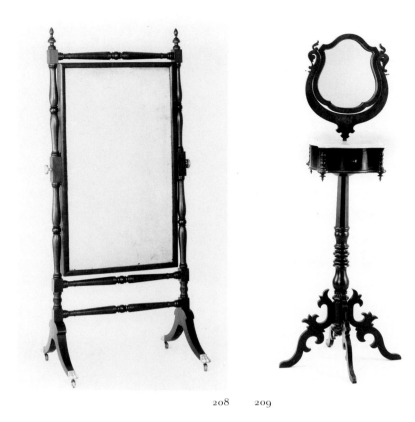

208 209

4. Agius 1984, p. 178.
5. *New York Prices* 1817, p. 85; *New York Prices* 1834, pp. 92–93.
6. Gaines 1973, p. 775; Weidman 1984, no. 108. A related screen glass has been attributed to Lannuier (Tracy 1970, no. 23).
7. Schiffer 1983, no. 543.
8. Schwartz 1989, p. 60; *Phyfe* 1847, no. 323 ("1 large rosewood splendid screen Glass, 60 in. by 30 in. 7 feet high, O G [ogee] cornice, back lined with purple silk").

209

SHAVING STAND

Probably northeastern United States, 1850–70

Mahogany (including the dowel connected to the standard), mahogany veneer; eastern white pine (mirror frame members, case sides and back, drawer front), yellow-poplar (mirror backboard, case bottom, drawer interior)

173 x 63.3 x 64.2 (68 1/8 x 24 7/8 x 25 1/4); mirror frame, 55.9 x 43 (22 x 16 7/8)

Bequest of Thomas Wells Farnam, B.A. 1899, 1986.140.2

Structure: The veneered mirror frame is composed of two laminates that are sawed to shape. The glass is fitted between the laminates. A bead molding is applied around the sight edge. The glass is secured with glue blocks, and the backboard is screwed over the back of the frame. The standard is composed of two halves joined together with a spline. Brass keys are screwed through the standard's sides into the sides of the frame. The standard is mounted on a long dowel that fits through the drawer case into the stand's shaft. The front and back members of the case are presumably butted and glued between the sides. The bottom is nailed and pinned to the sides.

The drawer's interior is U-shaped to fit around the dowel supporting the mirror. The drawer front and two back pieces are dovetailed to the exterior side members. The interior side pieces are dovetailed to the back pieces. The bottom has feathered edges fitted into grooves in the front and exterior side members. Drawer guides are glued to the inside of the case. The case's bottom is screwed to the base. The legs are doweled to the base. Turned drops are glued to the case and the underside of the base.

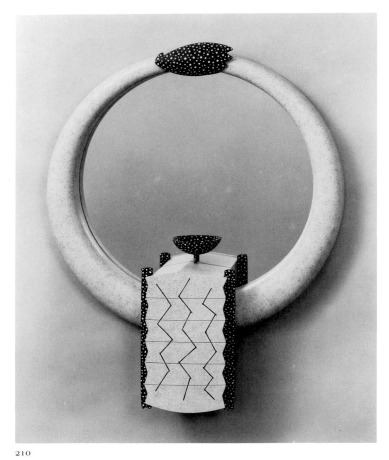

210

210 *Signature*

Condition: A hole in the base's left side suggests that there was at one time a key for securing the dowel supporting the mirror. The front and left legs have been broken and repaired; the rear leg is a replacement. The glass is original.

Provenance: This shaving stand is associated with a suite of bedroom furniture that came to Yale University as part of the bequest of Thomas W. Farnam (1877–1943) of New Haven. Farnam lived in his parents' house at 37 Hillhouse Avenue, which had been built in the mid-1860s and first occupied by Daniel Coit Gilman from 1869 to 1872. The furniture may have been original to this house and sold with it to the Farnams when Gilman moved to California. However, Thomas Farnam gave to Yale both his own home, which the University converted to offices and classrooms, and the house built in 1871 by his grandfather at 43 Hillhouse Avenue, which became the residence of Yale's president. Thomas Farnam's uncle, Charles Henry Farnam, owned a house built in 1884 at 28 Hillhouse Avenue that also became Yale property (Kelley 1974, pp. 39, 43, 45). In 1974, the bed from this suite (Kane 1976, no. 296) was found in a University-owned residence at 35 Hillhouse Avenue; the remainder of the furniture, including the shaving stand, was in the house at 43 Hillhouse Avenue. It is not known where the furniture was located at the time of Farnam's bequest.

The "shaving stand" described in late eighteenth- and early nineteenth-century price books was a basin stand with a small looking glass fitted into a recess in the case.[1] During the second quarter of the nineteenth century, as eighteenth-century basin stand forms ceased to be fashionable (see p. 268), shaving stands were changed into a form of dressing box with swinging glass (cat. 207) mounted on a pedestal or stand that brought the mirror to eye level. The box often had a water-resistant top of marble or ceramic tile and a single drawer for the shaving implements. Designs for shaving stands of this type were published in 1850: a very simple, Classical Revival example by William Smee and Sons of London and an "Elizabethan" style stand in Downing's *Architecture of Country Houses*.[2] An early documented example is a grain-painted shaving stand made in 1841 for Martin van Buren's home, "Linenwald." Derived from earlier dressing boxes, these shaving stands also continued a custom of the seventeenth and early eighteenth centuries, when dressing boxes owned by men almost invariably stood on chests of drawers and probably were used by their owners while standing.[3]

The present shaving stand apparently was purchased to complement a suite of bedroom furniture owned by the Farnam family of New Haven (see *Provenance*). Although it approximates the Rococo Revival style of the suite, the shaving stand is clearly not by the same maker as the bed, washstand, and chest

of drawers. These richly carved pieces are made of rosewood, whereas the stand is made of mahogany and achieves a dynamic silhouette with turned and jigsawed elements. It is possible that a local cabinetmaker made the shaving stand to match bedroom furniture ordered from a large urban center, such as New York City. The yellow-painted interior of the shaving stand's drawer seems to be a deliberate attempt to match the bird's-eye maple veneer used on the drawer interiors of the case pieces in the suite.

1. *London Prices* 1788, pp. 72–73, pl. 12; *New York Prices* 1796, pp. 52–53.
2. Joy 1977, p. 390; Downing 1850, p. 452.
3. Forman 1987, pp. 163–64.

2 1 0

EARRING CABINET *Color plate 28*

Rosanne Somerson (b. 1954)

Westport, Massachusetts, 1989

Yellow-poplar (frame), hard maple (cabinet); padauk (drawer interiors), birch plywood with Douglas-fir core (backboard, drawer bottoms, back of cabinet)

74.7 x 59.7 x 16.3 (29 3/8 x 23 1/2 x 6 3/8)

Bequest of Marie-Antoinette Slade, by exchange, 1989.66.1

Structure: The frame is composed of two pieces joined by crosspieces at the top and bottom. The crosspieces are double tenoned to the frame. The feather is tenoned to the upper crosspiece. The backboard is screwed into a rabbet on the back of the frame and secures the glass, which is also fitted into a rabbet. Four matboard shims separate the backboard and the glass. The hanger is an aluminum strip screwed across the back of the frame; a hollow is cut into the backboard behind the notch at the strip's center.

The cabinet is fitted over the lower crosspiece and glued to the frame. The case is assembled with tongue-and-rabbet joints. The drawer dividers are fitted into grooves in the sides. The back, covered with handmade paper, is screwed into a rabbet on the back of the cabinet. The painted strips are fitted into the sides with tongue-and-rabbet joints. The cup is mounted on a dowel covered with copper wire.

The backs and inner fronts of the drawers are dovetailed to the sides. The bottoms, covered with handmade paper, are fitted into grooves in the front and sides and extend beyond the backs as stops. The painted, outer fronts are screwed to the inner fronts. Each drawer is partitioned into four compartments.

Inscriptions: "8 R Somerson 9 / D.E.K." is incised on the back of the frame. The numerals 1 through 6 are stamped on the drawer bottoms. "29 89 LENOIR MIRROR3 6" is stamped on the back of the glass.

Provenance: The Art Gallery commissioned this object from the artist.

This earring cabinet is an inversion of the traditional dressing box and swinging glass (cat. 207), with the cabinet hanging from the mirror frame instead of the mirror being mounted on the box. Like other furniture makers of the 1980s, Somerson has created an unmistakably contemporary form that makes references, sometimes humorously, to the past. The circular frame with the applied feather ornament evokes Neoclassical looking glasses (cats. 180, 181); Somerson also chose the shape to suggest a hoop earring. The sponge-painted surface mimics the worn, multilayered surfaces of old painted furniture, conferring an instant patina on a new object. The conceit of placing half a cuplike tray in front of the glass to visually form a whole by its reflection is taken from Neoclassical pier tables with semicircular designs on their tops and shelves that became whole when reflected in the accompanying mirrors. The painted decoration and patterned paper used on this object, as well as the two-dimensional quality of the applied ornament, reflects Somerson's interest in African masks.[1] Non-traditional, so-called "primitive" sources were equally important for Judy McKie's contemporary painted table (cat. 27).

Somerson first created this design in 1986 for the collectors Ronald and Anne Abramson of Rockville, Maryland; she made the parts for both the Abramsons' and the Art Gallery's objects at the same time.[2] The two earring cabinets are identical except that the Art Gallery's has six drawers instead of five. When she assembled this frame in 1989, Somerson was assisted by Donald E. Krawczyk (b. 1957), whose initials are included in the inscription.

1. Somerson to the author, November 19, 1990, Art Gallery files.
2. The Abramsons' earring cabinet is illustrated in Cooke 1989, p. 118.

Study Collection

The following entries record objects in a Study Collection used in teaching connoisseurship of American decorative arts. These objects are distinguished from the Art Gallery's primary American furniture collection because they are not American, have been altered from their original appearance, or have been made to appear old. Objects of this type from the Mabel Brady Garvan Collection are included in this section not to emphasize mistakes made by a previous generation, but to catalogue completely one of the most important collections of American decorative arts assembled during the first decades of this century. Many of these objects previously have been published and exhibited as genuine, and this section is intended in part as a correction of the record. Misidentified, altered, or fraudulent objects also provide insights into the tastes and prejudices that governed the formation of the Garvan Collection as well as other collections of its era.

Misidentified Objects

The three objects in this section, all from the Mabel Brady Garvan Collection, were misidentified when acquired. Microanalysis of the secondary woods has been the most important tool for determining these new attributions.

A 1
PIER TABLE

England or Ireland, 1875–1915, previously identified as "Chippendale period"
Unidentified species of *Thespesia*; mahogany (corner blocks)
77.1 x 103.5 x 53.3 (30 3/8 x 40 3/4 x 21)
The Mabel Brady Garvan Collection, 1942.263

Provenance: Garvan purchased this table from Tiffany Studios in New York City in December 1916 or January 1917.

During an interview following his gift of the Mabel Brady Garvan Collection to Yale University, Francis P. Garvan discussed how he had begun collecting decorative arts. At the time of his marriage in 1910, he and Mabel Garvan were unhappy with the quality of contemporary furniture. They were convinced that "better craftsmanship and more beauty were to be obtained in the furniture of former years." The couple began purchasing European furniture, but eventually discovered that many of these objects were fakes. According to the interviewer, "They dumped about $40,000 worth of the articles they had acquired, mostly English, and started in to replace them with those of American manufacture."[1]

Purchased from Tiffany Studios in 1916, together with a pair of sixteenth-century Italian chairs and a large quantity of Georgian English furniture, this table may well be one of the objects of dubious date that Garvan referred to in the interview. Even at this early period in his collecting, Garvan approached each piece with great seriousness. He had Harry Oatway, an English agent for Tiffany Studios, supply him with research from the College of Arms identifying the coats of arms on this table as those of the descendants of William Day, Bishop of Winchester in 1595.[2] Despite this careful research, the construction and lack of age on the table indicates that it was made no earlier than the third quarter of the nineteenth century. It may well have been made for one of three Irish brothers named Day, of Huguenot descent, who had these arms confirmed to them by the Ulster King of Arms on September 8, 1875.[3]

1. Stow 1930.
2. Oatway to Garvan, December 5, 1916, Tiffany Studios file, FPG-AAA.
3. Howard 1877, II, p. 372.

A 2
PIER TABLE

England or Ireland, 1740–70; previously identified as "Philadelphia"
Mahogany; sylvestris pine (inner rails, glue blocks)
80.3 x 106.5 x 54.6 (31 5/8 x 41 7/8 x 21 1/2)
The Mabel Brady Garvan Collection, 1930.2528

Reference: Miller 1937, II, no. 1427.

Provenance: Two different but equally distinguished histories of ownership have been recorded for this table. In the late nineteenth century, it was in the collection of Dr. William H. Crim of Baltimore, Maryland; it was sold at the auction of Crim's estate in 1903 (*Crim* 1903, no. 1074; illustrated facing pp. 2, 78). According to the auction catalogue, the table originally belonged to Roger Brooke Taney (1777–1864) of Maryland, who served as Secretary of the Treasury, United States Attorney General, and Chief Justice of the Supreme Court. Taney was born too late to have been the table's original owner, although he may have inherited it. In 1929, R.T.H. Halsey purchased the table on Garvan's behalf in Annapolis, Maryland, for exhibition in the Hammond-Harwood House. Halsey reported that the table's original owner was Dr. Upton Scott (1722–1814) of Annapolis (Halsey to Garvan, May 3, 1929,

Halsey file, FPG-AAA; "Purchased in Annapolis by RT Halsey for Harwood House," manuscript list, Hammond-Harwood Loan file, Box 14, FPG-AAA). A pair of side chairs purportedly owned by Scott, acquired by Halsey at the same time, is also in the Art Gallery's collection (Kane 1976, no. 145); Garvan's catalogue card states, "These chairs were purchased from the heirs of Upton Scott, uncle of Francis Scott Key. They had always been in the Upton Scott House" (FPG-Y). The provenance recorded on the catalogue card for the table is less specific, stating only "This table was originally in the dining room of the Upton Scott House" (FPG-Y). If Halsey purchased the table from the same Scott descendants as the chairs, they could not have owned it prior to the Crim sale in 1903. Moreover, none of this furniture was in the Upton Scott house in 1929, as it was then the property of a Roman Catholic religious order and apparently unfurnished (photograph album, Hammond-Harwood Loan file, Box 14, FPG-AAA).

This table's carving, construction, and secondary wood are characteristic of Anglo-Irish furniture of the mid-eighteenth century. When it was owned by the Baltimore collector William Crim in the late nineteenth century, it was so admired that it inspired at least two copies, later acquired as eighteenth-century Philadelphia objects by the collectors George S. Palmer and Charles L. Pendleton.[1] The imitations incorporated several disfiguring repairs that had been made to Crim's table, particularly the poorly carved gadrooning on the front rail. The top is also a replacement.

This table apparently was made as one of a pair. The 1903 Crim auction catalogue illustrates a center table with an identical carved frame, mounted on a Classical Revival style pedestal.[2] This frame appears to retain its original gadrooning. It may have been salvaged as a relic of a famous owner when the legs were damaged beyond repair.

1. Monkhouse/Michie 1986, pp. 27–28.
2. *Crim* 1903, no. 1970.

A 3

MIRROR

Probably Northern Continental Europe, 1890–1925; previously identified as "Adam," 1780–1800

Basswood (carved elements, gilt moldings), mahogany veneer; sylvestris pine

167.5 x 63 (66 x 24 3/4)

The Mabel Brady Garvan Collection, 1930.2650

Provenance: Acting as Garvan's agent, Frank MacCarthy purchased this mirror from an otherwise unidentified Miss

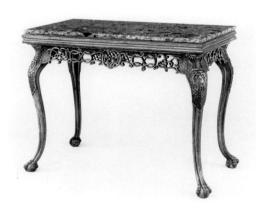

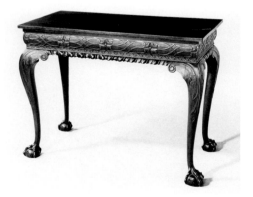

A1 A2

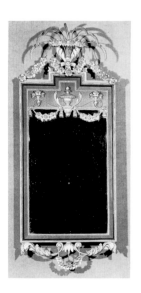

A3

Thompson of Northampton, Massachusetts, on September 16, 1929.

This mirror exhibits almost no age or wear and probably was relatively new when Garvan acquired it. The form is copied from German Neoclassical mirrors of about 1780, with rose garlands substituted for the husks and other foliage found on the originals.[1]

1. See Kreisel/Himmelheber 1973, III, no. 218.

Alterations and Restorations

The objects in this section have had significant alterations made to their original appearance. It is difficult to distinguish between changes resulting from earlier adaptations or embellishments of outmoded furniture and later attempts to make undistinguished pieces more salable to antique collectors. Objects in this category are currently considered too compromised to be exhibited, although Garvan and other collectors of his generation apparently felt differently. In 1932, he deliberately purchased a New Hampshire high chest with a faked upper case for the Art Gallery's collection; it was catalogued as "Top and base do not belong together—bought for type."[1] Several objects from Halsey's collection, including one in this section (cat. A7), were acquired with the knowledge that their inlays were later additions.[2]

1. "Goods at #109 West 64th St.: Keep for Yale," typescript, Loft Lists file, Box 18, FPG-AAA. The high chest is illustrated in Ward 1988, app.

18; it was purchased at Rains Auction Rooms in New York (*Lyon* 1932, no. 85).
2. "Margolis Report on Halsey Collection," typescript, Halsey Loan file, Box 13, FPG-AAA.

A 4

TEA TABLE

Boston area, 1740–60, with later additions and replacement
Mahogany; yellow-poplar (glue block residue on front rail)
68 x 71.3 x 46.8 (26 3/4 x 28 1/8 x 18 3/8)
Bequest of Olive Louise Dann, 1962.31.10

The top is old but not original to this frame. The candleslides are not old and relatively recent additions.

A 5

TABLE WITH DRAWER

Pennsylvania, 1750–1800, with later alterations and replacements
Maple; yellow-poplar
73.1 x 134.9 x 72.8 (28 3/4 x 53 1/8 x 28 5/8)
The Mabel Brady Garvan Collection, 1930.2600

All four frame rails have been reshaped from square to arched lower edges; originally there probably were bead moldings along their edges to match those on the stretchers. The top, cleats, and feet are replacements.

A4

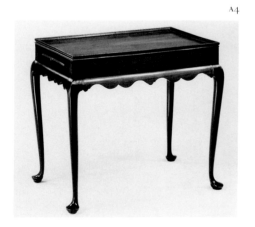

A5

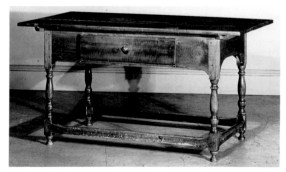

A6

A 6

TABLE

Probably Pennsylvania, 1750–1800, with later addition and replacements

Black walnut; yellow-poplar (drawer interior), eastern white pine (drawer runners)

75.1 x 96.2 x 70.6 (29 5/8 x 37 7/8 x 27 3/4)

The Mabel Brady Garvan Collection, 1930.2734

Provenance: Garvan purchased this table from Louis King.

The drawer is not old and has been added to what originally was a table without a drawer. The top, made from old falling leaves, and cleats are replacements.

A 7

DINING TABLE ONE OF A PAIR

Probably Baltimore, 1790–1820, with later inlay

Mahogany and mahogany veneer; white oak (hinged rail), eastern white pine (all other secondary wood)

73.1 x 120.3 x 56.7 (111.8 open) (28 3/4 x 47 3/8 x 22 3/8 [44])

The Mabel Brady Garvan Collection, 1930.2692A

Exhibition: Robinson Hall, Harvard University, Cambridge, Massachusetts, "Harvard Tercentenary Exhibition: Furniture and Decorative Arts of the Period 1636–1836," July 25-September 21, 1936.

Provenance: This table was part of the collection Garvan acquired from R.T.H. Halsey.

The crude eagle inlays are twentieth-century additions. The patterned banding along the rails' lower edge may be a replacement.

A 8

PEMBROKE TABLE

New York City, 1810–20, with later replacements

Mahogany (including corner blocks); eastern white pine (frame rails), soft maple (hinged side rails), hard maple (cross braces)

73.1 x 58.6 (114.3 open) x 91.6 (28 3/4 x 23 1/8 [45] x 36 1/8)

The Mabel Brady Garvan Collection, 1930.2249

Reference: Cornelius 1922, pl. 38.

Provenance: This table was part of the collection Garvan acquired from R.T.H. Halsey.

Aside from the poor quality of its carving, this table is so heavily restored that its appearance is far removed from the maker's original intentions. The top is old but not original to the frame. The drops as well as the right front fly support are replacements. The finial and casters are lost.

A 9

CARD TABLE

Probably New York or Connecticut, 1780–1800, with later additions

Mahogany (including corner blocks), mahogany veneer; redgum (hinged rail), eastern white pine (other frame rails)

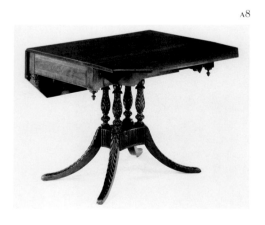

A8

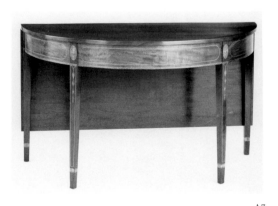

A7

A7 *Inlay*

74.2 x 90.9 x 44.6 (29 1/4 x 35 3/4 x 17 1/2)
The Mabel Brady Garvan Collection, 1930.2459

Exhibition: Robinson Hall, Harvard University, Cambridge, Massachusetts, "Harvard Tercentenary Exhibition: Furniture and Decorative Arts of the Period 1636–1836," July 25–September 21, 1936.

Provenance: This table was owned by the collector Howard Reifsnyder of Philadelphia. Garvan purchased it at the auction of Reifsnyder's estate on April 24, 1929 (*Reifsnyder* 1929, no. 185).

The veneer and inlay on the facade and legs are twentieth-century additions. Five of the openwork brackets appear to be old but are not original to the table; the left rear bracket is modern.

A 10
STAND

Probably New England, 1750–1800, with later alteration and replacements
Maple (base), black cherry (top)
71.1 x 47.5 x 51.9 (28 x 18 3/4 x 20 3/8)
The Mabel Brady Garvan Collection, 1930.2440

Reference: Nagel 1932, p. 139.

Provenance: Garvan purchased this stand from Henry Hammond Taylor on September 17, 1929.

The legs are replacements, and an adjustable book stand was substituted for the original top at the beginning of this century. No attempt was made to mask these changes.

A 11
STAND

Northeastern United States, 1800–20, with later addition and alteration
Mahogany
72.2 (103.6 top up) x 42.2 x 70.5 (28 3/8 [40 3/4] x 16 5/8 x 27 3/4)
The Mabel Brady Garvan Collection, 1930.2998

Exhibition: Katter/Boodro 1974, no. 31

References: Miller 1937, II, no. 1351; Davis 1947, p. 56.

Provenance: Garvan purchased this stand from Jacob Margolis in October 1924.

The top appears to be original, although its surface has been so heavily refinished that its age is difficult to determine. The eagle inlay, a twentieth-century addition, was a popular means of upgrading an otherwise damaged or unexceptional form (see cats. A7, A17). The feet have been reduced in height.

A 12
LOOKING GLASS

Possibly Northern Continental Europe, 1700–1800, with later restorations
Sylvestris pine

A10

A9

A11

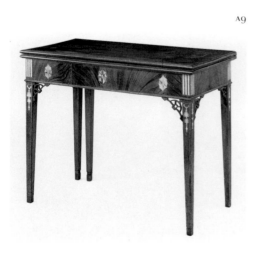

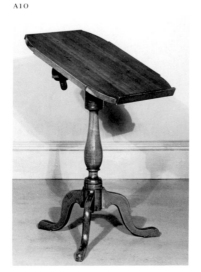

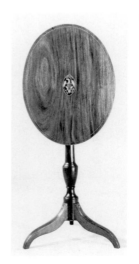

43.1 x 30.8 (17 x 12 1/8)
The Mabel Brady Garvan Collection, 1930.2142

Provenance: Garvan purchased this looking glass from C.R. Morson in 1923.

The crest's moldings and reverse-painted glass panels, the outer molding at the lower left corner, and the backboard are replacements. The glass plate has been resilvered and may also be a replacement.

A13
LOOKING GLASS

Probably England, 1725–50, with later addition and alterations
Walnut veneer; spruce
101.6 x 42.5 (40 x 16 3/4)
Bequest of Olive Louise Dann, 1962.31.21

This frame is veneered with walnut and was not originally painted to simulate japanning. The crest is lost. The frame was disassembled and possibly shortened at its lower end to accommodate the lower glass plate, which is a replacement dated June 30, 1916. The painted decoration probably was added after this date.

A14
LOOKING GLASS ONE OF A PAIR

Probably England, 1740–70, with later additions and a mate of
 c. 1900

Mahogany veneer, spruce
140.8 x 75.3 (55 3/8 x 29 5/8)
The Mabel Brady Garvan Collection, 1930.2066A

Reference: *YUAGB* 4 (December 1930), p. 106.

Provenance: Henry Hammond Taylor found this pair of looking glasses in Maine, where they came "from an old Portland family" (Taylor to Arthur W. Clarke, n.d. [August 1929], Taylor file, FPG-AAA). Acting as Garvan's agent, he bought them on August 14, 1929.

Most of the applied ornament on this frame, including the finial, was added around 1900 to match a reproduction made as its mate.

A15
LOOKING GLASS ONE OF A PAIR

Probably England, 1740–70, with later addition and
 replacements
Mahogany veneer, spruce
122.5 x 60.4 (48 1/4 x 23 3/4)
Gift of Mrs. Clark McIlwaine in memory of Margaret Tyler
 Clark, 1946.2B

Mid-nineteenth-century sconce sockets have been added to these frames. The finial, rosettes, and vines are twentieth-century restorations.

A14 A15

A13

A12

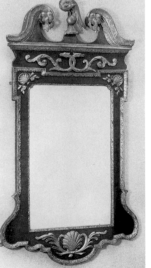

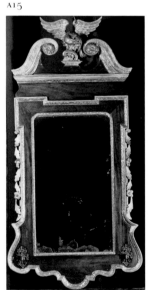

A16
LOOKING GLASS

New England, 1800–40, with later additions and replacements
Black cherry; yellow-poplar
87.1 x 46 (34 1/4 x 18 1/8)
The Mabel Brady Garvan Collection, 1930.2722

Provenance: Garvan purchased this looking glass from Frank MacCarthy on September 28, 1928. MacCarthy noted on the bill of sale that it was "from West Haven [Connecticut]" (Mac-Carthy File, FPG-AAA).

The original frame was an inexpensive New England looking glass of the early nineteenth century (see cat. 171). The reverse-painted glass panel appears to be a later addition, perhaps dating as early as a decade after the frame. The base, both upper brackets, and the lower right bracket are more recent replacements, probably made at the beginning of this century. The crude painted decoration on the base and crest also dates from this time.

A17
LOOKING GLASS

Probably New York City, 1800–20, with later restorations
Mahogany veneer; eastern white pine (crest, inner frame),
 yellow-poplar (restorations)

110.5 x 55.4 (43 1/2 x 21 3/4)
The Mabel Brady Garvan Collection, 1930.2244

Provenance: This looking glass was part of the collection Garvan acquired from R.T.H. Halsey in 1929. Halsey probably purchased it about 1907, when he had it restored by Ernest Hagen.

The New York cabinetmaker Ernest Hagen reconstructed this object in 1907 from a surviving crest and inner frame. The crest is similar to those found on documented New York frames from the early nineteenth century (cat. 170), and Hagen copied the base and brackets from appropriate models, as was characteristic of his method.[1] The eagle inlay appears to date from the early nineteenth century but may not be original to the crest. Hagen or Halsey may have felt it was a permissible addition given the degree of restoration they had undertaken. Similar eagle inlays have been found primarily on Massachusetts furniture, although at least one New York style looking glass has an inlay of this type.[2]

1. Stillinger 1988, pp. 8D–9D. The looking glass bears Hagen's label and a dated inscription similar to the one on cat. 68.
2. Montgomery 1966, nos. 216, 303; *Antiques* 93 (June 1968), p. 705.

A18
LOOKING GLASS

Probably New York City, 1800–35, with later addition and
 replacement

A16 A17

A18

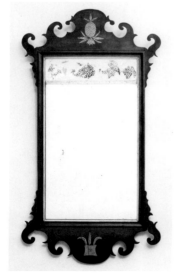
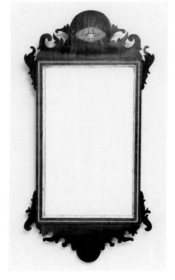
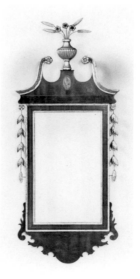

Mahogany veneer; eastern white pine
111.7 x 54 (44 x 21 1/4)
Gift of Mr. and Mrs. Kenneth Milne, 1975.111

Exhibition: The Bruce Museum, Greenwich, Connecticut, "Fabulous Fakes," May 4-July 1, 1984.

The inlay is a recent addition, the finial is a replacement, and the gilding is restored.

Objects Constructed from Old Parts

The objects in this section were constructed from surviving fragments of old pieces of furniture. In most cases these re-creations are presumed to have been made with the intention of deceiving collectors into believing that they were intact, genuine examples.

A19
TEA TABLE

Mahogany
73.2 x 53.8 x 79.9 (28 7/8 x 21 1/4 x 31 1/2)
Gift of Marshall Field, 1975.124.2

Exhibition: Chicago 1971, no. 39.

References: Hanks 1971, p. 117; Sack 1985, pl. 8, fig. 14.

Provenance: The donor purchased this table from the dealer Teina Baumstone of New York City.

Tea tables of this type, made in Portsmouth, New Hampshire, are among the rarest forms in American furniture. Only six examples are known. The value of a genuine table undoubtedly inspired the production of this object, created relatively recently from a mid-eighteenth-century English tea board with a gallery edge.

A20
TABLE WITH DRAWER

Eastern white pine (top), white oak (frame rails), hard maple (legs and stretchers); southern yellow pine (drawer interior), yellow-poplar (drawer runners)
57.9 x 77 x 50.6 (22 3/4 x 30 3/8 x 19 7/8)
Gift of C. Sanford Bull, B.A. 1893, 1949.246

Reference: "Living with Antiques" 1944, p. 190.

This table was constructed with fragments and wood from several earlier tables. The legs appear to date from the second half of the eighteenth century.

A21
STAND

Black walnut
68.7 x 35 diameter (27 x 13 3/4)
The Mabel Brady Garvan Collection, 1930.2380

Provenance: Acting as Garvan's agent, Jacob Margolis purchased this stand at auction in Pennsburg, Pennsylvania, on May 22–24, 1930 (Pennypacker 1930).

A19 A20

A21

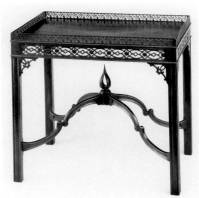
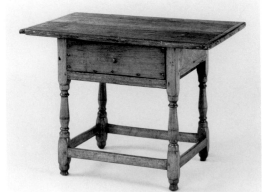
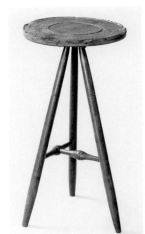

The top may date from the early nineteenth century. The original base was tenoned into the top; the present legs appear to date from the late nineteenth or twentieth century. At one time the top was upholstered, creating tack holes and heavy surface wear.

A 2 2
TABLE WITH FALLING LEAVES

Soft maple (legs, stretchers), black cherry (top, leaf supports, drawer front, frame rails); eastern white pine (drawer interior, supports, and stops)

67.2 x 32.2 (91.9 open) x 82.2 (26 1/2 x 12 5/8 [36 1/8] x 32 3/8)

The Mabel Brady Garvan Collection, 1930.2456

Exhibition: Katter/Boodro 1974, no. 19.

Provenance: In 1878 Irving W. Lyon purchased this table from Mary S. Andruss of Hartford, Connecticut. He recorded in his notebook: "It was used as a card table during the Revolutionary War in her grandfather W^m Andruss' hotel at Rocky-Hill, Conn. It is however *much* older than this history makes it" (Lyon Notebook, p. 59, no. 105). Garvan purchased the table from Charles Woolsey Lyon.

The top's center section and the side frame rails are late nineteenth- or twentieth-century replacements. The falling leaves and their supports are made from the same wood as the replacements and may also be restorations. This work may have been done by Robbins Brothers in Hartford, who restored other furniture for Irving W. Lyon, including cat. 6.

A 2 3
TABLE WITH FALLING LEAVES

Black cherry (including the right block supporting the top); white oak (left block supporting the top), eastern white pine (drawer interior and runners)

68 x 33.2 (104.8 open) x 90.2 (26 3/4 x 13 1/8 [41 1/4] x 35 1/2)

Gift of C. Sanford Bull, B.A. 1893, 1953.50.9

Exhibition: Katter/Boodro 1974, no. 18.

This table is constructed from fragments of at least two early eighteenth-century objects. Originally larger, the top was cut down to fit this frame. The stretchers are twentieth-century replacements that have been artificially worn to appear old. The entire table has been heavily refinished.

A 2 4
PEMBROKE TABLE

Mahogany, mahogany veneer; eastern white pine (inner frame rails, plinth of base), soft maple (hinged frame rails, medial brace)

73.9 x 55.3 (118.2 open) x 91.1 (29 1/8 x 21 3/4 [46 1/2] x 35 7/8)

The Mabel Brady Garvan Collection, 1930.2248

Provenance: This table was part of the collection Garvan acquired from R.T.H. Halsey.

The top and pedestal both date from the early nineteenth century but originally were not part of the same object.

A22

A23

A24

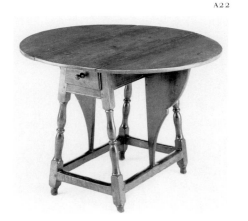

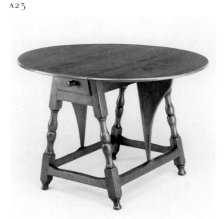

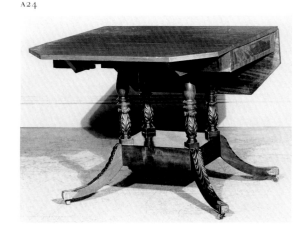

A 25

CARD TABLE

Mahogany, mahogany veneer; southern yellow pine (top, inner frame rails, blocks), white oak (hinged rail)

74.9 x 92.7 x 45.5 (29 1/2 x 36 1/2 x 17 7/8)

The Mabel Brady Garvan Collection, 1930.2010

Exhibitions: *Girl Scouts* 1929, no. 698; Baltimore 1947, no. 16; Ward 1977, no. 44; The Bruce Museum, Greenwich, Connecticut, "Fabulous Fakes," May 4-July 1, 1984.

References: Holloway 1927, p. 124; Holloway 1928, pl. 74; Nutting 1928, I, no. 1030; Miller 1937, II, no. 1516; Kirk 1970, fig. 178; Sack 1985, fig. 13.

Provenance: This table was owned by the collector Howard Reifsnyder of Philadelphia. Garvan purchased it at the auction of Reifsnyder's estate on April 26, 1929 (*Reifsnyder* 1929, no. 505).

A note on Garvan's catalogue card states: "This table marks the highest development which cabinet making reached in America." This reputation stood for almost forty years, although Edgar G. Miller had expressed reservations as early as 1930. Referring to the table and a chair of Garvan's that had been catalogued as Maryland pieces, he wrote: "I have not seen any chair or table of the exact or approximate character of these in my visits to one hundred and forty-eight homes of Baltimore people."[1] Miller's suspicions proved correct; this card table is a sophisticated fake made from the fragments of at least two late eighteenth-century tables. The side rails and inner rear rail of the frame can be attributed to Philadelphia or Baltimore on the basis of their construction, shape, and the use of southern yellow pine.[2] The front frame rail is modern. The top and legs were originally parts of other tables, and the inlays are twentieth-century additions. Part of this table's appeal for early twentieth-century antiquarians can be explained by the griffin inlay, based on a detail of the entablature of the Temple of Antoninus and Faustina in Rome that had been copied by several generations of English furniture designers, including Thomas Sheraton.[3] Its presence on this table "proved" American cabinetmakers' reliance on English design books.

1. Miller to Arthur W. Clarke, May 8, 1930, photograph order file, FPG-Y. The chair referred to by Miller was never given to the Art Gallery.
2. See Hewitt/Kane/Ward 1982, p. 71.
3. Sheraton 1793, pl. 56.

A 26

CARD TABLE

Mahogany, mahogany veneer; mahogany (front and side frame rails), eastern white pine (fixed rail, glue blocks), beech (fly rail)

75.3 x 91.8 x 44.9 (29 5/8 x 36 1/8 x 17 3/4)

The Mabel Brady Garvan Collection, 1930.2517

Exhibition: Katter/Boodro 1974, no. 29.

References: "Annapolis" 1930, p. 428; Miller 1937, II, no. 1493.

Provenance: Garvan purchased this table at Jacob Margolis' fifth auction on November 13, 1924 (*Margolis* 1924b, no. 242).

A25 A26

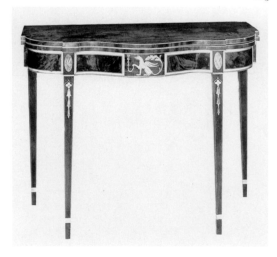
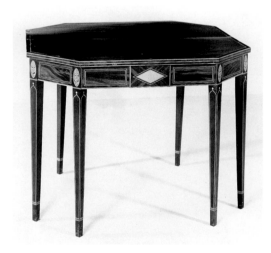

Garvan acquired this card table as American. It was recatalogued at the Art Gallery as eighteenth-century English in the 1950s and exhibited with that attribution in 1974. Among the features suggesting an English origin were the table's six legs, unlaminated mahogany frame rails, beech fly rail, and rear rails with red stain and extensive beetle damage.[1] Recent reexamination of this table indicates that it was made up in the twentieth century from an old top and a set of legs. The forgers also reused old boards with extensive beetle damage for the rear rails, cutting through many of these channels and thereby leaving evidence that the damage predated their use of the wood.

1. Katter/Boodro 1974, no. 29.

A 27
CARD TABLE

Mahogany; eastern white pine (side rail, glue blocks), southern yellow pine (inner rear rail), red oak (fly rail)

74.1 x 97.5 x 40.3 (29 1/8 x 38 3/8 x 15 7/8)

The Mabel Brady Garvan Collection, 1930.2599

Provenance: Acting as Garvan's agent, R.T.H. Halsey purchased this table around 1929 for exhibition in the Hammond-Harwood House, Annapolis, Maryland. He acquired it from Elizabeth Pumphrey of Annapolis, in whose family it purportedly descended.

The top and legs were reused from an early nineteenth-century table. The top was reduced in size and is now impractically shallow.

A 28
CARD TABLE

Mahogany, mahogany veneer; eastern white pine (frame rail, blocks), black cherry (fly rail, medial braces), redcedar (fixed half of hinged rail), basswood (filler block), yellow-poplar (strip of veneer over laminate on left side of frame)

73.6 x 60.9 x 29.9 (29 x 24 x 11 3/4)

Gift of Mrs. Roswell Skeel, Jr., in memory of Noah Webster, B.A. 1778, LL.D. 1823, and Rebecca Greenleaf Webster, 1949.172

Exhibition: Katter/Boodro 1974, no. 30.

Provenance: The donor, Emily E.F. Skeel, inherited this table from her mother, Mrs. Gordon Lester Ford. Mrs. Ford purportedly received it from her grandmother, Rebecca Greenleaf Webster, the wife of Noah Webster (1758–1843).

Created from parts of full-size card tables, this diminutive, crudely made piece is almost certainly the work of an amateur woodworker. It may have been assembled by a Webster descendant using fragments of decayed family furniture.

A 29
STAND

Mahogany (top), black cherry (top moldings, cleats, pedestal), satinwood and cherry inlay

73.1 (107.8 top up) x 47.2 x 46.9 (28 3/4 [42 1/2] x 18 5/8 x 18 1/2)

Gift of Mrs. Glen Wright, 1957.52.2

A28

A27

A29 A29

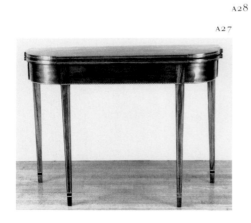
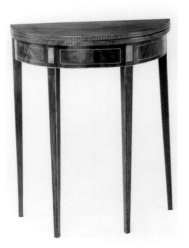
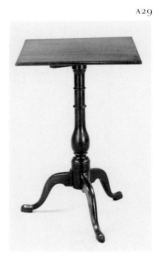
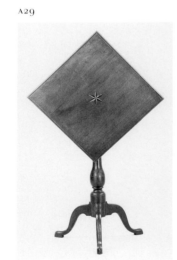

The base is a late-eighteenth century, probably eastern Connecticut interpretation of a coastal Massachusetts form. The top and cleats appear to have been fabricated in the late nineteenth or twentieth century.

A30
BOX ON STAND

Eastern white pine (box top and sides, drawer bottom), black cherry (box bottom and back, drawer front), soft maple (legs), sycamore (stretcher); yellow-poplar (drawer interior)
73 x 50.9 x 42.7 (28 3/4 x 20 x 16 3/4)
The Mabel Brady Garvan Collection, 1930.707

Exhibition: New Haven Colony Historical Society, "The Universal Instructor of the Home Arts," October 21, 1974–January 14, 1975.

Provenance: This is possibly the "painted table . . . done on paper in water-colors" that Garvan purchased from Charles Woolsey Lyon on November 1, 1918. According to the bill of sale, Lyon acquired this object from a W.B. Nichols of Springfield, Massachusetts, who in turn had purchased it from an unidentified woman in South Wethersfield, Connecticut, "in whose family it had always been" (Lyon to Garvan, November 1, 1918, Charles Woolsey Lyon file, FPG-AAA).

Apparently intended to look like a work table, this object was created from a mid-nineteenth-century decorated box or lap desk mounted on a twentieth-century base. The box originally may have had a hinged lid. The drawer front appears to be part of the original box, although the interior is twentieth-century. It has proved impossible to determine if the maple and sycamore in the base are European or American.

A31
FIRE SCREEN

Mahogany
133.3 x 36.4 x 30.8 (52 1/2 x 14 3/8 x 12 1/8); screen, 49 x 21.3 (19 1/4 x 8)
The Mabel Brady Garvan Collection, 1930.2577

Provenance: Garvan's catalogue card for this screen reads "Richmond Va. Purchased at Freehold, N.J." This notation almost certainly was intended to refer to the dealer L. Richmond of Freehold, from whom Garvan purchased a fire screen on January 22, 1921 (FPG-AAA).

This screen was constructed around the block and two legs of an early nineteenth-century stand.

A32
LOOKING GLASS

Sylvestris pine (frame); beech (backboard)
40.3 x 27.4 (15 7/8 x 10 3/4)
The Mabel Brady Garvan Collection, 1930.2143

Provenance: Garvan purchased this looking glass from C.R. Morson in 1923.

A31

A30

A32

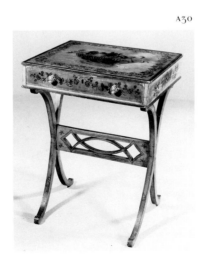
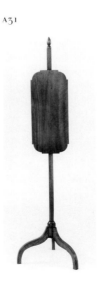
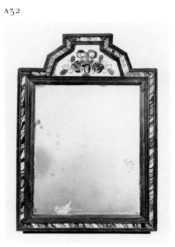

The age of this frame is difficult to determine. Although it exhibits shrinkage and remnants of old finish appropriate to an eighteenth-century object, there is no oxidation of the unfinished surfaces. The glass plate and backboard are secured with wire nails, and there is no evidence of any previous means of holding them in place. The frame probably was made in the late nineteenth or early twentieth century to salvage the old glass plate and reverse-painted glass panels.

A 33
LOOKING GLASS

Basswood (carving), walnut veneer; sylvestris pine
89.5 x 35.2 (35 1/4 x 13 7/8)
The Mabel Brady Garvan Collection, 1930.2532

Provenance: This mirror was in the collection of Irving W. Lyon. Garvan purchased it from Irving P. Lyon in 1929.

What appear to be carved ornaments from a late eighteenth-century, Continental European looking glass have been applied to a frame made in the late nineteenth or early twentieth century. The upper right section of the bowknot is restored.

A 34
DRESSING GLASS

Mahogany (molding on face of frame), beech (stand); eastern white pine
50.3 x 32.8 x 25 (19 3/4 x 12 7/8 x 9 7/8); mirror frame 43.8 x 28.5 (17 1/4 x 11 1/4)

A33 A34

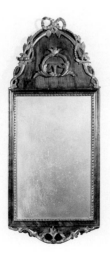 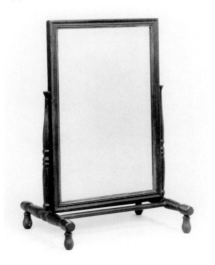

The Mabel Brady Garvan Collection, 1931.1215

Provenance: Garvan purchased this mirror from Charles Woolsey Lyon.

This object was constructed from an early nineteenth-century print frame that was painted black when it was mounted on the stand. Although its turnings are evocative of seventeenth-century or Windsor furniture, the stand copies no eighteenth- or early nineteenth-century form known to the author. A similar concoction, with a mid-eighteenth-century arched-crest looking glass mounted on a turned stand to create a dressing glass, was owned in Portsmouth, New Hampshire, during the late nineteenth century.[1]

1. Singleton 1900–01, II, p. 331.

Fakes

Fakes are defined in this section as objects created primarily from new elements as a deception. Beyond the date of acquisition by the donors, these objects are difficult to date. It is presumed that the majority were made at the end of the nineteenth or beginning of the twentieth century.

A 35
PIER TABLE

Mahogany
74 x 103.9 x 47.4 (29 1/8 x 40 7/8 x 18 5/8)
The Mabel Brady Garvan Collection, 1930.2510

Reference: Comstock 1958, pl. 66.

A35

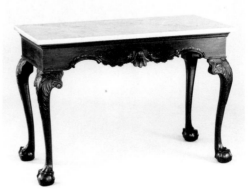

Provenance: According to the Philadelphia antiques dealer Thomas Curran, this table was purchased by his father, James Curran, "from an old Philadelphia family" (John Marshall Phillips to Garvan, May 29, 1931, FPG-Y). It was acquired prior to 1918 by the collector John L. Black of Washington, D.C. Garvan purchased the table at the auction of Black's collection on January 9, 1926 (*Black* 1926, no. 73).

This table appears to be a forgery intended to pass as a product of mid-eighteenth-century Philadelphia. The knee carving is based on a pattern popular in Philadelphia, but this carving is ineptly conceived, clumsily executed, and bears little relationship to the tight, mechanical carving applied to the skirt. This lack of finesse is atypical of the high quality of surviving pier tables from Philadelphia, which were costly objects. The block-like feet and shell also are unlike any documented Philadelphia work.

Thomas Curran claimed that the table had a gray marble top when his father owned it (see *Provenance*); it had a white marble top when Garvan acquired it in 1926. This top was replaced before 1933 by a mahogany top from another table. The marble slab photographed on the frame is from cat. 14.

A 36

PIER TABLE

Mahogany; Scots pine (inner rails), beech (splines)

80.3 x 123 x 49.3 (31 5/8 x 48 3/8 x 19 3/8)

Gift of Waldron Phoenix Belknap, Jr., in memory of John Marshall Phillips, 1953.12.2

Provenance: The donor purchased this table and its mate from Jacobs Antiques of Boston, Massachusetts, on May 13, 1944. According to W.M. Jacobs, the tables had been the property of "a very wealthy woman in New York State" (Jacobs to W.P.

Belknap, July 28, 1942, Art Gallery files). Jacobs acquired them from this unidentified woman's daughter in Michigan before 1942.

With the exception of the shells on the knees and the center of the skirt, this pier table was copied from one of the best-known pieces of eighteenth-century Philadelphia furniture, a pier table sold by the Cadwalader family in 1904 and acquired by The Metropolitan Museum of Art in 1918.[1] The secondary woods suggest that the Art Gallery's table was made in England, probably after the Metropolitan's table was published in the mid-1920s. At least one other pair of pier tables from this period appears to have been copied from the Cadwalader table.[2] Both the quality and construction of Yale's table reveal its twentieth-century origin: the frame rails are joined to the legs with vertical splines, the carving is stiff and poorly executed, losses on the original table were misinterpreted as gaps in the design, and the interior and exterior have been colored with a thick, dark stain. This table is one of a pair; the mate was sold at auction in 1973.[3]

1. Heckscher 1985, no. 97.
2. *Antiques* 15 (May 1929), p. 429.
3. Sotheby's 1973b, no. 458.

A 37

TEA TABLE

Black walnut; eastern white pine

65.8 x 80.8 x 50.3 (25 7/8 x 31 3/4 x 19 3/4)

Anonymous Gift, 1984.109

This table is a twentieth-century copy of a type of tea table made in Newport, Rhode Island, about 1740–60. It was artificially colored on the underside to appear old.

A36 A37

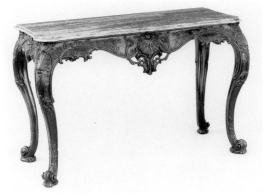 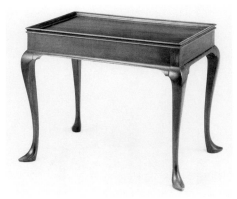

FOOTER

A 38

T A B L E

Pine
63.6 x 70.2 x 51.5 (25 x 27 5/8 x 20 1/4)
The Mabel Brady Garvan Collection, 1930.2460

Provenance: Garvan purchased this table from Brooks Reed in April 1926.

This table may be a mid-nineteenth-century version of a traditional form, constructed with traditional tools and woodworking techniques. Its surface shows evidence of age, including at least three coats of paint. However, the table's diminutive size, the attenuation of the legs and stretchers, and their champfered edges suggest the functional requirements and style preferences of the later nineteenth or twentieth century. It seems more likely to be a self-consciously handcrafted table in an earlier style. A similar table, formerly in the collection of Colonial Williamsburg, has been identified as a fake.[1] One stretcher and one of the crossed-leg units on the Art Gallery's table have been replaced since this photograph was taken.

1. Greenlaw 1974, no. 116.

A 39

T A B L E W I T H F A L L I N G L E A V E S

Red oak (turnings), black cherry (top), eastern white pine (frame rails)

56.9 x 25 (90.7 open) x 75.7 (22 3/8 x 9 7/8 [35 3/4] x 29 3/4)
The Mabel Brady Garvan Collection, 1930.2579

Provenance: This table was owned by Irving W. Lyon. Garvan bought it from Irving P. Lyon in 1929.

Garvan paid a high price for this table, but his advisers immediately recognized it as a fake. Apart from the lack of wear and a top that is too small for the base, this table's size is the best indicator of its inauthenticity. It is unlikely that an early eighteenth-century cabinetmaker would have made a small table with pivot leg supports.

A 40

P E M B R O K E T A B L E

Black cherry; eastern white pine
67.2 x 45.7 (86.3 open) x 90.9 (26 1/2 x 18 [34] x 35 3/4)
The Mabel Brady Garvan Collection, 1930.2582

Provenance: Garvan purchased this table from A.E. Carroll.

This crudely made pembroke table differs from genuine examples in size, construction, and overall quality. It is unclear if this object was made as a fake, although it was eventually sold as an eighteenth-century piece.

A39 A40

A38

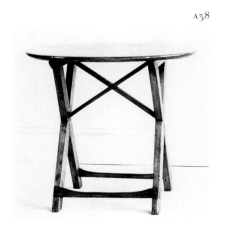
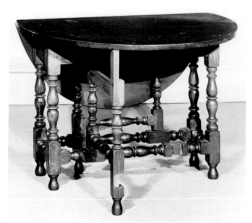
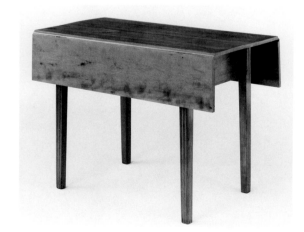

A 41

STAND WITH ADJUSTABLE TOP AND CANDLE ARM

Birch (top, candle arm, block), soft maple (shaft, legs)
101.6 x 34 (candle arm) x 35.2 diameter (40 x 13 3/8 x 13 7/8)
The Mabel Brady Garvan Collection, 1930.2138

References: *YUAGB* 3 (December 1928), p. 32; McClelland 1936, fig. 129.

Provenance: Garvan purchased this stand from Henry V. Weil in March 1925.

This stand is a skillful twentieth-century fabrication, since shrinkage is present on both the block and top. The turnings are atypical of any early period, however, and the candle arm was made without attachments for candles. An identical stand with a poorly faked surface was sold at auction in 1989.[1]

1. Christie's 1989a, no. 566.

A 42

WORK TABLE

Spanish-cedar (legs, rails), hard maple or plane (top), soft maple (edge strips of top), mahogany (drawer front); yellow-poplar (drawer sides and back), eastern white pine (drawer bottom)

69.4 x 51.1 x 50.3 (27 3/8 x 20 1/8 x 19 3/4)
The Mabel Brady Garvan Collection, 1930.2584

Provenance: Garvan purchased this stand from A.E. Carroll on March 12, 1931.

The deliberately crude construction of this table indicates that it was made early in the twentieth century to appear old.

A 43

LOOKING GLASS

Mahogany veneer, southern yellow pine (eagle), eastern white pine (other carved elements; crest, base, frame, blocks); yellow-poplar (brace behind eagle)

135.2 x 60 (53 1/4 x 23 5/8)
The Mabel Brady Garvan Collection, 1930.2719

Provenance: Garvan's records concerning this object are confused. A looking glass with this accession number was purchased from Henry V. Weil, but the photograph in Garvan's card file is not of the object that now bears this number.

This looking glass is a twentieth-century object that has been finished to appear old.

A41

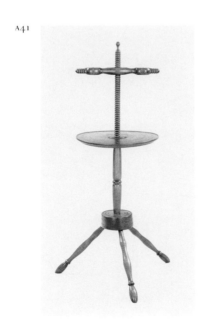

A42

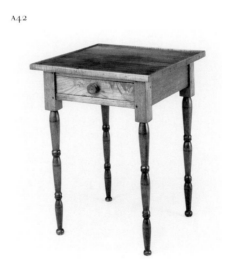

A43

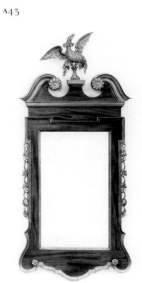

Appendix A
Diagrams of Terminology

Table with Falling Leaves and Pivot Leg Supports

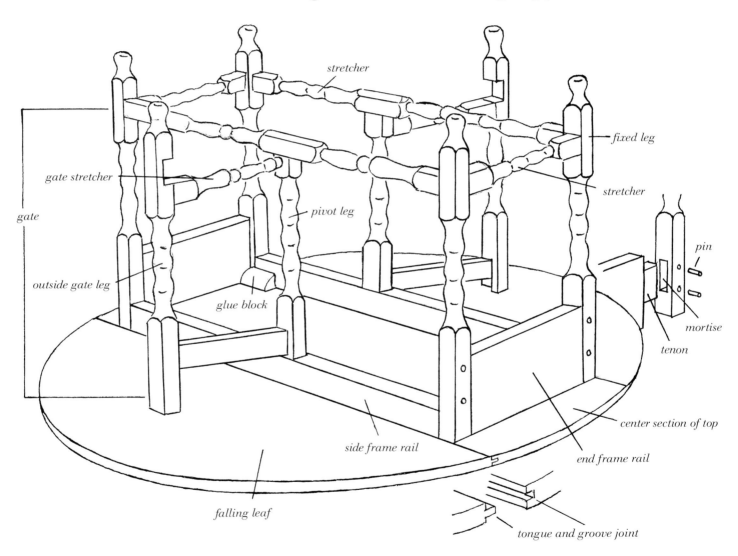

stretcher

fixed leg

gate stretcher

stretcher

gate

pivot leg

pin

outside gate leg

mortise

glue block

tenon

center section of top

side frame rail

end frame rail

falling leaf

tongue and groove joint

Table with Falling Leaves and Hinged Leg Supports

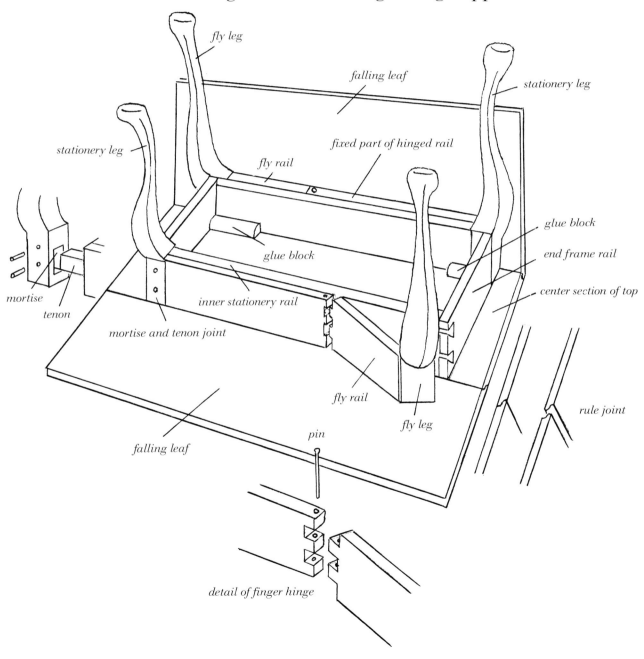

fly leg

falling leaf

stationery leg

stationery leg

fixed part of hinged rail

fly rail

glue block

glue block

end frame rail

mortise

tenon

glue block

inner stationery rail

center section of top

mortise and tenon joint

fly rail

fly leg

rule joint

falling leaf

pin

detail of finger hinge

Card Table

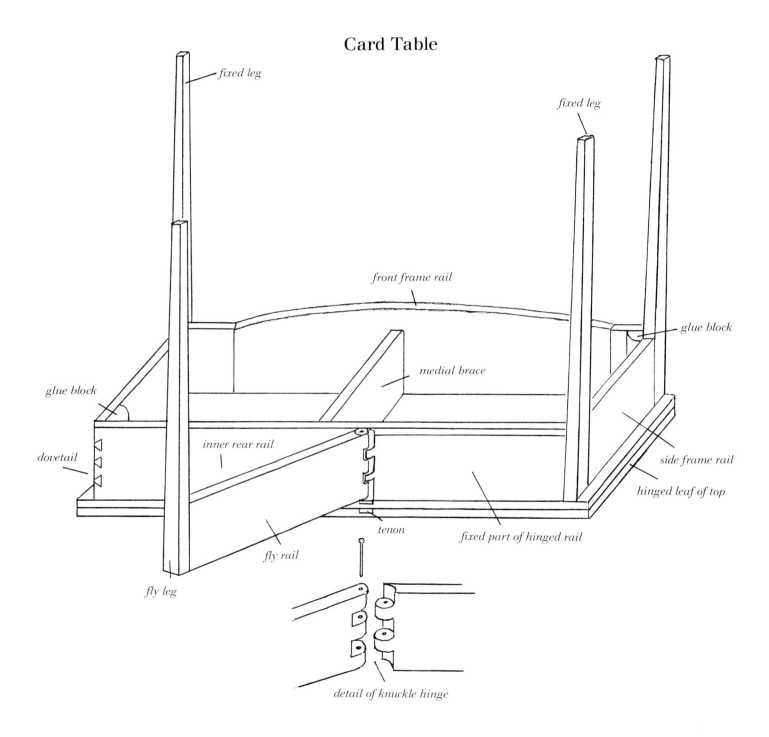

fixed leg

fixed leg

front frame rail

glue block

medial brace

glue block

inner rear rail

dovetail

side frame rail

hinged leaf of top

tenon

fixed part of hinged rail

fly rail

fly leg

detail of knuckle hinge

Table with a Top that Turns Up

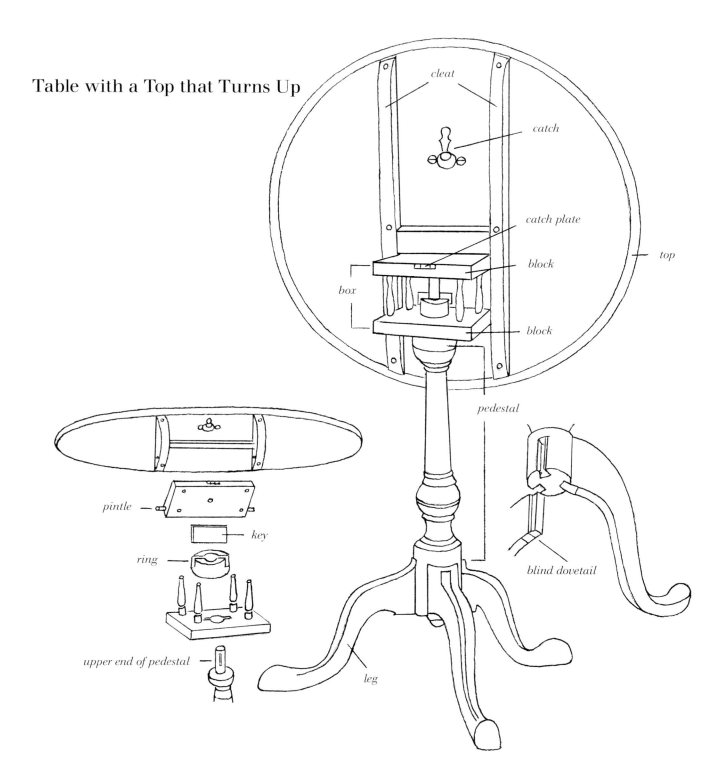

cleat

catch

catch plate

top

block

box

block

pedestal

blind dovetail

pintle

key

ring

upper end of pedestal

leg

Drawer Construction

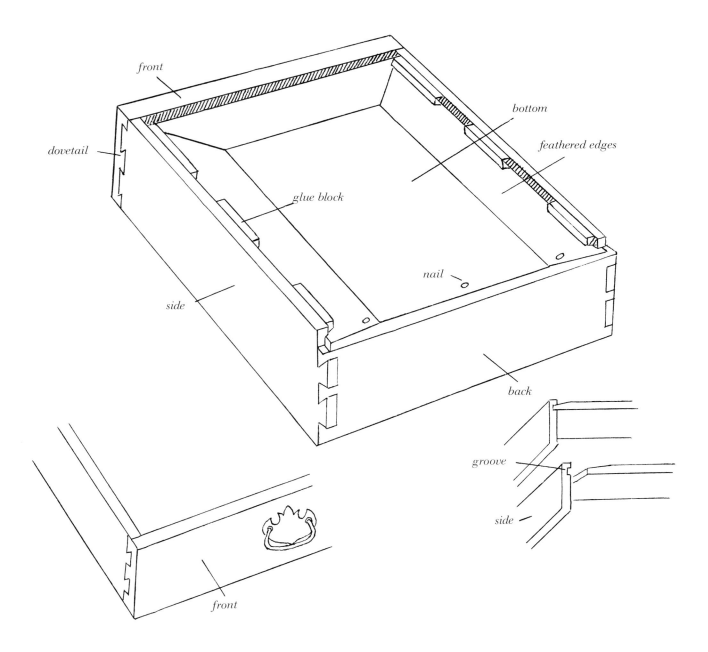

front

dovetail

side

glue block

bottom

feathered edges

nail

back

front

groove

side

Looking Glass

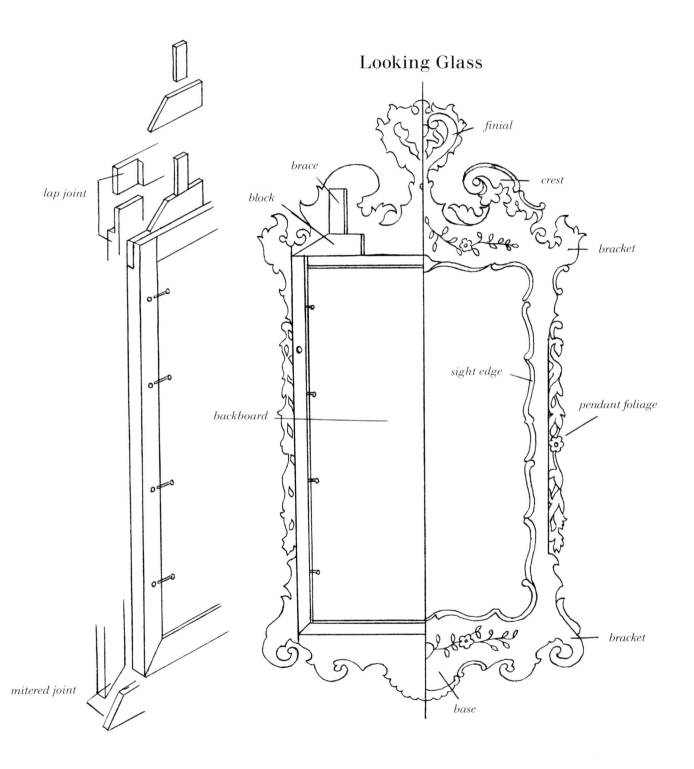

lap joint

mitered joint

brace

block

backboard

finial

crest

bracket

sight edge

pendant foliage

bracket

base

Appendix B
Woods

The following list provides the scientific names for woods listed by their preferred common names in the entries. Both sets of names follow Elbert L. Little, *Checklist of United States Trees (Native and Naturalized)* (Washington, D.C.: Government Printing Office, 1979). Within the three broad categories of conifers, temperate hardwoods, and tropical hardwoods, individual woods are listed alphabetically within generic groups such as "pine" and "maple."

Conifers

Atlantic white-cedar	*Chamaecyparis thyoides*
redcedar	*Juniperus* spp.
eastern redcedar	*J. virginiana*
southern redcedar	*J. silicicola*
baldcypress	*Taxodium distichum*
Douglas-fir	*Pseudotsuga menziesii*
hemlock	*Tsuga* spp.
eastern hemlock	*T. canadensis*
Ponderosa pine	*Pinus ponderosa*
southern yellow pine	*Pinus* spp.
shortleaf pine	*P. echinata*
slash pine	*P. elliottii*
longleaf pine	*P. palustris*
pitch pine	*P. rigida*
loblolly pine	*P. taeda*
[et al.]	
sylvestris pine	*Pinus* spp.
red (Norway) pine	*P. resinosa*
Scots pine	*P. sylvestris*
white pine	*Pinus* spp.
eastern white pine	*Pinus strobus*
spruce	*Picea* spp.
white spruce	*P. glauca*
red spruce	*P. rubens*
[et al.]	

Temperate Hardwoods

alder	*Alnus* spp.[1]
ash	*Fraxinus* spp.
white ash	*F. americana*
black ash	*F. nigra*
basswood	*Tilia* spp.[2]
American basswood	*T. americana*
red bay	*Persea borbonia*
beech	*Fagus* spp.
American beech	*F. grandifolia*
birch	*Betula* spp.
yellow birch	*B. alleghaniensis*
[et al.]	
butternut	*Juglans cinerea*
cherry	*Prunus* spp.
black cherry	*P. serotina*
chestnut	*Castanea* spp.
American chestnut	*C. dentata*
elm	*Ulmus* spp.
American elm	*U. americana*
[et al.]	
sweetgum (redgum)	*Liquidambar styraciflua*
hickory	*Carya* spp.
shagbark hickory	*C. ovata*
pignut hickory	*C. glabra*
[et al.]	
holly	*Ilex* spp.
hard maple	*Acer* spp.
plane[3]	*A. pseudoplatanus*
sugar maple	*A. saccharum*
soft maple	*Acer* spp.
red maple	*A. rubrum*
silver maple	*A. saccharinum*
red oak [group]	*Quercus* spp.
northern red oak	*Q. rubra*
[et al.]	
white oak [group]	*Quercus* spp.
white oak	*Q. alba*
[et al.]	
poplar (cottonwood, aspen)	*Populus* spp.[4]
eastern cottonwood	*P. deltoides*
bigtooth aspen	*P. grandidentata*
quaking aspen	*P. tremuloides*
[et al.]	
yellow-poplar (tulip)	*Liriodendron tulipifera*
sycamore	*Platanus* spp.[3]
sycamore (USA)	*P. occidentalis*
tupelo	*Nyssa* spp.
black tupelo	*N. sylvatica*
black walnut	*Juglans nigra*

Tropical Hardwoods

Spanish-cedar	*Cedrela* spp.
ebony	*Diospyros* spp.
mahogany	
African mahogany	*Khaya* spp.
American mahogany	*Swietenia* spp.
rosewood	*Dalbergia* spp.
Brazilian rosewood	*D. nigra*
satinwood	*Chloroxylon swietenia*
zebrawood	*Microberlinia* spp.

1. It is probable that *Alnus* found in furniture made prior to 1850 is not a North American species, as there are no major tree species of *Alnus* in eastern North America.
2. In the United Kingdom, wood of *Tilia* (excepting *T. americana*) is called "lime."
3. In the United Kingdom, *Platanus hybrida* (*P. acerifolia*) is called "European plane" or simply "plane," whereas *Acer pseudoplatanus* is commonly called "sycamore."
4. Species of the genus *Poplus* cannot be separated with certainty; however, the cottonwoods are usually more coarsely textured than the aspens.

Appendix C
Donors to the Collection

Millicent Todd Bingham (1880–1969) was the author of several books on geography. She was the daughter of David Peck Todd, a professor of astronomy at Amherst College, and Mabel Loomis Todd, an author. In 1920 she married Walter Van Dyke Bingham, a psychologist. Millicent Bingham presented her parents' papers to the Yale University Library and bequeathed the contents of her house to the Art Gallery. It is not known whether she purchased or inherited the furniture.

Doris Marguerite Brixey (1906–1983) was the daughter of Richard DeWolfe Brixey (1880–1943) and Bertha Marguerite Anness of New York City and Bedford Hills, New York. Among the objects she bequeathed to the Art Gallery were fifteen pieces of furniture from the collection assembled by her father, who received his B.S. from Yale University's Sheffield Scientific School in 1902 and was president and treasurer of the Kerite Insulated Wire and Cable Company.

Olive Louise Dann (1880–1961) was the daughter of Isaac Newton Dann (1833–1914) and Mary Fletcher Wood (1845–1927). A lifelong resident of New Haven, she collected American furniture and other decorative arts to furnish the home she shared with her brother Paul at 123 Ogden Street. Dann acquired furniture from Joe Kindig, Jr., as well as local dealers, but no records exist documenting her collection. Fifty-six objects from her collection were on permanent loan to the Art Gallery from 1959 until they were bequeathed.

Francis Patrick Garvan (1875–1937), who graduated from Yale College in 1897, assembled and donated a collection of approximately ten thousand American objects to the University beginning in 1930. This collection was named the Mabel Brady Garvan Collection in honor of his wife, who subsequently presented the University with a number of objects purchased by her husband. The Garvan Collection remains the core of the Art Gallery's holdings in American decorative arts.

As the provenances for individual objects make clear, Garvan did not personally purchase his furniture, but relied instead on agents. Those most directly involved with the furniture in this catalogue were Arthur W. Clarke, who with his daughter, Marion, supervised Garvan's collection before it was given to Yale; Jacob Margolis, who worked for Garvan as a cabinetmaker,

repairer, and adviser on furniture; Henry Hammond Taylor of Bridgeport, Connecticut; and the dealers Frank and Helen MacCarthy of Cheshire, Connecticut, and later Longmeadow, Massachusetts. Many of the objects in this catalogue were acquired through New York City antiques dealers whom Garvan patronized steadily during the teens and twenties, including Charles Woolsey Lyon, C.R. Morson, and Henry V. Weil. The records documenting Garvan's acquisitions are now divided between the Yale University Art Gallery and the Archives of American Art, Washington, D.C.

Garvan acquired many of the objects in this catalogue in 1929, when he negotiated the purchase of two important furniture collections, one assembled by Irving Whitehall Lyon (1840–1896) of Hartford, Connecticut, the other by Richard Townley Haines Halsey (1865–1942) of New York. Garvan wrote to Halsey that he wanted to create memorial rooms at Yale to Halsey and Lyon, "who have done so much to preserve our Americana.... You are the only other one [aside from Lyon] that I have decided upon who really did pioneer work" (Garvan to Halsey, May 9, 1929, Halsey file, FPG-AAA).

The furniture from Irving Lyon's collection had been divided among his three children, Charles Woolsey Lyon, Irving P. Lyon, and Mary Lyon Penney. These separate histories of ownership have been noted under Provenance. Garvan's agents undertook extensive correspondence with each of the heirs to ensure that the objects Garvan purchased had been in the elder Lyon's collection and were not acquisitions made by the younger Irving Lyon, who was a collector in his own right, or Charles Lyon, the New York antiques dealer.

The acquisition of the Halsey collection was even more complicated. Beginning in 1928, Halsey worked as Garvan's agent in purchasing furnishings for the Hammond-Harwood House in Annapolis, Maryland, and "Homewood" in Baltimore, two historic houses that Garvan had agreed to help restore. The ownership of objects Halsey purchased with Garvan's funds was a source of confusion at that time. Halsey and Garvan exchanged several different lists of the objects that were to come to Yale, but apparently no final agreement had been reached by the time of Garvan's unexpected death in 1937. It is therefore difficult to be precise about when Garvan formally acquired the Halsey collection. With the exception of objects purchased for the Hammond-Harwood House, all the furniture from Halsey's collection in this catalogue was physically at the Art Gallery in 1930 as part of the Garvan Collection.

Benjamin Attmore Hewitt (b. 1921), received his B.A. from Yale College in 1943 and his Ph.D. in 1952. A resident of New

Haven, he began studying American furniture with Charles F. Montgomery at Yale in 1970. Between 1971 and 1982, Hewitt conducted a systematic study of card tables made in America in the late eighteenth and early nineteenth centuries, which culminated in the Art Gallery's 1982 exhibition, "The Work of Many Hands: Card Tables in Federal America 1790–1820." Several of the tables lent to the exhibition by Hewitt and other private collectors subsequently entered the Art Gallery's collection.

Charles Franklin Montgomery (1910–1978) was curator of Garvan and Related Collections of American Art at the Art Gallery and professor of the history of art at Yale University from 1970 to 1978. He began his career in 1939 as an antiques dealer in Wallingford, Connecticut, and in 1949 he was engaged by Henry Francis du Pont to assist with the founding of the Winterthur Museum and the Winterthur Program in Early American Culture. An enthusiastic collector as well as a scholar of American decorative arts, Montgomery and his wife, Florence M. Montgomery, used most of the objects now in the Art Gallery's collection in their home in New Haven, the Everard Benjamin House, built in 1838.

J. Marshall and Thomas M. Osborn presented to the Art Gallery sixteen pieces of furniture as well as textiles, ceramics, and metalwares that had belonged to their parents, James Marshall Osborn (1906–1976) and Marie-Louise Montgomery Osborn (1905–1968). Most of these objects were purchased for the first two apartments the Osborns rented after their marriage, at 1468 Midland Avenue in Bronxville, New York, between 1929 and September 1930, and at 14 Sutton Place South in Manhattan, between September 1930 and June 1932. The Osborns rented a furnished house in Rowayton, Connecticut, between June 1932 and June 1933, at which time Marie-Louise put their furniture in storage. Pursuing a career as a literary historian, James Osborn moved his family to Oxford, England, between September 1933 and May 1938; during these years he began an important collection of English books and manuscripts that is now at the Beinecke Rare Book and Manuscript Library at Yale. The Osborns returned to the United States in the summer of 1938 and settled in New Haven, where they rented a furnished house at 300 East Rock Road from September 1938 to May 1941. In September 1941 they moved to two apartments at 426 Prospect Street, but moved again in the following year to 265 Bradley Street. In September 1945 they purchased a house at 77 Edgehill Road, where they remained until Marie-Louise's death in 1968. James Osborn moved to the Crown Towers Apartments and donated twenty-two pieces of furniture, most

of them purchased in the 1940s, to the Cooper-Hewitt Museum in New York City. After his death in 1976, his sons gave the remaining furniture to the Art Gallery.

Keith Smith, Jr. (1906–1988) graduated from Yale College in 1928 and worked for the J.M. Ney Company of Bloomfield, Connecticut, eventually serving as president and chairman of the board. J.M. Ney manufactured precious metal alloys used in dentistry and the electronics industry. Smith was an amateur jeweler and was a founder of the Society of Connecticut Craftsmen in 1935. The four pieces of furniture Smith donated to the Art Gallery in 1981 were purchased for a modernist house he built in 1941 in Farmington, Connecticut.

Ethel Mary Moss Wright was the second wife of Glen Wright (1869–1941), a New York City stockbroker who received his B.A. from Yale College in 1891. In 1941, she presented her husband's collection of forty-five early nineteenth-century glass flasks to the Art Gallery. The four pieces of furniture that she gave to the Art Gallery in 1957, as well as a silver teaspoon by William Moulton III, which she donated in 1952, were heirlooms from her family. She was the daughter of Frederick W. and Adelaide Hohorst Moss.

Appendix D
Dealers
Patronized by Francis P. Garvan

This appendix provides the addresses of dealers from whom Garvan purchased objects in this catalogue, as well as the years in which he did business with them. With a few exceptions, this information was taken only from Garvan's papers at the Art Gallery and the Archives of American Art in Washington, D.C., and is not intended as a complete record of individual careers.

Harry Arons 1919–30. 62 Beaver Street, Ansonia, Connecticut. Charles Montgomery also made purchases from him in the early 1960s.

Louise Barrett (Mrs. Thomas Barrett, Jr.) 1928–37. Azalea Cottage, 2236 Walton Way, Augusta, Georgia; summer address 16 Ocean Avenue, Wrightsville Beach, North Carolina. Mrs. Barrett acted as Garvan's principal agent in the South, particularly in Georgia and the Carolinas.

J.K. Beard 1921–37. 113 West Main Street, Richmond, Virginia (1921–22); Drewry's Mansion, Richmond (1923–30; 1936–37). Beard gave up his business in 1929, and the shop was managed as "Antiques in the Rough" by W.L. Parker in May 1930. By November, Beard reported that Parker "is not here any more" (Beard to Arthur W. Clarke, November 24, 1930, FPG-Y). Beard did not operate a shop during 1931–35, although he wrote to Garvan, "I just pick up choice things when I see them to keep or sell to my friends if they want them" (Beard to Garvan, January 23, 1931, FPG-Y).

Mrs. J.L. "Bessie" Brockwell. 232 Market Street, Petersburg, Virginia. A letter dated July 21, 1931, is the only surviving correspondence between Garvan and Brockwell.

Frances Wolfe Carey 1927–29. 38 Haddon Avenue, Haddonfield, New Jersey.

A.E. Carroll 1916–37. 735 and 727 Main Street, East Hartford, Connecticut (1916–36); 715 Main (1937). The shop name was "A.E. Carroll, Antique Furniture, Old China and Brasses." The proprietors, Annie E. Carroll (1865–1943) and Margaret May Carroll, were Francis Garvan's first cousins, the daughters of his mother's brother Edward. The business continued until 1955.

Joe Kindig, Jr. 1927–36. 504 West Market Street (1927–35), 325 West Market Street (1936), York, Pennsylvania. Olive Louise Dann also did business with Kindig at this time.

Louis King. 928 Pine Street, Philadelphia. Garvan's catalogue card for cat. A6 records that it was purchased from King; no correspondence between them is preserved.

Charles Woolsey Lyon (1872–1945) 1914–37. 29 Washington Street, Albany, New York (1898–1916); 416 Madison Avenue, New York City (1917–25). Charles Woolsey Lyon, Inc., 35 East 57th Street (1926–30); 61 East 57th Street (1930–32); 20 East 56th Street (1937). The firm was continued after Lyon's death by his sons, Charles W. Lyon, Jr., and Irving W. Lyon.

Frank MacCarthy 1925–30. Frank and Helen MacCarthy Antiques, Cheshire, Connecticut (1925–28); 1128 Longmeadow Street, Longmeadow, Massachusetts (1928–30). Frank MacCarthy was one of Garvan's principal agents for the collection now at Yale (see Appendix C).

Jacob Margolis 1918–37. Margolis Shop, 1122 Madison Avenue, New York City (1920–24). Early American Furniture, Margolis Shop, 1122–32 Madison Avenue (1924–25). Margolis Shop Antiques, 1132 Madison Avenue (1926–February 1927); 797 Madison Avenue (March 1927–January 1928); 1122–32 Madison Avenue (February 1928–29). Jacob Margolis Inc. Antiques, 179 East 87th Street (1929–31); 221 East 64th Street (1931–32); 1188 Second Avenue (1933–?); 319 East 64th Street (1937). Margolis worked for Garvan as a cabinetmaker, restorer, and adviser in addition to supplying him with antiques (see Appendix C and cat. 134). As the numerous changes of address suggest, financial difficulties plagued Margolis throughout his life, "having a very small clientele and as it seemed . . . the dealers had decided to keep away from me" (*Margolis* 1925, introduction). In 1904, he opened a shop on Park Avenue in New York City where he repaired furniture and sold antiques. After a few years he moved to Albany but returned to New York in 1917. The following year he first entered Garvan's employ as "expert and cabinet maker," and with Garvan's backing he opened the first shop on Madison Avenue in 1920. Between 1922 and 1928, Margolis held thirteen auctions of antique furniture at the Anderson Galleries and the American Art Association. He claimed that these sales enabled him to give up his retail busi-

ness (*Margolis* 1923, introduction), although Garvan acquired many objects directly from him during these years.

Charles R. Morson 1916–30. 301 Fulton Street, Brooklyn, New York (1916–17); 304 Fulton Street, Brooklyn (1917–20); 103 East 57th Street, New York City (1921–22); 109 East 57th Street (1922–23); 106 East 57th Street (1925–29); 8 East 54th Street (November 1929). Morson died in December 1929; the business was continued by his widow until November 1930. The contents of the shop were sold at auction in 1932 (*Morson* 1932a, 1932b).

John C. Norris 1919–30. Chestnut Avenue, Chestnut Hill, Pennsylvania; summer address Narragansett, Rhode Island.

A.J. Pennypacker 1928–36. Pennsburg, Pennsylvania (1928–31); Bethlehem Pike, Colmar, Pennsylvania (1935–36).

Brooks Reed 1918–36. 19 Arlington Street, Boston (1918–25); 22 Newbury Street (1926–33); 380 Boylston Street (January–November 1934); 70 Summer Street, Maynard, Massachusetts (November 1934–1936). Reed died on August 31, 1936.

Louis Richmond 1916–36. L. Richmond Antiques, 39 South Street, Freehold, New Jersey (1916–19); 42 East Main Street (1930–36). Richmond used no address other than Freehold, New Jersey, between 1920 and 1930.

C. Edward Snyder 1929. 855 Park Avenue, Baltimore, Maryland.

R.S. Somerville 1929. 3366 Boston Post Road, New York City.

Henry Hammond Taylor 1926–33. 287 Washington Avenue, Bridgeport, Connecticut. Taylor was one of Garvan's principal agents for the collection now at Yale (see Appendix C). After 1930, Taylor's daughter-in-law Mary (Mrs. Thomas Starr Taylor) took over much of his research and travel for Garvan.

Tiffany Studios 1916–20. 347–55 Madison Avenue, New York City.

H.C. Valentine and Company 1926–32. 207–209 East Franklin Street, Richmond, Virginia (1926–30); 203–209 East Franklin Street (1930–32).

Mrs. Philomen Watson. Indianapolis, Indiana. Genevieve Watson apparently was a relative or close friend of Francis and Mabel Garvan. She may have been selling antiques on a limited scale when Garvan purchased cat. 45. The wife of a telephone company executive, she owned a series of dress shops in Indianapolis between 1928 and 1934. In 1931, she was listed in the city directory as the proprietor of a "gift shop," and in 1935 as an antiques dealer (*Indianapolis Directory*, 1931, p. 1326; 1935, pp. 1219, 1719).

Henry V. Weil 1925–32. 126 East 57th Street, New York (1925–28); 247–249 East 57th Street (1928–32). Weil was one of Garvan's principal sources for furniture; unfortunately, none of the correspondence between the two has been preserved. Weil advertised in *Antiques* between May 1925 and February 1932. The stock of his shop was sold at auction in May 1932 (*Weil* 1932).

Wilkinson and Traylor. 504 West Main Street, Richmond, Virginia. Garvan's correspondence with this firm does not survive. They advertised in *Antiques* between September 1925 and February 1930.

Appendix E
Bibliographical Abbreviations

Ackerman 1954
Ackerman, James S. *The Cortile del Belvedere*. (Studi e Documenti per la Storia del Palazzo Apostolico Vaticano, 3). Vatican City: Biblioteca Apostolica Vaticana, 1954.

Adair 1983
Adair, William. *The Frame in America, 1700–1900: A Survey of Fabrication Techniques and Styles*. Washington, D.C.: A.I.A. Foundation, 1983.

Age of the Revolution 1977
Age of the Revolution and Early Republic in Fine and Decorative Arts: 1750–1824. Exhibition catalogue. New York: Kennedy Galleries and Israel Sack, 1977.

Agius 1984
Agius, Pauline. *Ackermann's Regency Furniture and Interiors*. Marlborough, England: Crowood Press, 1984.

American Art Association 1929
American and English Furniture. Auction catalogue. New York: American Art Association, November 19–21, 1929.

American Art Association 1934
Fine Furniture, Rugs, Notable English Silver. Auction catalogue. New York: American Art Association, December 18–19, 1934.

"American Furniture" 1980
"American Furniture." *The Saint Louis Art Museum Bulletin* 15 (Summer 1980), pp. 1–48.

"Annapolis" 1930
"Annapolis Windows." *Antiques* 17 (May 1930), pp. 426–30.

Aronson 1965
Aronson, Joseph. *The Encyclopedia of Furniture*. 3rd ed. New York: Crown Publishers, 1965.

Artek-Pascoe 1941
Untitled sales catalogue. New York: Artek-Pascoe, 1941.

Ayer 1929
American Furniture . . . Collection of Fred Wellington Ayer. Auction catalogue. New York: American Art Association, May 3–4, 1929.

Babcock 1985
"*Hark Away*": *The Estate of Elisabeth T. Babcock*. Auction catalogue. Bolton, Massachusetts: Robert W. Skinner, November 15–16, 1985.

"Baker" 1951
"For American Manufacture: Baker's Finn Juhl Furniture." *Interiors* 111 (November 1951), pp. 84–93.

Baker 1966
Baker, Hollis S. *Furniture in the Ancient World: Origins and Evolution, 3100–475 B.C.* New York: Macmillan, 1966.

Baker Modern
Baker Modern. Sales catalogue. Holland, Michigan: Baker Furniture, n.d.

Baldwin 1917
Baldwin, Thomas W., comp. *Vital Records of Hardwick, Massachusetts, to the Year 1850*. Boston: Wright and Potter, 1917.

Baltimore 1947
Baltimore Furniture: The Work of Baltimore and Annapolis Cabinetmakers from 1760 to 1810. Exhibition catalogue. Baltimore: The Baltimore Museum of Art, 1947.

Barbour 1963
Frederick K. and Margaret R. Barbour's Furniture Collection. Hartford: The Connecticut Historical Society, 1963.

Barnes/Meals 1972
Barnes, Jairus B., and Moselle Taylor Meals. *American Furniture in the Western Reserve, 1680–1830*. Exhibition catalogue. Cleveland: The Western Reserve Historical Society, 1972.

Barquist 1991
Barquist, David L. "Imported Looking Glasses in Colonial America." *Antiques* 139 (June 1991), pp. 1108–17.

Barrett 1889
Barrett, Walter [Joseph Alfred Scoville]. *The Old Merchants of New York City*. 5 vols. New York: Worthington Company, 1889.

Bartlett 1985
Important American Furniture: The Collection of Scott Bartlett. Auction catalogue. New York: Sotheby's, February 2, 1985.

Battison/Kane 1973
Battison, Edwin A., and Patricia E. Kane. *The American Clock 1725–1865: The Mabel Brady Garvan and Other Collections at Yale University*. Greenwich, Connecticut: New York Graphic Society, 1973.

BDSNY 1900
Biographical Directory of the State of New York. New York: Geographical Directory, 1900.

Beckerdite 1984
Beckerdite, Luke. "Philadelphia Carving Shops, Part I: James Reynolds." *Antiques* 125 (May 1984), pp. 1120–33.

Benes 1982
Benes, Peter. *Two Towns: Concord and Wethersfield, A Comparative Exhibition of Regional Culture, 1635–1850*. Exhibition catalogue. Concord, Massachusetts: Concord Antiquarian Museum, 1982.

Benes/Zimmerman 1979
———, and Philip D. Zimmerman. *New England Meeting House and Church: 1630–1850*. Boston: The Dublin Seminar for New England Folklife, 1979.

Benkard 1929
Furniture by Duncan Phyfe & Other Early American Craftsmen . . . from the Collection of Mrs. H.H. Benkard. Auction catalogue. New York: Anderson Galleries, April 20, 1929.

Bennet et al. 1947
Bennet, Richard Marsh, Edward S. Evans, Jr., Charles P. Parkhurst, Jr., and Walter Dorwin Teague. *Good Design Is Your Business*. Exhibition catalogue. Buffalo: The Buffalo Fine Arts Academy, Albright Art Gallery, 1947.

Bentley 1881
Bentley, William. "Parish List of Deaths Begun 1785." *Essex Institute Historical Collections* 18 (1881), pp. 73–80, 129–44, 206–23.

Bentley 1882
———. "Parish List of Deaths Begun 1785." *Essex Institute Historical Collections* 19 (1882), pp. 18–39, 91–104, 176–82.

Berry 1928
Eighteenth Century American Furniture Sold by Order [of] Morris Berry. Auction catalogue. New York: Anderson Galleries, November 9–10, 1928.

Berry/Johnson 1953
Berry, W. Turner, and A.F. Johnson. *Encyclopaedia of Type Faces*. London: Blandford Press, 1953.

Biddle 1963
Biddle, James. *American Art from American Collections*. Exhibition catalogue. New York: The Metropolitan Museum of Art, 1963.

Birmingham 1982
 The John Graham Collection. Exhibition catalogue. Birmingham, Alabama: Birmingham Museum of Art, 1982.

Bishop 1975
 Bishop, Robert. *American Furniture 1620–1720.* Dearborn, Michigan: The Edison Institute, 1975.

Bissell 1956
 Bissell, Charles S. *Antique Furniture in Suffield, Connecticut, 1670–1835.* Hartford: The Connecticut Historical Society and Suffield Historical Society, 1956.

Bivins 1988
 Bivins, John, Jr. *The Furniture of Coastal North Carolina, 1700–1820.* Winston-Salem, North Carolina: Museum of Early Southern Decorative Arts, 1988.

Bivins 1989
 ———. "A Catalog of Northern Furniture with Southern Provenances." *Journal of Early Southern Decorative Arts* 15 (November 1989), pp. 43–91.

Bivins 1990
 ———. "Furniture of Lower Cape Fear, North Carolina." *Antiques* 137 (May 1990), pp. 1202–13.

Bivins/Welshimer 1981
 ———, and Paula Welshimer. *Moravian Decorative Arts in North Carolina: An Introduction to the Old Salem Collection.* Winston-Salem, North Carolina: Old Salem, Inc., 1981.

Bjerkoe 1957
 Bjerkoe, Ethel Hall. *The Cabinetmakers of America.* Garden City, New York: Doubleday and Company, 1957.

Black 1926
 The Collection of the Late John L. Black, Esq., Washington, D. C. Auction catalogue. New York: American Art Association, January 9, 1926.

Blackburn 1976
 Blackburn, Roderic H. *Cherry Hill: The History and Collections of a Van Rensselaer Family.* Albany: Historic Cherry Hill, 1976.

Bondome 1927
 Bondome. "Shop Talk." *Antiques* 11 (May 1927), pp. 391–93.

Boston 1975
 Paul Revere's Boston, 1735–1818. Exhibition catalogue. Boston: Museum of Fine Arts, 1975.

Boston Directory
 Bibliographic information for specific directories cited is given in Spear 1961, pp. 45–57.

Bowdoin 1974
 The Art of American Furniture: A Portfolio of Furniture in the Collections of the Bowdoin College Museum of Art. Brunswick, Maine: Bowdoin College, 1974.

Brazer 1926a
 Brazer, Clarence Wilson. "Jonathan Gostelowe: Philadelphia Cabinet and Chair Maker." *Antiques* 9 (June 1926), pp. 385–92.

Brazer 1926b
 ———. "Jonathan Gostelowe: Philadelphia Cabinet and Chair Maker, Part II." *Antiques* 10 (August 1926), pp. 125–32.

Brewer 1988
 Brewer, Daryln. "Where to Find It: Steel Shelves Go Home." *The New York Times,* January 14, 1988, p. C2.

Brino 1987
 Brino, Giovanni. *Carlo Mollino: Architecture as Autobiography.* Transl. Huw Evans. New York: Rizzoli International Publications, 1987.

Brown 1820
 Brown, Richard. *The Rudiments of Drawing Cabinet and Upholstery Furniture.* London: 1820.

Brown 1978
 Brown, Michael K. "Duncan Phyfe." M.A. thesis. Newark: University of Delaware, 1978.

Brown 1980
 ———. "Scalloped-Top Furniture of the Connecticut River Valley." *Antiques* 117 (May 1980), pp. 1092–99.

Brusic 1986
 Brusic, Lucy McTeer. *Amidst Cultivated and Pleasant Fields: A Bicentennial History of North Haven.* Canaan, New Hampshire: Phoenix Publishing Company, 1986.

Burbank 1922
 Burbank, Emily. *Be Your Own Decorator.* New York: Dodd, Mead and Company, 1922.

Burke 1970
 Renowned Americana Antique Sale: The Collection of Mr. John W. Burke. Auction catalogue. Reading, Pennsylvania: Pennypacker Auction Centre, May 25, 1970.

Burris-Meyer 1937
 Burris-Meyer, Elizabeth. *Decorating Livable Homes.* New York: Prentice-Hall, 1937.

Burroughs 1931
 Burroughs, Paul H. *Southern Antiques.* Richmond, Virginia: Garrett and Massie, 1931.

Burton 1952
 Burton, E. Milby. "The Furniture of Charleston." *Antiques* 61 (January 1952), pp. 44–57.

Burton 1955
 ———. *Charleston Furniture, 1700–1825* (Contributions from the Charleston Museum, 12). Charleston: Charleston Museum, 1955.

Butler 1983
 Butler, Joseph T. *Sleepy Hollow Restorations: A Cross-Section of the Collection.* Tarrytown, New York: Sleepy Hollow Press, 1983.

Caldwell 1873
 Caldwell, Augustine. *Caldwell Records.* Boston: William P. Lunt, 1873.

Camard 1984
 Camard, Florence. *Ruhlmann: Master of Art Deco.* Transl. David Macey. New York: Harry N. Abrams, 1984.

Camp 1928
 Eighteenth Century American Furniture . . . Sold by Order of Mrs. Gertrude H. Camp. Auction catalogue. New York: Anderson Galleries, January 20–21, 1928.

Camp 1929
 Antique American and English Furniture . . . Sold by Order of Mrs. G. H. Camp. Auction catalogue. New York: Anderson Galleries, January 18–19, 1929.

Carrick 1922a
 Carrick, Alice van Leer. *The Next-to-Nothing House.* Boston: Atlantic Monthly, 1922.

Carrick 1922b
 ———. "Tabernacle Mirrors: A Reflective Study." *Antiques* 2 (July 1922), pp. 11–15.

Carson 1953a
 Carson, Marian Sadtler. "Henry Connelly and Ephraim Haines: Philadelphia Furniture Makers." *Philadelphia Museum Bulletin* 48 (Spring 1953), pp. 33–48.

Carson 1953b
 ———. "Sheraton's Influence in Philadelphia." *Antiques* 63 (April 1953), pp. 342–45.

Cathers 1981
 Cathers, David M. *Furniture of the American Arts and Crafts Movement: Stickley and Roycroft Mission Oak.* New York: New American Library, 1981.

Caylus 1756–67
 Caylus, Anne-Claude-Philippe, Comte de. *Receuil d'Antiquités Égyptiennes, Étrusques, Grecques, et Romaines.* 7 vols. Paris: Dessaint et Saillant, Chez Duchesne, and N.M. Tilliard, 1756–67.

Cennini 1960
 Cennini, Cennino. *The Craftsman's Handbook: The Italian "Il Libro dell'Arte."* Transl. Daniel V. Thompson, Jr. New York: Dover Publications, 1960.

Cescinsky 1929
Cescinsky, Herbert. *English Furniture from Gothic to Sheraton*. Grand Rapids, Michigan: Dean-Hicks, 1929.

Chambers 1791
Chambers, William. *A Treatise on the Decorative Part of Civil Architecture* (1759). London: Joseph Smeeton, 1791.

Chicago 1971
American Art of the Colonies and Early Republic: Furniture, Paintings and Silver from Private Collections in the Chicago Area. Exhibition catalogue. Chicago: The Art Institute of Chicago, 1971.

Chinnery 1979
Chinnery, Victor. *Oak Furniture: The British Tradition*. Woodbridge, England: Antique Collectors' Club, 1979.

Chippendale 1762
Chippendale, Thomas. *The Gentleman and Cabinet-maker's Director*. 3rd ed. London: The Author, 1762.

Christie's 1980
Furniture from America's First Modernistic Home: The de Lorenzo Collection. Auction catalogue. New York: Christie's, October 4, 1980.

Christie's 1987
Fine American Furniture, Silver, Folk Art and Decorative Arts. Auction catalogue. New York: Christie's, January 24, 1987.

Christie's 1989a
Fine American Furniture, Silver, Folk Art and Decorative Arts. Auction catalogue. New York: Christie's, January 20–21, 1989.

Christie's 1989b
Important American Furniture, Silver, Folk Art and Decorative Arts. Auction catalogue. New York: Christie's, October 21, 1989.

Christie's 1990
Fine American Furniture, Silver, Folk Art, and Decorative Arts. Auction catalogue. New York: Christie's, October 19, 1990.

Christie's 1991
Fine American Furniture, Silver, Folk Art and Historical Prints. Auction catalogue. New York: Christie's, January 26, 1991.

Christie's East 1989a
Art Nouveau, Art Deco, and Erté. Auction catalogue. New York: Christie's East, March 16, 1989.

Christie's East 1989b
Furniture, Old Master Paintings, and Decorative Objects. Auction catalogue. New York: Christie's East, October 10, 1989.

Churchill 1983
Churchill, Edwin A. *Simple Forms and Vivid Colors: An Exhibition of Maine Painted Furniture, 1800–1850*. Exhibition

catalogue. Augusta, Maine: Maine State Museum, 1983.

Clark 1986
Clark, Clifford Edward, Jr. *The American Family Home, 1800–1960*. Chapel Hill, North Carolina: University of North Carolina Press, 1986.

Clark 1987
———. "The Vision of the Dining Room: Plan Book Dreams and Middle-Class Realities." In *Dining in America, 1850–1900*. Ed. Kathryn Grover. Amherst, Massachusetts: University of Massachusetts Press, 1987.

Clouzot
Clouzot, Henri. *La Ferronnerie Moderne à l'Exposition Internationale des Arts Décoratifs*. 1st and 2nd series. Paris: Charles Moreau, n.d.

Clunie/Farnam/Trent 1980
Clunie, Margaret Burke. Anne Farnam, and Robert F. Trent. *Furniture at the Essex Institute*. Salem, Massachusetts: Essex Institute, 1980.

"Collectors' Notes" 1959
"Collectors' Notes: Another Unknown from Northampton." *Antiques* 75 (May 1959), p. 461.

Comstock 1952
Comstock, Helen. "Furniture of Virginia, North Carolina, Georgia, and Kentucky." *Antiques* 61 (January 1952), pp. 58–100. Reprinted in *Southern Furniture, 1640–1820*. Ed. Alice Winchester. New York: The Magazine Antiques, 1952.

Comstock 1956
———. "The C. Sanford Bull Collection of New England Antiques." *Antiques* 70 (August 1956), pp. 140–41.

Comstock 1958
———. *100 Most Beautiful Rooms in America*. New York and London: The Studio Publications, 1958.

Comstock 1962
———. *American Furniture: Seventeenth, Eighteenth, and Nineteenth Century Styles*. New York: The Viking Press, 1962.

Comstock 1967
———. "Southern Furniture Since 1952." *Antiques* 91 (January 1967), pp. 102–19.

Comstock 1968
———. *The Looking Glass in America, 1700–1825*. New York: The Viking Press, 1968.

Conger 1979
Conger, Clement E. "Decorative Arts at the White House." *Antiques* 116 (July 1979), pp. 112–34.

Conger/Pool 1974
———, and Jane W. Pool. "Some Eagle-Decorated Furniture at the Department of State." *Antiques* 105 (May 1974), pp. 1072–81.

"Connecticut Cabinetmakers" 1968
"Connecticut Cabinetmakers: Part II." *The Connecticut Historical Society Bulletin* 33 (January 1968), pp. 1–40.

Conran's 1986
Conran's Spring 1986. Sales catalogue. New York: Conran's, 1986.

Cook 1878
Cook, Clarence. *The House Beautiful: Essays on Beds and Tables, Stools and Candlesticks*. New York: Scribner, Armstrong, and Company, 1878.

Cooke 1989
Cooke, Edward S., Jr. *New American Furniture: The Second Generation of Studio Furnituremakers*. Exhibition catalogue. Boston: Museum of Fine Arts, 1989.

Cooper 1946
Cooper, Dan. *Inside Your Home*. New York: Farrar, Straus and Company, 1946.

Cooper 1980
Cooper, Wendy A. *In Praise of America: American Decorative Arts, 1650–1830*. Exhibition catalogue. Washington, D.C.: National Gallery of Art, 1980.

Cooper/Kane/Ward 1980
Cooper, Helen A., Patricia E. Kane, and Gerald W.R. Ward. *Francis P. Garvan, Collector*. New Haven: Yale University Art Gallery, 1980.

Copley Society 1911
Copley Society Retrospective Exhibition of the Decorative Arts. Exhibition catalogue. Boston: The Copley Society, 1911.

Cornelius 1922
Cornelius, Charles Over. *Furniture Masterpieces of Duncan Phyfe*. Garden City, New York: Doubleday, Page, and Company, 1922.

Cornell 1941
Cornell, William Frederick. *The Munn Family: Being a Record of Some of the Descendants of Benjamin Munn through Stephen Ball Munn of the Fifth Generation*. Freeport, New York: Privately printed, 1941.

Cornu
Cornu, Paul, ed. *Meubles et Objets de Goût 1796–1830: 678 Documents Tirés des Journaux de Modes et de la Collection de La Mésangère*. Paris: Librairie des Arts Décoratifs, n.d.

Cotton 1987
Cotton, B.D. *Cottage and Farmhouse Furniture in East Anglia: Regional Styles in the*

18th and 19th Centuries. Exhibition catalogue. Gressenhall, England: Norfolk Rural Life Museum, 1987.

Cox 1984
Highly Important American Furniture: The Collection of Mr. and Mrs. Hugh B. Cox. Auction catalogue. New York: Christie's, June 16, 1984.

Crim 1903
Catalogue of the Celebrated Dr. William H. Crim Collection of Genuine Antiques. Auction catalogue. Baltimore: O.A. Kirkland, April 22–May 5, 1903.

Cullity 1987
Cullity, Brian. *Plain and Fancy: New England Painted Furniture.* Exhibition catalogue. Sandwich, Massachusetts: Heritage Plantation of Sandwich, 1987.

Cummings 1964
Cummings, Abbott Lowell, ed. *Rural Household Inventories Establishing the Names, Uses and Furnishings of Rooms in the Colonial New England Home, 1675–1775.* Boston: The Society for the Preservation of New England Antiquities, 1964.

Currier 1964
The Decorative Arts of New Hampshire, 1725–1825. Exhibition catalogue. Manchester, New Hampshire: The Currier Gallery of Art, 1964.

Currier 1970
The Dunlaps and Their Furniture. Exhibition catalogue. Manchester, New Hampshire: The Currier Gallery of Art, 1970.

DAPC
Decorative Arts Photographic Collection. The Henry Francis du Pont Winterthur Museum, Winterthur, Delaware.

Darling 1984
Darling, Sharon. *Chicago Furniture: Art, Craft, and Industry, 1833–1983.* New York: W.W. Norton and Company, 1984.

Davidson 1967
Davidson, Marshall B. *The American Heritage History of Colonial Antiques.* New York: American Heritage, 1967.

Davies 1983
Davies, Karen. *At Home in Manhattan: Modern Decorative Arts, 1925 to the Depression.* Exhibition catalogue. New Haven: Yale University Art Gallery, 1983.

Davis 1947
Davis, Deering. *Annapolis Houses 1700–1775.* New York: Architectural Book Publishing Company, 1947.

Davis 1963
Davis, Richard Beale, ed. *William Fitzhugh and His Chesapeake World, 1676–1701.*

Chapel Hill, North Carolina: University of North Carolina Press, 1963.

DEF
The Dictionary of English Furniture from the Middle Ages to the Late Georgian Period. Eds. Percy Macquoid and Ralph Edwards. 3 vols. London: Country Life, 1924–27.

DEFM
Dictionary of English Furniture Makers 1660–1840. Eds. Geoffrey Beard and Christopher Gilbert. Leeds, England: Furniture History Society, 1986.

Defuccio 1970
The Defuccio Tables: Price List and Specifications. Sales brochure. New York: Knoll International, 1970.

Derby 1861
Derby, Perley. "Genealogy of the Derby Family." *Historical Collections of the Essex Institute* 3 (August 1861), pp. 154–67; (October 1861), pp. 201–07; (December 1861), pp. 283–89.

Derieux/Stevenson 1950
Derieux, Mary, and Isabelle Stevenson. *The Complete Book of Interior Decorating.* New York: Greystone Press, 1950.

"Designed" 1942
"Designed for the People's Housing." *Interiors* 101 (July 1942), p. 30.

"Design for Utility" 1933
"Design for Utility: Kitchen and Pantry." *Arts and Decoration* 40 (November 1933), pp. 24–25.

Deutsch 1989
Deutsch, Davida Tenenbaum. "The Polite Lady: Portraits of American Schoolgirls and Their Accomplishments, 1725–1830." *Antiques* 135 (March 1989), pp. 742–53.

deValinger 1942
deValinger, Leon, Jr. "John Janvier, Delaware Cabinetmaker." *Antiques* 41 (January 1942), pp. 37–39.

de Wolfe 1913
de Wolfe, Elsie. *The House in Good Taste.* New York: The Century Company, 1913.

Dietz 1983
Dietz, Ulysses G. *Century of Revivals: Nineteenth-Century American Furniture in the Collection of The Newark Museum.* Exhibition catalogue. Published in 1983 as *The Newark Museum Quarterly* 31 (Spring-Summer 1980), pp. 1–63.

Doggett Daybook
Doggett, John. Daybook, 1802–09. Joseph Downs Manuscript Collection, The Henry Francis du Pont Winterthur Museum, Delaware.

Doggett Letterbook
Doggett, John, and Company. Letterbook, 1825–29. Joseph Downs Manuscript Collection, The Henry Francis du Pont Winterthur Museum, Delaware.

Dow 1916–18
Dow, George Francis, ed. *The Probate Records of Essex County, Massachusetts.* 3 vols. Salem, Massachusetts: The Essex Institute, 1916–18.

Dow 1927
———. *The Arts and Crafts in New England 1704–1775.* Topsfield, Massachusetts: The Wayside Press, 1927.

Downing 1850
Downing, Andrew Jackson. *The Architecture of Country Houses.* New York: D. Appleton and Company, 1850.

Downs 1928
Downs, Joseph. "Some English and American Furniture in the Inaugural Exhibition." *Pennsylvania Museum Bulletin* 23 (May 1928), pp. 11–21.

Downs 1946
———. "Two Looking Glasses." *Antiques* 49 (May 1946), p. 299.

Downs 1951
———. "Furniture of the Hudson Valley." *Antiques* 60 (July 1951), pp. 45–47.

Downs 1952
———. *American Furniture: Queen Anne and Chippendale Periods.* New York: Macmillan, 1952.

Downs/Ralston 1934
———, and Ruth Ralston. *A Loan Exhibition of New York State Furniture with Contemporary Accessories.* Exhibition catalogue. New York: The Metropolitan Museum of Art, 1934.

Draper 1939
Draper, Dorothy. *Decorating is Fun! How To Be Your Own Decorator.* Garden City, New York: Doubleday and Company, 1939.

Dreppard 1945
Dreppard, Carl W. *The Primer of American Antiques.* Garden City, New York: Doubleday, Doran and Company, 1945.

Dresser 1862
Dresser, Christopher. *The Art of Decorative Design.* London: Day and Son, 1862.

Drexler 1986
Drexler, Arthur, ed. *An Illustrated Catalogue of the Mies van der Rohe Drawings in The Museum of Modern Art. Part I: 1910–1937.* 4 vols. New York: Garland Publishing, 1986.

Dubrow/Dubrow 1982
Dubrow, Eileen, and Richard Dubrow. *Furniture Made in America, 1875–1905.* Exton, Pennsylvania: Schiffer Publishing, 1982.

Ducoff-Barone 1991
 Ducoff-Barone, Deborah. "Philadelphia
 Furniture Makers, 1800–1815." *Antiques*
 139 (May 1991), pp. 982–95.

Duncan 1984
 Duncan, Alastair. *Art Deco Furniture*. New
 York: Holt, Rinehart and Winston, 1984.

Eames 1977
 Eames, Penelope. "Furniture in England,
 France and the Netherlands from the
 Twelfth to the Fifteenth Century." *Furniture History* 13 (1977), pp. i–xxiv, 1–303.

Eastlake 1878
 Eastlake, Charles L. *Hints on Household
 Taste in Furniture, Upholstery and Other
 Details*. 4th rev. ed. London: 1878. Reprint,
 New York: Dover Publications, 1969.

Edwards 1964
 Edwards, Ralph. *The Shorter Dictionary of
 English Furniture from the Middle Ages to
 the Late Georgian Period*. London: Country
 Life Books, 1964.

Elder 1968
 Elder, William Voss, III. *Maryland Queen
 Anne and Chippendale Furniture of the
 Eighteenth Century*. Exhibition catalogue.
 Baltimore: The Baltimore Museum of Art,
 1968.

Elder 1975
 ———. "The Carroll Family: An English
 Lifestyle in America." In *"Anywhere So
 Long As There Be Freedom": Charles Carroll of Carrollton, His Family and His
 Maryland*. Exhibition catalogue. Baltimore:
 The Baltimore Museum of Art, 1975.

Elder/Bartlett 1983
 ———, and Lu Bartlett. *John Shaw: Cabinetmaker of Annapolis*. Exhibition catalogue. Baltimore: The Baltimore Museum
 of Art, 1983.

Elder/Stokes 1987
 ———, and Jayne E. Stokes. *American Furniture 1680–1880 from the Collection of The
 Baltimore Museum of Art*. Baltimore: The
 Baltimore Museum of Art, 1987.

Elgin
 Elgin Century Line Steel Kitchen Cabinets.
 Sales catalogue. Elgin, Illinois: Elgin Stove
 and Oven Company, n.d.

Ellesin 1974
 Ellesin, Dorothy E., ed. "Collector's Notes:
 Michael Allison." *Antiques* 106 (July 1974),
 pp. 56, 142.

Emery 1879
 Emery, Sarah Anna. *Reminiscences of a
 Newport Nonagenarian* (1879). Reprint,
 Bowie, Maryland: Heritage Books, 1978.

Emlen/Steiner 1985
 Emlen, Robert P., and Sarah Steiner. "The

Short-Lived Partnership of Adrian Webb
and Charles Scott." *Antiques* 127 (May
1985), pp. 1141–43.

Failey 1976
 Failey, Dean F. *Long Island Is My Nation:
 The Decorative Arts and Craftsmen,
 1640–1830*. Setauket, New York: Society for
 the Preservation of Long Island Antiquities,
 1976.

Fairbanks 1967
 Fairbanks, Jonathan L. "American
 Antiques in the Collection of Mr. and Mrs.
 Charles L. Bybee, Part I." *Antiques* 92
 (December 1967), pp. 832–39.

Fairbanks 1968
 ———. "American Antiques in the Collection of Mr. and Mrs. Charles L. Bybee, Part
 II." *Antiques* 93 (January 1968), pp. 76–82.

Fairbanks 1981
 ———. "A Decade of Collecting American
 Decorative Arts and Sculpture at the
 Museum of Fine Arts, Boston." *Antiques*
 120 (September 1981), pp. 590–636.

Fairbanks/Bates 1981
 ———, and Elizabeth Bidwell Bates. *American Furniture, 1620 to the Present*. New
 York: Richard Marek, 1981.

Fairbanks/Trent 1982
 ———, and Robert F. Trent. *New England
 Begins: The Seventeenth Century*. Exhibition catalogue. 3 vols. Boston: Museum of
 Fine Arts, 1982.

Fales 1936
 Fales, Winnifred. *What's New in Home
 Decorating*. New York: Dodd, Mead and
 Company, 1936.

Fales 1957
 Fales, Dean A., Jr. "The Furniture of
 McIntire." In *Samuel McIntire: A Bicentennial Symposium, 1757–1957*. Salem, Massachusetts: The Essex Institute, 1957.

Fales 1958
 Fales, Martha Gandy. "Looking Glasses
 Used in America." In *The Concise Encyclopedia of American Antiques*. Ed. Helen
 Comstock. 2 vols. New York: Hawthorn
 Books, 1958, I, pp. 72–78.

Fales 1965
 Fales, Dean A., Jr. *Essex County Furniture:
 Documented Treasures from Local Collections, 1660–1860*. Exhibition catalogue.
 Salem, Massachusetts: The Essex Institute,
 1965.

Fales 1972
 ———. *American Painted Furniture,
 1660–1880*. New York: E.P. Dutton, 1972.

Fales 1974
 Fales, Martha Gandy. *Joseph Richardson
 and Family: Philadelphia Silversmiths*.

Middletown, Connecticut: Wesleyan University Press, 1974.

Fales 1976
 Fales, Dean A., Jr. *The Furniture of Historic
 Deerfield*. New York: E.P. Dutton, 1976.

Farnham 1972
 Farnham, Katharine Gross. "Living with
 Antiques: The Gordon-Banks House in the
 Georgia Piedmont." *Antiques* 102 (September 1972), pp. 434–47.

Fearon 1818
 Fearon, Henry Bradshaw. *Sketches of America: A Narrative of a Journey*. 2nd ed. London, 1818. Reprint, New York: Benjamin
 Blom, 1966.

Fede 1966
 Fede, Helen Maggs. *Washington Furniture
 at Mount Vernon*. Mount Vernon, Virginia:
 The Mount Vernon Ladies' Association of
 the Union, 1966.

Fennimore/Trump 1989
 Fennimore, Donald L., and Robert T.
 Trump. "Joseph B. Barry, Philadelphia
 Cabinetmaker." *Antiques* 135 (May 1989),
 pp. 1212–25.

Findlay/Friend 1981
 Findlay, Mimi, and Doris E. Friend, eds.
 The Lockwood-Mathews Mansion. Norwalk, Connecticut: Lockwood-Mathews
 Mansion Museum of Norwalk, 1981.

Fitz-Gerald 1981
 Fitz-Gerald, Desmond. "The Dublin Del
 Vecchios." *Antiques* 120 (October 1981),
 pp. 910–14.

Flanigan 1986
 Flanigan, J. Michael. *American Furniture
 from the Kaufman Collection*. Exhibition
 catalogue. Washington, D.C.: National
 Gallery of Art, 1986.

Flayderman 1930
 *Colonial Furniture, Silver & Decorations . . .
 The Collection of the Late Philip Flayderman*. Auction catalogue. New York: American Art Association, January 2–4, 1930.

Ford/Ford 1942
 Ford, James, and Katherine Morrow Ford.
 Design of Modern Interiors. New York:
 Architectural Book Publishing Company,
 1942.

Forman 1970
 Forman, Benno M. "Urban Aspects of
 Massachusetts Furniture in the Late Seventeenth Century." In *Country Cabinetwork
 and Simple City Furniture*. Ed. John D.
 Morse. Charlottesville, Virginia: The University Press of Virginia, 1970.

Forman 1983
 ———. "German Influences in Pennsylvania Furniture." In Scott T. Swank et al.,

Arts of the Pennsylvania Germans. Winterthur, Delaware: The Henry Francis du Pont Winterthur Museum, 1983.

Forman 1985
——. "The Chest of Drawers in America, 1635–1730: The Origins of the Joined Chest of Drawers." *Winterthur Portfolio* 20 (Spring 1985), pp. 1–30.

Forman 1987
——. "Furniture for Dressing in Early America, 1650–1730: Forms, Nomenclature, and Use." *Winterthur Portfolio* 22 (Summer-Autumn 1987), pp. 149–64.

Forman 1988
——. *American Seating Furniture, 1630–1730: An Interpretive Catalogue.* New York: W.W. Norton and Company, 1988.

Foster Brothers
Colonial Looking-Glasses and Mirrors. Sales catalogue. Boston: Foster Brothers, n.d.

Fowler/Cornforth 1974
Fowler, John, and John Cornforth. *English Decoration in the 18th Century.* Princeton, New Jersey: The Pyne Press, 1974.

FPG-AAA
Francis P. Garvan. Correspondence and Related Papers. Archives of American Art, Smithsonian Institution, Washington, D.C.

FPG-Y
Francis P. Garvan. Correspondence, Related Papers, and Collection Files. American Arts Office, Yale University Art Gallery, New Haven.

Franco 1973
Franco, Barbara. "New York City Furniture Bought for Fountain Elms by James Watson Williams." *Antiques* 104 (September 1973), pp. 462–67.

Frankl 1928
Frankl, Paul T. *New Dimensions: The Decorative Arts of Today in Words and Pictures.* New York: Payson and Clarke, 1928.

Frankl 1930
——. *Form and Re-Form: A Practical Handbook of Modern Interiors.* New York: Harper and Brothers, 1930.

Franklin 1980
Franklin, Benjamin V., ed. *Boston Printers, Publishers and Booksellers: 1640–1800.* Boston: G.K. Hall, 1980.

Franklin 1984
Highly Important American Furniture from the Collection of Dr. C. Ray Franklin. Auction catalogue. New York: Christie's, October 13, 1984.

Furniture Buyer 1929
"Early American Numbers Command High Prices at Ayer Dispersal." *Furniture Buyer and Decorator* 118 (June 1929), p. 34.

Gaines 1967a
Gaines, Edith, ed. "Collector's Notes: Another John Elliott and the Philadelphia Directories." *Antiques* 91 (April 1967), pp. 518–19.

Gaines 1967b
——. "Collector's Notes: Looking Glasses and Labels." *Antiques* 92 (October 1967), pp. 563–65.

Gaines 1972
——. "Collectors' Notes: John Sweeney, Looking-Glass Maker." *Antiques* 101 (May 1972), p. 881.

Gaines 1973
——. "Collector's Notes: Brass by Hendricks." *Antiques* 103 (April 1973), p. 775.

Galerie nächst St. Stephan 1975
Frederick Kiesler Architekt, 1890–1965. Exhibition catalogue. Vienna: Galerie nächst St. Stephan, 1975.

Gallatin 1924
Gallatin, A.E. *Max Kuehne: Sixteen Reproductions of the Artist's Work.* New York: E.P. Dutton, 1924.

Garrett 1972
Garrett, Wendell D. "Living with Antiques: The Home of Mr. and Mrs. Charles F. Montgomery." *Antiques* 101 (January 1972), pp. 185–92.

Garrett 1975
——, ed. "The Price Book of the District of Columbia Cabinetmakers, 1831." *Antiques* 107 (May 1975), pp. 888–97.

Garrett 1985
Garrett, Elisabeth Donaghy. *The Arts of Independence: The DAR Museum Collection.* Washington, D.C.: The National Society, Daughters of the American Revolution, 1985.

Garvan 1931
Furniture and Silver by American Master Craftsmen of Colonial and Early Federal Times . . . Sold by Order of Francis P. Garvan. Auction catalogue. New York: American Art Association, January 8–10, 1931.

Garvan 1975
Garvan, Beatrice B. *A Craftsman's Handbook: Henry Lapp.* Philadelphia: Philadelphia Museum of Art, 1975.

Garvan 1982
——. *The Pennsylvania German Collection.* Philadelphia: Philadelphia Museum of Art, 1982.

Garvan 1987
——. *Federal Philadelphia 1785–1825: The Athens of the Western World.* Philadelphia: Philadelphia Museum of Art, 1987.

"Georgian Art" 1931
"Exhibition of Georgian Art." *Pennsylvania Museum Bulletin* 26 (January 1931), pp. 5–7, 10, 12–14.

GE Supplement
Beautiful Elgin Steel Kitchen Cabinets . . . : Exclusive Supplement for General Electric Distributors. Sales catalogue. Elgin, Illinois: Elgin Stove and Oven Company, n.d.

Gibbs 1728
James Gibbs. *A Book of Architecture, Containing Designs of Buildings and Ornaments.* London: 1728.

Giffen 1969
Giffen, Jane C. "A Selection of New Hampshire Inventories." *Historical New Hampshire* 24 (Spring-Summer 1969), pp. 3–78.

Giffen 1970
——. "Susanna Rowson and Her Academy." *Antiques* 98 (September 1970), pp. 436–40.

Gilbert 1978
Gilbert, Christopher. *Furniture at Temple Newsam House and Lotherton Hall.* 2 vols. London and Leeds: The National Art Collections Fund and the Leeds Art Collections Fund, 1978.

Gillespie 1930
Gillespie, Harriet Sisson. "A Modernistic House on the Atlantic Beach." *Arts and Decoration* 32 (January 1930), pp. 52–53, 96, 98.

Gillies 1940
Gillies, Mary David. *Popular Home Decoration.* New York: Wise and Company, 1940.

Girl Scouts 1929
Loan Exhibition of Eighteenth and Nineteenth Century Furniture and Glass . . . for the Benefit of the National Council of Girl Scouts, Inc. Exhibition catalogue. New York: American Art Galleries, 1929.

Glaeser 1977
Glaeser, Ludwig. *Ludwig Mies van der Rohe: Furniture and Furniture Drawings from the Design Collection and the Mies van der Rohe Archive.* New York: The Museum of Modern Art, 1977.

Glenn 1979
Glenn, Virginia. "George Bullock, Richard Bridgens and James Watt's Regency Furnishing Schemes." *Furniture History* 15 (1979), pp. 54–67.

Golovin 1975
Golovin, Anne Castrodale. "Cabinetmakers and Chairmakers of Washington, D.C., 1791–1840." *Antiques* 107 (May 1975), pp. 898–922.

Goodison 1975
Goodison, Nicholas. "The Victoria and Albert Museum's Collection of Metal-Work

Pattern Books." *Furniture History* 11 (1975), pp. 1–30.

Gottesman 1938
Gottesman, Rita Susswein, comp. *The Arts and Crafts in New York, 1726–1776. Collections of The New-York Historical Society for the Year 1936.* New York: The New-York Historical Society, 1938.

Gottesman 1954
————. *The Arts and Crafts in New York, 1777–1799.* New York: The New-York Historical Society, 1954.

Gottesman 1965
————. *The Arts and Crafts in New York, 1800–1804.* New York: The New-York Historical Society, 1965.

Goyne 1968
Goyne, Nancy A. "An American Tray-Top Table." *Antiques* 93 (June 1968), pp. 804–06.

Grandjean 1966
Grandjean, Serge. *Empire Furniture 1800 to 1825.* London: Faber and Faber, 1966.

Gray 1983
Gray, Stephen, ed. *The Mission Furniture of L. and J.G. Stickley.* New York: Turn of the Century Editions, 1983.

Gray 1987
————. *The Early Work of Gustav Stickley.* New York: Turn of the Century Editions, 1987.

Gray/Edwards 1981
————, and Robert Edwards. *Collected Works of Gustav Stickley.* New York: Turn of the Century Editions, 1981.

Great Industries 1872
The Great Industries of the United States. Horace Greeley, Leon Case, Edward Howland, John B. Gough, et al., eds. Hartford, Connecticut: J.B. Burr and Hyde, 1872.

Greenlaw 1974
Greenlaw, Barry A. *New England Furniture at Williamsburg.* Williamsburg, Virginia: Colonial Williamsburg Foundation, 1974.

Grier 1988
Grier, Katherine C. *Culture & Comfort: People, Parlors, and Upholstery 1850–1930.* Amherst, Massachusetts: University of Massachusetts Press, 1988.

Gusler 1979
Gusler, Wallace B. *Furniture of Williamsburg and Eastern Virginia, 1710–1790.* Richmond, Virginia: Virginia Museum of Fine Arts, 1979.

Haase 1985
Haase, Gisela. "The Eighteenth-Century Interior Decorations of the Pillnitz Wasser-

and Bergpalais." *Furniture History* 21 (1985), pp. 91–106.

Hageman 1984
Hageman, Jane Sikes. *Ohio Furniture Makers: Volume 1.* Privately printed, 1984.

Hall 1840
Hall, John. *The Cabinet Makers' Assistant.* Baltimore: John Murphy, 1840.

Halsey/Cornelius 1922
Halsey, R.T.H., and Charles O. Cornelius. "An Exhibition of Furniture from the Workshop of Duncan Phyfe." *Bulletin of The Metropolitan Museum of Art* 17 (October 1922), pp. 207–14.

Halsey/Tower 1925
————, and Elizabeth Tower. *The Homes of Our Ancestors.* Garden City, New York: Doubleday, Page, and Company, 1925.

Hanks 1971
Hanks, David A. "Living with Antiques: The Chicago Apartment of Marshall Field." *Antiques* 100 (July 1971), pp. 116–19.

Hanks 1981
————. *Innovative Furniture in America: From 1800 to the Present.* Exhibition catalogue. Washington, D.C.: Smithsonian Institution Traveling Exhibition Service, 1981.

Hanks/Peirce 1983
————, and Donald C. Peirce. *The Virginia Carroll Crawford Collection: American Decorative Arts, 1825–1917.* Atlanta, Georgia: The High Museum of Art, 1983.

Hanks/Talbott 1977
————, and Page Talbott. "Daniel Pabst—Philadelphia Cabinetmaker." *Philadelphia Museum of Art Bulletin* 73 (April 1977), pp. 1–24.

Hanks/Toher 1987
————, and Jennifer Toher. *Donald Deskey: Decorative Designs and Interiors.* New York: E.P. Dutton, 1987.

Harlow 1979
Harlow, Henry J. "Signed and Labeled New England Furniture." *Antiques* 116 (October 1979), pp. 872–79.

Harris 1963
Harris, Eileen. *The Furniture of Robert Adam.* London: Alec Tiranti, 1963.

Harrisburg Directory
Boyd's Directory of Harrisburg and Steelton. Harrisburg, Pennsylvania: W.H. Boyd Company, 1891–1922.

Hartford Directory
Bibliographic information for specific directories published prior to 1860 is given in Spear 1961, pp. 141–50. Following 1860, the Hartford, Connecticut, publishers are:

Elihu Geer, 1860–61; Hartford Steam Printing Company, 1862–85; Hartford Printing Company, 1886–1927.

Haskell 1944a
Important Eighteenth-Century American Furniture . . . Collected by the Late Mrs. J. Amory Haskell: Part Two. Auction catalogue. New York: Parke-Bernet Galleries, May 17–20, 1944.

Haskell 1944b
Important Eighteenth-Century American Furniture . . . Collected by the Late Mrs. J. Amory Haskell: Part Four. Auction catalogue. New York: Parke-Bernet Galleries, November 8–11, 1944.

Havard
Havard, Henry. *Dictionnaire de l'Ameublement et de la Décoration.* 4 vols. Paris: Maison Quantin, n.d.

Hawley 1988
Hawley, Henry. "Philadelphia Tables with Lyre Supports." *The Bulletin of the Cleveland Museum of Art* 75 (January 1988), pp. 2–27.

Hayward 1965
Hayward, Helena, ed. *World Furniture: An Illustrated History.* London: Hamlyn, 1965.

Hayward 1971
Hayward, Mary Ellen. "The Elliotts of Philadelphia: Emphasis on the Looking Glass Trade, 1755–1810." M.A. thesis. Newark: University of Delware, 1971.

Heard 1933
Heard, Frances Taylor. "Pattern for a Modern Kitchen." *Home and Field* 43 (November 1933), pp. 36–39, 70.

Heard 1950
————. "American Taste Has an Unmistakable Flavor." *House Beautiful* 92 (May 1950), pp. 140–43.

Heckscher 1973
Heckscher, Morrison H. "The New York Serpentine Card Table." *Antiques* 103 (May 1973), pp. 974–83.

Heckscher 1985
————. *American Furniture in The Metropolitan Museum of Art. Vol. 2. The Late Colonial Period: The Queen Anne and Chippendale Styles.* New York: The Metropolitan Museum of Art, 1985.

Hennessey 1952
Hennessey, William J. *Modern Furnishings for the Home.* New York: Reinhold Publishing Corporation, 1952.

Hepplewhite 1794
Hepplewhite, George. *The Cabinet-Maker and Upholsterer's Guide.* 3rd ed. London: 1794. Reprint, New York: Dover Publications, 1969.

Herbert 1939
Herbert, G.W. "Bach's Design Psychology." *Furniture World* 139 (July 6, 1939), p. 8.

Herman Miller 1948
The Herman Miller Collection: Furniture Designed by George Nelson, Charles Eames, Isamu Noguchi, Paul Laszlo. Sales catalogue. Zeeland, Michigan: Herman Miller Furniture Company, 1948.

Herts 1915
Herts, B. Russell. *The Decoration and Furnishing of Apartments*. New York and London: G.P. Putnam's Sons, 1915.

Hewitt 1982
Hewitt, Benjamin A. "Regional Characteristics of Inlay on American Federal Period Card Tables." *Antiques* 121 (May 1982), pp. 1164–71.

Hewitt/Kane/Ward 1982
———, Patricia E. Kane, and Gerald W.R. Ward. *The Work of Many Hands: Card Tables in Federal America, 1790–1820*. Exhibition catalogue. New Haven: Yale University Art Gallery, 1982.

Hill 1967
Hill, John Henry. "The Furniture Craftsmen in Baltimore, 1783–1823." M. A. thesis. 2 vols. Newark: University of Delaware, 1967.

Hinckley 1953
Hinckley, F. Lewis. *A Directory of Antique Furniture*. New York: Crown Publishers, 1953.

Hinckley 1987
———. *Queen Anne and Georgian Looking Glasses*. New York: Washington Mews, 1987.

Hind 1979
Hind, Jan Garrett. *The Museum of Early Southern Decorative Arts: A Collection of Southern Furniture, Paintings, Ceramics, Textiles, and Metalware*. Winston-Salem, North Carolina: Old Salem, Inc., 1979.

Hingham 1893
History of the Town of Hingham, Massachusetts. 3 vols. Hingham, Massachusetts: 1893.

Hipkiss 1941
Hipkiss, Edwin J. *Eighteenth-Century American Arts: The M. and M. Karolik Collection*. Cambridge, Massachusetts: Harvard University Press, 1941.

Holloway 1927
Holloway, Edward Stratton. "Furniture of the Federal Era: Hepplewhite and Early Sheraton Seating Furniture, Sideboards, and Tables." *House and Garden* 51 (June 1927), pp. 88–89, 124, 126, 172.

Holloway 1928
———. *The Practical Book of American Furniture and Decoration: Colonial and Federal*. Philadelphia: J.B. Lippincott, 1928.

Holme 1688
Holme, Randle. *The Academy of Armory, or a Storehouse of Armory and Blazon*. Vol. II. London: The Roxburghe Club, 1905.

Hope 1807
Hope, Thomas. *Household Furniture and Interior Decoration*. London: T. Bensley, 1807.

Hopkins/Cox 1936
Hopkins, Thomas Smith, and Walter Scott Cox. *Colonial Furniture of West New Jersey*. Haddonfield, New Jersey: The Historical Society of Haddonfield, 1936.

Horn 1986
Horn, Richard. *Memphis: Objects, Furniture, and Patterns*. New York: Simon and Schuster, 1986.

Hornor 1928a
Hornor, William M., Jr. "Three Generations of Cabinetmakers I: Matthew Egerton, 1739–1802." *Antiques* 14 (September 1928), pp. 217–19.

Hornor 1928b
———. "Three Generations of Cabinetmakers II: Matthew Egerton, Jr., and His Sons." *Antiques* 14 (November 1928), pp. 417–21.

Hornor 1930a
———. "A New Estimation of Duncan Phyfe." *Antiquarian* 14 (March 1930), pp. 36–40, 96.

Hornor 1930b
———. "Documented Furniture by Jacob Wayne." *International Studio* 96 (June 1930), pp. 40–43.

Hornor 1930c
———. "Matthew Egerton, Jr., Cabinetmaker of New Jersey." *Antiquarian* 15 (December 1930), pp. 50–53, 114.

Hornor 1935a
———. *Blue Book: Philadelphia Furniture, William Penn to George Washington*. Philadelphia: Privately printed, 1935.

Hornor 1935b
———. *A Loan Exhibition of Authenticated Furniture of the Great Philadelphia Cabinet Makers*. Exhibition catalogue. Philadelphia: The Pennsylvania Museum of Art, 1935.

Hosley 1987
Hosley, William N., Jr. "Vermont Furniture, 1790–1830." In *New England Furniture: Essays in Memory of Benno M. Forman (Old-Time New England, 72)*. Bos-

ton: The Society for the Preservation of New England Antiquities, 1987.

"House in Good Taste" 1928
"The House in Good Taste: The Home of Mary Byers Smith in Andover, Massachusetts." *The House Beautiful* 64 (September 1928), pp. 257–60.

Howard 1877
Howard, Joseph Jackson, ed. *Miscellanea Genealogica et Heraldica*. 2 vols. London: Hamilton, Adams, and Company, 1877.

Hudnut 1927
Duncan Phyfe and Other Fine Early American Furniture . . . Collection of Alexander M. Hudnut of Princeton, N.J. Auction catalogue. New York: American Art Association, November 19, 1927.

Hughes 1962
Hughes, Judith Coolidge. "Courting Mirrors: Another European Export Product?" *Antiques* 82 (July 1962), pp. 68–71.

Hughes 1966
———. "North European Export Mirrors: The Evidence and Some Suggestions." *Antiques* 89 (June 1966), pp. 856–61.

Hummel 1976
Hummel, Charles F. *A Winterthur Guide to American Chippendale Furniture: Middle Atlantic and Southern Colonies*. New York: Crown Publishers, 1976.

Humphreys 1897
Humphreys, Arthur L. *The Private Library*. New York: J.W. Bouton, 1897.

Hurst/Priddy 1990
Hurst, Ronald L., and Sumpter T. Priddy III. "The Neoclassical Furniture of Norfolk, Virginia, 1770–1820." *Antiques* 137 (May 1990), pp. 1140–53.

Husher/Welch 1980
Husher, Richard W., and Walter W. Welch. *A Study of Simon Willard's Clocks*. Nahant, Massachusetts: Husher and Welch, 1980.

Huth 1974
Huth, Hans. *Roentgen Furniture. Abraham and David Roentgen: European Cabinetmakers*. London and New York: Sotheby Parke Bernet, 1974.

IGI
International Genealogical Index. Microfiche. Salt Lake City, Utah: The Church of Jesus Christ of the Latter-Day Saints, 1984.

Ince/Mayhew 1762
Ince, William, and John Mayhew. *The Universal System of Household Furniture* (1762). Reprint, London: Alec Tiranti, 1960.

Indianapolis Directory
R.L. Polk and Company's Indianapolis City Directory. Indianapolis, Indiana: R.L. Polk

and Company, 1900–26. Published as *Polk's Indianapolis City Directory*, 1927; *Polk's Indianapolis (Indiana) City Directory*, 1928–32; *Polk's Indianapolis (Marion County, Indiana) City Directory*, 1933–35.

Isaacson 1975
Isaacson, Philip M. *The American Eagle*. Boston: New York Graphic Society, 1975.

Jackson-Stops 1985
Jackson-Stops, Gervase, ed. *The Treasure Houses of Britain: Five Hundred Years of Private Patronage and Art Collecting*. Exhibition catalogue. Washington, D.C.: National Gallery of Art, 1985.

Jacobus 1930–32
Jacobus, Donald Lines. *History and Genealogy of the Families of Old Fairfield*. 3 vols. Fairfield, Connecticut: Daughters of the American Revolution, 1930–32.

Jervis 1974
Jervis, Simon. *Printed Furniture Designs Before 1650*. Leeds, England: The Furniture History Society, 1974.

Jobe/Kaye 1984
Jobe, Brock W., and Myrna Kaye. *New England Furniture: The Colonial Era*. Boston: Houghton Mifflin, 1984.

Johnson 1755
Johnson, Samuel. *A Dictionary of the English Language*. 2 vols. London: W. Strahan, 1755.

Johnson 1947
Johnson, Philip C. *Mies van der Rohe*. Stuttgart: Verlag Gerd Hatje, 1947.

Johnson 1964
Johnson, J. Stewart. "New York Cabinetmaking Prior to the Revolution." M.A. thesis. Newark: University of Delaware, 1964.

Johnson 1968
Johnson, Marilynn A. "John Hewitt, Cabinetmaker." *Winterthur Portfolio* 4 (1968), pp. 185–205.

Johnson 1972
Johnson, J. Stewart. "John Jelliff, Cabinetmaker." *Antiques* 102 (August 1972), pp. 256–61.

Johnson 1982
Johnson, Fridolf, ed. *Rockwell Kent: An Anthology of His Works*. New York: Alfred A. Knopf, 1982.

Johnston 1979
Johnston, Phillip. "Eighteenth- and Nineteenth-Century American Furniture in the Wadsworth Atheneum." *Antiques* 115 (May 1979), pp. 1016–27.

Jones 1739
Jones, William. *The Gentlemens or Builders Companion*. London: The Author, 1739.

Jones 1977
Jones, Karen M. "American Furniture in the Milwaukee Art Center." *Antiques* 111 (May 1977), pp. 974–83.

Jourdain 1965
Jourdain, Margaret. *Regency Furniture 1795–1830*. Rev. ed. London: Country Life Books, 1965.

Joy 1964
Joy, Edward T. "English Furniture Exports to America, 1697–1830." *Antiques* 85 (January 1964), pp. 92–98.

Joy 1965
———. "The Overseas Trade in Furniture in the Eighteenth Century." *Furniture History* 1 (1965), pp. 1–10.

Joy 1977
———. *Pictorial Dictionary of British 19th Century Furniture Design*. Woodbridge, England: The Antique Collectors' Club, 1977.

Kahle 1930
Kahle, Katharine Morrison. *Modern French Decoration*. New York: G.P. Putnam's Sons, 1930.

Kane 1973
Kane, Patricia E. *Furniture of the New Haven Colony: The Seventeenth-Century Style*. Exhibition catalogue. New Haven, Connecticut: The New Haven Colony Historical Society, 1973.

Kane 1976
———. *300 Years of American Seating Furniture: Chairs and Beds from the Mabel Brady Garvan and Other Collections at Yale University*. Boston: New York Graphic Society, 1976.

Kane 1980
———. "American Furniture in the Yale University Art Gallery." *Antiques* 117 (June 1980), pp. 1314–27.

Katter/Boodro 1974
Katter, Joan, and Michael Boodro. *The American Clock, 1725–1865* and *Forgeries and Restorations in American Furniture*. Exhibition catalogue. New Haven: Yale University Art Gallery, 1974.

Kelley 1974
Kelley, Brooks Mather. *New Haven Heritage: An Area of Historic Houses on Hillhouse Avenue and Trumbull Street*. New Haven: The New Haven Preservation Trust, 1974.

Kent 1727
Kent, William. *The Designs of Inigo Jones*. London: The Author, 1727.

Kent 1955
Kent, Rockwell. *It's Me O Lord: The Autobiography of Rockwell Kent*. New York: Dodd, Mead and Company, 1955.

Ketchum 1982
Ketchum, William C., Jr. *Chests, Cupboards, Desks, and Other Pieces*. The Knopf Collectors' Guides to American Antiques. New York: Alfred A. Knopf, 1982.

Kettell 1929
Kettell, Russell Hawes. *The Pine Furniture of New England*. New York: Doubleday, Doran and Company, 1929.

Keyes 1927
Keyes, Homer Eaton. "New Wings for an Old Butterfly." *Antiques* 11 (February 1927), p. 112.

Keyes 1935
———. "The Individuality of Connecticut Furniture." *Antiques* 28 (September 1935), pp. 110–13.

Kimball 1931a
Kimball, Marie G. "The Furnishings of Governor Penn's Town House." *Antiques* 19 (May 1931), pp. 374–78.

Kimball 1931b
———. "The Furnishings of Solitude: The Country Estate of John Penn." *Antiques* 20 (July 1931), pp. 27–31.

Kimball 1933a
Kimball, Fiske. "Furniture Carvings by Samuel Field McIntire." *Antiques* 23 (February 1933), pp. 56–58.

Kimball 1933b
———. "Salem Furniture Makers: II. Nehemiah Adams." *Antiques* 24 (December 1933), pp. 218–20.

Kirk 1967a
Kirk, John T. *Connecticut Furniture: Seventeenth and Eighteenth Centuries*. Exhibition catalogue. Hartford, Connecticut: Wadsworth Atheneum, 1967.

Kirk 1967b
———. "The Distinctive Character of Connecticut Furniture." *Antiques* 92 (October 1967), pp. 524–29.

Kirk 1970
———. *Early American Furniture*. New York: Alfred A. Knopf, 1970.

Kirk 1975
———. *The Impecunious Collector's Guide to American Antiques*. New York: Alfred A. Knopf, 1975.

Kirk 1982
———. *American Furniture and the British Tradition to 1830*. New York: Alfred A. Knopf, 1982.

Komanecky/Butera 1984
Komanecky, Michael, and Virginia Fabbri Butera. *The Folding Image: Screens by Western Artists of the Nineteenth and Twentieth Centuries*. Exhibition catalogue. New Haven: Yale University Art Gallery, 1984.

Koues 1945
Koues, Helen. *How To Be Your Own Decorator*. New York: Tudor Publishing Company, 1945.

Koues 1948
———. *The American Woman's Encyclopedia of Home Decorating*. Garden City, New York: Garden City Publishing Company, 1948.

Kreisel/Himmelheber 1973
Kreisel, Heinrich, and Georg Himmelheber. *Die Kunst des Deutschen Möbels*. 3 vols. Munich: C.H. Beck, 1973.

Kron/Slesin 1978
Kron, Joan, and Suzanne Slesin. *High Tech: The Industrial Style and Source Book for the Home*. New York: Clarkson N. Potter, 1978.

Kyle 1969
Kyle, W. Thomas. "Decorative Arts at the Newark Museum." *Antiques* 95 (June 1969), pp. 838–41.

Landon 1985
Landon, Eugene. "Queen Anne Handkerchief Table: Building a Three-Cornered Masterpiece." *Fine Woodworking*, no. 52 (May-June 1985), pp. 38–41.

Langley 1750
Langley, Batty. *The City and Country Builder's and Workman's Treasury of Designs*. London: S. Harding, 1750.

Langley/Langley 1747
———, and Thomas Langley. *Gothic Architecture Improved by Rules and Proportions*. London: John Millar, 1747.

Lavin 1968
Lavin, Irving. *Bernini and the Crossing of St. Peter's* (Monographs on Archaeology and the Fine Arts, 17). New York: New York University Press for The College Art Association of America, 1968.

Levy 1977
Distinguished American and English Antiques, Fine Paintings. Sales catalogue. New York: Bernard and S. Dean Levy, 1977.

Levy 1988
Sales catalogue. New York: Bernard and S. Dean Levy, 1988.

"Living with Antiques" 1944
"Living with Antiques: The Connecticut Home of Mr. and Mrs. C. Sanford Bull." *Antiques* 45 (April 1944), pp. 190–91.

Lloyd Chromium 1938
Lloyd Chromium Furniture. Sales catalogue. Menominee, Michigan: Lloyd Manufacturing Company, 1938.

Lockwood 1926
Lockwood, Luke Vincent. *Colonial Furni-*

ture in America. 3rd ed. 2 vols. New York: Charles Scribner's Sons, 1926.

Lockwood 1934
Lockwood, Sarah M. *Decoration: Past, Present, and Future*. Garden City, New York: Doubleday, Doran and Company, 1934.

London Prices 1788
The London Cabinet Book of Prices. London: 1788.

London Prices 1793
The Cabinet-Makers' London Book of Prices. London: The London Society of Cabinet Makers, 1793.

London Prices 1797
The Prices of Cabinet Work. London: S. Low, 1797.

London Prices 1802
The London Chair-Makers' and Carvers' Book of Prices for Workmanship. London: T. Sorrell, 1802.

London Prices 1811
The London Cabinet-Makers' Union Book of Prices. London: A Committee of Masters and Journeymen, 1811.

"Long Text" 1929
"Long Text and Brief Sermon." *Antiques* 16 (November 1929), pp. 366–69.

Lord 1953
Lord, William G. *History of Athol, Massachusetts*. Athol, Massachusetts: Privately printed, 1953.

Loudon 1833
Loudon, John Claudius. *An Encyclopaedia of Cottage, Farm, and Villa Architecture and Furniture*. London: Longman, Rees, Orme, Brown, Green, and Longman, 1833.

Louie 1987
Louie, Elaine. "Home Beat." *The New York Times*, June 11, 1987, p. C3.

Lunsingh Scheurleer 1961
Lunsingh Scheurleer, Th.H. *Van Haardvuur tot Beeldscherm: Vijf Eeuwen Interieur- en Meubelkunst in Nederland*. Leiden: A.W. Sijthoff, 1961.

Lunsingh Scheurleer 1976
———. "The Dutch at the Tea-Table." *Connoisseur* 193 (October 1976), pp. 85–93.

Lyle/Zimmerman 1980
Lyle, Charles T., and Philip D. Zimmerman. "Furniture of the Monmouth County Historical Association." *Antiques* 117 (January 1980), pp. 186–205.

Lyon Notebook
Lyon, Irving W. Notebook, 1879–83. The Mabel Brady Garvan Collection, Yale University Art Gallery, New Haven.

Lyon 1924
———. *The Colonial Furniture of New*

England. 3rd. ed. Boston and New York: Houghton Mifflin, 1924.

Lyon 1932
Early American Antiques, Furniture, China, Glass, Etc. of Great Importance . . . from the Stock of Charles Woolsey Lyon, Inc. Auction catalogue. New York: Rains Auction Rooms, January 20–22, 1932.

Made in Utica 1976
Made in Utica. Exhibition catalogue. Utica, New York: Museum of Art, Munson-Williams-Proctor Institute and Oneida Historical Society, 1976.

Margolis 1923
Third Sale of Fine Early American Furniture Gathered . . . by Jacob Margolis. Auction catalogue. New York: Anderson Galleries, November 16–17, 1923.

Margolis 1924a
Fourth Sale of Fine Early American Furniture Gathered by Jacob Margolis. Auction catalogue. New York: Anderson Galleries, April 11–12, 1924.

Margolis 1924b
Fifth Sale of Fine Early American Furniture Gathered by Jacob Margolis. Auction catalogue. New York: Anderson Galleries, November 12–15, 1924.

Margolis 1925
Sixth Sale of Fine Early American Furniture Gathered by Jacob Margolis. Auction catalogue. New York: Anderson Galleries, April 3–4, 1925.

Margolis 1926
Furniture of Our Forefathers. Auction catalogue. New York: American Art Association, November 5–6, 1926.

Mayer 1878
Mayer, Brantz. *Memoir and Genealogy of the Maryland and Pennsylvania Family of Mayer Which Originated in the Free Imperial City of Ulm, Württemberg: 1495–1878*. Baltimore: William K. Boyle and Son, 1878.

Mayer/Myers 1991
Mayer, Lance, and Gay Myers, eds. *The Devotion Family: The Lives and Possessions of Three Generations in Eighteenth-Century Connecticut*. Exhibition catalogue. New London, Connecticut: The Lyman Allyn Art Museum, 1991.

Mayhew/Myers 1980
Mayhew, Edgar deN., and Minor Myers, Jr. *A Documentary History of American Interiors: From the Colonial Era to 1915*. New York: Charles Scribner's Sons, 1980.

McClelland 1936
McClelland, Nancy V. *Furnishing the Colonial and Federal House*. Philadelphia and London: J.B. Lippincott, 1936.

McClelland 1939
———. *Duncan Phyfe and the English Regency, 1795–1830*. New York: W.R. Scott, 1939.

McClinton 1972
McClinton, Katharine Morrison. *Art Deco: A Guide for Collectors*. New York: Clarkson N. Potter, 1972.

McElroy 1970
McElroy, Cathryn J. "Furniture of the Philadelphia Area: Forms and Craftsmen Before 1730." M.A. thesis. Newark: University of Delaware, 1970.

Means 1941
Means, Anne, ed. *Let's Decorate Our Home*. New York: Robert M. McBride and Company, 1941.

Meikle 1979
Meikle, Jeffrey L. *Twentieth Century Limited: Industrial Design in America, 1925–1939*. Philadelphia: Temple University Press, 1979.

Mercer 1969
Mercer, Eric. *Furniture 700–1700*. New York: Meredith Press, 1969.

MESDA
Museum of Early Southern Decorative Arts, Winston-Salem, North Carolina.

Metro 1981
Metro Foodservice Equipment Digest. Sales catalogue. Wilkes-Barre, Pennsylvania: InterMetro Industries Corporation, 1981.

Metropolitan 1909
The Hudson-Fulton Celebration: Catalogue of an Exhibition Held at The Metropolitan Museum of Art. Exhibition catalogue. 2 vols. New York: The Metropolitan Museum of Art, 1909.

Metropolitan 1986
In Pursuit of Beauty: Americans and the Aesthetic Movement. Exhibition catalogue. New York: The Metropolitan Museum of Art, 1986.

Miller 1937
Miller, Edgar G., Jr. *American Antique Furniture: A Book for Amateurs*. 2 vols. Baltimore: The Lord Baltimore Press, 1937.

Miller 1956
Miller, V. Isabelle. *Furniture by New York Cabinetmakers, 1650 to 1860*. Exhibition catalogue. New York: Museum of the City of New York, 1956.

Milley 1980
Milley, John C., ed. *Treasures of Independence: Independence National Historical Park and Its Collections*. New York: Mayflower Books, 1980.

MISCO 1986
MISCO Computer Supplies and Accessories.

Sales catalogue. Holmdel, New Jersey: MISCO Inc., 1986.

Mitchell 1970
Mitchell, James R. *An Exhibition of Furniture and Furnishings from the Collection of the New Jersey State Museum*. Exhibition catalogue. Trenton: New Jersey State Museum, 1970.

Modern Priscilla 1925
Modern Priscilla Home Furnishing Book. Boston: The Priscilla Publishing Company, 1925.

Moir/Parker 1989
Moir, Rob, and Jackson Parker. "Massachusetts Waterfowl Decoys." *Antiques* 136 (September 1989), pp. 516–27.

Monahon 1980
Monahon, Eleanore Bradford. "The Rawson Family of Cabinetmakers in Providence, R.I." *Antiques* 118 (July 1980), pp. 134–47.

Monkhouse/Michie 1986
Monkhouse, Christopher P., and Thomas S. Michie. *American Furniture in Pendleton House*. Providence: Museum of Art, Rhode Island School of Design, 1986.

Montgomery 1957
Montgomery, Charles F. *America's Arts and Skills*. New York: E.P. Dutton, 1957.

Montgomery 1966
———. *American Furniture: The Federal Period*. New York: The Viking Press, 1966.

Montgomery 1975
———. "1776—How America Really Looked—Furniture." *American Art Journal* 7 (May 1975), pp. 52–67.

Montgomery/Kane 1976
———, and Patricia E. Kane, eds. *American Art: 1750–1800, Towards Independence*. Exhibition catalogue. New Haven: Yale University Art Gallery, 1976.

Montgomery Ward 1895
Catalogue and Buyers' Guide. Spring and Summer 1895. Montgomery Ward and Company. Sales catalogue. Chicago: 1895; Reprint, New York: Dover Publications, 1969.

Morson 1932a
Fine Early American Antiques: Being Part I of the Entire Stock of the Late Charles R. Morson. Auction catalogue. New York: Rains Auction Rooms, November 16–19, 1932.

Morson 1932b
Early American Antiques and a Group of Reproductions: Being Part II of the Entire Stock of Charles R. Morson. Auction catalogue. New York: Rains Auction Rooms, November 25–26, 1932.

Morton 1953
Morton, Ruth. *The Home and Its Furnishings*. New York: McGraw-Hill, 1953.

Moses 1984
Moses, Michael. *Master Craftsmen of Newport: The Townsends and Goddards*. Tenafly, New Jersey: MMI Americana Press, 1984.

Müller-Christensen 1948
Müller-Christensen, Sigrid. *Alte Möbel vom Mittelalter bis zum Jugendstil*. Munich: F. Bruckmann, 1948.

Myers 1921
Illustrated Catalogue of the Rare and Extremely Choice Collection of Early American and English Furniture . . . Formed . . . by . . . Mr. Louis Guerineau Myers. Auction catalogue. New York: American Art Association, February 24–26, 1921.

Myers/Mayhew 1974
Myers, Minor, Jr., and Edgar deN. Mayhew. *New London County Furniture, 1640–1840*. Exhibition catalogue. New London, Connecticut: The Lyman Allyn Museum, 1974.

Naeve 1981
Naeve, Milo M. *Identifying American Furniture*. Nashville, Tennessee: The American Association for State and Local History, 1981.

Nagel 1932
Nagel, Charles, Jr. "Room from the Joel Clark House, East Granby, Connecticut, 1737." *Bulletin of the Associates in Fine Arts at Yale University* 4 (October 1932), pp. 139–40.

Nagel 1949
———. *American Furniture, 1650–1850*. New York: Chanticleer Press, 1949.

NCCI
North Carolina Census Index. Eds. Ronald Vern Jackson, Gary Ronald Teeples, and David Schaefermeyer. Bountiful, Utah: Accelerated Indexing Systems, 1976–78.

New Hampshire 1973
The Decorative Arts of New Hampshire: A Sesquicentennial Exhibition. Exhibition catalogue. Concord, New Hampshire: The New Hampshire Historical Society, 1973.

New Hampshire 1979
Plain & Elegant, Rich & Common: Documented New Hampshire Furniture, 1750–1850. Exhibition catalogue. Concord, New Hampshire: The New Hampshire Historical Society, 1979.

New Hampshire Auction 1990
American, English and Continental Furniture. Auction catalogue. Hampton, New Hampshire: New Hampshire Auction, August 5, 1990.

New Haven Directory
Bibliographic information for specific directories published prior to 1860 is given in Spear 1961, pp. 217–21. Following 1860, the New Haven publishers are: J.H. Benham, 1860–74; Price, Lee, and Company, 1875–90; Price and Lee Company, 1891–1980.

"New House" 1943
"A New House in Connecticut." *Interiors* 103 (November 1943), pp. 24–27.

New Jersey 1973
A Royal Province: New Jersey 1738–1776. Exhibition catalogue. Trenton: New Jersey State Museum, 1973.

New Jersey 1976
The Pulse of the People: New Jersey 1763–1789. Exhibition catalogue. Trenton: New Jersey State Museum, 1976.

New London 1905
Genealogical and Biographical Record of New London County, Connecticut. Chicago: J.H. Beers and Co., 1905.

New York Directory
Bibliographic information for specific directories published prior to 1860 is given in Spear 1961, pp. 231–63. Between 1860 and 1872, the New York publisher was John F. Trow.

New York Prices 1796
The Journeymen Cabinet and Chairmakers' New-York Book of Prices. New York: T. and J. Swords, 1796.

New York Prices 1802
The New-York Book of Prices for Cabinet and Chair Work. New York: Southwick and Crooker, 1802.

New York Prices 1810
The New-York Revised Prices for Manufacturing Cabinet and Chair Work. New York: Southwick and Pelsue, 1810.

New York Prices 1817
The New-York Book of Prices for Manufacturing Cabinet and Chair Work. New York: J. Seymour, 1817.

New York Prices 1834
The New-York Book of Prices for Manufacturing Cabinet and Chair Work. New York: Harper and Brothers, 1834.

Nicholson/Nicholson 1826
Nicholson, Peter, and Michael Angelo Nicholson. *The Practical Cabinet-Maker, Upholsterer, and Complete Decorator.* London: H. Fisher, Son, and Co., 1826.

Norton 1984
Norton, Thomas E. *100 Years of Collecting in America: The Story of Sotheby Parke Bernet.* New York: Harry N. Abrams, 1984.

Noyes 1941
Noyes, Eliot F. *Organic Design in Home Furnishings.* Exhibition catalogue. New York: The Museum of Modern Art, 1941.

Nutting 1918
The Wallace Nutting Collection of American Antiques: Exhibition and Sale, Au Quatrième. Sales catalogue. New York: John Wanamaker, [1918].

Nutting 1924
Nutting, Wallace. *Furniture of the Pilgrim Century.* Framingham, Massachusetts: Old America Company, 1924.

Nutting 1928
———. *Furniture Treasury.* 3 vols. Framingham, Massachusetts: Old America Company, 1928–33.

Ormsbee 1934
Ormsbee, Thomas Hamilton. *The Story of American Furniture.* New York: Macmillan, 1934.

Ormsbee 1944
———. "The Del Vecchio Family, Mirror Makers of New York." *American Collector* 13 (June 1944), pp. 5, 20.

Ostergard 1987
Ostergard, Derek E., ed. *Bent Wood and Metal Furniture: 1850–1946.* Exhibition catalogue. New York: The American Federation of Arts, 1987.

Ott 1969
Ott, Joseph K. "Recent Discoveries Among Rhode Island Cabinetmakers and Their Work." *Rhode Island History* 28 (Winter 1969), pp. 3–25.

Otto 1962
Otto, Celia Jackson. "Pillar and Scroll: Greek Revival Furniture of the 1830s." *Antiques* 81 (May 1962), pp. 504–07.

Otto 1965
———. *American Furniture of the Nineteenth Century.* New York: The Viking Press, 1965.

Owsley 1972
Owsley, David T. "The Ailsa Mellon Bruce Collection of French Furniture." *Antiques* 102 (December 1972), pp. 1078–87.

Owsley 1976
———. "The American Furniture Collection." *Carnegie Magazine* 50 (June 1976), pp. 261–80.

Page 1979
Page, John F. "Documented New Hampshire Furniture, 1750–1850." *Antiques* 115 (May 1979), pp. 1004–15.

Pahlmann 1960
Pahlmann, William. *The Pahlmann Book of Interior Design.* Rev. ed. New York: The Viking Press, 1960.

Pallasmaa 1985
Pallasmaa, Juhani, ed. *Alvar Aalto Furniture.* Cambridge, Massachusetts: The MIT Press, 1985.

Palmer 1928
The George S. Palmer Collection. Auction catalogue. New York: Anderson Galleries, October 18–20, 1928.

Parke-Bernet 1969
Eighteenth-Century American Furniture. Auction catalogue. New York: Parke-Bernet Galleries, October 25, 1969.

"Parlor View" 1854
"A Parlor View." *Gleason's Pictorial Drawing-Room Companion*, November 11, 1854, p. 300.

Parsons 1939
Early American Furniture . . . Property of Miss Ella Parsons. Auction catalogue. New York: Parke-Bernet Galleries, January 14, 1939.

PB Eighty-Four 1980
Victorian International IX. Auction catalogue. New York: PB Eighty-Four, June 18, 1980.

PCI
Pennsylvania Census Index. Eds. Ronald Vern Jackson, Gary Ronald Teeples, David Schaefermeyer. Bountiful, Utah: Accelerated Indexing Systems, 1976–78.

Pearce 1962
Pearce, Lorraine W. "American Empire Furniture in the White House." *Antiques* 81 (May 1962), pp. 515–19.

Peirce 1979a
Peirce, Donald C. "Mitchell and Rammelsberg: Cincinnati Furniture Manufacturers, 1847–1881." *Winterthur Portfolio* 13 (1979), pp. 209–29.

Peirce 1979b
———. "New York Furniture at the Brooklyn Museum." *Antiques* 115 (May 1979), pp. 994–1003.

Pennsylvania 1860
Pennsylvania 1860 Central [Census Index]. Eds. Ronald Vern Jackson et al. North Salt Lake, Utah: Accelerated Indexing Systems International, 1986.

Pennypacker 1950
Early American Furniture. Auction catalogue. Pennsburg, Pennsylvania: A.J. Pennypacker, May 22–24, 1930.

Pepis 1957
Pepis, Betty. *Betty Pepis' Guide to Interior Decoration.* New York: Reinhold Publishing Corporation, 1957.

Percier/Fontaine 1812
Percier, Charles, and Pierre-François-

Léonard Fontaine. *Recueil de Décorations Intérieures*. 2nd ed. Paris: P. Didot, 1812.

Peterson 1971
Peterson, Harold L. *Americans at Home: From the Colonists to the Late Victorians*. New York: Charles Scribner's Sons, 1971.

Philadelphia 1976
Philadelphia: Three Centuries of American Art. Philadelphia: Philadelphia Museum of Art, 1976.

Philadelphia Directory
Bibliographic information for specific directories cited is given in Spear 1961, pp. 273–93.

Philadelphia Prices 1795
The Journeymen Cabinet and Chair-makers Philadelphia Book of Prices. Philadelphia: Ormrod and Conrad, 1795.

Philadelphia Prices 1796a
The Cabinet-Makers' Philadelphia and London Book of Prices. Philadelphia: Snowden and M'Corkle, 1796.

Philadelphia Prices 1796b
The Philadelphia Cabinet and Chair-Makers' Book of Prices. Philadelphia: Richard Folwell, 1796.

Philadelphia Prices 1811
The Journeymen Cabinet and Chair Makers' Pennsylvania Book of Prices. Philadelphia: The Society of Journeymen Cabinet and Chair Makers, 1811.

Philadelphia Prices 1828
The Philadelphia Cabinet and Chair Makers' Union Book of Prices for Manufacturing Cabinet Ware. Philadelphia: William Stavely, 1828.

Phillips 1987
Twentieth Century Furniture and Related Decorative Arts. Auction catalogue. New York: Phillips, November 24, 1987.

Phillips 1989
Phillips, Lisa. *Frederick Kiesler*. Exhibition catalogue. New York: Whitney Museum of American Art, 1989.

Phyfe 1847
Peremptory and Extensive Auction Sale of Splendid and Valuable Furniture . . . of Messers. Duncan Phyfe and Son. Auction catalogue. New York: Halliday and Jenkins, April 16–17, 1847.

Piranesi 1905
Coupes, Vases, Candélabres, Sarcophages, Trépieds, Lampes, et Ornements Divers Dessinés et Gravés par J.-B. Piranesi. Paris: Auguste Vincent, 1905.

Poesch 1983
Poesch, Jessie. *The Art of the Old South: Painting, Sculpture, Architecture, and the Products of Craftsmen, 1560–1860*. New York: Alfred A. Knopf, 1983.

Post 1923
Post, Emily. *Etiquette in Society, in Business, in Politics and at Home*. 9th ed. New York: Funk & Wagnalls, 1923.

Post 1930
———. *The Personality of a House*. New York: Funk & Wagnalls, 1930.

Prime 1929
Prime, Alfred Coxe. *The Arts and Crafts in Philadelphia, Maryland, and South Carolina, 1721–1785*. Topsfield, Massachusetts: The Walpole Society, 1929.

Prime 1932
———. *The Arts and Crafts in Philadelphia, Maryland, and South Carolina, 1786–1800*. Topsfield, Massachusetts: The Walpole Society, 1932.

Prown 1980
Prown, Jules D. "Style as Evidence." *Winterthur Portfolio* 15 (Fall 1980), pp. 197–210.

Quimby 1973
Quimby, Maureen O'Brian. "History in Houses: Eleutherian Mills in Greenville, Delaware." *Antiques* 103 (March 1973), pp. 550–60.

Ralston 1945
Ralston, Ruth. "The Style Antique in Furniture II: Its American Manifestations and Their Prototypes." *Antiques* 48 (October 1945), pp. 206–09, 220–23.

Randall 1962
Randall, Richard H., Jr. "Works of Boston Cabinetmakers, 1795–1825: Part II." *Antiques* 81 (April 1962), pp. 412–15.

Randall 1963
———. "Sources of the Empire Style." *Antiques* 83 (April 1963), pp. 452–53.

Randall 1965
———. *American Furniture in the Museum of Fine Arts, Boston*. Boston: Museum of Fine Arts, 1965.

Reifsnyder 1929
Colonial Furniture: The Superb Collection of the Late Howard Reifsnyder. Auction catalogue. New York: American Art Association, April 24–27, 1929.

Revere
Revere, Paul, II. Waste and Memoranda Book, 1783–97. Revere Family Papers, Massachusetts Historical Society, Boston.

Reynolds 1930
Reynolds, Grace. *Decorating Your Home*. 2nd. ed. New York: Bigelow-Sanford Carpet Company, 1930.

Rhode Island 1965
The John Brown House Loan Exhibition of Rhode Island Furniture. Exhibition catalogue. Providence: The Rhode Island Historical Society, 1965.

Rice 1962
Rice, Norman S. *New York Furniture in the Collection of the Albany Institute of History and Art*. Albany, New York: Albany Institute of History and Art, 1962.

Richardson 1929
Richardson, Leslie. "An Early Connecticut Interior." *Antiques* 16 (December 1929), pp. 500–01.

"Richmond Hill" 1927
"The Furnishings of Richmond Hill in 1797: The Home of Aaron Burr in New York City." *Quarterly Bulletin of The New-York Historical Society* 11 (April 1927), pp. 17–23.

Richter 1966
Richter, Gisela M.A. *The Furniture of the Greeks, Etruscans, and Romans*. London: Phaidon Press, 1966.

Rieder 1984
Rieder, William. *France 1700–1800* (Guides to European Decorative Arts, 3). Philadelphia: Philadelphia Museum of Art, 1984.

Rijksmuseum 1952
Catalogus van Meubelen en Betimmeringen. Amsterdam: Rijksmuseum, 1952.

Ring 1980
Ring, Betty. "Peter Grinnell and Son: Merchant-Craftsmen of Providence, Rhode Island." *Antiques* 117 (January 1980), pp. 212–20.

Ring 1981
———. "Check List of Looking-Glass and Frame Makers and Merchants Known by Their Labels." *Antiques* 119 (May 1981), pp. 1178–95.

Robie 1916
Robie, Virginia. *The Quest of the Quaint*. Boston: Little, Brown, 1916.

Roche/Courage/Devinoy 1985
Roche, Serge, Germain Courage, and Pierre Devinoy. *Mirrors*. Transl. Colin Duckworth and Angus Munro. New York: Rizzoli International Publications, 1985.

Rodriguez Roque 1984
Rodriguez Roque, Oswaldo. *American Furniture at Chipstone*. Madison, Wisconsin: University of Wisconsin Press, 1984.

Rogers 1931
Rogers, Meyric R. "The American Rooms." *Bulletin of the City Art Museum of St. Louis* 16 (October 1931), pp. 42–61.

Rogers 1960
———. "Garvan Furniture at Yale." *Connoisseur Year Book 1960*, pp. 52–63.

Rogers 1962a
———. "The Mabel Brady Garvan Collection of Furniture." *Yale Alumni Magazine* 25 (January 1962), pp. 4–15.

Rogers 1962b
Rogers, Kate Ellen. *The Modern House, U.S.A.: Its Design and Decoration.* New York and Evanston: Harper and Row, 1962.

Rogers/Fales 1961
Rogers, Meyric R., and Martha Gandy Fales. "George Shipley: His Furniture and His Label. A Set of Side Chairs, a Classical Sideboard." *Antiques* 79 (April 1961), pp. 374–75.

Rokoko 1961
Rokoko: Udstilling af Møbler og Kunstgenstande. Exhibition catalogue. Copenhagen: Ole Haslunds Hus, 1961.

Rothstein 1987
Rothstein, Natalie, ed. *A Lady of Fashion: Barbara Johnson's Album of Styles and Fabrics.* London: Thames and Hudson, 1987.

Rumford 1980
Rumford, Beatrix T. "Uncommon Art of the Common People: A Review of Trends in the Collecting and Exhibiting of American Folk Art." In *Perspectives on American Folk Art.* Eds. Ian M.G. Quimby and Scott T. Swank. New York: W.W. Norton and Company, 1980.

Russell 1986
Russell, Frank, ed. *Mies van der Rohe: European Works.* London: Academy Editions, 1986.

Rutherford 1983
Rutherford, Jessica. *Art Nouveau, Art Deco, and the Thirties: The Furniture Collections at Brighton Museum.* Brighton, England: The Royal Pavilion, Art Gallery and Museums, 1983.

Rutt 1948
Rutt, Anna H. *Home Furnishing.* 2nd ed. New York: John Wiley & Sons, 1948.

Saarinen 1962
Saarinen, Aline, ed. *Eero Saarinen on His Work.* New Haven and London: Yale University Press, 1962.

Sack 1948
Sack, Albert. "Good, Better, Best in American Eighteenth-Century Furniture." *Antiques* 54 (December 1948), pp. 420–23.

Sack 1950
———. *Fine Points of Furniture: Early American.* New York: Crown Publishers, 1950.

Sack 1985
Sack, Harold. "Authenticating American Eighteenth-Century Furniture." *Antiques* 127 (May 1985), pp. 1121–33.

Sack 1987a
Sack, Albert. "Regionalism in Early American Tea Tables." *Antiques* 131 (January 1987), pp. 248–63.

Sack 1987b
Sack, Harold. "The Furniture [in the Department of State]." *Antiques* 132 (July 1987), pp. 160–73.

Sack Collection
American Antiques from Israel Sack Collection. 9 vols. Washington, D.C. (vols. 1–6) and Alexandria, Virginia (vols. 7–9): Highland House Publishers, 1976–90.

St. George 1979
St. George, Robert Blair. *The Wrought Covenant: Source Material for the Study of Craftsmen and Community in Southeastern New England, 1620–1700.* Exhibition catalogue. Brockton, Massachusetts: Brockton Art Center—Fuller Memorial, 1979.

Sale 1927
Sale, Edith Tunis. *Interiors of Virginia Houses of Colonial Times.* Richmond, Virginia: William Byrd Press, 1927.

Salem 1916
Vital Records of Salem, Massachusetts to the End of the Year 1849: Volume 1—Births. Salem, Massachusetts: The Essex Institute, 1916.

Salem 1924
Vital Records of Salem, Massachusetts to the End of the Year 1849: Volume 3—Marriages. Salem, Massachusetts: The Essex Institute, 1924.

Salem 1925
Vital Records of Salem, Massachusetts to the End of the Year 1849: Volume 5—Deaths. Salem, Massachusetts: The Essex Institute, 1925.

Sanchez 1980
Sanchez, Léopold Diego. *Jean-Michel Frank; Adolphe Chanaux.* Transl. John D. Edwards. Paris: Éditions du Regard, 1980.

Sander 1982
Sander, Penny J., ed. *Elegant Embellishments: Furnishings from New England Homes, 1660–1860.* Exhibition catalogue. Boston: The Society for the Preservation of New England Antiquities, 1982.

Sands 1983
Sands, Gordon E. "The Osborn Furniture: Modern Decorative Arts and the Department Store." *The Decorative Arts Society Newsletter* 9 (September 1983), pp. 1–10.

Santore 1981
Santore, Charles. *The Windsor Style in America.* Ed. Thomas M. Voss. Philadelphia: Running Press, 1981.

Sargent 1926
Sargent, Charles Sprague. *Manual of the Trees of North America.* 2nd ed. Boston: 1926; Reprint, 2 vols. New York: Dover Publications, 1961.

Sartorio 1925
Sartorio, Enrico. "Concerning Italian Renaissance Furniture." *Antiques* 7 (April 1925), pp. 203–06.

Scherer 1984
Scherer, John L. *New York Furniture at the New York State Museum.* Alexandria, Virginia: Highland House Publishers, 1984.

Schiffer 1966
Schiffer, Margaret B. *Furniture and Its Makers of Chester County, Pennsylvania.* Philadelphia: University of Pennsylvania Press, 1966.

Schiffer 1974
———. *Chester County, Pennsylvania, Inventories 1684–1850.* Exton, Pennsylvania: Schiffer Publishing, 1974.

Schiffer 1983
Schiffer, Herbert F. *The Mirror Book: English, American, & European.* Exton, Pennsylvania: Schiffer Publishing, 1983.

Schiffer/Schiffer 1972
———, and Peter B. Schiffer. *Miniature Antique Furniture.* Wynnewood, Pennsylvania: Livingston Publishing, 1972.

Schoenfeld 1960
Schoenfeld, Morton. *Newlyweds' Furniture Handbook.* New York: Crown Publishers, 1960.

Schwartz 1968
Schwartz, Marvin D. *American Interiors, 1675–1885: A Guide to the American Period Rooms in The Brooklyn Museum.* Brooklyn, New York: The Brooklyn Museum, 1968.

Schwartz 1989
———. "John Meads: Albany Cabinetmaker." *Antiques and the Arts Weekly,* August 18, 1989, pp. 1, 60–61.

Scott 1979
Scott, G.W.. Jr. "Lancaster and Other Pennsylvania Furniture." *Antiques* 115 (May 1979), pp. 984–93.

SCPR
Suffolk County Probate Records, 1636–1860. Massachusetts State Archives, Boston.

Scudder 1877
Scudder, H.E., ed. *Recollections of Samuel Breck with Passages from His Note-Books.* Philadelphia: Porter and Coates, 1877.

Seymour 1958
George Dudley Seymour's Furniture Collection in The Connecticut Historical Society. Hartford, Connecticut: The Connecticut Historical Society, 1958.

Shackleton/Shackleton 1913
Shackleton, Robert, and Elizabeth Shackleton. *The Quest of the Colonial*. New York: The Century Company, 1913.

Sheraton 1793
Sheraton, Thomas. *The Cabinet-Maker and Upholsterer's Drawing-Book*. London: T. Bensley, 1793.

Sheraton 1802
———. *Appendix to the Cabinet-Maker and Upholsterer's Drawing-Book*. 3rd ed. London: T. Bensley, 1802.

Sheraton 1803
———. *The Cabinet Dictionary*. London: W. Smith, 1803.

Shettleworth 1974
Shettleworth, Earle G. "The Radford Brothers: Portland Cabinetmakers of the Federal Period." *Antiques* 106 (August 1974), pp. 285–89.

Sikes 1976
Sikes, Jane E. *The Furniture Makers of Cincinnati, 1790–1849*. Cincinnati: Privately printed, 1976.

Simons 1929
Simons, H.A. "Building and Equipping Your Home." *Arts and Decoration* 31 (June 1929), pp. 76, 78, 90, 104.

Singleton 1900–01
Singleton, Esther. *The Furniture of Our Forefathers*. 2 vols. New York: Doubleday, Page and Company, 1900–01.

Singleton 1902
———. *Social New York Under the Georges, 1714–1776*. New York: D. Appleton and Company, 1902.

Sironen 1936
Sironen, Marta K. *A History of American Furniture*. East Stroudsburg, Pennsylvania, and New York: Towse Publishing, 1936.

Sizer 1930
Sizer, Theodore. "The Mabel Brady Garvan Collection of American Arts and Crafts." *Bulletin of the Associates in Fine Arts at Yale University* 4 (December 1930), pp. 109–11.

Skinner 1984
Fine Americana. Auction catalogue. Bolton, Massachusetts: Robert W. Skinner, March 30, 1984.

Skinner 1987
Fine Americana. Auction catalogue. Bolton, Massachusetts: Robert W. Skinner, January 2, 1987.

Skinner 1989
Americana. Auction catalogue. Bolton, Massachusetts: Robert W. Skinner, January 14, 1989.

Skinner 1991
Americana. Auction catalogue. Bolton, Massachusetts: Skinner, Inc., January 12, 1991.

Sloane 1987
Sloane, Jeanne Vibert. "A Duncan Phyfe Bill and the Furniture It Documents." *Antiques* 131 (May 1987), pp. 1106–13.

Smith 1808
Smith, George. *A Collection of Designs for Household Furniture and Interior Decoration*. London: J. Taylor, 1808.

Smith 1854
Smith, John Jay, comp. *Letters of Doctor Richard Hill and His Children*. Philadelphia: Privately printed, 1854.

Smith 1973
Smith, Robert C. "The Furniture of Anthony G. Quervelle, Part III: The Worktables." *Antiques* 104 (August 1973), pp. 260–68.

Smith 1976
———. "Architecture and Sculpture in Nineteenth-Century Mirror Frames." *Antiques* 109 (February 1976), pp. 350–59.

Smith 1979
Smith, Michael O. "North Carolina Furniture, 1700–1900." *Antiques* 115 (June 1979), pp. 1266–77.

Sotheby's 1973a
Americana Week. Auction catalogue. New York: Sotheby Parke Bernet, January 24–27, 1973.

Sotheby's 1973b
Americana: Important Queen Anne, Chippendale and Federal Furniture. Auction catalogue. New York: Sotheby Parke Bernet, May 16–19, 1973.

Sotheby's 1974
Americana. Auction catalogue. New York: Sotheby Parke Bernet, January 24–26, 1974.

Sotheby's 1977
Fine Americana. Auction catalogue. New York: Sotheby Parke Bernet, January 26–29, 1977.

Sotheby's 1979
Fine Americana. Auction catalogue. New York: Sotheby Parke Bernet, January 31–February 3, 1979.

Sotheby's 1983
Fine American Furniture, Silver, Folk Art, and Related Decorative Arts. Auction catalogue. New York: Sotheby's, June 30–July 1, 1983.

Sotheby's 1986a
Important Americana. Auction catalogue. New York: Sotheby's, January 30–February 1, 1986.

Sotheby's 1986b
Fine American Furniture, Folk Art, Folk Paintings and Silver. Auction catalogue. New York: Sotheby's, June 26, 1986.

Sotheby's 1988a
Important Americana Including Furniture, Folk Art, Quilts, Paintings, Prints and Silver. Auction catalogue. New York: Sotheby's, January 28–30, 1988.

Sotheby's 1988b
Important American Furniture, Folk Art, Folk Paintings and Silver. Auction catalogue. New York: Sotheby's, October 22, 1988.

Sotheby's 1989
Important American Furniture and Folk Art. Auction catalogue. New York: Sotheby's, October 14, 1989.

Sotheby's 1990a
Important Americana. Auction catalogue. New York: Sotheby's, January 24–27, 1990.

Sotheby's 1990b
19th Century Furniture, Decorations, and Works of Art. Auction catalogue. New York: Sotheby's, September 19, 1990.

"Southern Table" 1925
"A Rare Southern Table." *Antiques* 8 (July 1925), p. 12.

Spear 1961
Spear, Dorothea N. *Bibliography of American Directories Through 1860*. Worcester, Massachusetts: American Antiquarian Society, 1961.

SPNEA
The Society for the Preservation of New England Antiquities, Boston.

Sprackling 1929
Sprackling, Helen. "The Growing Use of Metal in Decorative Art." *The House Beautiful* 66 (September 1929), pp. 264–66, 309, 312.

Sprackling 1930
———. "An Apartment in the Twentieth-Century Manner." *The House Beautiful* 68 (November 1930), pp. 484–86, 528–30.

Sprague 1987
Sprague, Laura Fecych, ed. *Agreeable Situations: Society, Commerce, and Art in Southern Maine, 1780–1830*. Exhibition catalogue. Kennebunk, Maine: The Brick Store Museum, 1987.

Springfield 1985
Albert Paley: The Art of Metal. Exhibition catalogue. Springfield, Massachusetts: Museum of Fine Arts, 1985.

Springfield Directory
Springfield Directory, including Chicopee

and West Springfield. Springfield, Massachusetts: The Price and Lee Company, 1892–1904.

Stamford Directory
Stamford, Darien, Noroton, Noroton Heights, New Canaan Directory (1941–43); *Stamford Directory* (1944–62). New Haven: The Price and Lee Company.

Stamm 1986
Stamm, Richard. "Victorian Mechanical Tables." *The Victorian* 14 (Summer 1986), pp. 8–9.

Stein 1931
Stein, Aaron Mark. "English and American Furniture in the Collection of Mr. and Mrs. Richard de Wolfe Brixey." *The Fine Arts* 18 (December 1931), pp. 35–42.

Stevenson 1921
Stevenson, Edward Luther. *Terrestrial and Celestial Globes*. New Haven: Yale University Press, 1921.

Stickley 1909
Catalogue of Craftsman Furniture Made by Gustav Stickley at the Craftsman Workshops. Eastwood, New York: Gustav Stickley, 1909.

Stickley 1910
Catalogue of Craftsman Furniture Made by Gustav Stickley at the Craftsman Workshops. Eastwood, New York: Gustav Stickley, 1910.

Stiles 1895
Stiles, Henry Reed. *The Stiles Family in America: Genealogies of the Connecticut Family*. Jersey City, New Jersey: Doan and Pilson, 1895.

Stillinger 1980
Stillinger, Elizabeth. *The Antiquers*. New York: Alfred A. Knopf, 1980.

Stillinger 1988
———. "Ernest Hagen—Furniture Maker." *Maine Antique Digest* 16 (November 1988), pp. 8D–16D.

Stoneman 1959
Stoneman, Vernon C. *John and Thomas Seymour: Cabinetmakers in Boston, 1794–1816*. Boston: Special Publications, 1959.

Stoneman 1965
———. *A Supplement to John and Thomas Seymour: Cabinetmakers in Boston, 1794–1816*. Boston: Special Publications, 1965.

Storey 1945
Storey, Walter Rendell. *Furnishing With Color*. New York and London: The Studio Publications, 1945.

Stow 1930
Stow, Charles Messer. "This Country Needs Collectors, Is Opinion of Francis P. Garvan." *The New York Sun*, July 26, 1930, p. 6.

Strickland 1976
Strickland, Peter L.L. "Documented Philadelphia Looking Glasses, 1800–1850." *Antiques* 109 (April 1976), pp. 784–94.

Swan 1929
Swan, Mabel M. "The Man Who Made Simon Willard's Clock Cases: John Doggett of Roxbury." *Antiques* 15 (March 1929), pp. 196–200.

Swan 1931
———. "Where Elias Hasket Derby Bought His Furniture." *Antiques* 20 (November 1931), pp. 280–82.

Swan 1934
———. *Samuel McIntire, Carver, and the Sandersons, Early Salem Cabinet Makers*. Salem, Massachusetts: The Essex Institute, 1934.

Swan 1937
———. "John Seymour and Son, Cabinetmakers." *Antiques* 32 (October 1937), pp. 176–79.

Swan 1953
———. "American Slab Tables." *Antiques* 63 (January 1953), pp. 40–43.

Swan 1954
———. "General Stephen Badlam— Cabinet and Looking Glass Maker." *Antiques* 65 (May 1954), pp. 380–83.

Sweeney 1984
Sweeney, Kevin M. "Furniture and Furniture Making in Mid-Eighteenth-Century Wethersfield, Connecticut." *Antiques* 125 (May 1984), pp. 1156–63.

Symonds 1930
Symonds, R.W. "English Eagle and Dolphin Console Tables." *Antiques* 18 (October 1930), pp. 304–07.

Symonds 1935
———. "The English Export Trade in Furniture to Colonial America." *Antiques* 28 (October 1935), pp. 156–59.

Symonds 1955
———. *Furniture Making in Seventeenth and Eighteenth Century England*. London: The Connoisseur, 1955.

Talbott 1975
Talbott, Page. "Boston Empire Furniture: Part 1." *Antiques* 107 (May 1975), pp. 878–87.

Tatham 1799
Tatham, Charles Heathcote. *Etchings Representing the Best Examples of Ancient Ornamental Architecture*. London: The Author, 1799.

Taylor/Warren 1975
Taylor, Lonn, and David B. Warren. *Texas Furniture: The Cabinetmakers and Their Work, 1840–1880*. Austin, Texas: University of Texas Press, 1975.

Teal 1984
Teal, Alison. "This Avant-Garde Furniture Designer Thinks It's About Time the Tables were Turned." *The Denver Post, Empire Magazine*, June 10, 1984, p. 26.

Temple Newsam 1977
An Exhibition of Back-Stairs Furniture from Country Houses. Exhibition catalogue. Leeds, England: Temple Newsam, 1977.

Theus 1967
Theus, Mrs. Charlton M. *Savannah Furniture 1735–1825*. 1967.

Thornton 1978
Thornton, Peter. *Seventeenth-Century Interior Decoration in England, France and Holland*. New Haven and London: Yale University Press, 1978.

Thornton/Tomlin 1980
———, and Maurice Tomlin. "The Furnishing and Decoration of Ham House." *Furniture History* 16 (1980), pp. i–ix, 1–194.

Thorpe 1901
Thorpe, Sheldon B. *North Haven in the Nineteenth Century*. North Haven, Connecticut: Twentieth Century Committee, 1901.

Todd/Mortimer 1929
Todd, Dorothy, and Raymond Mortimer. *The New Interior Decoration*. New York: Charles Scribner's Sons, 1929.

Tracy 1961
Tracy, Berry B. "Nineteenth-Century American Furniture in the Collection of the Newark Museum." *The Museum* 13 (Fall 1961), pp. 1–23.

Tracy 1970
———. *19th-Century America: Furniture and Other Decorative Arts*. Exhibition catalogue. New York: The Metropolitan Museum of Art, 1970.

Tracy 1981
———. *Federal Furniture and Decorative Arts at Boscobel*. New York: Harry N. Abrams, 1981.

Tracy/Gerdts 1963
———, and William H. Gerdts. *Classical America 1815–1845*. Exhibition catalogue. Newark, New Jersey: The Newark Museum, 1963.

Tucker 1969
Tucker, Marcia. *American Paintings in the Ferdinand Howald Collection*. Columbus, Ohio: The Columbus Gallery of Fine Arts, 1969.

Untracht 1957
Untracht, Oppi. *Enameling on Metal.* New York: Greenberg, 1957.

Valhne 1986
Valhne, Bo, ed. *Möbelhistoria på Gripsholm.* Stockholm: Kungl. Husgerådskammaren, 1986.

Van Cott 1989
Van Cott, Margo C. "The Del Vecchios of New York." *Furniture History* 25 (1989), pp. 221–34.

Vandal 1990
Vandal, Norman. *Queen Anne Furniture: History, Design and Construction.* Newtown, Connecticut: The Taunton Press, 1990.

Van Liew 1910
Van Liew, Thomas Lillian. *Genealogy and Annals of the Van Liew Family in America from the Year 1670 Down to the Present Time.* Privately printed, 1910.

Van Ravenswaay 1958
Van Ravenswaay, Charles. "The Anglo-American Cabinetmakers of Missouri, 1800–1850." *Bulletin of the Missouri Historical Society* 14 (April 1958), pp. 251–57.

Venable 1989
Venable, Charles L. *American Furniture in the Bybee Collection.* Austin, Texas: University of Texas Press, 1989.

Victorian 1853
Blackie and Son. *The Victorian Cabinet-Maker's Assistant* (1853). Reprint, New York: Dover Publications, 1970.

Wadsworth 1985
The Great River: Art and Society in the Connecticut Valley, 1635–1820. Exhibition catalogue. Hartford, Connecticut: Wadsworth Atheneum, 1985.

Wainwright 1964
Wainwright, Nicholas B. *Colonial Grandeur in Philadelphia: The House and Furniture of General John Cadwalader.* Philadelphia: The Historical Society of Pennsylvania, 1964.

Wallick 1915
Wallick, Ekin. *Inexpensive Furnishings in Good Taste.* New York: Hearst's International Library Company, 1915.

Wallick 1916
———. *The Attractive Home.* Boston: The Carpenter-Morton Company, 1916.

Wansey 1798
Wansey, Henry. *An Excursion to the United States of North America, in the Summer of 1794.* 2nd ed. Salisbury, England: J. Easton, 1798.

Ward 1977
Ward, Gerald W.R., ed. *The Eye of the Beholder: Fakes, Replicas and Alterations in American Art.* Exhibition catalogue. New Haven: Yale University Art Gallery, 1977.

Ward 1988
———. *American Case Furniture in the Mabel Brady Garvan and Other Collections at Yale University.* New Haven: Yale University Art Gallery, 1988.

Ward/Ward 1979
Ward, Barbara M., and Gerald W.R. Ward, eds. *Silver in American Life.* Exhibition catalogue. New York: American Federation of Arts, 1979.

Ward-Jackson 1958
Ward-Jackson, Peter. *English Furniture Designs of the Eighteenth Century.* London: Victoria and Albert Museum, 1958.

Warren 1975
Warren, David B. *Bayou Bend: American Furniture, Paintings, and Silver from the Bayou Bend Collection.* Houston: Museum of Fine Arts, 1975.

Watkins 1966
Watkins, Lura W. "Highfields and its Heritage." *Antiques* 90 (August 1966), pp. 204–07.

Watson 1830
Watson, John Fanning. *Annals of Philadelphia.* Philadelphia: E.L. Carey and A. Hart, 1830.

Watson 1966
Watson, F.J.B. *The Wrightsman Collection.* 2 vols. New York: The Metropolitan Museum of Art, 1966.

Watson 1973
———. *Louis XVI Furniture.* London: Academy Editions, 1973.

Wayland 1944
Wayland, John W. *The Washingtons and Their Homes.* Staunton, Virginia: McClure Printing Company, 1944.

Webber 1935
Webber, Mabel L. "The Thomas Elfe Account Book, 1769–1775." *South Carolina Historical and Genealogical Magazine* 36 (January 1935), pp. 7–13; (April 1935), pp. 56–66; (July 1935), pp. 79–88; (October 1935), pp. 122–33.

Webber 1938
———. "The Thomas Elfe Account Book, 1769–1775." *South Carolina Historical and Genealogical Magazine* 39 (January 1938), pp. 36–41; (April 1938), pp. 83–90; (July 1938), pp. 134–42; (October 1938), pp. 160–67.

Webber 1939
———. "The Thomas Elfe Account Book, 1769–1775." *South Carolina Historical and Genealogical Magazine* 40 (January 1939), pp. 21–27; (April 1939), pp. 58–63; (July 1939), pp. 81–86; (October 1939), pp. 145–50.

Weber 1985
Weber, Eva. *Art Deco in America.* Greenwich, Connecticut: Exeter Books, 1985.

Weidman 1984
Weidman, Gregory R. *Furniture in Maryland, 1740–1940: The Collection of the Maryland Historical Society.* Baltimore: Maryland Historical Society, 1984.

Weil 1932
Henry V. Weil Collection of Early American Furniture. Auction catalogue. New York: National Art Galleries, May 12–13, 1932.

Weil 1979
Weil, Martin Eli. "A Cabinetmaker's Price Book." *Winterthur Portfolio* 13 (1979), pp. 175–92.

Wenham 1928
Wenham, Edward. *The Collector's Guide to Furniture Design (English and American) from the Gothic to the Nineteenth Century.* New York: Collector's Press, 1928.

Werner
Werner, Charles J. "Painted [sic] by William Sydney [sic] Mount 1807–1868, Particularly His Portraits." Undated typescript. Thomas J. Watson Library, The Metropolitan Museum of Art, New York.

West 1956
West, Ben. "Master-Builder Alfons Bach." *Fairfield County Fair,* January 12, 1956, pp. 5–6.

White 1958
White, Margaret E. *Early Furniture Made in New Jersey 1690–1870.* Exhibition catalogue. Newark, New Jersey: The Newark Museum, 1958.

Whitehill/Fairbanks/Jobe 1974
Whitehill, Walter Muir, Jonathan L. Fairbanks, and Brock W. Jobe, eds. *Boston Furniture of the Eighteenth Century* (Publications of the Colonial Society of Massachusetts, 48). Boston: Colonial Society of Massachusetts, 1974.

Who's Who
Who's Who in American Art. Vols. 1–4, Washington, D.C.: American Federation for the Arts, 1936–47. Vols. 5–present, New York: R.R. Bowker Company, 1953–present.

Wilk 1981
Wilk, Christopher. *Marcel Breuer Furniture and Interiors.* New York: The Museum of Modern Art, 1981.

Willard 1911
Willard, John Ware. *Simon Willard and His Clocks* (1911). Reprint, New York: Dover Publications, 1968.

Williams/Jones 1878
Williams, Henry T., and Mrs. C.S. Jones. *Beautiful Homes; or, Hints in Home Furnishing*. New York: Henry T. Williams, 1878.

Williamsburg 1966
The Glen-Sanders Collection from Scotia, New York. Exhibition catalogue. Williamsburg, Virginia: Colonial Williamsburg, 1966.

Wills 1965
Wills, Geoffrey. *English Looking-Glasses: A Study of the Glass, Frames and Makers (1670–1820)*. South Brunswick and New York: A.S. Barnes, 1965.

Wilson/Pilgrim/Tashjian 1986
Wilson, Richard Guy, Dianne H. Pilgrim, and Dickran Tashjian. *The Machine Age in America 1918–1941*. Exhibition catalogue. New York: The Brooklyn Museum, 1986.

Wood 1968
Wood, Charles B. "Some Labeled English Looking Glasses." *Antiques* 93 (May 1968), pp. 647–49.

Wood/Burbank 1916
Wood, Grace, and Emily Burbank. *The Art of Interior Decoration*. New York: Dodd, Mead and Company, 1916.

Wright/Wright 1951
Wright, Mary, and Russel Wright. *Mary and Russel Wright's Guide to Easier Living*. New York: Simon and Schuster, 1951.

Yates 1989
Yates, Simon. *An Encyclopedia of Tables*. Secaucus, New Jersey: Wellfleet Press, 1989.

Yonge 1968
Yonge, Ena L. *A Catalogue of Early Globes Made Prior to 1850 and Conserved in the United States*. New York: American Geographical Society, 1968.

YUAGB
Yale University Art Gallery Bulletin (published 1926–57 as *Bulletin of the Associates in Fine Arts at Yale University*).

Zea 1985
Zea, Philip. "New England Furniture." *Antiques* 127 (March 1985), pp. 650–61.

Zimmerman 1988
Zimmerman, Philip D. "Regionalism in American Furniture Studies." In *Perspectives on American Furniture*. Ed. Gerald W.R. Ward. New York: W.W. Norton and Company, 1988.

Zwalf 1985
Zwalf, W., ed. *Buddhism: Art and Faith*. Exhibition catalogue. London: The British Museum, 1985.

Appendix F
Concordance
OF YALE UNIVERSITY
ART GALLERY
ACCESSION NUMBERS
AND
CATALOGUE NUMBERS

Accession	Cat.	Accession	Cat.
1930.498	7	1930.2252	20
1930.2002	119	1930.2255	22
1930.2004B	117	1930.2263	196
1930.2005	118	1930.2270	192
1930.2009	108	1930.2274	41
1930.2010	A25	1930.2314	101
1930.2024	112	1930.2380	A21
1930.2028	68	1930.2440	A10
1930.2041	133	1930.2456	A22
1930.2044	1	1930.2457	6
1930.2045	137	1930.2458	123
1930.2047	19	1930.2459	A9
1930.2048	33	1930.2460	A38
1930.2049	42	1930.2461	49
1930.2063	73	1930.2468	145
1930.2064	125	1930.2481	152
1930.2066A	A14	1930.2482	4
1930.2067	161	1930.2489	18
1930.2068	97	1930.2504	207
1930.2069	185	1930.2507	160
1930.2080	98	1930.2510	A35
1930.2081	110	1930.2511	105
1930.2082	50	1930.2517	A26
1930.2087	77	1930.2519	83
1930.2091	155	1930.2521	208
1930.2110	43	1930.2528	A2
1930.2113	158	1930.2532	A33
1930.2130	46	1930.2534	115
1930.2131	47	1930.2535	45
1930.2138	A41	1930.2536	2
1930.2141	205	1930.2537	170
1930.2142	A12	1930.2539	67
1930.2143	A32	1930.2540	141
1930.2151	104	1930.2576	206
1930.2155	113	1930.2577	A31
1930.2169	174	1930.2579	A39
1930.2181	31	1930.2580	21
1930.2223B	197	1930.2581	32
1930.2224	54	1930.2582	A40
1930.2225	126	1930.2583A	60
1930.2226	53	1930.2584	A42
1930.2243	171	1930.2586	34
1930.2244	A17	1930.2593	173
1930.2248	A24	1930.2597	100
1930.2249	A8	1930.2598	179

Accession	Cat.	Accession	Cat.	Accession	Cat.
1930.2599	A27	1952.50.2	29	1980.87.2	78
1930.2600	A5	1953.12.2	A36	1981.53.6	24
1930.2604	38	1953.50.9	A23	1981.71	82
1930.2605A	61	1954.37.26	127	1981.73.2	148
1930.2607	132	1957.52.1	71	1981.73.4	23
1930.2618	75	1957.52.2	A29	1981.82	85
1930.2620	56	1962.31.3	166	1982.94	37
1930.2628	76	1962.31.4	129	1982.109	39
1930.2650	A3	1962.31.5	193	1983.23	96
1930.2652	48	1962.31.7	130	1983.96	107
1930.2654	150	1962.31.10	A4	1983.111	25
1930.2657	204	1962.31.12	194	1984.14.5	26
1930.2659	151	1962.31.20	72	1984.32.33	109
1930.2661	12	1962.31.21	A13	1984.32.34	55
1930.2662	186	1962.31.23	124	1984.32.36	131
1930.2679	153	1962.31.28	163	1984.32.38	159
1930.2686	11	1962.31.31	172	1984.101.1	65
1930.2692A	A7	1962.31.32	175	1984.101.2	95
1930.2694	146	1962.31.34	169	1984.102	116
1930.2700	84	1962.32.100	154	1984.109	A37
1930.2713	62	1963.5	28	1985.114.4	142
1930.2717	44	1965.117	121	1986.19.1	149
1930.2718	79	1966.64	87	1986.64.1	16
1930.2719	A43	1966.76	195	1986.113.1	91
1930.2720A	200	1966.127	120	1986.113.2	92
1930.2722	A16	1966.165	63	1986.115.2	203
1930.2725A	182	1967.29	57	1986.140.2	209
1930.2734	A6	1969.42.3	36	1987.2.1	10
1930.2763	30	1969.42.4	122	1987.2.2	58
1930.2776	114	1969.42.8	70	1987.2.3	189
1930.2777	99	1969.42.12	51	1987.2.4	198
1930.2784	178	1969.44.2	190	1987.46.1	134
1930.2794	201	1969.44.4	184	1987.46.2	199
1930.2998	A11	1971.126	9	1987.84.15	139
1931.312	147	1972.10	5	1989.35.1	64
1931.316	180	1972.78.1	136	1989.57.1	183
1931.1215	A34	1972.113	165	1989.57.2	191
1931.1217	164	1972.139	138	1989.57.3	176
1931.1234	88	1973.123.1	135	1989.57.4	187
1931.1238	157	1974.64.1	14	1989.66.1	210
1931.2207	59	1974.64.3	35	1989.93.1	27
1934.401B	102	1974.118.1	94	1990.3.1	17
1936.306	162	1975.4.1	3	1990.29.1	202
1936.308	74	1975.111	A18	1990.29.2	144
1936.311	86	1975.124.2	A19		
1936.414	69	1976.99.2	143		
1942.263	A1	1976.121	89		
1946.2B	A15	1977.40.4	15		
1946.3B	103	1977.40.5	140		
1946.16	66	1977.40.6	52		
1946.403	181	1977.135	156		
1946.405A	177	1977.183.1	93		
1949.172	A28	1977.183.2	106		
1949.246	A20	1978.129.1	80		
1950.695	40	1978.129.2	81		
1950.707	A30	1979.49	8		
1950.718	167	1979.103.1	111		
1950.719	168	1980.87.1	90		

Index

Entries in italics refer to illustrations.

Aalto, Alvar, 97: tea trolley, 271–72
Abramson, Ronald and Anne (collectors), 365
Ackermann, Rudolph (designer), 315, 362
Adam, Robert (designer), 158, 314
Adams, John, 32
Adams, Lemuel (cabinetmaker), 32, 304–05, 314
Adams, Nehemiah (cabinetmaker), 274, 279
Adams, Samuel (cabinetmaker), 204
Adams Family, The, 19
Affleck, Thomas (cabinetmaker), 82, 164, 173
Albany, NY: tea table, 90–91; pembroke table, 151; work table, 282
Albany (NY) Institute of History and Art: related example in, 118
Albemarle Sound region, NC: falling-leaf table in, 124
Alder: as primary wood, 321
Aldersey, Thomas: looking glass, 308–10, 312, 316
Aldrich, Malcolm P. (donor), 242
Alexander, William (cabinetmaker): sideboard, 29
Alexander House (Springfield, MA): related example in, 332
Allen, Ezra (owner), 240
Allen, Lucy Clark (author), 35
Allerton family (owners), 116
Allison, Michael (cabinetmaker), 151, 158, 161, 217
Allvine, Glendon and Louise (owners), 88
Allyn family (owners), 103
Altered furniture, 568–73
Aluminum: as primary material, 79, 88
Amenia, NY: card table in, 176
American Art Galleries: exhibition, 201, 222, 375
American Federation of Arts: exhibition, 236
American Woman's Home, The (Beecher and Stowe), 19
Anderson, Elbert (cabinetmaker), 149
Anderson, Samuel (cabinetmaker), 293
Andover, MA: pembroke table in, 154
Andruss, Mary S. (owner), 374
Annapolis, MD: sideboard table, 80–82; pembroke table, 156; looking glass in, 316; pier table in, 366–67; card table in, 376
Anne, Queen, 354

Anne Humphreys with Her Daughter Eliza (Brunton), 32, *33*
Annesley, Lawson (craftsman), 32
Annin, Mary Miller (owner), 302
Anonymous donors, 151, 379
Anthony, Eliza (table decorator), 83
Antiques, 124
Antrim, NH: card tables, 176–79
Apollo (god), 336
Appleton, Nathaniel (cabinetmaker), 279
Archdeacon, Charles Q. (guardian), 262
Architecture of Country Houses, The (Downing), 27, 364
Archives of American Art, 389, 391
Arkell, Peter (restorer), 79, 92, 111, 116, 131, 145, 156, 162, 167, 169, 172, 179, 185, 186, 188, 197, 204, 212, 219, 220, 236, 242, 252, 255, 260, 264, 278, 282, 284, 286, 309, 310, 349
Arons, George and Benjamin (dealers), 151
Arons, Harry (dealer), 127, 128, 194, 279, 305; address, 391
Art Institute of Chicago: related example in, 73; exhibition, 373
Art of Decorative Design, The (Dresser), 264
Ash: as primary wood, 104, 227; as secondary wood, 112, 156, 158, 176, 221, 231, 250
Ashcraft, Norman (writer), 18
Ashley, Jonathan and Dorothy (owners), 136
Asquam, Lake, NH: table in, 73
Athol, MA: card table, 179–80
"Audley" (Clarke County, VA, house), 247
Augusta, ME: looking glass in, 303
Ayer, Fred Wellington (collector), 136, 197, 225

Bach, Alfons: end table, 95–96, 135
Bachman, Johannes (cabinetmaker), 101
Badlam, Stephen, Sr. (cabinetmaker), 190, 192, 205
Baker, Barnard (looking-glass maker), 357
Baker, Hollis S. (manufacturer), 100
Baker Furniture: cocktail table, 98–100
Baldcypress: as secondary wood, 104, 108
Ball and Ball (manufacturers), 284, 360
Ballin, Claude (designer), 229
Baltimore, MD: pembroke tables, 153–55, 162–63; dining table, 369; pier table in, 366
Baltimore (MD) Museum of Art: exhibition, 82, 375
Bangor, ME, 241: dining table in, 136; card tables in, 197, 225
Banks, John (cabinetmaker), 225
Bardwell, Anderson, and Company (manufacturer), 252
Barnard, Samuel: card tables, 188–91, 192
Barnes, Alfred (collector), 267
Barrell, Joseph (owner), 34
Barrett, Louise (dealer), 220; address, 391
Barry, Joseph (cabinetmaker), 147

Barstow, John and Betsey (owners), 145
Bartels, Mr. and Mrs. Henry E. (donors), 196
Bartlett, Dr. Josiah (owner), 182
Bartlett family (owners), 230
Bartram family (owners), 122
Barzillai Hudson (Wentworth), 74, *75*
Basin stands: history, 267–68; examples, *268,* 269–71
Basswood: as primary wood, 82, 367, 378; as secondary wood, 116, 141, 186, 376
Bath (ME) Female Academy, 277, 282
Baudouine, Charles (cabinetmaker), 111, 275
Bauduy, Ferdinand (owner), 287
Bauhaus, 96
Baumstone, Teina (dealer), 373
Bay, red: as primary wood, 108
Bayard, William (owner), 220, 268
Bayou Bend Collection (Houston): related example in, 169, 305–06
Beach, Clementina (teacher), 262
Beal, Jack (artist), 267
Beale, Gustavus (cabinetmaker), 158
Beard, J.K. (dealer), 69, 91, 105; address, 391
Beaujour, Felix de (writer), 32
Beech: as primary wood, 126, 378; as secondary wood, 213, 375, 377, 379
Beecher, Catharine E. (author), *19,* 31
Beeken, Bruce (cabinetmaker), 271
Beekman family (owners), 90, 142
Behaim, Martin, 262
Belknap, Waldron Phoenix (donor), 379
Bell, Isaac (owner), 220
Bembe, Anthony (cabinetmaker), 111
Bembe, Carl (cabinetmaker), 111
Bendell, Freegrace (owner), 103–04
Benkard, Harry H. and Bertha (collectors), 247, 289
Bennett, Polly (owner), 28
Bent and Brothers (manufacturers): side chairs, 77
Berlin, MA: communion table, 84
Bernarda, John, 305, 327: looking glass, 328
Berry, Morris (collector), 312
Besson, Jacques (designer), 254
Beverly, MA: tea tables, 90
Biddle, Charles, Jr. (merchant), 316
Bigelow, Francis Hill (owner), 278
Billard, J. (merchant), 339
Billings, John (owner), 28
Bingham, Joseph (owner), 34
Bingham, Millicent Todd (donor), 112, 133, 162, 231, 330, 336; biography, 389
Birch: as primary wood, 76, 82, 102, 107, 127, 178, 260, 271, 320, 328, 381; as secondary wood, 73, 79, 128, 176, 180, 182, 183, 186, 191, 197, 198, 205, 250, 264, 284; veneer, 197, 240
Bishop, Abraham (donor), 142–44
Bivins, John (author), 70, 105, 124–26
Bjerkoe, Ethel Hall (author), 196
Black Monday (Jones), *15*
Black, John L. (collector), 379

Blanchard, Ephraim (cabinetmaker), 163
Block Island, RI; bridge table in, 257
Block Island (RI) Exchange (dealer), 257
Bond, Lewis (cabinetmaker), 28
Bongianni, Umberto (restorer), 198
Bonnell, Albert (cabinetmaker), 284
Boott, Kirk (owner), 324
Bordley, James (owner), 236
Boscobel (Garrison, NY, house): related
 example in, 117
Bosley, James (owner), 362
Boston, MA: pier tables, 80, 82–83; table
 with drawer, 102–04; falling–leaf table,
 119–20; corner table, 138–40; card tables,
 165–66, 180–82, 192–205; looking glasses,
 326–27, 306–07, 331–32; tea table, 368;
 card table in, 185, stand in, 241
Bourgeault, Ronald (auctioneer), 190
Bouy, Jules (designer), 88
Bowan, Jonathan (owner), 147
Bowdoin College Museum of Art, related
 example in, 332
Bowdoin family (owners), 120
Bowes, William (merchant), 309
Bowman, Jonathan (owner), 310
Bowne, Eliza Southgate (author), 34
Box on stand, 377
Boyse, Antipas (owner), 101, 104, 119
Bracket, Richard (owner), 138
Bradlee, Samuel (looking-glass maker), 306
Bradley, Clara E. (owner), 304
Brady, Matthew, 26
Brandt, Edgar (ironworker), 88
Branson, William (joiner), 296
Brantly family (owners), 124
Brass: as primary material, 351
Bray and Bailey (merchants), 297
Brazer, C.W. (author), 360
Braznell, Mr. and Mrs. W. Scott (donors), 257
Breakfast tables, 133, 163. See also Pembroke
 tables
Breese, Sidney (merchant), 27, 294
Breuer, Marcel (designer), 96, 98, 271
Bridge table, 257–58
Bridgens, Richard (designer), 111
Bridgeport, CT: dining tables in, 146
Briggs (cartoonist), 258
Briggs, Cornelius (manufacturer), 250, 251
Briggs, Eliphalet, Jr.: card table, 175–76, 198
Bright, George (cabinetmaker), 138, 147, 148
Brighton, England: Royal Pavilion, 83
Brinckerhoff, James Lefferts (owner), 147,
 161, 220
British Architect, The (Swan), 311
Brixey, Doris M. (donor), 138, 213, 244, 285;
 biography, 389
Brixey, Richard de Wolfe (owner), 140, 389
Brockwell, Mrs. J.L. (dealer), 122, 124;
 address, 391
Bronxville, NY: 134, 390
Brown, James, House, 26

Brown, John (owner), 27, 33, 34
Brown, Richard (designer), 74, 336, 362
Bruce Museum (Greenwich, CT): exhibition,
 373, 375
Brunschwig and Fils (textile manufacturers),
 278
Brunton, Richard (artist), 32, 33
Budd, John (cabinetmaker), 284
Buffalo, NY: tea table in, 96–97
Buffalo (NY) Fine Arts Academy: exhibition,
 96
Buffet table, 88–89
Bull, C. Sanford (donor), 104, 185, 230, 373,
 374
Bull, Edward (supplier), 84
Burd, Edward (owner), 84, 173
Burkhart, J. and F. (cabinetmakers), 227
Burling, Thomas (cabinetmaker), 235
Burr, Aaron, 102, 148
Burroughs, Paul H. (author), 124
Burton, Milby (author), 109
Bushnell family (owners), 314
Butler, John A. (looking-glass maker), 306,
 323
Butterfly table (term), 126. See Falling-leaf
 tables: pivot supports
Butternut: as secondary wood, 77
Byrd, William, 32, 90

Cabinet, earring, 365
Cabinet Dictionary (Sheraton), 14, 294, 299,
 305, 327
Cabinet–Maker and Upholsterer's Drawing-
 Book, The (Sheraton), 180–82, 275, 291,
 324, 362
Cabinet–Maker and Upholsterer's Guide, The
 (Hepplewhite), 318, 319
Cabinet Makers' Assistant (Hall), 79
Cabinetmakers of America, The (Bjerkoe), 196
Cadwalader, John (owner), 164, 361
Cadwalader family (owners), 80, 296, 379
Cady and Company, J.C. (architects), 252
Caldwell, John: card table, 174–75
Caldwell, Josiah (cabinetmaker), 175
Cambridge, MA: snake table, 100–01; work
 table in, 278
Camden, SC: table in, 70
Camp, Frank and Gertrude (dealers), 280,
 360
Camp, William (cabinetmaker), 250
"Camp Waialva" (Lake Asquam. NH, house),
 73
Campbell, Douglas A. (owner), 282
Canadian Craft Council Gallery (Saskatoon,
 Saskatchewan): exhibition, 101
Cardboard: as secondary material, 112
Card tables: with drawers, 116–17; Colonial,
 164–73; Federal, 173–216; pil-
 lar–and–claw, 216–20; swivel–top,
 220–31; bridge, 257–58; altered and
 restored, 369–70; constructed from old
 parts, 375–76; diagram, 384

Card Tables (Terry after Sheraton), 181
Careless Maria, 31
Carey, Frances Wolfe (dealer), 214, 247;
 address, 391
Carlin, Martin (cabinetmaker), 255, 274
Carmichael, Mrs. Ray (owner), 208
Carmick, Stephen (merchant), 361
Carnegie Museum of Art, Pittsburgh: related
 example in, 138
Caroline County, MD: falling–leaf table in,
 124
Carroll, A.E. (dealer), 380, 381; address, 391
Carroll, Charles (owner), 30, 80, 297
Carts: history, 271; types, 271–74
Castle, Wendell (woodworker), 253
Catawissa, PA: pembroke table, 130–31
Caylus, Comte de (author), 222
Cecil County, MD: falling–leaf table in, 122
Center table, 77–79
Cermenati, Barnard (looking-glass maker),
 327, 331
Cermenati, Paul, 296, 305: looking glasses,
 326–29
Cermenati and Bernarda, 305, 327, 330, 341:
 looking glass, 328
Cermenati and Monfrino, 306: looking glass,
 326–27
Chair, side, 261
Chambers, Sir William (designer), 323
Champion Slacks advertisement, 16, 18
Chapin, Eliphalet (cabinetmaker), 130
Chapman family (owners), 216
Charles F. Montgomery Collection, 315–16,
 528, 333–36, 337–38. See also Montgom-
 ery, Mr. and Mrs. Charles F.
Charlestown, MA: card table, 191–92
Charleston, SC: table with drawer, 108–09;
 falling–leaf table, 124–26; pembroke tables
 in, 130
Charleston (SC) Auction and Sales Company,
 108–09
Chase family (owners), 247
Chauchet–Guilleré, Charlotte (designer),
 94–95
Cheesman, Dr. John (owner), 342
Cherry: as primary wood, 242; inlay, 376
Cherry, black: as primary wood, 69, 74, 77,
 90, 98, 107, 114, 128, 129, 150, 145, 146,
 176, 178, 179, 233, 235, 237, 262, 264,
 269, 280, 336, 370, 372, 374, 376, 377,
 380; as secondary wood, 77, 84, 109, 138,
 149, 150, 166, 195, 208, 210, 221, 222, 227,
 270, 282, 376; veneer, 153–54, 176, 178,
 179, 269
Cherry Valley, NY: work table in, 282
Cheshire, CT: joint stool in, 128
Chestnut: as secondary wood, 133, 185, 282
Chest of drawers, 359
Cheval glass, 30, 31. See also Screen dressing
 glass
Chew family (owners), 296

Cheyneys, The (dealer), 360
Chimney glass, 26
Chimney Piece of the Honourable Mr. Pelham (Fourdrinier after Kent), *309*
Chimney–Piece with a very rich Frame over it (Rooker after Swan), *311*
Chinnery, Victor (author), 103, 164
Chinn family (owners), 30
Chippendale, Thomas, 14, 82, 147, 172, 268
Chipstone (Milwaukee, WI): related example in, *170*
Christofle (ironworker), 88
Clap family (owners), 121
Clapier, Louis (owner), 325
Clark, Simeon and Susanna (owners), 240
Clarke, Arthur W. (agent), 82, 108–09, 389
Clarke, Marion (agent), 349, 389
Clay, Daniel (cabinetmaker), 130, 175
Claypoole, Josiah (cabinetmaker), 80
Cleaveland, William (joiner), 84
Cleaves, Daniel and Sarah (owners), 310
Cleaves, Robert E. (dealer), 180
Clopper, H.G. (owner), 287
Clytie (nymph), 336
Cockcroft, William (owner), 299
Coe, Adam S. (cabinetmaker), 145
Coffee tables, 94–95
Coffee–Table with Chair (Lathrop), *95*
Coggeshall, Calvert: tea table, 96–97
Coit, Job, Jr. (cabinetmaker), 29
Coit, Job, Sr. (cabinetmaker), 29
Coley family (owners), 341
Collection of Designs for Household Furniture and Interior Decoration, A (Smith), *315, 333*, 334
Colleton, John (owner), 27
Collings and Collings (dealers), 357
Colonial Furniture of New England, The, (Lyon), 126
Colonial Williamsburg (VA), related example in, 380
Communion table, 84
Concord, MA: looking glass in, 306
Conifers, 388
Connecticut: stand, 74–76; tables with drawer, 104, 114–16; falling–leaf table, 120–21; pembroke table, 128–30; dining table set, 146–47; work table, 281–82; card table, 369–70; stand, 376–77. *See also* Bridgeport; Cheshire; Fairfield; Farmington; Granby; Hamden; Hartford; Kensington; Middlebury; Middletown; New Canaan; New Hartford; New Haven; New London; North Haven; Plainville; Rocky Hill; South Wethersfield; West Haven; Weston; Wethersfield; Windham; Windsor
Connecticut Historical Society (Hartford): related example in, 22
Connecticut River Valley: pembroke table, 128–30
Connelly, Henry, 191, 220: work table, 290–93

Console tables, designs, *229*
Constitution mirrors, 343, 347
Cook, Clarence (author), *95*, 264, *343*, 349
Cooke, James H. (cabinetmaker), 284
Cooley, Paul (dealer), 228
Cooper, Dan (designer), *95*, 98, 261
Copper: as primary material, 351
Corner table, 138–40
Corti, P. (looking-glass maker), 305
Corti, Vecchio, Donegani, and Company (craftsmen), 305
Cotter, John P., Jr. (dealer), 178
Cottier and Company (manufacturer), 250
Coverly, Nathaniel, Jr. (printer), 192
Coverly, Nathaniel, Sr. (printer), 192
Cowdrey, Mrs. (owner), 222
Craftsman Workshops: table, 73
Craig, Martin (designer), 98
Crane, Walter (illustrator), 349
Cresson, Jeremiah (owner), 299
Crim, Dr. William H. (collector), 366, 367
Crisand, Emil (artist), 78
Cubism, 258
Cummings, Abbott Lowell (author), 22
Cunningham, Andrew (owner), 332
Cupboard table, *164*
Curran, James (dealer), 379
Curran, Thomas (dealer), 379
Curtain Lecture, The, 119
Curtains, *333, 334*
Curtis, Joel (cabinetmaker), 290
Customs House (New Haven, CT), 144
Cutler, Joseph (owner), 28
Cutler-Bartlett House (Newburyport, MA), 270
Cutt, Ursula (owner), 354

Daggett, Frederick (cabinetmaker), 77
Dali, Salvador, 98
Danish Modern, 100
Dann, Olive Louise (donor), 165, 235, 242, 244, 280, 299, 301, 304, 308, 312, 341, 368, 371; biography, 389
Darlington, Amos, Jr. (cabinetmaker), 76
Dart, John (dealer), 27
Davenport, W.H., 78
Davidson family (owners), 254
Day brothers (owners), 366
Day, William (bishop), 366
De Blok and De Vos (merchants), 339
Dean, George (merchant), 332
Deerfield, MA: tables in, 116
DeFuccio, Robert: extension table, 252
Del Vecchio, Charles (looking-glass maker), 305, 306, 314, 360
Del Vecchio, Francis (looking-glass maker), 305
Del Vecchio, James, Sr. (looking-glass maker), 305
Del Vecchio, Joseph and John Paul: looking glass, 305–06

Del Vecchio family (craftsmen), 327
Delaplaine, Joshua (cabinetmaker), 140, 144, 232, 269
Delius, F. and E. (merchants), 305
Demarest family (owners), 227
Denniston family (owners), 227
Denny, Ebenezer (owner), 228
Derbacher, Karl (upholsterer), 277, 278, 280
Derby family (owners), 34, 82–83, 294–95, 320–21, 331–32
Designs of Inigo Jones (Kent), *309*
Desk and bookcase, *29*
Deskey, Donald (designer), 88, 261, 267
Dalziel, William (cabinetmaker), 250
Dictionary of the English Language (Johnson), *294*
Diederich, Hunt (designer), 88
Dikeman, John (cabinetmaker), 149
Dining tables, 79–80, 135–38, 140–47, 247–49, 250–52, 260–61, 369
Dinner Party, The (Sargent), 16, *17*, 24
Distressed Poet, The (Hogarth), 342
Dixey, John (looking-glass maker), 332, 335
Doggett, John, 262, 295, 296, 297, 305, 327, 328, 332, 361: looking glass, 320–21; label, *320*
Doggett, Samuel, Jr. (craftsman), 321
Douglas, Lloyd (writer), 31
Douglas family (owners), 194
Douglas-fir: as primary wood, 265, 351; as secondary wood, 365
Downing, Andrew Jackson (author), 19, 74, 27, 148, 250, *251*, 257, 364
Drawer construction, *386*
Draw tables: 22, *23*, 260–61
Dreppard, Carl (author), 343
Dresser, Christopher (author), 264
Dressing boxes: with swinging glass, 358–61
Dressing glasses: history, 354–*55*; examples, 348–49, 356–65; constructed from old parts, 378. *See also* Cabinet, earring; Cheval glass; Screen dressing glass; Shaving stands; Swinging glasses
Dressing tables, 101
Drop-leaf table (term), 118. *See* Falling-leaf tables
Drottningholm Palace (Sweden): related example in, 301
DuBois, Mrs. (owner), 152
Dudley, William (owner), 118
Duffour, William (looking-glass maker), 316
Dunand, Jean (artist), 267
Dunbar, Azell (looking-glass maker), 327
Dunham, Emily Phyfe (owner), 222
Dunlap, John, II: card tables, 176–79, 186
Dunlap, Miss, and family (owners), 328
du Pont, Evelina, 34
du Pont, Henry Francis (collector), 291
du Pont, Victorine (owner), 287
Durand–Ruel (dealer), 267
Dyckman, Elizabeth Corne (owner), 268

Eagle supports, *226, 227–28, 229*
Earl, James (artist), *173*
Earl, Ralph (artist), *316*
Easels, 264–65
East Greenville, PA: table, 70–71; dining table, 79–80; extension table, 253
Eastlake, Charles Locke (author), 112, 252, 264, 265
Eastwood, NY: table, *73*
Eaton, Sarah (student), 277
Ebony: as primary wood, 227; veneer, 205, 290
Edenton, NC: tea table in, 91
Edgecomb, Samuel (cabinetmaker), 145
Egerton, John B. (cabinetmaker), 153
Egerton, Matthew, Jr., 284: pembroke table, 151–53
Eggleston, Edward P. (donor), 342
Eglee, Jacob (cabinetmaker), 293
Elfe, Thomas (cabinetmaker), 147, 232
Elliott, John (merchant), 335–36
Elliott, John, Sr. (looking-glass merchant), 32, 296, 299, 309, 336, 357
Ellis, Harvey (architect), *73*
Ellis, John A. (cabinetmaker), 281
Elm: as secondary wood, 132
Emery, Sarah Anna (author), 28, 173, 268
Emmons and Archibald (cabinetmakers), 83
Encyclopaedia of Cottage, Farm, and Villa Architecture and Furniture, An (Loudon), 250
Endicott, John (owner), 80
End table, 95–96
England: chimney glass, 26; looking glasses, 298–301, 301–05, 311–12, 316–20, 330, 371; mirrors, 342, 344–46; dressing glass, 362; pier tables, 366–67. *See also* Brighton; London; Portsmouth
Essex County, MA: work table, 278–80
Essex Institute (Salem, MA): related example in, 188
Étagère, 29
Etchings Representing the Best Examples of Ancient Ornamental Architecture (Tatham), 222
Etting, Solomon (owner), 323
Europe, Continental: looking glasses, 338–41, 370–71; mirror, 367–68
Evans, David (cabinetmaker), 173
Evans, James (looking-glass maker), 360
Evans, Lewis (owner), 294
Evans, Mr. and Mrs. John J., Jr. (donors), *73*
Evans family (owners), 360
Examination table, 77, *78*
Extension-top tables: history, 250; examples, 250–53

Fairchild, Anson T. (cabinetmaker), 182
Fairfield, CT: looking-glass in, 341
Fakes, 378–81
Falling-leaf tables: history, 118; pivot supports: 118–34, constructed from old parts,

374, fake, 380, diagram, *382*; hinged leg supports: 135–46, altered and restored, 369, diagram, *383*; hinged fly supports: 147–63, altered and restored, 369, constructed from old parts, 374, fake, 380
Faneuil, Peter (owner), 166
Farm, The (dealer), 221
Farmington, CT, 390
Farnam, Charles Henry (owner), 364
Farnam, Thomas Wells (donor), 363, 364
Fassitt, Thomas and James (merchants), 316
Faulkner family (owners), 158
Fearon, Henry Bradshaw (author), 295, 296
Federal Hall (New York), 227
Fentham, Thomas (looking-glass maker), 323
Field, Leiter, and Company (manufacturers), 265
Field, Marshall (donor), 373
Fife, Thomas (cabinetmaker), 32
Finlay, Hugh and John (decorators), 277, 323
Fire screen, 377
First, Second, and Last Scene of Mortality, The, (Punderson), 31, *33*
Fischer, Bernard W.: mirror, 351–53; drawing, *352*
Fischer family (owners), 296
Fisher, Julian H. (donor), 89
Fisher, Sidney George (author), 32
Fisk, Samuel, 175: card table, 196–97
Fisk, William: card table, 196–97
Fitts, George (cabinetmaker), 180
Fitzhugh, William (owner), 73–74
Fitzsimmons, George (cabinetmaker), 235
Flayderman and Kaufman (dealers), 327
Flint, Archelaus (cabinetmaker), 270
Foddy, James (looking-glass maker), 294, 301, 354
Folding tables, 257–58
Folwell, John (cabinetmaker), 173
Fondey, John (looking-glass maker), 325
Foote, Amelia (owner), 242
Foote, Sarah Wells (owner), 132, 242
Ford, Mrs. Gordon Lester (owner), 376
Foreman, Martin and Judith (donors), 88
Forman, Benno (author), 118–19, 122, 126
Form and Re–Form (Frankl), 98
Forrester, Ralph E. (cabinetmaker), 163
Forster, Jacob, 270, 281: card table, 191–92
Foster, Mrs. Daniel (owner), 114
Foster Brothers (frame makers), 330
Fourdrinier, P. (engraver), *309*
Frank, Jean–Michel (designer), 94–95, 135
Frankl, Paul T., 14, 95: coffee table, 98
Franklin, Benjamin, 35
Franklin, Josiah (owner), 120
Franklin, VA: tea table in, 91
Franks, Isaac (owner), 542
Fraser, Duncan (looking-glass maker), 335
Fraser, Eliza (owner), 360
Fredericksburg, VA: falling-leaf table in, 126
Frelinghuysen, Rev. John and Dina Van Bergh (owners), 308

Frid, Tage (woodworker), 253
Frothingham, Benjamin (cabinetmaker), 166
Fuessenich, Frederick and Jean C. (dealers), 103
Fuller, Elizabeth (owner), 140
Fuller, Joseph and Mary (owners), 338
Furniture Treasury (Nutting), 327

Gallery Jazz (New Haven, CT), 89
Gansevoort, Catharine (owner), 32
Garvan, Francis P. (donor), 247, 249, 347; biography, 389; dealers patronized by, 391–92. *See also* Mabel Brady Garvan Collection
Gatee, Captain Patrick (owner), 35
Gate-leg table (term), 118. *See* Falling-leaf tables: pivot supports
Gavet, Jonathan (cabinetmaker), 240
Gaylord, Edwin (looking-glass maker), 338
Gaylord, Wells M. (looking-glass maker), 334, 335, 338, 357
Geffroy, Nicholas (looking-glass maker), 30, 306, 324
Gentleman and Cabinet-maker's Director, The (Chippendale), 14, 147, 268
George III, 335
Gerritse, Maria (owner), 32
Gibbs, James (architect), 308, 323
Gillingham, James (cabinetmaker), 236
Gillow, Richard (cabinetmaker), 147, 235, 250
Gilman, Daniel Coit (owner), 364
Girard, Alexander (designer), 98
Girard, Stephen (owner), 220, 293, 316
Glen family (owners), 90
Globes, 262
Goffman, Erving (author), 18
Goldstone, Harmon (distributor), 272
Gonsalves, Lura Bailey (owner), 265
Goodwin, Eliza M. (owner), 330
Gordon, Patrick (owner), 158
Gostelowe, Jonathan: dressing box with swinging glass, 357, 358–61; chest of drawers, *359*
Gothick Colonade, A (Langley), *326*
Gould, William, and Son (looking-glass makers), 323
Gracie, Charles, and Sons (decorators), 267
Granby, CT: table in, 116
Grand Rapids, MI: coffee table, 98
Grand Rapids Furniture Company, 95
Grant, Joseph, Jr. (merchant), 299
Great Industries of the United States, 295
Green, T. (cabinetmaker), 182
Greene, Caleb (merchant), 296
Grinnell, Peter, and Son (looking-glass makers), 296, 332
Griswold, Ursula Wolcott (owner), 235
Guilford County, NC: adjustable stand in, 254
Gumley, John: looking glass, *298*

Hagen, Ernest (cabinetmaker), 158, 217, 372
Haines, Ephraim (cabinetmaker), 293
Haines, Simeon (cabinetmaker), 284
Hains, Adam (cabinetmaker), 148
Hall, Edward T. (writer), 18, 19
Hall, John (designer) 79, 87, 133
Hall, William (owner), 28
Halsey, Richard T.H. (collector), 156, 158, 198, 201, 216, 219, 306, 331, 366, 368, 369, 372, 374, 376, 389
Hamden, CT: coffee table in, 98; card table in, 208
Hammitt, Kenneth (dealer), 116, 196, 214
Hammond family (owners), 82
Hammond–Harwood House (Annapolis, MD), 156, 376, 389
Hancock, John, 28
Hancock, Thomas (owner), 299
Hancock family (owners), 120
Hardwoods, 388
Haring, Elbert (owner), 28
Harkness, Mrs. Edward S. (donor), 242
Harlot's Progress, A (Hogarth), 354, *355*
Harnett, William M. (artist), 14, *15*
Harris family (owners), 255
Harrisburg, PA: card table in, *171*
Harrison, George (owner), 220
Harrison, Wallace (distributor), 272
Hart family (owners), 116
Hartford, CT, 116, 389: card table, 166–67; mirror, 344–45; stand in, 74–76; dining table in, 142–44; falling-leaf table in, 374
Hartmann, Johann (author), 356
Harvard University: exhibition, 369, 370
Harwood family (owners): 82
Haskell, William (cabinetmaker), 186
Hasket family (owners), 82–83
Hatfield, Ann (designer), 98
Hatfield, MA: tables in, 116
Hawthorne, Nathaniel, 30
Hay, Joseph (retailer), 196
Hebron, ME: card table, 174–75
Heckscher, Morrison (author), 169, 170, 244
Heinrich, Francis (artist), *33*
Hemlock: as secondary wood, 206
Hendricks, Harmon (brazier), 362
Henkels, George J. (cabinetmaker), 14, 253
Henri, Robert (artist), 266
Henry Ford Museum (Dearborn, MI): related examples in, 198, 217, 228
Hepplewhite, George, 21, 268, 314, 318, *319*
Heritage Plantation of Sandwich (MA): exhibition, 277
Herman Miller Company: table, 98
Herter Brothers (manufacturer), 264
Hervieu, August (artist), *29*
Hess, George (cabinetmaker), 275
Hewitt, Benjamin A.: writings, 14, 154, 174, 178, 185, 191, 192, 196–97, 209, 314; donations, 116, 154, 174, 176, 178, 179, 183, 188, 190, 191, 195, 206, 208, 214, 221; biography, 389–90

Hewitt, Catherine E. (owner), 341
Hewitt, John (cabinetmaker), 158, 217
Heywood, Jonathan (owner), 309
Hickory: as secondary wood, 77, 146, 151, 170, 174, 179, 183, 185, 191, 204, 206, 214, 285
Hidden Dimension, The (Hall), 18
Hilbert Brothers (dealers), 154
Hill, Henry (owner), 32
Hill, NH: looking glass in, 306
Historic Deerfield (MA): related examples in, 138, 166, 192, 204
Hitchings, Samuel: card table, 192–94
Hoepfner, Edward (restorer), 291
Hoepfner, Otto, and Sons (craftsmen), 222, 240, 302, 349
Hogarth, William, 342, 354, *355*
Holland, MI: cocktail table, 98–100
Hollingsworth, Henry (owner), 293
Holme, Randall (author), 74, 118, 267
Holmes, Edward (cabinetmaker), 284
Holtkamp, Ewald (designer), 272
"Homewood" (Baltimore, MD, house), 389
Hone, Philip (owner), 220
Hood, Raymond (designer), 88
Hook, William (cabinetmaker), 190, 270
Hope, Thomas (designer), 74, 161, 332, 362
Hopkins family (owners), 122
Hornor, William M. (author), 152–53
Hosmer, Joseph (cabinetmaker), 138
House Beautiful, The (Cook), 95, *343*, 349
House Book, The (Leslie), 30
Howe, Edward (owner), 328
Hôtel du Collectionneur, 261
Hôtel Ducharne, 260
Hudnut, Alexander M. (collector), 217
Hughes, Judith (author), 338
Humphrey Courtney (Earl), *173*
Hurlburt, John (owner), 360
Huse, Nancy Pearson (student), 277
Hutchinson, Mrs. Israel Pemberton (owner), 32

Ince, William (cabinetmaker), 294
Ince and Mayhew (cabinetmakers), 82
Independence Hall: exhibition, 360
Indiana: kitchen table, 112–14
InterMetro Industries Corporation: utility cart, 273–74
International Nickel Company, The: kitchen table, 112–14
Ireland: pier tables, 366–67
Iron, as primary material: wrought, 88; sheet, 351
Isaac, Rhys (historian), 22
Ivory: inlay, 282; primary material, 358
Izard, Mrs. Ralph (owner), 34

Jackson, William (looking-glass maker), 310
Jacobs, Carl (dealer), 328
Jacobs, W.M. (dealer), 379
Jacobs Antiques (dealer), 379

James Furniture (wholesaler), 70
Jefferson, Thomas, 250
Jekyll, John (owner), 164
Jelliff, John (cabinetmaker), 111
Jensen, Gerrit (cabinetmaker), 354
John, Eneas P. (cabinetmaker), 271
Johnson, Samuel, 294
Johnson Furniture Company: coffee table, 98
Johnston, Sir William (owner), 118, *119*
Jones, Horace (looking-glass maker), 324, 334
Jones, Inigo, 308
Jones, John (artist), *15*
Jones, William (merchant), 296–97
Joyner family (owners), 91
Judkins and Senter (cabinetmakers), 180, 182
Jugiez, Martin (carver), 295
Juhl, Finn: cocktail table, 98–100

Kay, John (supplier), 84
Keating, Grace (author), 98
Keene, NH: card table, 175–76
Kegel, F.J. (designer), *95*
Keith, William (owner), 118
Kemp, George, and Son (looking-glass makers), 308
Kensington, CT: desk and table in, 116
Kent, George (owner), 192
Kent, Rockwell, 267; mirror, 349–51; drawings, *350*
Kent, William (architect), 227, 308, *309*
Kettell family (owners), 323
Kettle stands: 82
Key, Francis Scott, 367
Kiesler, Frederick (designer), 98
Kimball, Abraham (cabinetmaker), 102
Kimball and Sargent (cabinetmakers), 271
Kimbel, Anthony (designer), 111
Kindig, Joe, Jr. (dealer), 170, 236, 291, 389; address, 391
King, Louis (dealer), 369; address, 391
King, Thomas (designer), 257
King Hooper House (dealer), 204
Kirk, John T. (writer), 16, 24, 127–28, 135, 147
Kitchen table, 112–14
Kneeland, Samuel (cabinetmaker), 32, 304–05, 314
Kneeland and Adams (cabinetmakers), 32, 304–05, 314
Knickerbacker family (owners), 142
Knight, Sarah (author), 22
Knoll, Florence Schust: table, 70–71
Knoll International: table, 70–71; dining table, 79–80; extension table, 253
Knox, Thomas (factor), 164
Krawczyk, Donald E. (woodworker), 365
Kroll, Leon (artist), 267
Kuehne, Max: folding screen, 265–67; mirror, 349–51
Kuehne, Mr. and Mrs. Richard E.(donors), 266, 349, 351

Ladies' Home Journal, The, 250
Ladies New Memorandum Book, The, 323
Lady's Work Table, A (Terry after Sheraton), 275
Ladsen family (owners), 109
Lamar, Mary Hill (author), 32, 90
Laminate veneer, 70, 79
Lamson, Daniel (merchant), 296
Langley, Batty (designer), 323, 327
Langley, Thomas (designer), 327
Lannuier, Charles–Honoré, 74, 220, 221, 224, 228, 255, 362
Lathrop, Francis (illustrator), *95, 343*
Latrobe, Benjamin Henry, 29, 220
Launay, Nicolas de (designer), *229*
Laurel: as primary wood, 108
Law, Jonathan and Stella (owners), 142–44
Lead: as secondary material, 351
Learnard, Elisha (cabinetmaker), 220, 230
Leigh, Peter (owner), 266
Lemon Hill (Philadelphia house), 291
L'Enfant, Pierre–Charles, 227
Leslie, Eliza (writer), 30, 31, 33
Leverett, William, 197, 198, 202, 296: card table, 195–96
Lewis, Eleanor Parke Custis (owner), 247
Lewis, H.L. Daingerfield (owner), 247
Lewis, Lorenzo (owner), 247
Library tables, 102, 109–111
Liebert, Herman W. (donor), 264
Lincoln family (owners), 185
"Linenwald" (Kinderhook, NY, house), 364
Linnell, William and John (cabinetmakers), 314
Little, Bertram K. and Nina Fletcher (owners), 176
Little, W. Torrey, Inc. (dealer), 195
"Little Looking Glass, New Fram'd and Enlarg'd, The," 27
LiVolsi, Joseph (upholsterer), 291
Lloyd, James (senator), 295
Lloyd, William (cabinetmaker), 130
Lloyd Manufacturing Company: end table, 95–96
Lock, Matthias (designer), 314, *315*, 323, 357
Loeb, Mr. and Mrs. John E. (donors), 98
Logan, James (owner), 295, 360
Logan family (owners), 173
London: looking glass, 308–10
London Cabinet Book of Prices, 357, 361
Longfellow, Henry Wadsworth, 102
Looking glasses: with painting, *26*; history in America, 27–35; terminology, 294; connoisseurship, 294–97; with crests with arched centers, 298–308; pediment, 308–14; Neoclassical with openwork crests, 314–23; pillar, 323–58; from Continental Europe, 338–41; small and dressing, 354–65; altered and restored, 370–73; constructed from old parts, 377–78; fake, 381; diagram, *387*. *See also* Chimney glass; Dressing glasses; Mirrors; Pier glasses

Lord and Taylor (department store), 261
Lothrop, Edward (looking-glass maker), 296, 297, 306
Lothrop, Stillman, 296: looking glass, 331–32
Loudon, J.C. (architect), 79, 250, 257, 323
Low, Robert (cabinetmaker), 194
Low–Life "Modern" (Petty), 21, *23*
Low tables, 94–100
Lyman, Luke C. (looking-glass maker), 306
Lyman Allyn Museum (New London, CT): exhibition, 103, 235
Lyng, John Burt (silversmith), 212
Lyon, Charles Woolsey (dealer), 71, 121, 131, 138, 166–67, 180, 182, 262, 269, 277, 287, 327, 345, 374, 377, 378, 389; address, 391
Lyon, Irving P. (owner), 104, 237, 345, 378, 380, 389
Lyon, Irving W. (collector), 74, 92, 104, 126, 130, 237, 345, 374, 378, 380, 389
Lyon, Mary E. (owner), 74. *See also* Penney, Mary Lyon

Mabel Brady Garvan Collection: tables without drawers, 69–70, 71–73, 74–76, 80–83, 90–94; tables with drawers, 102–04, 104–09, 114–16, 368–69; falling-leaf tables, 119–26, 127–32, 136–38, 141–42, 145–47, 149–51, 151–53, 156–61, 166–73, 175–76, 374, 380; card tables, 180–82, 185–86, 197–204, 205–06, 210–12, 214, 215–16, 217–20, 222–30, 369–70, 375–76; tables with turn-up tops, 233–35, 237; stands, 237–40, 245–47, 254–55, 370, 373–74, 381; globe, 262; basin stands, 269–71; work tables, 277–80, 281–82, 283–85, 286–93, 381; looking glasses, 301, 302–03, 305–08, 310–12, 516–23, 526–27, 330–32, 340–41, 354–61, 370–71, 372, 377–78, 381; mirrors, 342, 344–46, 348–49, 367–68; chest of drawers, *359*; dressing glasses, 362, 378; misidentified objects, 566–68; alterations and restorations, 568–73; objects made from old parts, 373–74, 374–76, 377–78; box on stand, 377; fire screen, 377; fakes, 378–79, 380–81
Mabel Brady Garvan Fund, 70. *See also* Mabel Brady Garvan Collection
MacArthur, Warren (designer), 258
MacCarthy, Frank and Helen (dealers), 94, 235, 341, 367, 372, 389; address, 391
McDonald, Elizabeth Bleecker (owner), 32
M'Elwee, John (craftsman), 297
M'Gibbon, James (looking-glass maker), 296, 327
McGuffin, Robert, 274: work table, 290–93
McGuffin and Anderson (cabinetmakers), 293
McIlwaine, Mrs. Clark (donor), 204, 371
McIntire, Samuel Field (carver), 279

McKie, Judy Kensley: snake table, 100–01, 365
McKim, Charles Follen, 343
McKim, Mead and White, 21, 154
Mackintosh, Charles Rennie (designer), 73
Maguire, John J. (owner), 171
Mahogany: as primary wood, 29, *31*, 77, 80, 84, 98, 116, *119*, 130, 132, 133, 136, 138, 141, 142, 144, 149, 150, 151, 153, 154, 156, 158, 162, 163, 165, 166, 167, 169, 170, 171, 174, 175, 180, 182, 183, 185, 186, 188, 191, 192, 195, 196, 197, 198, 201, 202, 203, 204, 205, 206, 208, 210, 213, 214, 215, 217, 218, 219, 221, 222, 224, 225, 227, 230, 231, 237, 240, 242, 247, 277, 278, 280, 282, 285, 286, 289, 306, 333, 335, 349, 357, 358, *359*, 362, 365, 366, 368, 369, 370, 373, 374, 375, 376, 377, 378, 379, 381; as secondary wood, 108, 270, 284, 290, 346, 366, 375; veneer, 146, 149, 150, 151, 156, 158, 162, 163, 169, 174, 175, 179, 180, 183, 185, 186, 188, 191, 192, 195, 196, 197, 198, 201, 202, 203, 204, 205, 206, 208, 210, 213, 214, 215, 217, 218, 219, 221, 222, 224, 225, 230, 240, 278, 280, 282, 285, 286, 289, 304, 305, 306, 308, 310, 311, 312, 333, 335, 336, 345, 346, 349, 357, 362, 363, 367, 369, 371, 372, 373, 374, 375, 376, 381
Maine, 371: stand, 240–41; work tables, 277–78. *See also* Augusta; Bangor; Hebron; Portland
Maine State Museum (Augusta): related example in, 203
Malatre et Tonnellier (ironworkers), 88
Manney, Mr. and Mrs. Richard (collectors), 264
Manual of Domestic Economy, A (Leslie), 30
Maple: as primary wood, 368, 370; inlay, 237; veneer, 179, 182, 185, 188, 191, 198, 202, 204, 205, 230, 280, 282
Maple, hard: as primary wood, 100, 271, 277, 284, 365, 373, 381; as secondary wood, 119, 163, 185, 206, 250, 260, 369; veneer, 260, 271, 277
Maple, soft: as primary wood, 71, 76, 92, 104, 127, 136, 227, 262, 270, 277, 282, 284, 347, 374, 377, 381; as secondary wood, 107, 120, 138, 141, 142, 144, 146, 156, 158, 165, 169, 178, 185, 191, 196, 202, 203, 280, 369, 374; stringing, 149; veneer, 206, 277
Margaret (ship), 266
Margolis, Harold (cabinetmaker), 312
Margolis, Jacob, 108, 124, 149, 150, 176, 202, 203, 204, 205, 212, 349, 370, 373, 375, 389: dining table, 247–49; mirror, 347–48; address, 391–92
Margolis, Nathan (cabinetmaker), 249. *See also* Nathan Margolis Shop
Marie–Antoinette, Queen, 225
Marlboro, MA: card table in, 209

Maryland: falling–leaf table, 126; tea table, 237; stand, 247. *See also* Annapolis; Baltimore; Caroline County; Cecil County; St. George's Island

Maryland Historical Society (Baltimore): related examples in, 87, 335

Maslow, Louis: utility cart, 273–74

Massachusetts: pembroke table, 128–30; dining tables, 136–38; card tables, 182, 230; stands, 237–41; basin stand, 269–70; work tables, 277–81. *See also* Andover; Athol; Berlin; Beverly; Boston; Cambridge; Charlestown; Concord; Deerfield; Essex County; Hatfield; Marlboro; Newburyport; Northampton; Roxbury; Salem; Springfield; Suffolk County; West Newbury; Westport

Mathews, Charles D. (owner), 264

May, Perrin (owner), 185

Mayer family (owners), 291

Mayhew, John (cabinetmaker), 294

Mazzola, Emilio (restorer), 163, 185, 186, 225, 230, 236, 237, 242, 279, 305, 312, 341, 354, 357

Mead, John (cabinetmaker), 279

Meads, John (cabinetmaker), 362

Meeks, John and Joseph (cabinetmakers), 79, 87, 133

Meeks, Joseph (cabinetmaker), 74

Memphis group (Milan), 89

Menominee, MI: end table, 95–96

Merk, Linda (restorer), 353

Mésangère, Pierre de la, 79; pier table, 87

Metal, sheet: as primary material, 112

Metropolitan Museum of Art (New York): related examples in, 14, 30, 379

Meubles et Objets de Goût (Mésangère), 87

Meunier, Nicolas (looking-glass maker), *339*

Meyer, Conrad (artist), 22, *23*

Michigan: end table, 95–96; coffee table, 98; cocktail table, 98–100

Middle Atlantic region: table, 68; dining table, 145–46; card tables, 209. *See also* Maryland; New Jersey; New York; Northeast; Pennsylvania

Middlebury, CT: table with drawer in, 104

Middletown, CT: card table, 166–67

Midwest: extension dining table, 250–52; bridge table, 257–58; easel, 264–65; mirror, 346–47. *See also* Indiana; Michigan; Wisconsin

Mies van der Rohe, Ludwig, 95

Milan, Italy, 89

Miller, Edgar G. (author), 375

Miller, Kenneth Hayes (artist), 266

Miller, Susan (owner), 284

Millicent Todd Bingham Fund, 253. *See also* Bingham, Millicent Todd

Milne, Mr. and Mrs. Kenneth (donors), 373

Minot, Peter (owner), 232

Mirrors: with pier table, 88; terminology, 294; Neoclassical, 321–23; Rococo Revival, 342;

Colonial Revival, 342–49; modernist, 349–53; misidentified, 367–68; design, *315*. *See also* Looking glasses

Misidentified objects, 366–68

Miss Rattle Dressing for the Pantheon, *355*

Mr. and Mrs. Ernest Fiedler and Their Children (Heinrich), *33*

Mitchell and Rammelsberg, (cabinetmakers), 275

Mollino, Carlo (architect), 98

Mondelly, Paul (looking-glass maker), 294

Monel metal: as primary material, 112

Monfrino, G., 305; looking glass, 326–27

Monroe, Daniel (cabinetmaker), 293

Montgomery, Mr. and Mrs. Charles F., 152: donations, 186, 187, 192, 194, 301; writings of Charles F., 202, 287, 306, 314, 321; biography, 390. *See also* Charles F. Montgomery Collection

Montgomery Ward and Company, 252

Monypeny, Perin B. (owner), 73

Moore, Henry (owner), 254

Moore, James: looking glass, *298*

Moore, William (owner), 149

Morris, John R. (carver), 293

Morrison, William (cabinetmaker), 293

Morse, Samuel F.B. (artist), 102, *103*

Morse Family, The (Morse), 102, *103*

Morson, Charles R. (dealer), 107, 240, 285, 371, 377, 389; address, 392

Moulton, Emery (cabinetmaker), 202

Mount, Elizabeth: globe, 262

Mount, Shepherd Alonzo (artist), 262

Mount, William Sidney (artist), 262

Mount family (owners), 262

Mount Vernon (VA house): tea table in, 91

Munn, Stephen Ball (owner), 228

Murray, Amelia (author), 34

Museum of Early Southern Decorative Arts (Winston–Salem, NC), 109

Museum of Fine Arts (Boston): related examples in, 194, 227

Museum of Modern Art (New York): exhibitions, 98, 272

Museum of the City of New York: related example in, 169

Mutschler Brothers Company: kitchen table, 112–14

Myers, Louis Guerineau (collector), 227, 357, 362

Nappanee, IN: kitchen table, 112–14

Nathan Hawley and His Family (Wilkie), *148*

Nathan Margolis Shop (cabinetmakers), 312

Nathaniel Coleman and His Wife (Collins), 275

Natt, Thomas J. (looking-glass maker), 357, 360

Neal, W. (looking-glass maker), 297

Needham, Thomas, II: card table, 188

Needles, John (cabinetmaker), 163, 231

Nelson, Horatio, 323

Newark (NJ) Museum: exhibitions, 161, 214, 353

New Book of Pier–Frames, A (Lock), *315*

New Brunswick, NJ: pembroke table, 151–53

Newburyport, MA: card tables, 183–86; looking glass in, 331

New Canaan, CT: falling-leaf table in, 119–20

New England: trestle table, 14, *15*; stands, 71–73, 370; tea tables, 92–94; table with drawer, 104; falling–leaf table, 127–28; dining table set, 146–47; breakfast table, 163; card tables, 174; looking glasses, 306–07, 330–31, 372. *See also* Connecticut; Maine; Massachusetts; New Hampshire; Northeast; Rhode Island

New Furniture (distributor), 272

New Hampshire: dining table, 136; card table, 182; stands, 240–41, 269–70; work tables, 277–78. *See also* Antrim; Asquam, Lake; Hill; Keene; Portsmouth; Rumney

New Hampshire Historical Society (Concord, NH): related example in, 136; exhibition, 178

New Hartford, CT: stand in, 74

New Haven, CT: examination table, 77, *78*; communion table, 84; pembroke table, 132; stand, 242. Furniture in: 92, 389–90; pier table, 87; tea table, 97; library table, 111; kitchen table, 114; dining table, 144; rising side table, 255; looking glasses, 330, 346; shaving stand, 364

New Haven Colony Historical Society: exhibition, 71, 377

New Jersey: pembroke table, 150–51; work tables, 282–85. *See also* New Brunswick

New London, CT: table with drawer in, 102–04; corner table in, 138–40; mirror in, 342

Newport, RI, 379; basin stand, *268*

New–York Book of Prices for Manufacturing Cabinet and Chair Work, 229, 362

New York, NY: pier table and mirror, 88; buffet table, 88–89; tea table, 90–91; library table, 109–111; pembroke tables, 132, 149, 150–51, 151, 156–58, 158–61; falling-leaf table, 133–35; card tables, 167–70, 209–12, 369; dining tables, 141–42, 142–44, 247–49, 260–61; pillar–and–claw card tables, 217–20; swivel–top card tables, 221–30; stand, 242; folding screen, 265; work tables, 282, 286–90; looking glasses, 305–06, 312–14, *325*, 333–35, 336–37, 372–73; mirrors, 347–48, 349–53; tea table in, 96–97

New York State: table, 73; dining table, 141–42; pembroke table, 150–51; basin stand, 269; work tables, 282–85; looking glass, 337–38; card table, 369–70; pier table in, 379. *See also* Albany; Amenia; Buffalo; Cherry Valley; Eastwood; New York, NY; Rochester; Schenectady County; Setauket; Wingdale

New York State Museum (Albany): related example in, 335
Nichols, W.B. (owner), 377
Nicholson, Eddy G. (collector), 198
Nicholson, Peter and Michael Angelo (designers), 362
Nickelson, Angus (owner), 316
Noe, A.E. (cabinetmaker), 284
Noguchi, Isamu, 95; table, 98
Nolen, Charles and Spencer (looking-glass makers), 296
Nolen, Spencer (looking-glass maker), 306
Nollekens, Joseph (artist), 232, *233*
Norris, John C. (dealer), 392
Northampton, MA: tables in, 116; mirror in, 367–68
North Carolina: table, 69–70; tea tables, 91–92, 237; falling–leaf table, 122–24; adjustable stand, 254–55. *See also* Albemarle Sound region; Edenton; Guilford County; Salem
Northeast: center table, 77–79; pier table, 84–87; table with drawers, 111–12; breakfast table, 133; card table, 231; extension dining table, 250–52; rising side table, 255–57; bridge table, 257–58; pedestal, 264; easel, 264–65; looking glasses, 335–36; mirrors, 346–47, 348–49; shaving stand, 363–65; restored stand, 370. *See also* Middle Atlantic region; New England
North Haven, CT: pembroke table in, 132; looking glass in, 304
Northumberland County, VA, 69
Nutting, Wallace: writings, 22–24, 124, 126, 140, 327; owner of basin stand, 269–70

Oak: as primary wood, *15*
Oak, red: as secondary wood, 104, 120, 145, 156, 171, 214, 260, 376, 380
Oak, white: as primary wood, *23*, 73, 250, 253, 373; as secondary wood, 77, 154, 156, 167, 169, 170, 215, 219, 284, 285, 369, 374, 375
Oatway, Harry (agent), 366
Ocotea: as secondary wood, 347
Oliver, Richard W. (auctioneer), 185
Original Cubist, The (Briggs), *258*
Osborn, J. Marshall and Thomas M. (donors), 88, 133, 260; biography, 390
Osborn, Mr. and Mrs. James M. (collectors), 133, *134*, 260–61, 266; biography, 390
Otis, Harrison Gray (owner), 34
Otis, Samuel Allyne (owner), 360
Ovitt, A.W. and S.D. (manufacturers), 250–51

Pabst, Daniel (cabinetmaker), 111, 250
Padauk: as secondary wood, 365
Paige, T.: stand, 76–77
Paley, Albert: sideboard table, 89
Palladio, Andrea, 308
Palmer, George S. (collector), 140, 367

Paperboard: as secondary material, 257
Paris Exposition (1925), 261, 353
Parkinson, John (looking-glass maker), 316, 361
Parsell, Oliver (cabinetmaker), 274
Parsons, Anna Thaxter (owner), 28
Parsons, Ella (collector), 291
Parsons, John (cabinetmaker), 232
Parsons, Theodosius: tea table, 233–35
Particle board: as secondary material, 70, 79
Paschall, Joseph (merchant), 232
Pascoe, Clifford (importer), 272
Patten, Raymond E.: kitchen table, 112–14
Pedestals, 73–80, 264
Pembroke tables: examples, 128–32, 149–63, 369, 374, 380; history, 147–48
Pendleton, Charles L. (collector), 367
Penn, John (owner), 82, 148, 173
Penn, William, 119
Penney, Mary Lyon (owner), 130, 389. *See also* Lyon, Mary E.
Penniman, John Ritto (artist), 277, 327
Pennsburg, PA, 373
Pennsylvania: tables with drawers, 105–08, 368–69; falling–leaf table, 126; basin stand, 270–71; work table, 284–85. *See also* Catawissa; East Greenville; Harrisburg; Pennsburg; Philadelphia; West Chester; Wilkes–Barre
Pennypacker, A.J. (dealer), 108, 373; address, 392
Percier, Charles (designer), 362
Perit, Peletiah, house (New Haven), 346
Perley, Daniel Jewett (owner), 140
Peter Manigault and His Friends (Roupel), 16, 17
Pettigrew, Charles (owner), 91
Petty, Mary (artist), 21, 23
Phaepoe, Thomas (owner), 32
Phelps, Charles, Jr. (owner), 316
Philadelphia, PA, 227; pier table, 80; table with drawers, 107–08; card table, 116–17, 170–73, 212–16; falling–leaf table, 121–22; pembroke tables, 130; tea table, 235–37; stands, 242–47; work table, 290–93; looking glasses, 315–16, 335; dressing box with swinging glass, 358–61; chest of drawers, *359*; card tables in, 370, 375; pier table in, 379
Philips, John (merchant), 354
Phillips, John Marshall (Art Gallery curator and director), 120, 185
Phillips, Mr. and Mrs. Gifford (donors), 98
Phyfe, Duncan, 87, 147, 161, 217, 220, 222, 228, 268, 274, 284, 287, 290, 361, 362
Pierce, Rufus (cabinetmaker), 163
Pier glasses, 299; Lock designs, *315*; Hepplewhite designs, *319*
Pier tables: history, 80; examples, 82–83, 84–88, 566–67, 378–79; design, *226*. *See also* Console tables

Pine: as primary wood, *15*, 26, 29, 298, 325, 380
Pine, eastern white: as primary wood, 82, 92, 102, 227, 301, 304, 310, 312, 315, 318, 320, 321, 326, 328, 330, 331, 336, 337, 342, 348, 349, 354, 356, 373, 375, 377, 380, 381; as secondary wood, 29, 71, 84, 105, 109, 111, 114, 116, 119, 129, 130, 132, 133, 136, 138, 141, 144, 146, 149, 150, 151, 154, 156, 158, 162, 163, 165, 167, 169, 170, 174, 175, 176, 178, 179, 180, 182, 183, 185, 186, 188, 191, 192, 195, 196, 197, 198, 201, 202, 203, 204, 205, 206, 208, 210, 213, 214, 215, 217, 218, 219, 221, 222, 224, 225, 237, 250, 264, 269, 270, 277, 278, 280, 282, 284, 285, 289, 290, 304, 305, 306, 533, 335, 336, 346, 347, 349, 357, 363, 369, 372, 373, 374, 376, 378, 379, 380, 381
Pine, Ponderosa: as secondary wood, 265
Pine, Scots: as primary wood, 311, 318; as secondary wood, 340, 341, 379
Pine, southern yellow: as primary wood, 69, 104, 381; as secondary wood, 80, 104, 107, 112, 119, 122, 151, 154, 162, 170, 171, 285, *359*, 373, 375, 376
Pine, sugar: as secondary wood, 29
Pine, sylvestris: as primary wood, 316, 318, 321, 330, 341, 345, 370, 377; as secondary wood, 204, 366, 367, 378
Pinkney family (owners), 156
Piranesi, Giovanni Battista (artist), 222
Pitman, Mark: card table, 186–88
Plain, Bartholomew (looking-glass maker), 306, 324, 325
Plainville, CT: looking glass in, 312
Plan & Section of a Drawing Room (Terry after Sheraton), *324*
Plane: as primary wood, 381
Platt, Isaac (looking-glass maker), 295, 323, 338
Plyline Products: tea table, 96–97
Plywood, as primary wood, 271: birch, 95; mahogany, 96; Douglas-fir, 265
Plywood, as secondary wood, 98: from *Ocotea*, 347; Douglas-fir, 351; birch with Douglas–fir core, 365
Poganuc People (Stowe), 31
Politics in an Oyster House (Woodville), 19, *20*
Polk, Christine Stevens Mayer (owner), 291
Poor, Mary Ann (student), 277
Portland, ME: mirror in, 322; looking glass in, 371
Portsmouth, England: mirror, 321–23
Portsmouth, NH, 136, 378: tea tables, 82, 373; pembroke tables in, 130; card table, 180–82; card table in, 190
Post, Emily, 94, 114, 271
Post, Walter and Ulilla (owners), 252
Postell, James (owner), 30
Post Road Antiques (dealer), 264
Potts, Meriam (owner), 27

Powell, Samuel (merchant), 27
Pratt, Henry (merchant), 291
Pratt, Susan Theresa (owner), 291
Pratt, Wayne (dealer), 179
Prendergast, Charles (artist), 267
Prendergast, Maurice (artist), 267
Price, Larry (restorer), 518
Prichard, Mary Briggs, house (New Haven),
 87, 111
Priou, Gaston (artist), 267
Priscilla Shop (dealer), 205–06
Prodigal Son Receiving His Patrimony, The
 (Doolittle), 19
Prodigal Son Revelling with Harlots, The
 (Doolittle), 19, 20
*Proposed Interior Elevations for the Dining
 Room of the Tayloe House* (Latrobe), 29
Prouty, Amariah Taft (cabinetmaker), 284
Providence, RI: card tables, 206–09
Pumphrey, Elizabeth (owner), 376
Punderson, Prudence (needleworker), 31, 33

Quervelle, Anthony G. (cabinetmaker), 28,
 275
Quincy, Eliza Susan (author), 35

Radford, Benjamin (cabinetmaker), 241
Randall, Richard (author), 227
Rateau, Armand–Albert (designer), 101, 267
Rauschenberg, Bradford (author), 109
Rawson, George Burrill (cabinetmaker), 265
Rawson, Joseph, Sr., 251: card table, 203,
 206–08
Rawson, Samuel, 251: card table, 203,
 206–08
Ray, John (cabinetmaker), 163
Recueil d'Antiquités (Comte de Caylus), 222
Redcedar: as secondary wood, 376
Redcedar, eastern: as secondary wood, 358
Redgum: as secondary wood, 119, 156, 167,
 369
Reed, Abner (engraver), 313
Reed, Brooks (dealer), 380; address, 392
Reeves, Ruth (designer), 258
Reifsnyder, Howard (collector), 128, 171, 370,
 375
Repository (Ackermann), 562
Restorations, 368–73
Revere, Paul, II (owner), 185
Reynolds, James, 30, 294, 296, 310, 339:
 swinging glass, 357, 358–61
Reynolds, Joseph (owner), 120
Rhode Island: dining tables, 144–45, 146–47;
 work table, 281–82. *See also* Block Island;
 Newport; Providence
Richardson, Francis (silversmith), 294
Richardson, John (owner), 270
Richardson, William S., 154
Richmond, Louis (dealer), 377; address, 392
Richmond, VA: falling-leaf table in, 124
Ridout family (owners), 156, 516
Riesener, Jean-Henri (cabinetmaker), 225

Rietveld, Gerrit Thomas (designer), 89
Riker family (owners), 142
Rising side table, 255–57
Ritchie, Andrew C. (owner), 96
Ritchie, Jane (donor), 96
Rittenhouse, David (owner), 173
Robbins, Silas and Elisha (merchants), 345
Robbins Brothers (cabinetmakers), 74, 374
Robertnier, Louis de (author), 32
Roberts, Thomas, 116
Robie, Virginia (author), 342
Robinson, Charles N. (looking-glass maker),
 562
Rochester, NY: sideboard table, 89
Rockefeller, Laurance (distributor), 272
Rockford Union Furniture Company, 252
Rockwell, Norman, 16, 18
Rockwood, James (cabinetmaker), 220
Rocky Hill, CT: falling-leaf table in, 374
Rogers, Katherine R. (owner), 120
Rohde, Gilbert (designer), 258, 353
Rollinson, William (engraver), 209
Rome, Italy, 375
Rooker, Edward (engraver), 311
Rorimer, Louis (designer), 261
Rose Bush, The, 31
Rosewood: as primary wood, 29, 215; veneer,
 151, 186, 188, 191, 198, 205, 227, 286, 290
Rosewood, Brazilian: as primary wood, 133
Roupel, George (artist), 16, 17
Roux, Alexander (cabinetmaker), 111
Rowley, Charles C. (supplier), 84
Rowson, Susanna (teacher), 262
Roxbury, MA: card table, 196; looking glass,
 320–21
Rubber: as primary material, 89, 112
Ruggles, Nathan (looking-glass maker), 314,
 327; label, 313
Ruhlmann, Jacques–Émile (cabinetmaker),
 94–95, 260–61
Rumney, NH: card table in, 192
Rundlet, James (owner), 182
Russell, Joseph Shoemaker (artist), 74, 75
Russell, Nathaniel (owner), 34

Saarinen, Eero: dining table, 79–80
Sack, Israel (dealer), 140, 186, 204, 228, 326
St. George's Island, MD: falling–leaf table in,
 124
Salem, MA, 136: communion table in, 84;
 corner table, 138–40; card tables, 186–91,
 293; looking glass, 328, 331–32
Salem, NC: tables in, 69
Sanders family (owners), 90
Sanderson, Elijah (cabinetmaker), 252, 279
Sanderson, Jacob (cabinetmaker), 202, 252
Santa Monica, CA: cocktail table in, 98–100
"Sarah" (student), 277
Sargent, Henry (artist), 16, 17, 24, 265
Sargent family (owners), 265
Satinwood: as primary wood, 290; veneer,
 153, 154, 180, 197, 201, 203, 205, 213, 286,
 290; inlay, 285, 376

Saunders, Judith (teacher), 262
Sayward, Jonathan (owner), 302
Schenectady County, NY: falling–leaf table,
 118, 119
Schloss Pillnitz (Germany), 140
School for American Craftsmen, 253
Schumo, Barney (turner), 293
Scott, Charles (cabinetmaker), 240
Scott, Dr. Upton (owner), 366–67
Scott, Dorothy (collector), 170
Screen dressing glass, 362–63. *See also* Cheval glass
Screens, folding: 265–67
Sebring, Isaac (owner), 158
Seddon, Sons and Shackleton (cabinet-
 makers), 274
Semon Bache and Company (manufacturers),
 88
Sergeants, The (dealer), 188
Setauket, NY: globe, 262
Setze, Josephine (Art Gallery curator), 151
Sewall, Samuel, 22
Seymour, John and Thomas (cabinetmakers),
 361
Seymour, Lot Norton (owner), 74
Seymour, Thomas (cabinetmaker), 196, 277
Sharp, Horatio (owner), 316
Shaving stands, 363–65
Shaw, John, 357: pembroke table, 156
Shaw, Thomas (owner), 145
Shearer, Thomas (designer), 357
Sheeler, Charles (artist), 267
Sheldon, Epaphras (owner), 130
Sheraton, Thomas, 18, 28, 147, 180–82, 225,
 233, 250, 257, 268, 270, 271, 274, 275,
 291, 294, 299, 305, 306, 314, 323, 324,
 327, 336, 362, 375
Shipley, George, 149; card table, 208–09
Short, Joseph: card table, 183–85
Sideboard, 29
Sideboard tables, 80–82, 89
Simons, Edwin (cabinetmaker), 74, 126
Skeel, Emily E.F. (donor), 376
Slade, Marie–Antoinette (donor), 100, 365
Slee, Richard (refinisher), 209
Sloane, W. and J. (department store), 258
*Small Tables Which Go Far Toward Human-
 izing Any Room* (Kegel), 95
"Smartline" (trade name), 112–14
Smee, William, and Sons (cabinetmakers),
 364
Smith, Catherine A.: bridge table, 257–58
Smith, George (designer), 74, 161, 233, 257,
 297, 306, 315, 324, 333, 334, 562
Smith, Isaac (owner), 136
Smith, John: card table, 192–94
Smith, John Duke (owner), 154
Smith, Keith (donor), 95, 271, 272; biography,
 390
Smith, Mary Byers (donor), 154
Smith, Paschal N. (owner), 144
Smith, Rev. Thomas (owner), 308

Smith, Robert (owner), 228

Snake table, 100–01

Snead, Robert Whitehurst (owner), 237

Snyder, C. Edward (dealer), 312; address, 392

Sognot, Louis (designer), 258

Somers family (owners), 215

Somerson, Rosanne: earring cabinet, 365

Somerville, R.S. (dealer), 92; address, 392

Somner, Robert (writer), 18–19

Soule, Robert M. (restorer), 178

Southampton County, VA: table in, 91–92

South Carolina: table without drawers, 69–70. *See also* Charleston

South-Carolina Gazette, 299

Southeast: table with drawer, 104–05; falling-leaf table, 124–26. *See also* Maryland; North Carolina; South Carolina; Virginia; Washington, DC

South Parlour of Abraham Russell (Russell), 74, 75, 147

South Wethersfield, CT: box on stand in, 377

Spadaccino, Patrick M., Jr. (collector), 190

Spanish-cedar: as primary wood, 333, 381

Speicher, Eugene (artist), 267

Spencer, Thomas (cabinetmaker), 194

Spooner, Alden: card table, 179–80

Spooner and Fitts (cabinetmakers), 180

Spooner and Thayer (cabinetmakers), 180

Spotswood, Mr. and Mrs. Alexander (owners), 32, 90

Sprackling, Helen (author), 353

Springfield, MA: stand, 76–77

Spruce: as primary wood, 301, 302, 308, 318, 321, 344, 371; as secondary wood, 156, 202, 206, 299, 311, 316, 341, 345, 358, 362, 371

Stands: stationary tops, 71–73, 74–77, 373–74; tops that turn up, 237–47, 370, 376–77; adjustable, 254–55, 381

Stebbins, Theodore E. (donor), 264

Steel, as primary material: 70, 88, 89; mesh, 88; sheet, 88, 89; tube, 88, 95, 112

Stephens, William (designer), 253

Stetson, Charles (donor), 240, 241

Stevens, Linus W. (looking-glass maker), 335

Stevenson, Peter (owner), 147

Stewart family (owners), 220

Stewart G. Rosenblum Fund, 273

Stickley, Gustav: table, 73

Stickley, L. and J.G. (manufacturer), 233

Stickley–Brandt Furniture Company, 252

Stijl, De, 89

Stiles, Ezra (owner), 132, 242

Stiner, Mr. and Mrs. Richard (donors), 112

Stinson, Carl W. (dealer), 209

Stockholm, 301

Stockholm, Royal Palace: related example in, 339

Stocking, Luther (owner), 116

Stokes, James (cabinetmaker): pembroke table, 130–31

Stokes, James (merchant), 323, *324,* 325, 328: looking glass, 315–16

Stone family (owners), 328

Storer, Ebenezer (owner), 35

Stott, Robert (merchant), 361

Stowe (Buckinghamshire, England, house), 357

Stowe, Harriet Beecher, *19,* 31

Strickland, Peter L.L. (author), 334

Strong, Henry H. (donor), 76

Study Collection, 366–81

Study Table, A (Harnett), 14, *15*

Subes, Raymond (ironworker), 88

Suffolk County, MA, probate records, 294

Surrealism, 98

Susanna Rowson's Academy, 277

Swaine family (owners), 144

Swan, Abraham (designer), 310, *311*

Swan, James (owner), 230

Swan, Mabel M. (author), 196

Swartwout, Egerton (architect), 249

Sweden, 301, *339:* looking glass, 341

Sweeney, John (looking-glass maker), 335

Sweetgum: as primary wood, 257, 269

Swinging glasses: history, 354; examples, 348–49, 357–65; constructed from old parts, 378. *See also* Dressing glasses

Sycamore: as primary wood, 120, 377

Sykes, Reuben (cabinetmaker), 231

Symonds, R.W. (author), 294

Syntagma pathologicotherapeuticum (Hartmann), 356

Sypher and Company (merchants), 342–43, 349

Table Manners (Meyer), 22, 23

Tables: social role of, 14–24; stationary tops without drawers, 69–101; 366–67, 368, 373, 378–80; stationary tops with drawers, 101–17, 368–69, 373, 377; diagrams, 382–87. *See also* Basin stands; Breakfast tables, Buffet table; Card tables; Center table; Coffee tables; Console tables; Corner table; Cupboard table; Dining tables; Draw tables; Dressing tables; End table; Examination table; Extension-top tables; Falling-leaf tables; Kitchen table; Library tables; Low tables; Pembroke tables; Pier tables; Rising side table; Sideboard tables; Snake table; Stands; Tea tables; Trestle table; Turn-up tops, tables with; Work tables

Taney, Roger Brooke (owner), 366

Tatham, Charles Heathcote (author), 222

Tatham, John (owner), 354

Tavern table (term), 101–02

Taylor, Henry Hammond (agent), 105, 132, 142, 147, 161, 167, 186, 254, 279, 284, 305, 322, 370, 371, 389; address, 392

Taylor, Mary (agent), 392

Tea tables, 82: square, 89–94; low, 96–97; turn-up tops, 233–37; altered, 368; constructed from old parts, 373; fake, 379

Tea trolley 271–72

Temple of Antoninus and Faustina, 375

Terry, G. (engraver), *181,* 275, *324*

Textile, "Electric" pattern (Reeves for Sloane), *258*

Thanksgiving Dinner, 20, *21*

Thayer (cabinetmaker), 180

Thayer, Ziphion (merchant), 294

Thespesia: as primary wood, 366

Things New and Old (Lathrop), *343*

Thomas, Elias (looking-glass maker), 295, 306, 324, 335

Thompson, Hugh (owner), 274

Thompson, Miss (owner), 367–68

Tiffany Studios (dealers), 366; address, 392

Tilia: as primary wood, 318, 340

Tillman, William I. (looking-glass maker), 324, 325

Tilt-top table (term), 232. *See* Turn-up tops, tables with

Tischzucht (Meyer), 22, 23

Todd, James (looking-glass maker), 295, 296, 306, 318

Todd, William (cabinetmaker), 204

Toilet, The (Hervieu), 29

Tower family (owners), 360, 361

Townsend, John (cabinetmaker), 135

Trail, John (owner), 28

Traveling box, 275

Treat, Adna (looking-glass maker), 335

Trestle table, 14, *15*

Trick-leg table (term), 216. *See* Card tables, pillar-and-claw

Trollope, Frances, 34

True, Joseph (cabinetmaker), 190, 233

Trumbull, Caroline (author), 32

Tuck, Fred Bishop (dealer), 254

Tucker, Elisha (cabinetmaker), 202, 306

Tufft, Thomas (cabinetmaker), 173

Turn-up tops, tables with: history, 232–33; examples, 233–49; diagram, *385. See also* Stands; Tea tables

Two Children of the Nollekens Family (Nollekens), 232, *233*

Tyler, Royall (owner), 35

Uncle Tom's Cabin (Stowe), 31

United States Capitol, 111

United States Department of State, Diplomatic Reception Rooms: related example in, 198

Utility cart, 273–74

Utility of Cork Rumps 1777, The, 355

Vaill, Edward W. (manufacturer), 257

Valentine, H.C., and Company (dealer), 124; address, 392

Van Buren, Martin, 364

Van Doorn, Anthony (cabinetmaker), 271

Van Liew family (owners), 161, 167–69

VanName, Ralph G. (owner), 255

Vannuck, P. (looking-glass maker), 318, 327
Van Rensselaer, Elizabeth (owner), 360
Van Rensselaer, Philip (owner), 309
Van Rensselaer, Solomon (owner), 79
Van Rensselaer, Stephen, IV (owner), 220, 323
Vardy, John (designer), 227
Vasi (Piranesi), 222
Versailles, 229, 230
Vicksville, VA: table in, 91–92
Virginia: table without drawers, 69–70; tea tables, 91–92, 237; falling–leaf tables, 122–24, 126; stand, 247; work table, 285–86. *See also* Franklin; Fredericksburg; Northumberland County; Richmond; Southampton County; Vicksville; Williamsburg; Yorktown
Virginia Museum of Fine Arts (Richmond): exhibition, 122
Voight, William (merchant), 323, 324, 325
Vorce, A.D., and Company (retailer): mirror, 344–45
Vorce, Allen D. (merchant), 345
Voysey, C.F.A. (designer), 73

Wadsworth Atheneum (Hartford, CT): exhibition, 103, 115, 235; related example in, 104
Wallick, Ekin (author), 250
Waln, William (owner), 220
Walnut: as primary wood, 29; as secondary wood, 270; veneer, 299, 301, 302, 340, 341, 344, 371, 378
Walnut, black: as primary wood, 91, 98, 105, 108, 109, 111, 119, 121, 122, 124, 133, 214, 244, 245, 253, 254, 255, 369, 373, 379; as secondary wood, 70–71, 162; veneer, 214, 253
Walter, Thomas U. (architect), 111
Walton, John, Inc.(dealer), 116
Walton, Mr. and Mrs. John M. (donors), 77
Wanamaker's (department store), 270
Wansey, Henry (author), 262
Ware, Isaac (architect), 308
Washington, DC: tea table, 96–97
Washington, George, 91, 135, 164, 247, 294, 296, 310, 516; commemoratives, 523, 524
Washington, GA: card table in, 220
Washington mirrors, 343, 347
Watson, F.J.B. (author), 118
Watson, John Fanning (author), 252
Watson, Mrs. Philomen (dealer), 126; address, 392
Watson, O. Michael (writer), 18
Wayne, Caleb Perry (merchant), 516
Wayne, Jacob (cabinetmaker), 268
Webb, Adrian (cabinetmaker), 240
Weber, Kem (designer), 96
Webster, Noah, 376
Webster, Rebecca Greenleaf (owner), 576
Weil, Henry V. (dealer), 82, 90, 115, 205, 282, 310, 320, 321, 356, 381, 389; address, 392

Welch, John (carver), 227
Wendell, Jacob (owner), 180
Wentworth, Thomas H. (artist), 74, 75
Werner, Charles J. (antiquarian), 262
West, Elizabeth Derby (owner), 185, 321
West Chester, PA: stand in, 76
West Haven, CT: looking glass in, 372
West Newbury, MA: table in, 128
"Westomere" (New London, CT, house), 140
Weston, CT: looking glass in, 341
Westport, MA: earring cabinet, 565
Westtown (PA) School, 262
West Town House (New York, NY, store), 273
Wetherill, Thomas (cabinetmaker), 220
Wethersfield, CT: table in, 116
Weyman, Edward (looking-glass maker), 296
Wharton, Richard (owner), 119
Whipple family (owners), 158
White-cedar, Atlantic: as secondary wood, 107, 121, 170, 171, 315, 358, *359*
"Whitehall" (Annapolis, MD, house), 316
Whitehead, A. Pennington (donor), 282
Whitehead, William (cabinetmaker), 212
White House, 21
Whiting, Stephen, Sr. (looking-glass maker), 302
Wiener Werkstätte, 351
Wildenstein and Company (dealer), 267
Wilder, I. (owner), 158
Wilder, Isaiah (cabinetmaker), 182
Wilk, Christopher (author), 96
Wilkes–Barre, PA: utility cart, 273–74
Wilkie, William (artist), *148*
Wilkinson and Traylor (dealers), 70; address, 392
Williams, John H., 338: looking glass, 333–35
Williams, Samuel (PA cabinetmaker), 232
Williams, Samuel S. (MA looking-glass maker), 321
Williamsburg, VA: tea table in, 91
Williford, D. (merchant), 296
Willing, Charles (merchant), 299, 305
Willis, Robert (looking-glass maker), 332
Willton, Edward: mirror, 321–23
Wilmerding, William (merchant), 304, 305, 314
Windham, CT: tea table, 233–35
Window Curtain (Smith), *333*
Windsor, CT: draw table, 22, *23*
Wingdale, NY: mirror in, 353
Winne, Jellis (looking-glass maker), 325
Winslow, Joshua (owner), 120
Winterthur (DE) Museum: related examples in, 85, 158, 188, 202, 212, 236, 291, 295, 295, 314
Wirt, William (author), 35
Wisconsin: tea trolley, 271
Wise, Daniel (cabinetmaker), 186
Wood, David (cabinetmaker), 205
Wood, John and Rebecca (owners), 135
"Woodlawn" (Fairfax County, VA, house), 247

Woodruff, George (cabinetmaker), 151
Woods, list of, 388
Woodville, Richard Caton (artist), 19, *20*
Worcester (MA) Art Museum, related example in, 267
Work tables: history, 274–75; examples, 276–93, 381
Wragg, Joseph (owner), 28
Wright, Mrs. Glen (donor), 163, 376; biography, 390

Yale Biennial Examination (Crisand), 77, *78*
Yale University: Alumni Hall, 77, *78*; College Chapel, 84, *85*; Infirmary (Prospect Street), 79, 252; Library, 144; Beinecke Rare Book and Manuscript Library, 274; Saybrook College, 336; Faculty Club, 349
Yale University Art Gallery: office furniture, 70, 79, 249, 253, 348; exhibitions, 87, 88, 91, 165, 167, 174, 176, 178, 179, 180, 185, 186, 188, 190, 192, 194, 197, 198, 203, 204, 205, 208, 209, 212, 214, 264, 360, 370, 374, 375, 376; commissions, 89, 100, 365
Yates, Joseph C. (owner), 325
Yellow-poplar: as primary wood, 82, 264, 308, 346, 358, 365, 369; as secondary wood, 77, 84, 88, 98, 104, 105, 107, 108, 109, 112, 116, *119*, 121, 122, 132, 141, 145, 149, 150, 151, 154, 156, 158, 162, 166, 169, 170, 171, 210, 214, 215, 219, 222, 224, 227, 231, 250, 255, 271, 280, 282, 289, 290, 304, 305, 312, *359*, 363, 368, 372, 373, 376, 377, 381
York, Pennsylvania, Family with Servant, 26, 27
Yorktown, VA: card table in, 172
Young, Stephen and Moses (cabinetmakers), 158

Zea, Philip (author), 180
Zebrawood: veneer, 186
Zelman, David: buffet table, 88–89

PHOTOGRAPH CREDITS

All photographs are by Charles Uht with the exception of those noted below. Photographs of objects in other collections were supplied by the owners. Additional acknowledgments appear below.

Michael Agee: cats. 17, 183; Figs. 9, 17, 41, 51, 55, 56, 60, 68, 76, 82; color plate 10, p.48.

Gilbert Ask: Fig. 66.

The Beinecke Rare Book and Manuscript Library, Yale University, New Haven: Figs. 11, 16, 28, 49, 69, 70, 72.

E. Irving Blomstrann: cats. 12, 49 (detail), 50, 67, 99 (details), 112, 123 (detail), 170, 175, 180, 182, 185, 186, 206, 207 (detail), A4, A8.

Richard Caspole: cat. 181 (detail); Figs. 64, 65, 75, 83.

Country Life, Ltd.: Fig. 63.

Curtis Publishing Company: Fig. 10.

Emiddio de Cusati: cat. A15.

David Hays: Fig. 59.

General Photographic Company, New York City: cat. A25.

Helga Photo Studio: Fig. 22.

Israel Sack, Inc., New York City: Figs. 71, 73.

Kungl. Husgerådskammaren, Stockholm: Fig. 77.

Allan I. Ludwig: cats. 127 (view with top up), 164, 192, 193, A2, A11, A26, A30, A32, A33.

The Metropolitan Museum of Art, New York: Fig. 78.

The Museum of Modern Art, New York: Fig. 57.

Museum of the City of New York: Fig. 33.

Natchez Photos: Fig. 27.

Henry E. Peach: Fig. 30.

Statens Konstmuseer, Stockholm: Fig. 52.

Joseph Szaszfai: cats. 5 (detail), 50 (closed view), 78, 80, 81, 89 (detail), 90 (detail), 93 (detail), 96, 98 (details), 107, 108 (detail), 150 (details), 156 (detail), 162 (detail).

Unknown: cats. 28, 86, 147, 195, A3, A5, A10, A12, A14, A24, A27, A38, A39.

Yale Center for British Art, New Haven, Paul Mellon Collection: Figs. 64, 65, 75, 83.

Yale University Library, New Haven: Figs. 40, 69, 70, 79.

Design	Greer Allen
Typesetting	Yale University Printing Service
Diagrams	John O.C. McCrillis
Mechanical art	Page Rhinebeck
Printing	Stinehour Press
Binding	Acme Bookbinding Company